THE
IMPRESSIONISTS

THE IMPRESSIONISTS

A RETROSPECTIVE

Edited by Martha Kapos

BEAUX
ARTS
EDITIONS

"Happy energies and a shadow in the act of painting"
for Andrea and Peter

ISBN 0-88363-972-6

This book was produced by Elisabeth Ingles, London, for Hugh Lauter Levin Associates, Inc.

Designer Robert Updegraff
Typeset by Rowland Phototypesetting Ltd., Bury St Edmunds, UK
Printed in China

The excerpts in this book are reproduced by kind permission of the copyright owners and publishers, as follows:

George Heard Hamilton, *Manet and His Critics*, 1986. Yale University Press, New Haven and London. Reprinted by permission.

Pierre Courthion and Pierre Cailler (eds.), *Portrait of Manet by Himself and His Contemporaries*, trans. Michael Ross, 1960. By permission of Macmillan Publishing Co., New York.

Daniel Wildenstein, *Claude Monet, Biographie et Catalogue Raisonné*, Vols. 1–4. © 1974 Daniel Wildenstein. Bibliothèque des Arts, Lausanne/Paris.

Jean Renoir, *Renoir My Father*, trans. Randolph and Dorothy Weaver, 1958. Reprinted by permission of Little, Brown and Co., Boston/Toronto, and A. D. Peters & Co. Ltd., London.

Émile Zola, *Salons*, recueillis, annotés et présentés par F. W. J. Hemmings et Robert J. Niess. By permission of Librairie Droz, Geneva.

The Correspondence of Berthe Morisot, edited by D. Rouart, 1957. By permission of Lund Humphries Publishers, London.

Bazille and Early Impressionism, exhibition catalogue, trans. J. Patrice Marandel, 1978. Courtesy of the Art Institute of Chicago.

Lionello Venturi, *Les Archives de l'Impressionnisme*. Durand-Ruel, Paris/New York, 1939. Reprinted by permission.

John Rewald, *Studies in Impressionism*, 1985. Reprinted by permission of Thames and Hudson Ltd.

Ambroise Vollard, *Degas, An Intimate Portrait*, (1937) 1986. By permission of Dover Publications Inc., New York.

Paul Valéry, *Degas Manet Morisot*, trans. David Paul. Routledge, UK, and Princeton University Press, USA, 1960. By permission.

J.-K. Huysmans, *L'Art Moderne*, Paris 1928–40. By permission of Christian Bourgois Éditeur, Paris.

John Rewald, *A History of Impressionism*, 1961. © the author.

Janine Bailly-Herzberg (ed.), *Correspondance de Camille Pissarro*, Presses Universitaires de France, Paris, 1980. Reprinted with permission.

John Rewald, *Paul Cézanne*. By permission of Schocken Books, Inc., New York, 1988.

The Complete Letters of Vincent van Gogh, 1958. Reprinted by permission of Thames and Hudson Ltd.

Ambroise Vollard, *Renoir: An Intimate Record*, trans. Van Doren and Weaver. © 1925, renewed 1953 Alfred A. Knopf Inc. Reprinted by permission of the publisher.

Walter Pach, *Queer Thing, Painting*. © Harper and Row, New York, 1938. Reprinted by permission of the publisher.

John Rewald (ed.), *Camille Pissarro, Letters to His Son Lucien*, Routledge, UK, and Paul Appel, USA, 1980. By permission.

Gerd Muehsam, *French Painters and Paintings from the Fourteenth Century to Post-Impressionism: A Library of Art Criticism*. © The Frederick Ungar Publishing Company, New York.

Françoise Cachin (ed.), *Félix Fénéon, Au-delà de l'impressionnisme*, (1887) 1966. By permission of Librairie Droz, Geneva.

Edward Fry, *Cubism*, 1966. Reprinted by permission of Thames and Hudson Ltd.

Kate Flint (ed.), *The Impressionists in England: The Critical Reception*, Routledge, 1984. By permission.

Hans Hofmann, "On the Aims of Art," trans. Ernst Stolz and Glenn Wessels, 1932. Reprinted with permission of Addison Gallery of American Art, Phillips Academy, Andover, Massachusetts.

Alfred Barr, *Matisse, His Art and His Public*. © Museum of Modern Art, New York, 1951.

Gaston Bachelard, *The Right to Dream*, originally published 1970 as *Le droit de rêver*, © 1970 Presses Universitaires de France. Translation by J. A. Underwood first published in USA in 1971, © 1971 The Viking Press, Inc., and reprinted by The Dallas Institute Publications, © 1988.

Clement Greenberg, "Claude Monet – The Later Monet," © Clement Greenberg 1957.

Kenneth Clark, *Landscape into Art*, 1961. By permission of John Murray (Publishers) Ltd. and HarperCollins Publishers, Inc., New York.

Rosalind E. Kraus, "Manet's Nymph Surprised." By permission of The Burlington Magazine, London.

Michel Butor, "Monet, or the World Turned Upside-Down." By permission of *ARTnews* Associates, New York.

Anton Ehrenzweig, *The Hidden Order of Art*, Weidenfeld & Nicolson Ltd, 1968. Reprinted by permission.

Thomas Crow, "Modernism and Mass Culture." By permission of the author (Professor of History of Art, University of Sussex).

Lawrence Gowing, "Renoir's Sentiment and Sense," 1985. By permission of the author. © Estate of Lawrence Gowing.

Christopher Yetton, "The Pool of Narcissus." © 1990 Christopher Yetton.

Full information for each excerpt is given in the Bibliographical Index, page 10.

Jacket: Detail of *Oarsmen at Chatou* by Pierre-Auguste Renoir. 1879. National Gallery of Art, Washington DC (Gift of Sam A. Lewisohn). See Colourplate 54.

CONTENTS

ACKNOWLEDGEMENTS

In a large measure I owe my understanding of Impressionism to my teachers in the studio and in the lecture theatre who are now colleagues and friends, in particular to Christopher Yetton and Nicholas Wadley whose advice and support throughout this project have been very valuable to me. My warmest thanks are due to Steven Bury, the head librarian at the Chelsea School of Art, and to Liz Ward on his staff who both came to my rescue on innumerable occasions. I would also like to thank Michael Doran, the head librarian at the Courtauld Institute, for his generous assistance. I am grateful to Barbara Wright and especially to Judith Landry for their work on the translations, and to the research, design and editorial team who worked with me, to Sara Waterson, to Robert Updegraff and particularly to Elisabeth Ingles for her congenial and conscientious supervision of this book in all of its stages. I am also grateful for more than help to two people, David Black and James Greene.

MARTHA KAPOS

Bibliographical Index

Full details of each source book are listed at the first reference, and in abbreviated form thereafter. Where a later edition has been used, the original publication date is given in parentheses. Translations of material previously unpublished in English are by Judith Landry.

p. 39 Claude Pichois (ed.), *Lettres à Baudelaire*, IV, No. 5 of *Langages: Études Baudelairiennes*, Neuchâtel 1973, pp. 233–4. G. H. Hamilton, *Manet and his Critics* (1954), London & New Haven 1986, p. 40.

p. 40 T. J. Clark, "Preliminaries to a possible treatment of *Olympia* in 1865," *Screen*, Spring 1980, pp. 27–9.

p. 50 Pierre Courthion and Pierre Cailler (eds.), *Portrait of Manet by Himself and his Contemporaries* (1950), trans. Michael Ross, Cassell, London 1960.

p. 54 Daniel Wildenstein, *Claude Monet, Biographie et Catalogue Raisonné*, Bibliothèque des Arts, Lausanne/Paris 1974, Vol. I, W. 8, p. 420. Wildenstein op. cit., W. 11, I, p. 421.

p. 56 Jean Renoir, *Renoir My Father*, Little Brown, Boston/Toronto 1958, pp. 109–111, 113–15.

p. 58 Wildenstein op. cit., W. 40, I, p. 425. Wildenstein op. cit., W. 44, I, pp. 425–6.

p. 59 É. Zola, *Salons recueillis, annotés et présentés* par F. W. J. Hemmings et Robert J. Niess, Droz, Geneva and Minard, Paris 1959, p. 78; pp. 126–9.

p. 62 Wildenstein op. cit., W. 53, I, p. 427.

p. 63 *The Correspondence of Berthe Morisot*, compiled and ed. Denis Rouart, trans. Betty Hubbard (1957), Lund Humphries Publishers Ltd; new edn, Kathleen Adler and Tamar Garb, Camden Press, London, 1986, pp. 35–6.

p. 73 Paul Mantz, *Gazette des Beaux-Arts*, July 1, 1869, p. 13.

p. 74 Richard Kendall (ed.), *Degas by Himself: drawings, prints, paintings, writings*, Macdonald Orbis, London 1987, pp. 36–7, 112–13.

p. 76 George Moore, *Reminiscences of the Impressionist Painters*, Maunsel, Dublin, 1906, pp. 14–20, 24–6, 30–1, 34–6.

p. 79 *Bazille and Early Impressionism*, exhibition cat., trans. J. Patrice Marandel, Chicago, Art Institute 1978, nos. 76, 77.

p. 81 Anne Dayez et al., *Le Centenaire de l'Impressionnisme*, exhibition cat., Paris, Grand Palais 1974, pp. 262–3.

p. 83 Dayez op. cit., pp. 264–5.

p. 86 Dayez op. cit., pp. 268–70.

p. 97 Lionello Venturi, *Les Archives de l'Impressionnisme*, Durand-Ruel & Cie, Paris 1939, Vol. II, pp. 297–8.

p. 97 Charles S. Moffett (ed.), *The New Painting: Impressionism 1874–1886*. Phaidon/Fine Arts Museum of San Francisco 1986: pp. 39–40, 42, 43, 44, 45, 46, 47.

p. 103 Albert Wolff, *Le Figaro*, April 3, 1876.

p. 104 Renoir op. cit., pp. 174–5.

p. 105 Rouart op. cit., pp. 102, 104.

p. 108 S. Mallarmé, *Art Monthly Review*, No. 9, Edinburgh, September 1876, pp. 11–18.

p. 126 Venturi op. cit., Vol. II, pp. 308–14, 322–4.

p. 129 Marc de Montifaud, *L'Artiste*, May 1, 1877, pp. 337–8, 339–40.

p. 131 Théodore Duret, *Les Peintres Impressionnistes*, Paris 1878.

p. 133 Zola, *Salons* op. cit., pp. 226–8, 230.

p. 135 John Rewald, *Studies in Impressionism*, Thames & Hudson, London 1985, p. 18.

p. 145 Rewald op. cit., pp. 125–6, 180, 145–6.

p. 148 Jacques de Biez, *Conférence faite à la Salle des Capucines*, Baschet, Paris January 22, 1884, pp. 60–3.

p. 150 Kendall op. cit., p. 299–300.

p. 152 Ambroise Vollard, *Degas, An Intimate Portrait* (1937), Dover, New York 1986, pp. 55–7.

p. 153 Paul Valéry, *Degas Manet Morisot* (1936), trans. David Paul, Routledge, Kegan Paul, London 1960, pp. 39–41.

p. 155 Paul Mantz, *Le Temps*, April 23, 1881.

p. 157 Joris-Karl Huysmans, *Oeuvres Complètes* Vol. VI, *L'Art Moderne*, Crès, Paris 1928–40, pp. 247–50.

p. 158 Gustave Geffroy, *La Justice*, May 26, 1886.

p. 160 Huysmans op. cit., *Certains*, Vol. X, pp. 20–5.

p. 162 George Moore, *Impressions and Opinions*, David Nutt, London 1891, pp. 313–18.

p. 165 George Moore, *Modern Painting*, Walter Scott Ltd, London and C. Scribner's Sons, New York 1898, p. 28.

p. 166 Valéry op. cit., pp. 42–5; pp. 54–7.

p. 169 Kendall op. cit., pp. 221–2.

p. 171 R. Goldwater and M. Treves (eds.), *Artists on Art*, Kegan Paul, London and Pantheon, New York 1947, pp. 308–10.

p. 171 John Rewald, *History of Impressionism*, (1946) Museum of Modern Art, New York 1961, pp. 447–9.

p. 173 Janine Bailly-Herzberg (ed.), *Correspondance de Camille Pissarro*, I, 1865–1885, Presses Universitaires de France, 1980, No. 86, p. 145.

p. 174 Venturi op. cit., Vol. I, pp. 115–22.

p. 176 Rouart op. cit., p. 143.

p. 176 Huysmans op. cit., Vol. VI, *L'Art Moderne*, pp. 285–93.

p. 188 Linda Nochlin (ed.), *Impressionism and Post-Impressionism, Sources and Documents*, Prentice Hall, New Jersey 1966, Jules Laforgue, trans. William Jay Smith, "Impressionism: The Eye and the Poet," Art News LV, May 1956, pp. 43–5, pp. 16–18.

p. 189 Bailly-Herzberg op. cit., No. 149, p. 207.
Judith Wechsler (ed.), *Cézanne in Perspective*, Prentice Hall, Englewood Cliffs, New Jersey, 1975, p. 30, trans. John Rewald, *Paul Cézanne*, Schocken, New York 1968, p. 129.

p. 191 Wechsler op. cit., p. 31: Huysmans, *Certains*, 1889, "Cézanne".

p. 192 V. W. van Gogh (ed.), *The Complete Letters of Vincent van Gogh*, Thames and Hudson, London and New York Graphic Society, Boston 1958, Vol. III, pp. 432–3.

p. 193 V. W. van Gogh op. cit., Vol. III, pp. 6–7.

p. 195 Georges Clemenceau, *Claude Monet*, Gallimard, Paris 1929, New York 1930.

p. 196 Nochlin op. cit., p. 53.

p. 196 Barbara Ehrlich White, "Renoir's Trip to Italy," *The Art Bulletin*, LI, December 1969, p. 350.

p. 197 Ambroise Vollard, *Renoir, An Intimate Record*, Knopf, New York 1925, pp. 118–21, 122–3.

p. 200 Venturi op. cit., Vol. I, pp. 131–2.

p. 200 Renoir op. cit., pp. 250, 219–22, 202–4.

p. 211 Walter Pach, *Queer Thing, Painting*, Harpers, New York 1938, p. 107.

p. 213 Georges Rivière, *Renoir et Ses Amis*, Floury, Paris 1921, p. 81.

p. 214 Albert André, *Renoir*, Crès, Paris (1919) 1928.

p. 216 Gerd Muehsam (ed.), *French Painters and Paintings from the Fourteenth Century to Post-Impressionism*, Frederick Ungar, New York 1970, pp. 424–5.

p. 216 John Rewald (ed.), *Camille Pissarro, Letters to his Son Lucien*, Routledge, Kegan Paul, London 1980, pp. 29–30, 42.

p. 218 Bailly-Herzberg op. cit., Vol. I, No. 278, p. 336. Nochlin op. cit., p. 59, trans. J. Rewald, *Georges Seurat*, Wittenborn, New York 1946, p. 68.

p. 219 Françoise Cachin (ed.), *Félix Fénéon, Au-delà de l'impressionnisme, L'Emancipation sociale*, Narbonne, April 3, 1887; Hermann, Paris 1966, pp. 81–6.

p. 222 Rewald, *Pissarro Letters to his Son Lucien* op. cit., pp. 91–2, 120, 131–2.

p. 224 Nochlin op. cit., p. 60, from notes of Louis Le Bail cited in and trans. J. Rewald, *The History of Impressionism* op. cit., p. 458.

p. 239 Nochlin op. cit., p. 59, trans. Rewald, *Georges Seurat* op. cit.

p. 239 Wildenstein op. cit., W. 107, Vol. I, p. 432.

p. 240 Wildenstein op. cit., W. 173, Vol. I, p. 458.

p. 241 Émile Taboureux, *La Vie Moderne*, June 12, 1880.

p. 243 Wildenstein op. cit., W. 366, Vol. II, p. 230; Venturi op. cit., Vol. I, pp. 237–8, No. 33; Vol. I, p. 264, No. 79.

p. 244 Wildenstein op. cit., W. 313, Vol. II, p. 223; W. 318, Vol. II, p. 224; W. 324, Vol. II, p. 225.

p. 245 François Thiébault-Sisson, *Le Temps*, January 8, 1927.

p. 247 Gustave Geffroy, *Claude Monet, Sa Vie, Son Oeuvre*, Paris (1897), 1924 I, pp. 185–6.

p. 247 Theodore Reff (ed.), *Modern Art in Paris, 1855–1900*, Garland Publishing, New York 1981: Octave Mirbeau, *Claude Monet*, Galerie Georges Petit, Paris 1889, pp. 5–18, 20–6.

p. 254 Lilla Cabot Perry, *American Magazine of Art*, Vol. XVIII, No. 3, March 1927.

p. 266 Wildenstein op. cit., W. 1066, Vol. III, p. 257; W. 1076, Vol. III, p. 258.

p. 267 Gustave Geffroy, *L'Art dans les Deux Mondes*, Paris May 9, 1891, trans. Catherine J. Richards.

p. 269 Georges Lecomte, *La Revue Indépendante*, April 1892, No. 66.

p. 271 Wildenstein op. cit., W. 1151, Vol. III, p. 266.

p. 272 Wildenstein op. cit., W. 1533, Vol. IV, p. 345; W. 1593, Vol. IV, p. 351; W. 1611, Vol. IV, p. 355.

p. 273 Trévise, *La Revue de l'Art Ancien et Moderne*, Vol. LI, January 1927; February 1927, trans. Catherine J. Richards.

p. 274 Jeanne Baudot, *Renoir*, Éditions Littéraires, Paris 1949, pp. 49–50. Wildenstein op. cit., W. 1565, Vol. IV, p. 348.

p. 275 Wildenstein op. cit., W. 180, Vol. IV, p. 428; W. 1764, Vol. IV, p. 368.

p. 276 Rouart op. cit., pp. 174–5, 202–3.

p. 278 Téodor de Wyzewa, *Peintres de Jadis et d'Aujourd'hui*, Perrin & Cie, Paris 1903, pp. 213–20.

p. 288 Jules Huret, *Enquête sur l'Évolution Littéraire*, Charpentier, Paris 1891, pp. 55–60.

p. 290 Mary Ann Caws (ed.), *Mallarmé, Selected Poetry and Prose*, New Directions, New York 1982, pp. 65–7, trans. Bradford Cook.

p. 292 Louis Gillet, *La Revue Hébdomadaire*, No. 8, August 21, 1909, pp. 397–415.

p. 300 François Thiébault-Sisson, *La Revue de l'Art Ancien et Moderne*, June 1927.

p. 318 Clemenceau op. cit., pp. 149–55.

p. 319 Evan Charteris, *Life of John S. Sargent*, Heinemann, London 1927, pp. 123–4, 130–1.

p. 320 Robert L. Herbert (ed.), *Modern Artists on Art*, Prentice Hall, Englewood Cliffs, New Jersey 1964, pp. 26–7.

p. 321 Edward Fry (ed.), *Cubism*, Thames and Hudson, London 1966, pp. 121–6.

p. 325 Herbert op. cit., pp. 2–4.

p. 326 Kate Flint (ed.), *The Impressionists in England: The Critical Reception*, Routledge, Kegan Paul, 1984, pp. 236–41.

p. 329 Hans Hofmann, "On the Aims of Art," *Fortnightly*, Vol. I, February 26, 1932, pp. 7–11, trans. Ernst Stolz and Glenn Wessels, "Plastic Creation," *The League*, Vol. 5, Winter 1932–3, pp. 11–15, 21. Reprinted in Herschel B. Chipp, *Theories of Modern Art*, University of California Press, 1968, pp. 543–4.

p. 330 Meyer Schapiro, *Marxist Quarterly*, Vol. I, January 1937. Reprinted in Schapiro, *Modern Art, The Nineteenth and Twentieth Centuries*, George Braziller, New York 1978, pp. 190–3.

p. 332 Alfred Barr, *Matisse, His Art and His Public*, Museum of Modern Art, New York 1951 and Secker & Warburg, London 1975, p. 38.

p. 349 André Masson, *Verve*, Vol. VII, 1952, p. 68.

p. 351 Gaston Bachelard, *Verve*, New Series 27–8, 1952, "Waterlilies or Surprises of a Summer's Dawn." *XXième Siècle*, New Series, 11–12, January 1954, "The Painter Solicited by the Elements," reprinted in Bachelard, *The Right to Dream*, trans. J. A. Underwood. *The Bachelard Translations*, Dallas Institute of Humanities and Culture, Dallas 1988, pp. 3–6, 25–8.

p. 355 Clement Greenberg, *Art News Annual*, XXVI, 1957.

p. 360 Kenneth Clark, *Landscape into Art*, John Murray, London (1949) and Beacon Press, Boston 1961, pp. 92–6.

p. 362 Rosalind E. Krauss, *Burlington Magazine*, No. 776, Vol. CIX, November 1967, p. 622.

p. 364 Michel Butor, *Art News Annual*, XXXIV, 1968, pp. 21–5.

p. 365 Anton Ehrenzweig, *The Hidden Order of Art, A Study in the Psychology of Artistic Imagination*, Weidenfeld and Nicolson, London 1968, pp. 67–8.

p. 367 *Modernism and Modernity*, Vancouver Conference Papers (eds.) B. Buchloh, S. Guilbaut, D. Solkin, Press of NSCAD, Halifax (NS) 1983.

p. 369 Lawrence Gowing, *Renoir*, Arts Council of Great Britain Catalogue, Hayward Gallery, London 1985, pp. 30–3.

p. 372 Christopher Yetton, *Royal Academy Magazine*, No. 28, Autumn 1990 (Monet Special Exhibition issue).

CHRONOLOGY

1830
JULY 10. Birth of Jacob Abraham Camille Pissarro in Charlotte Amalie, St Thomas, Danish Virgin Islands.

1832
JANUARY 23. Birth of Édouard Manet in Paris.

1834
JULY 19. Birth of Edgar Degas in Paris.

1839
JANUARY 19. Birth of Paul Cézanne in Aix-en-Provence.
OCTOBER 30. Birth of Alfred Sisley in Paris.

1840
NOVEMBER 14. Birth of Oscar-Claude Monet in Paris.

1841
JANUARY 14. Birth of Berthe Morisot in Bourges.
FEBRUARY 25. Birth of Pierre-Auguste Renoir in Limoges.

1844
MANET enters Collège Rollin. Meets Antonin Proust.
RENOIR: family moves to Paris.

1845
DEGAS enters Lycée Louis-le-Grand. Taught drawing by Léon Cogniat.
MONET: family moves to Le Havre. Father enters his brother-in-law's business as wholesale grocer.

1848–9
MANET travels to Rio de Janeiro on training steamer.

1850
MANET fails to get a place at the École Navale. Begins to study painting under Thomas Couture. Registers to copy paintings at the Louvre.

1852
Birth of Léon-Édouard Koëlla, illegitimate son of Suzanne Leenhoff, piano teacher in the Manet household. He is now thought to be the son of Manet's father.
CÉZANNE enters Collège Bourbon in Aix where he meets Zola.

1853
MANET makes first trip to Italy: Venice, Florence and Rome.
DEGAS registers as copyist at the Louvre and the Bibliothèque Impériale.

1854
RENOIR apprenticed for four years as a porcelain painter, then works painting fans, murals and as a decorator for a manufacturer of blinds. Studies drawing with the sculptor Callouette.

1855
PISSARRO gives up business career in West Indies and arrives in Paris. Enrols at École des Beaux-Arts and works in Anton Melbye's studio.
MANET visits Delacroix's studio with Proust.
DEGAS enrols at the École des Beaux-Arts as a pupil of Louis Lamothe. Meets and is advised by Ingres.

1856
MANET leaves Couture's studio.
DEGAS studies and travels in Italy (1856–9).

MONET: his caricatures of local figures in Le Havre are exhibited in shop window. Attracts attention of Boudin with whom he begins to paint out of doors.

1857
PISSARRO following Corot's advice, paints from nature in Montmorency.
MANET makes second trip to Italy.
SISLEY goes to London to prepare for a career in business.
MORISOT: Berthe and her sister Edma study painting with Chocarne and subsequently with Guichard.

1858
CÉZANNE studies at drawing academy in Aix.

1859
PISSARRO attends Atelier Suisse and meets MONET.
MANET: *Absinthe Drinker* rejected by the Salon. Registers to copy paintings at the Louvre where he meets DEGAS.
CÉZANNE studies Law at university in Aix.

1860
MANET rents studio in Batignolles quarter.
RENOIR and MORISOT register to copy at the Louvre.

1861
MANET exhibits *Portrait of M. and Mme Manet* and *The Spanish Singer* at the Salon and *The Nymph Surprised* at the Imperial Academy in St Petersburg.
CÉZANNE arrives in Paris and enrols at Académie Suisse where he meets PISSARRO. Returns to Aix in September and works at his father's bank.
MONET selected by lottery for military service. Serves in Algeria for one year until following an illness he is bought out by his family.
RENOIR enters studio of Charles Gleyre, École des Beaux-Arts.
MORISOT with her sister studies with Corot at Ville d'Avray.

1862
MANET makes studies out of doors at Tuileries Gardens. Paints Camprubi troupe of Spanish dancers appearing at the Hippodrome. Victorine Meurent begins to pose for him.
SISLEY, MONET and BAZILLE join studio of Charles Gleyre, meet RENOIR and become friends. Renoir meets PISSARRO and CÉZANNE returns to Paris. Renoir meets Diaz, Courbet, Corot and Daubigny painting out of doors in the forest of Fontainebleau.

1863
PISSARRO: his son Lucien is born.
MANET: *Le Déjeuner sur l'Herbe* is rejected by the Salon. Exhibits 14 paintings at the Galerie Martinet. The Salon des Refusés is opened where the *Déjeuner sur l'Herbe* is a *succès de scandale*. Also showing are works by PISSARRO, Jongkind, Guillaumin, Whistler, Fantin-Latour and CÉZANNE. Manet marries Suzanne Leenhoff.
MONET paints with BAZILLE in Chailly-en-Brière in the forest of Fontainebleau.

1864
PISSARRO exhibits two landscapes as "pupil of Corot" at the Salon. Works at La Varenne-Saint-Hilaire.
MANET exhibits *The Bullfight* and *Dead Christ with Angels* at the Salon.

CÉZANNE rejected by the Salon. Returns to Aix in July.

MONET paints with BAZILLE, Boudin and Jongkind along the coast at Honfleur and at Le Havre.

RENOIR exhibits *La Esmeralda* at the Salon, but subsequently destroys it.

MORISOT exhibits two landscapes at the Salon.

1865

PISSARRO exhibits two landscapes at the Salon.

MANET exhibits *Jesus Mocked by the Soldiers* and *Olympia* at the Salon. During a trip to Spain meets Théodore Duret.

DEGAS exhibits *Medieval War Scene* at the Salon.

CÉZANNE rejected by the Salon. Works at Académie Suisse and returns to Aix in autumn.

MONET exhibits two landscapes at the Salon. Shares a studio with BAZILLE who poses for a *Déjeuner sur l'Herbe* which Monet is painting out of doors at Chailly.

RENOIR works with SISLEY in Marlotte in the forest of Fontainebleau.

MORISOT spends summers painting in Normandy, 1864–74.

1866

PISSARRO and DEGAS exhibit at the Salon.

MANET rejected by the Salon. Meets CÉZANNE, Zola and MONET. The Café Guerbois, 11 Grande rue des Batignolles, begins to become a popular venue for artists and writers.

SISLEY exhibits at the Salon. Marries Marie Lescouezec. Works with RENOIR in the forest of Fontainebleau.

CÉZANNE rejected by the Salon. Spends a year between Paris and Aix.

MONET exhibits *Camille ou La Robe Verte* at the Salon, a great success. Camille Doncieux poses for the *Women in the Garden* at Sèvres where she is living with Monet. In the summer financial difficulties force Monet to leave Sèvres for Honfleur, where he sees Boudin and Courbet and spends the winter of 1866–7.

RENOIR rejected by the Salon, in spite of the intervention of Corot and Daubigny who have become members of the Salon jury.

1867

PISSARRO rejected by the Salon. He, RENOIR, SISLEY and BAZILLE sign an unsuccessful petition demanding a new Salon des Refusés.

MANET: Courbet and Manet hold one-man shows at their own expense in special pavilions outside the grounds of the Exposition Universelle. A biographical and critical study of Manet by Zola is reprinted as a pamphlet.

DEGAS exhibits two portraits at the Salon.

CÉZANNE rejected by the Salon. Spends summer in Aix, returns to Paris in autumn.

MONET rejected by Salon. Discusses with BAZILLE the possibility of organizing exhibitions independently of the Salon. His son Jean is born, but financial problems force Monet to live with his aunt in Ste-Adresse, leaving Camille in Paris.

1868

PISSARRO: Salon accepts two views of Pontoise. Because of financial difficulties works painting shop signs and blinds with Guillaumin. Moves with his family to Louveciennes, 1868–9.

MANET exhibits *Young Lady in 1866* and *Portrait of Zola* at the Salon. Fantin-Latour introduces him to Berthe and Edma Morisot at the Louvre. Paints *The Balcony* for which Berthe MORISOT poses. Spends summer in Boulogne-sur-Mer.

DEGAS exhibits *Mlle Fiocre* at the Salon. Registers to copy at the Louvre, sponsored by Émile Lévy.

SISLEY exhibits landscape at the Salon. He and his wife pose for RENOIR in April at Chailly.

CÉZANNE rejected by the Salon. Returns to Aix in May; back in Paris in December.

MONET exhibits one painting at the Salon. In Le Havre for the winter. Spends spring and summer in Bennecourt and then at Fécamp and in December in Étretat where he rejoins Camille.

RENOIR: *Lise* is accepted at the Salon. Moves to a new studio with BAZILLE near the Café Guerbois where he meets DEGAS, Duret, Zola, Burty, Silvestre.

MORISOT exhibits one painting at the Salon. Meets MANET and poses for him for *The Balcony*. Begins friendship with Puvis de Chavannes and with DEGAS.

1869

PISSARRO has two views of Pontoise accepted at the Salon.

MANET: Zola writes to *La Tribune* in defence of *The Execution of the Emperor Maximilian*, because the government has opposed its exhibition. Alfred Stevens brings Eva Gonzalès to Manet's studio; she becomes his pupil and poses for him. Manet exhibits *The Balcony* and *The Luncheon in the Studio* at the Salon. He spends the summer at Boulogne and visits England.

DEGAS makes a trip to Brussels where he sells paintings and negotiates a contract with a Belgian dealer. He travels in Italy. In the summer he works in Boulogne near Manet and at Étretat. His *Portrait of Mme G.* is accepted at the Salon.

SISLEY rejected at the Salon.

CÉZANNE returns to Paris where he spends most of the year. Meets Hortense Fiquet. He is rejected at the Salon.

MONET returns from Étretat in February and is rejected at the Salon. He settles in St-Michel-de-Bougival and works with RENOIR at La Grenouillère for the summer.

RENOIR has one painting, *Summer*, accepted at the Salon. Works with MONET painting La Grenouillère.

MORISOT does not submit to the Salon. Marriage of her sister Edma to Adolphe Pontillon.

1870

PISSARRO exhibits two views of Louveciennes at the Salon. The outbreak of the Franco–Prussian War, July 19, forces Pissarro to flee from Louveciennes with his family. They take refuge first in Brittany and later in London where he stays in Upper Norwood.

MANET exhibits *The Music Lesson* and *Portrait of Eva Gonzalès* at the Salon. Closes his studio in Paris because of the war and enlists in the National Guard as a lieutenant.

DEGAS has two portraits accepted at the Salon. Enlists and serves in the army under his old school friend Henri Rouart. He is discovered to be almost blind in his right eye.

SISLEY exhibits two scenes of Paris at the Salon.

CÉZANNE taking refuge with Hortense Fiquet in Provence, avoids the draft. He works in Aix and L'Estaque, and is joined by Zola.

MONET refused at the Salon; Daubigny and Corot both resign from the jury. He marries Camille on June 28, works in Trouville and Le Havre and then leaves for London in September to avoid the war.

BAZILLE is killed in action.

RENOIR: *Woman of Algiers* and *Bather with a Griffon* are accepted at the Salon. He is drafted into the cavalry in October and is posted to Tarbes, Libourne where he falls ill with dysentery, and then to Bordeaux.

MORISOT exhibits a portrait of her sister and a view of the port of Lorient at the Salon. She remains in Paris during the siege.

1871

PISSARRO meets up with Monet in London, where Daubigny introduces them both to Durand-Ruel. He marries Julie Vellay on June 14, and returns to Louveciennes to discover "20 years' worth" of paintings lost due to the war.

MANET joins his family at Oloron-Sainte-Marie, near Bordeaux, and moves to Arcachon in the spring. After the repression of the Commune they return to Paris during the summer.

DEGAS at Ménil-Hubert with the Valpinçons during the Commune, March–May, and visits London in October.

SISLEY: his father dies and, having been ruined financially in the war, leaves Sisley without support. He rents a house at Voisins-Louveciennes near the home of RENOIR's parents where Renoir is staying.

CÉZANNE after the Commune, returns to Paris.

MONET: Durand-Ruel to whom he has been introduced in London by Daubigny exhibits his paintings. He leaves London in May to work in Zaandam, Holland, and then returns to France in the autumn, renting a house at Argenteuil.

RENOIR during the Commune, in Paris, and then with his parents at Louveciennes where he works with SISLEY. Returns to Paris in the autumn.

MORISOT during the Commune stays with her parents at St Germaine-en-Laye and then with her sister at Cherbourg before returning to Paris.

1872

PISSARRO, MONET, DEGAS and SISLEY decide not to submit to the Salon. Pissarro co-signs a petition with CÉZANNE and RENOIR for a new Salon des Refusés. He settles in Pontoise where he is joined by Guillaumin and Cézanne.

MANET exhibits *Battle of the "Kearsage" and the "Alabama"* at the Salon and sells paintings to Durand-Ruel for exhibition in London. He begins to frequent the Café de la Nouvelle-Athènes, a popular venue for artists and writers. Travels in Holland.

DEGAS introduced to Durand-Ruel. In the autumn he travels to New Orleans with his brother René Degas.

SISLEY: MONET and PISSARRO introduce him to Durand-Ruel who begins to buy his paintings. He works with Monet at Argenteuil, and at Bougival, Villeneuve-La-Garenne, Port-Marly.

CÉZANNE: birth of his son Paul. He then moves to Saint-Ouen-l'Aumône and to Auvers-sur-Oise; there he works side by side with PISSARRO who is living at Pontoise.

MONET works at Rouen and Le Havre and makes a trip to Holland. In the summer is joined at Argenteuil by RENOIR and they work together. Durand-Ruel begins to buy his paintings in large numbers.

RENOIR: MONET introduces him to Durand-Ruel who buys two paintings to be exhibited in London. His two submissions to the Salon are both rejected and he co-signs with CÉZANNE and PISSARRO a petition for a new Salon des Refusés. In the summer he works with Monet at Argenteuil and together they visit Caillebotte.

MORISOT stays at St-Jean de Luz and travels in Spain visiting Toledo and Madrid.

1873

PISSARRO begins to consider plan with MONET, SISLEY and RENOIR to organize a society of independent artists for exhibitions outside the Salon. Continues working in Pontoise, also in Osny and Auvers-sur-Oise. Makes etchings in the studio of Dr Gachet at Auvers.

MANET exhibits *A Good Glass of Beer* (*Le Bon Bock*) to great acclaim, and a portrait of Berthe MORISOT, *Repose*, at the Salon. Meets and becomes a close friend of the poet Stéphane Mallarmé. The summer is spent at Berck-sur-Mer.

DEGAS in New Orleans works on a painting of his uncle's cotton exchange office. In March returns to Paris.

SISLEY works in Louveciennes, Marly, Bougival and Pontoise.

CÉZANNE continues to work with PISSARRO in and around Auvers. Makes etchings with Pissarro and Guillaumin at Dr Gachet's studio. Pissarro introduces him to Père Tanguy.

MONET with SISLEY, RENOIR and PISSARRO plans to organize a society of artists to exhibit independently of the Salon. By the end of the year they adopt a charter as the Société Anonyme Coopérative des Artistes Peintres, Sculpteurs, Graveurs. Works in Argenteuil and builds a studio-boat for painting on the Seine.

RENOIR: after rejection at the Salon two paintings are shown at a Salon des Refusés. Stays with MONET at Argenteuil and participates in the planning of a new collective artists' association.

MORISOT exhibits at the Salon for the last time. Works at Fécamp and during the summer at Maurecourt with her sister Edma.

1874

PISSARRO exhibits five paintings at the first group exhibition (April–May) of the Société Anonyme Coopérative des Artistes Peintres, Sculpteurs, Graveurs at Nadar's studios on the boulevard des Capucines. In the autumn takes his family to stay with Piette in Montfoucault, Brittany, for the winter.

MANET: *Gare St-Lazare* is accepted at the Salon, but two other paintings are rejected. Despite the insistence of DEGAS and MONET, declines to exhibit at the first Impressionist exhibition. In August while at Gennevilliers visits Monet and works with him and RENOIR at Argenteuil.

DEGAS exhibits ten works with the Impressionists at the first exhibition. In the summer travels in Italy.

SISLEY exhibits five landscapes at the first group show. Spends the summer working near Hampton Court, England, in the company of Faure.

CÉZANNE, backed by Pissarro, exhibits *A Modern Olympia* and two landscapes at the first group show. Returns to Paris, spends summer in Aix, November in Auvers.

MONET exhibits 12 works at the first group show. In the summer RENOIR and MANET join him at Argenteuil.

RENOIR exhibits six paintings at the first group show. Works with MONET and MANET during the summer at Argenteuil.

MORISOT exhibits nine works at the first group show. Part of the summer is spent at Fécamp with the Manet family, and also with her sister Edma at Maurecourt. She marries Eugène Manet, the brother of Édouard, on December 22.

1875

PISSARRO returns to Pontoise from Montfoucault at the beginning of February. During the summer participates in the founding of a new short-lived artists' cooperative, L'Union.

MANET exhibits *Argenteuil* at the Salon. Mallarmé's translation of Edgar Allan Poe's *The Raven* is published with illustrations by Manet. Travels to Venice.

DEGAS, repaying his brother's debts following the death of their father, suffers financial difficulties for the rest of the decade. Travels in Italy in the spring.

SISLEY lives in Marly-le-Roi until 1877.

CÉZANNE introduced by Renoir to the collector Victor Chocquet whose portrait he paints. Lives in Paris, Quai d'Anjou.

13

MONET participates with RENOIR, SISLEY, and MORISOT at an auction sale of Impressionist paintings at the Hôtel Drouot on March 24, but prices are low. Camille becomes ill and Monet is in financial difficulties.

RENOIR sells 20 paintings at low prices at the Hôtel Drouot auction. Meets Victor Chocquet and the publisher Georges Charpentier. He widens his circle of patrons through contacts at the salons of Mme Charpentier.

MORISOT sells (comparatively) well at the Drouot auction. Spends the summer in Gennevilliers and works in England and on the Isle of Wight.

1876

PISSARRO exhibits 12 paintings at the second group exhibition, 11 rue Le Peletier. Divides his working time between Pontoise and Montfoucault where he takes his family in the autumn. Participates in the Wednesday Impressionist dinners at the restaurant of Eugène Murer, a collector and pastry-cook.

MANET shows the two paintings rejected by the Salon at his own "open studio," where he and Mallarmé meet Méry Laurent.

DEGAS exhibits 24 works at the second group show. Visits Naples in June–July.

SISLEY exhibits eight landscapes at the second group show. Works in Louveciennes.

CÉZANNE does not exhibit with the group. Submits to the Salon instead, but is rejected. He works in L'Estaque in the spring and returns to Paris in the autumn.

MONET is introduced to Chocquet by Cézanne. He exhibits 18 paintings at the second group show. Becomes friendly with Hoschedé family, who invite him to carry out a decorative commission at Montgeron. Meets John Singer Sargent.

RENOIR shows 15 paintings with the Impressionists at the second group show which he invites Caillebotte to join, and two paintings at the Société des Amis des Arts, Pau.

MORISOT exhibits 19 works at the second group show.

1877

PISSARRO becomes friendly with Gauguin. Exhibits 22 landscapes at the third group exhibition at 6 rue Le Peletier, participates in a second auction with poor results. Murer in an attempt to help Pissarro and SISLEY organizes a lottery. Works with CÉZANNE at Pontoise.

MANET: *Portrait of Faure in the Role of Hamlet* exhibited at the salon; *Nana* rejected.

DEGAS active in the organization of the third group exhibition and invites Mary Cassatt to join. Exhibits 22 paintings, plus drawings and monotypes. Stays at Ménil-Hubert in September.

SISLEY exhibits 17 landscapes in the third group show and participates in the second auction sale. Settles in Sèvres in the autumn.

CÉZANNE exhibits 16 works at the third group show. Works with PISSARRO at Pontoise, also Auvers and Issy.

MONET takes a studio near the Gare St-Lazare, for which Caillebotte pays the rent, and works on a series of paintings of the station. Exhibits 30 works in the third group show.

RENOIR exhibits 21 paintings in the third group show. Helps to found the journal *L'Impressionniste* with Georges Rivière to accompany the show. Participates in the second auction sale.

MORISOT exhibits 12 works in the third group show.

1878

PISSARRO rents a room in Montmartre to show paintings to collectors, begins to paint fans. Meets the Florentine critic Diego Martelli.

MANET plans a private exhibition rather than submit to the jury of the World's Fair to be held that year, but it never materializes. Does badly at auctions of both the Faure and Hoschedé collections.

DEGAS: *Cotton Exchange Office*, painted in New Orleans, is purchased by the Musée des Beaux-Arts, Pau, his first painting to enter a public collection.

SISLEY continues to work in Sèvres; convinced by Renoir to submit again to the Salon.

CÉZANNE rejected by the Salon. Works in Aix and with Monticelli in L'Estaque.

MONET settles at Vétheuil where Alice Hoschedé and her children join him after her husband's bankruptcy. Camille's health weakens.

RENOIR: *The Cup of Chocolate* is exhibited at the Salon. Sells three paintings at low prices at the Hoschedé auction.

MORISOT gives birth to her daughter Julie Manet.

1879

PISSARRO exhibits 38 works at the fourth group exhibition, 28 avenue de l'Opéra, which has received financial backing from Caillebotte. Invites Gauguin to participate and works with him at Pontoise during the summer.

MANET exhibits *Boating* and *In the Conservatory* at the Salon. Meets the Irish writer George Moore. Has recurring trouble with his left leg for which he takes spa treatment at Bellevue, but which will prove to be a fatal illness. *The Execution of the Emperor Maximilian* is exhibited in Boston and New York through the auspices of the singer Émilie Ambre.

DEGAS: although 25 works are listed in the catalogue of the fourth group exhibition, Degas exhibits a small proportion of these. He introduces friends such as Mary Cassatt, Forain, and Zandomeneghi. Collaborates with PISSARRO, Cassatt and Bracquemond on the publication of a portfolio of prints, *Le Jour et La Nuit*.

SISLEY submits to the Salon, but is rejected. Evicted from one address in Sèvres, but moves to another with the help of Georges Charpentier.

CÉZANNE rejected by the Salon. Returns from L'Estaque and settles in Melun. Visits Zola at Médan, and returns to Paris.

MONET exhibits 29 paintings at the fourth group show. Works at Vétheuil and Lavacourt. Death of Camille on September 5.

RENOIR declines to exhibit with the Impressionists, but has great success at the Salon where *Mme Charpentier and Her Children*, *Portrait of Jeanne Samary* and two pastels are accepted. Holds two solo exhibitions at the premises of Charpentier's journal *La Vie Moderne*.

MORISOT does not exhibit and spends the summer in Beuzeval-Houlgate.

1880

PISSARRO exhibits 11 paintings and a series of etchings at the fifth group exhibition, 10 rue des Pyramides.

MANET exhibits *Portrait of Antonin Proust* and *At Père Lathuille's* at the Salon. *La Vie Moderne* holds one-man exhibition of new work. Spends summer at Bellevue having treatment for illness.

DEGAS exhibits eight paintings, pastels, drawings and etchings at the fifth group exhibition, in which he invites the controversial Jean-François Raffaëlli to participate.

SISLEY moves to Véneux-Nadon. Signs a contract with Durand-Ruel.

CÉZANNE divides time between Melun, Paris, and Médan where he visits Zola.

MONET following Camille's death paints scenes of the frozen Seine. Two paintings of Lavacourt submitted to the Salon of which one is accepted. *La Vie Moderne* gives him a one-man show in June. Does not participate in the Impressionist group show.

RENOIR does not participate in the Impressionist group show. *Mussel-Fishers at Berneval, Young Girl Asleep* and two pastels are exhibited at the Salon. Begins work on *Luncheon of the Boating Party*, for which Aline Charigot poses.

MORISOT exhibits 15 paintings and watercolours at the fifth group show. Spends the summer at Bougival and Beuzeval-Houlgate.

1881

PISSARRO exhibits 11 landscapes at the sixth group exhibition, 35 boulevard des Capucines. Works in Pontoise with Gauguin and CÉZANNE, and Guillaumin during the summer.

MANET exhibits at the Salon: *Portrait of M. Pertuiset the Lion Hunter* and *Portrait of M. Henri Rochefort*, for which he is awarded a second-class medal. Created Chevalier de la Légion d'Honneur in December.

DEGAS exhibits statuette: *The Little Dancer of 14 Years* and seven other works at the sixth group show.

SISLEY exhibits 14 paintings at a one-man show at *La Vie Moderne*; does not exhibit with the Impressionists.

CÉZANNE in Paris until April, spends May to October in Pontoise with PISSARRO and Gauguin. Visits Zola in Médan and returns to Aix in November.

MONET does not exhibit with the Impressionists or at the Salon. Paints along the coast of Normandy. In December moves to Poissy with Alice Hoschedé and her children.

RENOIR exhibits two portraits at the Salon, but does not participate in the sixth Impressionist show. Travels in Algeria in the spring and then leaves for Italy in October, visiting Venice, Rome, Naples, Calabria, Sorrento, Capri.

MORISOT exhibits seven paintings and pastels at the sixth group show. Spends summer in Bougival and winter in Nice.

1882

PISSARRO exhibits 36 paintings and gouaches at the seventh group exhibition, organized by Durand-Ruel, 251 rue St-Honoré. Moves to Osny near Pontoise.

MANET exhibits *The Bar at the Folies-Bergère* and *Spring: Jeanne* at the Salon. Stays at Rueil for the summer, health increasingly worsening.

DEGAS does not exhibit with the Impressionists. Visits the Halévys at Étretat in July. In September makes a trip to Geneva.

SISLEY exhibits 27 landscapes at the seventh group show. Moves to Moret-sur-Loing in September.

CÉZANNE exhibits *Portrait of M.L.A.* at the Salon as a "pupil of Guillemet." Spends most of the year in Paris, but visits Zola at Médan, and returns to Aix in October where he works at the Jas de Bouffan.

MONET works at Dieppe and Pourville in February. Exhibits 35 paintings at the seventh Impressionist show. Returns to Pourville with the family.

RENOIR on his return from Italy stays with CÉZANNE and works at L'Estaque. Contracts pneumonia and recuperates in Algeria. Durand-Ruel contributes 25 paintings from his holdings to the seventh group show, although Renoir has declined to participate. The Salon accepts one portrait. During the summer he visits MONET at Pourville.

MORISOT exhibits nine paintings and pastels with the group. Spends the summer in Bougival.

1883

PISSARRO: Durand-Ruel holds a one-man show at 9 boulevard de la Madeleine. Works with Gauguin at Osny and Rouen where he is also visited by MONET in October.

MANET dies on April 30 after the amputation of his left leg. He is buried at Passy Cemetery, Paris, on May 3.

DEGAS refuses offer of one-man show at Durand-Ruel's, but allows him to show seven paintings in London at Dowdeswell and Dowdeswell in April.

SISLEY has one-man show at Durand-Ruel in June and exhibits 70 paintings. Moves to Sablons in October.

CÉZANNE spends most of the year around Aix: May–November in L'Estaque. Meets up with RENOIR and MONET working on the Riviera.

MONET works during the winter along the channel coast, mainly Étretat. Has one-man show at Durand-Ruel in March. Moves to Giverny in April.

RENOIR shows 70 paintings at a one-man show at Durand-Ruel in April. Has *Portrait of Mme Clapisson* accepted at the Salon. Trip to Jersey and Guernsey in the autumn; in December travels with MONET to the Riviera and meets CÉZANNE.

MORISOT organizes posthumous exhibition of MANET's work and sale to take place in January/February 1884.

1884

PISSARRO moves from Osny and settles in Éragny-sur-Epte near Gisors.

DEGAS spends summer in Ménil-Hubert with the Valpinçons.

SISLEY works along the Canal du Loing near Les Sablons.

CÉZANNE submits to the Salon, but is rejected in spite of intervention by Guillemet. Spends most of the year working in and around Aix.

MONET works in south of France with RENOIR at Bordighera, Menton, then at Étretat and Giverny. Durand-Ruel introduces him to Octave Mirbeau.

RENOIR and MONET try to persuade Durand-Ruel who is facing bankruptcy to sell paintings for lower prices. Renoir conceives the idea of a new association of painters, the "Société des irrégularistes," whose aesthetic is to be based on irregularity. Works in Paris and La Rochelle.

MORISOT in Paris and in Bougival for the summer.

1885

PISSARRO meets Signac at Guillaumin's studio and Guillaumin introduces him to Seurat at Durand-Ruel's.

DEGAS at Dieppe during the summer meets Gauguin and Sickert. Visits St-Malo and Mont St-Michel.

SISLEY works at Les Sablons, St-Mammès, and in the forest of Fontainebleau. Suffering financially.

CÉZANNE works in L'Estaque, Aix and Gardanne. During June and July takes family to stay with the Renoirs at La Roche-Guyon. Visits Zola in Médan.

MONET exhibits ten works in the fourth Exposition Internationale de la Peinture at the Galerie Georges Petit in Paris. Works at Giverny and returns for three months to Étretat in the autumn.

RENOIR: birth of first son Pierre. Works at La Roche-Guyon with CÉZANNE, and in Essoyes and Wargemont.

MORISOT begins to hold Thursday evenings at home which RENOIR, Mallarmé and DEGAS regularly attend.

1886

PISSARRO exhibits 20 paintings and other works at the eighth and last group show, 1 rue Laffitte, and insists that Seurat and Signac be included. Meets Vincent van Gogh

through his brother Theo of Boussod and Valadon. Durand-Ruel shows his work in New York.

DEGAS exhibits 15 works at the eighth group show and is also shown by Durand-Ruel in New York. Visits Naples in January.

SISLEY does not exhibit with the Impressionists, but is shown by Durand-Ruel in New York.

CÉZANNE marries Hortense Fiquet. Receives inheritance following the death of his father in October. Breaks off friendship with Zola after the publication of his novel *L'Oeuvre*. Works in Gardanne.

MONET exhibits ten works at the exhibition of the Société des XX in Brussels. Does not exhibit with the Impressionists, but shows 49 works in Durand-Ruel's exhibition in New York and 13 works at the Galerie Georges Petit: the fifth Exposition Internationale de la Peinture. Returns to Étretat in February, visits Holland, and works in Belle-Île-en-Mer where he is visited by Mirbeau and meets Gustave Geffroy.

RENOIR exhibits eight paintings at the Société des XX in Brussels and 38 paintings at the exhibition organized by Durand-Ruel in New York. Georges Petit shows five paintings at the fifth Exposition Internationale. He does not exhibit with the Impressionists. Works in La Roche-Guyon, in Brittany, and at Essoyes.

MORISOT exhibits 14 works at the eighth group show, and is shown in New York by Durand-Ruel. Spends June in Jersey.

1887

PISSARRO shows works at exhibition of the Société des XX in Brussels and at sixth Exposition Internationale at Georges Petit.

DEGAS visits Spain and Morocco.

SISLEY shows works at sixth Exposition Internationale at Georges Petit.

CÉZANNE spends most of the year working in and around Aix.

MONET shows works at sixth Exposition Internationale at Georges Petit. Exhibits 12 paintings at National Academy of Design organized by Durand-Ruel, and two paintings at Royal Society of British Artists in London. Works at Giverny.

RENOIR: Durand-Ruel sends ten paintings to New York, divided between an auction and an exhibition at National Academy of Design. Exhibits *Grandes Baigneuses* and five other paintings at the international exhibition at Georges Petit. Visits Le Vésinet, Louveciennes, and Auvers where he meets up with PISSARRO.

MORISOT exhibits at the international exhibition at Georges Petit and with Les XX in Brussels. Visits Mallarmé at Valvins.

1888

PISSARRO exhibits at the international exhibition held at Durand-Ruel's gallery. Begins to suffer from chronic eye infection.

DEGAS has not exhibited with Georges Petit out of loyalty to Durand-Ruel, but this year declines invitation also to exhibit with Les XX in Brussels. Begins writing sonnets. Spends August–September at Cauterets.

SISLEY participates in the international exhibition held at Durand-Ruel. Works at Les Sablons.

CÉZANNE with RENOIR in L'Estaque, then working in Paris and Chantilly.

MONET works at Antibes, Juan-les-Pins and Giverny. Exhibits ten landscapes of Antibes at Boussod & Valadon. Refuses Légion d'Honneur.

RENOIR exhibits 24 works at the international exhibition

held at Durand-Ruel. With CÉZANNE at the Jas de Bouffan in Aix, then in Martigues. Rest of year at Argenteuil and Essoyes.

MORISOT participates in the international exhibition at Durand-Ruel. Spends the winter at Cimiez.

1889

PISSARRO builds own studio in Éragny. Sells important group of paintings to Durand-Ruel. Meets Tabarant, founder of Club de l'Art Sociale.

DEGAS declines offer of special exhibition at the Paris World's Fair. Travels in Spain and Morocco with Boldini.

SISLEY moves from Les Sablons to Moret. Participates in the exhibition of Les XX in Brussels. Durand-Ruel organizes one-man show in New York.

CÉZANNE: *Maison du Pendu* shown at Paris World's Fair. Visits Chocquet in Normandy, then in Aix.

MONET exhibits 20 works at Boussod & Valadon and four works with Les XX in Brussels. Three paintings are shown at the Paris World's Fair. In June a joint retrospective is held with Rodin at Galerie Georges Petit. Painting La Creuse valley series.

RENOIR declines to exhibit at Paris World's Fair. Summers in Provence.

MORISOT works in Cimiez and Mézy for the summer.

1890

PISSARRO exhibits with Les XX in Brussels and with Boussod & Valadon in Paris. Illustrates anarchist *Les Turpitudes Sociales*. Introduced by Fénéon to Lecomte.

DEGAS visits brother in Geneva, travels to Burgundy. Develops collection of art.

SISLEY invited to exhibit with Les XX in Brussels but Petit refuses to send paintings.

CÉZANNE exhibits three works with Les XX in Brussels. Spends summer in Switzerland; returns to Aix in the autumn. Begins to suffer from diabetes.

MONET has raised a subscription fund to purchase Manet's *Olympia* and it is now offered to the nation and hung in the Musée du Luxembourg. Buys property in Giverny, begins Grainstack series. Works on Poplar series on the Epte.

RENOIR exhibits five works with Les XX in Brussels. His last submission to the Salon, *The Daughters of Catulle Mendès*, is accepted. Marries Aline Charigot.

MORISOT spends summer in Mézy where RENOIR visits.

1891

PISSARRO makes etchings and lithographs on press in new studio.

DEGAS shows works at New English Art Club in London.

SISLEY works at Véneux-Nadon.

CÉZANNE divides time between Aix and Paris. References to work begin to appear in the press.

MONET exhibits Grainstack series at Durand-Ruel. Brief visit to London in December.

RENOIR travels to Tamaris with Wyzewa, then to Le Lavandou, Nîmes, Mézy where he visits MORISOT. Trip to Spain.

1892

PISSARRO has large and successful retrospective exhibition at Durand-Ruel. Visits son Lucien in London.

DEGAS exhibits landscape monotypes at Durand-Ruel. Spends the summer at Ménil-Hubert.

SISLEY works on series of paintings of Moret church.

CÉZANNE works in Aix, Paris and in the forest of Fontainebleau. Aurier describes him as important forerunner of Symbolism.

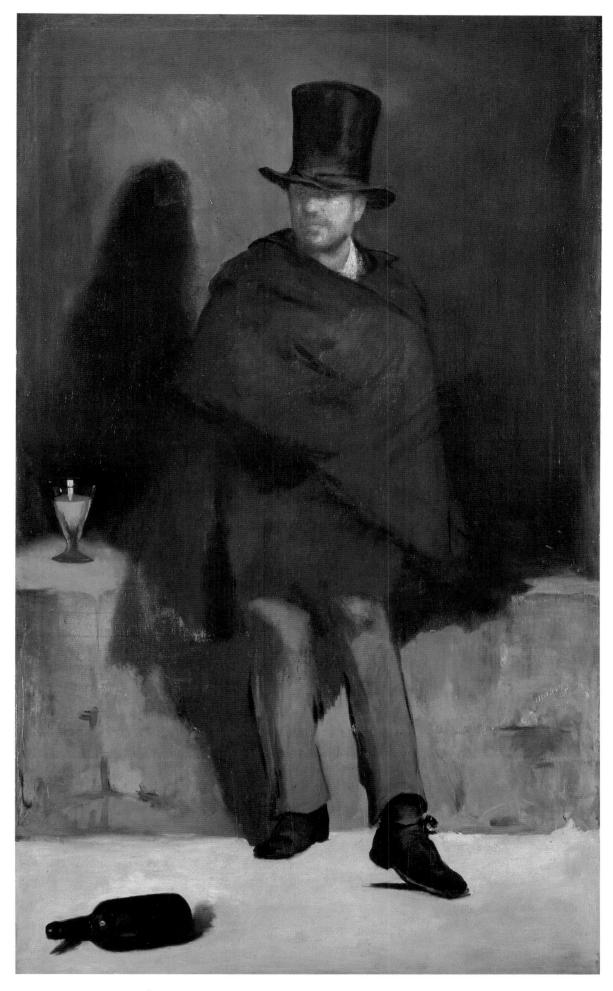

COLOURPLATE 1. Édouard Manet. *The Absinthe Drinker.* 1859. 31¾ × 41¾″ (81 × 106 cm).
Ny Carlsberg Glyptotek, Copenhagen.

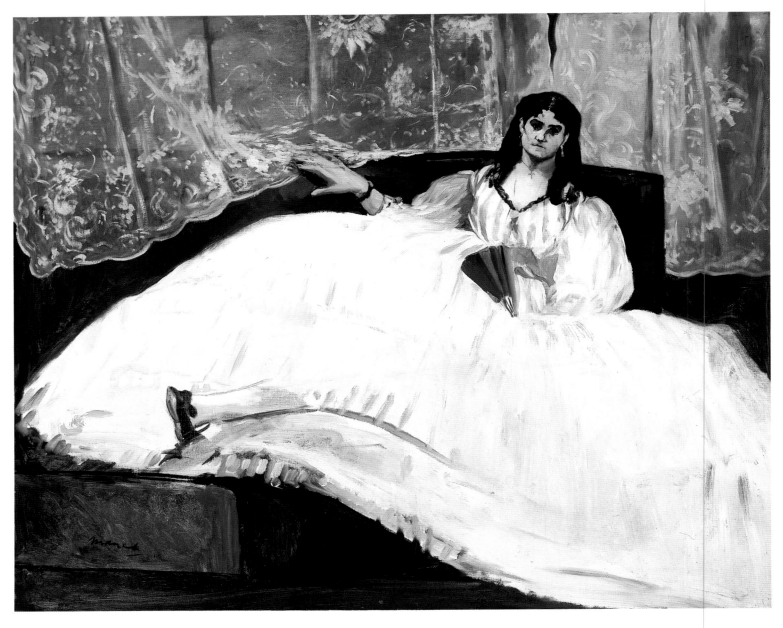

COLOURPLATE 2. Édouard Manet. *Baudelaire's Mistress Reclining*. 1862. 35 × 44½″ (90 × 113 cm). Szépmüvészeti Museum, Budapest.

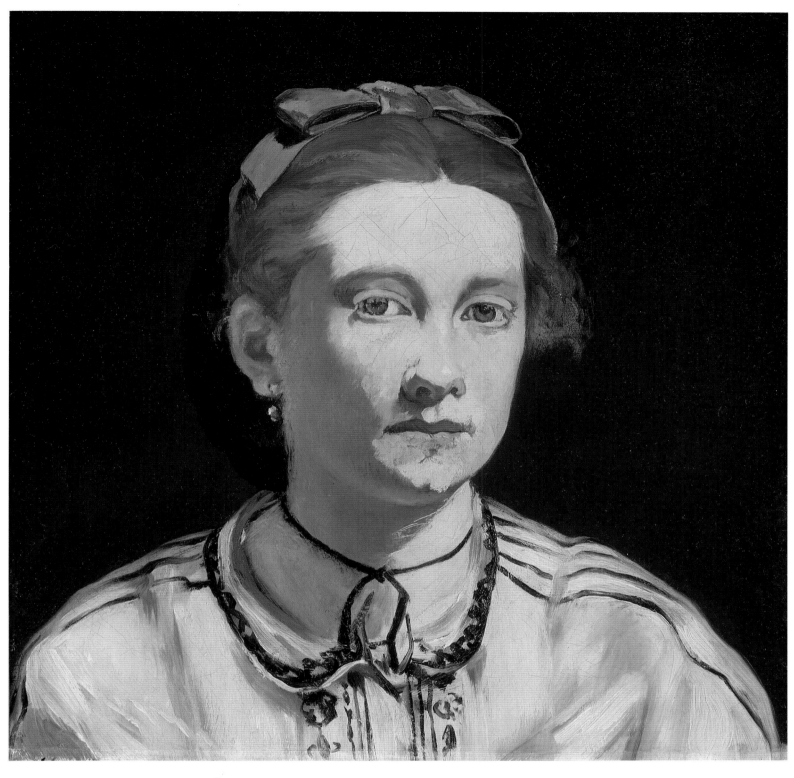

COLOURPLATE 3. Édouard Manet. *Portrait of Victorine Meurent.* 1862. 16⅞ × 17¼″ (42.9 × 43 cm).
Museum of Fine Arts, Boston (Gift of Richard C. Paine, in memory of his father Robert Treat Paine, 1946).

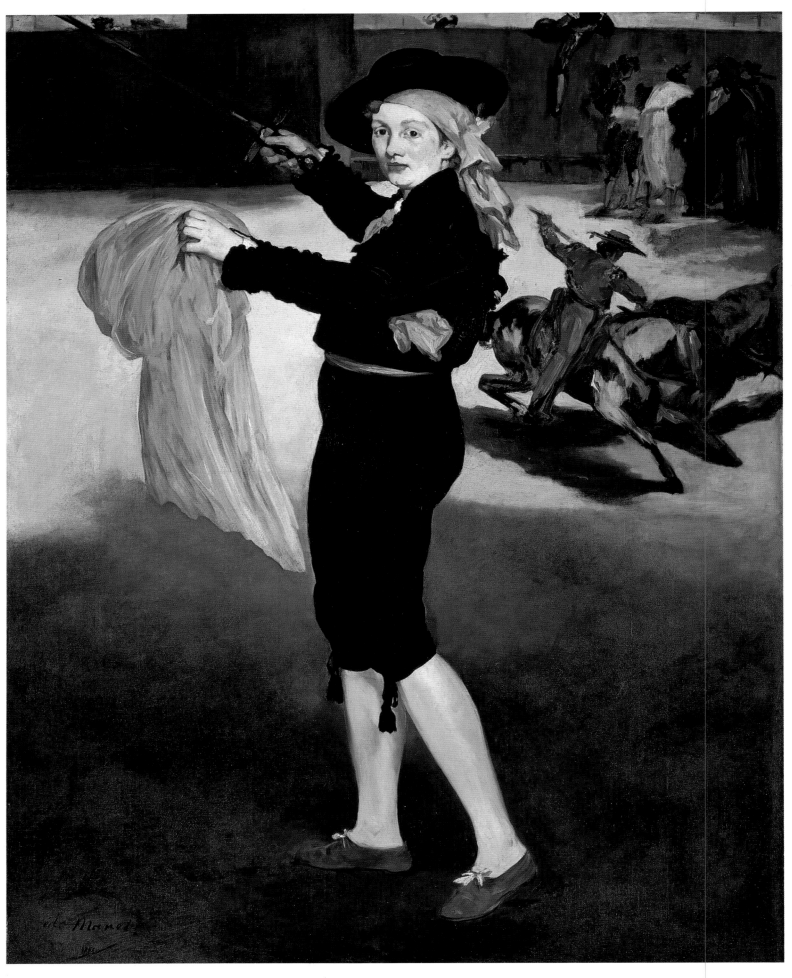

COLOURPLATE 4. Édouard Manet. *Mlle Victorine in the Costume of an Espada*. 1862. 65 × 50¼″ (165.1 × 127.9 cm).
Metropolitan Museum of Art, New York (Bequest of Mrs H. O. Havemeyer, 1929;
The H. O. Havemeyer Collection).

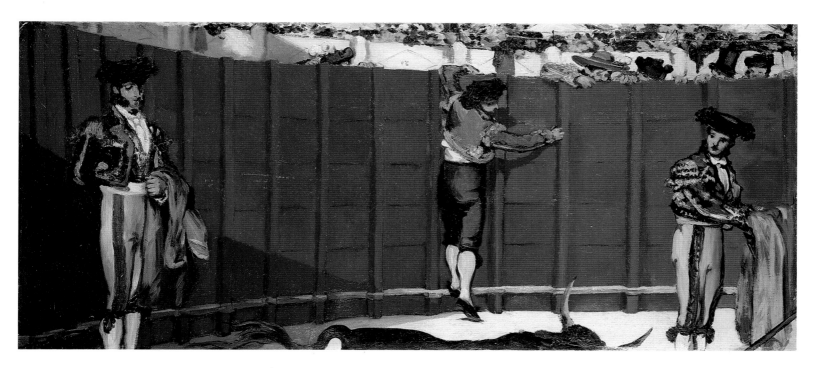

COLOURPLATE 5. Édouard Manet. *The Bullfight*. 1864–5. 19 × 42½″ (48 × 108 cm).
Frick Collection, New York.

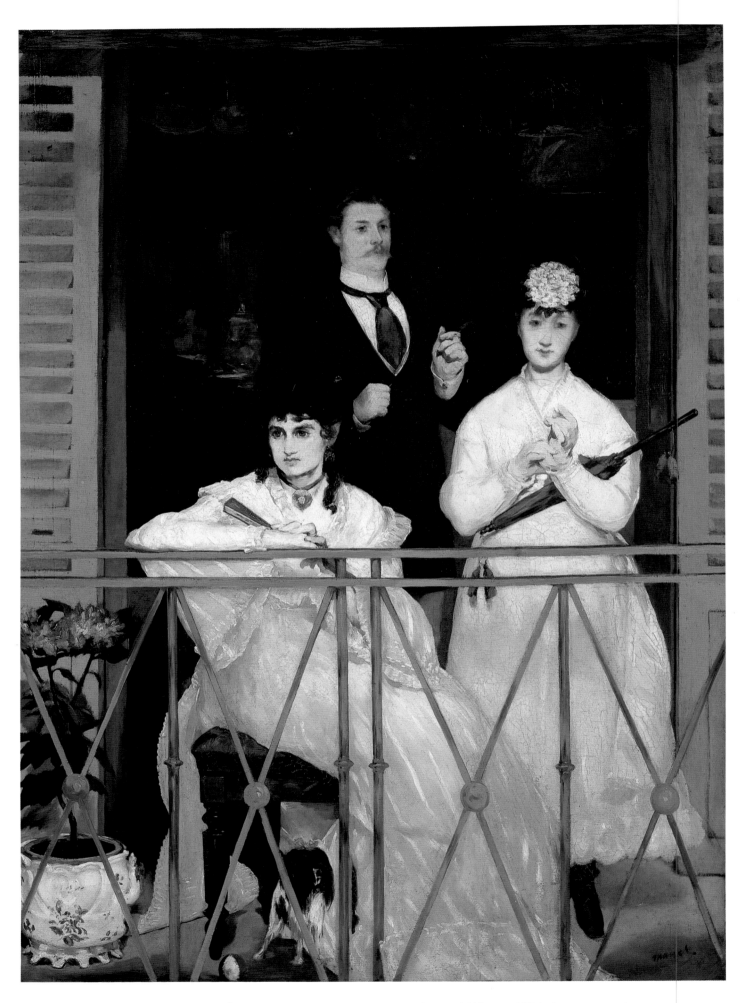

COLOURPLATE 6. Édouard Manet. *The Balcony*. 1868–9. 66½ × 49¼″ (169 × 125 cm).
Musée d'Orsay, Paris.

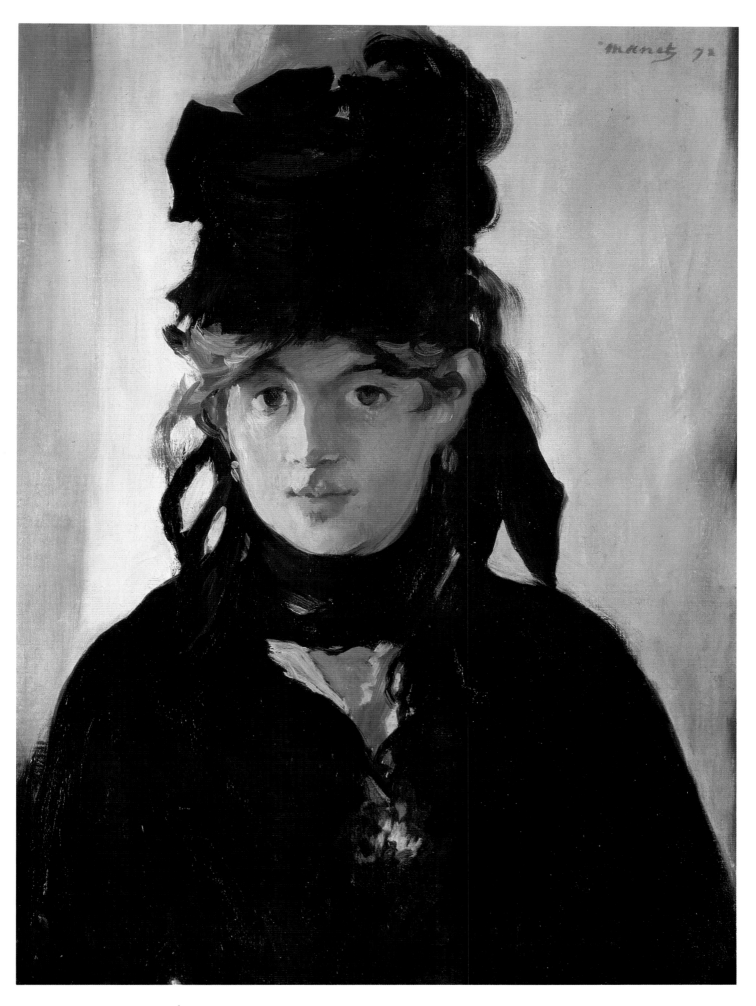

COLOURPLATE 7. Édouard Manet. *Berthe Morisot with a Bouquet of Violets*. 1872. 21½ × 15″ (55 × 38 cm).
Private Collection, Paris.

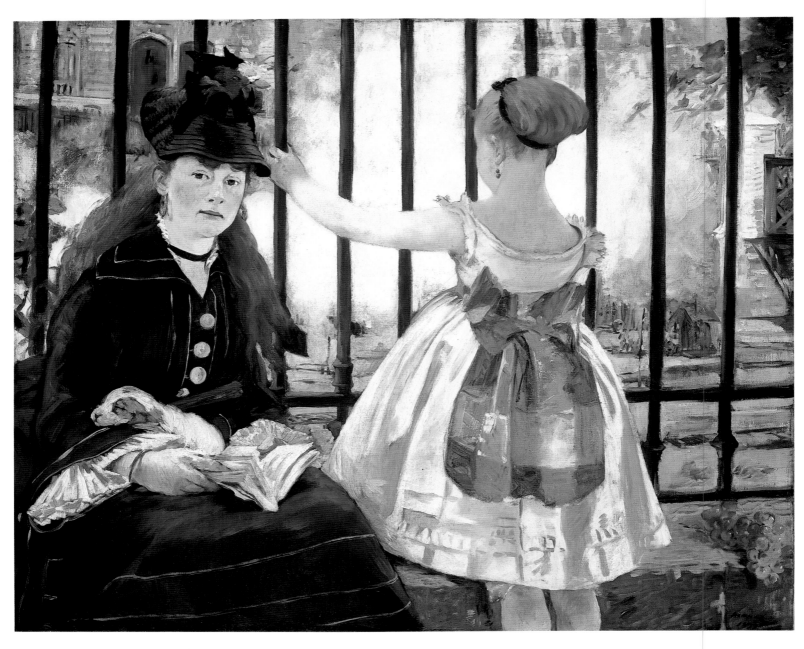

COLOURPLATE 8. Édouard Manet. *The Railway (The Gare St-Lazare)*. 1872–3. 36¾ × 45⅛″ (93.3 × 114.5 cm).
National Gallery of Art, Washington DC (Gift of Horace Havemeyer in memory of his mother
Louisine W. Havemeyer).

MONET exhibits 15 paintings at Durand-Ruel. Begins on Cathedral series at Rouen. Marries Alice Hoschedé on July 16.

RENOIR exhibits 110 works in retrospective at Durand-Ruel. Travels to Spain with Gallimard. Visits Brittany from August to October. Meets Émile Bernard in Pont-Aven.

MORISOT exhibits 40 paintings plus pastels, drawings and watercolours in her first solo exhibition at Boussod & Valadon. Her husband Eugène Manet dies.

1893
PISSARRO exhibits recent work at Durand-Ruel. Album *Les Travaux des Champs* is published.

DEGAS travels in Switzerland.

SISLEY exhibits at the Salon de la Société des Beaux-arts and at Boussod & Valadon.

CÉZANNE works in Aix, Paris and in the forest of Fontainebleau.

MONET works at Giverny, begins to build water-garden. Returns to Rouen to continue Cathedral series.

RENOIR stays in Beaulieu with family, then visits Gallimard in Benerville. From there travels to Essoyes, and stays in St-Marcouf on the channel coast in Normandy, and in Pont-Aven.

MORISOT visits Mallarmé in Valvins and SISLEY at Moret.

1894
PISSARRO meets Vollard. At risk because of his anarchist sympathies, travels June–September in Belgium where he meets up with Henri van de Velde.

DEGAS works on new scenes with jockeys.

SISLEY works at Moret, visits Rouen.

CÉZANNE visits MONET at Giverny and is introduced to Clemenceau, Rodin and Geffroy.

MONET works on the Cathedrals at Giverny.

RENOIR: Caillebotte dies, leaving his collection of Impressionist works to the state. Renoir appointed as executor of his will oversees the bequest. Gabrielle Renard enters his household. His son Jean is born. Meets Ambroise Vollard and Albert André.

MORISOT travels in Belgium and spends the summer in Brittany. Exhibits works with La Libre Ésthetique in Brussels.

1895
PISSARRO works in Rouen with Dario de Regoyos.

DEGAS visits Saint-Valéry-sur-Somme.

SISLEY in poor health and serious financial difficulties.

CÉZANNE: large retrospective held at Ambroise Vollard's gallery: receives critical acclaim.

MONET visits Sandviken, Norway. Exhibits 50 paintings including 20 of Rouen Cathedral at Durand-Ruel.

RENOIR at Carry-le-Rouet in the spring. Spends the summer in Brittany visiting Quimper, Pont-Aven, Tréboul. Purchases a house in Essoyes.

MORISOT dies on March 2 of a sudden illness. RENOIR is guardian of her daughter Julie Manet.

1896
PISSARRO returns to Rouen to paint.

DEGAS works on bathers and dancers.

SISLEY exhibits landscapes at the Société Nationale des Beaux-arts.

CÉZANNE visits Giverny, Vichy, and stays at Talloires on the Lac d'Annecy. Meets the poet Joachim Gasquet.

MONET returns to previous motifs at Varengeville, Pourville and Dieppe. Begins Mornings on the Seine series. Exhibits works in New York and Berlin.

RENOIR with MONET and DEGAS helps to organize a retrospective exhibition of MORISOT at Durand-Ruel. Exhibits 30 paintings in Rouen and 42 at Durand-Ruel in Paris.

1897
PISSARRO stays in Paris and visits London where son Lucien is ill. Paints landscapes of Bedford Park.

DEGAS visits Musée Ingres at Montaubon with Bartholomé. Breaks off friendship with the Halévys over the Dreyfus Affair.

SISLEY has unsuccessful exhibition showing 146 paintings at Galerie Georges Petit with few sales and little critical notice.

CÉZANNE works in Paris, in the forest of Fontainebleau, at Marlotte and Mennecy. Returns to Aix.

MONET works at Pourville. Continues Mornings on the Seine series.

RENOIR works in Essoyes and Paris.

1898
PISSARRO shows paintings of Paris and Éragny at Durand-Ruel. Works at Rouen and visits Rembrandt exhibition in Amsterdam.

DEGAS with his family at Saint-Valéry-sur-Somme.

SISLEY in deteriorating health.

CÉZANNE works in and around Aix. Returns to Paris in autumn, works near Pontoise.

MONET exhibits 61 works at Galerie Georges Petit including Mornings on the Seine series.

RENOIR exhibits jointly with MONET, PISSARRO and SISLEY at Durand-Ruel. Attends funeral of Mallarmé at Valvins. Makes a trip to Holland.

1899
PISSARRO in Paris from January. In the autumn stays at Varengeville and Moret.

DEGAS with his family at Saint-Valéry-sur-Somme.

SISLEY dies in extreme poverty of cancer of the throat on January 29.

CÉZANNE working in Paris. Returns to Aix in autumn; forced to sell Jas de Bouffan following his mother's death.

MONET exhibits at Durand-Ruel, Georges Petit in Paris and the Lotus Club in New York. Begins first series of Watergarden paintings. Visits London and begins painting the Thames from the Savoy Hotel.

RENOIR exhibits jointly with MONET, PISSARRO and SISLEY at Durand-Ruel. Treatment for rheumatism at Cagnes and Aix-les-Bains. For the winter at Grasse and Magagnose.

1900
PISSARRO: Paris World's Fair shows *100 Years of French Art* with a large representation of Impressionism including works by Pissarro. Stays in Paris, visits Dieppe and Berneval.

DEGAS: his works are exhibited at the Centennial exhibition, although without his approval.

CÉZANNE in increasing retirement in Aix.

MONET exhibits recent work at Durand-Ruel. Returns to London to work on Thames series. Works at Vétheuil.

RENOIR exhibits 68 works at a one-man show at Bernheim-Jeune, Paris, and 11 paintings at the Centennial exhibition of the Paris World's Fair. Holds a joint exhibition with MONET at Durand-Ruel, New York. Accepts the order of Chevalier de la Légion d'Honneur. Spends the winter at Magagnose.

1901
PISSARRO exhibits at Durand-Ruel. Works in the summer in Dieppe and Berneval.

CÉZANNE in Aix. Buys land on the chemin des Lauves to build a studio.

25

MONET returns to work at Vétheuil. Returns to London in January.

RENOIR exhibits 23 works at a mixed show at Paul Cassirer, Berlin. Visits Grasse and Aix-les-Bains.

1902

PISSARRO exhibits with MONET at Bernheim-Jeune. Stays at Moret and Dieppe.

DEGAS: his eyesight is failing.

CÉZANNE exhibits three paintings at Salon des Indépendants.

MONET exhibits with PISSARRO at Bernheim-Jeune.

RENOIR exhibits 40 works at Durand-Ruel. Works with André at Le Cannet.

1903

PISSARRO works in Le Havre. Exhibits works at one-man show at Durand-Ruel in New York. Dies on November 13.

CÉZANNE exhibits seven paintings at the Secession in Vienna and three in Berlin.

MONET works on London paintings in the studio at Giverny. Begins second Water-garden series.

RENOIR at Le Cannet, Cagnes and Essoyes.

1904

Durand-Ruel holds retrospective exhibition of PISSARRO's work.

DEGAS, with failing eyesight, works only on sculpture or in pastel. Visit to Les Vosges.

CÉZANNE receives visit from Émile Bernard who is preparing an article on him. Exhibits nine paintings at La Libre Ésthetique in Brussels and at the Salon d'Autômne in Paris. Has one-man show at Paul Cassirer in Berlin.

MONET exhibits 37 of London series at Durand-Ruel. Makes trip to Madrid.

RENOIR exhibits 12 works at La Libre Ésthetique in Brussels and at the Salon d'Autômne in Paris.

1905

CÉZANNE receives visit from Maurice Denis in Aix. Exhibits ten paintings at the Salon d'Autômne.

MONET: major exhibition of Impressionist paintings is organized by Durand-Ruel at the Grafton Galleries in London. Monet exhibits 55 works.

RENOIR exhibits 59 works at Grafton Galleries and nine works at the Salon d'Autômne.

1906

CÉZANNE exhibits ten paintings at the Salon d'Autômne. Dies in Aix on October 22.

MONET works at Giverny on Water-Lilies series.

RENOIR exhibits five paintings at the Salon d'Autômne. Year spent in Cagnes, Paris and Essoyes.

1907

MONET: a *Rouen Cathedral* is purchased by the State for the Musée du Luxembourg.

Monet's influence on Clemenceau effects the transfer of *Olympia* from the Luxembourg to the Louvre.

RENOIR spends most of the year in Cagnes where he purchases a property, "Les Collettes," on which he builds a house. Metropolitan Museum in New York buys *Portrait of Mme Charpentier and Her Children*.

1908

MONET makes a trip to Venice. Joint exhibition of landscape paintings with RENOIR at Durand-Ruel.

RENOIR exhibits in joint landscape exhibition with MONET,

and in exhibition of still-lifes, both at Durand-Ruel, Paris. Exhibits 41 works in a one-man show at Durand-Ruel, New York. Moves into his new house at Les Collettes.

1909

MONET exhibits 48 Water-Lilies at Durand-Ruel.

RENOIR spends year in Cagnes.

1910

MONET makes improvements to the water-garden following flooding of the Seine.

RENOIR exhibits 37 works in retrospective at the Venice Biennale, and 35 works at joint exhibition with MONET, PISSARRO and SISLEY at Durand-Ruel.

1911

DEGAS, in spite of very poor eyesight, visits Ingres exhibition at Galerie Georges Petit.

MONET: his wife Alice dies on May 19. Exhibits 45 paintings at one-man show at the Museum of Fine Arts, Boston.

RENOIR in Paris and Cagnes.

1912

DEGAS: at the auction of the collection of Henri Rouart, his work fetches very high prices.

MONET exhibits 29 paintings of Venice at Bernheim-Jeune. Cataracts in both eyes diagnosed.

RENOIR has two exhibitions at Durand-Ruel, at which 74 works are shown in April–May and 58 portraits are shown in June. Exhibits 41 works at Galerie Thannhauser, Munich, and Paul Cassirer, Berlin. Meier-Graefe's monograph on Renoir is published. Severe rheumatism prevents use of studio in Cagnes; confined to wheelchair following a stroke.

1913

MONET visits St Moritz, Switzerland.

RENOIR exhibits 52 works at one-man show at Bernheim-Jeune. Vollard suggests that he makes sculpture; collaborates with Richard Guino, a pupil of Maillol.

1914

MONET: Camondo bequest leaves works by Monet to the Louvre.

RENOIR exhibits 30 works at Durand-Ruel, New York. Stays in Paris and Cagnes.

1915

MONET begins construction of third studio to accommodate new series of mural-sized Water-Lily Decorations.

RENOIR in Paris and Cagnes. His wife Aline dies on June 27.

1916

MONET works on Decorations in the new studio.

RENOIR spends year in Cagnes, summer in Essoyes. Exhibits 26 works at exhibition of French art at Winterthur, Switzerland.

1917

DEGAS dies on September 27.

MONET continues work on Decorations. Visits Le Havre, Honfleur, Étretat and sites of earlier "campaigns" of painting on Normandy coast.

RENOIR exhibits 18 works at Durand-Ruel, 60 works in exhibition of modern French art at Kunsthaus, Zurich.

1918

MONET: Clemenceau and Geffroy visit Giverny and negotiations begin for presentation of Decorations to the State.

RENOIR, in failing health, divides year between Cagnes and Nice. Exhibits 28 works at Durand-Ruel.

1919

MONET's sight worsens.

RENOIR appointed Commandeur de la Légion d'Honneur. Exhibits 35 works at Durand-Ruel. Monograph on him by Albert André is published. Dies in Cagnes on December 3.

1920

Negotiations with the State about donation of MONET's Decorations involve proposal for pavilion in grounds of Hôtel Biron (Musée Rodin). Monet refuses nomination to Institut de France.

1921

MONET sells *Women in the Garden* (1867) to the State for 200,000 francs. State refuses funding for Hôtel Biron pavilion.

1922

The Decorations are officially presented to the State for installation at the Orangerie des Tuileries.

1923

Two operations on MONET's right eye, with partial success.

1924

Large retrospective of work held at Galerie Georges Petit. Recent Water-Lilies exhibited at Durand-Ruel in New York.

1925

Still working on Decorations, health and sight permitting.

1926

MONET dies on December 5 at Giverny.

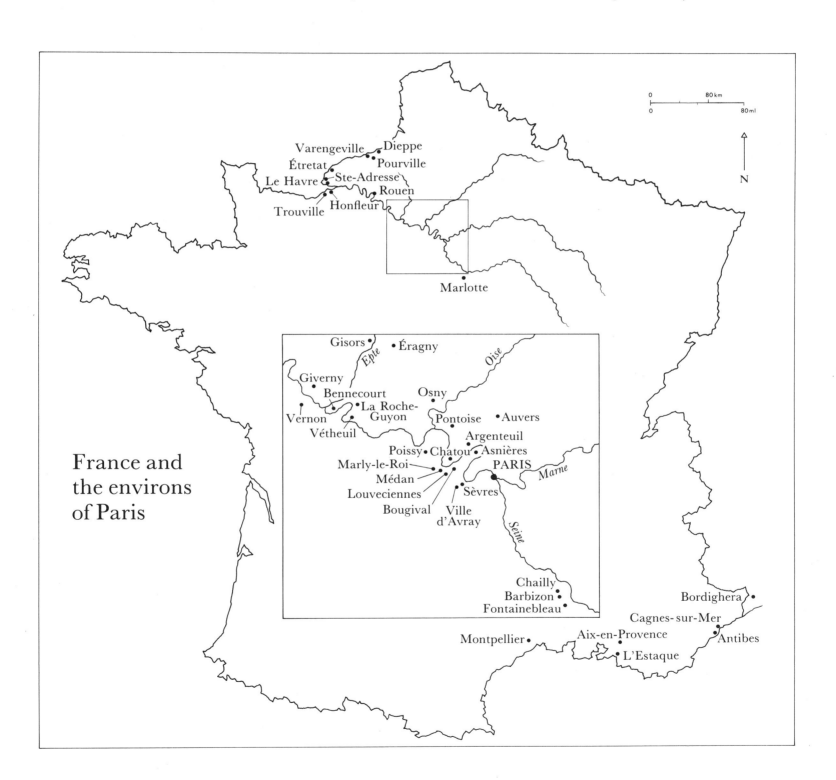

France and the environs of Paris

INTRODUCTION

When the official Salon opened in Paris in May 1865, one painting among the thousands on the walls provoked such an uproar that the authorities were forced to put two uniformed guards on duty to protect it from assault. This was Édouard Manet's *Olympia*. Bewildered and upset by the barrage of criticism that was "raining down on him like hail," Manet turned for support to his friend the poet Charles Baudelaire. This book begins with the exchange of letters between them. Baudelaire's reply to Manet's request for a "sane opinion" on his painting is the prophetic yet enigmatic remark, "You are only the first in the decrepitude of your art." Although Baudelaire does not explain this further than to add (comparing Manet to Chateaubriand and to Wagner) that ridicule is the fate of genius, it is clear that he sees Manet's position as an artist to be a turning point which is both an end and a beginning.

See page 40.

Manet regarded the Salon as "the real field of battle." But Baudelaire, whose collection of poems *Les Fleurs du Mal* was prosecuted for obscenity in 1857, had suffered enough at the hands of the Establishment to make him less vulnerable than Manet. He could see the authority of the Salon as demeaning and recognized the paintings exhibited there as an impoverishment of the forms and values of art.

The first indication that an independent and alternative means of exhibiting before the public was under discussion appears in the letter that Frédéric Bazille, the younger friend of Monet, Renoir and Pissarro, sent to his parents in Montpellier in 1867. Referring to a "plan of a group of young people to have their separate exhibition" which had collapsed through lack of funds, he wrote: "We must therefore abandon our desired project. We will have to return to the bosom of the administration whose milk we have not sucked and which disowns us." Nevertheless, the plan to exhibit independently of the Salon and the academic establishment was revived in the spring of 1873, this time successfully. After much discussion within the group of Pissarro's proposal for a cooperative based on the statutes of a bakers' union in Pontoise, the participants formed a joint-stock company with an open membership, funded through an annual subscription and a levy on sales. The charter of the "Société anonyme coopérative" of painters, sculptors and printmakers was signed on December 27, 1873 by, among others, Pissarro, Degas, Sisley, Cézanne, Monet, Renoir and Morisot: the future "Impressionists."

See page 79.

Bazille had wanted to reassure his parents in 1867 that this idea should be considered as nothing more than a "student revolt." Yet their founding exhibition in the spring of 1874, which historians now describe as the first Impressionist exhibition, came to be recognized as an historic event: "the first coherent organic and consciously avant-garde movement in the history of modern art."

Renato Poggioli: The Theory of the Avant-Garde, *1968 (p. 132).*

Impressionism now appears to us as the most familiar and acceptable of all the modern movements in art. The fact that pleasure is one of its themes makes it difficult to experience this art as disturbing, provocative or radical. In the paintings we see now we enjoy a sunlit, relaxed image of nature and an image of a carefree sociability: the middle class taking time off in the café or in the countryside. Nature and society are both at their most "natural." Recent art historians have been concerned with showing some of the darker social realities that lay behind the bright world of this stereotype.

T. J. Clark: The Painting of Modern Life: Paris in the art of Manet and his followers, *1985; Charles S. Moffett (ed.):* The New Painting: Impressionism 1874–1886, *1986; Robert L. Herbert:* Impressionism, Art, Leisure and Parisian Society, *1988.*

Earlier histories, beginning with John Rewald's *History of Impressionism*, have defined the Impressionists as a closely knit and heroic group of artists breaking free of the orthodoxy of the Establishment. Their choice of contemporary subjects, their practice of painting out of doors, and their concentration on the visual are seen as a new style of painting created in opposition to the academic art of the time. Equally, "the crisis of Impressionism" in the 1880s, the return to work in the studio, the concern with structure, weight, expression, memory or idea in Post-Impressionism and in

John Rewald: The History of Impressionism, *1946.*

the later work of Renoir, Monet and Pissarro are seen as a reaction against the Impressionist interest in light, vision and the visible world. The issue of change, however, within art is not now seen exclusively as an issue of style. The avant-garde role played by the leading protagonists, Manet, Pissarro, Degas, Sisley, Cézanne, Monet, Renoir and Morisot, singled out by Rewald as emblematic of "Impressionism" as a whole, is also up for debate. A very mixed constituency of artists exhibited in the eight Impressionist exhibitions, many of whom are names now known only to specialist art historians of the period. Although Monet was anxious to reserve the term for aspects of his own practice, the title of his painting *Impression: Sunrise* shown at the first exhibition had suggested an appropriate name for the group as a whole. Yet there was a debate within the criticism and philosophy of art of the period about its meanings and, to Monet's regret, there was no consensus among his colleagues as to who was a "true" Impressionist. "I am very sorry," he wrote at the end of his life, "to have been the cause of the name given to a group the majority of which had nothing to do with Impressionism."

See page 330.

John House: *"Impressionism and History: The Rewald Legacy,"* Art History, *Vol. 9, No. 3, September 1986.*

Richard Shiff: Cézanne and the End of Impressionism: A study of the theory, technique and critical evaluation of modern art, *1984.*

See page 320.

The writings in this book will confirm both the range of complexity within contemporary interpretations of Impressionism, and the changes in understanding that the term has undergone in this century. But the choice of texts and illustrations is primarily designed to reveal two themes: the radical difference from contemporary painting within the practice of Impressionism, and how this difference was experienced by audiences and by the artists themselves. A number of critics, perhaps bending over backwards to be generous, greeted the first Impressionist exhibition with positive and supportive reviews. But it is the savagery of the negative criticism, as is often the case in the reception of art, that shows exactly where the new painting has touched a nerve. Artists are the spectators as well as the creators of their paintings. The anxiety, despair and sense of crisis conveyed in the letters of Monet, Renoir and Pissarro in the late 1870s and early '80s, which frequently echo the criticism found in earlier negative reviews, reveal a dimension of their art which held radical extremes even for them.

One aspect of this extremism involved their subject matter: the representation of nature. In spite of their avant-garde stance, the Impressionists inherited the very traditional notion, which had been the unifying principle within art since the Renaissance, that art was a likeness of reality. Alberti had written that painting was a window on the world. To "copy nature" was to create in painting an authentic image of the real. Yet painting only looks as "real" as conventions for representation can make it. The fragmentary broken brush-stroke, the indeterminacy and fluidity of the new methods of painting (to which the critics reacted with such hostility), seemed to lead in unpredictable directions away from the image of nature. The Impressionists quickly found themselves in an area of dynamic conflict between representation and the abstraction of their painterly means. This was entirely new. Did Baudelaire in describing Manet as "only the first in the decrepitude of (his) art" have an intimation of the jeopardy into which representation was to be thrown? The complex symbol that combines elements of representation with elements of the medium of painting, even within a single brush-stroke, is the legacy of Impressionism to the modern art of the twentieth century.

The conflict between representation and abstraction within Impressionism involved a number of interrelated issues. The documents assembled here show that "painting problems" cannot be separated from the problems that these artists as individuals had to confront and solve within their personal lives and professional careers. Defiance of the Salon and the Academy faced this generation of artists with the new question of how to establish a relationship with an audience outside the institutionalized frameworks for art. This was an issue both of communication and remuneration: how to be understood and how to make a living.

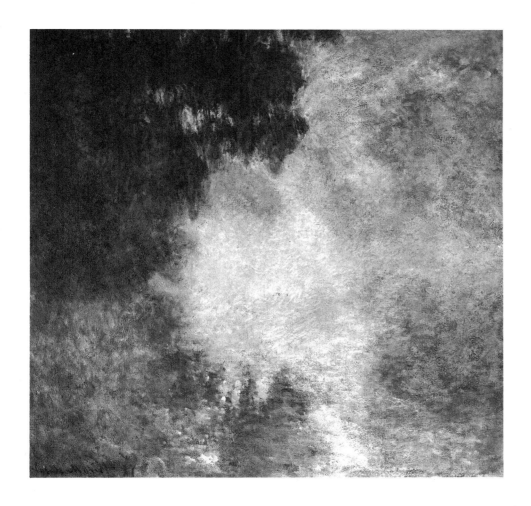

Claude Monet. *A Morning on the Seine.*
*c.*1897. 34½ × 35¼″ (87.6 × 89.5 cm).
The Art Institute of Chicago.

In his letter to his parents in 1867 Bazille had described the plan to exhibit independently of the Salon as merely a "student revolt." The tone of his letter is designed to conceal the evident risks involved for these artists personally in cutting themselves off from the only established means of reaching prospective buyers. Although by the late '60s and early '70s the support of the dealer Durand-Ruel and the appearance of a small number of sympathetic critics and collectors had offered at least the possibility of an alternative livelihood, the only secure professional career remained within the structure of the Academy and the Salon. Its routes were familiar and well-rewarded. Outside this, the artists who threw in their lot with the avant-garde then forming, but without the sense of identity lent by a fully fledged notion of the avant-garde, were committing themselves to careers without any known future. The starkness of these choices is frequently borne out in their letters. They are preoccupied with money: with borrowing or even earning it (see Monet's letter to a patron in which he both asks for money and threatens to get a job), with selling (see Monet and Renoir returning to the Salon to have a better chance of selling paintings), and with "selling out" (see Pissarro's contempt for Monet's "salesman's game" and Monet's contempt for Renoir's Légion d'Honneur).

See page 239.
See pages 240, 174.
See page 222.
See page 275.

The new artists' cooperative, the Société Anonyme, had been set up with three specifically stated aims: to show their work directly to the public without the mediation of a jury, to promote sales, and to publish their own critical journal on the arts. The venue for their first exhibition, the studios of the photographer Nadar on the boulevard des Capucines, was an accessible and busy central location frequented by shoppers and tourists. The site chosen for the show and its opening hours, specially extended until 10 pm, were designed to make the most immediate possible bid for public attention.

The decision to bypass the government "supermarket" and to go straight to the public with their work placed this generation of artists at the mercy of the public in a new way. It was the same confident anti-institutional

attitude that had led to the new practice of painting out of doors directly from looking. *Plein-air* painting also seemed to deny the need for mediation. Direct painting (without preparatory studies, without compositional planning) had been practised by Courbet, Daubigny, Jongkind and Boudin. It demanded a spontaneous and immediate response to the subject. And the subject itself, the natural world accessible to the vision of all, was a common experience shared between artist and audience. Viewed as if detached from any wider structure of meaning or value, from society at large, nature could almost seem to replace culture. "Let us try to see things as they are," wrote Flaubert, with regard to realism in the novel, "and not try to be cleverer than God. Once upon a time it was thought that only sugar cane produces sugar. Nowadays it is extracted from almost anything; it is the same with poetry. Extract it from anything at all, for there are deposits of it everywhere."

Gustave Flaubert: March 27, 1853, cited in Charles Rosen and Henri Zerner: Romanticism and Realism, *1984 (p. 150).*

Painting "things as they are" and concentrating on the visual seemed to offer a way of resisting "deposits" of poetry, culture, or received ideas of style. The myths in which the physical world had been clothed, the classical, romantic or pastoral styles through which it had been viewed and through which it had been interpreted to its audiences, could, so it seemed, for the first time be removed. To paint directly from nature was to see the model naked, as if unmediated by subjective imagination or any cultural fiction. The landscapes of the '60s by Pissarro, Sisley and Monet have that deadpan realism which Baudelaire criticized in Courbet as painting things "without imagination" and "as if the '*I*' did not exist. The universe without man." Painting directly from looking was a new and highly individualistic experience. It was protestant in an oppositional, secular sense; to make one's own contract with nature, without intermediaries, and entirely on one's own terms enabled each artist in front of nature to be "his own priest." Monet's early letters to Bazille emphasize both the importance of being alone with nature and the capacity of painting to take an open impartial view free of influence or preconception. Describing a recent painting, he admits that it may bear a "certain resemblance to Corot," but only the mist is responsible. He has painted it "as conscientiously as possible without thinking of any other painting."

Charles Baudelaire: "Salon de 1859," Oeuvres complètes, *1968 (p. 400).*

The notion that when you went to paint out of doors you left behind in the studio the institutional baggage of art, the influence of other artists and the past history of picture-making is lampooned by Daumier in one of his series of cartoons, *The Landscape Painters*: "The first copies from nature; the second copies from the first." The cartoon itself indicates that these ideas had a wide currency. Monet publicly denied that he ever painted except from nature. In an interview with Émile Taboureux in June 1880, replying to a question about his studio, Monet replied, "But I have no studio! That," he said, pointing to the fields, "that is my studio." Yet by the early '80s his letters to Alice Hoschedé and to his dealer Durand-Ruel reveal the extent to which he was reworking his paintings in the studio away from the motif. The image of the Impressionist painter working exclusively from his immediate perceptual responses to a moment of vision was a popular stereotype that frequently appeared in contemporary criticism.

See page 54.

See page 59.

See page 241.

See pages 243, 244.

Monet was himself the most assiduous promulgator of this myth. Yet his attachment to it and his denial of his studio may be connected to a larger idea of modernism. "The pleasure which we derive from the representation of the present," Baudelaire wrote in *The Painter of Modern Life*, "is due not only to the beauty with which it can be invested, but also to its essential quality of *being present*." This "'present-ness' of the present" was the essence of the experience of direct painting with its new emphasis on immediacy of sensation. Pissarro's "Advice to a Young Painter" was to work on everything "simultaneously. Don't work bit by bit, but paint everything at once by placing tones everywhere . . . try to put down your perceptions immediately . . . work at the same time upon sky, water, branches, ground, keeping everything going on an equal basis." This advice differed radically

This myth of the Impressionist painter had its most naïve reception in Britain in the writings of Roger Fry, Characteristics of French Art, *1932, Clive Bell, see page 326, "The Importance of the Impressionists,"* Art, *1914, and Evan Charteris, see page 319,* The Life of John Sargent, *1927, for whom Impressionist paintings were the "scientific" recordings of the impressions of light from nature on the retina.*
"'Present-ness' of the present": Paul de Man's translation of sa qualité essentielle du présent *in "Le Peintre de la Vie*

from conventional practice, which prescribed the careful staging of phases of painting. The generalized preliminary "laying-in" (*ébauche*) led to the gradual refinement and particularization of detail required of the finished painting (*tableau*). By contrast Pissarro's advice is to keep the painting in the open condition of a sketch so that it maintains its fluid improvisational qualities. There are no stages of painting; each approach would seem to be continuously beginning again. The experience of painting was of a permanent immediacy of sensation, a constantly recurring present moment.

This way of painting was entirely new. Castagnary, Chesneau and other critics writing on the first Impressionist show were shocked to see paintings exhibited before they were finished. Huysmans wrote in 1882 on the seventh exhibition that Impressionism, largely through Monet's influence, had come to refer to painting which "remained in a state of inchoate confusions, of uncertain beginnings." But Monet, too, agonized over the problem of finishing his own paintings, on the one hand feeling dissatisfied with "easy things that come in a flash" where spontaneity was in danger of remaining superficial, and on the other hand in despair when paintings were overworked and freshness was lost.

To "keep everything going on an equal basis" meant to keep the painting in the paradoxical state of being continuously new, as if a fresh response might be discovered even with the final brush-stroke. The extreme nature of this ideal of immediacy must be emphasized. It links Impressionism with that defiance of culture which is characteristic of the avant-garde movements of the twentieth century. It also proposes a laying bare of sensation that reason says is impossible. "I am seeking the impossible," wrote Monet, "it is enough to drive you stark raving mad."

This emphasis on freshness, improvisation and immediacy: "the presentness of the present" (Baudelaire), "the untouched alive now" (Mallarmé), put the Impressionists in an ambivalent relation to the past. Their attitudes about this were very different. Degas was clearest in his allegiance to tradition, particularly to Ingres, and in his scepticism about landscape painting out of doors, recommending "a little dose of grapeshot now and then as a warning." Renoir was the most sensitive to the conflict between the two. "Nature brings one isolation," he reported to Walter Pach, "I want to remain in the ranks. – But if it is not before nature that a young man becomes an artist, where is it? – By God, in the museum!" Monet's denial of the studio and all that working in the studio from memory represented involved two issues. It was a denial both of his own personal memory and past – those feelings of "sense and sentiment" that Renoir had no problem in accepting – and of the influence of past art. On the other hand Monet was a sophisticated artist with a tremendous knowledge and love of painting. He was a passionate devotee of Corot and of Watteau. Yet he wanted to paint, as Mallarmé said later, as a *civilisé édénique*, a civilized first man, an inhabitant of the world museum who is still, like Adam, inventing painting for the first time.

Monet's very first experiences of painting out of doors with Boudin in 1858 suggest the excitement of painting as if on a clean slate: "Suddenly a veil was torn away. I had understood. I had realized what painting could be." The quality of revelation implied in the image of a veil being torn away seems connected with the wish that he had been born blind so that he could have begun to paint "without knowing what the objects were that he saw before him." In the same context Lilla Cabot Perry remembers him saying, "When you go out to paint, try to forget the objects you have before you: a tree, a house, a field or whatever. Merely think, here is a little square of blue, here an oblong of pink, here a streak of yellow . . ." Here Monet seems to suggest that in painting images of things a sequence of patches of colour could erase their identity. This plunge into the unknown, to paint the world with no given boundaries or definitions, no familiar identities, no "names" so to speak, was one of the new potentialities for painting which Impressionism offered. It was "what painting could be." Mallarmé also opposes

Moderne," *Baudelaire:* Oeuvres complètes, *1968 (p. 547). See Paul de Man: "Literary History and Literary Modernity" in* Blindness and Insight, *1971 (pp. 142–65), for a discussion of the modernist aesthetic of immediacy.*
For Pissarro see page 224.
See Albert Boime: The Academy and French Painting in the Nineteenth Century, *1971, for a discussion of the relationship between Impressionist and academic techniques.*

See page 176.

Christopher Yetton's translation of Mallarmé, Le vierge le vivace et le bel aujourd'hui.

See page 152.

See page 211.

Quoted by Harold Rosenberg in an interview with Philip Guston in Philip Guston Recent Paintings and Drawings, *Jewish Museum, New York, January–February 1966.*

G. Jean-Aubry: "Une visite à Giverny," Havre Éclair, *Le Havre, August 1, 1911 (p. 1), cited in W. Seitz,* Seasons and Moments, *Museum of Modern Art, New York, 1960 (p. 5).*

See page 254.

See page 108.

memory and forgetting in the same way: "Each work should be a new creation of the mind . . . The eye should forget all else it has seen . . . it should abstract itself from memory, seeing only that which it looks upon . . . as for the first time."

Monet's early paintings show startling effects of light that do not fit into conventional schemes of pictorial unity or representation. *Women in the Garden* was begun out of doors in the summer of 1866. If we compare it to a similar composition by his friend Bazille of 1868 we see that rather than confirming, as Bazille does, the way we habitually conceive of a woman's face with light and shadow moulding its form, Monet has used light to deprive the face of our knowledge of it, presenting it in a surprising unthought-of sequence of colours. In *The Seine at Bennecourt* (1868) Monet has not indicated the slightest allegiance to the idea of a woman's face as opposed to the surrounding space or background. Two brush-strokes hover together, but there is no gestural turning of the brush; there is no hint of a priority of one tone as representing a human face over the adjacent patch as representing water. In a totally unprejudiced way, as if there were no distinction between figure and background, patches of colour seem applied across a field of vision without any order of priority, without even acknowledging where one image stops and another begins. Colour and brush-stroke pursued in this way are antagonistic to the traditional means of representing things in the world and our process of recognizing them. The figure of the woman feels as though it is only very tenuously held together, as if it might fall apart or explode.

Yet we tend to see Impressionism now in terms of an ideal naturalness. Fragments come together to form a perfectly unified scene: "real meadows and rivers in the sun." But "the statements that compose them are enigmatic in themselves. They are the simplest dabs of paint that a brush can make which cannot imitate a single leaf or ripple" (Lawrence Gowing). These single patches of colour have such a startling immediacy and independence that they resist being used as a representational means. They resist "likeness." Their tendency is to remain as visible strokes of paint, as fragments floating forward to the surface of the picture, detached from all the organizing, focusing, combining and separating activities that are essential to representation. Pissarro advised that it was "the brush-stroke of the right value and colour that should produce the drawing." But without the intention to produce continuous lines drawing, as it had been understood, could be lost; if tones were not considered as a sequence, modelling could be lost. Without continuity of line or tonal contrast, there might be no distinction between object and space, no perspective, no foreground as opposed to background. These representational means which enable us to see a picture as a view of nature were put under tremendous stress.

By the late 1870s the surfaces of paintings by Monet, Renoir and Pissarro were developing a tremendous complexity. Concentration on colour relationships tended to diminish all other contrasts in favour of those of colour itself. Complicated surfaces were built up through layering, glazing and minute temperature changes between warm and cool colour in which the image seemed granulated or pulverized. Huysmans described a painting of Pissarro's of 1878 as a "strange wrinkled patchwork, a stew of colours" [see page 157]. The effect of all these techniques, which allowed a continuous interrelating and transition among colours, was to endanger the image itself.

Our enjoyment of these paintings now makes it easy to overlook the violent assault that Impressionism represented on contemporary modes of perception in art. We can only guess at the real sense of fragmentariness and incoherence – how difficult it was to "read" these pictures, in what seemed like a chaos of fragments of colour – from contemporary criticism and also from the anxiety and despair expressed by the painters themselves. The documents in this book show how the two are often remarkably connected.

In some of the negative reactions to the first two Impressionist exhibitions, in the reviews of Cardon, Castagnary, Chesneau, Blémont and Wolff, even though they may now read as crass or naïve, there is nevertheless a real

Claude Monet. *Women in the Garden* (detail). 1867. Whole picture 100¾ × 82″ (256 × 208 cm). Musée d'Orsay, Paris.

Frédéric Bazille. *View of the Village* (detail). 1868. 52⅛ × 35⅝″ (132.3 × 90.4 cm). Musée Fabre, Montpellier.

Lawrence Gowing: Watercolour and Pencil Drawings by Cézanne, *Arts Council of Great Britain, 1973 (p. 6).*

Cham. *Le Charivari*, April 20, 1879. "New School – Independent Painting: Independent of their Will. Let us Hope So for Them." British Library, London.

recognition of something new and disturbing [see pages 81, 83, 86, 97, 103].
Albert Wolff wrote: "They take canvas, paint and brushes, fling something
at random and hope for the best;" Émile Cardon: "Smear a panel with grey,
plonk some black and yellow lines across it and . . . the visionaries exclaim,
'Isn't that a perfect impression of the bois de Meudon?'" Kandinsky, on
seeing a Monet for the first time in Moscow in 1895, wrote, "that it was a
haystack the catalogue informed me. I could not recognize it. At first this
lack of recognition was distressing to me. I felt that the painter had no right
to paint so indistinctly" [see page 320]. These reactions have in common the
sense of the actual materials of painting overpowering image and meaning.
The artist seems to be infuriatingly or distressingly unable to make us
believe in the reality of a depicted world.

The difference between the clarity of image in Monet's 1871 *Houses of
Parliament* (National Gallery, London) and the paintings made after he
returned to London in 1899–1900 shows the unforeseen and often bewilder-
ing direction in which Impressionism was leading. Pissarro, unconsciously
echoing one of the earliest critics of Impressionism (who said in *La Patrie*
"looking at the first rough sketch, and rough is the right word"), wrote to
Lucien in 1883, "I am much disturbed by my unpolished and rough
execution . . . therein lies the difficulty, not to speak of drawing." Renoir,
reminiscing to Vollard about the "break" that occurred in his work around
1883, felt he had come to the end of Impressionism: "I was reaching the
conclusion that I knew neither how to paint nor how to draw."

The poet Jules Laforgue in October 1883 wrote perceptively about the
constant state of flux, of hovering between interpretations, even of the
disorientation that the painter experiences, "everything is obtained by a
thousand little strokes dancing in every direction like straws of colour – all in
vital competition for the whole impression . . . Subject and object are then
irretrievably in motion, inapprehensible and unapprehending." By the
early 1880s, as Laforgue indicates, Impressionism seemed so floating and
fluid, so indefinite and ambiguous as to raise serious questions of apprehen-
sion and comprehension. Both Pissarro and Renoir retreat in the face of
these questions and develop ways of painting that give them a firmer grip on
the representation of images, and a firmer grasp of the understanding of
their subject matter, with a greater emphasis on thought, feeling, memory
and idea. In a diatribe against Impressionism in 1886 Fénéon wrote: "They
persist in practising their wild bravuras at random, launching onomato-
poeias that never congeal into phrases. The time has come for words that are
precise and complete." Renoir reported to Vollard that Impressionism had
led him to such a desire for precision that "there were certain canvases on
which I had drawn all the smallest details with a pen before painting." It
was at around this time (1881–2) that Renoir made a trip to Italy in order to
see Raphael and Roman wall painting at first hand. His ambitious *Bathers* of
1885–6 (Philadelphia) emphasizes those classical qualities of linearity and
form that he had found lacking in Impressionism.

In 1885, a few months after the birth of his first child, Renoir wrote to
Durand-Ruel that he had gone back to "the old painting [which he
compares to Fragonard], the gentle light sort." In his biography of his
father Jean Renoir emphasizes the importance to Renoir of his son's birth in
consolidating his feelings. It is from this point perhaps that "the love of
painting and the painting of love" (Gowing) finally come together.

Pissarro, also, turned to figuration in a new way. In the early '80s his
paintings of peasants, who dominate the canvas both spatially and emo-
tionally, are a more explicit expression of qualities of feeling and of
Pissarro's political thinking than the paintings of the previous decade. In
Seurat's ideas, which attempted to organize and rationalize Impressionism,
he found a welcome refuge from its uncertainties. Although later beset with
doubts about "the dot," in 1885 he became an enthusiastic convert to Neo-
Impressionism and to the conceptual clarity of its theory and practice.

Although associated with Impressionism, Degas neither adopted its
broken brush-stroke, nor did he paint out of doors. He had no quarrel with

Claude Monet. *Thames: Parliament.* 1871.
18½ × 28¾" (47 × 73 cm). National
Gallery, London.

COLOURPLATES 107–109

A.L.T., "Chronique," La Patrie, *April
21, 1874, cited in Dunlop,* The Shock of
the New, *1974 (p. 78).*
See page 216.

See page 197.

See page 188.

Félix Fénéon: Au-delà de
l'Impressionnisme *(ed.) Françoise
Cachin, 1966 (p. 96).*
See page 199.

See page 200.

See page 369.

COLOURPLATES 80, 81

COLOURPLATES 82, 83

anecdotal subject matter, the staple of the Salon. When Duranty wrote in *The New Painting* in 1876, "A man opens a door, he enters, and that is enough: we see that he has lost his daughter," it was Degas that he had in mind. Degas remained sceptical of the whole ethos of *plein-air* painting: both the premium it placed on immediacy and its ambivalence about the past. Degas also stands apart from the Impressionism I have been describing because of the quality that Valéry recognized as the "intelligence" of the draughtsman. "It is a question," wrote Valéry, "of the one inspired line that is right, of not losing control over one's hand, of recognizing and rehearsing to oneself before putting down . . ."

See page 97.

Valéry: Degas, Danse, Dessin, 1938 (1983, p. 85), trans. Nicholas Wadley, Impressionism and the Art of Drawing, *1991.*

On the other hand, a number of writers pointed out an important area of sensibility which Degas shared with the Impressionists. His notebooks of the '60s and '70s express an interest in the fragmenting of forms carved up by special angles of vision which deprive them of their identity [see page 74]. Valéry wrote about the strangeness of the unpreconceived in Degas as an "exercise in formlessness . . . we can learn not to confuse what we think we see with what we see. There is a kind of structural activity in the eyesight of which habit makes us unaware" [see page 153]. This freshness of looking was particularly disturbing in images of women viewed, both Geffroy in 1886 and George Moore in 1891 felt, as if "through a keyhole" or as if altogether "unseen" [see pages 158, 162]. This implied a sense of the (near) absence of the artist himself and the absence of the "appropriate" feelings that might accompany looking at and representing women.

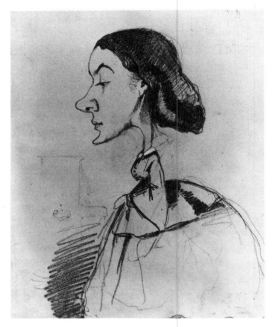

Claude Monet. *The Pianist.* 1858. Pencil, 12½ × 13¼" (32 × 34 cm). Musée Marmottan, Paris.

Monet, by contrast, had the deepest involvement with Impressionism's oceanic complexity, the ambiguity of interrelationships of colour, and with the image of nature. He reacted to the "crisis" of the 1880s with "campaigns" of painting which took him around the country to seek out "fugitive effects" in the most extreme weather and conditions. Nevertheless he was one of the strongest representational talents of the group. Sheer mimetic skill retrieved recognition from all the forces of painting that seemed to conspire against it. This is the significance of his early talent as a caricaturist. The same skills in the later work enabled him to "capture a likeness" in spite of the indeterminacy of painting.

See page 318.

Late in life Monet told Clemenceau, "I am simply expending my energies upon the maximum of appearances in close correlation with unknown realities." Yet he had become increasingly attracted to subjects for which any criteria of likeness became more and more indeterminate. He wrote to Geffroy on June 22, 1890, "Once more I have undertaken things which are impossible to do: water with grasses waving in the depths . . . It's wonderful to see, but it drives you mad to want to do it. But I am always trying things like that." The continuous flux in the image of water, which means that it almost has no "image," had become, in the final huge decorations of water-lilies, the subject of his last years, "the metaphor for painting."

See page 364.

By focusing on an experience of nature that in its ambiguity most closely matched the experience of painting, Monet was able to hold together and explore the opposed dimensions within Impressionism of representation and abstraction. The 1890s, when Monet started painting his water garden, was also the period of his closest association with the Symbolist movement and particularly with Mallarmé. This connection with poetry led to a new kind of criticism. The early critics of Impressionism and the artists themselves had been disturbed by the apparent lack of relation between the new means of painting, the single mark of colour, and the object in nature. Mallarmé, in an interview he gave in 1891, suggested a way that this relation might be understood. He said that the aim of the new poetry was not to represent things directly but to "evoke an object little by little in order to show a state of mind." This proposal of an integration of image, formal means, thought and feeling is central to the criticism of Monet's later painting by writers influenced by Symbolism such as Mirbeau, Geffroy, Lecomte and Gillet. In these writings the image qualities and painting qualities of Impressionism are brought together and understood as a whole.

See page 288.

See pages 247, 267, 269, 292.

THE
IMPRESSIONISTS

ÉDOUARD MANET AND CHARLES BAUDELAIRE

Correspondence

May 1865

MANET TO BAUDELAIRE, PARIS, EARLY MAY 1865

I would love to have you here, my dear Baudelaire, insults are raining down on me like hail, I've never known anything like it. Anyway Verwée will tell you all about it, he has sent two outstanding pictures which are very highly thought of. I would have liked your sane opinion on my pictures: all this criticism is very irritating, and it is clear that someone is in the wrong; Fantin has been charming, his defence of me is all the more creditable in that the painting he's done this year, although full of excellent things, is less striking than last year's (and he knows it).

Your long period away there must be tiring for you, I so look forward to seeing you again, as indeed do all your friends here . . .

The Academy in London has rejected my pictures.

Farewell my dear friend, my warmest greetings.

Ed. Manet

I am sending you the Liszt rhapsody you asked me for some time ago, I would have done so much earlier but my wife had lent it and the person who had it couldn't find it, here it is at last.

The art critic Ernest Chesneau (1833–98) had demonstrated his support for Manet in March 1865 by purchasing a small painting; then, writing in Le Constitutionnel *in May, about* Olympia, *he accused Manet of 'an almost childish ignorance of the fundamentals of drawing . . . He succeeds in provoking scandalous laughter, which causes the Salon visitors to crowd around this ludicrous creature called Olympia . . . In this case the comedy is caused by the loudly advertised intention of producing a noble work, a pretension thwarted by the absolute impotence of the execution.''*
Alfred Jacques Verwée (1838–95).
Henri Fantin-Latour (1836–1904) painted a homage to Manet, A Studio in the Batignolles Quarter, *exhibited at the Salon of 1870. In financial difficulties, Baudelaire had moved to Brussels in 1864.*

(Below left) Édouard Manet. *Profile Portrait of Baudelaire. 1862. Etching, 5 × 3″ (13 × 7.4 cm). British Museum.*

(Below) Frédéric Bazille. *Manet at his Easel. 1869. Charcoal, 11⅝ × 8¾″ (29.5 × 22.5 cm). Metropolitan Museum of Art, New York (Lehmann Collection).*

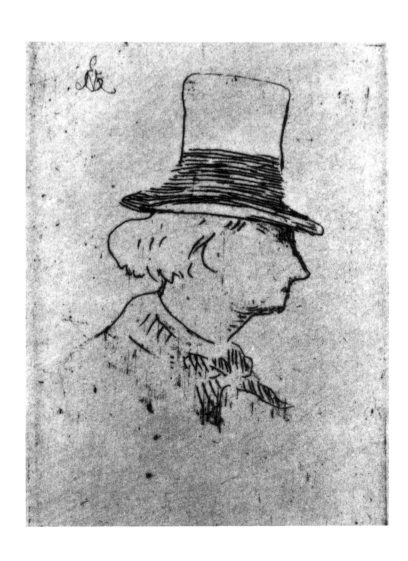

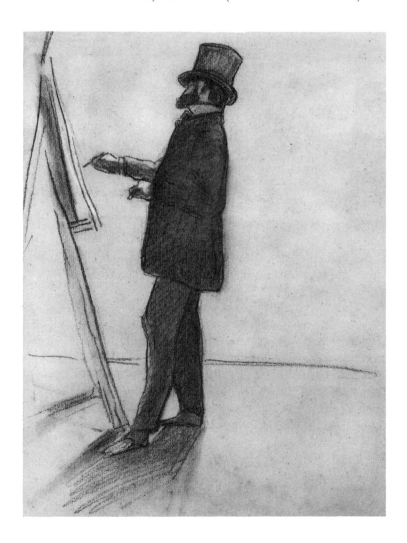

I thank you for the good letter which Chorner brought me this morning, as well as for the piece of music. . . . If you see Rops, don't attach too much importance to certain violently provincial mannerisms. Rops likes you, Rops has understood the value of your intelligence, and has confided to me certain observations which he made about the people who hate you (because it seems that you have the honour of inspiring hatred). Rops is *the only real artist* (in the sense in which I, and perhaps I only, understand the word *artist*) that I have found in Belgium.

So I must speak to you of yourself. I must try to show you what you are worth. What you demand is really stupid. *They make fun of you; the jokes aggravate you; no one knows how to do you justice, etc., etc.* . . . Do you think you are the first man put in this predicament? Are you a greater genius than Chateaubriand or Wagner? Yet they certainly were made fun of. They didn't die of it. And not to give you too much cause for pride, I will tell you that these men are examples, each in his own field and in a very rich world; and that you, *you are only the first in the decrepitude of your art.* I hope you won't be angry with me for treating you so unceremoniously. You are aware of my friendship for you.

I wanted to get a *personal* impression from this Chorner, at least in so far as a Belgian can be considered an *individual*. I must say that he was kind, and what he told me fits in with what I know of you, and with what some imaginative people say of you: *There are some faults, some failings, a lack of balance, but there is an irresistible charm.* I know all that, I was one of the first to understand it. He added that the painting of the nude woman, with the negress and the cat (is it really a cat?), was far superior to the religious painting.

JEAN RAVENEL

L'ÉPOQUE

"M. Manet – Olympia"

June 7, 1865

The scapegoat of the Salon, the victim of Parisian lynch law. Each passer-by takes a stone and throws it in her face. *Olympia* is a very crazy piece of Spanish madness, which is a thousand times better than the platitude and inertia of so many canvases on show in the Exhibition.

Armed insurrection in the camp of the bourgeois: it is a glass of iced water which each visitor gets full in the face when he sees the BEAUTIFUL courtesan in full bloom.

Painting of the school of Baudelaire, freely executed by a pupil of Goya; the vicious strangeness of the little *faubourienne*, woman of the night out of Paul Niquet, out of the mysteries of Paris and the nightmares of Edgar Poe. Her look has the sourness of someone prematurely aged, her face the disturbing perfume of a *fleur de mal*; the body fatigued, corrupted, but painted under a single transparent light, with the shadows light and fine, the bed and the pillows are put down in a velvet modulated grey. Negress and flowers insufficient in execution, but with real harmony to them, the shoulder and arm solidly established in a clean and pure light. The cat arching its back makes the visitor laugh and relax, it is what saves M. Manet from a popular execution.

> *De sa fourrure noire* [sic] *et brune*
> *Sort un parfum si doux, qu'un soir*
> *J'en fus embaumé pour l'avoir*
> *Caressé* [sic] *une fois . . . rien qu'une.*

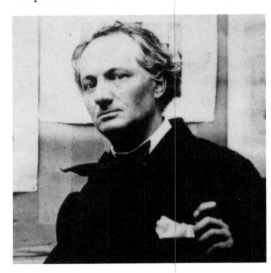

Félicien Rops (1833–98), Belgian painter and printmaker.

Etienne Carjat. *Portrait of Baudelaire.* 1861–2. From an album of contemporary portraits. c.1879. Bibliothèque Nationale, Paris.

The religious painting was Jesus Mocked by the Soldiers, *1864–5.*

Jean Ravenel: the pseudonym of Alfred Sensier (1815–77), friend and biographer of Millet.

faubourienne: *a girl from the working-class suburbs of Paris.*
Paul Niquet owned a bar in the rue aux Fers frequented by down-market prostitutes.
Les Mystères de Paris *by Eugène Sue, a melodramatic novel about the city's underworld, was published in 1843.*
The final volume of Edgar Allan Poe's short stories, translated by Baudelaire, had just been published in 1865 under the title Histoires grotesques et sérieuses.
"Corrumpu" also carries the meaning "tainted", "putrid".

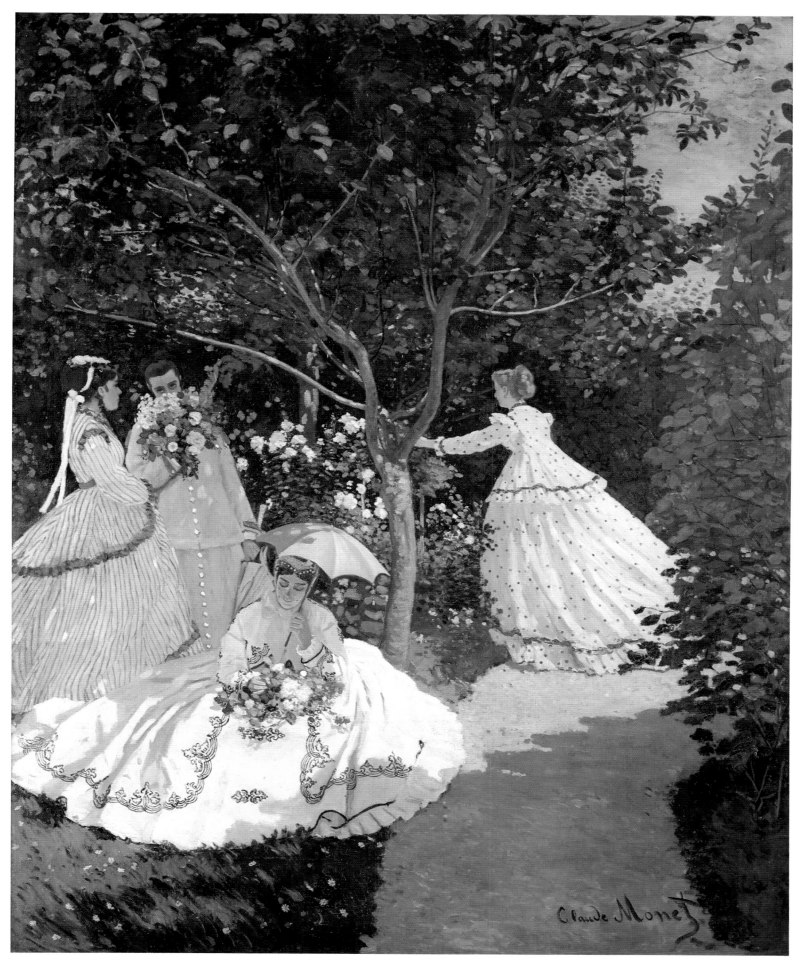

COLOURPLATE 9. Claude Monet. *Women in the Garden*. 1867. 100¾ × 82″ (256 × 208 cm).
Musée d'Orsay, Paris.

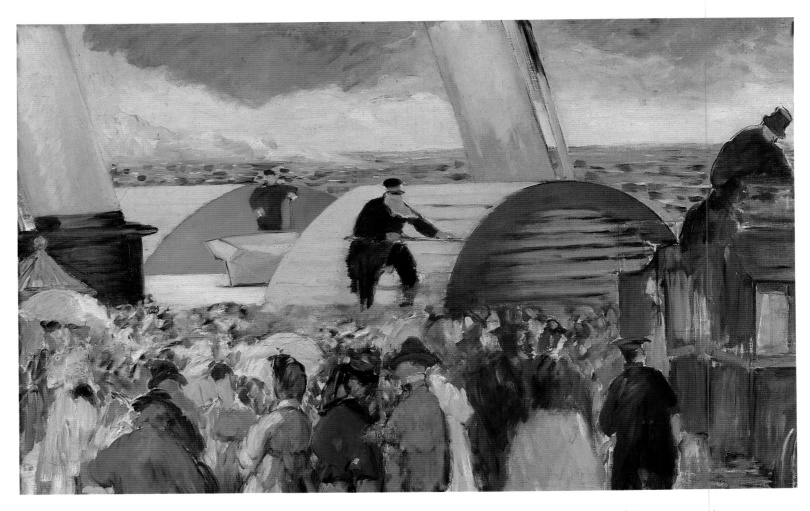

COLOURPLATE 10. Édouard Manet. *The Departure of the Folkestone Boat*. 1869. 24¾ × 39¾ (63 × 101 cm). Oskar Reinhart Collection, Winterthur.

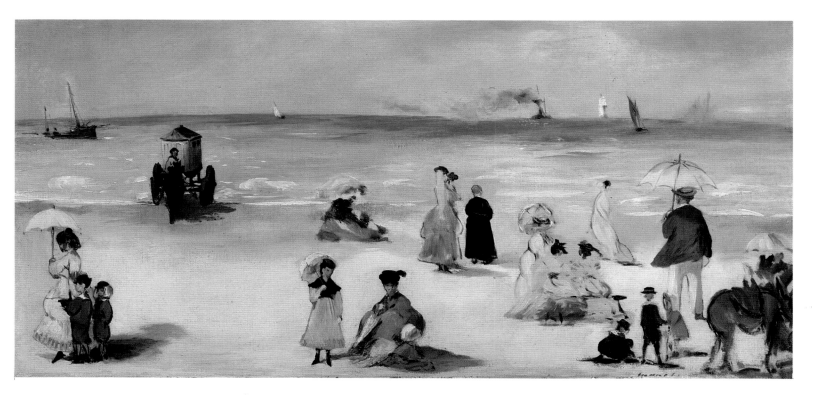

COLOURPLATE 11. Édouard Manet. *On the Beach at Boulogne*. 1869. 12¾ × 26″ (32.4 × 66 cm).
Virginia Museum of Fine Arts, Richmond (Mr and Mrs Paul Mellon Collection).

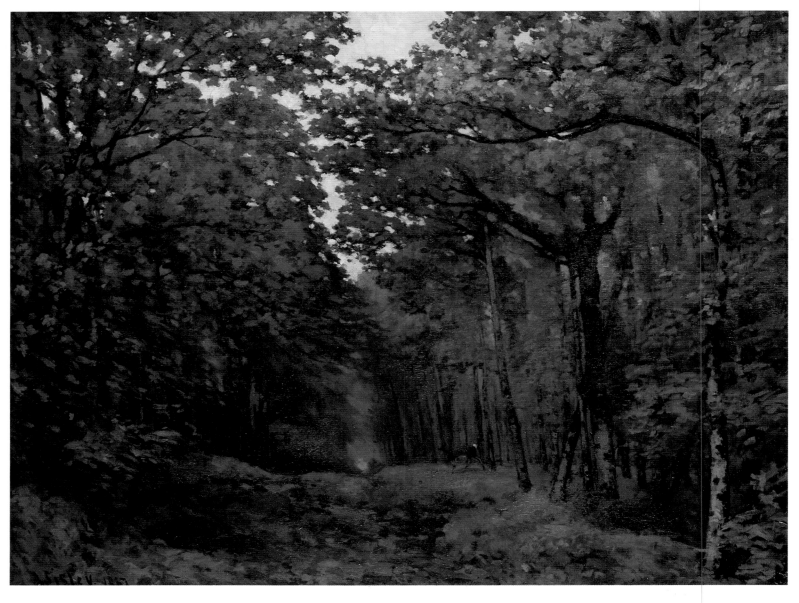

COLOURPLATE 12. Alfred Sisley. *Avenue of Chestnut Trees*. 1867. 37½ × 48″ (95.5 × 122.2 cm). Southampton Art Gallery, Southampton, UK.

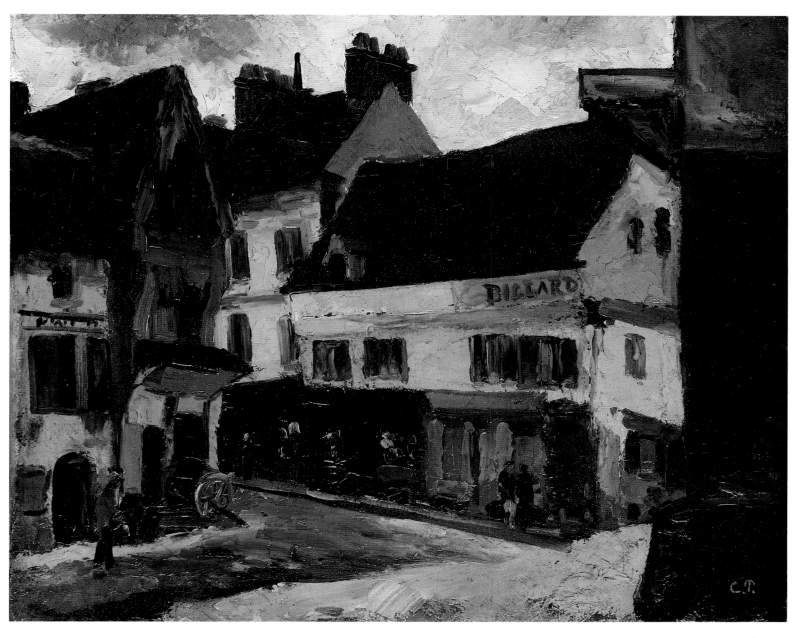

COLOURPLATE 13. Camille Pissarro. *A Square at La Roche-Guyon*. 1867. 19¾ × 24″ (50 × 61 cm). Staatliche Museen Preussischer Kulturbesitz, Nationalgalerie, Berlin.

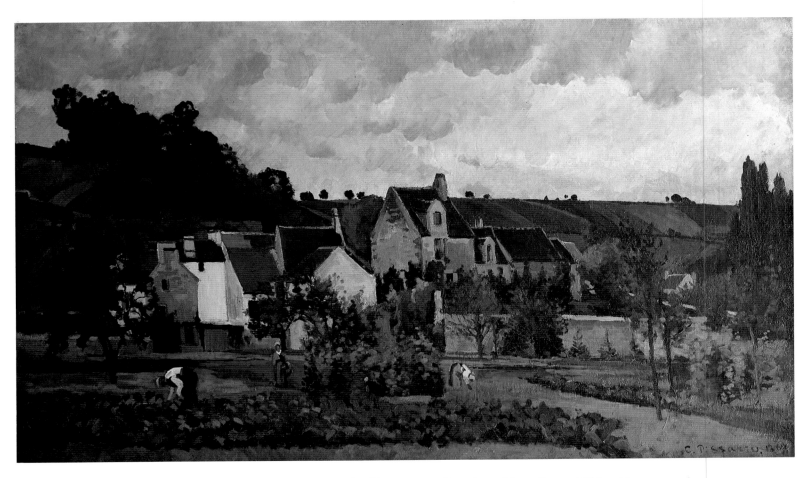

COLOURPLATE 14. Camille Pissarro. *The Hermitage at Pontoise*. 1867. 36 × 59¼″ (91 × 150.5 cm).
Wallraf-Richartz Museum, Cologne.

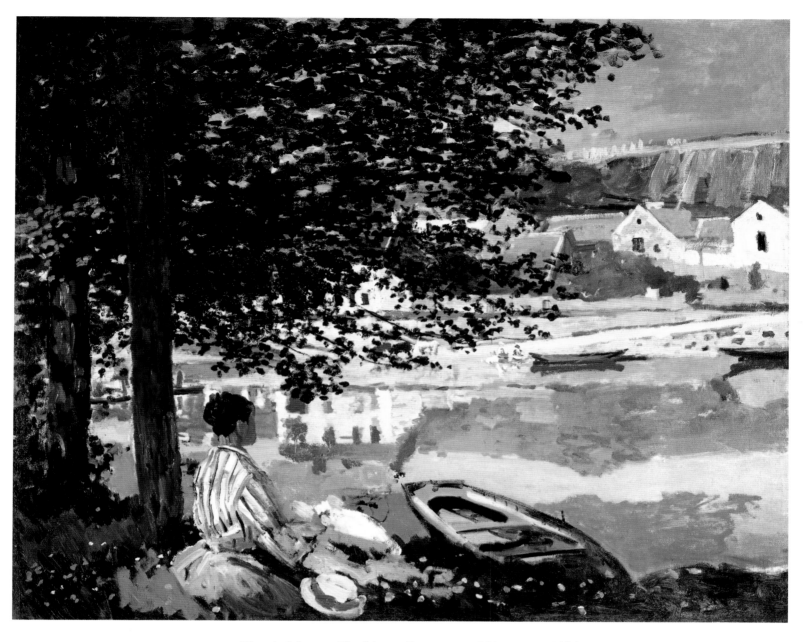

COLOURPLATE 15. Claude Monet. *The Seine at Bennecourt*. 1868. 32 × 39½″ (81.5 × 100.7 cm).
The Art Institute of Chicago (Potter Palmer Collection).

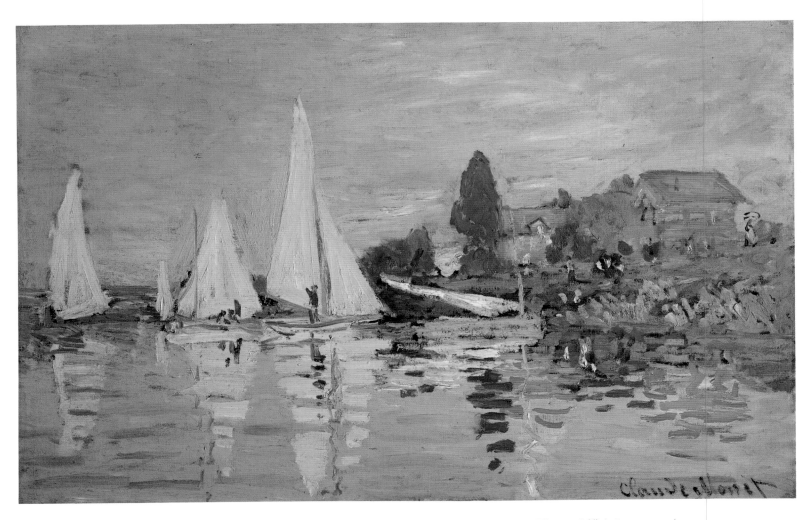

COLOURPLATE 16. Claude Monet. *Yacht Races at Argenteuil*. 1872. 18⅞ × 29½″ (48 × 75 cm).
Musée d'Orsay, Paris.

(From its black and brown fur / Comes a perfume so sweet, that one evening / I was embalmed in it, from having / Caressed it once . . . only once.)

C'est l'esprit familier du lieu;
Il juge, il préside, il inspire
Toutes choses dans son empire;
Peut-être est-il fée, est-il dieu?

(It is the familiar spirit of the place; / It judges, presides, inspires / All things within its empire; / Is it perhaps a fairy, or a god?)

M. Manet, instead of M. Astruc's verses would perhaps have done well to take as epigraph the quatrain devoted to Goya by the most *advanced* painter of our epoch:

GOYA – Cauchemar plein de choses inconnues
De foetus qu'on fait cuire au milieu des sabbats,
De vieilles au miroir et d'enfants toutes nues
Pour tenter les démons ajustant bien leurs bas.

(Goya – Nightmare full of unknown things / Of foetuses cooked in the middle of witches' sabbaths, / Of old women at the mirror and children quite naked / To tempt demons who are making sure their stockings fit.)

Two verses quoted, not quite accurately, from "Le Chat" in Baudelaire's Les Fleurs du Mal.

Zacharie Astruc (1835–1907), critic, artist and friend of Manet, was the author of a long poem about Olympia, *the first stanza of which the painter inscribed on the frame of the painting and had printed in the Salon catalogue.*
Goya etc. A quatrain quoted from Baudelaire's poem "Les Phares".
For an interpretation of Ravenel's text see T. J. Clark's The Painting of Modern Life: Paris in the Art of Manet and His Followers, *1985: "Olympia's Choice", pp. 79–146.*

(*Left*) Alexandre Cabanel (1823–89). *The Birth of Venus.* 1863. 41¾ × 71⅞" (106 × 182.6 cm). Metropolitan Museum of Art, New York (Gift of John Wolfe, 1893).

(*Below left*) Bertall. *Le Journal Amusant*, May 27, 1865. "Promenade at the 1865 Salon": Caricature of *Olympia*. Bibliothèque Nationale, Paris.

(*Below*) Honoré Daumier. *Le Charivari*, June 19, 1865. "Why is that big red woman in a chemise called Olympia? – But my dear, that may be the name of the cat." Lithograph, 9 × 7½" (22.8 × 19 cm). Cabinet des Estampes, Bibliothèque Nationale, Paris.

ÉMILE ZOLA

L'ARTISTE: REVUE DU XIXe SIÈCLE

"Édouard Manet"

January 1, 1867

He spoke in a language full of harshness and grace which thoroughly alarmed the public. I do not claim that it was an entirely new language and that it did not contain some Spanish turns of phrase (about which moreover I will have to make some explanation). But judging by the forcefulness and truth of certain pictures, it was clear that an artist had been born to us. He spoke a language which he had made his own, and which henceforth belonged entirely to him.

This is how I explain the birth of a true artist, Édouard Manet, for example. Feeling that he was making no progress by copying the masters, or by painting Nature as seen through the eyes of individuals who differed in character from himself, he came to understand, quite naturally, one fine day, that it only remained to him to see Nature as it really is, without looking at the works or studying the opinions of others. From the moment he conceived this idea, he took some object, person or thing, placed it at the end of his studio and began to reproduce it on his canvas in accordance with his own outlook and understanding. He made an effort to forget everything he had learned in museums; he tried to forget all the advice that he had been given and all the paintings that he had ever seen. All that remained was a singular gifted intelligence in the presence of Nature, translating it in its own manner.

Thus the artist produced an *oeuvre* which was his own flesh and blood. Certainly, this work was linked with the great family of works already created by mankind; it resembled, more or less, certain among them. But it had in a high degree its own beauty – I should say vitality and personal quality. The different components, taken perhaps from here and there, of which it was composed, combined to produce a completely new flavour and personal point of view; and this combination, created for the first time, was an aspect of things hitherto unknown to human genius. From then onwards Manet found his direction; or to put it better, he had found himself. He was seeing things with his own eyes, and in each of his canvases he was able to give us a translation of Nature in that original language which he had just found in himself.

And now, I beg the reader, who has been kind enough to follow me thus far and who is willing to understand me, to look at things from the only logical point of view by which a work of art can be judged properly. Without doing so, we will never understand each other. He would only stick to his prejudices, while I would propound quite different axioms, and so we would go on, becoming more and more separated from each other. On reaching the last line of this article he would regard me as a fool, and I would regard him as a man of little intelligence. We must proceed as the artist himself proceeded; we must forget the treasures of museums, and the necessity of obeying so-called laws; we must banish from our memory the accumulated pictures of dead painters. We must only see Nature face to face, Nature as it really is. We must look, in fact, for nothing more in the works of Édouard Manet than a translation of reality, peculiar to his own outlook and full of human interest.

I am forced here, to my greatest regret, to set forth some general ideas. My aesthetic, or rather the science which I will call "the modern aesthetic," differs too much from the dogma which has been taught up till now, to risk speaking without making myself perfectly clear.

Here is the popular opinion concerning art. There is an "absolute" of beauty which is regarded as something outside the artist or, to express it better, there is a perfect ideal for which every artist reaches out, and which he attains more or less successfully. From this it is assumed that there is a common denominator of beauty. This common denominator is applied to every picture produced, and according to how far the work approaches or recedes from this common denominator, the work is declared good or less good. Circumstances have elected that the Classical Greek should be regarded as the standard of beauty, so that all works of art created by mankind have ever since been judged on their greater or lesser resemblance to Greek works of art.

So here you see the whole output of human genius, which is always in a state of renascence, reduced to terms of the simple flowering of Greek genius. The artists of this country have discovered the "absolute" of beauty and thereafter all has been already said. The common denominator having been fixed, it is only a question of imitating and reproducing the original models as exactly as possible. There are some people who will insist that the artists of the Renaissance are very great because they were imitators. For 2,000 years the world has been constantly changing, civilizations have flourished and crumbled, society has advanced or languished in the midst of ever-changing customs; on the other hand, artists are born here or there, on pale, cold mornings in Holland, or in the warm, voluptuous evenings of Italy and Spain – but what of that! The "absolute" of beauty is there, unchangeable, dominating the centuries. All life, all passions, all that creative energy which has enjoyed itself and suffered for 2,000 years is miserably crushed under this idea.

Manet photographed by Nadar. 1865. Bibliothèque Nationale, Paris.

Here, then, is what I believe concerning art. I embrace all humanity that has ever lived and which at all times, in all climates, under all circumstances, has felt, in the presence of Nature, an imperious need to create and reproduce objects and people by means of the arts. Thus I have a vast panorama, each part of which interests and moves me profoundly. Every great artist who comes to the fore gives us a new and personal vision of Nature. Here "reality" is the fixed element, and it is the differences in outlook of the artists which has given to works of art their individual characteristics. For me, it is the different outlooks, the constantly changing viewpoints, that give works of art their tremendous human interest. I would like all the pictures of all the painters in the world to be assembled in one vast hall where, picture by picture, we would be able to read the epic of human creation. The theme would always be this self-same "nature," this self-same "reality" and the variations on the theme would be achieved by the individual and original methods by which artists depict God's great creation. In order to pronounce fair judgement on works of art, the public should stand in the middle of the vast hall. Here beauty is no longer "absolute" – a ridiculous denominator. Beauty becomes human life itself; the human element, mixed with the fixed element of "reality" giving birth to a creation which belongs to mankind. Beauty lies within us, and not without. What is the use of philosophic abstractions! Of what use is a perfection dreamed up by a little group of men! It is humanity that interests me. What moves me, what gives me exquisite pleasure is to find in each of the creations of man an artist, a brother, who shows me with all his strength and with all his tenderness the face of Nature under a different guise.

A work of art, seen in this way, tells me the story of flesh and blood; it speaks to me of civilizations and of countries. And when in the midst of the vast hall I cast an eye over the immense collection, I see before me the same poem in a thousand different languages, and I never tire of re-reading it in each different picture, enchanted by the delivery or strength of each dialect.

I cannot give you here, in its entirety, the contents of the book which I propose to write on my artistic beliefs, and I content myself with giving only a broad outline. I overthrow no idols – I do not abjure any artist. I accept all works of art under the same title, the title of the manifestation of human

genius. They all interest me almost equally; they all possess true beauty and life – life in its thousand different expressions, always changing, always new. The ridiculous common denominator does not exist any more; the critic studies a picture for what it is, and pronounces it a great work when he finds in it a vital and original interpretation of reality. He can then state that to the genesis of human creation another page has been added; that an artist has been born who has given Nature a new soul and new horizons. Our creation stretches from the past into an infinite future. Every society will produce its artists, who will bring with them their own points of view. No systems, no theories can hold back life in these unceasing productions.

Our task then, as judges of art, is limited to establishing the language and the characters; to study the languages and to say what new subtlety and energy they possess. The philosophers, if necessary, will take it on themselves to draw up formulas. I only want to analyse facts, and works of art are nothing but simple facts.

Thus I put the past on one side – I have no rules or standards – I stand in front of Édouard Manet's pictures as if I were standing in front of something quite new which I wish to explain and comment upon.

What first strikes me in these pictures, is how true is the delicate relationship of tonal values. Let me explain. . . . Some fruit is placed on a table and stands out against a grey background. Between the fruit, according to whether they are nearer or further away, there are gradations of colour producing a complete scale of tints. If you start with a "note" which is lighter than the real note, you must paint the whole in a lighter key; and the contrary is true if you start with a note which is lower in tone. Here is what I believe is called "the law of values." I know of scarcely anyone of the modern school, with the exception of Corot, Courbet and Édouard Manet, who constantly obeys this law when painting people. Their works gain thereby a singular precision, great truth and an appearance of great charm.

Manet usually paints in a higher key than is actually the case in Nature. His paintings are light in tone, luminous and pale throughout. An abundance of pure light gently illuminates his subjects. There is not the slightest forced effect here; people and landscapes are bathed in a sort of gay translucence which permeates the whole canvas.

What strikes me is due to the exact observation of the law of tonal values. The artist, confronted with some subject or other, allows himself to be guided by his eyes which perceive this subject in terms of broad colours which control each other. A head posed against a wall becomes only a patch of something more, or less, grey; and the clothing, in juxtaposition to the head, becomes, for example, a patch of colour which is more, or less, white. Thus a great simplicity is achieved – hardly any details, a combination of accurate and delicate patches of colour, which, from a few paces away, give the picture an impressive sense of relief.

I stress this characteristic of Édouard Manet's works, because it is their dominating feature and makes them what they are. The whole of the artist's personality consists in the way his eye functions: he sees things in terms of light colour and masses.

What strikes me in the third place is his elegance – a little dry but charming. Let us understand each other. I am not referring to the pink and white elegance of the heads of china dolls, I am referring to a penetrating and truly human elegance. Édouard Manet is a man of the world and in his pictures there are certain exquisite lines, certain pretty and graceful *attitudes* which testify to his love for the elegance of the salons. Therein the unconscious element, the true nature of the painter is revealed. And here I take the opportunity to deny the existence of any relationship (as has been claimed) between the paintings of Édouard Manet and Charles Baudelaire. I know that a lively sympathy has brought painter and poet together, but I believe that the former has never had the stupidity, like so many others, to put "ideas" into his painting. The brief analysis of his talent which I have just made, proves with what lack of affectation he confronts Nature.

If he groups together several objects or several figures, he is only guided in his choice by a desire to obtain beautiful touches of colour and contrasts. It is ridiculous to try to turn an artist, obeying such instincts, into a mystical dreamer.

After analysis, synthesis; let us take no matter what picture by the artist, and let us not look for anything other than what is in it – some illuminated objects and living creatures. The general impression, as I have said, is of luminous clarity.

Faces in the diffused light are hewn out of simple bold patches of flesh colour; lips become simple lines; everything is simplified and stands out from the background in strong masses.

The exact interpretation of the tonal values imbues the canvas with atmosphere and enhances the value of each object.

It has been said that Édouard Manet's canvases recall the "penny-plain, twopence-coloured" pictures from Épinal. There is a lot of truth in this joke which is in fact a compliment. Here and there the manner of working is the same, the colours are applied in broad patches, but with this difference, that the workmen of Épinal employ primary colours without bothering about values, while Édouard Manet uses many more colours and relates them exactly. It would be much more interesting to compare this simplified style of painting with Japanese engravings, which resemble Manet's work in their strange elegance and magnificent bold patches of colour.

One's first impression of a picture by Édouard Manet is that it is a trifle "hard." One is not accustomed to seeing reproductions of reality so simplified and so sincere. But as I have said, they possess a certain stiff but surprising elegance. To begin with one's eye only notices broad patches of colour, but soon objects become more defined and appear in their correct place.

After a few moments, the whole composition is apparent as something vigorous; and one experiences a real delight in studying this clear and serious painting which, if I may put it this way, renders Nature in a manner both gentle *and* harsh.

On coming close to the picture, one notices that the technique is more delicate than bold; the artist uses only a brush and that with great caution; there is no heavy impasto, only an even coat of paint. This bold painter, who has been so hounded, works in a very calculated manner, and if his works are in any way odd, this is only due to the very personal way in which he sees and translates objects on to canvas.

In a word, if I were interrogated, if I were asked what new language Manet was speaking, I would answer, "He speaks in a language which is composed of simplicity and truth." The note which he strikes in his pictures is a luminous one which fills his canvas with light. The rendering which he gives us is truthful and simplified, obtained by composing his pictures in large masses.

I cannot repeat too often that, in order to understand and savour his talent, we must forget a thousand things. It is not a question, here, of seeking for an "absolute" of beauty. The artist is neither painting history nor his soul. What is termed "composition" does not exist for him, and he has not set himself the task of representing some abstract idea or some historical episode. And it is because of this that he should neither be judged as a moralist nor as a literary man. He should be judged simply as a painter. He treats figure subjects in just the same way as still-life subjects are treated in art schools; what I mean to say is that he groups figures more or less fortuitously, and after that he has no other thought than to put them down on canvas as he sees them, in strong contrast to each other. Don't expect anything of him except a truthful and literal interpretation. He neither sings nor philosophizes. He knows how to paint and that is all.

Épinal, the capital of the département *of the Vosges in north-eastern France, had been famous for its production of cheap popular prints since the late 18th century. The brightly coloured and crude forms of this popular imagery became emblematic of a naïve realism in opposition to Renaissance traditions of illusionism.*

53

CLAUDE MONET
Letters to Bazille
1864

Frédéric Bazille (1841–70). An important figure in the early history of Impressionism, he attended the studio of Charles Gleyre where he met and became a close friend of Monet and Renoir. His career was cut short when he was killed in the Franco-Prussian War on November 28, 1870.

HONFLEUR, JULY 15

I ask myself what you can be doing in Paris in such fine weather, for I imagine it must be as good there as it is here. Here, my dear fellow, it is marvellous, and I discover lovelier things each day. My desire to paint everything is enough to drive me mad, my head is bursting with it. Good Lord, now it's the sixteenth, why don't you pack your bags and come straight up and spend a fortnight here, it's the best thing you could do, for it can't be very easy working in Paris.

From today, I'll have exactly a month left in Honfleur; in fact I've almost finished my studies, I've even started some others. In a word, I'm fairly satisfied with my stay here, even though my studies are far from what I'd like them to be. There's no doubt that it's terribly difficult to do something that is complete in all respects, and I think almost everyone makes do with approximation. Well, my dear fellow, I want to struggle, to scrape off, to start again, because one can do only what one sees and what one understands, and it seems to me when I see nature, that I'm going to be able to do everything, write down everything, and then, blast it, when one actually starts doing it. . . .

Which all proves that one must think only about this. It is by observation and reflection that one succeeds. So let's keep digging and delving. Are you making any progress? Yes, I'm sure you are, but I'm also sure that you're not working hard enough and not in the right way. You won't be able to work with fellows like that Villa and the others. It's better to work alone, though when you do there are a lot of things you cannot sense. In short, it's all very demanding.

Have you done your life-size figure? I've got some splendid plans. When I'm at Sainte-Adresse and Paris, in the winter, that is, it's quite frightening what I see in my head. . . .

I'd greatly appreciate a letter. Tell me what you're doing and what's going on in Paris. Do you ever go out of town? Above all, come and see me, I'm expecting you, if not right away, at least on 1 August. By that time almost all my canvases will be finished. In the meantime, a warm embrace.
Your good friend, Claude Monet.

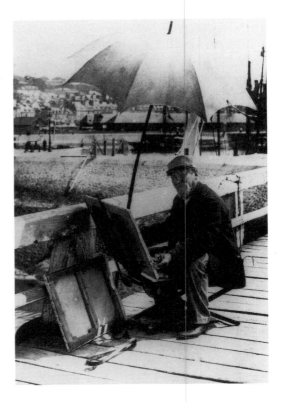

Eugène Boudin, photograph, June 1896. Musée Boudin, Honfleur.

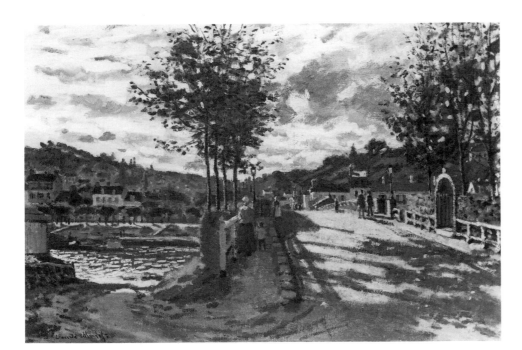

Claude Monet. *The Bridge at Bougival.* 1869. 25¾ × 36½″ (65.5 × 92.5 cm). Currier Gallery of Art, Manchester, New Hampshire.

My dear Bazille,

I received your kind letter which gave me great pleasure, I never doubted that you would put yourself out to do me a favour, and I'm so grateful.

Next Monday I shall be putting a crate on the express train containing three pictures I've just done, and their frames, because as you know a picture gains a hundred per cent by being in a good frame. One of them is a simple study which you haven't seen at all, it's entirely done from nature, you may see a certain resemblance to Corot, though I was not imitating him in the slightest. It's just the subject matter and particularly the calm, hazy effect that produce this likeness. I did it as conscientiously as possible without thinking of any other painting. In any case you know that that is not my system. The two other canvases are the small boatyard below St-Siméon, and the road in front of the farm. These are two of my best studies, but it's not the studies I'm sending you, it's two paintings which I'm in the process of finishing on the basis of my studies. I hope that you, and in particular M. Bruyas, will like them. I would have liked to send you a seascape which I'm rather pleased with, but unfortunately I still have a little to do on it. So, my dear friend, try to place at least one canvas for me because I could really do with the proceeds, and what a life I shall have in Paris as a result.

I'm really ashamed of always bothering you like this, I'm truly sorry for all the trouble I cause you, as well as to your father who doesn't even know me and who is good enough to concern himself with me.

Believe me, my dear friend, I shan't forget your kindness. Your letter did me a power of good for I was really worried and now at least I can have some hope. . . .

So, a thousand thanks, until our next meeting,

with all my heart Claude Monet.

Alfred Bruyas (1821–77), patron of Delacroix and Courbet and a fellow countryman and friend of Bazille, also from Montpellier.

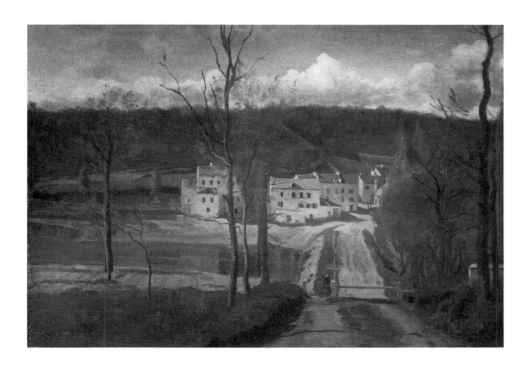

Camille Corot. *Cabassud Houses at Ville d'Avray.* 1835–40. 11 × 15¾″ (35 × 40 cm). Musée du Louvre, Paris.

JEAN RENOIR
RENOIR MY FATHER
Renoir and Monet
1958

Jean Renoir (1894–1974), the film director, was Renoir's second son. His biography of Renoir has been an important source.

Pissarro and Monet were the most fanatical of the whole crowd. They were the first to condemn the study of the great masters, and to advocate learning direct from nature, and from nature only. Corot, Manet, Courbet, and the Fontainebleau School were already working from nature. But in interpreting it, they followed the teachings of the old masters. The intransigents' object was to transcribe their immediate perceptions onto their canvases without any interpretation. They considered any pictorial explanation as a capitulation. Renoir agreed, but with a few reservations. He could not forget Fragonard's enticing bourgeois women. The question he posed himself was whether Fragonard had painted in his portraits "what he saw," or had made use of the formulae handed down by his predecessors. Yet the current was irresistible. And, after hesitating for a short time, the "cork" plunged enthusiastically into this pool of impressions of nature, which constituted the "credo" of the new painting.

Fontainebleau School: the group of landscape painters working in the vicinity of Barbizon, a small village in the forest of Fontainebleau, who first adopted the practice of plein-air painting.
Jean-Honoré Fragonard (1732–1806).

Even before he left the art school, Renoir was faced with the dilemma of his whole existence. Two contrary propositions which were to evolve later already troubled him and kept him awake at night. The choice was between the excitement of direct perception and the austere ecstasy found in the study of the old masters. This choice was presently to assume a more definite technical character. One would be forced either to work from nature, with all the uncertainties that that implied, including the tricks played by the sunlight, or else to work in the studio under the cold precision of controlled light. The real dilemma which can be considered the central theme of his life – the contest between subjectivism and objectivism – Renoir always refused to put to himself in the form of a direct question. I hope that the reflections and recollections recorded in this book will help the reader to solve it for him.

Everything conspired to influence him to follow the intransigents: his love of life, his need to enjoy all the perceptions registered by his senses, as well as the talent of his comrades. The "official school," only imitations of imitations of the old masters, was dead. Renoir and his friends were very much alive; and it was to them that the duty of revitalizing French painting fell.

The meetings of the intransigents were lively in the extreme. They were fired by the desire to share with the world their knowledge of reality. Ideas were tossed about; controversies broke out; declarations poured forth. Someone very seriously proposed burning down the Louvre. My father suggested that the Museum should be kept as a shelter for children on rainy days. Their convictions did not hinder Monet, Sisley, Bazille and Renoir from regular attendance at the school run by old Gleyre. After all, the cult of nature was not incompatible with the study of drawing. Monet amazed old Gleyre. Everyone, in fact, was impressed, not only by his virtuosity but also by his worldly manner. When he first came to the school, the other students were jealous of his well-dressed appearance and nicknamed him "the dandy." My father, who was always so modest in his choice of clothes, was delighted with the spectacular elegance of his new friend.

"He was penniless, and he wore shirts with lace at the cuffs!"

Monet began by refusing to use the stool which was assigned to him when he first entered the classroom. "Only fit for milking cows." As a rule, the students painted standing up, but they had the right to a stool if they wanted it. Until then it had never occurred to anyone to bother about these stools one way or the other.

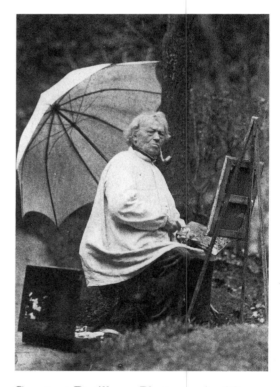

Constant Dutilleux. Photograph of Corot at Arras, 1871. Collection Sirot-Angel, Paris.

Charles Gleyre (1808–74), studio master at the École des Beaux-Arts. It was at his atelier in 1861–2 that Renoir, Sisley, Monet and Bazille first met.

Good old Gleyre had the habit of getting up on the little platform on which the model posed, and giving advice from that vantage point to this or that novice. One day he found Monet installed in his place. Monet's explanation was that he needed to get nearer the model in order to examine the texture of the skin.

* * *

After Renoir had given up his decorating work entirely, he and Monet shared lodgings. They managed to eke out a living by doing portraits of small tradespeople. Monet had a knack for arranging the commissions. They were paid fifty francs for each portrait. Sometimes months would go by before they were able to get another commission; nevertheless, Monet continued to wear shirts trimmed with lace and to patronize the best tailor in Paris. He never paid the poor man, and when presented with a bill treated him with the haughty condescension of Don Juan receiving Monsieur Dimanche.

"Monsieur, if you keep insisting like this, I shall have to withdraw my custom."

And the tailor did not insist, for he was overcome with pride in having a gentleman with such elegant manners as his customer.

"He was born a lord," said Renoir.

All the money the two friends could scrape together went to pay for their studio, a model, and coal for the stove. For the problem of food, they had worked out the following scheme:

Since they had to have the stove for the girl who posed for them in the nude, they used it at the same time for cooking their meals. Their diet was strictly spartan. One of their sitters happened to be a grocer, and he paid them in food supplies. A sack of beans usually lasted about a month. Once the beans were eaten up, the two switched to lentils for a change. And so they went on confining themselves to starchy dishes which required little attention while cooking. I asked my father if eating beans at every meal had not been hard on their digestion.

"I've never been happier in my life. I must admit that Monet was able to wangle a dinner from time to time, and we would gorge ourselves on turkey with truffles, washed down with Chambertin!"

A few canvases remain from this period, miraculously saved from being lost in moves from one house to another, or being left in an attic, or burned by the artist himself, or involved in any of countless other hazards. Renoir painted so many pictures that his work has escaped wholesale destruction from one cause or another. When one reflects on early paintings which have survived, such as the portraits of my grandmother, my grandfather, and Mlle Lacaux, as well as *The Sleeping Woman* and *Diana, the Huntress*, one can understand why the French public of nearly a hundred years ago left it for a later generation to pour out a stream of insulting criticism. It is good painting in the best French tradition. I am surprised, however, that this public did not discern in those pictures that little something which is, properly speaking, the sign of genius. How could they not have been struck by the serenity of the models, which relates them to those of Corot or Raphael? One critic, my father told me, thought he detected in the *Diana* a trace of that discovery of nature which was to make all Paris howl with rage ten years later. He spoke of the "purity of the tones" and he even used the expression "love of flesh." Young Renoir felt very flattered by the critic's appraisal: "I began to think I was Courbet himself." But, as an older man, Renoir took quite a different view:

"I have a horror of the word 'flesh,' which has become so shopworn. Why not 'meat,' while they're about it? What I like is skin, a young girl's skin that is pink and shows that she has a good circulation. But what I like above all is serenity."

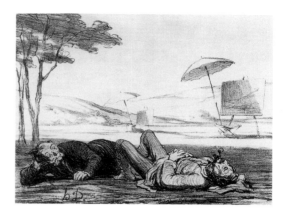

Honoré Daumier. *Le Boulevard*, August 17, 1862. *Landscapists at Work*. Lithograph. Bibliothèque Nationale, Paris.

Renoir's Diana *(1867) was rejected by the Salon of 1867.*

CLAUDE MONET
Letters to Bazille
1868

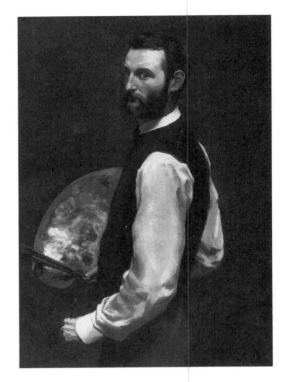

PARIS, JUNE 29

My dear friend,
I am writing you a couple of words in haste to ask you for immediate help, if that is at all possible, I must have been born under an unlucky star. I've just been thrown out of the inn where I was staying, without a shirt on my back into the bargain. I've housed Camille and poor little Jean somewhere safe in the country for a few days. I myself came here this morning and leave this evening, more or less immediately, for Le Havre, to see whether my collector will come up with anything.

As soon as you receive this letter, write to me without fail, letting me know whether you can do anything for me; I shall expect to hear from you come what may.

Write to me at Le Havre, poste restante, because my family refuse to do anything more for me; I still don't know where I'll be sleeping tomorrow night.

Your loyal and troubled friend Claude Monet.

I was so upset yesterday that I had the stupid idea of throwing myself into the water, luckily nothing untoward happened. CM

ÉTRETAT, DECEMBER

As I told you in my little scribble, I'm in a state of enchantment. I'm living like a fighting cock, surrounded by all that I love. I spend my time in the open air on the beach when the weather is bad or when the boats have gone out fishing, or I go into the countryside, which is so lovely around here, and which perhaps I even prefer in winter to summer, and of course I'm working all the time, and I think I'm going to do some serious work this year. Then in the evening, my dear friend, I find a good fire in my little house, and a nice little family. If you could see how sweet your godson is at the moment. My dear chap, it is a delight to watch this little boy growing up and, my word, I'm very lucky to have him. I'm going to paint him for the Salon, with other figures around him, of course. This year I'm going to do two figure pictures, an interior with a baby and two women, and some sailors outdoors, and I want them to be truly splendid. Thanks to the gentleman from Le Havre who came to my rescue, I feel utterly at peace now – no more sleepless nights, I'd always like to be somewhere like this, in such a peaceful corner of the countryside. I assure you, I don't envy you being in Paris, and I hardly miss the meetings [at the Café Guerbois], though sometimes I would like to see some of the regulars, but frankly I do not believe that one can do anything really good in such an environment; don't you feel that one is better off alone in direct contact with nature? I'm certain of it. Furthermore, I've always thought so, and I've always done my best work in such conditions.

We are too preoccupied with what we see and hear in Paris, however strong we are, and what I am doing here at least has the merit of not resembling anyone else's work, at least I think not, because it will simply be the expression of what I personally feel. The further I progress, the more I regret the little I know; that is definitely the stumbling-block. The further I go, the more I realize that one never frankly dares to express what one feels. It's odd. That's why I'm doubly happy to be here; I don't think I'll be spending much time in Paris from now on, a month a year at most. . . .
Warmest greetings to you, Claude Monet.

Frédéric Bazille. *Self-Portrait with Palette.* *c.*1865. 40 × 28¼″ (99 × 71.8 cm). The Art Institute of Chicago (Mr and Mrs Frank H. Woods restricted gift in memory of Mrs Edward Harris Brewer, 1962).

The Luncheon *(1868), Städelsches Kunstinstitut, Frankfurt-am-Main.*

The Café Guerbois at 11 rue des Batignolles, where artists and writers met in the late 1860s, played an important role in the intellectual and artistic life of the period.

ÉMILE ZOLA

SALONS

Pissarro

1866, 1868

MAY 20, 1866

M. Pissarro is an unknown, and in all likelihood no one will ever speak of him. I am making a point of shaking him vigorously by the hand before leaving. Thank you, Monsieur, your landscape afforded me a good half-hour's respite during my journey through the great wilderness that is the Salon. I know that you were narrowly admitted, and I congratulate you warmly thereon. Furthermore, you must know that no one likes you, and that your painting is considered too bare, too dark. So why the devil do you have the signal tactlessness to paint so solidly and to study nature so candidly?

Come now – you choose a wintry season and paint a simple stretch of avenue, with a hillside in the background, and empty fields as far as the horizon. Not the slightest respite for the eye: an austere and solemn painting, with an extreme concern for truth and exactitude, inspired by a strong and bitter will. You are an artist sadly lacking in tact, Monsieur – you are an artist whom I like.

Banks of the Marne in Winter *(1866)*, *Art Institute of Chicago.*

* * *

THE NATURALISTS

MAY 19, 1868

They form a group which is growing daily. They are at the head of the artistic movement, and soon we shall have to reckon with them. I am choosing one of their number, perhaps the least known, and the one whose particular talent will serve me to introduce the group as a whole.

Camille Pissarro has been exhibiting for nine years, for nine years he has been offering critics and the public strong, assured canvases, without critics or the public having deigned to notice them. The occasional salon critic has been good enough to mention him, in a list, as they mention everyone; but no one yet appears to suspect that his is one of the deepest, most serious talents of our time.

The painter, rejected at some Salons and accepted at others, has hitherto failed to understand the rule obeyed by the jury in accepting and rejecting his works. His early works were well received; then he was shown the door; then re-admitted. Yet his pictures had remained more or less unchanged: the same austere interpretation of nature, the same artistic temperament, solidly professional, with broad, precise views. The implication would seem to be that the jury is like a pretty woman: it takes only what it pleases, and what pleases it today may not always please it tomorrow.

Besides, it is easy to explain the whims of the jury and the indifference of critics and public. Every effect has a cause. In art, when you go back to the causes, when you seek out the reason for a man's success or failure, you are thereby engaging in a study of his talent.

If Camille Pissarro does not hold the public, if he perplexes the jury, which accepts or rejects him at random, it is because he has none of the petty skills of his colleagues. He is engaged in the pursuit of excellence, on a fierce search for the truth, and he is heedless of the tricks of his profession. His canvases are completely lacking in dash, in any kind of spicy sauce to

Honoré Daumier. *Le Charivari*, May 12, 1865. Lithograph. "The Landscapists: The First copies from Nature – the Second copies from the First." Bibliothèque Nationale, Paris.

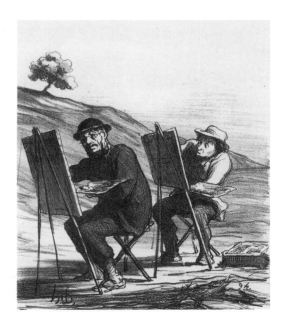

heighten the powerful, raw reality of nature. He paints with a sovereign precision and the result verges on the bleak. How the devil do you expect such a man, or such works, to please?

Consider the other landscape painters. They are all poets who pen fables, odes or madrigals to nature. They paint springtime, April moonlight, sunrise and sunset; they murmur Millevoye's elegy *Falling leaves*, or tell La Fontaine's fable, *The Wolf and the Lamb*. They are men of letters who have taken the wrong turning, people who think they are giving painting a new lease of life, because they are no longer painting at all but using a paintbrush as a pen. And if at least they knew how to paint, if they but had the solid professionalism of the masters, the subject-matter would be of little importance. But in order to make their canvases more striking, more exciting, gallantly turned out in the latest fashion, they have stooped to gimmickry, to painting that is all scraping and buffing; glazed, touched up. The fish gets the sauce it deserves. The alleged originality of certain artists lies solely in the particular way in which they proceed to paint a tree or a house. As soon as a painter has found a glaze or a way of lifting off impasto with a knife, he becomes a master.

Look closely at the "successful" paintings. You will be greatly surprised by the strange trick the artist has employed. Certain outwardly brutal paintings are the height of skill. From a distance all is neat and dainty; sometimes even solid and energetic. But one soon sees that all is lies, that the work is empty of strength and originality, that it is simply the work of an ineffective craftsman who has had recourse to sleight of hand and has managed to fake good, true painting.

In the midst of these exquisitely got-up canvases, those of Camille Pissarro appear distressingly naked. For the unintelligent eyes of the crowd, accustomed to the flashiness of the adjacent pictures, they are dull, grey, ungroomed, rough and coarse. The artist is scrupulous, concerned only with the truth; he puts himself in front of a piece of nature, setting himself the task of interpreting the severe breadth of the skyline, without adding the slightest softening touch of his own invention; he is neither poet nor philosopher, but simply a naturalist, a maker of earth and sky. Dream if you wish, this is what he saw.

Here the originality is deeply human. It does not consist in dexterity of hand, in a mendacious translation of nature. It lies in the very temperament of the painter – one of precision and seriousness. Never have paintings seemed to me to be of a more masterly breadth. In them one can hear the earth's deep voices, one can sense the powerful life of the trees. The austerity of these horizons, the disdain of fuss, the complete absence of striking touches, gives the whole a sort of epic grandeur. Such a reality is greater than the dream. The frames are quite small, yet one feels oneself beholding a boundless countryside.

One need only glance at such works to understand that their creator is a true man, an upright and vigorous personality, incapable of lying, making of art a pure and eternal verity. Never will this hand agree to deck out rude nature as a girl, it will never repudiate itself by engaging in the sweet nothings of the poet-painter. Pissarro's is above all the hand of a workman, a man who is truly a painter, who puts all the forces of his being into painting well.

It is sad that we should have arrived at a point where we no longer know what a true painter is. Today those adroit artists who scrape and glaze their works so cleverly are regarded as founts of knowledge, as knowing their métier thoroughly and even something more. It would come as a surprise to these people if I told them that they are nothing more than diverting buffoons, and that they have invented a mere pleasant form of "colouring" which is at best a falsification of painting.

Ah! if those gentlemen could see themselves, if at the same time they could see the masters of the Renaissance whose names are ever on their lips, they would soon see that they are barely worthy of colouring in a penny print.

They talk of traditions, they say they are following the rules, and I would swear that they have never seen and understood a Veronese or a Velasquez, for if they had seen and understood such models, they would try to paint quite differently.

The sons of the masters, the artists who carry on the tradition, are the Camille Pissarros, those painters who seem dull and clumsy, and whom you sometimes reject, pleading the dignity of art. Similarly, you would reject certain paintings from the Louvre, if you were presented with them, with the excuse that they were not sufficiently finished, that they had not been carefully polished and that they dishonoured the temple. I shall begin to think that you talk of rules from hearsay, to have us believe that there is some perfect cookery book of art where you learn the recipe for the sauces to which you adjust the ideal.

But do you not see that when you want to rediscover the true rules, the true traditions and masters, then you must look for them in the works of those artists whom you accuse of ignorance and rebellion. It is you who are the innovators, the inventors of a shrill, false, empty painting. They, for their part, are following the high road of truth and power. Camille Pissarro is one of the three or four painters of this age. He has solidity and breadth of touch, he paints generously, following tradition, like the masters. I have rarely come upon a painter with a deeper knowledge of his art. A fine painting by this artist is the deed of an honest man. I could not better define his talent.

There are two marvels at this year's Salon. But they have been hung so high that no one notices them. Actually, they might not receive more attention even were they on the line. They are too strong, too straightforward for the public at large. In the foreground of the *Hermitage* we see a stretch of ground which broadens out and dips down; beyond it is a building standing in a clump of large trees. Nothing more. But the ground is alive, the trees are filled with sap, the horizon seems vast! After a few moments' observation I felt I saw the countryside opening out before me.

Possibly I even prefer the other canvas, the *Côte de Jallais*. A valley, a few houses whose roofs are visible on a level with a rising path; then, on the other side, a hillside slashed with crops of green and brown. This is the modern countryside. One feels that man has passed by, ransacking the earth, parcelling it up, dulling the skyline. And this valley, this hillside are of a heroic plainness and simplicity. If this were not great, it would be banal. The painter's temperament has used the unvarnished truth as the basis for a rare poem of life and strength.

Thus in exhibiting such works, Camille Pissarro has been awaiting success for nine years, and success has not come. Never mind! All that is needed is for some authoritative critic to opine that he has talent, and the crowd will admire him. Everyone has their hour of fame; but what everyone does not have is Pissarro's powerful calling as a painter, and his true and candid eye. With such qualities, when circumstance puts him in the limelight, he will be accepted as a master. I do not know if anyone recognizes what an honourable and interesting figure he is. This artist walks alone, unshaken, following his own path, never allowing himself to be downcast. All around·him, the swaggerers receive decorations; their paintings are bought. If he let himself do as they do, he would share their good fortune. And he persists in the face of public indifference, he remains the proud, lonely lover of the truth.

It was conventional practice within mass public exhibitions such as the Salon, in which there might be as many as 5,000 exhibits, to hang paintings on the walls in several tiers. Paintings hung "on the line" had the privileged viewing position: at eye-level.

Two paintings by Pissarro entitled simply Hermitage *were exhibited at the Salons of 1868 and 1869. The painting to which Zola refers could have been either* L'Hermitage at Pontoise *(1867), Wallraf-Richartz Museum, Cologne, or* The Hillsides of l'Hermitage, Pontoise *(c. 1867–8), Solomon R. Guggenheim Museum, New York.*
"Côte du Jallais", Pontoise (1867), Metropolitan Museum of Art, New York.

CLAUDE MONET

Letter to Bazille

25 September 1869

This is to inform you that I have not followed your (inexcusable) advice to walk to Le Havre. I've been a bit happier this month than during the previous ones, because I'm always in a desperate state. I sold a still life and I've been able to work a little. But, as always, I'm thwarted for lack of colours. Happy mortal, you are going to take back whole quantities of canvases! Only I shall have achieved nothing this year. That makes me furious with everyone, I'm jealous, mean, angry: if I could work, all would be well. You tell me that neither 50 nor 100 francs would get me out of trouble: that may be so but, at that rate, I might as well bang my head against the wall, for I can lay claim to no immediate fortune and, if all those who have talked to me as you do had sent me, some 50, some 40 francs etc., I would certainly not be in the position I am now in. I am rereading your letter, my dear friend: it is indeed very comical and, if I did not know you, I would take it as a joke. You tell me seriously, because you believe it, that in my place you would set to chopping up wood. It is only people in your position who think like that and, if you were in mine, you might be even more upset than I am. It is harder than you think, and I warrant that you would chop very little wood. No, you see, it is hard to give advice and, I believe, pointless, if I may say so without offence. That does not mean that I am probably not at the end of my troubles. Winter is on its way, and it is a season that holds little charm for the unfortunate. Then there is the Salon. Unfortunately! Once again no work of mine will be shown, because I have done nothing. I have a dream of doing a picture, the bathing-place at la Grenouillère, for which I have done some rather poor sketches, but it is just a dream. Renoir, who has just spent two months here, wants to do the same picture. Talking of Renoir, that reminds me that at his brother's place I

La Grenouillère was a popular bathing resort on the Seine at Bougival where Renoir and Monet worked side by side for the summer of 1869.

Nineteenth-century French critical terminology distinguished between the stages of preparation and finish for a work, which have no equivalents in English. The "poor sketches" to which Monet refers were pochades *(probably the two relatively large paintings of La Grenouillère in the Metropolitan Museum, New York, and the National Gallery, London). A* pochade *is a quick study indicating the overall unity of light and atmosphere of the motif, often the result of one or two sessions of painting. Monet's ideas about the relationship between the study and the finished painting are changing at this time. His ambition of doing a* tableau *of this subject, a completed painting according to his criteria for finish, may have been realized in the (now destroyed)* Bathing Place at La Grenouillère *(W136).*

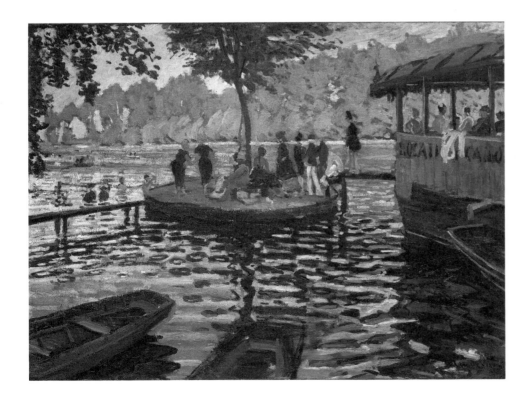

Claude Monet. *La Grenouillère.* 1869. 29⅜ × 39¼″ (74.6 × 99.7 cm). Metropolitan Museum of Art, New York (Gift of Mrs H. O. Havemeyer, 1929. The H. O. Havemeyer Collection).

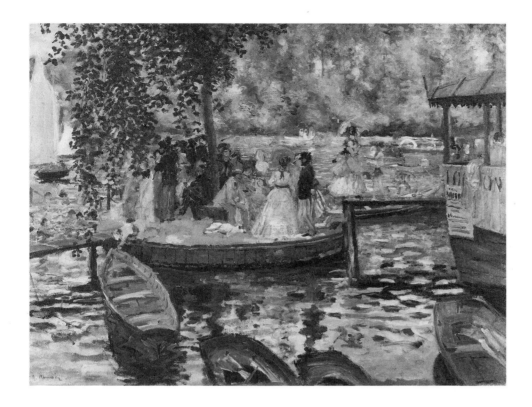

Pierre-Auguste Renoir. *La Grenouillère*. 1869. 26 × 31⅞″ (66.5 × 84 cm). Statens Konstmuseer, Stockholm.

drank some very good wine he had just received from Montpellier. That also reminds me that it is absurd to have a friend from Montpellier and not to be able to get a consignment of wine from him. Come, Bazille, there can be no shortage of wine in Montpellier at this moment. Could you not send me a cask and deduct the price from what you still owe me? At least we would not drink water so often, and it would cost us little. You cannot know what a favour you would be doing me, for wine is a considerable expense and I would be most grateful.

BERTHE MORISOT

Letter to her Sister Edma

May 2, 1869

Edma (1840–92) and Berthe (1841–95) Morisot both studied painting. Berthe Morisot met Manet in 1868 and became a close professional colleague and friend. She posed for The Balcony *the following year. In 1874 she married Manet's brother Eugène.*

Pierre Puvis de Chavannes (1824–98), painter, met Berthe Morisot in 1868 and became a family friend.
Jules Jacquemart (not Jacquemard as Morisot has it) (1837–80), printmaker and illustrator.
Charles-Émile Carolus-Duran (1838–1917), much-decorated academic painter, member of the Salon jury and friend of Manet.

The first thing we beheld as we went up the big staircase was Puvis's painting. It looked well. Jacquemard was standing in front of it and seemed to admire it greatly. What he seemed to admire less was my person. There is nothing worse than a former admirer. Consequently he forsook me very quickly. However, we next met Carolus-Duran, who was with his wife, and who on seeing us blushed violently. I shook hands with him, but he did not have a word to say to me. His wife is a tall and handsome woman. He is showing a portrait of her, which, I think, is going to be a success, although it is quite vulgar. It isn't absolutely bad, but I find it mannered and flat. I don't have to tell you that one of the first things I did was to go to Room M. There I found Manet, with his hat on in bright sunlight, looking dazed. He begged me to go and see his painting, as he did not dare move a step.

I have never seen such an expressive face as his; he was laughing, then had a worried look, assuring everybody that his picture was very bad, and adding in the same breath that it would be a great success. I think he has a decidedly charming temperament, I like it very much.

His paintings, as they always do, produce the impression of a wild or even a somewhat unripe fruit. I do not in the least dislike them, but I prefer his portrait of Zola.

* * *

I am more strange than ugly. It seems that the epithet of *femme fatale* has been circulating among the curious, but I realize that if I tell you about everything at once, the people and the paintings, I will use up all my writing paper, and so I think I had better tell you another time about my impressions of the paintings, all the more so because I could scarcely see them. However, I did look for our friend Fantin. His insignificant little sketch was hung incredibly high, and looked extremely forlorn. I finally found him, but he disappeared before I could say a word about his exhibit. I do not know whether he was avoiding me, or whether he was conscious of the worthlessness of his work.

I certainly think that his excessive visits to the Louvre and to Mademoiselle Dubourg bring him no luck. Monsieur Degas seemed happy, but guess for whom he forsook me – for Mademoiselle Lille and Madame Loubens. I must admit that I was a little annoyed when a man whom I consider to be very intelligent deserted me to pay compliments to two silly women.

I was beginning to find all this rather dull. For about an hour Manet, in high spirits, was leading his wife, his mother, and me all over the place, when I bumped headlong into Puvis de Chavannes. He seemed delighted to see me, told me that he had come largely on my account as he was beginning to lose hope of seeing me again at the Stevenses, and he asked if he might accompany me for a few minutes. I wanted to see the pictures, but he implored me so eagerly: "I beg of you, let us just talk. We have plenty of time for looking at paintings." Such conversation might have appealed to me had I not found myself confronted at every step by familiar faces. What is more, I had completely lost sight of Manet and his wife, which further increased my embarrassment. I did not think it proper to walk around all alone. When I finally found Manet again, I reproached him for his behaviour; he answered that I could count on all his devotion, but nevertheless he would never risk playing the part of a child's nurse.

Edgar Degas. *Mary Cassatt at the Louvre.* 1879–80. Etching and aquatint. 11¾ × 5″ (30.1 × 12.5 cm). Art Institute of Chicago (Gift of Walter S. Brewster).

"The Stevenses": Alfred Stevens (1823–1906), Belgian painter and friend of Morisot and Manet.

Photograph of Berthe Morisot.

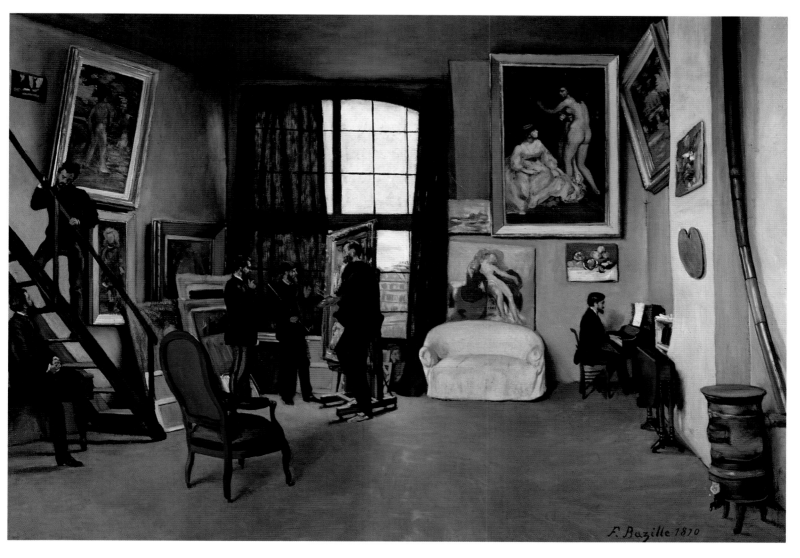

COLOURPLATE 17. Frédéric Bazille. *The Artist's Studio, Rue de la Condamine*. 1870. 38⅞ × 47″ (98 × 128 cm). Musée d'Orsay, Paris.

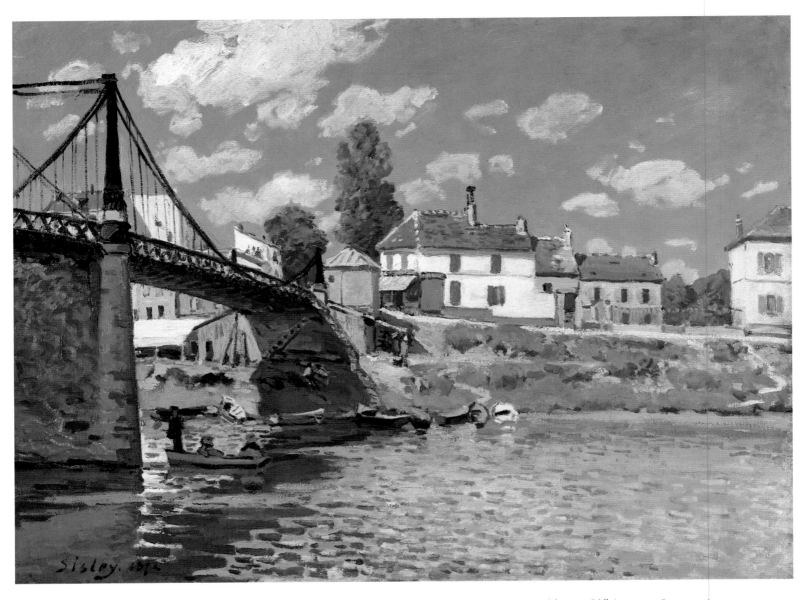

COLOURPLATE 18. Alfred Sisley. *The Bridge at Villeneuve-la-Garenne*. 1872. 19½ × 25¾″ (49.5 × 65.5 cm).
Metropolitan Museum of Art, New York (Gift of Mr and Mrs Henry Ittleson Jr.).

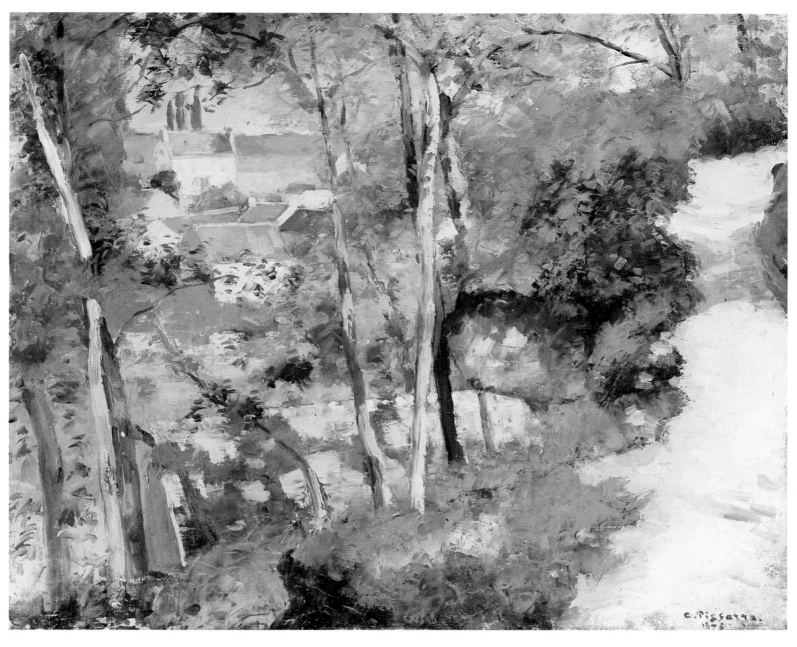

COLOURPLATE 19. Camille Pissarro. *Climbing Path in the Hermitage, Pontoise.* 1875. 21¼ × 25½″ (54 × 65 cm). Brooklyn Museum, New York.

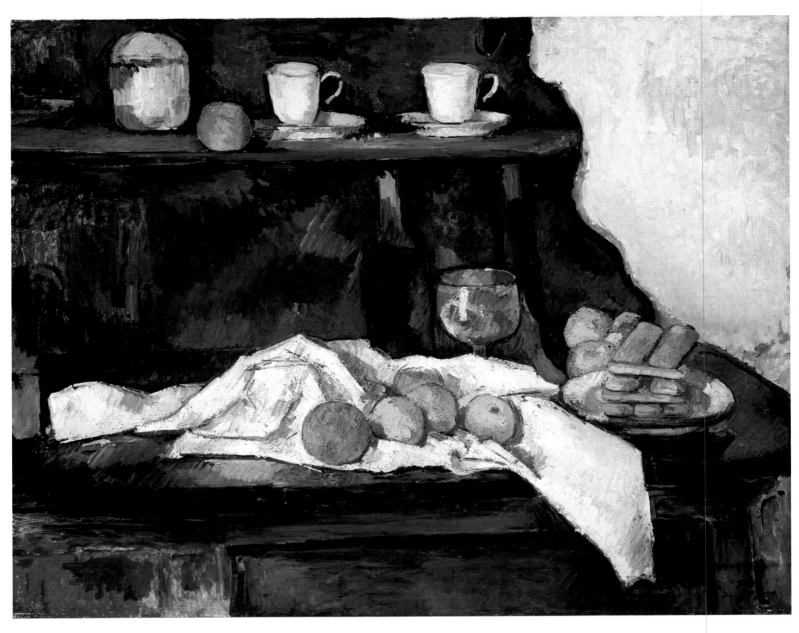

COLOURPLATE 20. Paul Cézanne. *The Buffet*. 1873–7. 29½ × 32″ (75 × 81 cm). Szépmüvészeti Museum, Budapest.

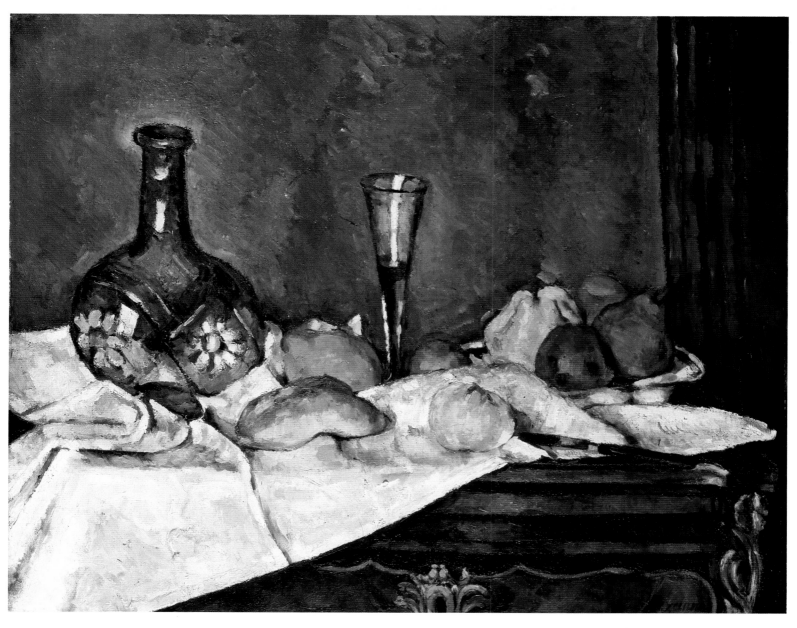

COLOURPLATE 21. Paul Cézanne. *Bottle, Glass and Fruit (Le Dessert)*. 1873–7. 23¼ × 28¾″ (60 × 73 cm).
Philadelphia Museum of Art (Mr and Mrs Carroll S. Tyson Collection).

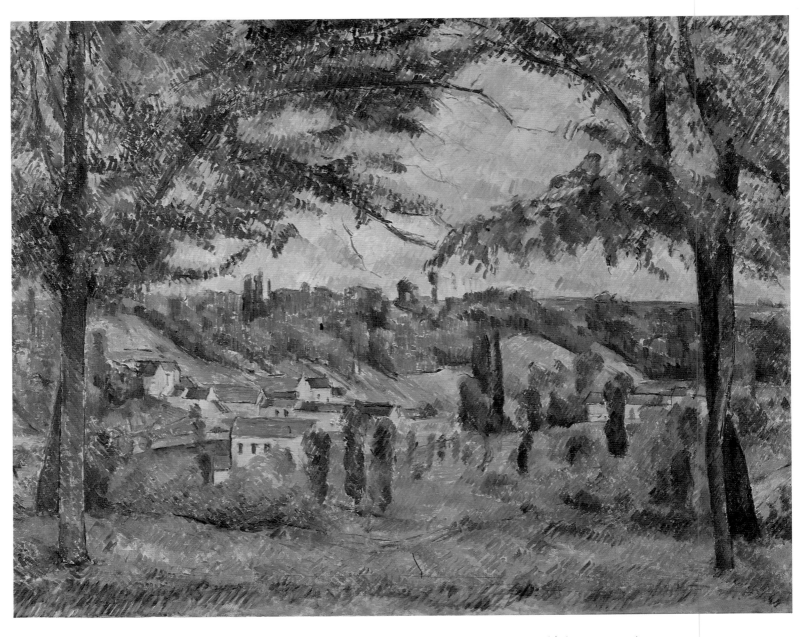

COLOURPLATE 22. Paul Cézanne. *Landscape.* 1879–82. 29 × 28½ (74 × 73 cm).
Nationalmuseum, Stockholm.

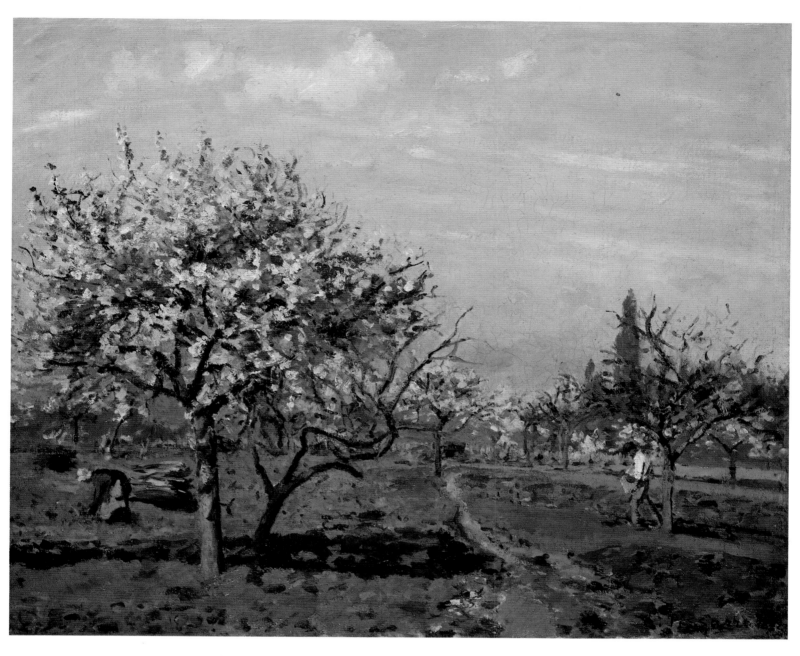

COLOURPLATE 23. Camille Pissarro. *Orchard in Bloom, Louveciennes*. 1872. 17¾ × 21⅝″ (45 × 55 cm).
National Gallery of Art, Washington DC (Ailsa Mellon Bruce Collection).

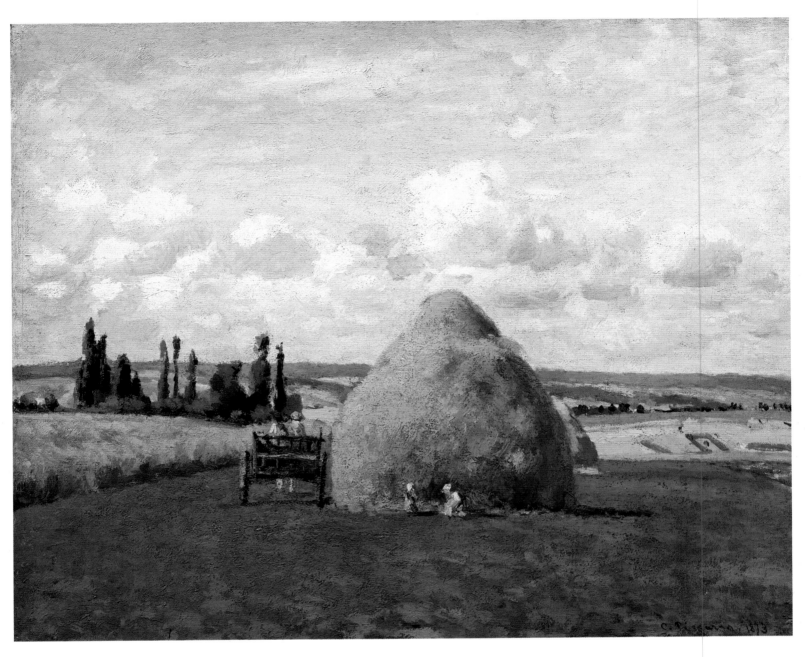

COLOURPLATE 24. Camille Pissarro. *The Haystack, Pontoise*. 1873. 18⅛ × 21⅝″ (46 × 54.9 cm).
Archives Durand-Ruel, Paris.

Édouard Manet. *Exhibition of Paintings.*
1876? Watercolour and wash on pencil.
5½ × 3½″ (14 × 9 cm). Musée du
Louvre (Cabinet des Dessins), Paris.

PAUL MANTZ

GAZETTE DES BEAUX-ARTS

"Salon of 1869"

July 1, 1869

*Paul Mantz (1821–95), art critic, historian
and administrator. He became Director-
General of the Ministry of Fine Arts in 1882.*

Lovers of unusual effects briefly pinned their hopes on Manet. The idea that
we had seen the birth of a Velasquez had something consoling about it and,
while alarming the philistines, certain pictures formerly exhibited on the
boulevard des Italiens had aroused quite legitimate curiosity. M. Manet
seems to want to keep us waiting: it is evident that, if he has something to
say, he is not yet saying it. We disapprove of such unforthcoming behaviour.
The time has come to speak up, even at the risk of somewhat scandalizing

the uninitiated. But M. Manet does not yield up his secret either in the *Luncheon* or in the *Balcony*. Although it presents some accessories in a delicate grey, the first of these paintings is of little significance; the second is more important. A woman is seated at a window framed by two shutters of a cheery green, with a rosy-complexioned young girl beside her; in the background we see the torso of a dandy dressed in black: the two women are in white. It is not clear what these good folk are doing on their balcony, and German critics, curious as to the philosophical meaning of things, would here be hard-pressed to understand and explain. The stressing of a type, the characterization of a feeling or an idea, would be sought in vain in this thoughtless painting. Let us admit that we have here a combination of colours and let us look at it as we would the wayward arabesques of a piece of Persian pottery, the harmony of a bouquet, the decorative splendour of a fine wallpaper. Seen in this light, M. Manet has great gifts and sometimes he seems actually to deliberate. The robust light green of the shutters heightening the rosy complexion of the young girl, and the blacks and whites of the costumes, would have been used by a colourist to create a joyous and striking picture. M. Manet has not entirely succeeded in this: he has however created extremely delicate flesh tints and, if he has not wholly resolved the problem, one must be grateful to him for having posed it. His picture has almost as much interest as a still life.

Luncheon in the Studio *(1868)*, *Neue Pinakothek, Munich.*
The Balcony *(1868–9)*, *Musée d'Orsay, Paris.*

EDGAR DEGAS

NOTEBOOKS

1860s; 1876

What is certain is that setting a piece of nature in place and drawing it are two very different things.

There are good people who are badly turned out; there are, I think, even more bad ones who are well turned out.

One doesn't like to hear people say, as if to children, concerning rosy and gleaming flesh: Ah! what life, what blood. Human flesh is as varied looking, especially among our people, as the rest of nature, fields, trees, mountains, water, forests. It is possible to encounter as much resemblance between a face and a stone as between two stones, since everyone knows that you often see two faces which are more or less alike. (I am speaking from the point of view of colouring, for the question of form is not at issue, since you often find so many points of similarity between a pebble and a fish, a mountain and a dog's head, clouds and horses etc.)

Thus it is not instinct alone which makes us say that it is in colouring that one must look everywhere for the affinity between what is living and what is dead or vegetal. I can easily bring to mind certain hair colouring, for example, because it struck me as being the colour of varnished walnut or tow, or like horse-chestnut bark, real hair with its suppleness and lightness or its hardness and heaviness. And then one paints in so many different ways, on so many different surfaces that the same tone will appear as one thing here and another there. I am not speaking of contrasts which would distort it in an entirely different way.

What a great "artist manqué" this Géricault is! He sensed that he could never be one even with his fortune, all his firmness of hand and the rest. There is something of Bandinelli in this unfortunate Gaul.

Moreau's painting is the dilettantism of a man of feeling, if you consider only the subject, and that of a man of intellect if you see only the manner of execution.

Edgar Degas. *Self-Portrait.* Drawing. Musée du Louvre (Cabinet des Dessins), Paris.

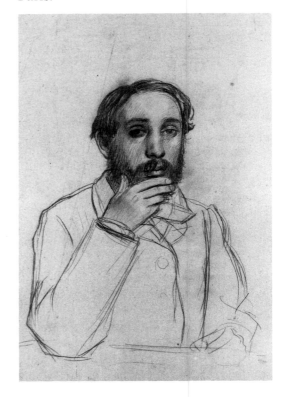

Oh Giotto! Let me see Paris, and you, Paris, let me see Giotto!

Make of the *Tête d'expression* a study of modern feeling – it's like Lavater, but a more relative Lavater in a way. – Study Delsarte's observations on those movements of the eye inspired by feeling. – Its beauty must be nothing more than a specific physiognomy. Work a lot on the effects of, say, a lamp, a candle etc. The point is to not always show the source of light, but its effect. This aspect of art can become immensely important today. Is it possible not to see it?

Draw a lot. Oh! the beauty of drawing!

Think about a treatise on ornament for or by women, according to their way of observing, combining, sensing the way they dress and everything else. – Every day they compare a thousand more visible things with one another than a man does.

When I get up in the morning I can still salvage everything from my highly compromised life . . .

Make portraits of people in typical, familiar poses, being sure above all to give their faces the same kind of expression as their bodies. Thus if laughter typifies an individual, make her laugh. – There are, of course, feelings which one cannot convey, out of propriety, as portraits are not intended for us painters alone. How many delicate nuances to put in.

NOTEBOOKS 20 AND 23

For the *Journal*; a severely truncated dancer – do some arms or legs, or some backs – draw the shoes, the hands of a hairdresser, the built-up hairstyle, bare feet in the act of dancing etc. etc.

Draw all kinds of everyday objects placed, accompanied in such a way that they have in them the *life* of the man or woman – corsets that have just been removed, for example, and which retain the form of the body etc. etc.

Series on instruments and instrumentalists, their forms, the twisting of the hands and arms and neck of a violinist; for example, swelling out and hollowing of the cheeks of the bassoonists, oboeists, etc.

Do a series in aquatint on *mourning*, different blacks – black veils of deep mourning floating on the face – black gloves – mourning carriages, undertakers' vehicles – carriages like Venetian gondolas.

On smoke – smokers' smoke, pipes, cigarettes, cigars – smoke from locomotives, from tall factory chimneys, from steam boats etc. Smoke compressed under bridges – steam.

On evening – infinite variety of subjects in cafés – different tones of the glass globes reflected in the mirrors.

On bakery, *Bread* – Series on bakers' boys, seen in the cellar itself, or through the basement windows from the street – backs the colour of pink flour – beautiful curves of dough – still lifes of different breads, large, oval, long, round, etc. Studies in colour of the yellows, pinks, greys, whites of bread.

Perspectives of rows of bread, delightful arrangements of bakeries – cakes – the corn – the mills – the flour, the bags, the strong men of the market. . . .

Neither monuments nor houses have ever been done from below, close up as they appear when you walk down the street. . . .

Still-life – cook cleaning her copper utensils – a pink range of utensils reflected in one another, reflecting everything, linen, windows, arms, apron, etc. . .

2 panels on birth – delicate mother, fashionable – food – large wet-nurse – large behind – enormous ribbons, large behind. Lilac coloured dress fluted like a pillar. . . .

There is a kind of shame in being known especially by people who don't understand you. A great reputation is therefore a kind of shame. It is a very good thing to aim for the middle way, but certainly better than being like the Institute, at both extremes of something. One will enjoy oneself, as knowingly as possible.

Recipes. Oil the plate a little and sprinkle with powdered copal, that forms a particular grain. Warm sufficiently.

The academy style of the time.
Johann Kaspar Lavater (1741–1801), Swiss poet and theologian, developed a theory of human nature based on the reading of physiognomy.

Once a grain has taken, soap the plate well and wash well afterwards. You can paint on acid without it running so much. Apparently by leaving some Spanish white in the holes you can bring out the varnish and even re-bite the grains again.

After having done portraits seen from above, I will do some seen from below – sitting very close to a woman and looking up at her. I will see her head in the chandelier, surrounded by crystals – and perform simple operations such as drawing a profile which wouldn't move, moving myself, going up or down, the same for a whole figure, a piece of furniture, an entire lounge.

Draw a series of arm movements of the dance, or of legs which wouldn't move, turning around them oneself – etc. Finally study from all perspectives a face or an object, anything.

For this one can use a mirror – one wouldn't have to move from one's place. Only the position would lower or incline, one would turn around it.

Workshop plans; set up tiers all round the room to get used to drawing things from above and below. Only paint things seen in a mirror so as to become used to a hatred of *trompe-l'œil*.

For a portrait, pose the model on the ground floor and work on the first floor to get used to retaining forms and expressions and to never drawing or painting *immediately*.

NOTEBOOKS 30 AND 34

GEORGE MOORE

REMINISCENCES OF THE IMPRESSIONIST PAINTERS

Manet and Degas

1906

George Moore (1852–1933), Irish writer and friend of Manet and Whistler. He came to Paris in 1873, initially to study under Cabanel. His anecdotal Reminiscences of Impressionist Painters *helped introduce Impressionism to British audiences.*

The work of the great artist is himself, and, being one of the greatest painters that ever lived, Manet's art was all Manet; one cannot think of Manet's painting without thinking of the man himself. The last time I saw Monet was at the dinner in the Café Royal, and, after talking of many things, suddenly, without any transition, Monet said, speaking out of a dream, "How like Manet was to his painting," and I answered delighted, for it is always exciting to talk about Manet: "Yes, how like. That blonde, amusing face, the clear eyes that saw simply, truly and quickly;" and having said so much, my thoughts went back to the time when the glass door of the café grated upon the sanded floor, and Manet entered. Though by birth and by education essentially Parisian, there was something in his appearance and manner of speaking that often suggested an Englishman. Perhaps it was his dress – his clean-cut clothes and figure. That figure! Those square shoulders that swaggered as he went across the room, and the thin waist; the face, the beard, and the nose, satyr-like shall I say? No, for I would evoke an idea of beauty of line united to that of intellectual expression – frank words, frank passion in his convictions, loyal and simple phrases, clear as well water, sometimes a little hard, sometimes as they flowed away bitter, but at the fountain head sweet and full of light.

I should emphasize Manet's courage, for without courage there cannot be art. We have all heard the phrase, "I should not like to think like that," and whosoever feels that he would not like to think out to its end every thought that may happen to come into his mind I would dissuade from art if I could. Manet's art is the most courageous ever seen. One looks in vain for those

subterfuges that we find in every other painter. What he saw he stated candidly, almost innocently, and what he did not see he passed over. Never in his life did he stop to worry over a piece of drawing that did not interest him because it was possible that somebody might notice the omission. It was part of his genius to omit what did not interest him. I remember a young man whom Manet thought well of – a frequent visitor to the studio – and one day he brought his sister with him – not an ill-looking girl, no better and no worse than another, a little commonplace, that was all. Manet was affable, and charming; he showed his pictures, he talked volubly, but next day when the young man arrived and asked Manet what he thought of his sister, Manet said, extending his arm (the gesture was habitual to him): "The last girl in the world I should have thought was your sister." The young man protested, saying Manet had seen his sister dressed to her disadvantage – she was wearing a thick woollen dress, for there was snow on the ground. Manet shook his head. "I have not to look twice; I am in the habit of judging things." These were his words, or very nearly, and I think this anecdote throws a light upon Manet's painting. He saw quickly and clearly, and he stated what he saw candidly, almost innocently.

<center>* * *</center>

The glass door of the café grates upon the sand again. It is Degas, a round-shouldered man in a suit of pepper and salt. There is nothing very trenchantly French about him either, except the large necktie. His eyes are small, his words are sharp, ironical, cynical. Manet and Degas are the leaders of the Impressionistic school, but their friendship has been jarred by the inevitable rivalry. "Degas was painting *Semiramis* when I was painting *Modern Paris*," says Manet. "Manet is in despair because he cannot paint atrocious pictures like Duran and be fêted and decorated; he is an artist not by inclination but by force, he is a galley slave chained to the oar," says Degas. And their methods of work are quite different. Manet paints his whole picture from nature, trusting to his instinct to lead him aright through the devious labyrinth of selection. But his instinct never fails him, there is a vision in his eyes which he calls nature, and which he paints unconsciously as he digests his food, thinking and declaring vehemently that the artist should not seek a synthesis, but should paint merely what he sees. This extraordinary oneness of nature and artistic vision does not exist in Degas, and even his portraits are composed from drawings and notes.

<center>* * *</center>

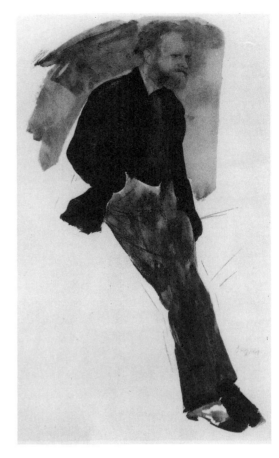

Edgar Degas. *Portrait of Manet.* 1864–6. Pencil and wash, 13⅞ × 9″ (35 × 22.8 cm). Private Collection, Paris.

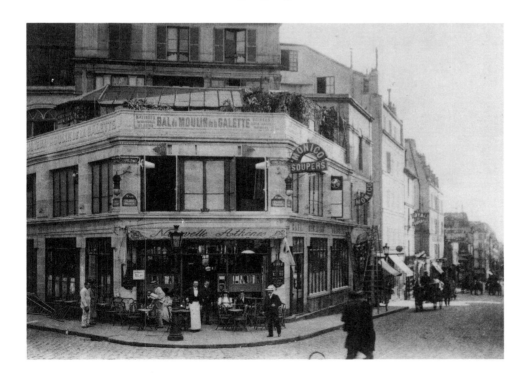

Café de la Nouvelle-Athènes, Montmartre. Photograph. 1906. Bibliothèque Nationale (Cabinet des Estampes), Paris.

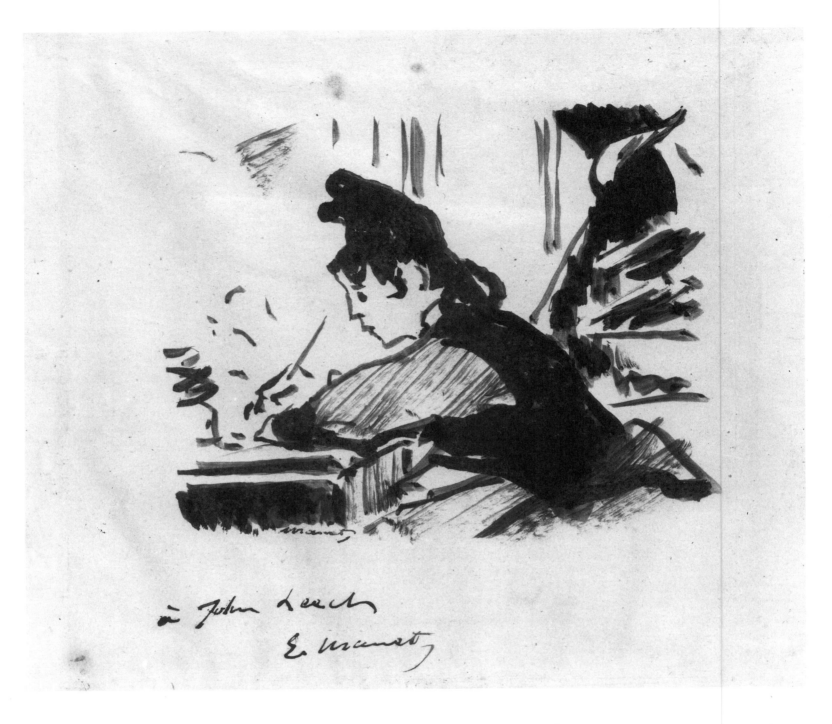

Édouard Manet. *Woman Writing.* 1862–4. Pen and black ink, 6 × 6¼″ (15.2 × 15.9 cm). Sterling and Francine Clark Art Institute, Williamstown, Mass.

I think that Degas was more typical of his time than was Manet. Looking at a picture by Degas we think, "Yes, that was how we thought in the seventies and in the eighties." Manet desired modernity as earnestly as Degas, but his genius saved him from the ideas that were of his time. Manet was a pure painter, and it mattered nothing to him whether he painted a religious subject – angels watching by the side of the Dead Christ – or yachting at Argenteuil. Manet was an instinct, Degas an intellectuality, and his originality is according to the prescription of Edgar Poe, who held that one is original by saying, "I will not do a certain thing because it has been done before." So the day came when Degas put *Semiramis* aside for a ballet girl. *Semiramis* had been painted, the ballet girl in pink tights, clumsy shoes and bunched skirts, looking unnatural as a cockatoo, had not. And it was Degas who introduced the acrobat into art, and the *repasseuse* [laundress]. His portrait of Manet on the sofa listening to Madame Manet playing the piano is one of the most intellectual pieces of painting ever done in the world; its intellectuality reminds one of Leonardo da Vinci, for, like Degas, Leonardo painted by intellect rather than by instinct.

Edgar Degas: Édouard Manet and Madame Manet, c. *1865. The painting was a gift from Degas to Manet. Unhappy with the depiction of his wife, Manet cut off that section of Degas's canvas.*

* * *

Manet said to me once, "I tried to write but I couldn't write," and I thought he spoke apologetically, whereas his words were a boast. "He who paints as I paint could never think of doing anything else," was what was in his mind, and if Manet had lived till he was a hundred he would have painted to the last. But Degas, being merely a man of intellect, wearied of painting; he turned to modelling for relaxation, and he has collected pictures. His collection is the most interesting in Paris, for it represents the taste of one man. His chief admirations are Delacroix and Ingres and Manet, especially Ingres. There was a time when he knew everyone who owned an Ingres, and it is said that the *concierges* used to keep him informed as to the health of the owners of certain pictures, and hearing of an appendicitis that might prove fatal, or a bad attack of influenza, Degas at once flapped his wings and went away like a vulture. One day I met him in the rue Mauberge. "I've got it," he said, and he was surprised when I asked him what he had got: great egoists always take it for granted that everyone is thinking of what they are doing. "Why, the *Jupiter*, of course the *Jupiter*," and he took me to see the picture – not a very good Ingres, I thought – good, of course, but somewhat tedious – a Jupiter with beetling brows, and a thunderbolt in his hand. But next to it was a pear, and I knew that pear, just a speckled pear painted on six inches of canvas; it used to hang in Manet's studio, six inches of canvas nailed to the wall, and I said to Degas, "I think, after all, I like the pear better than *Jupiter*;" and Degas said, "I put it there, for a pear painted like that would overthrow any god."

Jean-Auguste-Dominique Ingres: Jupiter and Thetis, *1811.*

Édouard Manet: Still Life with Pear, *1880.*

FRÉDÉRIC BAZILLE

Letters to his Parents

1867, 1869

FRAGMENT OF A LETTER (1867)

. . . a few weeks or a month at Aigues-Mortes or at the Saintes to paint some pine trees; it would be wise to choose a season when there aren't fevers going around. I am also planning to do a painting at Méric which will be rather large and will take the whole end of summer.

At this moment there is a deluge of painters in Paris. Ingres's exhibit is very interesting, and it would be a pity to miss it by not taking your trip.

Almost all of his portraits are masterpieces, but his other paintings are very boring. This salon is the most mediocre I have seen to date. At the Exposition Universelle there are about twenty beautiful canvases by Millet and Corot. Very soon the one-man exhibitions of the work of Courbet and Manet will open, and I am very eager to see them.

Jean-François Millet, 1814–75.
Camille Corot, 1796–1875.

In one of my last letters I told you about the plan of a group of young people to have their separate exhibition. With each of us pledging as much as possible, we have been able to gather the sum of 2500 francs, which is not enough. We must therefore abandon our desired project. We will have to re-enter the bosom of the administration whose milk we have not sucked and who disowns us.

(1869)

Dear Mother,
Papa's last letter made me very unhappy, even more than you can imagine. I have been sad for a few days. Now that's over. My dreams of marriage have received a hard blow. I probably won't have any more for quite some

time. Maybe it is better for me to be completely free to work at my own pace as I wish. That is what I am doing now, more than ever.

I have another piece of bad news to announce. The pictures I submitted to the Exposition have been rejected. Don't take this too much to heart, there is nothing discouraging about it, quite the contrary. I share the lot of all that was best at the Salon this year. Right now a petition is being circulated for an *Exposition des refusés* signed by all the best painters in Paris. But, it will come to nothing.

At any rate, I will never be annoyed again as I have this year, because I will never send anything again to the Jury. It is really too ridiculous for a considerably intelligent person, to expose himself to administrative caprice, especially if medals and prizes hold absolutely no interest.

A dozen talented young people agree with what I have just said. We have therefore decided that each year we will rent a large studio where we will exhibit our works in as large a number as we wish. We will invite any painters who wish to send us work. Courbet, Corot, Dias, Daubigny and many others whom you may not know, have promised to send work, and heartily support our idea. With these people, and Monet, the best of all of them, we are certain of success. You will see how much attention we will get. If by chance they do endorse a *Salon des Refusés* we will not do anything this year, and our association would begin only next year. I would prefer that. It would give me time to do two or three important paintings at Montpellier. Don't be concerned, I assure you that I am being very reasonable. We are certainly in the right, and this is nothing more serious than a student revolt. At the moment I am working on a life-size painting of two women arranging flowers. It will be finished by peony time. I would very much like to have it finished for our private showing if it takes place this year. I shall also send a portrait I am doing of Monet. . . .

Give me lots of details about your plans for this spring. I really urge you not to come this time. There is already a mob of people, and it is not the right time to see Paris. You might not find a place to stay, and I think, that if papa comes, he should come and stay in my room.

I kiss you along with my cousins. Give my regards to the Gachons.

F. Bazille

Narcisse-Virgile Diaz (1808–76), landscape painter and, together with Charles-François Daubigny (1817–79), member of the Barbizon group who painted in the forest of Fontainebleau.

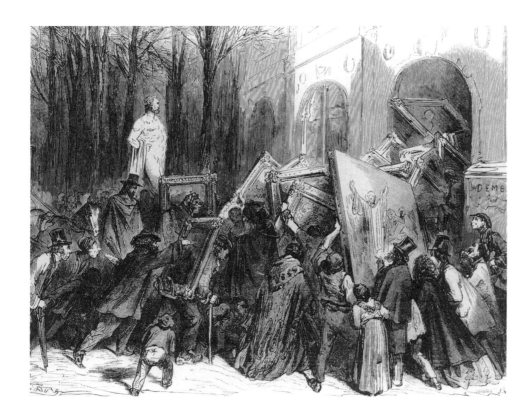

Gustave Doré. *The Last Day for Sending in.* Engraving.

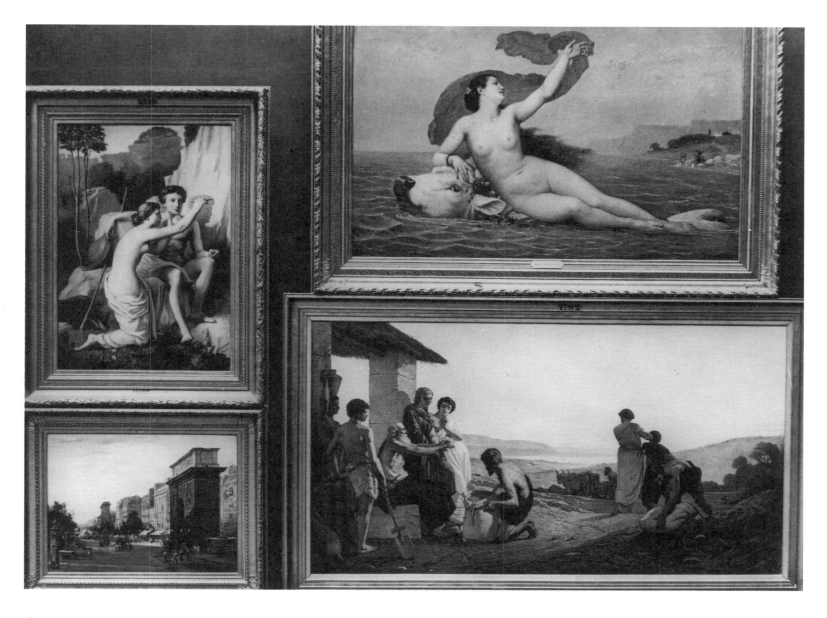

ÉMILE CARDON

LA PRESSE

"The exhibition of the Révoltés"

April 29, 1874

Contemporary photograph of State purchases from the 1865 Salon. Top left, Louis Lamothe: *The Origin of Drawing*; top right, Louis-Frédéric Schutzenberger: *Europa carried off by Jupiter*. Bibliothèque Nationale, Paris.

In all justice, in approaching the exhibition on the boulevard des Capucines, one should divide it into two parts: one which cannot be too highly encouraged, the other against which one cannot react too strongly; the first which has every right to our praise, the second which should be very vigorously rejected; the latter despicable, the former worthy of great interest.

This is not the first time that artists have come together to form a company and thus to free themselves from administrative supervision. A first attempt was made about 15 years ago: two hundred artists came together on the boulevard des Italiens to exhibit their works and sell them directly to collectors. Interesting exhibitions took place, the public was already aware of the Exhibition of the *Société nationale des beaux-arts*, when hostilities amongst its administrative staff brought about the liquidation of the company.

Louis Martinet, a commercial dealer, had exhibited Manet and other new painters at his gallery on the boulevard des Italiens. His publication Courrier Artistique *contributed to the pressure on the Count de Nieuwerkerke (1811–92), Director-General of National Museums and newly-appointed Superintendent of Fine Art, that led to his decision to open a Salon des Refusés in 1863.*

Today, the new association of artists will encounter only sympathy on the part of the administration, which has officially announced that it wishes to give up the management of artistic exhibitions, from next year onwards.

I know that many people feel great alarm at the advent of an age when artists, abandoned to their own devices, will take responsibility for the organization of their own annual exhibition, draw up their own regulations, form their own jury, accept or reject the works to be exhibited, make awards or at least present the administration with the list of artists recognized as being the most deserving.

The Limited Company of artist-painters has settled these difficult questions in the simplest fashion; it has done away with the admission jury, and with awards. Is the absence of all rules a good thing? Only the future will enlighten us.

Other artists will undoubtedly follow the example of the Limited Company of painters and we shall see 20 or 30 artistic companies created, each with its own public, as happens in England. This is a good thing, for art can only gain from the growth of intellectual freedom.

The principle which has presided at this association is thus utterly praiseworthy, and we are unreservedly in favour of the founders of this association, as you may see. It now remains for us to evaluate the first exhibition of the Limited Company from a purely artistic point of view; we shall do so with equal sincerity.

One hundred and sixty-five pictures, drawings, watercolours, engravings etc. are exhibited in Nadar's former studio by 30 artist-members of the Company. Of these, some should certainly have been presented to the jury of the official Exhibition and would certainly have been accepted; but we should add that their authors in no way belong to the new school. The artists who painted them have been seduced by the idea of freeing themselves from administrative supervision, and have associated themselves with an attempt at emancipation which they approve of.

M. de Nittis, who has had a very justifiable success in recent Salons; M. Lépine, a young landscape painter with a great future, and a conscientious artist; M. Boudin, whose seascapes are highly thought of; M. Bracquemond, a master of the etching; and MM. Brandon, Cals and de Molins, could not justly be considered as adepts of the new School. We shall not therefore concern ourselves here with either them or their work, certain that we shall find them at the Palais des Champs-Élysées or on rue Le Peletier. There thus remain MM. Degas, Cézanne, Monnet [sic], Sisley, Pissarro, Mlle Berthe Morisot etc. etc., the disciples of M. Manet, the pioneers of the painting of the future, the most convinced and authoritative representatives of the *School of Impressionism*.

This school does away with two things: line, without which it is impossible to reproduce any form, animate or inanimate, and colour, which gives the form the appearance of reality.

Dirty three-quarters of a canvas with black and white, rub the rest with yellow, dot it with red and blue blobs at random, and you will have an *impression* of spring before which the initiates will swoon in ecstasy.

Smear a panel with grey, plonk some black and yellow lines across it, and the enlightened few, the visionaries, exclaim: Isn't that a perfect impression of the bois de Meudon?

When the human figure is involved, it is another matter entirely: the aim is not to render its form, its relief, its expression – it is enough to give an *impression* with no definite line, no colour, light or shadow; in the implementation of so extravagant a theory, artists fall into hopeless, grotesque confusion, happily without precedent in art, for it is quite simply the negation of the most elementary rules of drawing and painting. The scribblings of a child have a naivety, a sincerity which make one smile, but the excesses of this school sicken or disgust.

The famous Salon des Refusés, whose very name brings a smile to the lips – with its nut-brown women on yellow horses in forests of blue trees – that

Thirty-nine artists participated in the exhibition from April 15 to May 15, 1874 of the self-styled "Société anonyme des artistes, peintres, sculpteurs, graveurs, etc.", the first Impressionist exhibition, at studios recently vacated by the photographer Nadar on the boulevard des Capucines. Degas showed ten pictures, the largest number by any single artist.

Honoré Daumier. *Nadar Elevating Photography to the Height of Art. Le Charivari*, May 25, 1862. Lithograph, 10¾ × 8¾" (27.3 × 22.2 cm). Bibliothèque Nationale (Cabinet des Estampes), Paris.

salon was a veritable Louvre in comparison with the Exhibition on the boulevard des Capucines.

In examining the works exhibited (I particularly recommend numbers 54, 42, 60, 43, 97 and 164) one wonders whether one is seeing the fruit either of a process of mystification which is highly unsuitable for the public, or the result of mental derangement which one could not but regret. In this latter case, this exhibition would no longer be the concern of the critics, but of Dr Blanche.

But alas, all this is serious – seriously executed, seriously discussed, regarded as a new lease of life for art, as the last word in painting. Raphael, Michelangelo, Correggio, Velasquez, Greuze, Ingres, Delacroix and Th. Rousseau are pedestrian painters who never understood the first thing about nature, plodders who have had their hour and whose works the keepers of our museums should consign to the attics.

And let no one accuse us of exaggeration – we have heard the arguments of these painters and their admirers, at the Hôtel Drouot where their paintings have never been known to sell, at the dealers on rue Laffitte who stack up their sketches in the extremely faint hope of an opportunity for a sale. We have heard them propounding their theories while looking with superb pity on the works we are accustomed to admiring; despising all that study has taught us to love, and intoning with quite irrational pride, "If you understand anything of the soarings of genius, you will admire Manet and us who are his disciples."

Furthermore, they speak with such sincerity that they have ultimately convinced one art lover, though admittedly only one: M. Faure, who sold his fine Duprés, his splendid Delacroix, his marvellous Corots and his Roybes, to purchase some Degats [sic], Cézannes and Manets!

It is true that M. Faure has always liked to attract attention. Buying Cézannes is as good a way as any of so doing, and of achieving a unique piece of self-advertisement.

No. 54 Degas, Dance Examination in the Theatre, *in the collection at the time of J.-B. Faure, present whereabouts unknown; No. 42 Cézanne*, House of the Hanged Man, Auvers *1873–4, Musée d'Orsay; No. 60 Degas*, Rehearsal of the Ballet on Stage *(Lemoisne 400), Metropolitan Museum of Art, New York; No. 43 Cézanne*, A Modern Olympia, *1872–3, Musée d'Orsay; No. 97 Monet*, Boulevard des Capucines, *1873, Nelson-Atkins Museum of Art, Kansas City, Missouri; No. 164 Sisley*, Verger *(Daulte 82), Private Collection, Paris.*

Jean-Baptiste Faure (1830–1914), famous baritone and collector who had purchased work by Manet and was his most important patron.

JULES CASTAGNARY

LE SIÈCLE

"L'exposition du boulevard des Capucines – Les impressionnistes"

April 29, 1874

Jules-Antoine Castagnary (1830–88), art critic, journalist and art administrator; he became Minister of Fine Art in 1887. A committed spokesman for the realist movement, he invented the term "naturalism" to describe the younger generation of painters influenced by Courbet. The term was subsequently borrowed by Zola and his circle to apply to the new novel.

Let us begin with the exhibition on the boulevard des Capucines. A few years ago, word went around the studios that a new school of painting had been born. What were its aims, its method, its field of observation? How were its products to be distinguished from those of earlier schools, and what did it contribute to the balance of contemporary art? At first it was difficult to know. The members of the jury, with their usual intelligence, aspired to bar the way to the newcomers. They closed the door of the Salon to them, forbade them any publicity and, by means of all the sillinesses to which egoism, stupidity and envy have access in this world, forced them to be delivered up to ridicule.

Persecuted, hounded, shunned, banned by official art, the alleged anarchists formed a group. Durand-Ruel, who is untroubled by administrative prejudices, put one of his rooms at their disposal and for the first time the public was able to judge for itself the tendencies of those who, for some reason, were being referred to as the "Japanese" of painting. Since then, time has moved on. Strengthened by a number of new supporters, encour-

Photograph of Renoir. 1875. Musée d'Orsay, Paris.

aged by considerable approbation, the painters of whom we are speaking formed a cooperative association and rented Nadar's former studio on the boulevard des Capucines; it is there, in premises of their own, arranged by their own hand, that they have just organized their first exhibition; and it is on the subject of this exhibition that we propose to address our readers.

Let us say firstly, for artists who might be tempted to take part in such an enterprise, that it is based on excellent principles. All the partners have an equal interest, for whose maintenance an administrative council of 15 members has been appointed, elected and renewable by a third each year. Works are hung according to size: the small ones on the line, the others above; and all in alphabetical order, after a lottery for the beginning letter and with the stipulation that in no case will there be more than two rows of paintings. Wise arrangements, which guarantee each shareholder exactly the same overall advantages.

Let us say next, for the information of the public, that they will find there no canvases already compromised and stigmatized by rejection. These are all original works, which have not appeared before any jury, and which consequently have not been the object of any decision that might cast a slur upon them. They appear virgin before the art-lover, who thus has complete freedom of appreciation. Nor should it be thought that the whole is meagre or of scant importance. The catalogue includes 165 items: paintings, watercolours, etchings, pastels, drawings etc.; and if there are some among the exhibitors who are still struggling for recognition, there are also a number who have already joined the ranks of the honoured. Such are MM. Eugène Boudin, whose *beaches* and *seascapes* today command the highest prices; Stanislas Lépine, who has made himself a reputation with his *banks of the Seine*, so delicately rendered; Brandon, who devoted himself solely to the

painting of Jewish life; Gustave Colin, whose Pyrenean pages flame with light and sun; Cals, who applies his meditative and reflective art to the representation of popular types and scenes. I shall mention just one engraver by name, but it is that of a master – M. Félix Bracquemond, the well-known etcher. His contribution consists of over 30 plates, mostly first-class, some of which are valuable historical documents: the portrait of *Auguste Comte*, those of *Théophile Gautier, Baudelaire, Meryon, Charles Kean* etc.

But the question of school, which I mentioned at the beginning, does not arise in connection with these known names, nor with these accepted works. To gain some idea of the nature of the newcomers, of their aims, their dreams, their achievements; to assess the gap which separates their method of interpretation from that adopted before them, one must stand in front of the canvases by MM. Pissarro, Monet, Sisley, Renoir, Degas and Guillaumin and also of those of Mlle Berthe Morisot. These are the "directors" of the new school – if school it be – and this is what we shall shortly be considering.

What an irony! Here we have four [sic] young men and one young woman who have caused the jury to tremble for five or six years! It is with the aim of barring the route to these four young men and this young woman that, for five or six years, the jury has heaped idiocy on idiocy, piled up abuses of power, compromised itself so utterly before public opinion that there is not a man in France who dares speak in its favour.

Let us therefore look at what these terrible revolutionaries have to offer us that is so monstrous, so subversive of the social order.

I swear on the ashes of Cabanel and Gérôme, there is talent here, even much talent. These young people have a way of understanding nature which is not in the least boring or banal. It is lively, light, alert; it is ravishing. What instant understanding of the object and what amusing brushwork! True, it is summary, but how accurate the pointers are!

* * *

The common view that brings these artists together in a group and makes of them a collective force within our disintegrating age is their determination not to aim for perfection, but to be satisfied with a certain general aspect. Once the impression is captured, they declare their role finished. The term *Japanese*, which was given them first, made no sense. If one wishes to characterize and explain them with a single word, then one would have to coin the word *impressionists*. They are *impressionists* in that they do not render a landscape, but the sensation produced by the landscape. The word itself has passed into their language: in the catalogue the *Sunrise* by Monet is called not *landscape*, but *impression*. Thus they take leave of reality and enter the realms of idealism.

So what essentially separates them from their predecessors is a matter of degree of finish. The object of their art has not changed, the means of translation alone is altered, some would say debased. Such, in itself, is the aim, the whole aim, of the *impressionists*.

Now what is the value of this novelty? Does it constitute a real revolution? No, since the principle and to a great extent the form of the art remain unchanged. Does it lay the ground for the emergence of a school? No, because a school feeds on ideas and not on material means, is distinguished by its doctrines and not by its techniques. If it does not constitute a revolution or contain the seed of any school, what is it then? A manner and nothing more. After Courbet, after Daubigny, after Corot, one cannot say that the *impressionists* invented the unfinished. They vaunt it, they glorify it, they raise it to the dignity of a system. They make it the keystone of their art, they put it on a pedestal and adore it; that is all. This exaggeration is a manner. And what is the fate of manners in art? It is to remain typical of the person who invented them or the small clique who accepted them, it is to shrink rather than to expand; it is to become stationary without reproducing, and soon to perish where they stand.

Nadar's studio, 35 boulevard des Capucines. Photograph. Bibliothèque Nationale (Cabinet des Estampes), Paris.

Alexandre Cabanel (1824–89), highly successful and influential academic painter whose Birth of Venus, *exhibited at the Salon of 1863, was purchased by Napoleon III. His presence on the Salon jury and that of Jean-Léon Gérôme (1824–1904) effectively restricted the range of exhibitors.*

The rhetoric of criticism of the new painting returned repeatedly to the issue of un-finish: the status of the mere sketch, the pochade, étude *or* esquisse *as opposed to the completed work or* tableau, *which was considered appropriate for exhibition.*

In a few years, the artists today gathered together on the boulevard des Capucines will be divided. The strongest among them, those who are distinguished and courageous, will have recognized that, if there are some subjects which lend themselves to a rapid 'impression' and are adequately expressed by a sketch, there are others, many in number, which demand clear expression and precise execution; that the superiority of the painter consists precisely in treating each subject according to the manner that suits it; and, consequently, that they should not be dogmatic, and should boldly choose the form which renders the idea in all its fullness. Those who, continuing their course, will have perfected their draughtsmanship, will abandon *impressionism* as an art truly too superficial for them. As for the others who, failing to reflect and learn, will have pursued the *impression* to excess, the example of M. Cézanne (*A Modern Olympia*) may immediately serve to show them the fate which awaits them. Starting from idealization, they will arrive at that degree of unbridled romanticism where nature has become a mere excuse for dreaming, and where the imagination becomes powerless to formulate anything except personal subjective fantasies, with no echo in general reason, because they are without control or any possible verification in reality.

ERNEST CHESNEAU

PARIS-JOURNAL

"Le plein air, Exposition du boulevard des Capucines"

May 7, 1874

Chesneau became Inspector of Fine Art in 1869 through his friendship with the Count de Nieuwerkerke. His Salon criticism appeared in book form in 1864 as L'Art et les artistes modernes en France et en Angleterre.

[A young group of painters has] opened an exhibition on the boulevard des Capucines. If they had had the complete courage of their convictions (or strong enough backs to run and bear the risks) they might perhaps have managed to strike a considerable blow.

Their attempt, very deserving of sympathy, is in danger of being still-born because it is not sufficiently emphatic. To have invited the participation of certain painters who are shuffling around the edges of the official Salon's latest batch of inanities, and even artists of unquestionable talent, but who are active in areas quite different from their own, such as MM. de Nittis, Boudin, Bracquemond, Brandon, Lépine and Gustave Colin, was a major mistake in both logistics and tactics.

One must always reckon with the inertia of public judgment. The public has no initiative. Initiative has to be taken on its behalf. If it has to choose between two works presented to it simultaneously, one in conformity with accepted conventions, the other baffling all tradition, it is a foregone conclusion that the public will declare itself in favour of the conventional work at the expense of the work of innovation.

That is what is happening at the boulevard des Capucines. The only really interesting part of the exhibition, the only part worthy of study, is also the only part whose curious implication eludes the great majority of visitors.

This rapprochement was premature, at the very least. It may work in a few years' time. So it is possible that it may offer a lesson and, in certain conditions, may provide the opportunity for a triumph for the "*plein air* school".

Claude Monet. *Boulevard des Capucines.* 1873. 31¾ × 22¾" (79.4 × 60.6 cm). Nelson-Atkins Museum of Art, Kansas City, Missouri (Kenneth A. and Helen F. Spencer Acquisition Fund).

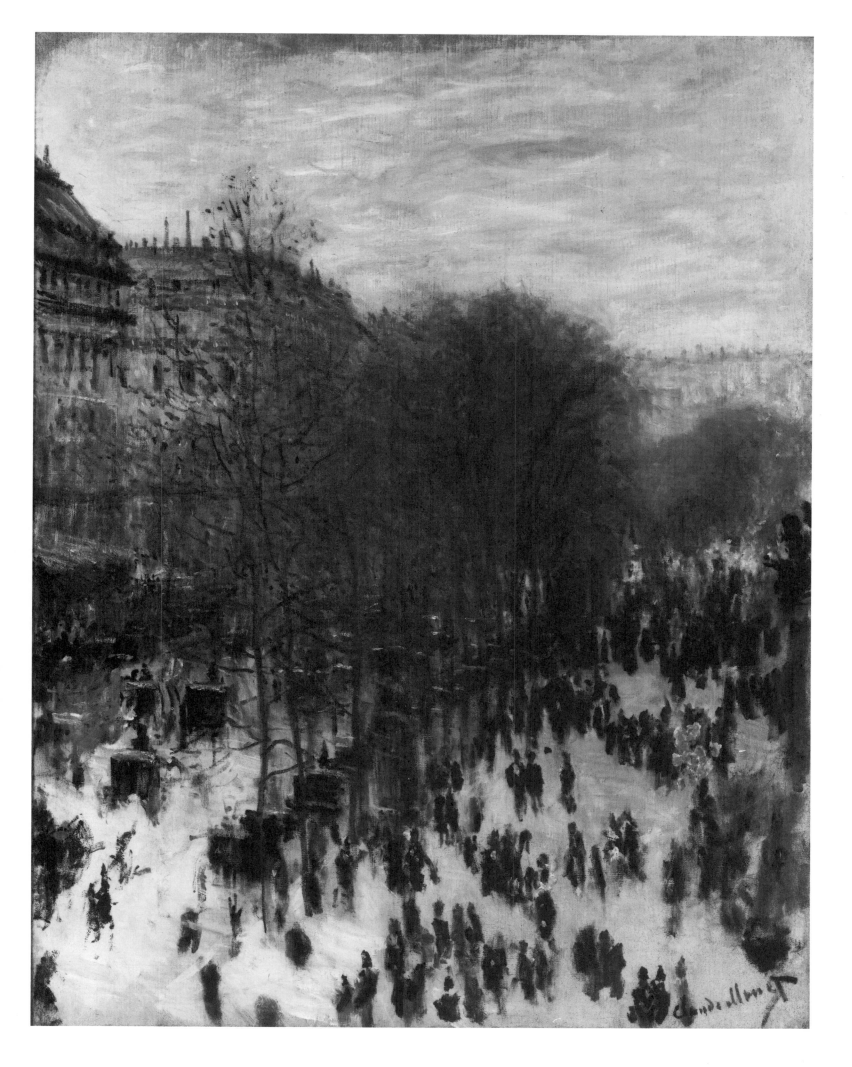

For this is what I would like to call this school – which has somewhat oddly been christened the group of the Intransigents – as that pursuit of reality in the *plein air* is its clearest objective.

The *plein air* school is represented at the boulevard des Capucines by MM. Monet, Pissaro [sic], Sisley, de Gas [sic], Rouart, Renoir and Mlle Morisot.

Their leader, M. Manet, is absent. Did he fear the eccentricities of certain paintings whose authors I have not named? Did he disapprove of the compromise which allowed into so restricted an exhibition pictures conceived and painted in a spirit quite different from that of the school? I do not know. Was he right or wrong to hold back? I offer no answer. But there is no doubt at all that a selection of his paintings would have provided this exhibition with a more decisive, or at the very least more complete, statement of intent.

It is also possible that M. Manet, who has a fighting spirit, prefers to fight on common ground, that of the official Salon. Let us respect each man's ideal freedom to prefer one course of action to another.

It may be helpful to inform the visitor that none of the pictures exhibited here has been submitted to the scrutiny of the official jury. As the exhibition opened on April 15, it is by no means an exhibition of Refusés. But those who have seen it do not need to be told that not one would have been accepted, had they indeed been subjected to that trial. Why? In my eyes, that is their merit, for they break openly with all the traditional conventions.

That said, there are a dozen canvases in this exhibition which open up quite unexpected vistas of the richness of realistic effect that may be obtained with colour.

Never, for example, has the northern daylight in our apartments been rendered with the realistic power contained in the canvas by M. Manet entitled *Luncheon*. Never has the seething life of the street, the teeming of the crowd on the asphalt and of vehicles on the roadway, the waving of the trees on the boulevard in dust and light, the elusiveness, the transience, the immediacy of movement been captured and fixed in all its prodigious fluidity as it is in the extraordinary and marvellous sketch which M. Manet has catalogued under the title *Boulevard des Capucines*. From a distance, this stream of life, this great shimmering of light and shade, spangled with brighter light and stronger shade, must be saluted as a masterpiece. As you approach, everything vanishes; all that remains is an indecipherable chaos of palette scrapings.

Clearly, this is not the ultimate statement of art in general, nor of this art in particular. This sketch must be transformed into a finished work. But what a clarion call for those who have a subtle ear to hear, and how far it carries into the future!

* * *

We are told that a new exhibition by the same group of artists will take place this autumn. At that time, less hard-pressed by the other exhibitions, we shall no doubt be able to study these curious artistic revelations at greater leisure.

But let the Limited Company – since that is what it is; indeed it might even be described as a cooperative – take stock. Its current organization opens the door to all the inept painters, all the laggards of the official exhibitions upon application for a share. This is the kiss of death.

If the company does not alter its status, does not affirm a common principle, it will not survive as an artistic company. That it might survive as a commercial one does not interest me at all.

Although the Impressionists were popularly known as "la bande à Manet", Manet declined the role as their "leader" and consistently refused invitations to participate in the group's exhibitions.

M. Manet (sic), misprint for Monet.

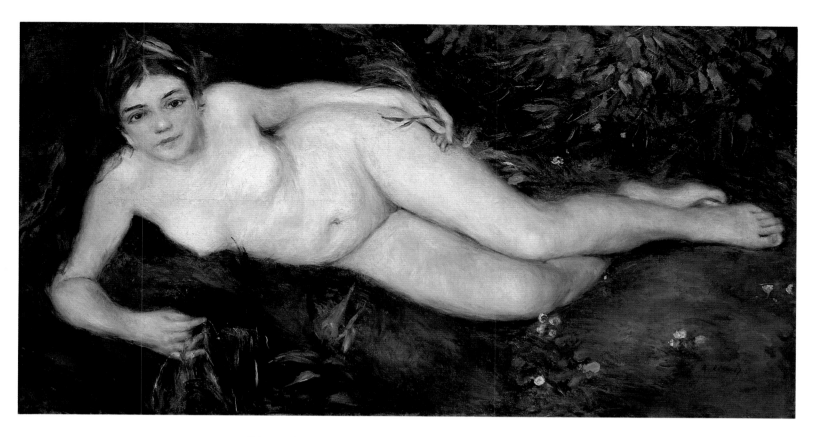

COLOURPLATE 25. Pierre-Auguste Renoir. *Water Nymph*. 1871. 26¾ × 48½″ (67 × 123 cm). National Gallery, London.

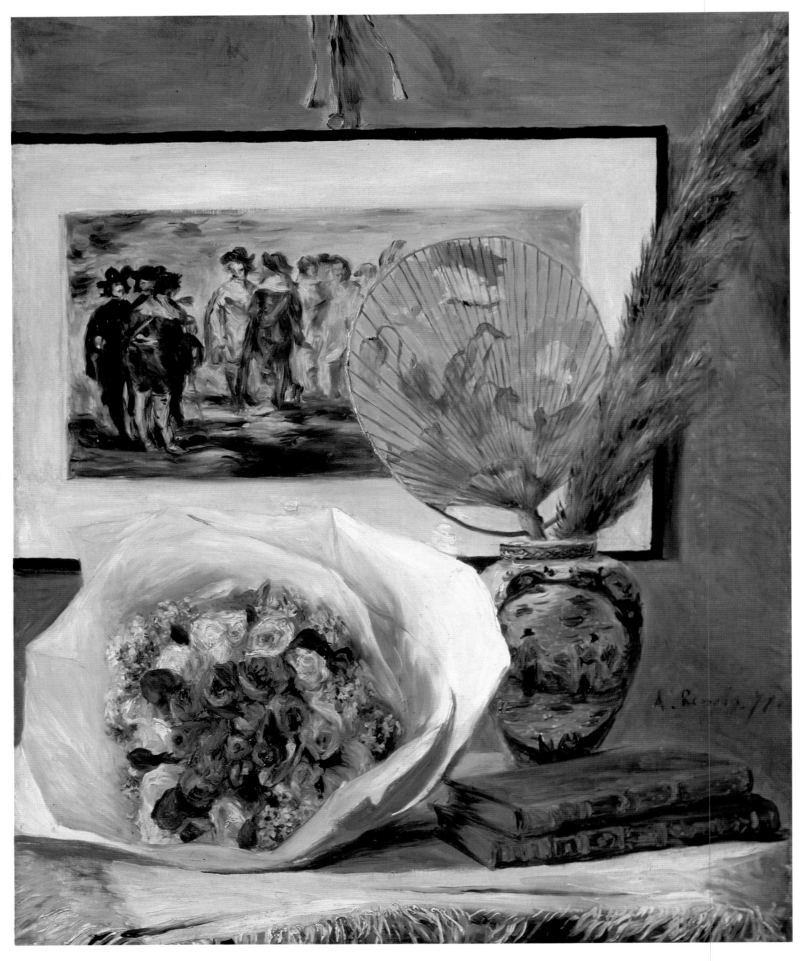

COLOURPLATE 26. Pierre-Auguste Renoir. *Still Life with Bouquet*. 1871. 29½ × 23¼″ (75 × 59 cm).
Museum of Fine Arts, Houston, Texas.

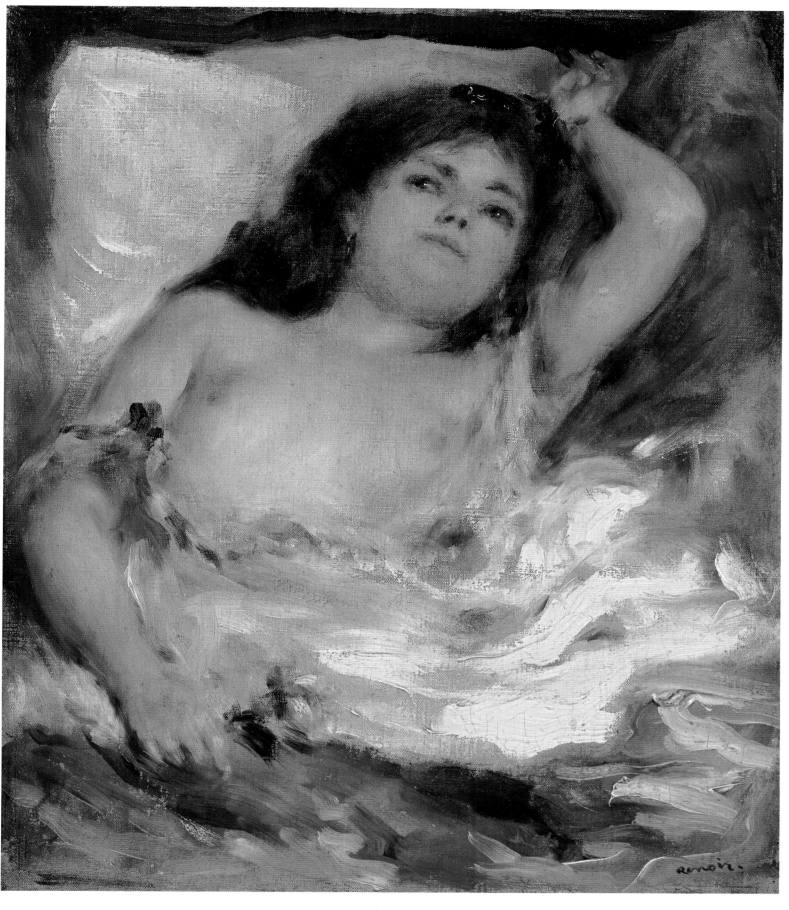

COLOURPLATE 27. Pierre-Auguste Renoir. *The Rose*. 1872. 11⅜ × 9¾″ (29 × 25 cm).
Musée d'Orsay, Paris.

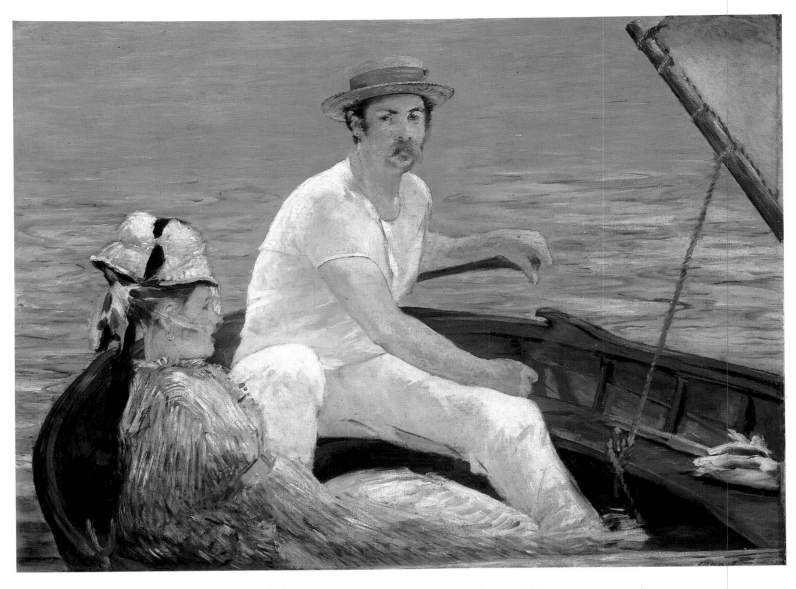

COLOURPLATE 28. Édouard Manet. *Boating*. 1874. 38¼ × 51¼″ (97.2 × 130.2 cm).
Metropolitan Museum of Art, New York (Bequest of Mrs H. O. Havemeyer, 1929;
The H. O. Havemeyer Collection).

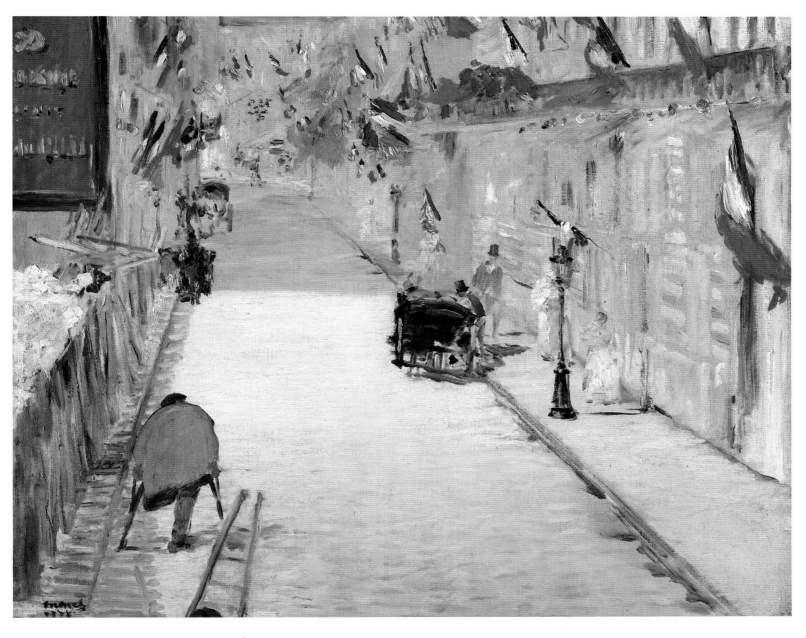

COLOURPLATE 29. Édouard Manet. *Rue Mosnier with Flags*. 1878. 25¾ × 31¾ (65.5 × 81 cm).
J. Paul Getty Museum, Malibu.

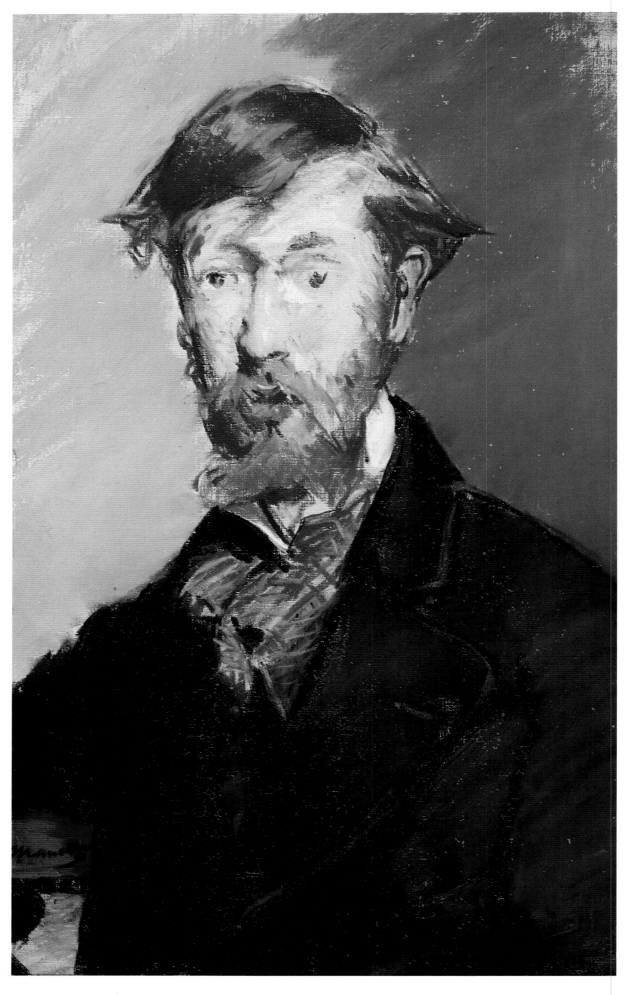

COLOURPLATE 30. Édouard Manet. *Portrait of George Moore*. 1879. Pastel, 21¾ × 13⅞″ (55.2 × 35.5 cm).
Metropolitan Museum of Art, New York (Bequest of Mrs H. O. Havemeyer, 1929;
The H.O. Havemeyer Collection).

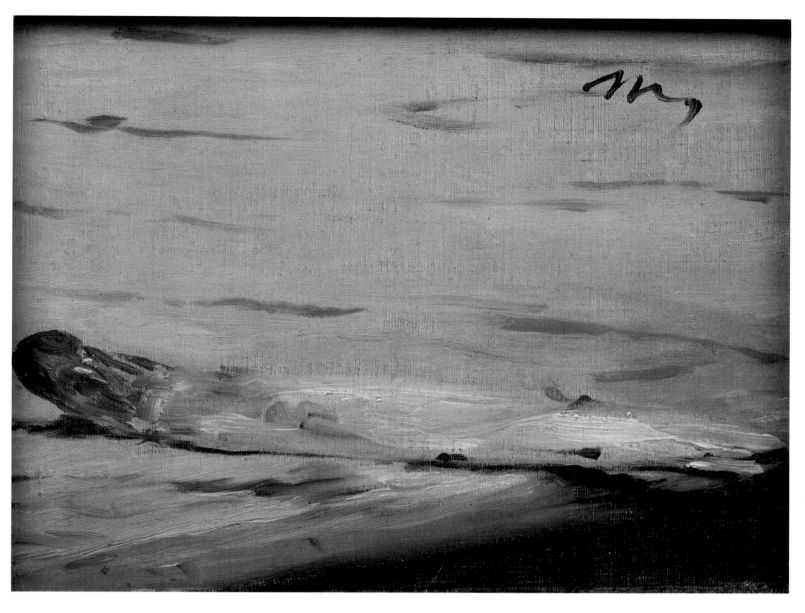

COLOURPLATE 31. Édouard Manet. *Asparagus.* 1880. 6½ × 8¼″ (16.5 × 21 cm).
Musée d'Orsay, Paris.

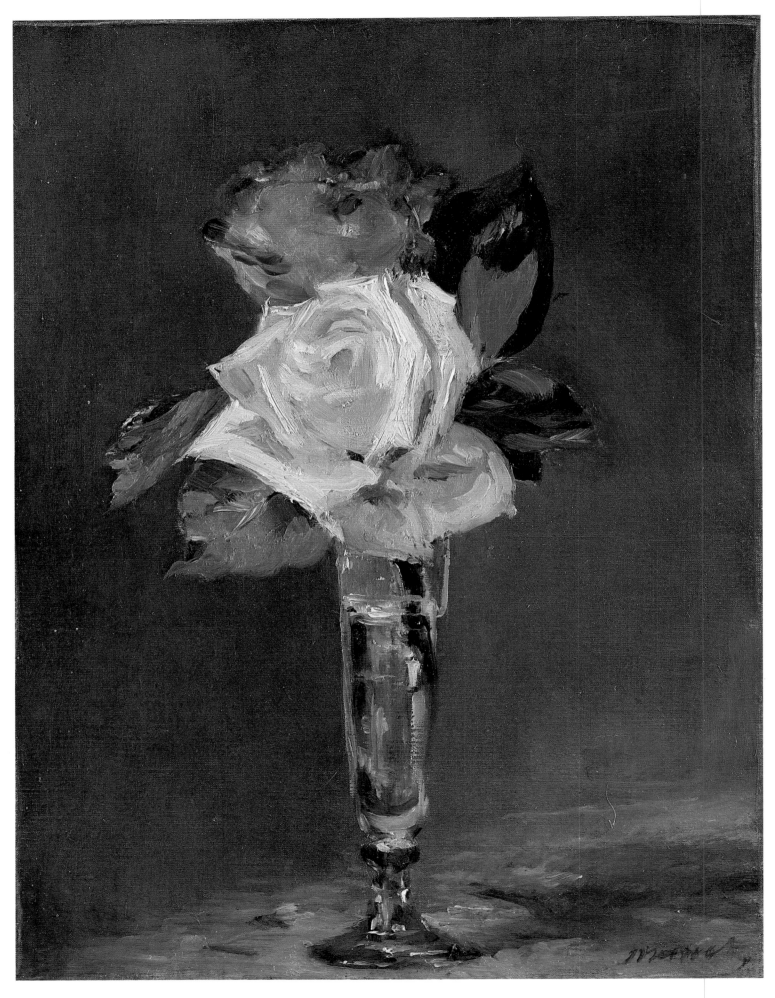

COLOURPLATE 32. Édouard Manet. *Roses in a Champagne Glass*. 1882. 12¾ × 9¾″ (32.4 × 24.8 cm).
Burrell Collection, Glasgow.

ÉMILE BLÉMONT

LE RAPPEL

"Les impressionnistes"

April 9, 1876

What is an impressionist painter? We have scarcely been given a satisfactory definition, but it seems to us that the artists who gather together or are brought together under this heading pursue a similar goal through different methods of execution: to render with absolute sincerity the impression aroused in them by the appearance of reality, without compromise or softening, and using free and simple means.

For them, art is not a minute and punctilious imitation of what used to be called 'la belle nature'. They are not concerned with reproducing beings and things more or less slavishly, nor with laboriously reconstructing an overall view detail by tiny detail. They do not imitate; they translate, they interpret, they concentrate upon extricating the complex messages of the multiple lines and colours which the eye perceives instantly before any outward appearance.

They are synthetists and not analysts, and in that we believe they are right; for if analysis is the scientific method *par excellence*, synthesis is the true method for art. They know no laws other than the necessary relations between things; they think, like Diderot, that the idea of the beautiful is the perceiving of these relations. And as there are not perhaps two men on earth who perceive exactly the same relations in a single object, they do not see the need to modify their personal and direct perception in accordance with this or that convention.

In principle, in theory, we therefore feel that we can give them our full approval.

In practice, it is not quite like that. One does not always do what one wants to do as it should be done; one does not always attain the goal one sees so clearly.

EDMOND DURANTY

THE NEW PAINTING: CONCERNING THE GROUP OF ARTISTS EXHIBITING AT THE DURAND-RUEL GALLERIES

1876

. . . Well! Gentlemen! As artists you have nothing to be proud of in receiving an education that only turns out a race of sheep, for you will be called the Dishley-Merinos of art.

Nevertheless, it would appear that you are disdainful of the endeavours of an art that tries to capture life and the modern spirit, an art that reacts viscerally to the spectacle of reality and of contemporary life. Instead, you cling to the knees of Prometheus and the wings of the Sphinx.

And do you know why you do it? Without suspecting it, what you really want is to ask the Sphinx for the secret of our time and Prometheus for the sacred fire of the present age. No, you are not as disdainful as you appear.

Émile Blémont's favourable review in the left-wing newspaper Le Rappel *found a reply two days later on April 11 in the conservative* Moniteur Universel. *An anonymous critic wrote: "Let us gain from this instance the understanding that the 'Impressionists' have found an obliging judge in* Le Rappel. *The Intransigents in art joining hands with the Intransigents in politics, nothing could be more natural." The term "Intransigent" had recently been imported into the political and cultural vocabulary from Spain where "los intransigentes" designated the anarchist wing of the Spanish Federalist Party of 1872. The terminology of the embattled anarchist left lent itself to both positive and negative criticism, and by the end of the 1870s the name "Intransigents" had become a popular alternative to "Impressionists". See Albert Wolff, writing in* Le Figaro, *April 3, 1876 (no. 23): "These self-proclaimed artists call themselves the Intransigents . . . they barricade themselves behind their own inadequacy." See also Stéphane Mallarmé,* Art Monthly Review, *September 1876 (no. 27), and Marc de Montifaud,* L'Artiste, *May 1, 1877 (no. 29).*

Louis-Émile Edmond Duranty (1833–80), realist-naturalist novelist and critic and editor of the short-lived review Réalisme *(1856–7). He is best known for this essay, which was published as a 38-page pamphlet in 1876 at the time of the Impressionists' second exhibition.*

Ignacio Merino (1818–76) exhibited at the Salon between 1850 and 1875. "Dishley-Merinos" may also be a reference to the particularly hardy breed of sheep from Spain.

Edgar Degas. *Edmond Duranty*. 1879. Charcoal/chalk, 12⅛ × 18⅝″ (30.7 × 47.2 cm). Metropolitan Museum of Art, New York (Rogers Fund, 1918).

You are made uneasy by this artistic movement that already has lasted for a long time, which perseveres despite the obstacles and despite the little sympathy shown it.

But despite all that you know, ultimately you would like to be individuals. You begin to be disgusted by this mummification, this sickening embalming of the spirit. You start to look over the wall into the little garden of these new painters, perhaps just to throw stones into it, or perhaps simply to see what is going on there.

* * *

These, then, are the artists who exhibit in the Durand-Ruel galleries, in association with those who preceded them and those who accompany them. They are isolated no longer. It would be a mistake to consider them as drawing alone upon their own resources.

I am less concerned with the present exhibition than its *cause* and *idea*.

What, then, do this cause and idea bring us? What does the movement contribute? . . . A new method of colour, of drawing, and a gamut of original points of view.

Some of them limit themselves to transforming tradition, striving to translate the modern world without deviating too far from the superannuated and magnificent formulas that served earlier eras. Others cast aside the techniques of the past without another thought.

In the field of colour they made a genuine discovery for which no precedent can be found, not in the Dutch master, not in the clear, pale tones of fresco painting, nor in the soft tonalities of the eighteenth century.

They are not merely preoccupied by the refined and supple play of colour that emerges when they observe the way the most delicate ranges of tone either contrast or intermingle with each other. Rather, the real discovery of these painters lies in their realization that strong light mitigates colour, and that sunlight reflected by objects tends, by its very brightness, to restore that luminous unity that merges all seven prismatic rays into one single colourless beam – light itself.

Proceeding by intuition, they little by little succeeded in splitting sunlight into its rays, and then re-establishing its unity in the general harmony of the iridescent colour that they scatter over their canvases. With regard to visual subtleties and delicate blending of colours, the result is utterly extraordinary. Even the most learned physicist could find nothing to criticize in these painters' analysis of light.

In this connection, some speak of the Japanese, and maintain that these new painters do nothing more than imitate the colour of Japanese prints.

Indeed, I said earlier that they had set off to round Art's Cape of Good Hope. Was it not, then, in order to travel to the Far East? For if the same instincts of the Asian peoples, who live in the perpetual daze of the sun, impels these painters to render the sensation that continually strikes them – specifically, that of clear, matte tones, amazingly live and light, and of its luminous quality distributed almost equally everywhere – then why not investigate such an instinct, placed as it is for observation at the very sources of the sun's brilliance? . . .

Everyone has crossed 75 miles of countryside in the middle of summer, and seen how the hillsides, meadows, and fields disappear, as it were, into a single luminous reflection that they share with the sky. For such is the law that engenders light in nature – in addition to the particular blue, green, or composite ray of light that each substance absorbs, it reflects both the spectrum of all light-rays and the tint of the vault that curves above the earth. Moreover, for the first time painters understand and reproduce these phenomena, or try to. In certain canvases you feel the vibration and palpitation of light and heat. You feel an intoxication of light, which is something of no merit or importance for those painters trained outside of nature and in opposition to it. It is something much too bright and distinct, much too crude and explicit.

Turning to drawing, it is well understood that among these new painters as elsewhere, the inevitable differences between colourists and draughts-men persist. Thus, when I speak of colour, you should only think of those who primarily are colourists. And, when I refer to drawing, you should only envision those who primarily are draughtsmen.

In his *Essay on Painting* on the Salon of 1765, the great Diderot established the *ideal* of modern drawing – that is, drawing from nature, based on observation:

> We say of a man passing in the street that he is a poor specimen. Measured in terms of our wretched little rules, yes. But in terms of nature, it is a different matter. We say of a statue that its proportions are beautiful. Yes, following our wretched little rules, but in terms of nature. . . !

> Were I initiated into the mysteries of art, perhaps I would know how much the artist ought to submit to the accepted rules of proportion, and I would tell you. But what I do know is that these rules cannot compete against the omnipotence of nature, and that the age and condition of the subject predicate compromise in a hundred different ways. I never have heard a figure accused of being poorly drawn as long as it convincingly demonstrated through its external appearance its age, bearing, and the ability to carry out its everyday activities. For this determines both the overall size of the figure and the correct proportions of the limbs, as well as whether they fit together. From these characteristics emerge the child, the grown man, and the old man; the savage or civilized man; the magistrate, the soldier, and the stevedore. If there is a figure difficult to envisage, it would be that of a 25-year-old man, created instantly from the raw clay, who never had done anything. Such a man, however, is only a figment of the imagination.

What we seek at present is neither a calligraphic technique for features or contours, nor decorative elegance in lines, nor an imitation of the Greek figures of the Renaissance. The same Diderot, describing the figure of a hunchback, said, "Cover this figure, and show nothing but the feet to Nature, and Nature will tell you without hesitation: 'These are the feet of a hunchback'."

This extraordinary man is at the threshold of everything that the art of the nineteenth century would like to accomplish.

And what drawing wants in terms of its current goals is just to know nature intensely and to embrace nature with such strength that it can render faultlessly the relations between forms, and reflect the inexhaustible diversity of character. Farewell to the human body treated like a vase, with an eye for the decorative curve. Farewell to the uniform monotony of bone structure, to the anatomical model beneath the nude. What we need are the special characteristics of the modern individual – in his clothing, in social situations, at home, or on the street. The fundamental idea gains sharpness of focus. This is the joining of torch to pencil, the study of states of mind reflected by physiognomy and clothing. It is the study of the relationship of a man to his home, or the particular influence of his profession on him, as reflected in the gestures he makes: the observation of all aspects of the environment in which he evolves and develops.

A back should reveal temperament, age, and social position, a pair of hands should reveal the magistrate or the merchant, and a gesture should reveal an entire range of feelings. Physiognomy will tell us with certainty that one man is dry, orderly, and meticulous, while another is the epitome of carelessness and disorder. Attitude will reveal to us whether a person is going to a business meeting, or is returning from a tryst. "A man opens a door, he enters, and that is enough: we see that he has lost his daughter!" Hands kept in pockets can be eloquent. The artist's pencil will be infused with the essence of life. We will no longer simply see lines measured with a compass, but animated, expressive forms that develop logically from one another. . . .

But drawing is such an individual and indispensable means of expression that one cannot demand from it methods, techniques, or points of view. It fuses with its goal, and remains the inseparable companion of the idea.

Thus, the series of new ideas that led to the development of this artistic vision took shape in the mind of a certain draughtsman [Edgar Degas], one of our own, one of the new painters exhibiting in these galleries, a man of uncommon talent and exceedingly rare spirit. Many artists will not admit that they have profited from his conceptions and artistic generosity. If he still cares to employ his talents unsparingly as a *philanthropist* of art, instead of as a businessman like so many other artists, he ought to receive justice. The source from which so many painters have drawn their inspiration ought to be revealed.

The very first idea was to eliminate the partition separating the artist's studio from everyday life, and to introduce the reality of the street that shocks the writer in the *Revue des Deux Mondes*. It was necessary to make the painter come out of his sky-lighted cell, his cloister, where his sole communication was with the sky – and to bring him back among men, out into the real world.

Now these new painters have demonstrated a fact of which that writer was totally unaware. Our lives take place in rooms and in streets, and rooms and streets have their own special laws of light and visual language. . . .

Suppose, for example, that at a given moment we could take a coloured photograph of an interior. We would have a perfect match, a truthful and real representation, with every element sharing the same feeling. Suppose then that we waited, and when a cloud covered the sun, we immediately took another picture. We would have a result analogous to the first. It is up to observation to compensate for these instantaneous means of execution that we do not possess, and to preserve intact the memory of the images they would have rendered. But what if we were to take some details from the first photograph and combine them with some of the detail from the second, and to create a painting? Then homogeneity, harmony, and the truth of the impression will have disappeared and have been replaced by a false and inexpressive note. Every day, however, that is what painters do who do not look but instead rely on ready-made formulae provided by paintings already done.

In a copy of the pamphlet which he sent to the Italian critic Diego Martelli, Duranty inserted in the margins the names of the artists cited who were anonymous in the original publication.

Eugène Fromentin (1820–76) had defended academicism against "the new painting" in the Revue des Deux Mondes *on February 15, 1876.*

And, as we are solidly embracing nature, we will no longer separate the figure from the background of an apartment or the street. In actuality, a person never appears against neutral or vague backgrounds. Instead, surrounding him and behind him are the furniture, fireplaces, curtains, and walls that indicate his financial position, class, and profession. The individual will be at a piano, examining a sample of cotton in an office, or waiting in the wings for the moment to go onstage, or ironing on a makeshift table. He will be having lunch with his family or sitting in his armchair near his worktable, absorbed in thought. He might be avoiding carriages as he crosses the street or glancing at his watch as he hurries across the square. When at rest, he will not be merely pausing or striking a meaningless pose before the photographer's lens. This moment will be a part of his life as are his actions.

The language of an empty apartment must be clear enough to enable us to deduce the character and habits of its occupant. The passers-by in a street should reveal the time of day and the moment of everyday life that is shown.

In real life views of things and people are manifested in a thousand unexpected ways. . . . From indoors we communicate with the outside world through windows. A window is yet another frame that is continually with us during the time we spend at home, and that time is considerable. Depending on whether we are near or far, seated or standing, the window frames the scene outside in the most unexpected and changeable ways, providing us with constantly changing impromptu views that are the great delights of life.

For example, if in turn one considers a figure, either in a room or on the street, it is not always in a straight line with two parallel objects or at an equal distance from them. It is confined on one side more than on the other by space. In a word, it is never in the centre of the canvas or the centre of the scene. It is not shown whole, but often appears cut off at the knee or mid-torso, or cropped lengthwise. At other times the eye takes it in from up close, at its full height, and relegates to perspectival diminution others in a street crowd, or a group gathered in a public place. It would be an endless task to detail every cut or to describe every scene – the railways, notion shops, construction scaffolds, lines of gaslights, benches on the boulevards and newspaper kiosks, omnibuses and teams of horses, cafés with their billiard-rooms, and restaurants with their tables set and ready.

The new painters have tried to render the walk, movement, and hustle and bustle of passers-by, just as they have tried to render the trembling of leaves, the shimmer of water, and the vibration of sun-drenched air – just as they have managed to capture the hazy atmosphere of a grey day along with the iridescent play of sunshine.

But there are so many things that the art of landscape has not yet dreamed of expressing. Almost all landscape artists lack a feel for the *structure* of the land itself. If the hills are of a certain shape, the trees are sure to be grouped in a certain way, the houses nestled together in a certain fashion among the fields, and the riverbanks given a certain shape. Thus the character of the countryside takes form. No one yet has discovered how to capture the essence of the French countryside. And as we have made so much of bold colour, now that we have had a little fling with intoxicating colour, it is time to call *form* to the banquet.

At the very least, it seems preferable to paint the whole landscape *in situ*, and not from a sketch brought back to the studio, because one gradually loses the first impression. With very few exceptions, one must admit that everything in this new movement is new or wants to be free.

* * *

Rather than acting as a group who share the same goal and who arrive successively at this crossroads where many paths diverge, these artists above all are people of independent temperaments. They come in search of freedom, not dogma.

Originality in this movement coexists with eccentricity and ingenuousness, visionaries exist with strict observers, and ignorant naïfs with scholars who want to rediscover the naivety of the ignorant. There are voluptuous delights in painting for those who know and love it, and there are unfortunate attempts that grate on the nerves. An idea ferments in one's brain while almost unconscious audacity spills from another's brush. All of this is interrelated.

The public is bound to misunderstand several of the leading artists. It only accepts and understands correctness in art, and, above all, it demands finish. The artist, enchanted by delicacy or brilliance of colour, or by the character of a gesture or a grouping, is much less concerned with the finish and the correctness, the *only* qualities valued by those who are not artists. If, among our own, the new painters, there are those for whom freedom is an easy question and who would be pleased if beauty in art were to consist of painting without inconvenience, difficulty, and pain, such pretentiousness will be dealt with appropriately.

But for the most part, what they want is to work without ceremony, cheerfully and without restraint.

Besides, it matters very little whether the public understands. It matters more that the artists understand. For them one can exhibit sketches, preparatory studies, and preliminary work in which the thought, intention, and draughtsmanship of the painter often are expressed with greater speed and concentration. In this work one sees more grace, vigour, strength, and acute observation than in a finished work. It would astonish many, even many students of painting, to learn that things they believe to be mere daubs embody and reveal the highest degree of grace, strength, and acuity of observation, as well as the most delicate and intense feeling.

Laissez faire, laissez passer. Do you not see the impatience in these attempts? Do you not see the irresistible need to escape the conventional, the banal, the traditional, as well as the need to find oneself again and run far from this bureaucracy of the spirit with all its rules that weigh on us in this country? Do you not see the need to free your brow from this leaden skullcap of artistic routine and old refrains, to abandon at last this common pasture where we all graze like sheep?

They have been treated like madmen. They may be madmen, but the little finger of a fool is assuredly worth more than the entire head of a banal man.

* * *

However, when I see these exhibitions, these attempts, I, too, become somewhat disheartened, and say to myself, where are these artists going – who are almost all my friends, whom I watched with pleasure as they set off on an unknown path, who have partially achieved the goals defined in our youth? Will they increase their endowment and preserve it?

Will they become the founders of a great artistic resurgence? Will their successors, relieved of the preliminary difficulties of sowing the seeds, reap a great harvest? Will they have the respect for their precursors that sixteenth-century Italians had for the *quattrocentists*?

Or will they simply be cannon fodder? Will they be no more than the front-line soldiers sacrificed by marching into fire, whose bodies fill the ditch to form the bridge over which those following must pass? The fighters, or rather the swindlers, for in Paris, in all the arts, there are a goodly number of clever people lying in wait with lazy and cunning minds, but busy hands. In the naïve world of inventors – some of whom are wildly successful – they reenact the fable of the chestnuts snatched from the fire and those scenes in natural history that occur between ants and aphids. With great agility they snatch the ideas, research, techniques, and subjects that their neighbour has painstakingly created with the sweat of his brow and considerable nervous energy. They arrive fresh and alert and, with an adroit flick of the wrist, neat and clean, they abscond with all or part of the property of the poor other fellow, making fun of him in the bargain. The comedy is really

rather amusing. And the poor other fellow can only retain the consolation of saying, "So, my friend, you take what's mine!"

In France, especially, the inventor is eclipsed by the one who perfects and patents the invention – virtuosity takes precedence over naïve clumsiness and the popularizer reaps the reward of the innovator.

But then, no one is a prophet in his own country. That is why our painters are far more appreciated in England and Belgium, lands of independent spirit, where no one is offended at the sight of people breaking the rules, and where they neither have nor create academic canons. In these countries, the present efforts of our friends to break the barrier that imprisons art – sometimes scholarly, brilliant, and successful, and sometimes disorderly and desperate – seem straightforward and worthy of praise.

But then why, you still ask, do they refuse to send their works to the Salon? Because theirs is not a painting exam, and because we must abolish official ceremony, the distribution of schoolboy prizes, the university system of art. If we do not begin to extricate ourselves from this system, we will never convince other artists to abandon it either.

And now, I wish fair wind to the fleet – let it carry them to the Hesperides of Art. I urge the pilots to be careful, determined, and patient. The voyage is dangerous, and they should have set out in bigger, more solid vessels. Some of their boats are quite small and narrow, only good for coastal painting.

Let us hope, however, that this painting is fit for a long voyage.

ALBERT WOLFF

LE FIGARO

Exhibition at Durand-Ruel's

April 3, 1876

Rue Le Peletier is jinxed. After the fire at the Opéra, a new misfortune has befallen the district. An exhibition has just opened at Durand-Ruel, supposedly of painting. The unsuspecting passer-by goes in, drawn by the banners decorating the façade, and a grievous spectacle meets his appalled gaze. Five or six lunatics, including one woman, a group of unfortunates stricken by the madness of ambition, have gathered here to exhibit their work.

Some people bray with laughter before these works. I myself am saddened by them. These self-styled artists call themselves the intransigents, the Impressionists; they take canvases, colour and brushes, throw on a few shades at random, and sign: just as, at la Ville-Évrard, deranged souls pick up pebbles from their way and imagine that they have found diamonds. It is a frightful spectacle of human vanity misguided to the point of dementia. Try to make M. Pissarro understand that trees are not purple, that the sky is not the colour of fresh butter, that nowhere in the world does one see such things as he paints and that no person of intelligence can accept such ramblings! You might as well waste your time trying to convince a patient of Dr Blanche who believes himself to be the Pope that he lives in the Batignolles and not the Vatican. Try to make M. Degas see reason: tell him that in art there are certain qualities called draughtsmanship, colour, execution and intent; he will laugh in your face and treat you as a reactionary. Try to explain to M. Renoir that a woman's torso is not just a mass of decomposing flesh with blotches of the kind of purplish green which denotes a state of complete putrefaction in a corpse! There is also a woman in the group, as in all self-respecting groups; she is called Berthe Morisot and her work repays attention. In it, feminine grace persists in the midst of the outbursts of a fevered mind.

Albert Wolff (1835–91), novelist, playwright and critic. Writing for Le Figaro *he was one of the most savage of the opponents of Impressionism.*

Cham. *Le Charivari*, April 22, 1877. "The Impressionist Painter: 'Madame, for your portrait some tones are lacking in the face. Couldn't you spend a few days at the bottom of a river?'" British Library.

This unleavened heap is being exhibited to the public without any thought of the fatal consequences it might bring in its wake. Yesterday some poor fellow was arrested in the rue Le Peletier: on leaving the exhibition, he had begun biting the passers-by.

Seriously, one should pity this deranged group; kindly mother nature had endowed some of them with qualities which might have made artists of them. But in the mutual admiration of their common aberration, the members of this vain, mediocre and clamorous coterie have raised the negation of all that constitutes art into a positive principle; they have tied a paint rag to a broom handle and made of it a banner. Knowing full well that the complete lack of any artistic education forever prevents them from crossing the deep divide which separates an attempt from a work of art, they barricade themselves behind their own inadequacy, which is the equal of their complacency, and every year they return to the Salon with their iniquitous oils and watercolours to protest against that magnificent French school which was so rich in great artists. These poor moonstruck folk put me in mind of some skilful poet, some confectioner of jingles who – quite unburdened by the mysteries of spelling, style or sustained thought – might come up to you and say: "Lamartine has had his day. Now make way for the intransigent poet!"

I know some of these wayward Impressionists; they are charming young people, deeply sincere, who seriously imagine that they have found their way. The spectacle is as distressing as the sight of that poor madman I looked upon at Bicêtre: holding a shovel tucked under his chin like a violin, and using a stick which he took to be a bow, he would, so he said, execute the *Carnival in Venice*, which he boasted of having performed to acclaim before all the crowned heads of Europe. If one could put this virtuoso to play at the entrance to the exhibition, the artistic slapstick on the rue Le Peletier would be complete.

JEAN RENOIR

RENOIR MY FATHER

Monet paints the Gare St-Lazare

1958

Fortunately, there was Monet. He rose to the occasion immediately, in an amazing manner. He refused to give in to the first setback or to any that were to follow. He mapped out a plan so utterly fantastic that my father laughed whenever he thought about it, even forty years later. Monet's landscape, *Impression*, had been jeered at because "no one could see anything in it." Monet shrugged his shoulders haughtily. "Poor blind idiots. They want to see everything clearly, even through the fog!" One critic had informed him that fog was not a fit subject for a picture: "Why not a scene of Negroes fighting in a tunnel?" he suggested. The general lack of understanding gave Monet an irresistible desire to do a painting that would be still more foggy.

One fine day he said to Renoir triumphantly:

"I've got it! The Gare Saint-Lazare! I'll show it just as the trains are starting, with smoke from the engines so thick you can hardly see a thing. It's a fascinating sight, a regular dream world."

He did not, of course, intend to paint it from memory. He would paint it *in situ* so as to capture the play of sunlight on the steam rising from the locomotives.

"I'll get them to delay the train for Rouen half an hour. The light will be better then."

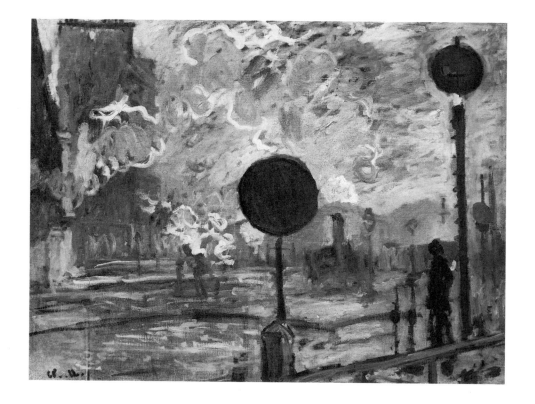

Claude Monet. *The Signal, Gare St-Lazare.*
1876. 25½ × 32″ (65 × 81.5 cm). Private
Collection, Paris.

"You're mad," said Renoir. . . .

Monet, however, seemed to rise above all contingencies. He put on his best clothes, ruffled the lace at his wrists, and twirling his gold-headed cane went off to the offices of the Western Railway, where he sent in his card to the director. The usher, overawed, immediately showed him in. The director asked Monet to be seated. His visitor introduced himself modestly as "the painter, Claude Monet." The head of the company knew nothing about painting, but did not quite dare to admit it. Monet allowed his host to flounder about for a moment, then deigned to announce the purpose of his visit. "I have decided to paint your station. For some time I've been hesitating between your station and the Gare du Nord, but I think that yours has more character." He was given permission to do what he wanted. The trains were all halted; the platforms were cleared; the engines were crammed with coal so as to give out all the smoke Monet desired. Monet established himself in the station as a tyrant and painted amid respectful awe. He finally departed with a half-dozen or so pictures, while the entire personnel, the director of the company at their head, bowed him out.

BERTHE MORISOT

Letters to her Sister Edma

1875

It is not too expensive here, and it is the prettiest place for painting – if one had any talent. I have already made a start, but it is difficult. People come and go on the jetty, and it is impossible to catch them. It is the same with the boats. There is extraordinary life and movement, but how is one to render it? I began something in the sitting room, of Eugène. The poor man has taken your place. But he is a less obliging model; at once it becomes too much for him . . .

Nothing is nicer than the children in the streets, bare-armed, in their English clothes. I should like to get some of them to pose for me, but all this

The year after her marriage to Eugène Manet, Édouard Manet's brother, Berthe Morisot and her husband travelled to London and to the Isle of Wight. Her letters are available only in the compilation made by her grandson, Denis Rouart.

is very difficult. My English is so horribly bad, and Eugène's is even worse . . .

The little river here is full of boats, a little like the river at Dartmouth in the photographs Tiburce sent us. I am sure you would like all this very much, and that it would even give you a desire to start working again. The beach is like an English park plus the sea; I shall have to make a watercolour of it, for I shall never have the courage to set up my easel to do it in oil.

At Ryde, everything takes place on the pier, which is interminably long. It is the place of promenading, for bathing, and where the boats dock.

I found a superb Reynolds there, for a little less than two francs. My black hat with the lace bow made the sailors in the port burst out laughing.

You should really write me a little. Cowes is very pretty, but not gay; besides, we constantly miss our home life. Eugène is even more uncommunicative than I.

I have worked a little, but what rain we have had for a week! Today we have been to Ryde. I set out with my sack and portfolio, determined to make a watercolour on the spot, but when we got there I found the wind was frightful, my hat blew off, my hair got in my eyes. Eugène was in a bad humour as he always is when my hair is in disorder – and three hours after leaving we were back again at Globe Cottage. I nevertheless took the time to take a little walk through the big town of Ryde, which I decidedly find even drearier than Cowes. There are more people in the streets but fewer boats on the water; and the pretty little river adds a lot of charm to the place. Anyway I am happy with our choice, which is a rare thing.

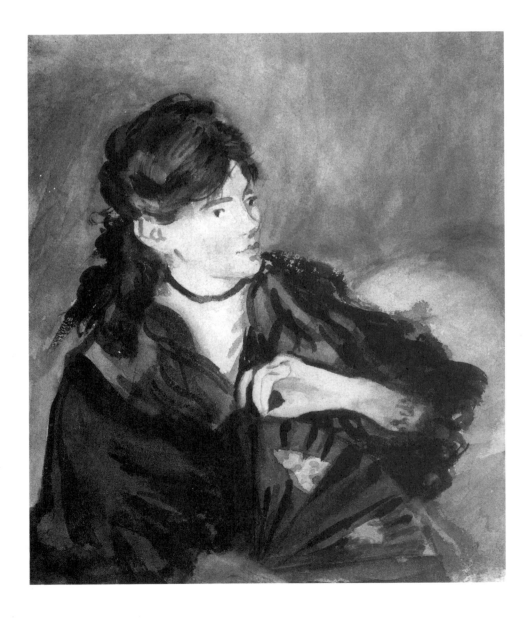

Édouard Manet. *Berthe Morisot with a Fan.* 1874. Watercolour, 8 × 6½″ (20.5 × 16.5 cm). Courtesy Art Institute of Chicago (Joseph and Helen Regenstein Foundation, 1963).

At Ryde there are many shops, and even a picture dealer. I went in. He showed me watercolours by a painter who, I am told, is well known; they sell for no less than four hundred francs a piece – and they are frightful. No feeling for nature – these people who live on the water do not even see it. That has made me give up whatever illusions I had about the possibility of success in England. In the whole shop, the only thing that was possible and even pretty was by a Frenchman; but the dealer says that sort of thing does not sell.

* * *

I regret very much, my dear Edma, that your wish should be a wish impossible of realization, and that you cannot come to join me here. It is actually no more difficult to get here than to go anywhere in France, but one makes a great to-do of this crossing. Cowes has become extremely animated; a few days ago the whole of the smart set landed from a yacht. The garden of the Yacht Club is full of ladies of fashion. At high tide there is an extraordinary bustle. But all that is not for us – we are only humble folk, too insignificant to mingle with this fashionable society. Moreover, I do not know how one would go about it, unless one had a fortune of several millions and a yacht, and were a member of the club. I am completely indifferent to all this; I do not care for new acquaintances, and this society, from the little I have seen of it, seems to be as dull as it is wealthy. At the Goodwood races I was struck by the elegance and the bored air of the women. On the other hand, the populace seemed very gay – there was an animation that contradicts the notions we have about the people of the north.

I am horribly depressed tonight, tired, on edge, out of sorts, having once more the proof that the joys of motherhood are not meant for me. That is a misfortune to which you would never resign yourself, and despite all my philosophy, there are days when I am inclined to complain bitterly over the injustice of fate.

My work is going badly, and this is no consolation. It is always the same story: I don't know where to start. I made an attempt in a field, but the moment I had set up my easel more than fifty boys and girls were swarming about me, shouting and gesticulating. All this ended in a pitched battle, and the owner of the field came to tell me rudely that I should have asked for permission to work there, and that my presence attracted the village children who caused a great deal of damage.

On a boat one has another kind of difficulty. Everything sways, there is an infernal lapping of water; one has the sun and the wind to cope with, the boats change position every minute, etc. . . . The view from my window is pretty to look at, but not to paint. Views from above are almost always incomprehensible; as a result of all this I am not doing much, and the little I am doing seems dreadful to me . . . I miss the babies as models; one could make lovely pictures with them on the balcony. If Bébé Blanc were willing to come to see me with her Lize, I should gladly paint them.

I am sending you an article on Goodwood to give you an idea of its splendours. I was enchanted by my day there, but it was rather costly – though I shall tell the *mamans* the opposite – and horribly fatiguing. Never in my life have I seen anything as picturesque as these outdoor luncheons. Gustave Doré was there with a group of women of fashion. Why doesn't he know how to profit from all this?

Au revoir, a thousand *tendresses* for the darlings and for you; do not forget to remember us to your husband when you write to him. I always forget to tell you that Eugène has a great feeling for you; the brothers-in-law would gladly change places.

STÉPHANE MALLARMÉ

ART MONTHLY REVIEW
"The Impressionists and Édouard Manet"
September 1876

Without any preamble whatsoever, without even a word of explanation to the reader who may be ignorant of the meaning of the title which heads this article, I shall enter at once into its subject, reserving to myself either to draw my deductions, new from an art point of view, as the facts I relate present themselves or leave them to ooze out when and as they may.

Briefly, then, let us take a short glimpse backward on art history. Rarely do our annual exhibitions abound with novelty, and some few years back such years of abundance were still more rare; but about 1860 a sudden and a lasting light shone forth when Courbet began to exhibit his works. These then in some degree coincided with that movement which had appeared in literature, and which obtained the name of Realism; that is to say, it sought to impress itself upon the mind by the lively depiction of things as they appeared to be, and vigorously excluded all meddlesome imagination. It was a great movement, equal in intensity to that of the Romantic school, just then expiring under the hands of the landscape painters, or to that later one whence issued the bold decorative effects of Henri Regnault, and it then moved on many a new and contemporaneous path. But in the midst of this, there began to appear, sometimes perchance on the walls of the Salon, but far more frequently and certainly on those of the galleries of the rejected, curious and singular paintings – laughable to the many, it is true, from their very faults, but nevertheless very disquieting to the true and reflective critic, who could not refrain from asking himself what manner of man is this? and what the strange doctrine he preaches? For it was evident that the preacher had a meaning; he was persistent in his reiteration, unique in his persistency, and his works were signed by the then new and unknown name of EDOUARD MANET. There was also at that time, alas! that it should have to be written in the past tense, an enlightened amateur, one who loved all arts and lived for one of them. These strange pictures at once won his sympathy; an instinctive and poetic foresight made him love them; and this before their prompt succession and the sufficient exposition of the principles they inculcated had revealed their meaning to the thoughtful few of the public many. But this enlightened amateur died too soon to see these, and before his favourite painter had won a public name.

That amateur was our last poet, Charles Baudelaire.

Following in appreciative turn came the then coming novelist Emile Zola. With that insight into the future which distinguishes his own works, he recognized the light that had arisen, albeit that he was yet too young to then define that which we today call Naturalism, to follow the quest, not merely of that reality which impresses itself in its abstract form on all, but of that absolute and important sentiment which Nature herself impresses on those who have voluntarily abandoned conventionalism.

In 1867 a special exhibition of the works of Manet and some few of his followers, gave to the then nameless school of recent painting which thus grew up, the semblance of a party, and party strife grew high. The struggle with this resolute intruder was preached as a crusade from the rostrum of each school. For several years a firm and implacable front was formed against its advance; until at length vanquished by its good faith and persistency, the jury recognized the name of Manet, welcomed it, and so far recovered from its ridiculous fears, that it reasoned and found it must either declare him a self-created sovereign pontiff, charged by his own faith with the cure of souls, or condemn him as a heretic and a public danger.

The original French manuscript of Mallarmé's essay is now lost, but he approved the translation and may have made his own contributions to the text in English. In 1863 he visited London to learn the language so that he could read the works of Edgar Allan Poe. He subsequently supported himself as a teacher of English in French schools. His translation of Poe's The Raven *(1875) and his own* L'après-midi d'un faune *(1876) were illustrated by Manet.*

Henri Regnault (1843–71), academic painter influenced by Delacroix. Gustave Moreau (1826–98), painter of biblical and mythological subjects who belonged to the Symbolist movement.

Photograph of Mallarmé, Méry Laurent and Manet. 1872. Bibliothèque Nationale (Cabinet des Estampes), Paris.

The latter of these alternatives being nowadays definitively adopted, the public exhibition of Manet's works has of late taken place in his own studio. Yet, and notwithstanding all this, and in spite of concurrent Salons, the public rushed with lively curiosity and eagerness to the Boulevard des Italiens and the galleries of Durand-Ruel in 1874 and 1876, to see the works of those then styled the Intransigeants, now the Impressionists. And what found they there? A collection of pictures of strange aspect, at first view giving the ordinary impression of the motive which made them, but over beyond this, a peculiar quality outside mere Realism. And here occurs one of those unexpected crises which appear in art. Let us study it in its present condition and its future prospects, and with some attempt to develop its idea.

Manet, when he casts away the cares of art and chats with a friend between the lights in his studio, expresses himself with brilliancy. Then it is that he tells them what he means by Painting; what new destinies are yet in store for it; what it is, and how that it is from an irrepressible instinct that he paints, and that he paints as he does. Each time he begins a picture, says he, he plunges headlong into it, and feels like a man who knows that his surest plan to learn to swim safely is, dangerous as it may seem, to throw himself into the water. One of his habitual aphorisms then is that no one should paint a landscape and a figure by the same process, with the same knowledge, or in the same fashion; nor what is more, even two landscapes or two figures. Each work should be a new creation of the mind. The hand, it is true, will conserve some of its acquired secrets of manipulation, but the eye should forget all else it has seen, and learn anew from the lesson before it. It should abstract itself from memory, seeing only that which it looks upon, and that as for the first time; and the hand should become an impersonal abstraction guided only by the will, oblivious of all previous cunning. As for the artist himself, his personal feeling, his peculiar tastes, are for the time absorbed, ignored, or set aside for the enjoyment of his personal life. Such a result as this cannot be attained all at once. To reach it the master must pass through many phases ere this self-isolation can be acquired, and this new evolution of art be learnt; and I, who have occupied myself a good deal in its study, can count but two who have gained it.

Wearied by the technicalities of the school in which under Couture, he studied, Manet, when he recognized the inanity of all he was taught, determined either not to paint at all or to paint entirely from without himself. Yet, in his self-sought insulation, two masters – masters of the past – appeared to him, and befriended him in his revolt. Velasquez, and the painters of the Flemish school, particularly impressed themselves upon him, and the wonderful atmosphere which enshrouds the compositions of the grand old Spaniard, and the brilliant tones which glow from the canvases of his northern compeers, won the student's admiration, thus presenting to him two art aspects which he has since made himself the master of, and can mingle as he pleases. It is precisely these two aspects which reveal the truth, and give paintings based upon them living reality instead of rendering them the baseless fabric of abstracted and obscure dreams. These have been the tentatives of Manet, and curiously, it was to the foreigner and the past that he turned for friendly counsel in remedying the evils of his country and his time. And yet truth bids me say that Manet had no pressing need for this; an incomparable copyist, he could have found his game close to hand had he chosen his quarry there; but he sought something more than this, and fresh things are not found all at once; freshness, indeed, frequently consists – and this is especially the case in these critical days – in a co-ordination of widely scattered elements.

The pictures in which this reversion to the traditions of the old masters of the north and south are found constitute Manet's first manner. Now the old writers on art expressed by the word "manner," rather the lavish blossoming of genius during one of its intellectual seasons than the fact fathered, found, or sought out by the painter himself. But that in which the painter declares most his views is the choice of his subjects. Literature often departs

from its current path to seek for the aspirations of an epoch of the past, and to modernize them for its own purpose, and in painting Manet followed a similarly divergent course, seeking the truth, and loving it when found, because being true it was so strange, especially when compared with old and worn-out ideals of it. Welcomed on his outset, as we have said, by Baudelaire, Manet fell under the influence of the moment, and, to illustrate him at this period, let us take one of his first works, *Olympia*; that wan, wasted courtesan, showing to the public, for the first time, the non-traditional, unconventional nude. The bouquet, yet enclosed in its paper envelope, the gloomy cat (apparently suggested by one of the prose poems of the author of the *Fleurs du Mal*) and all the surrounding accessories, were truthful, but not immoral – that is, in the ordinary and foolish sense of the word – but they were undoubtedly intellectually perverse in their tendency. Rarely has any modern work been more applauded by some few, or more deeply damned by the many, than was that of this innovator.

If our humble opinion can have any influence in this impartial history of the work of the chief of the new school of painting, I would say that the transition period in it is by no means to be regretted. Its parallel is found in literature, when our sympathies are suddenly awakened by some new imagery presented to us; and this is what I like in Manet's work. It surprised us all as something long hidden but suddenly revealed. Captivating and repulsive at the same time, eccentric and new, such types as he gave us were needed in our ambient life. In them, strange though they were, there was nothing vague, general, conventional or hackneyed. Often they attracted attention by something peculiar in the physiognomy of his subject, half hiding or sacrificing to those new laws of space and light he set himself to inculcate, some minor details which others would have seized upon.

Bye and bye, if he continues to paint long enough, and to educate the public eye – as yet veiled by conventionality – if that public will then consent to see the true beauties of the people, healthy and solid as they are, the graces which exist in the bourgeoisie will then be recognized and taken as worthy models in art, and then will come the time of peace. As yet it is but one of struggle – a struggle to render those truths in nature which for her are eternal, but which are as yet for the multitude but new.

The reproach which superficial people formulate against Manet, that whereas once he painted ugliness now he paints vulgarity, falls harmlessly to the ground, when we recognize the fact that he paints the truth, and recollect those difficulties he encountered on his way to seek it, and how he conquered them. *Luncheon on the Grass, The Execution of the Emperor Maximilian, A Table Corner, People at the Window, A Good Glass of Beer, A Corner of the Masked Ball, The Railway* and the two *Boaters* – these are the pictures which step by step have marked each round in the ladder scaled by this bold innovator, and which have led him to the point achieved in his truly marvellous work, this year refused by the Salon, but exhibited to the public by itself, entitled *Doing the Washing* – a work which marks a date in a lifetime perhaps, but certainly one in the history of art.

The whole of the series we have just above enumerated with here and there an exception, demonstrate the painter's aim very exactly; and this aim was not to make a momentary escapade or sensation, but by steadily endeavouring to impress upon his work a natural and general law, to seek out a type rather than a personality, and to flood it with light and air; and such air! air which despotically dominates over all else. And before attempting to analyse this celebrated picture I should like to comment somewhat on that truism of tomorrow, that paradox of today, which in studio slang is called "the theory of open air" or at least on that which it becomes with the authoritative evidence of the later efforts of Manet. But here is first of all an objection to overcome. Why is it needful to represent the open air of gardens, shore or street, when it must be owned that the chief part of modern existence is passed within doors? There are many answers; among these I hold the first, that in the atmosphere of any interior, bare or furnished, the

Luncheon on the Grass *(1863)*, Musée d'Orsay; The Execution of the Emperor Maximilian *(1868)*, Kunsthalle, Mannheim; A Good Glass of Beer *(1873)*, Philadelphia Museum of Art; Masked Ball at the Opéra *(1873–4)*, National Gallery of Art, Washington DC; The Railway (The Gare St-Lazare) *(1872–3)*, National Gallery of Art, Washington DC; Argenteuil *(1874)*, Musée des Beaux-Arts, Tournai; Boating *(1874)*, Metropolitan Museum of Art, New York.

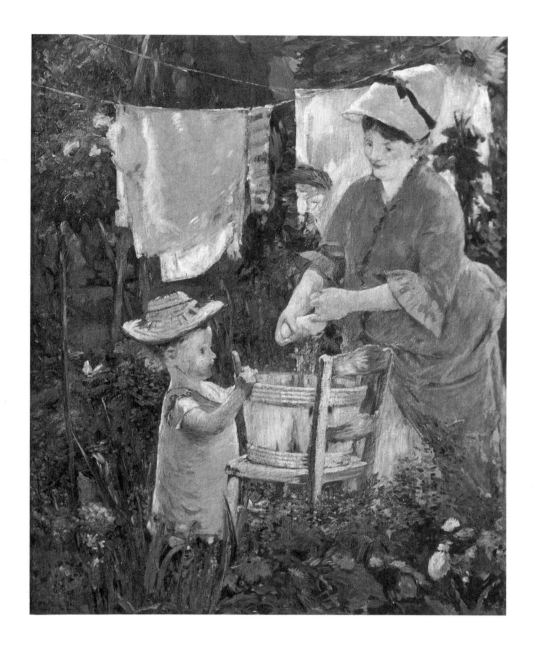

Édouard Manet. *Doing the Washing*. 1874.
57 × 45¼″ (145 × 115 cm). Barnes
Foundation, Merion Station,
Pennsylvania.

reflected lights are mixed and broken and too often discolour the flesh tints.
For instance I would remind you of a painting in the Salon of 1873 which our
painter justly called a *Rêverie*. There a young woman reclines on a divan
exhaling all the lassitude of summer time; the jalousies of her room are
almost closed, the dreamer's face is dim with shadow, but a vague,
deadened daylight suffuses her figure and her muslin dress. This work is
altogether exceptional and sympathetic.

Woman is by our civilization consecrated to night, unless she escapes
from it sometimes to those open-air afternoons by the seaside or in an
arbour, affectionated by moderns. Yet I think the artist would be in the
wrong to present her among the artificial glories of candle-light or gas, as at
that time the only object of art would be the woman herself, set off by the
immediate atmosphere, theatrical and active, even beautiful, but utterly
inartistic. Those persons much accustomed, whether from the habit of their
calling or purely from taste, to fix on a mental canvas the beautiful
remembrance of woman, even when thus seen amid the glare of night in the
world or at the theatre, must have remarked that some mysterious process
despoils the noble phantom of the artificial prestige cast by candelabra or
footlights, before she is admitted fresh and simple to the number of every day
haunters of the imagination. (Yet I must own that but few of those whom I
have consulted on this obscure and delicate point are of my opinion.) The
complexion, the special beauty which springs from the very source of life,

changes with artificial lights, and it is probably from the desire to preserve this grace in all its integrity, that painting – which concerns itself more about this flesh-pollen than any other human attraction – insists on the mental operation to which I have lately alluded, and demands daylight – that is space with the transparence of air alone. The natural light of day penetrating into and influencing all things, although itself invisible, reigns also on this typical picture called *Washing*, which we will study next, it being a complete and final repertory of all current ideas and the means of their execution.

Some fresh but even-coloured foliage – that of a town garden – holds imprisoned a flood of summer morning air. Here a young woman, dressed in blue, washes some linen, several pieces of which are already drying; a child coming out from the flowers looks at its mother – that is all the subject. This picture is life-size, though this scale is somewhat lower in the middle distance, the painter wisely recognizing the artificial requirements forced upon him by the arbitrarily fixed point of view imposed on the spectator. It is deluged with air. Everywhere the luminous and transparent atmosphere struggles with the figures, the dresses and the foliage, and seems to take to itself some of their substance and solidity; whilst their contours, consumed by the hidden sun and wasted by space, tremble, melt and evaporate into the surrounding atmosphere, which plunders reality from the figures, yet seems to do so in order to preserve their truthful aspect. Air reigns supreme and real, as if it held an enchanted life conferred by the witchery of art; a life neither personal nor sentient, but itself subjected to the phenomena thus called up by the science and shown to our astonished eyes, with its perpetual metamorphosis and its invisible action rendered invisible. And how? By this fusion or by this struggle ever continued between surface and space, between colour and air. Open air: – that is the beginning and end of the question we are now studying. Aesthetically it is answered by the simple fact that there in open air alone can the flesh tints of a model keep their true qualities, being nearly equally lighted on all sides. On the other hand if one paints the real or artificial half-light in use in the schools, it is this feature or that feature on which the light strikes and forces into undue relief, according an easy means for a painter to dispose a face to suit his own fancy and return to bygone styles.

The search after truth, peculiar to modern artists, which enables them to see nature and reproduce her, such as she appears to just and pure eyes, must lead them to adopt air almost exclusively as their medium, or at all events to habituate themselves to work in it freely and without restraint: there should at least be in the revival of such a medium, if nothing more, an incentive to a new manner of painting. This is the result of our reasoning, and the end I wish to establish. As no artist has on his palette a transparent and neutral colour answering to open air, the desired effect can only be obtained by lightness or heaviness of touch, or by the regulation of tone. Now Manet and his school use simple colour, fresh, or lightly laid on, and their results appear to have been attained at the first stroke, that the ever-present light blends with and vivifies all things. As to the details of the picture, nothing should be absolutely fixed in order that we may feel that the bright gleam which lights the picture, or the diaphanous shadow which veils it, are only seen in passing, and just when the spectator beholds the represented subject, which being composed of a harmony of reflected and ever-changing lights, cannot be supposed always to look the same, but palpitates with movement, light and life.

But will not this atmosphere – which an artifice of the painter extends over the whole of the object painted – vanish, when the completely finished work is as a repainted picture? If we could find no other way to indicate the presence of air than the partial or repeated application of colour as usually employed, doubtless the representation would be as fleeting as the effect represented, but from the first conception of the work, the space intended to contain the atmosphere has been indicated, so that when this is filled by the represented air, it is as unchangeable as the other parts of the picture. Then

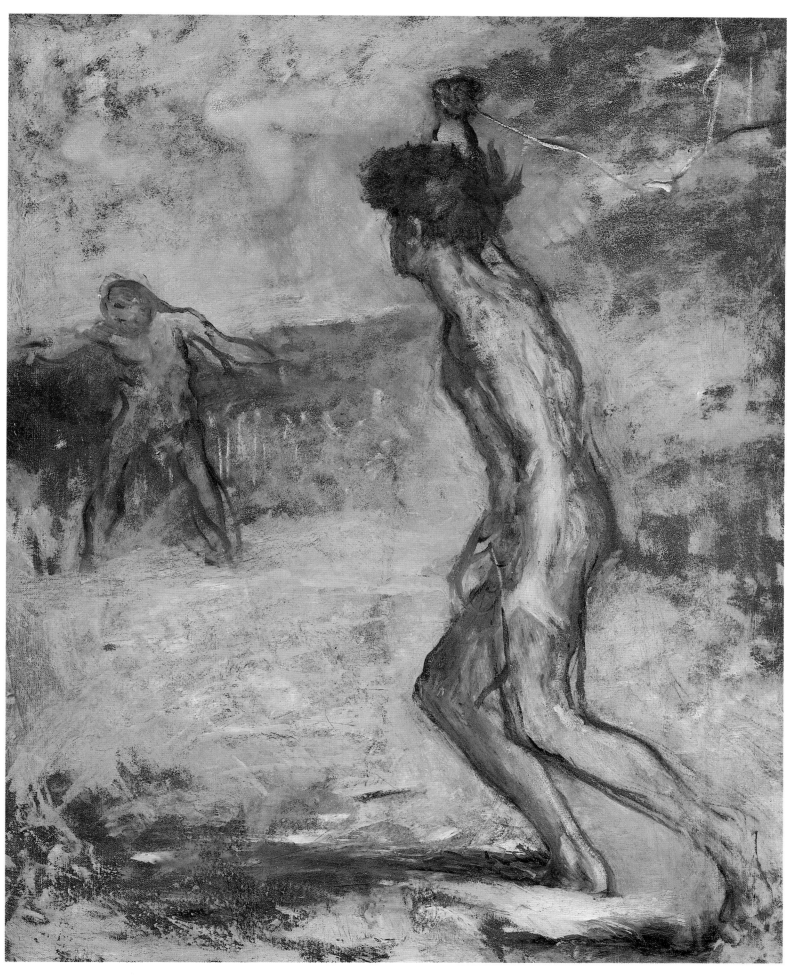

COLOURPLATE 33. Edgar Degas. *David and Goliath*. 1864. 33½ × 25½″ (85 × 65 cm).
Trustees of the Fitzwilliam Museum, Cambridge.

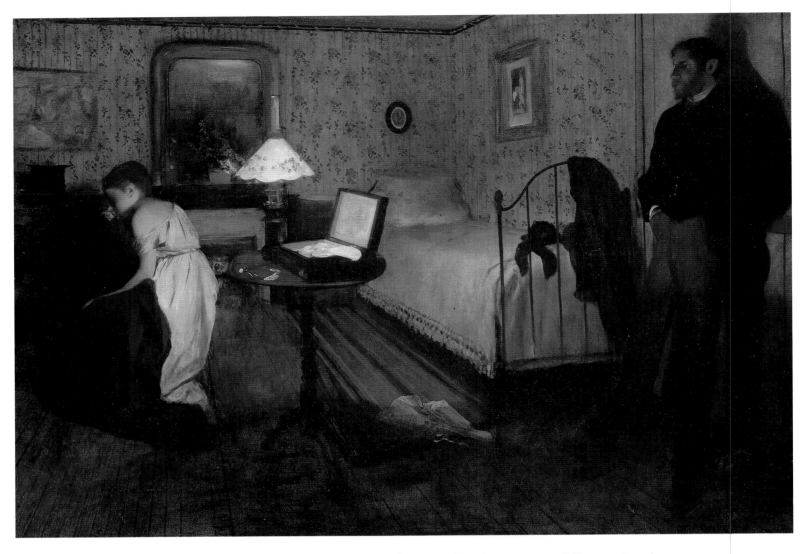

COLOURPLATE 34. Edgar Degas. *Interior (The Rape)*. 1868–9. 32 × 45″ (81 × 116 cm).
Philadelphia Museum of Art (Henry P. McIlhenny Collection in memory of Frances P. McIlhenny).

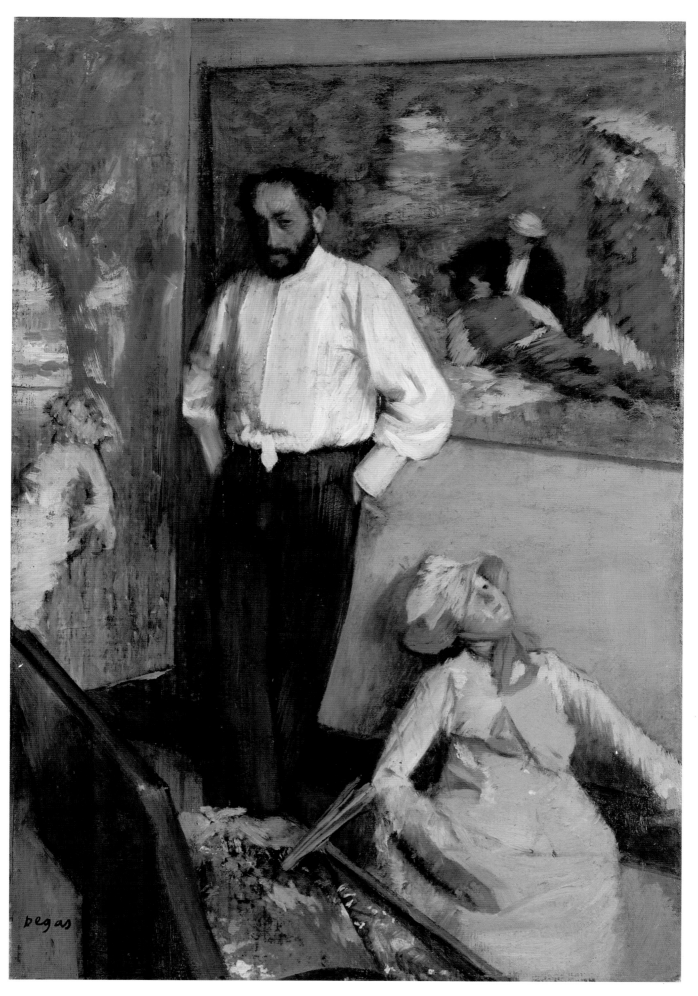

COLOURPLATE 35. Edgar Degas. *Portrait of Michel-Lévy.* 1873. 16⅛ × 10⅝″ (41 × 27 cm).
Gulbenkian Foundation, Lisbon.

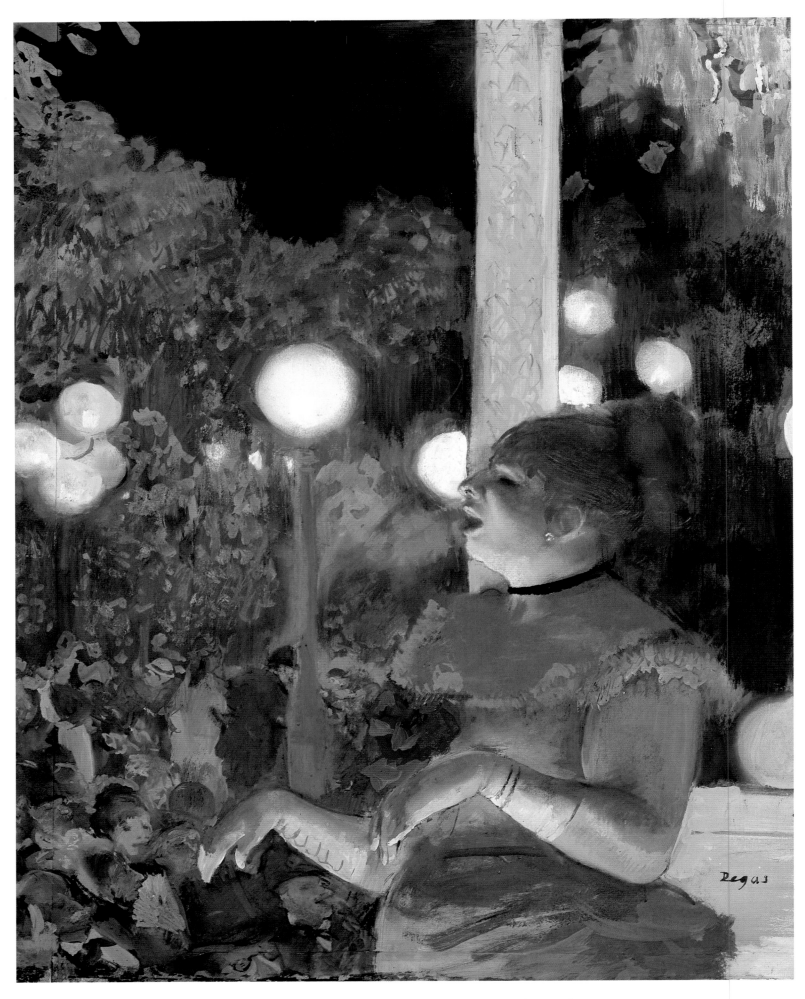

COLOURPLATE 36. Edgar Degas. *The Song of the Dog*. Pastel and gouache on monotype,
c. 1875–8. 21½ × 17¾″ (55 × 45 cm).
Private Collection, USA.

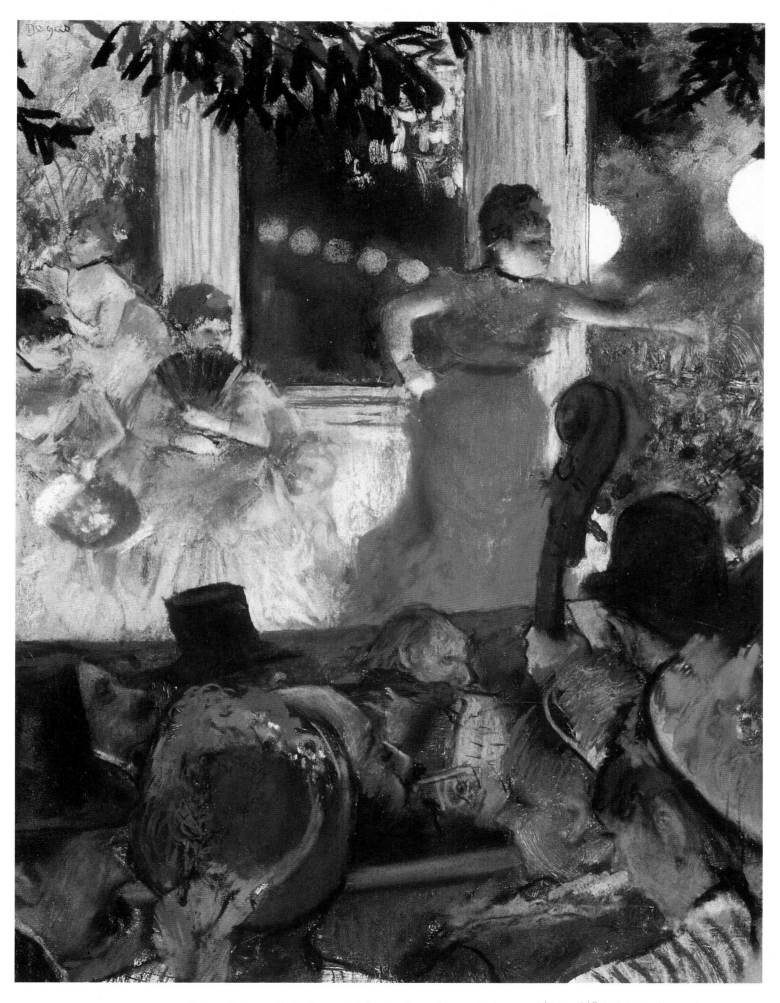

COLOURPLATE 37. Edgar Degas. *Café-Concert at Les Ambassadeurs.* 1876–7. 14½ × 10⅝″ (36.8 × 26.9 cm).
Musée des Beaux-Arts, Lyons.

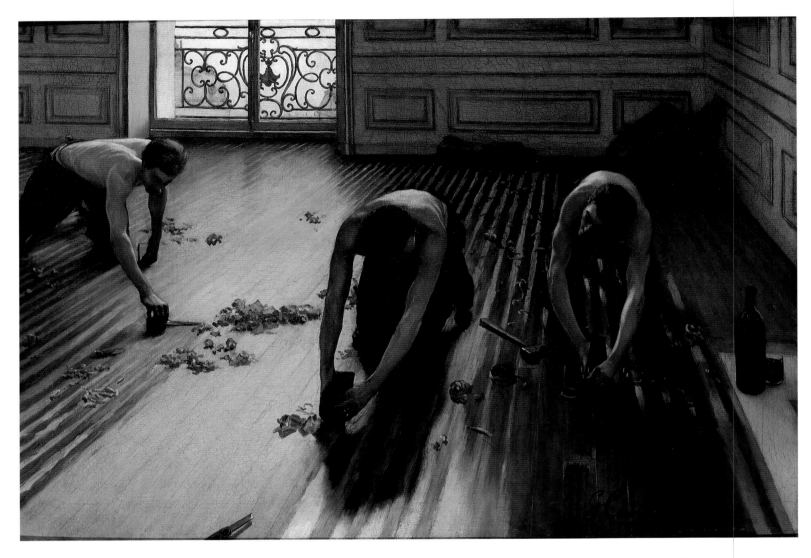

COLOURPLATE 38. Gustave Caillebotte. *The Floor-Scrapers*. 1875. 40 × 57¾″ (102 × 146.5 cm). Musée d'Orsay, Paris.

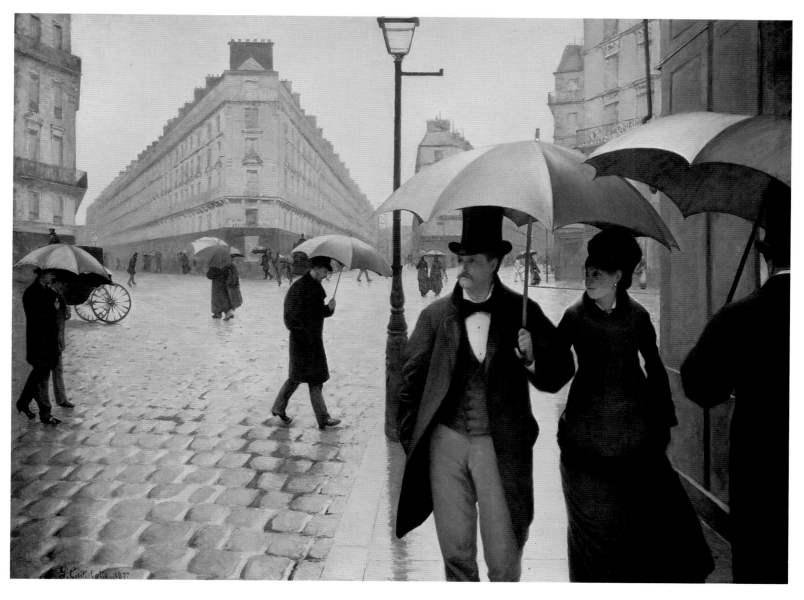

COLOURPLATE 39. Gustave Caillebotte. *Paris: A Rainy Day*. 1877. 83½ × 108¾" (212.2 × 276.2 cm).
The Art Institute of Chicago (Charles H. and Mary F. S. Worcester Collection 1964.336).

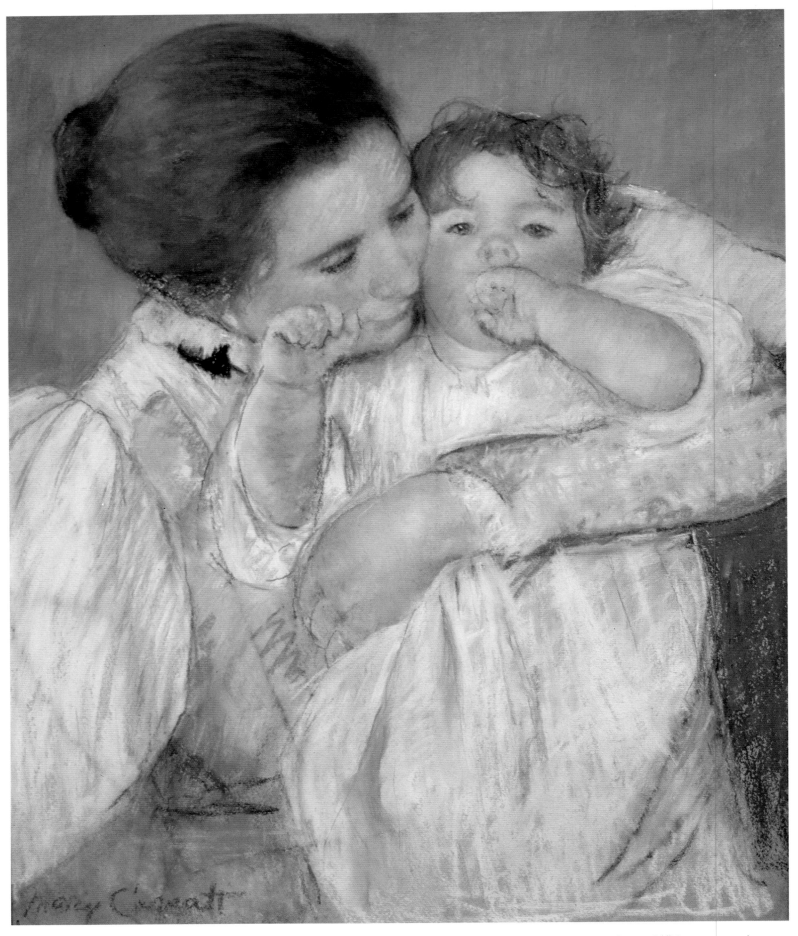

COLOURPLATE 40. Mary Cassatt. *Mother and Child against a Green Background*. 1897. Pastel, 21⅝ × 17¾″ (55 × 45 cm).
Musée d'Orsay, Paris.

composition (to borrow once more the slang of the studio) must play a considerable part in the aesthetics of a master of the Impressionists? No; certainly not; as a rule the grouping of modern persons does not suggest it, and for this reason our painter is pleased to dispense with it, and at the same time to avoid both affectation and style. Nevertheless he must find something on which to establish his picture, though it be but for a minute – for the one thing needful is the time required by the spectator to see and admire the representation with that promptitude which just suffices for the connection of its truth. If we turn to natural perspective (not that utterly and artificially classic science which makes our eyes the dupes of a civilized education, but rather that artistic perspective which we learn from the extreme East – Japan for example) – and look at the sea-pieces of Manet, where the water at the horizon rises to the height of the frame, which alone interrupts it, we feel a new delight at the recovery of a long obliterated truth.

The secret of this is found in an absolutely new science, and in the manner of cutting down the pictures, and which gives to the frame all the charm of a merely fanciful boundary, such as that which is embraced at one glance of a scene framed in by the hands, or at least all of it found worthy to preserve. This is the picture, and the function of the frame is to isolate it; though I am aware that this is running counter to prejudice. For instance, what need is there to represent this arm, this hat, or that river bank, if they belong to someone or something exterior to the picture; the one thing to be attained is that the spectator accustomed among a crowd or in nature to isolate one bit which pleases him, though at the same time incapable of entirely forgetting the adjured details which unite the part to the whole, shall not miss in the work of art one of his habitual enjoyments, and whilst recognizing that he is before a painting half believes he sees the mirage of some natural scene. Some will probably object that all of these means have been more or less employed in the past, that dexterity – though not pushed far – of cutting the canvas off so as to produce an illusion – perspective almost conforming to the exotic usage of barbarians – the light touch and fresh tones uniform and equal, or variously trembling with shifting lights – all these ruses and expedients in art have been found more than once in the English school, and elsewhere. But the assemblage for the first time of all these relative processes for an end, visible and suitable to the artistic expression of the needs of our times, this is no inconsiderable achievement in the cause of art, especially since a mighty will has pushed these means to their uttermost limits.

But the chief charm and true characteristic of one of the most singular men of the age is, that Manet (who is a visitor to the principal galleries both French and foreign, and an erudite student of painting) seems to ignore all that has been done in art by others, and draws from his own inner consciousness all his effects of simplification, the whole revealed by effects of light incontestably novel. This is the supreme originality of a painter by whom originality is doubly forsworn, who seeks to lose his personality in nature herself, or in the gaze of a multitude until then ignorant of her charms.

Without making a catalogue . . . it has been necessary to mark the successive order of his pictures, each one of them an exponent of some different effort, yet all connected by the self-same theory; valuable also as illustrating the career of the head of the school of Impressionists, or rather the initiator of the only effective movement in this direction; and as showing how he has patiently mastered the idea of which he is at present in full possession. The absence of all personal obtrusion in the manner of this painter's interpretation of nature, permits the critic to dwell so long as he pleases on his pictures without appearing to be too exclusively occupied by one man; yet we must be careful to remember that each work of a genius, singular because he abjures singularity, is an artistic production, unique of its kind, recognizable at first sight among all the schools of all ages. And can such a painter have pupils? Yes, and worthy ones; notably Mademoiselle Eva Gonzalès, who to a just understanding of the master's standpoint unites qualities of youthfulness and grace all her own.

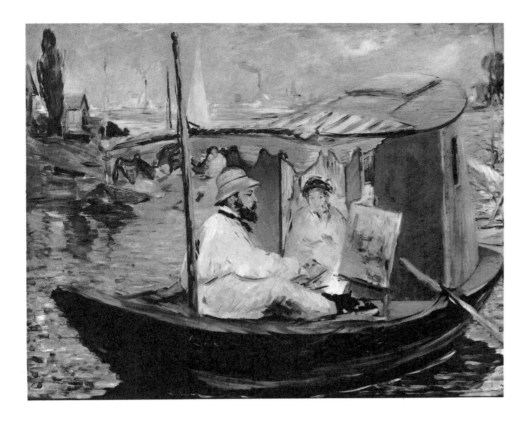

Édouard Manet. *Monet Working on his Boat, Argenteuil.* 1874. 32½ × 39½″ (82.5 × 100.5 cm). Neue Pinakothek, Munich.

Antoine Chintreuil (1814–73), follower of Corot whose choice of subjects and technique anticipated Impressionism.

But his influence as from friend to friend is wider spread than that which the master exercises over the pupil, and sways all the painters of the day; for even the manner of those artists most strongly opposed in idea to his theory is in some degree determined by his practice. There is indeed no painter of consequence who during the last few years has not adopted or pondered over some one of the theories advanced by the Impressionists, and notably that of the open air, which influences all modern artistic thought. Some come near us and remain our neighbours; others, like M. Fantin-Latour and the late M. Chintreuil, painters without any common point of resemblance, while working out their own ideas have little by little attained to results often analogous to those of the Impressionists, thus creating between his school and that of academic painting a healthy, evident, true and conjunctive branch of art, at present upheld even by the generality of art lovers. But the Impressionists themselves, those whom cosy studio chats and an amicable interchange of idea have enabled to push together towards new and unexpected horizons, and fresh-formed truths, such as MM. Claude Monet, Sisley and Pizzaro [*sic*], paint wondrously alike; indeed a rather superficial observer at a pure and simple exhibition of Impressionism would take all their works to be those of one man – and that man, Manet. Rarely have three workers wrought so much alike, and the reason of the similitude is simple enough, for they each endeavour to suppress individuality for the benefit of nature. Nevertheless the visitor would proceed from this first impression, which is quite right as a synthesis, to perceiving that each artist has some favourite piece of execution analogous to the subject accepted rather than chosen by him, and this acceptation fostered by reason of the country of his birth or residence, for these artists as a rule find their subjects close to home, within an easy walk, or in their own gardens.

Claude Monet loves water, and it is his especial gift to portray its mobility and transparency, be it sea or river, grey and monotonous, or coloured by the sky. I have never seen a boat poised more lightly on the water than in his pictures, or a veil more mobile and light than his moving atmosphere. It is in truth a marvel. Sisley seizes the passing moments of the day; watches a fugitive cloud and seems to paint it in its flight; on his canvas the live air moves and the leaves yet thrill and tremble. He loves best to paint them in spring, "when the young leves on the lyte wode, waxen al with wille," or

when red and gold and russet-green the last few fall in autumn; for then space and light are one, and the breeze stirring the foliage prevents it from becoming an opaque mass, too heavy for such an impression of mobility and life. On the other hand, Pizzaro [*sic*], the eldest of the three, loves the thick shade of summer woods and the green earth, and does not fear the solidity which sometimes serves to render the atmosphere visible as a luminous haze saturated with sunlight. It is not rare for one of these three to steal a march on Manet, who suddenly perceiving their anticipated or explained tendency, sums up all their ideas in one powerful and masterly work. For them, rather are the subtle and delicate changes of nature, the many variations undergone in some long morning or afternoon by a thicket of trees on the water's side.

The most successful work of these three painters is distinguished by a sure yet wonderfully rapid execution. Unfortunately the picture buyer, though intelligent enough to perceive in these transcripts from nature much more than a mere revel of execution, since in these instantaneous and voluntary pictures all is harmonious, and were spoiled by a touch more or less, is the dupe of this real or apparent promptitude of labour, and though he pays for these paintings a price a thousand times inferior to their real value, yet is disturbed by the afterthought that such light productions might be multiplied *ad infinitum*; a merely commercial misunderstanding from which, doubtless, these artists will have still to suffer. Manet has been more fortunate, and receives an adequate price for his work. As thorough Impressionists, these painters (excepting M. Claude Monet, who treats it superbly) do not usually attempt the natural size of their subjects, neither do they take them from scenes of private life, but are before everything landscape painters, and restrict their pictures to that size easiest to look at, and with shut eye preserve the remembrance of.

With these, some other artists, whose originality has distanced them from other contemporary painters, frequently, and as a rule, exhibit their paintings, and share in most of the art theories I have reviewed here. These are Degas, Mademoiselle Berthe Morisot, (now Madame Eugène Manet,) and Renoir, to whom I should like to join Whistler, who is so well appreciated in France, both by critics and the world of amateurs, had he not chosen England as a field of his success.

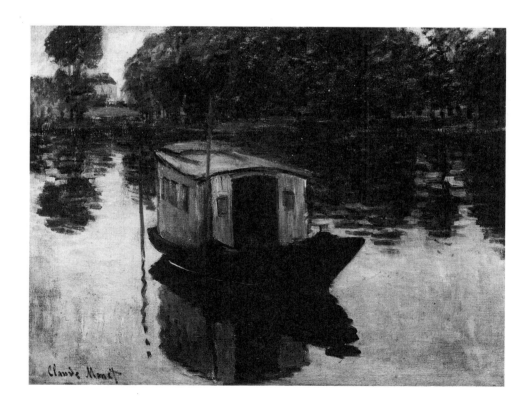

Claude Monet. *The Artist's Floating Studio.* 1874. 19¾ × 25¼" (50 × 64 cm). Rijksmuseum Kröller-Müller, Otterlo.

The muslin drapery that forms a luminous, ever-moving atmosphere round the semi-nakedness of the young ballet dancers; the bold, yet profoundly complicated attitudes of these creatures, thus accomplishing one of the at once natural and yet modern functions of women, have enchanted M. Degas, who can, nevertheless, be as delighted with the charms of those little washerwomen, who fresh and fair, though poverty-stricken, and clad but in a camisole and petticoat, bend their slender bodies at the hour of work. No voluptuousness there, no sentimentality here; the wise and intuitive artist does not care to explore the trite and hackneyed view of his subject. A master of drawing, he has sought delicate lines and movements exquisite or grotesque, and of a strange new beauty, if I dare employ towards his works an abstract term, which he himself will never employ in his daily conversation.

More given to render, and very succinctly, the aspect of things, but with a new charm infused into it by feminine vision, Mademoiselle Berthe Morisot seizes wonderfully the familiar presence of a woman of the world, or a child in the pure atmosphere of the sea-shore, or green lawn. Here a charming couple enjoy all the limpidity of hours where elegance has become artless; and there how pure an atmosphere veils this woman standing out of doors, or that one who reclines under the shade of an umbrella thrown among the grasses and frail flowers which a little girl in a clean dress is busy gathering. The airy foreground, even the furthermost outlines of sea and sky, have the perfection of an actual vision, and that couple yonder, the least details of whose pose is so well painted that one could recognize them by that alone, even if their faces, seen under the shady straw hats, did not prove them to be portrait sketches, give their own characteristics to the place they enliven by their visit. The air of preoccupation, of mundane care or secret sorrows, so generally characteristic of the modern artist's sketches from contemporary life, were never more notably absent than here; one feels that the graceful lady and child are in perfect ignorance, that the pose unconsciously adopted to gratify an innate sense of beauty is perpetuated in this charming water-colour.

The shifting shimmer of gleam and shadow which the changing reflected lights, themselves influenced by every neighbouring thing, cast upon each advancing or departing figure, and the fleeting combinations in which these dissimilar reflections form one harmony or many, such are the favourite effects of Renoir – nor can we wonder that this infinite complexity of execution induces him to seek more hazardous success in things widely opposed to nature. A box at the theatre, its gaily dressed inmates, the women with their flesh tints heightened and displayed by rouge and rice powder, a complication of effects of light – the more so when this scene is fantastically illuminated by an incongruous daylight. Such are the subjects he delights in.

All these various attempts and efforts (sometimes pushed yet farther by the intrepid M. de Césane [sic]) are united in the common bond of Impressionism. Incontestably honour is due to these who have brought to the service of art an extraordinary and quasi-original newness of vision, undeterred by a confused and hesitating age. If sometimes they have gone too far in the search of a novel and audacious subject, or have misapplied a freshly discovered principle, it is but another canvas turned to the wall; and as a set off to such an accident they have attained a praiseworthy result, to make us understand when looking on the most accustomed objects the delight that we should experience could we but see them for the first time.

If we try to recall some of the heads of our argument and to draw from them possible conclusions, we must first affirm that Impressionism is the principal and real movement of contemporary painting. The only one? No; since the other great talents have been devoted to illustrate some particular phase or period of bygone art; among these we must class such artists as Moreau, Puvis de Chavannes, etc.

At a time when the romantic tradition of the first half of the century only lingers among a few surviving masters of that time, the transition from the

old imaginative artist and dreamer to the energetic modern worker is found in Impressionism.

The participation of a hitherto ignored people in the political life of France is a social fact that will honour the whole of the close of the nineteenth century. A parallel is found in artistic matters, the way being prepared by an evolution which the public with rare prescience dubbed, from its first appearance, Intransigeant, which in Political language means radical and democratic.

The noble visionaries of other times, whose works are the semblance of worldly things seen by unworldly eyes, (not the actual representations of real objects) appear as kings and gods in the far dream-ages of mankind; recluses to whom were given the genius of a dominion over an ignorant multitude. But today the multitude demands to see with its own eyes; and if our latter-day art is less glorious, intense and rich, it is not without the compensation of truth, simplicity and childlike charm.

At that critical hour for the human race when nature desires to work for herself, she requires certain lovers of hers – new and impersonal men placed directly in communion with the sentiment of their time – to loose the restraint of education, to let hand and eye do what they will, and thus through them, reveal herself.

For the mere pleasure of doing so? Certainly not, but to express herself, calm, naked, habitual, to those newcomers of tomorrow, of which each one will consent to be an unknown unit in the mighty numbers of an universal suffrage, and to place in their power a newer and more succinct means of observing her. Such, to those who can see in this the representative art of a period which cannot isolate itself from the equally characteristic politics and industry, must seem the meaning of the manner of painting which we have discussed here, and which although marking a general phase of art has manifested itself particularly in France.

Now in conclusion I must hastily re-enter the domain of aesthetics, and I trust we shall thoroughly have considered our subject when I have shown the relation of the present crisis – the appearance of the Impressionists – to the actual principles of painting – a point of great importance.

In extremely civilized epochs the following necessity becomes a matter of course, the development of art and thought having nearly reached their far limits – art and thought are obliged to retrace their own footsteps, and to return to their ideal source, which never coincides with their real beginnings. English Preraphaelitism, if I do not mistake, returned to the primitive simplicity of mediaeval ages. The scope and aim (not proclaimed by authority of dogmas, yet not the less clear), of Manet and his followers is that painting shall be steeped again in its cause, and its relation to nature. But what, except to decorate the ceilings of saloons and palaces with a crowd of idealized types in magnificent foreshortening, what can be the aim of a painter before everyday nature? To imitate her? Then his best effort can never equal the original with the inestimable advantages of life and space. – "Ah no! this fair face, that green landscape, will grow old and wither, but I shall have them always, true as nature, fair as remembrance, and imperishably my own; or the better to satisfy my creative artistic instinct, that which I preserve through the power of Impressionism is not the material portion which already exists, superior to any mere representation of it, but the delight of having recreated nature touch by touch. I leave the massive and tangible solidity to its fitter exponent, sculpture. I content myself with reflecting on the clear and durable mirror of painting, that which perpetually lives yet dies every moment, which only exists by the will of Idea, yet constitutes in my domain the only authentic and certain merit of nature – the Aspect. It is through her that when rudely thrown at the close of an epoch of dreams in the front of reality, I have taken from it only that which properly belongs to my art, an original and exact perception which distinguishes for itself the things it perceives with the steadfast gaze of a vision restored to its simplest perfection."

GEORGES RIVIÈRE

L'IMPRESSIONNISTE, JOURNAL D'ART

"The Impressionist Exhibition"

April 6–28, 1877

What enchantments, what remarkable works, what masterpieces, even, are packed into the rooms on rue Le Peletier! Nowhere, and at no time, has a comparable exhibition been offered to the public. One is dazzled and charmed from the outset, and the charm increases the further one goes. In the first room, some very beautiful canvases by M. Renoir, and pictures by MM. Monet and Caillebotte. In the second, the large picture of turkeys by M. Monet, pictures by M. Renoir, landscapes by MM. Monet, Pissarro, Sysley [sic], Guillaumin, Cordey and Lamy, give this room an inexpressible and quasi-magical gaiety.

Entering the middle room, we see first the "Bal" by M. Renoir, and a large landscape by M. Pissarro; we turn around, and are instantly plunged into admiration of the masterly canvases by M. Cézanne, and Mlle Morizot's [sic] charming pictures, so delicate and above all so feminine.

In the large adjacent room we see the work of MM. Monet, Pissarro, Sysley and Caillebotte.

And at the end, in a small gallery, paintings by M. Degas, and some of the ravishing watercolours of Mlle Berthe Morizot.

This, roughly speaking, is the general layout of the exhibition. The paintings are displayed with exquisite taste; each wall offers an agreeable vista and not a false note is struck, despite the wide disparity between the works hung.

The exhibition on rue Le Peletier shows us only lively scenes which sadden neither the eye nor the heart; landscapes that are light-filled, joyous or grandiose; none of those lugubrious tones which leave a black spot on the eye.

Let us begin with the works of Renoir, and the most important of his works, *Dancing at the Moulin de la Galette*. In a garden inundated with sunlight, barely shaded by some spindly acacia plants whose thin foliage trembles with the least breeze, there are charming young girls in all the freshness of their fifteen years, proud of their light homemade dresses fashioned of inexpensive materials, and young men full of gaiety. These make up the joyous crowd whose brouhaha is louder than the band's music. Lost notes of a country dance are barely audible from time to time to remind the dancers of the beat. Noise, laughter, movement, sunshine, in an atmosphere of youth: such is the *Dancing at the Moulin de la Galette* by Renoir. It is an essentially Parisian work. These young girls are the same ones with whom we rub elbows every day, and whose prattling fills Paris at certain hours. A smile and some shirt cuffs are enough to make them pretty. Renoir has proved it well. Look at the grace with which the girl leans on a bench! She is chatting, emphasizing her words with a subtle smile, and her curious glance tries to read the face of the young man talking to her. And that young philosopher, leaning back in his chair and smoking his pipe, what profound disdain he must have felt for the jigging of the gallant dancers who seem oblivious to the sun in the ardour of a polka!

Surely Renoir has a right to be proud of *Dancing at the Moulin de la Galette*. Never has he been more inspired. It is a page of history, a precious monument to Parisian life done with rigorous exactitude. No one before him had thought of portraying an event in ordinary life on a canvas of such big dimensions; it is an act of daring which will be rewarded by success, as is fitting. This painting has a very great significance for the future, which cannot be overemphasized. This is an historical painting. Renoir and his friends have understood that historical painting is not the more or less

Georges Rivière (1855–1943), journalist, civil servant, and friend of Renoir. He published a broadsheet, L'Impressionniste, *which appeared weekly during the public run of the third exhibition in April 1877. He and Renoir wrote most of the articles. Gustave Caillebotte (1848–94) had been largely responsible for the organization of the 1877 show; he had paid the rent in advance for the premises, a large apartment at 6 rue Le Peletier across the street from Durand-Ruel's galleries, the location of the previous year's exhibition.*

Renoir: Dancing at the Moulin de la Galette *(1876), Musée d'Orsay.*

Honoré Daumier. *In the Studios. Le Boulevard,* April 20, 1862. "Wow! Amazing! Gosh! Superb! It sings . . ."

ludicrous illustration of tales of the past; they have blazed a trail that others will certainly follow. Let those who want to do historical painting do the history of their own era, instead of raising the dust of past centuries. What do those operetta kings, rigged out in yellow and blue robes, bearing a sceptre in their hands and a crown upon their heads, matter to us! When, for the hundredth time, we are shown St Louis dispensing justice under an oak, have we thereby made any progress? What documents will artists who indulge in such overlaboured works bring to future centuries concerning the history of our own era?

Every conscientious artist tries to immortalize his work; by what right can such paintings, which bring nothing new in colour or the choice of subject, hope for this immortality?

Treating a subject for the sake of tone and not for the sake of the subject itself, this is what distinguishes the Impressionists from other painters. For there are Italians, Belgians and others who paint miniatures of people in contemporary dress and who contribute also, it will be said, to the history of our period. We will not deny it, we will even add that the photographers and tailors who publish fashion illustrations contribute at least as much as they do; but are they artists for that reason?

It is especially this pursuit, this new way of treating a subject, which is the very personal quality of Renoir; instead of seeking the secret of the great masters, of Velasquez or of Frans Hals . . . he sought and found a contemporary note and *Dancing at the Moulin de la Galette*, whose colouring has so many charms and so much that is new, will surely be the big success of this year's exhibitions.

* * *

M. Monet is not content with rendering the awesome and grandiose aspect of nature, he also captures the friendly, charming side that a young and happy man might see. Never does a sad thought steal upon the spectator in front of this powerful painter. After the pleasure of admiring the luxuriant nature which blossoms in his pictures, one feels only a sense of regret at not being able to dwell forever in its midst.

This year, M. Monet has several canvases representing steam engines, both uncoupled and harnessed to a string of carriages in the Gare St-Lazare. These paintings are enormously varied, despite the monotony and aridity of the subject. Here, more than elsewhere, one can sense the immense skill that goes into the arrangement, into the lay-out of the canvas, which is one of M. Monet's principal qualities.

In one of the largest pictures, the train has just arrived and the engine is about to set off again. Like a fiery, straining animal, excited rather than wearied by its long haul, it shakes a mane of smoke which rises to meet the glass roof of the great station hall. Men teem around the monster on the track like pygmies at the feet of a giant. Beyond it, sleeping engines stand in readiness. We can hear the shouting railwaymen, the engines' piercing whistles spreading their cry of alarm, the endless clanking of metal and the awesome hiss of steam.

We see all the wild, grandiose movement of a station where the very ground quakes at each turn of the wheels. The platforms are damp with soot, and the air is filled with the acrid smell of burning coal.

Looking at this magnificent picture, we are seized with the same emotion as we feel before nature, and this emotion is perhaps stronger still because the picture contains the emotion of the artist as well.

* * *

We intentionally first chose two artists of equal talent, whose names have been constantly linked in praise or criticism, but whose manner is so different, though it has a common starting point.

We have shown that they both have the same fecundity and variety; anything we might add would be superfluous.

[Now we come to] M. Degas. It is hard to do verbal justice to this

essentially Parisian artist, whose every work contains as much literary and philosophical talent as it does draughtsmanship and knowledge of colour.

A single line by his hand expresses everything one might have to say of him more tersely than words, for his works are always witty, subtle and sincere. He does not try to convince us of a naivety he cannot possess . . . his prodigious expertise shines out everywhere; he has a particularly individual and attractive talent for arranging his figures in the most unexpected and amusing fashion, though always truthfully and naturally. What M. Degas hates most . . . is romantic elation, the substitution of dream for life, in a word, panache. He is an observer; he never seeks exaggeration; the effect is always obtained from nature, without caricature. That is what makes him the most accurate historian of the scenes he shows us.

You no longer need to go to the Opéra after having seen his pastels of the "ladies of the corps de ballet." His studies of "cafés-concerts" have far more of an effect than the places themselves, because the artist has an expertise and an art that you do not have. The "café-concert" with the woman in a red dress is truly marvellous. What art has gone into the depicting of the women in the background, in their muslin dresses, behind their fans, and of the absorbed spectators, in the foreground, all with raised heads, craning necks, enjoying a crude song accompanied by smutty gestures! That woman, as you will have guessed, has the husky voice of a soak. The audience's darling! That gesture and that voice must be oh so carefully studied in the silence of the boudoir by a pretty *marquise* who will be seeking the applause of her women friends when she sings: "Am I a cardboard cut-out?"

The *chanteuse* leans towards the audience in an extraordinary gesture, necessarily the product of success. This woman has not got stage fright; on the contrary, she heckles her audience, she challenges it, knowing it will answer her as she wishes – for is she not mistress of the despot whose vices she gratifies?

Over here we have women at the door of a café, at evening. One, who is flicking her thumbnail against her teeth, saying "not only that," is a poem in herself. Another is displaying her large gloved hand on the table. In the background is the boulevard, its hubbub easing slightly. Another extraordinary page of history. The little dancer holding a bouquet, the chorus, the dancers in blue skirts are so many masterpieces that can never be sufficiently admired. M. Degas has exhibited a portrait of a woman done several years ago. The portrait is a marvel of draughtsmanship, as lovely as the loveliest by Clouet, the greatest of the primitives.

Although the works by M. Degas are relatively restricted in number, they are sufficient to show that the artist is not living on his laurels and that he is still developing artistically quite as much as his friends. His constant concerns, to be found in all his works, have ensured him a position among them and he needs no help from us.

* * *

. . . For the last fortnight certain journalists have been asking why the artists who are exhibiting on rue Le Peletier have used the title "Impressionists." It is quite simple. They have put the word impressionist at the door of their exhibition because they did not wish to be confused with other painters and because this word designated them clearly to the public. In any case, it was the public and the press which first gave them this name, and such godfathers would be ill-advised to come and quiz their godchildren in connection with a name which the latter have simply respectfully accepted. What did the words *classical* and *romantic* mean in 1830? Nothing very clear in themselves, as far as I know; yet they served to distinguish two very different schools in the clearest way in the world.

* * *

There are some criticisms which in themselves are not worthy of note, but whose persistence causes them to assume an importance that cannot be disregarded.

marquise: *prostitute, loose woman.*

Degas: Women in Front of a Café, Evening *(1877), Musée d'Orsay.*

Front cover of *L'Impressionniste,* April 21, 1877, with Renoir's drawing after *The Swing.* Bibliothèque Nationale, Paris.

Such is the criticism which forms the basis of the opposition encountered by the Impressionists. Some of them are asked the reasons for the subject they have chosen, all of them are criticized for the tones they have used. Such critics are exceeding their rights as judges. One has no right to ask an artist to account for his subject and his palette, any more than one may ask a poet the reason for his rhythm or a novelist the wherefore of his novel. It is enough that a thing be beautiful, the means employed matter little. In painting, each person must have a particular sense of colour in accordance with his own eye, and a predilection for such and such a subject in accordance with his bent; the public may judge if the conception is beautiful in its result, but it can go no further without becoming ridiculous. . . .

To those who say: "Rembrandt and Ruysdael did not paint like that," when looking at the work of MM. Monet, Renoir or Pissarro, one can answer only one thing, which is that if our contemporaries the Impressionists painted like Rembrandt and Ruysdael, they would be shocking and despicable plagiarists. Plagiarism knows no periods, it is as ugly to steal a colour from Velasquez as it is from Delacroix. . . .

There are also people who imagine that the Impressionist painters seek out originality in order to amaze the public, with the sole aim of playing to the gallery. This is more extraordinary still. Can one imagine artists engaging in a very painful struggle, lasting many years, just to astonish a handful of gawpers? It would be ridiculous, mad, or worse! When I think that some among those who spread this preposterous idea were painters themselves, I feel seized with pity for these poor folk. All artists, I maintain, are sincere; their true value always appears in their works; if what they produce is bad, it is not their fault, they can do neither better, nor differently. The "Impressionists" are like that, their works are the result of the sensation they have felt, and I cannot conceive that artists could for one moment doubt the sincerity of the works exhibited on the rue Le Peletier.

MARC DE MONTIFAUD

L'ARTISTE
"Salon of 1877"
May 1, 1877

Marie-Émilie Chartroule de Montifaud adopted the pseudonym Marc de Montifaud; under this name she was a frequent contributor to critical reviews in the 1860s and 1870s.

The language of the Impressionists bears some resemblance to that of *L'Assommoir*; their canvases seem made to bludgeon the critic; and, while we are at it, what exactly is an Impressionist? Of all the definitions that have been given, I recall one in particular: "The ethics of the new religion can be summed up as follows: My children, impress yourselves upon one another. What is an intransigent? An impressionist who staunchly refuses to come to terms with the need of the bourgeois to understand what he is shown, and to compromise with his well-known horror of puzzles and mystifications. The bourgeois is totally insensitive to the charm of mystery, to the lure of the vague, the incomprehensible, the incomplete. He will never understand that a sketch can be more interesting than a finished picture. What is in a finished picture? What has been put there; in a sketch you see what is not there and what could be put there." There is some truth in this definition, but the rue Le Peletier sect is made up of intelligent people who are quite aware of their weak points and who, without denying their starting point, simply pursue nothing less than what they recognize they lack. It is clear that the cunning creatures have engaged in a conspiracy whose aim, to use the stock phrase, is to "get them to fall for it." Now, by virtue of the precept that two augurs cannot look one another in the eye without laughing, they

Zola's novel L'Assommoir ("The Grog-shop") was published in 1877.

would be the first to poke fun, and rightly, at those who, this year, might take them seriously.

M. Caillebotte and M. Renoir are the two painters to be exempted from a final judgment; they have indisputable value amidst these extremists of the palette who foist ochres, greens, truculent reds and delirious mauves upon us; if it is in the hope that the last bourgeois will fall prey to an apoplectic fit at the very threshold, then we understand them completely; we are in agreement; it is a delicate way of getting rid of them although, truth to tell, we find the worthy bourgeois a diversion rather than an embarrassment. But in the absence of this murderous aim, if you cannot even draw blood, what does this mean? What good does it do you to put the trees at the top of the sky, the sky where the road should be and the road above the trees, why this vengeful harshness? What have women done to you that you should affix apparent sealing wax to their eyes, and peasants that you should enclose them in a jar of jangling green, with violet skin and a stick of yellow wax between their fingers by way of a fishing rod? A candid, natural touch, you say? the painting of impressions? We could not ask for more, had we to cross 25 Sinais each more grotesque than the last to see the tables of a new law emerge amidst the thunder of modern revelations; but after such a series of ascents, we wonder what MM. Monet and Pissarro, for example, think they are destined for, on the first floor of the rue Le Peletier. To rouse the world? We do not doubt it. Of course, our dislike of the Eliakims of art is well known. But when summer foliage appears ox-blood in hue in full daylight, doubt will creep in.

Eliakim was the grandson of Racine's Athalie. *The term meant (often jocularly) the sole hope of a group or party.*

* * *

Of course, we do not believe that the work of an artist should be called upon to fulfil the function of a camera lucida, reflecting objects with the minuteness of a transfer; to give an impression instead of a reproduction does not strike us as being contrary to art, far from it; but is this indeed what the Impressionists are doing? We were moved, in the works of some masters, by the light scumbling, the thinly-painted skies, the roughly outlined bushes, although they may not contain the first and last word on art. We understand the approximate, the elusive, the imprint of the object left behind in its scent, just as it struck us. It is then up to the art-lover to complete the painter's thought, to reconstitute the complete form, if he feels he should do so; so be it. But if there is just one phrase of melody, then that phrase must ring true; feeling should perhaps shine through only mysteriously where we have intimation but, however vaguely it may appear, there it must be.

This is the moment to recall what one of our most respected critics said in connection with Corot, the first of the Impressionists, at the time of his journey to Italy: "He performed miracles of precision and limpidity with just a few brush-strokes. Here, the unfinished has immense charm; nothing is formulated, but the character of the whole is understood, and it is easy for the spectator to reconstruct or to imagine the absent detail, so exact is the general line, so expertly rendered the effect of light. That was impressionism's age of gold. So much determination, so much innocence!" That candour and that sincerity have been much invoked in connection with Mlle Berthe Morizot [sic], with her simplicity, her uncheating hand. Is she really shown to her greatest advantage on rue Le Peletier? We cannot say, for we do not fully share the view that in painting there are only beginnings. People never weary of saying that, to judge the Impressionists, one has to take one's distance. At 50 paces, we are assured, arms become rounded, bare legs emerge from skirts, eyes light up, the painting takes on body, suppleness, movement, each tint comes into its own and each value suddenly finds its place. In this way the impression is given of a thing seen that is less conveyed by exactness of form than translated by feeling. One or two of the coterie barely realize this programme; all strive laboriously to spread colour over the canvas, while aiming for transparency; and, by putting green in their shadows, they become dull, flat and lacking in freshness.

THÉODORE DURET

LES PEINTRES IMPRESSIONNISTES
1878

Théodore Duret (1838–1927), critic, collector, a friend of Manet and one of his leading critical supporters. He was an early historian of Impressionism, and was one of the first European travellers to visit Japan.

The Impressionists did not create themselves. They did not grow like mushrooms. They are the product of the steady evolution of the modern French school. "Natura non fecit saltum," not more so in painting than in anything else. The Impressionists are the descendants of the naturalist painters. Their forefathers are Corot, Courbet, and Manet. The art of painting is indebted to these three masters for introducing simple techniques and spontaneous methods of painting which have withstood the test of time. They are responsible for providing us with light paintings, free, once and for all, of lead monoxide, bitumens, chocolates, chigoe juice, siennas, and gratin. It is to them that we owe the study of broad daylight; the sensation, not only of colour, but of the slightest nuances of colour and tone, as well as the investigations of the rapport between the state of the atmosphere, which lights up the painting, and the general tonality of the objects depicted. The impressionists received all this from their predecessors and were also influenced by Japanese art.

If you walk along the banks of the Seine – at Asnières, for example – in a single glance you will be able to see the red roof and brilliantly white fence of a cottage, the pale green of a poplar, the yellow road, and the blue river. In the summer, at noon, all the colours will seem raw, intense, impossible to tone down, or enveloped by an encompassing semi-tint. Well! These may seem strange, but nothing could be more realistic. It required the presence of Japanese prints for one of us to dare to sit by the edge of a river and juxtapose a bright red roof, a white fence, a green poplar, a yellow road and blue water on a canvas. Before Japan, this was impossible. The painter always lied. The straightforward colours of nature would blind him. All we ever saw on a canvas was attenuated colours drowning in a predominant half-tint. Only after having seen the Japanese pictures, on which the most contrasting and intense colours are set side by side, did we finally understand that there were new techniques worth using for the reproduction of certain aspects of nature that had been neglected or considered impossible

Contemporary Japanese woodblock prints began to arrive in France in the 1850s and were sold in Paris in specialist shops such as La Porte Chinoise and L'Empire Chinoise. Works by Utamaro, Hiroshige and Hokusai were not imported until the mid-1870s.

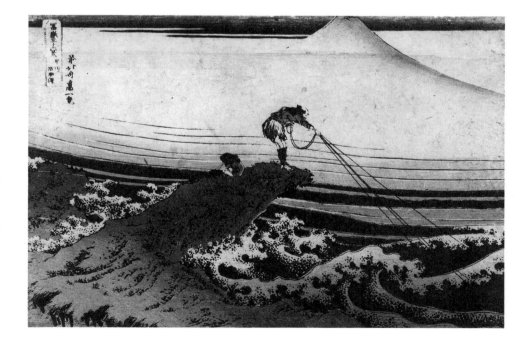

Katsushika Hokusai. *Kajikazawa in the province of Kai.* From the series *36 Views of Fuji.* Woodblock print, *ōban* size. Japanese print collection of Monet at Giverny.

to render until this day. These Japanese pictures, which so many people initially chose to think of as gaudy, are actually strikingly faithful reproductions of nature. Let us ask those who have visited Japan. For my part, at every instant I would discover the exact sensation of a Japanese countryside, reproduced on a fan or in an album. I look at a Japanese album and I say: "Yes, this is exactly how Japan appeared to me. It is exactly thus, beneath a luminous and transparent atmosphere that the blue and multi-coloured sea appeared. Here are the roads and the fields surrounded by the lovely cedars, whose branches have such strangely angular shapes. Here is Mount Fuji, the highest volcano, and the masses of light bamboo which cover the hillsides. And finally, here are the teeming and picturesque inhabitants of the cities and countrysides." Japanese art rendered particular aspects of nature with bold new techniques of colouration. It could not help but impress artists with open minds, and it strongly influenced the Impressionists.

The Impressionists adopted the techniques used by their immediate predecessors of the French school: their earnest manner of painting in broad daylight, their spontaneity, and their vigorous application of paints. They understand the bold new Japanese techniques of colouration. They have gone on to develop their own originality and to revel in their own sensations.

The Impressionist sits on the bank of a river. The water takes on every possible hue according to the state of the sky, the perspective, the time of day, and the calmness or agitation of the air. Without hesitation, he paints water which contains every hue. The sky is overcast and it is rainy: he paints water that is glaucous, thick, and opaque. The sky is clear and the sun is bright: he paints the reflections seen in the agitated water. The sun sets and hurls its rays at the water: to depict these effects, the Impressionist covers his canvas with yellows and reds. And so the public begins to laugh.

Winter is here. The Impressionist paints snow. He sees that, in the sunlight, the shadows on the snow are blue. Without hesitation, he paints blue shadows. So the public laughs, roars with laughter.

Certain parts of the countryside are covered with clay that produces a purple tint. The Impressionist paints purple landscapes. So the public begins to get indignant.

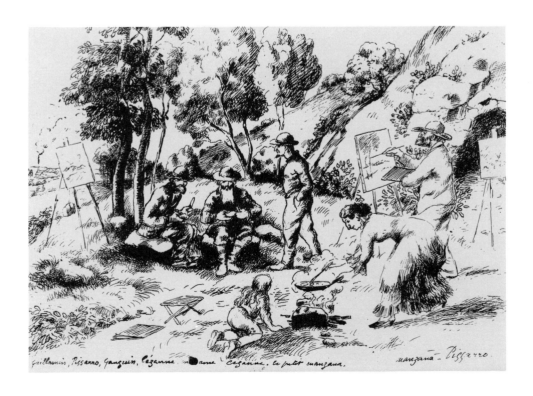

Georges Manzana-Pissarro. *Impressionist Picnic – Souvenir of Summer*. Guillaumin, Pissarro, Gauguin, Cézanne, Mme Cézanne and Manzana-Pissarro. 1881. Pen and ink, 8¼ × 10¼" (21 × 26 cm). Pissarro Museum Archive, Pontoise.

In summer sunlight reflected by green foliage, skin and clothing take on a violet hue. The Impressionist paints people in violet forests. So the public loses all control. Critics shake their fists and call the painter a vulgar scoundrel.

The unhappy Impressionist can protest that his sincerity is absolute. He can declare that he reproduces only what he sees and that he remains faithful to nature. But the public and the critics condemn him. They have no way of knowing whether the things they see on the canvas correspond to those actually seen by the painter in nature. For them, only one fact pertains: the things that the Impressionists put on their canvases do not correspond to those found on the canvases of previous painters. It is different, and so it is bad.

ÉMILE ZOLA

VIESTNIK EUROPI

Letter from Paris: "Salon of 1879"

June 1879

The dominant feature of our modern French school, a persistent search for truths of nature, is emerging increasingly clearly. After the dazzling works of Eugène Delacroix, Courbet was the first to thrust in this direction. He was an astonishing master: the solidity of his style and his infallible technique are still unrivalled in our school. One would have to go back to the Italian Renaissance to find a touch as bold and as true as his. Today the movement is continuing and is marked even more clearly by an ever-growing need for analysis. I think I have already spoken of the small group of painters who have taken the name of Impressionists. This term strikes me as unfortunate; but it is nonetheless undeniable that these Impressionists – since they set store by this name – are at the spearhead of the modern movement. Each year, when visiting the Salon, one realizes that their influence is being felt increasingly strongly; and the strangest part is the jury's inexorable refusal to accept their work, so that these artists finally stopped sending in any work at all; they have set up a company and each year they hold an independent exhibition; visitors flock in, admittedly drawn by pure curiosity, and quite uncomprehending. Thus we witness the following astonishing phenomenon: a handful of artists, persecuted and mocked at by the press, which never mentions them with a straight face, is nonetheless put forward as the true inspiration for the official Salon from which they have been expelled.

To explain this strange state of affairs, I would like to say a few words about the Impressionist painters who, this year, have in fact put on an exhibition on the avenue de l'Opéra. It includes paintings by Monet, who renders nature so faithfully; by Degas, who finds his models in the contemporary world and portrays them with such striking truthfulness; by Pissarro, whose scrupulous study sometimes produces a stunning impression of truth – and by many others whom I shall not mention here. Furthermore I intend to restrict myself to general comment.

The impressionists have introduced *plein air* painting, the study of the changing effects of nature according to the myriad conditions of time and weather. They believe that Courbet's fine methods can produce only magnificent pictures painted in the studio. They push the analysis of nature further, to the decomposition of light, the study of air in movement, of the nuances of colour, the random vibrations of light and shade, all the optical phenomena which make a horizon so mobile and difficult to render. It is

In 1879 Zola began writing a monthly "Letter from Paris" reporting on contemporary art for the Russian publication Viestnik Europi ("The Messenger of Europe"), published in St Petersburg. He got into trouble with Manet when the passages of negative criticism were translated back into French and published in the June 27, 1879 edition of Le Figaro.

The fourth Impressionist exhibition was held from April 10 to May 11, 1879 at 28 avenue de l'Opéra.

hard to grasp the revolutionary implications of the mere fact of painting in the open, when one must reckon with the flow of air, instead of shutting oneself up in a studio where a cold, well-balanced light comes in through a north-facing window. It is the final blow for classical and romantic painting and, what is more, it signifies the Realist movement, launched by Courbet, freed from the shackles of craftsmanship and seeking the truth in the numberless effects of the play of light.

I have not named Édouard Manet, who was the leader of the Impressionist group. His pictures are exhibited at the Salon. He carried on the movement after Courbet, thanks to his perceptive eye, so expert at discerning the right tones. His long struggle against public bafflement is explained by the difficulty he finds in execution – I mean that his hand is not the equal of his eye. He has not been able to forge himself a technique; he has remained the enthusiastic novice who always sees clearly what is going on in nature but who is not confident of being able to translate his impressions in a thorough and definitive fashion. That is why, when he starts out, one never knows how he will reach his goal or even if he will reach it at all. He works blind. When a painting succeeds, it is outstanding: absolutely true, and of a

Photograph of Émile Zola at home.
Bibliothèque Nationale, Paris.

rare skilfulness; but he does sometimes lose his way – and then his canvases are flawed and uneven. In a word, for 15 years now we have seen no painter more subjective. If his technique equalled the soundness of his perceptions, he would be the greatest painter of the second half of the nineteenth century.

Actually, all the Impressionist painters sin through technical inadequacy. In the arts as in literature, form alone supports new ideas and new methods. To be a talented man, one has to realize what is alive within one, otherwise one is just a pioneer. The Impressionists, in my view, are just that. At one point they placed great hope in Monet; but he seems exhausted by over-rapid production; he is content with the approximate; he does not study nature with the passion of a true creator. All these artists are too easily satisfied. Wrongly, they disdain the solidity of works pondered upon at length; this is why one may fear that they are merely pointing the way to the great artist of the future whom the world is waiting for.

It is true that clearing the ground for the future is already honourable, providing one happens to have found the right way. Thus there is nothing more characteristic than the influence of the Impressionist painters – rejected each year by the Jury – when it is exercised upon those painters with deft techniques who are conspicuous in the Salon each year.

Therefore, let us examine the official exhibition from this point of view. This year's winners, namely the painters upon which the critics concentrate, and which attract the public, are Bastien-Lepage, Duez, Gervex; these gifted artists owe their success to the application of the naturalist method in their painting.

Émile Bastien-Lepage (1854–1938), Henri Gervex (1852–1929), Ernest-Ange Duez (1843–96), academic artists who adopted some aspects of Impressionism.

* * *

This will be my conclusion, since it is pointless to list new names and prolong this discussion of the Salon. I have wanted simply to use certain examples to show that the triumph of Naturalism is making increasing headway in painting as in literature. Today success crowns those particular young painters who have broken with the establishment and who appear as innovators vis-à-vis those masters who have outlived their day. The way is clear for the painter of genius.

JOHN REWALD

GAZETTE DES BEAUX-ARTS

"Auguste Renoir and his Brother"

March 1945

The fifth exhibition organized in the galleries of *La Vie Moderne* was devoted to the works of Renoir, constituting his first one-man show. He presented mostly pastels. His brother, in charge, as in the past, of writing an article on the exhibition, did so in the form of a friendly letter to the editor, Émile Bergerat. He who up to now had abstained from any serious art criticism, could this time speak knowledgeably of the subject, and particularly so since Auguste Renoir himself must have revised his article. Edmond Renoir first mentioned that he had lived for fifteen years in the close intimacy of the painter "not only as a brother, but as a companion." He insisted especially on the absence of *convenu* in the work of Renoir and specifically wrote:

John Rewald (b. 1912), art historian whose History of Impressionism *(1946) is the pioneering work on which all subsequent studies of the subject depend. This account was given to Rewald by Edmond Renoir in conversations in Paris, 1939–40, and in writing, 1943.*

Edmond Renoir (1849–1944), Renoir's younger brother, was an editor and journalist working principally for La Presse *and* La Vie Moderne.

La Vie Moderne *was a weekly review of the arts founded by Georges Charpentier in April 1879. Its premises on the boulevard des Italiens became the venue for Renoir's first one-man show that summer.*

convenu: *the conventional or the expected.*

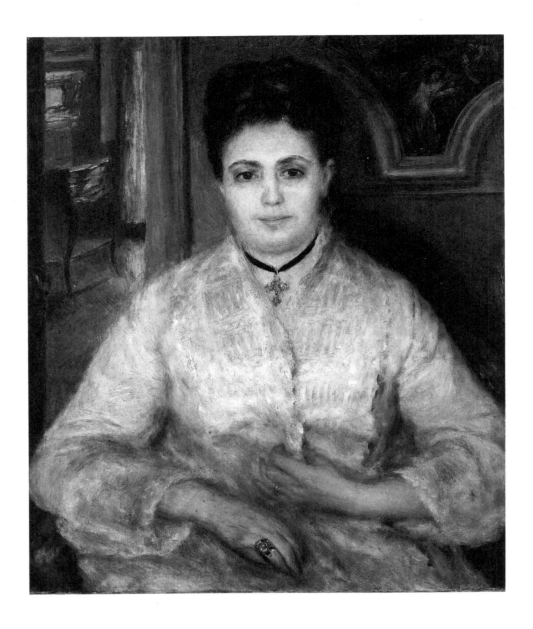

Pierre-Auguste Renoir. *Madame Chocquet.*
1875. 28¾ × 23⅜″ (75 × 60 cm).
Staatsgalerie, Stuttgart.

Does he make a portrait? He begs his model to maintain a customary
attitude, to seat herself the way she naturally does, to dress as she dresses,
so that nothing smacks of constraint and preparation. Thus his work has,
aside from its artistic value, all the charm *sui generis* of a faithful picture of
modern life. What he paints, we see every day; it is our very existence that
he has registered in the studies which are certain to remain among the
most living and most harmonious of the epoch. . . . This absence of
convenu upon which I insist so much, gives me extreme pleasure; it gives
me the impression of nature with all its unexpected and intense harmony;
it is indeed this which speaks to me, without my being obliged to reckon
with the "talent" of the artist, this "talent" which pursues us, interposing
itself and destroying all sensation. It is in following my brother's work in
its ensemble that one discovers that the manufacture, the routine, does
not exist. In none of his works, perhaps, does one find the same method of
procedure; however the work has unity, it has been entirely felt the first
day, and pursued with the unique preoccupation of achieving not a
perfection of rendering, but the most complete perception of the har-
monies of nature.

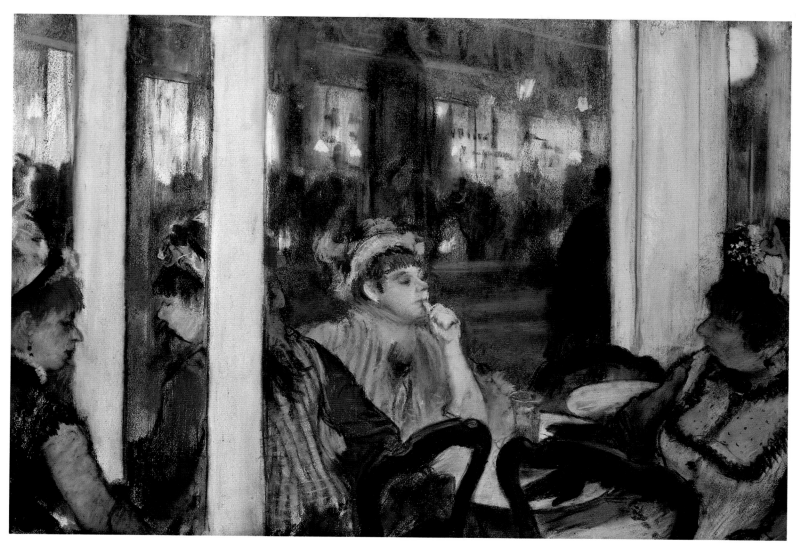

COLOURPLATE 41. Edgar Degas. *Women on a Café Terrace*. 1877. Pastel and monotype, 16 × 23½″ (41 × 60 cm). Musée d'Orsay, Paris.

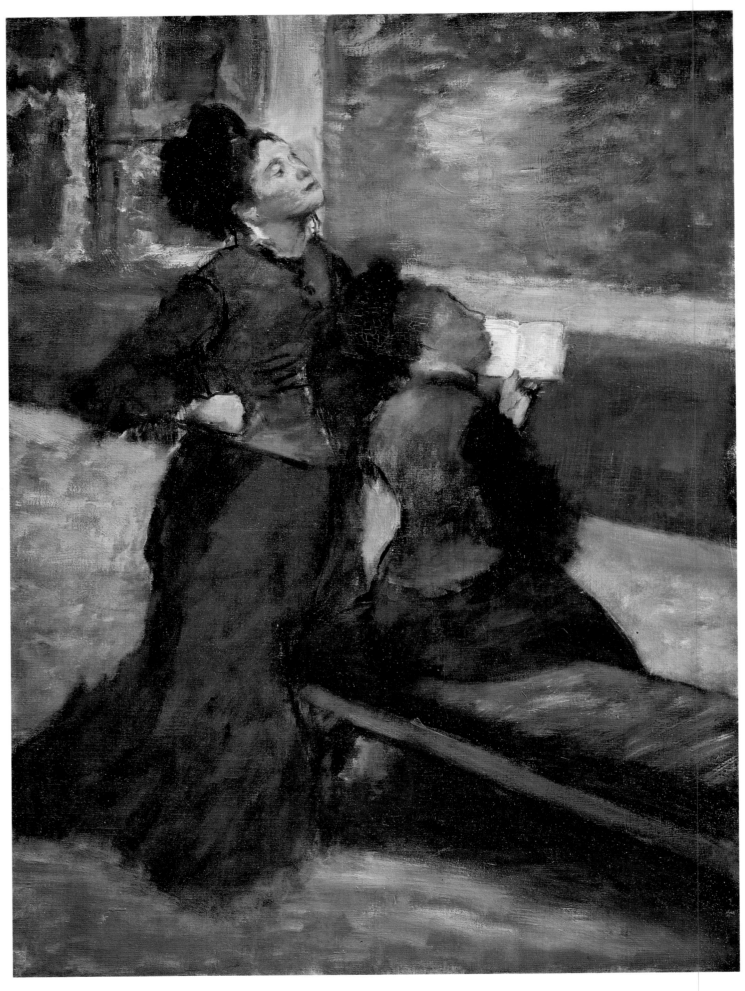

COLOURPLATE 42. Edgar Degas. *Visit to a Museum*. 1877–80. 35½ × 26″ (90 × 67 cm).
Museum of Fine Arts, Boston (Gift of Mr and Mrs John McAndrew).

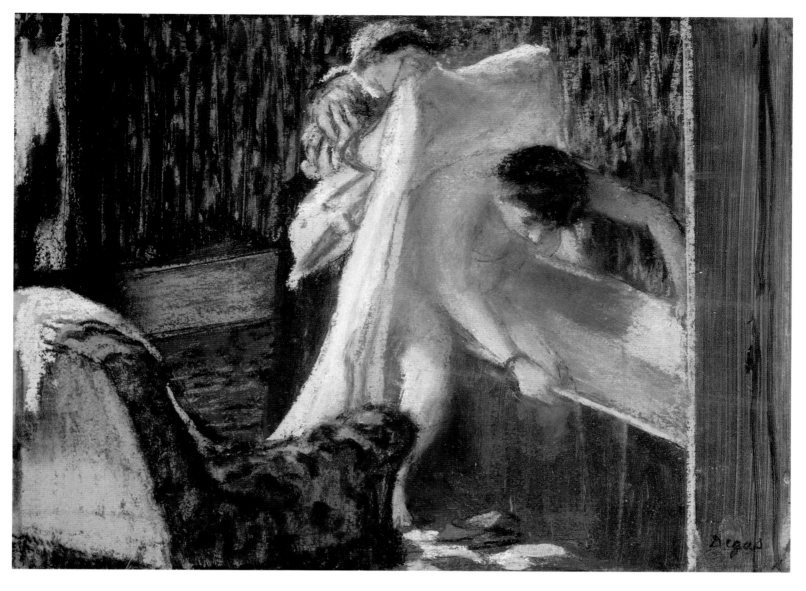

COLOURPLATE 43. Edgar Degas. *Woman Getting out of the Bath*. 1877. Pastel and monotype, 9 × 12¼″ (23 × 31 cm).
Musée d'Orsay, Paris.

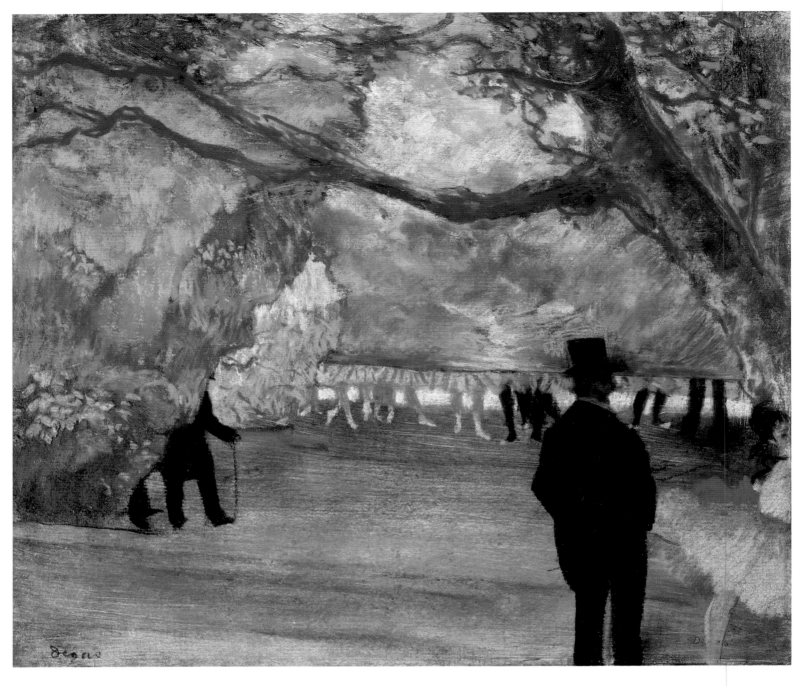

COLOURPLATE 44. Edgar Degas. *The Curtain*. *c*.1880. Pastel and monotype, 10¾ × 12¾" (35 × 41 cm).
Mr and Mrs Paul Mellon Collection, Upperville, Virginia.

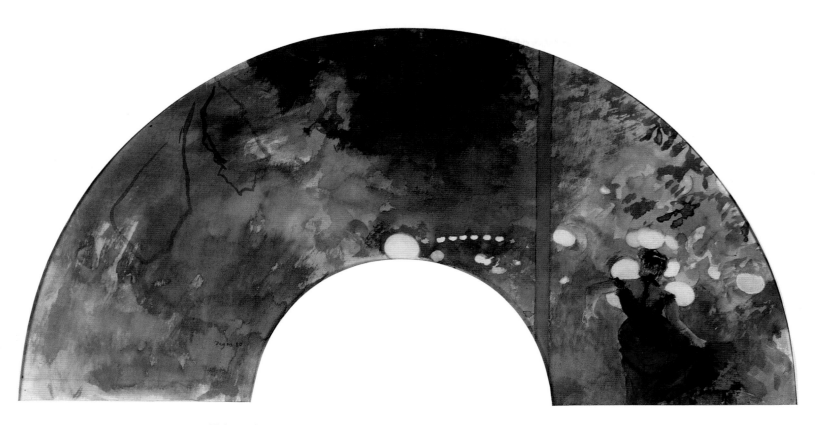

COLOURPLATE 45. Edgar Degas. *Chanteuse in a Café-Concert*. 1880. Watercolour and gouache on silk fan.
12 × 23⅞″ (30.7 × 60.7 cm).
Kupferstichkabinett der Staatlichen Kunsthalle, Karlsruhe.

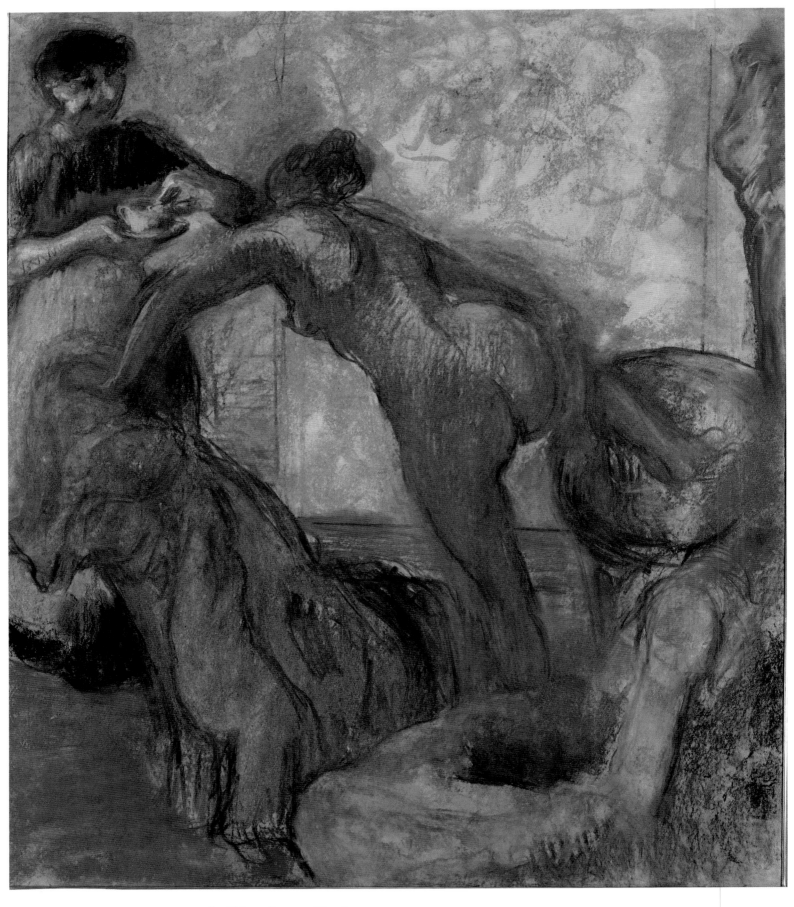

COLOURPLATE 46. Edgar Degas. *The Cup of Chocolate*. 1900–5. Pastel, 36½ × 31″ (93 × 79 cm). Öffentliche Kunstsammlung, Kunstmuseum, Basle.

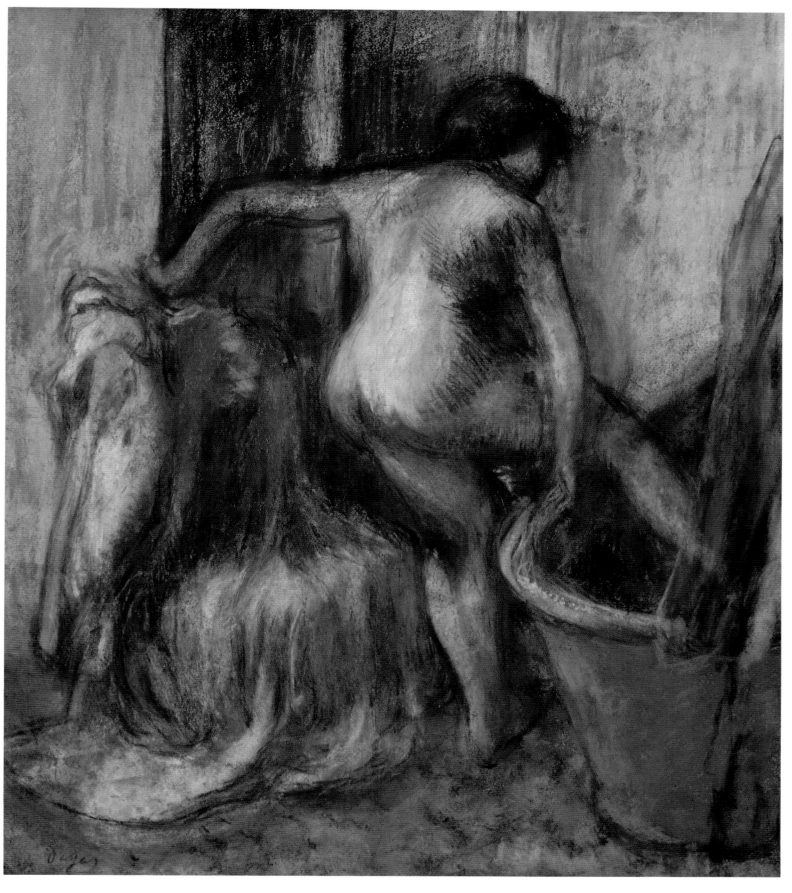

COLOURPLATE 47. Edgar Degas. *Nude Stepping out of the Bath*. 1895–1900. Pastel, 28¾ × 25″ (73 × 64 cm).
National Museum of Wales, Cardiff.

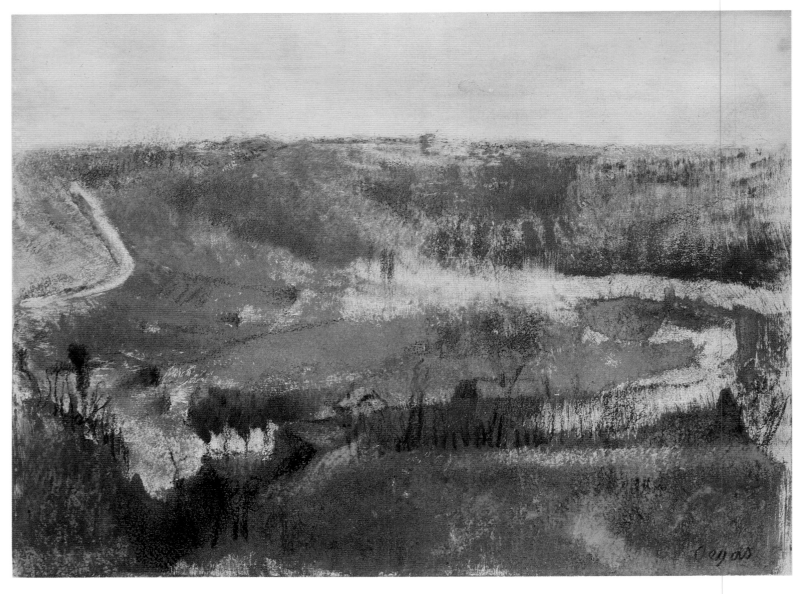

COLOURPLATE 48. Edgar Degas. *Landscape*. 1890–3. Pastel and monotype, 11⅞ × 15¾″ (30.3 × 40 cm). Museum of Fine Arts, Boston (Denman Waldo Ross Collection).

JOHN REWALD

GAZETTE DES BEAUX-ARTS
"Chocquet and Cézanne"
July–August 1969

Victor Chocquet (1821–91), a customs official with private means, a passionate collector first of Delacroix, and then of Impressionism, particularly the work of Renoir and Cézanne.

In the annals of art history, Victor Chocquet reappears on the occasion of the first Impressionist group exhibition in 1874, although in a negative way. It seems that he wished to visit the show, but was dissuaded by "well-meaning" friends. Thus he did not see, among others, Cézanne's *House of the Hanged Man*, one of the artist's three works on exhibit, which was purchased by Count Doria for 300 francs. The next year, however, Chocquet did attend the public auction organized in March by Monet, Renoir, Sisley, and Berthe Morisot. Almost fifty years later, Monet said that after the sale he was introduced to Chocquet, who had bought one of his Argenteuil landscapes for 100 francs. "It was with real tears that he said to me, 'When I think that I have lost a year, that I could have been able to know your painting one year sooner. How has it been possible to deprive me of such pleasure!'"

Unfortunately, this anecdote is contradicted by documented facts. Not only is there a letter of Monet's dated February 1876 which proves that at that time he had not yet met Chocquet, but the *procès-verbal* of the sale shows that the collector did not buy anything, even though the prices were ridiculously low. As a result of the auction, however, Chocquet is said to have discovered in Renoir's work certain affinities with the much-admired Delacroix. He reputedly wrote to the artist on the very evening of the sale to compliment him and to ask whether he would be willing to do a portrait of Madame Chocquet. Renoir immediately went to see this unexpected benefactor who received him in his rue de Rivoli apartment filled with pictures and with precious eighteenth-century furniture. Later, Renoir was to remember: "As soon as I met Monsieur Chocquet, I thought about having him buy a Cézanne! I accompanied him to *père* Tanguy's where he took a small *Study of Nudes*. He was delighted with his acquisition, and while we were returning to his home [remarked], 'How well that will go between a Delacroix and a Courbet!'"

However, the circumstances of this purchase seem to have been somewhat convoluted. According to what Renoir himself apparently later told a friend, Chocquet asked Renoir to keep the Cézanne for him, and during the following month whenever he invited the painter to dinner made it a point to ask him for his opinion of Cézanne in front of Madame Chocquet. "I have a very fine one at home," Renoir would say. "It has its defects, but it is a beautiful thing." On several occasions Renoir would bring the picture along but at the bottom of the staircase Chocquet would say, "No, no, not today." Finally, he did take it up. Madame Chocquet was horrified. "Marie, let's see, Marie, it is not mine, it is Monsieur Renoir's." But eventually Renoir took advantage of the absence of Chocquet to tell the whole story to his wife: "Act as if you didn't know anything," he suggested, "you would make him so happy."

* * *

Whether he painted a still life or a portrait there, Cézanne was obviously a frequent visitor at the Chocquet home where he not only found congenial company, but could feast his eyes on numerous oils, watercolours, and drawings by Delacroix. (Ultimately there were to be over 80 and it is likely that most of these were acquired before the collector became interested in the Impressionists.) It is one thing to admire a work of art in a museum or exhibition and another to handle it, to take it from the wall, examine it upside down or from the back, walk over to the window with it, let one's

finger glide over its surface, or to take drawings and watercolours out of the portfolios where they are protected from the light, and to spread them out, assemble them by date, or subject, or colour, or other affinities. Although Chocquet is supposed to have proudly – and rightfully – declared, "I do not need anyone to explain to me why and how I ought to like painting," one can easily imagine how avidly he listened to Cézanne's enthusiastic comments in which a great painter marvelled at the discoveries, virtuosity, and genius of a venerated master. Rivière reports that one day, when Chocquet "had laid out [some of Delacroix's works] on the living room rug to show them to Cézanne, these two supersensitive beings, on their knees, bent over the sheets of yellowed paper which for them were so many relics, began to weep."

[Rewald adds a note:] An apocryphal anecdote, published after the death of both Chocquet and his wife, seems typical of the stories that circulated in their lifetime. According to this tale, the collector one day discovered a painting by Delacroix which he was able to buy for 5,000 francs only after having scraped together his savings and borrowed money left and right. But how was he going to admit this to his wife? He told her that his purchase had cost him 700 francs, yet even at this price there were tears, reproaches, lamentations, a quarrel. One evening, however, Mme Chocquet triumphantly arrived in her husband's office, exclaiming: "I got 1,500 francs! We made a profit of 800!" – "how is that?" – "I sold the Delacroix!"

(*Opposite*) Paul Cézanne. *Portrait of Victor Chocquet. c.*1877. 13⅞ × 10¾" (35.2 × 27.3 cm). Virginia Museum of Fine Art, Richmond, Virginia (Gift of Mr and Mrs Paul Mellon).

This anecdote appeared in the July 2 edition of Le Gaulois, *1899.*

Paul Cézanne. Study for *The Apotheosis of Delacroix*. 1891–4. 10⅝ × 15" (27 × 35 cm). Musée Granet, Aix-en-Provence.

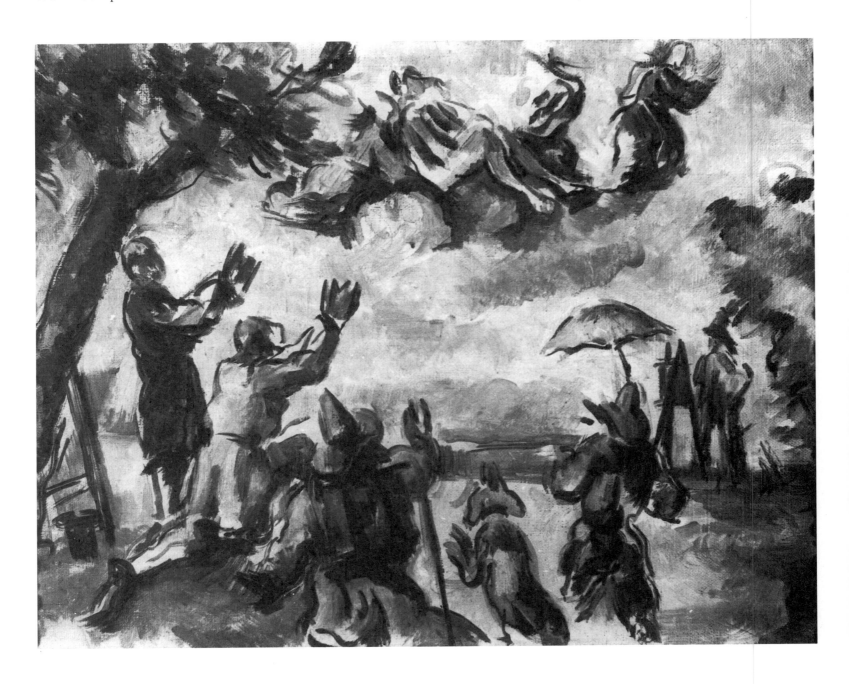

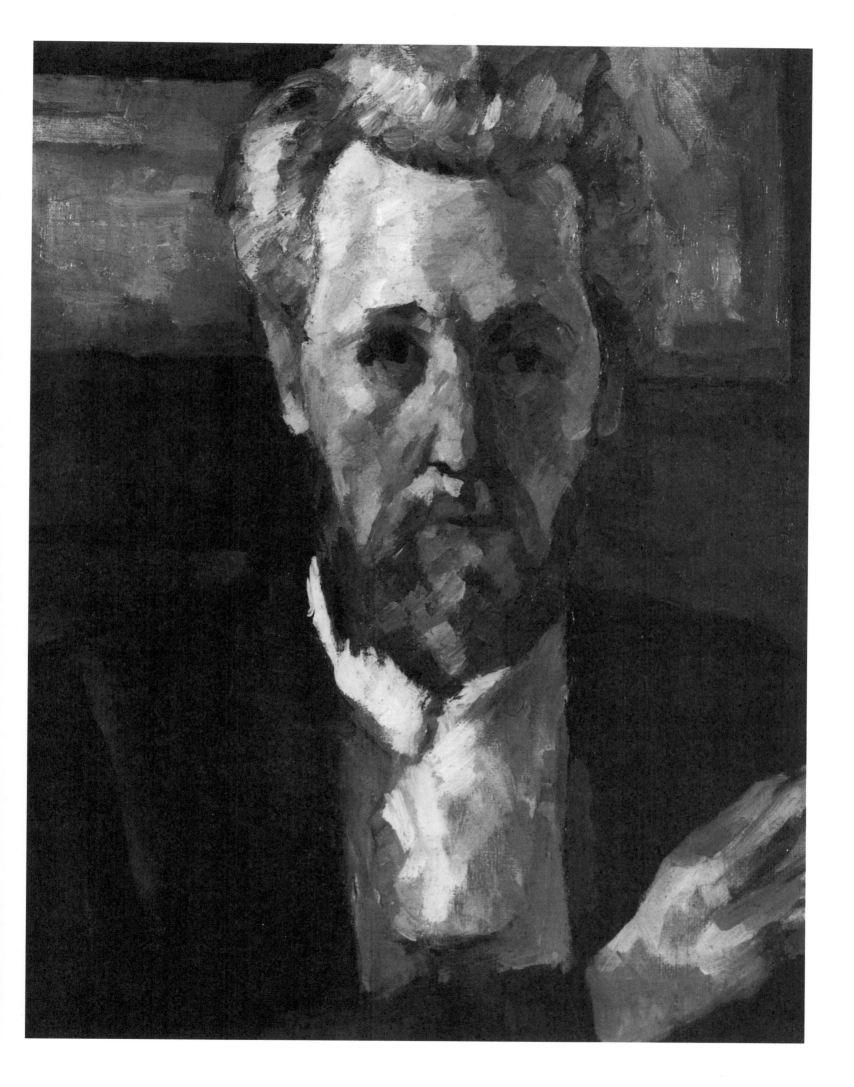

JACQUES DE BIEZ

ÉDOUARD MANET. CONFÉRENCE FAITE À LA SALLE DES CAPUCINES

Manet's Realism

January 22, 1884

Jacques de Biez (1852–1915), journalist, art critic, and historian, delivered this lecture on Manet at the Salle des Capucines to coincide with Manet's posthumous exhibition at the Ecole des Beaux-Arts.

As I understand it, Manet is a less powerful analyst than the author of the Rougon-Macquart. If he is working with the living document, he does not slash at it with sabre cuts. Zola persists, tries again, delves and delves once more into all the unexplored corners. Less deep than his critic, Manet has an attitude of delicate tenderness which is quite unlike the general tone of Emile Zola's novels. If we were to have to find a true equivalent for him in the world of letters, we would perhaps have to look to the Goncourts when they write of life in the eighteenth century. Like them, he proceeds using a delicate, elegant, vivid, brilliant (and very French) type of synthesis of the external aspects of the aristocratic France of the last century.

The title given to the cycle of 20 novels written (1871–83) by Émile Zola.

The quintessential French spirit is of this temper, it is clear and moves rapidly over the surface of things. It is quick-witted. It understands immediately. No need to insist too much, that wearies it. Any superfluity of explanatory details stuns it, numbs it. To a German who might proffer 20 volumes of notes to explain Molière, it replies that it can't abide the slogging approach, and that it learns far more from going to see a performance of *Le Misanthrope*.

In order to know what Manet might have done had he been a man of letters, one might turn to this delicious picture of an omnibus in *Manette Salomon*, "that contraption which gives the impression of moving forward and yet is constantly stopping," which is in fact given by a painter, Coriolis. Here everything is written in terms of light, of shifting patches of colour, glimpses of passing forms, shadows, waves, touches, which are as it were the plastic expression of things seen.

Manette Salomon *by Edmond and Jules de Goncourt was published in 1866.*

". . . I had finished spelling out those lowering advertisements, the Étoile candle, Collas benzene. I was staring dully at houses, streets, shadowy masses, things lit up, gas jets, shop windows, a little pink woman's shoe in a watch on a glass shelf, little things, nothing really, just whatever passed by. . . . I had reached a point where I was mechanically following the endless flow of shadows of people as they passed across the shutters of closed shops . . . a series of silhouettes. . . . Opposite me I had a man with glasses who was doggedly trying to read a newspaper . . . there were always reflections in his glasses. . . .

"Have *you* noticed how mysteriously pretty women look, at night, in carriages? . . . They seem to have something shadowy, ghostly, mask-like about them . . . a veiled look, a voluptuous appearance, things one can guess at and not clearly see, a vague hue, a night smile, with lights falling on their features, all those half-reflections which swim beneath their hats, the great touches of black they have in their eyes, their very skirts, so full of shadows. . . . This is how she appeared . . . elegant and eyes lowered. . . . The light of the lantern shone on her forehead (which had the silkiness of ivory) . . . and cast a sprinkling of light on to the roots of her hair, which looked like floss in sunlight. . . . Three touches of brightness, on the line of the nose, on a cheek-bone, on a chin tip . . . then, total eclipse . . . she has turned her back to the lantern. . . . Her face opposite me is an intense patch of darkness. . . . Nothing now except a shaft of light on a corner of her temple and a tip of her ear where a little diamond button glints fiercely. . . . The Carousel, the embankment, the Seine, a bridge with plaster sculptures on

Édouard Manet. *At the Café, study of legs.*
*c.*1880. Watercolour, 7¼ × 4¾″ (18.5 ×
11.9 cm). Musée du Louvre (Cabinet des
Dessins), Paris.

the parapet . . . then dark streets with glimpses of laundry women working
by candlelight . . .''

Compare this style, which I regard as close to that of Manet, with Zola's
turn of phrase, which often has the weightiness, the heaviness of a lead being
crushed. Here the line is less evident, less heavy to the eye. It lightens under
the rattle of the words, almost disappears, just as Manet's line fades as the
patch of light takes flight. To tell the truth, I find nothing in the Goncourts'
work of the magisterial realism of *L'Assommoir* and *La Curée*. Their realism as
they describe both our century and the previous one offers the eye and the
taste a savour and harmony of artistic elegance, distinction and scepticism,
full of reminiscences of La Tour's pastels, with their bright velvety touches,
very similar to the glowing, mellow downiness of those of Manet.

The de Goncourt brothers, Edmond
(1822–96) and Jules (1830–70), wrote on
18th-century French painting and, in the
1860s, novels of contemporary life. The
well-known Journal des Goncourts, *which*
they began together in 1851, was continued by
Edmond after his brother's death.

GEORGES JEANNIOT

LA REVUE UNIVERSELLE

"Memories of Degas"

October 15 and November 1, 1933

Georges Jeanniot (1848–1934), painter, illustrator and member of Degas's circle of friends. His recorded accounts of Degas's remarks constitute an important primary source.

"It is very good to copy what one sees; it is much better to draw what you can't see any more but in your memory. It is a transformation in which imagination and memory work together. You only reproduce what struck you, that is to say the necessary. That way, your memories and your fantasy are freed from the tyranny of nature. This is why pictures made in such a way, by a man who has a cultured memory and knows the old masters and his craft, are almost always remarkable works – look at Delacroix."

During this conversation, we were going up the stairs at the Louvre.

"Did you see, a while ago," he said to me, stopping when we were in front of the Medici Venus, "that she is out of the vertical? She is in a position which she could not hold if she were alive. By this detail, a fault according to people who know nothing about art, the Greek sculptor gave his figure a splendid movement, while still retaining the calm which characterizes masterpieces."

* * *

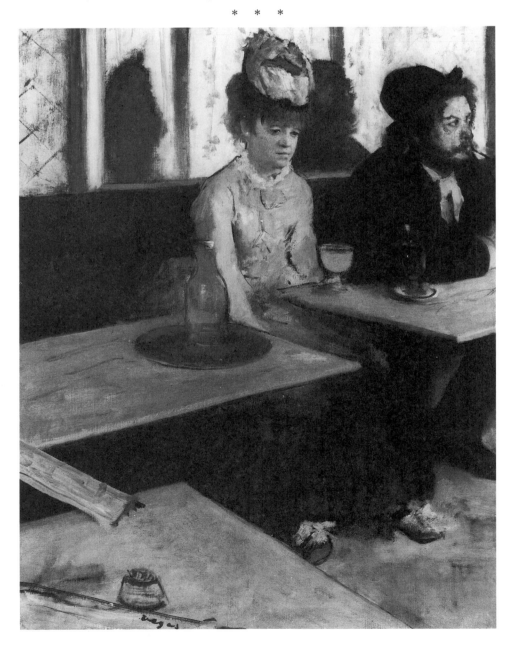

Edgar Degas. *Absinthe*. 1876. 36¼ × 26¾″ (92 × 68 cm). Musée d'Orsay, Paris.

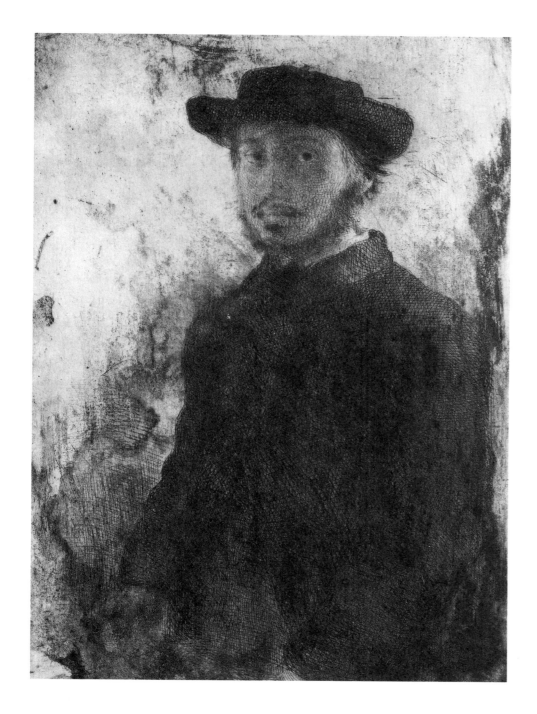

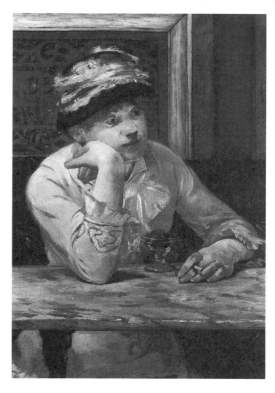

"It has to be said, we are living in strange times: this oil painting we are doing, this very difficult craft we are practising without knowing it! Such incoherence has probably never been seen before."

* * *

"Oh! Women can never forgive me; they hate me, they can feel that I am disarming them. I show them without their coquetry, in the state of animals cleaning themselves!"

"You think they don't like you?"

"I am sure of it; they see in me the enemy. Fortunately, for if they did like me, that would be the end of me!"

* * *

"At the moment, it is fashionable to paint pictures where you can see what time it is, like on a sundial, I don't like that at all. A painting requires a little mystery, some vagueness, some fantasy. When you always make your meaning perfectly plain you end up boring people. Even working from life, you must compose. Some people think it is forbidden!

"On this subject, Monet told me: 'When Jongkind needed a house or a tree, he would turn round and take them from behind him.'"

AMBROISE VOLLARD

DEGAS. AN INTIMATE PORTRAIT

"Some of Degas' Views on Art"

1937

Ambroise Vollard (*1868–1939*), dealer,
writer and publisher. He was instrumental in
promoting the careers of many artists of the
Impressionist generation, and along with
Durand-Ruel was one of the great dealers of
the period. He wrote memoirs of the lives of
Cézanne, Renoir and Degas.

Knowing the difficulty Degas had in making up his mind to leave his studio,
I was not a little surprised when he informed me that he was going to spend a
fortnight with his friend Monsieur Henri Rouart at La Queue-en-Brie.

"I ought to be able to get a few landscapes out of it," he said. "Will you
come to see me there?"

I was only too glad to accept his invitation. When I had arrived at La
Queue, Monsieur Rouart's gardener directed me to a pavilion, where, on
the door-step, I saw an old man with thick glasses, dressed in denim trousers
and a straw hat. No one would ever have suspected that this mild figure was
the terrible Degas.

"I've been outside long enough," he said, as I approached. "There's still
a few minutes before lunch; I'm going to work a little more."

I made as if to go, but he stopped me. "Oh, you can come with me. I'm
only doing landscape at present."

Henri Rouart (*1833–1912*), industrialist and
collector of works by Degas, as well as one of
his closest friends. An amateur artist, he
contributed to seven of the Impressionist
exhibitions.

I followed him into a little studio he had fixed up for himself on the
grounds. He turned his back to the window and began to work on one of his
extraordinary out-of-door studies.

I could not get over my surprise at this method of doing a landscape
indoors, and when I mentioned the fact, Degas replied:

"Just an occasional glance out of the window is enough when I am
travelling. I can get along very well without even going out of my own house.
With a bowl of soup and three old brushes, you can make the finest
landscape ever painted. Now take old Zakarian, for example. With a nut or
two, a grape and a knife, he had material enough to work with for twenty
years, just so long as he changed them around from time to time. There's
Rouart, who painted a watercolour on the edge of a cliff the other day!
Painting is not a sport. . . ."

"As I was walking along Boulevard Clichy the other day," I said, "I saw a
horse being hoisted into a studio."

"Degas picked up a little wooden horse from his work table, and
examined it thoughtfully.

"When I come back from the races, I use these as models. I could not get
along without them. You can't turn live horses around to get the proper
effects of light."

"What would the Impressionists say to that, Monsieur Degas?"

Degas replied with a quick gesture:

"You know what I think of people who work out in the open. If I were the
government I would have a special brigade of gendarmes to keep an eye on
artists who paint landscapes from nature. Oh, I don't mean to kill anyone;
just a little dose of bird-shot now and then as a warning."

"But Renoir paints out in the open air, doesn't he?" I queried.

"Renoir is a law unto himself. He can do anything he likes. I have a
Renoir in my studio in Paris I'll show you some time. Lord, what acid tones
it has!" Degas was suddenly silent, then:

"Renoir and I do not see each other any more," he said.

PAUL VALÉRY

DEGAS, DANSE, DESSIN

"Work and Beware; Horse, Dancer, Photograph"

1936

Paul Valéry (1871–1945), poet, philosopher and critical writer who belonged to the 1890s circle of artists and writers including Renoir, Degas, Morisot, Redon and Mallarmé, the principal influence on his poetry. He married Jeannie Gobillard, Berthe Morisot's niece.

Every work by Degas was done in earnest.

However comic, however playful it may appear at times, his pencil, his pastel chalk, his brush never relaxes. The will is all-powerful. His stroke is never *near* enough for him. He never attains the eloquence, or the poetry of painting; his whole search is for accuracy in style, and style in accuracy. His art is in the tradition of the moralists: the clearest prose enclosing, forcefully articulating some new and verifiable observation.

For all his devotion to dancers, he *captures* rather than cajoles them. He defines them.

He is like a writer striving to attain the utmost precision of form, drafting and redrafting, cancelling, advancing by endless recapitulation, never admitting that his work has reached its *final* stage: from sheet to sheet, copy to copy, he continually revises his drawing, deepening, tightening, closing it up.

At times he turns back to these trial sketches, adding colours, mingling pastel with charcoal; in one version the petticoats may be yellow, in another purple. But the prose, the line and movement are always implicit, essential, distinguishable, usable in other designs. Degas was one of that family of abstract artists who separate form from colour or from subject. I believe he would have been afraid of letting his hand go on the canvas, of surrendering to the joy of actual painting.

He was an excellent horseman who did not trust horses.

A horse walks on its toes. Four hoofs, like toenails, support it. No animal is closer to a *première danseuse*, a star of the corps de ballet, than a perfectly balanced thoroughbred, as it seems to pause in flight under the hand of its rider, and then trips forward in the bright sunshine. Degas painted it in a single line of a poem:

Tout nerveusement nu dans sa robe de soie.

The line occurs in a fine sonnet in which Degas, for pastime, has deployed all his skill to display every aspect and function of the race-horse: the training, the pace, the betting and cheating, the beauty, the supreme elegance.

He was among the first to study the real positions of the noble animal in movement, in the "instantaneous" photographs taken by Major Muybridge. For he had a liking and appreciation for photography at a time when artists still despised, or dared not admit they made use of it. He took some very fine ones himself: and I still treasure one particular enlargement he gave me.

It shows Mallarmé leaning against the wall, close by a mirror, with Renoir sitting opposite on a divan. In the mirror you can just make out, like phantoms, Degas and the camera, Mme and Mlle Mallarmé. This masterpiece of its kind involved the use of nine oil lamps . . . and a fearful quarter-hour of immobility for the subjects. It has the finest likeness of Mallarmé I have ever seen, apart from Whistler's admirable lithograph, which involved another ordeal for its subject, endured with all the good grace in the world: for numbers of sittings, he had to pose almost glued to a stove – roasted, but not daring to complain. The result was worth this martyrdom. No portrait could be more delicate, more *spiritually* like, than that one.

"naked and shivering with nerves in his silk coat."

Eadweard Muybridge (1830–1904), an English photographer working in America whose experimental high-speed techniques were important for the early photographic study of movement. His photographs of animals were known in Paris in the 1870s and changed the conventional artistic portrayal of the galloping horse (the rocking-horse gallop). Animal Locomotion was first published in 1887.

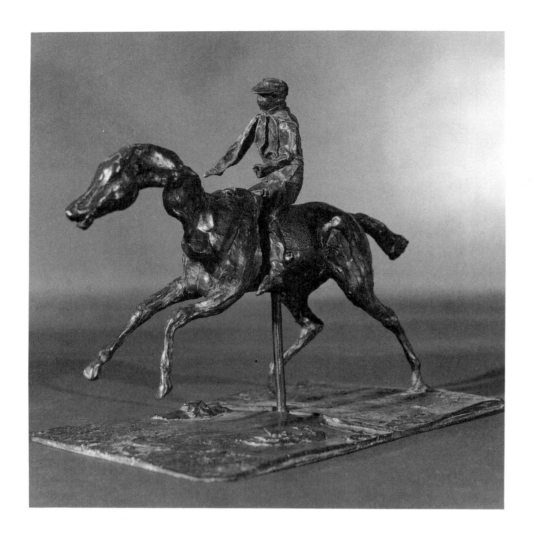

Edgar Degas. *Horse with Jockey*. 1880. Bronze, height 11¼" (26 cm). Norton Simon Art Foundation, Pasadena, California.

Muybridge's photographs laid bare all the mistakes that sculptors and painters had made in their renderings of the various postures of the horse.

They showed how inventive the eye is, or rather how much the sight elaborates on the data it gives us as the positive and impersonal result of observation. Between the state of vision as mere *patches of colour* and as *things* or *objects*, a whole series of mysterious operations takes place, reducing to order as best it can the incoherence of raw perceptions, resolving contradictions, bringing to bear judgments formed since early infancy, imposing continuity, connection, and the systems of change which we group under the labels of *space*, *time*, *matter*, and *movement*. This was why the horse was imagined to move in the way the eye seemed to see it; and it might be that, if these old-style representations were examined with sufficient subtlety, the *law* of unconscious falsification might be discovered by which it seemed possible to picture the positions of a bird in flight, or a horse galloping, as if they could be studied at leisure; but these interpolated pauses are imaginary. Only *probable* positions could be assigned to movement so rapid, and it might be worth while to try to define, by means of documentary comparisons, this kind of *creative* seeing by which the understanding filled the gaps in sense perception.

PAUL MANTZ

LE TEMPS

"Exposition des Oeuvres des Artistes Indépendants"

April 23, 1881

The true and only sculptor of the intransigent academy is M. Degas. Along with a few pastels, which will do nothing to augment his fame, he is exhibiting the *Little Dancer of Fourteen*, the little wax statue he had long promised us. Last year M. Degas had restricted himself to showing us

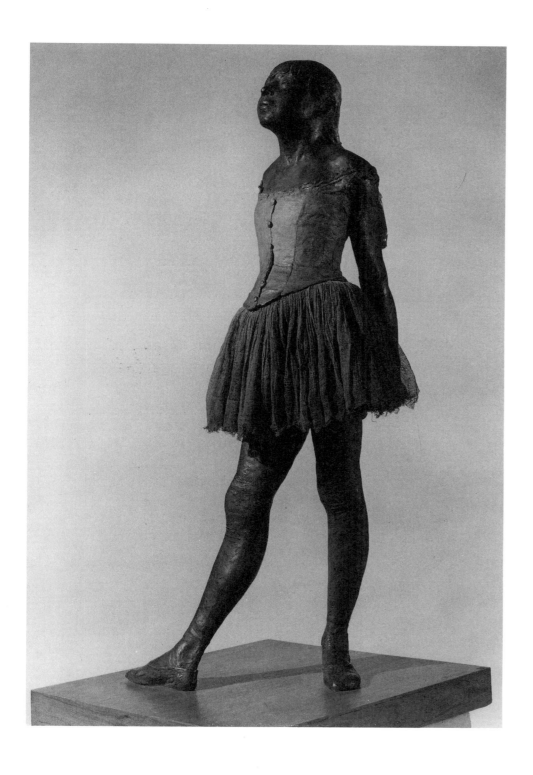

Edgar Degas. *The Little Dancer of Fourteen.* *c.*1881. Bronze, silk, satin ribbon, hair, height 38¾″ (98.4 cm). Tate Gallery, London.

the glass case intended to serve as haven for this figurine; but sculpture is no impromptu art: M. Degas wanted to perfect his work and we all know that Michelangelo himself required time to model a form and bring it alive.

The piece is now finished and, we may as well admit as much forthwith, the result is almost alarming. We walk around this little Dancer, and we are not reassured. This statuette will no doubt give rise to a little favourable criticism and much adverse comment; we had been warned; but she remains utterly unexpected in her out-and-out realism. The hapless child is standing, wearing a cheap gauze dress, a blue ribbon round her waist, her feet shod in those supple shoes which facilitate the first exercises of elementary choreography. She is at work. Chest thrown forward, already a little weary, she is holding her arms stretched stiffly behind her back. Unnerving in her blankness, she thrusts forward her face, or rather her little muzzle (that is indeed the word) with animal effrontery, for this poor little girl has something of the rat about her. Why is she so ugly? Why are her lips and forehead, half-covered by her hair, already marked with so deeply vicious a character? M. Degas is probably a moralist. He may know things about the dancers of the future that we do not know. He has plucked a precociously depraved flower from the trained ranks of the theatre, and he presents it to us, withered before its time. The intellectual aim is achieved. Upon contemplation of this waxen creature, the bourgeoisie are stunned for a moment, and one hears fathers exclaim: "God forbid that my daughter should become a *sauteuse!*"

Yet something in this disagreeable figurine is clearly the work of an honest and observant artist, guided by the spirit of a Baudelairean philosopher: namely, the utter accuracy of the whole posture, the exactitude of the almost mechanical movement, the artificial grace of the pose, the raw inelegance of the schoolgirl who will become a woman for whom diplomats will commit imprudences. The facial expression is clearly intentional. M. Degas has set himself an ideal of ugliness. Happy man! He has attained it. Certain details are well rendered: the arms have the desired thinness and youthfulness, though they could be a little more strongly modelled and – here I speak as a mere Philistine – they could be cleaner. It is not essential for a wax figure to have the gleaming pink cleanliness of those dolls which rotate in hairdressers' windows; but since naturalism still reigns supreme, it is only reasonable that life-like forms should wear life-like colouring. Furthermore, how might one persuade the onlooker that Terpsichore's small apprentices have never heard tell of that naïve art which consists in washing one's arms and hands? The blemishes, the blotches and pockmarks which M. Degas has inscribed on the flesh of this unfortunate girl are truly horrible to behold, and they run counter both to the principles of the school and to the desired optical effect, since the result is in fact a diminished power of illusion. What then may still be said in favour of the *Little Dancer*? We may admire the singular truth of the general movement, the instructive ugliness of a face where every vice has left the mark of its loathsome promise. The spectacle is not without eloquence; but it is disturbing. How ideals do differ! Many artists pursue a soothing, dream-inspiring grace; others, less consolatory, are seduced by fear. M. Degas is implacable. If he continues to make sculpture and retains his present style, he will earn a modest place in the history of the cruel arts.

"rat": *pupil of the Opéra ballet.*

"sauteuse": *a "leaper" or "tumbler", but also a prostitute.*

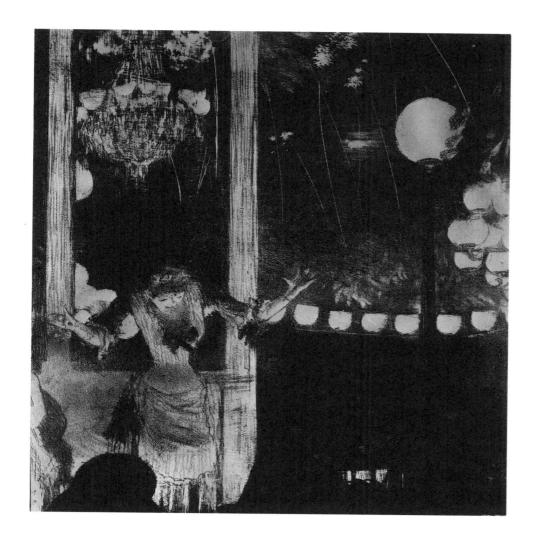

Edgar Degas. *Mlle Bécat at the Ambassadeurs. c.*1877. Lithograph, 8 × 7½″ (20.5 × 19.3 cm). Metropolitan Museum of Art, New York (Rogers Fund, 1919).

J.-K. HUYSMANS

L'ART MODERNE

"The 1881 Exhibition of the Indépendants"

1881

Joris-Karl Huysmans (1848–1907), novelist and art critic. At first the writer of proletarian novels under the influence of Zola, in the 1880s he became an arch-spokesman for the Symbolist movement with his novel À Rebours *("Against Nature"), 1884.*

M. Degas has proved himself singularly niggardly. He has contented himself with exhibiting a view of the wings, with a gentleman tightly clasping a woman, virtually gripping her legs between his thighs, behind an upright lit by the red glow of the briefly glimpsed auditorium, and several drawings and sketches representing dancers on stage, pointing feet which move like those of grotesque Dresden china figures and apparently blessing the heads of the musicians above whom the neck of a cello emerges in the foreground like an enormous figure five, or contorting themselves showily into those inept convulsions which have earned near-celebrity status for the epileptic doll, la Bécat.

Add to these two more sketches: faces like those of criminals, boorish faces, with low foreheads, protruding jaws, short chins, shifty eyes devoid of lashes, and a most astonishing naked woman at the back of a room, and you will have the sum total of the drawings and paintings contributed by this artist.

Degas's personality permeates both his most casual sketches and his most finished works; his terse and sensitive draughtsmanship, as striking as that

of the Japanese, a movement caught in mid-flight, an attitude captured, are his and his alone; but this year it is not his drawing or painting that is interesting, for these add nothing to what he exhibited in 1880, and which I have already described; it lies entirely in a wax statue called *Little Dancer of Fourteen* before which the public flees in bewildered embarrassment.

The terrible reality of this small statue visibly disconcerts them; all their ideas on sculpture, on that cold inanimate whiteness, on those memorable clichés copied throughout the ages, are overturned. The fact is that M. Degas has toppled the traditions of sculpture at a stroke, as he has already shaken the conventions of painting.

Though M. Degas adopts the methods of the old Spanish masters, the originality of his talent immediately makes it entirely individual, entirely modern.

Like certain robed and painted Madonnas, like the Christ in Burgos cathedral whose hair is real hair, whose thorns are real thorns, whose drapery is real material, M. Degas's little dancer has real skirts, real ribbons, a real bodice and real hair.

The painted head, thrown slightly backward, chin in air, mouth slightly open in the sickly grey-brown face, which is drawn and old beyond her years, her hands joined behind her back, her flat chest tightly encased in a white waxen bodice, her legs positioned ready for the fray, wonderful legs, broken in by exercises, muscular and contorted, topped by the muslin canopy of her skirts, her neck straining and surrounded by a pale green ribbon, her hair falling down her back, her chignon, decked with a ribbon matching the one round her neck, sporting real hair – such is this dancer who comes to life before one's very gaze, and seems about to leave her plinth.

Both refined and barbaric, with her ingenious costume, her coloured, breathing flesh, furrowed by the work of the muscle beneath, this little statue is the only true bid for modernity in sculpture that I know.

GUSTAVE GEFFROY

LA JUSTICE
"M. Degas"
May 26, 1886

Gustave Geffroy (1855–1926), art critic, novelist and journalist. He began his career on Clemenceau's paper La Justice *and became interested in Impressionism in the late 1870s. His closest connection was with Monet, whom he met in 1886.*

Here is another artist whose situation is exceptional. His name is known to a somewhat restricted world of painters and literary types. But even within this particular world, which is quite up-to-date with the development of talents and daily production, the work of M. Degas is more divined than known. The man is mysterious and sardonic; he bolts his door and sports an absolute disdain for public discussion. He has forged himself a double existence: one is that of a blithe and observant man-about-town who circulates, all deceptive smiles and baffling words, through the thick of social and artistic happenings; the other is that of the recluse, immured with models and sketches, and grimly pursuing colour conjunctions and unexpected combinations of line. Thus he is piling up material, accumulating an enormous range of documentation, composing a dictionary of details which, when called into being, would immediately provide the whole of a decorative oeuvre, possibly the most original and personal of the second half of the nineteenth century. Whence comes it that this artist – with his unique knowledge of the curve of the human form, of the ceilings and promenades of music and dance theatres, of the vestibules and halls of the Turkish bath – has never been vouchsafed hanging space in the gallery of some modern building, or the salon of some newly built house? In such places he could

have displayed his special knowledge of the animal grace of the girls at the Opéra, the elegant leanness of the race-horse, the demeanour of the working girl at her task, the costume and the déshabillé of the woman of today. But no, all we have seen of Degas (and this at a few dealers or at the occasional exhibition) are mere fragments of series, mere pencil sketches of outlines, mere beginnings and summaries. Is there not too much reserve here, an excessive distrust for the judgement of others, an excessive partiality for solitude? Would it not be to his advantage to dust down the works he has accumulated, to empty his studio into some gallery, to enter the fray from time to time? He would undoubtedly have to undergo unjust attacks, run up against incomprehension and ill-will. But even if the artist found himself almost alone in the face of hostile crowds, he would emerge informed, enlightened by the criticism of his work, by the overall review of his efforts and achievements.

This year, M. Degas has departed a little from his excessive discretion. One may see as many as nine pastels at the rue Lafitte: a *Portrait* where the face and hand, though very soberly treated, achieve the most complicated expression; some *Little Shop-girls*, dry, dark, sharp, adjusting hats with a simian, workaday grace; a *Woman Trying on a Hat at the Milliner's*, dressed in colours of a muted richness, raising her arms with the same simplified gesture, an astounding silhouette reminiscent of a figure in a fresco standing out against a background of gold; and, lastly, to use the catalogue's very precise description, a *Series of Nudes of Women Bathing, Washing, Drying, Rubbing Down, Combing their Hair or Having it Combed*. It is these last pieces, six in number, which may offer the surprised spectator the clearest and finest idea of this great and unapproachable talent. Because there are undoubtedly surprises in store for eyes accustomed to flesh seen as wood, as sugar, as lather, as alabaster, as rose-tinted mother of pearl, to flesh that has been pared, blanched, buffed, spun, flesh in accordance with the academic or society formula, of the kind that is hung in profusion 'on the line' at Salons and polite exhibitions. But if it is a faithful spirit which is compelling the spectator's gaze – offended at first by the attitudes and colouring of the woman it is being asked to contemplate – then a sudden change will occur and sincerity and truth will emerge. Without need for recourse to artistic precedents, without any mention of Rembrandt's *Bathsheba*, one may easily imagine the painter confronted with realities of this kind and striving to transcribe them through the visible sign of draughtsmanship and colour. It is indeed woman we see here in these six poses, but woman expressionless, without the play of the eye, without the camouflage of costume, woman reduced to gesture, to the sole appearance of her body, woman considered as a female, expressed through her animal nature alone, as though this were a treatise on zoology demanding superior illustration. The draughtsman has rejected the usual model poses, feet together, arms making rounded movements, hips in evidence, waist pleasingly twisted. Fascinated by lines overlooked, indeed positively shunned, Degas wanted to paint the woman *who does not know that she is being looked at*, as one would see her, hidden by a curtain or through a keyhole. It is thus that he has succeeded in seeing her, bending, standing up in her tub, feet reddened by the water, sponging the nape of her neck, raising herself on her short sturdy legs, stretching out her arms to put on her chemise, drying herself, kneeling, with a towel, head lowered and rump protruding, or leaning over on her side. He has looked at her, from floor level – a floor cluttered with scissors, brushes, combs, hairpieces – and he has concealed nothing of her frog-like bearing, the ripeness of her breasts, the heaviness of her nether regions, her twisted, bandy-looking legs, the length of her arms, the amazing appearance of stomach, knees and feet in unexpected foreshortenings. It is thus that he has written this heart-rending and pitiful poem to flesh, as an artist enamoured of the great lines which envelop a figure from head to toe, as an expert familiar with the positions of the bones, the play of the muscles, the tautening of the ligaments, the marbling and the denseness of the skin.

Degas: Petites Modistes *(1882), Nelson-Atkins Museum of Art, Kansas City, Missouri.*
Woman Trying on a Hat at the Milliner's *(1882), Metropolitan Museum of Art, New York.*
Ten pastels of these subjects were listed in the catalogue, of which at least six were exhibited.

Edgar Degas. *Seated Nude Drying her Neck and Back*. 1890–95. Charcoal and pastel on tracing paper, 47½ × 39¾" (121 × 101 cm). Staatsgalerie, Stuttgart (Graphische Sammlung).

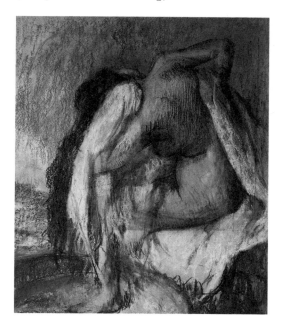

J.-K. HUYSMANS

CERTAINS

Degas's Pastels of Women

1886

You may be certain too that those artists whose stay-at-home mentality and home-loving imaginations cause them to cleave to the present time (if they are superior spirits and not those inferior souls for whom alone the method inaugurated by M. Taine is suited), feel a loathing no less intense, a contempt that is no less certain.

Then their art develops in a different way; it becomes concentrated and digs in its heels, and they paint teasing or savage works portraying the milieu they abhor, that milieu whose ugliness and shame they scrutinize and express.

This is the case with M. Degas.

This painter, the most personal, the most penetrating that this hapless country possesses without even knowing it, has voluntarily withdrawn from individual exhibitions and public places. At a time when painters are wallowing in the trough of publicity, he has retired from the fray to create, in silence, some incomparable pictures.

Some were exhibited, like an insulting farewell, in a house on rue Laffitte in 1886.

These were a series of pastels described in the catalogue as: "Series of female nudes bathing, washing themselves, drying themselves, wiping themselves or having their hair combed."

M. Degas, whose admirable pictures of dancers had already so implacably rendered the degeneration of the female hireling stupefied by mechanical frolickings and monotonous leapings, has brought an attentive cruelty and a patient hatred to bear on his studies of nudes.

Apparently exasperated by the baseness of those around him, he wanted to exact some form of reprisal and to hurl the most flagrant insults full in the face of his century by knocking down that ever delicately treated idol, woman, whom he duly debases when he represents her in her bath-tub, in the humiliating postures of intimate ablution.

The better to concentrate his deflations, he chooses his woman fat, short and pot-bellied, that is, he drowns the grace of her outline beneath tubular rolls of skin, so that she loses all bearing and elegance from the sculptural point of view; whatever class of society she may actually belong to, she becomes a charcutière, a butcher's wife, in a word a creature whose vulgarity of figure and whose coarseness of feature counsel continence and arouse horror!

Here we see a red-head, dumpy and over-fed, bending forward so that the bone of her sacrum protrudes from the taut roundness of her buttocks; she strains in an effort to get her arm behind her shoulder so as to press the sponge which is dripping down her spine and the small of her back; there, a thick-set blonde is standing, also with her back to us; she has finished her work of maintenance and, pressing her hands against her rump, she stretches with the rather masculine movement of a man warming himself at a fireplace, lifting his coat-tails; then we have a great lump of a girl, squatting; she is leaning to one side, balancing on one leg; she slips an arm underneath it and attains her aim in the zinc bath; finally, a woman seen front view, this time drying her stomach.

Such, briefly, are the pitiless poses assigned by this iconoclast to the being hymned in a thousand empty gallantries. These pastels have about them something of the stump of the maimed, the rolling gait of the legless cripple,

Hippolyte Taine (1828–93), aesthetic philosopher and principal exponent of the notion of positivism in the arts. His Philosophie de l'art *was published in 1881.*

The eighth Impressionist exhibition was held at 1 rue Laffitte from May 15 to June 15, 1886.

Edgar Degas. *The Customer.* 1876–85. Monotype, 8½ × 6¼" (21.5 × 15.9 cm). Musée du Louvre, Paris (Cabinet des Dessins).

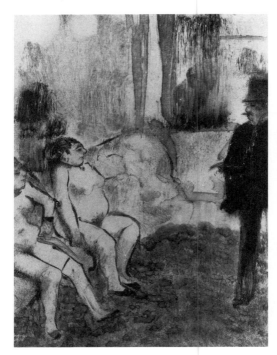

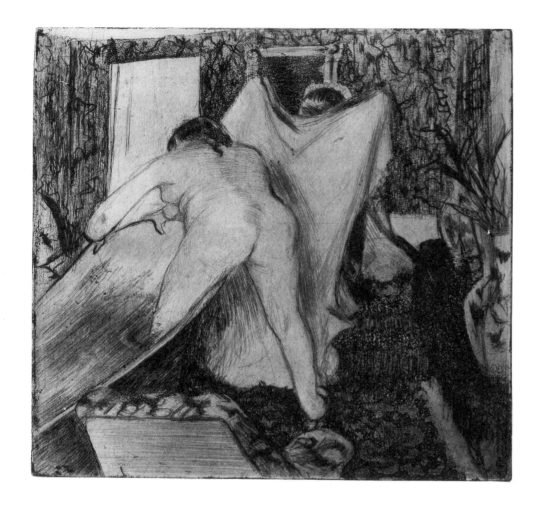

Edgar Degas. *Woman Getting out of her Bath.* 1879–80. Electric crayon, etching, drypoint and aquatint, 5 × 5″ (12.7 × 12.7 cm). Courtesy Museum of Fine Arts, Boston.

the fishwife's bawl, a whole series of attitudes inherent in woman even when she is young and pretty, adorable reclining or standing, a lover of cold baths, and simian, when she too has to lower herself in order to mask her wastage with such grooming.

But what one should look for in these works, beyond this particular tone of contempt and hatred, is the unforgettable veracity of these women – the broad, basic draughtsmanship, the lucid and controlled passion, a sort of chill fever; what one should look for in these scenes is the burning and muted colour, the mysterious and opulent tone; the supreme beauty of the flesh, tinted pink or blue by water, lit by closed windows draped in muslin, in dark rooms lit by the dim daylight of an internal courtyard, revealing walls covered with cretonnes de Jouy, tubs and basins, phials and combs, boxwood-backed brushes and pink copper hot-water bottles!

Here we no longer have the flesh of the goddess, even and slippery, ever naked, a flesh which is most relentlessly expressed in a picture by Régnault in the Musée Lacaze, a picture where one of the three Graces sports a behind apparently of veiled pink percale and lit from within by a night-light; this is flesh undressed, real and alive, flesh kneaded by ablutions, whose chill granular appearance is destined to fade.

In the presence of the woman seen squatting, in front-view, and whose belly is relieved of the usual deceits, some of those visiting this exhibition cried out in indignation at such frankness, struck though they were by the life flowing from these pastels. In the end, they exchanged some doubtful or disgusted comments, their parting shot being: "It's obscene!" Ah! if ever works were less so; if ever they were without fussy precautions and without guile, fully and decisively chaste, these are they! They even glorify disdain of the flesh as no artist since the Middle Ages has dared to do!

They go even further, for this is not a man's modifiable disdain, it is rather the penetrating, convinced loathing of certain women for the misguided joys

of their sex, a loathing which causes them to overflow with atrocious justifications and to sully themselves, admitting aloud to the damp horror of a body unpurified by any lotion.

A powerful and solitary artist, without established precedents, without issue of any worth, in each of his pictures M. Degas gives the feeling of strangeness precisely rendered, of the unseen so rightly appreciated that one is surprised, almost resentful at being surprised; his work belongs to realism, as the boorish Courbet never understood it, but as some of the Primitives did: namely, to an art which expresses a sudden manifestation of the soul, expansive or brief, in living bodies, in perfect accord with their surroundings.

GEORGE MOORE

IMPRESSIONS AND OPINIONS

"Degas"

1891

If led to speak on the marvellous personality of his art, Degas will say, "It is strange, for I assure you no art was ever less spontaneous than mine. What I do is the result of reflection and study of the great masters; of inspiration, spontaneity, temperament – temperament is the word – I know nothing. When people talk about temperament it always seems to me like the strong man in the fair, who straddles his legs and asks some one to step up on the palm of his hand." Again, in reply to an assurance that he of all men now working, whether with pen or pencil, is surest of the future, he will say, "It is very difficult to be great as the old masters were great. In the great ages you were great or you did not exist at all, but in these days everything conspires to support the feeble."

Artists will understand the almost superhuman genius it requires to take subject-matter that has never received artistic treatment before, and bring it at once within the sacred pale. Baudelaire was the only poet who ever did this; Degas is the only painter. Of all impossible things in this world to treat artistically the ballet-girl seemed the most impossible, but Degas accomplished that feat. He has done so many dancers and so often repeated himself that it is difficult to specify any particular one. But one picture rises up in my mind – perhaps it is the finest of all. It represents two girls practising at the rail; one is straining forward lifting her leg into tortuous position – her back is turned, and the miraculous drawing of that bent back! The other is seen in profile – the pose is probably less arduous, and she stands, not ungracefully, her left leg thrown behind her, resting upon the rail. The arrangement of the picture is most unacademical; the figures are half-way up the canvas, and the great space of bare floor is balanced by the watering-pot. This picture is probably an early one. It was natural to begin with dancers at rest; those wild flights of dancers – the *première danseuse* springing amid the *coryphées* down to the footlights, her thin arms raised, the vivid glare of the limelight revealing every characteristic contour of face and neck – must have been a later development. The philosophy of this art is in Degas' own words, "La danseuse n'est qu'un prétexte pour le dessin." Dancers fly out of the picture, a single leg crosses the foreground. The

Edgar Degas. *Admiration. c.*1880. Monotype on pale ochre paper, 8½ × 6⅜″ (21.5 × 16.1 cm). Bibliothèque d'Art et d'Archéologie (Fondation Jacques Doucet), Paris.

Première danseuse, coryphée: *the dancers of the Opéra were rigidly graded by examination; the* étoiles (stars) *were selected from the top rank of* premières danseuses. *The* coryphées *led the* corps de ballet. *The youngest pupils were known as* rats. *See reference to Degas's* Little Dancer, *p. 155.*

162

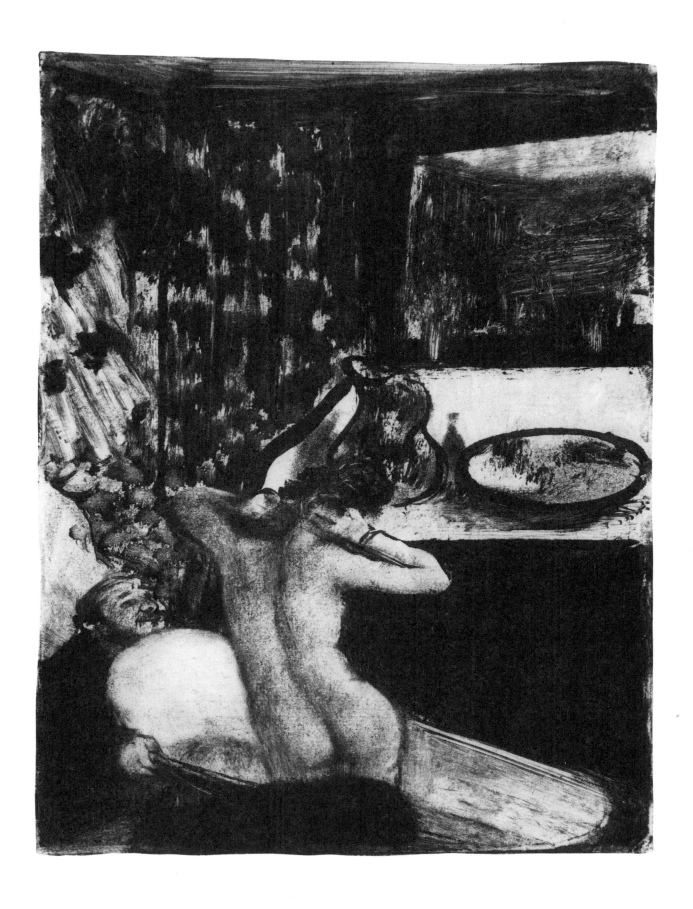

première danseuse stands on tiptoe, supported by the *coryphées*, or she rests on one knee, the light upon her bosom, her arms leaned back, the curtain all the while falling. As he has done with the ballet, so he has done with the race-course. A race-horse walks past a white post which cuts his head in twain.

The violation of all the principles of composition is the work of the first fool that chooses to make the caricature of art his career, but, like Wagner, Degas is possessed of such intuitive knowledge of the qualities inherent in the various elements that nature presents that he is enabled, after having disintegrated, to re-integrate them, and with surety of ever finding a new and more elegant synthesis. After the dancers came the washerwoman. It is one thing to paint washerwomen amid decorative shadows, as Teniers would have done, and another thing to draw washerwomen yawning over the ironing table in sharp outline upon a dark background. But perhaps the most astonishing revolution of all was the introduction of the shop-window into art. Think of a large plate-glass window, full of bonnets, a girl leaning forward to gather one! Think of the monstrous and wholly unbearable thing any other painter would have contrived from such a subject; and then imagine a dim, strange picture, the subject of which is hardly at first clear; a strangely contrived composition, full of the dim, sweet, sad poetry of female work. For are not those bonnets the signs and symbols of long hours of weariness and dejection? and the woman that gathers them, iron-handed fashion has moulded and set her seal upon. See the fat woman trying on the bonnet before the pier-glass, the shopwomen around her. How the lives of those poor women are epitomized and depicted in a gesture! Years of servility and obeisance to customers, all the life of the fashionable woman's shop is there. Degas says, "Les artistes sont tellement pressés! et que nous faisons bien notre affaire avec les choses qu'ils ont oubliées."

David Teniers (1610–90), Flemish genre painter.

But perhaps the most astonishing of all Degas' innovations are his studies of the nude. The nude has become well-nigh incapable of artistic treatment. Even the more naïve are beginning to see that the well-known nymph exhibiting her beauty by the borders of a stream can be endured no longer. Let the artist strive as he will, he will not escape the conventional; he is running an impossible race. Broad harmonies of colour are hardly to be thought of; the gracious mystery of human emotion is out of all question – he must rely on whatever measure of elegant drawing he can include in his delineation of arms, neck, and thigh; and who in sheer beauty has a new word to say? Since Gainsborough and Ingres, all have failed to infuse new life into the worn-out theme. But cynicism was the great means of eloquence of the Middle Ages; and with cynicism Degas has again rendered the nude an artistic possibility. Three coarse women, middle-aged and deformed by toil, are perhaps the most wonderful. One sponges herself in a tin bath; another passes a rough night-dress over her lumpy shoulders, and the touching ugliness of this poor human creature goes straight to the heart. Then follows a long series conceived in the same spirit. A woman who has stepped out of a bath examines her arm. Degas says, "La bête humaine qui s'occupe d'elle-même; une chatte qui se lèche." Yes, it is the portrayal of the animal-life of the human being, the animal conscious of nothing but itself. "Hitherto," Degas says, as he shows his visitor three large peasant women plunging into a river, not to bathe, but to wash or cool themselves (one drags a dog in after her), "the nude has always been represented in poses which presuppose an audience, but these women of mine are honest, simple folk, unconcerned by any other interests than those involved in their physical condition. Here is another; she is washing her feet. It is as if you looked through a key-hole."

"Artists are always in such a hurry, and we find all that we want in what they have left behind."

"A human animal as engrossed as a cat cleaning herself with her tongue."

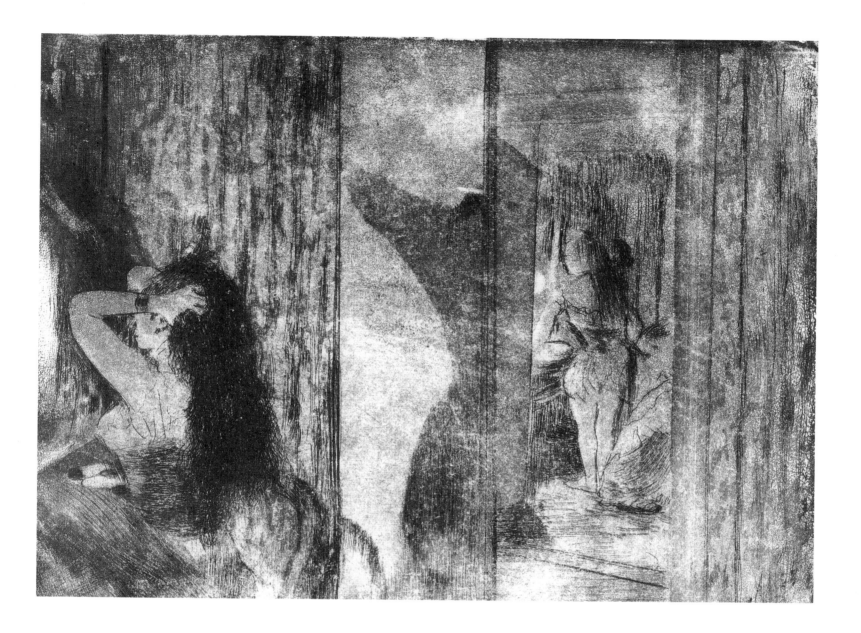

GEORGE MOORE

MODERN PAINTING

On Degas

1898

Degas . . . draws for the sake of the drawing – The Ballet Girl, The Washerwoman, The Fat Housewife bathing herself, is only a pretext for drawing; and Degas chose these extraordinary themes because the drawing of the ballet girl and the fat housewife is less known than that of the nymph and the Spartan youth. Painters will understand what I mean by the drawing being "less known," – that knowledge of form which sustains the artist like a crutch in his examination of the model, and which as it were dictates to the eye what it must see. So the ballet girl was Degas' escapement from the thraldom of common knowledge. The ballet girl was virgin soil. In her meagre thwarted forms application could freely be made of the supple incisive drawing which bends to and flows with the character – that drawing of which Ingres was the supreme patron, and of which Degas is the sole inheritor.

PAUL VALÉRY

DEGAS, DANSE, DESSIN

"The Ground and the Formless; Mime"

1936

Degas is one of the rare painters who gave due emphasis to the *ground*.

His floors are often admirable.

Sometimes he will view a danseuse from a fair height, projecting her shape against the plane of the stage, just as we see a crab on the beach, a standpoint which gives him novel angles and interesting juxtapositions.

The ground is an essential factor in our perception of things. By its nature it accounts in large part for the reflection of light. As soon as the painter begins to study colour, no longer as a local quality acting in isolation and contrasting with neighbouring colours, but as a local result of all the different sheddings and reflections of light in space, passing and repassing between all the bodies contained in it; as soon as he forces himself to recognize the subtleties of these repercussions, and uses them to give his work a unity quite distinct from that of composition, his idea of form is thereby altered. Pushed to its limit, this method amounts to impressionism.

Though Degas was well acquainted with this "way of seeing," having watched it develop all round him, he never gave up that cult of form in itself to which he was predestined by temperament and education.

Landscape, which had given birth to "impressionism" through the successive interpretations to which it had committed the painter, never attracted him. The few he did paint were painted in his studio, as a *flourish*. For him they were a recreation, not without a certain sly enjoyment at the expense of the open-air fanatics. There was something oddly arbitrary about them; but those which he used as backgrounds to his riders, and for various other subjects, are defined, on the other hand, with all the exactitude he loved.

It has been asserted that he drew studies of rocks *indoors*, heaping bits of coke borrowed from his stove, as models; and that having overturned a bucketful on the table, he set about making a studious drawing of the random landscape thus precipitated by his own act. There was no object of reference in the drawing to allow you to think that the piled-up boulders were nothing but pieces of coke no bigger than a fist.

If true, this notion seems to me to be rather Leonardesque. And it reminds me of certain ideas I had long ago, which are not perhaps so very remote from these prompted by my memories of Degas.

They were concerned with *formlessness*. There are things – colours, masses, outlines, volumes – which have only, so to speak, a *de facto* existence; they can only be apprehended, not comprehended, by us; we cannot reduce them to a single law, deduce their whole from an analysis of one of their parts, or reconstruct them by a process of reasoning. We can modify them very freely. Almost their one property is to occupy a place in space. To say that these things are formless is not to say that they have *no* form, but that there is nothing in their forms which can enable us to duplicate them by any simple act of recognition or copying. In fact, the only impression left by these formless forms is one of possibilities. . . . Just as a series of notes struck at random is not a melody, no more are pools, rocks, clouds, stretches of coast line definable as forms. I do not want to press these considerations; they can lead far. Let me return to drawing. Let us suppose that we want to draw one of these formless things, but one which has a certain recognizable correspondence between its parts. If I throw a crumpled handkerchief onto

a table, it looks like nothing. To the eye, at first, it is simply a chaos of creases. I can move one of the corners without disturbing the others. My problem, however, is to make my drawing show that it is a piece of cloth of a certain kind, thickness, and flexibility, and all in one piece. The question is, then, how to make *intelligible* a particular structure of an object which has no determinate structure, no stereotype or remembered shape that can serve as guide, as is the case when we are drawing a tree, a man, an animal, all of which are divisible into recognizable parts. This is where the artist has to use his intelligence; and the eye, as it moves over what it sees, has to trace the paths the pencil will follow on the paper – just as a blind man builds up the tactile qualities of a shape by feeling it with his fingers, arriving by degrees at the sense of unity of a regular solid.

From such an exercise in formlessness we can learn, among other things, not to confuse what we think we see with what we see. There is a kind of structural activity in the eyesight of which habit makes us unaware. In general we are apt to guess or foresee more than we see; visual impressions act upon us as signals, not as *unique presences* anterior to everything in the way of arrangement, summary, short cut, and instantaneous substitution, all of which we take in with our first teaching.

Just as the thinker tries to defend himself from the platitudes and set phrases which protect the mind from surprise at everything, and make practical living possible, so the painter can try, by studying formlessness, or rather *singularity* of form, to rediscover his own singularity, and with it the original and primitive state of co-ordination between hand and eye, subject and will.

* * *

Degas had a curious aptitude for *mimicry*. The dancers and ironers he chose for subject are shown in the attitudes that characterize their work, which is what enabled him to renew our vision of the body, analysing a host of positions that had interested no painter before him. He turned his back on softly reclining beauties, on Venuses and odalisques; nor did he try to create his own supreme, obscene, and brutally factual Olympia on her bed. Flesh, whether golden, white, or rosy, seems not to have inspired his painting. His passion was to reconstruct the body of the female animal as the specialized slave of the dance, the laundry . . . or the streets; and the more or less distorted bodies whose articulated structure he always arranges in very precarious attitudes (tying a ballet shoe, or driving the iron over the cloth with both fists) make the whole structural mechanism of a living being seem to grimace like a face.

If I were an art critic, I believe I would now risk propounding a theory of triple origin. I should try to explain Degas' *mimetic* way of seeing as the result of three simultaneous conditions. First, the Neapolitan blood which I mentioned: mime is native to Naples, where there is never a word without a gesture, a story without acting, no individual without his store of parts to play, always available and always convincing.

Next I would say that Degas' problem, the choice he had to make at the artist's age of decision, in the face of all contemporary tendencies, schools, and opposing styles, was resolved by adopting the simplifying formulas of "realism." He abandoned Semiramis and constructions in the grand manner in order to devote himself to looking at things that can be seen.

But he was far too intelligent and cultivated to consent to being merely an indiscriminate observer, a pure revolutionary claiming to abolish the past in order to make room for himself. Degas turned upon the study of reality all the scrupulousness that makes for "classicism." And that is the third condition in my theory.

A passionate pursuit of the one and only line that defines a form, a form seen in daily life, in the street, at the Opéra, at the modiste's (and even . . . elsewhere); and at the same time, taken unawares in its most characteristic

attitude, at a particular moment, always a moment of action and expression: such, more or less, sums up my idea of Degas. He tried, he dared try to combine the snapshot with the endless labour of the studio, enshrining his impression of it in prolonged study – the instantaneous given enduring quality by the patience of intense meditation.

As for the mimic aptitude I mentioned, I will try to give an example of it.

As his loneliness and gloom increased, at a loss what to do with his evenings, Degas had the idea of spending them, in fine weather, travelling on the open deck of trams and buses. He would board them, travel to the terminus, and from there return to the stop nearest his home. One day he described to me something he had seen the evening before on his open-air jaunt. It is the kind of observation that reveals the observer more than anything. Telling me how a woman came and sat down not far away from him, he described the precautions she took to be well arranged and comfortably seated. She ran her fingers over her dress to uncrease it, contrived to sit well back so that she fitted closely into the curve of the support, drew her gloves as tightly as possible over her hands, buttoned them carefully, ran her tongue along her lips which she had bitten gently, worked her body inside her clothes, so as to feel fresh and at ease in her warm underwear. Finally, after lightly pinching the end of her nose, she drew down her veil, rearranged a curl of hair with an alert finger, and then, not without a lightning survey of the contents of her bag, seemed to put an end to this series of operations with the expression of one whose task is done, or whose mind is at rest, since all that is humanly possible in the way of preparations has been done, and the rest must be left to providence.

Edgar Degas. *Photograph of a Nude: After the Bath.* 1890–96. 6¹¹/₁₆ × 4¾" (16.5 × 12 cm). J. Paul Getty Museum, Malibu.

Degas at home with his housekeeper Zoé, Rue Victor Massé, Paris, *c.*1908.

The tram went rattling along. The lady, finally settled, remained for about fifty seconds in this state of total wellbeing. But at the end of what must have seemed to her an interminable period, Degas (who mimed to perfection what I am describing with great difficulty) saw dissatisfaction appear: she drew herself up, worked her neck inside her collar, wrinkled her nostrils a little, rehearsed a frown; then recapitulated all her adjustments of attitude and dress – the gloves, the nose-pinching, the veil. . . A whole routine, intensely *personal*, followed by another apparently stable condition of equilibrium, which lasted only for a moment.

Degas, for his part, went through his pantomime again. He was charmed with it. There was an element of misogyny in his enjoyment. A moment ago I spoke of the female animal: that, I fear, was the right term. Didn't Huysmans write that Degas felt nothing but repulsion for the dancers he painted? He was exaggerating; yet, apart from a few rare ones who had all the grace and wit his refinement could wish for, Degas doubtless judged the sex according to his workaday models, viewed in the attitudes I have described. He took not the smallest pains to beautify them.

Of the sentimental side of his private life I know nothing: Our judgment of woman is often the echo of our experience.

A man needs to be a kind of sage, to reproach nobody but himself when affairs of this nature leave him only with disgust, bitterness, or worse feelings still. But Degas' character makes me feel that his past counted for little in his way of reducing woman to what he made of her in his works. His dark eye saw nothing in a rosy light.

GEORGES JEANNIOT

MEMOIRS

"A Visit to Burgundy"

1890

"And now, take me to your studio," Degas said to me as we were leaving the table.

As he walked in, an expression of pleasure and well-being appeared on his face. And yet this country studio, installed in the garret of our house, really was very simple. In short, an attic with a few antique chairs, two or three easels, a settee with cushions, an etching press, a stove and everything necessary for making prints.

"That's the spirit!" he cried out, "we are going to be able to work in your Swiss clockmaker's workshop, you have paper, ink, the printer's brush with your initials on! Heavens! Then it is serious. This pad is superb and fits well in one's hand. Let's get on! Have you a smock?"

"Yes, and it is a printer's smock, brand new."

"Your press must be hard work, with only one gear-wheel."

"Yes, quite hard, but we have muscles!"

"Your studio is charming."

I put the smock on him, he had taken off his jacket and rolled up his sleeves.

"Do you have copper or zinc plates?"

"Here you are. . . ."

"Perfect! I will ask you for a piece of cloth to make a pad for my own use; I have been wanting for so long to make a series of monotypes!"

Once supplied with everything he needed, without waiting, without allowing himself to be distracted from his idea, he started. With his strong but beautifully-shaped fingers, his hand grasped the objects, the tools of genius, handling them with a strange skill and little by little one could see emerging on the metal surface a small valley, a sky, white houses, fruit trees with black branches, birches and oaks, ruts full of water after the recent downpour, orangey clouds dispersing in an animated sky, above the red and green earth.

All this fell into place, coming together, the tones setting each other off and the handle of the brush traced clear shapes in the fresh colour.

These lovely things seemed to be created without the slightest effort, as if the model was in front of him.

Bartholomé could recognize the places they had gone through, following the gait of the trotting white horse.

After half an hour, no more, Degas' voice suggested:

"If you don't mind, we'll print this proof. Is the paper wet? Have you got the sponge? You do know that semi-sized paper is the best?"

"Calm down, I have some strong Chinese."

"He has got some Chinese! Let us see this Chinese. . . ."

I put down an imposing roll on the corner of the table. When everything was ready, the plate laid on the press, the paper on the plate, Degas said: "What an anxious moment! Roll, roll!" It was an antique press with heavy cross-shaped spars. Once the proof was obtained, it was hung on lines to dry. We would do three or four in a morning.

Then, he would ask for some pastels to finish off the prints and it is here, even more than in the making of the proof, that I would admire his taste, his imagination and the freshness of his memories. He would remember the variety of shapes, the construction of the landscape, the unexpected oppositions and contrasts; it was delightful! . . .

One morning at Diénay Degas said to me:

"I would like to show you how one should go about putting a picture together."

The previous day, we had been to Gérard, Diénay's baker. In the billiards-room (for Gérard was also a publican), there were some seasoned players looking like poachers, colourful faces and heavy drinkers' eyes, of the type you find there. They were playing amidst pipe-smoke and in the warm, enlivening atmosphere of a sunny day . . .

I had done sketches of these strange characters. Degas, taking a canvas, said to me:

"Here you are, draw what we saw at Gérard's, and fix it in Indian ink in bold strokes."

Once this was done, he took hold of the canvas and started to trace with a ruler some horizontal lines in lemon pastel and some vertical lines in vermilion.

The result: a flamboyant rectangle.

He asked for linseed oil, as old as possible, some spirit of turpentine, some siccative, making it into a mixture which he spread rapidly over the rectangle with the aid of a large brush. The white canvas became an orange surface under which, in black, appeared the drawing in Indian ink. He prepared five or six colours: a strong green, light and more blue than yellow; a Prussian blue; a cadmium orange; a flesh tone with white and mars orange to re-touch the black drawing on top of the orange.

"You understand," he said to me, "that this performance is intended to fix the procedure in the memory, and it may provide a little amusement as well."

Degas photographed by Paul-Albert Bartholomé. Bibliothèque Nationale, Paris.

ALFRED SISLEY

"An Impressionist's View"

January 1892

Alfred Sisley (1839–99), born in Paris of English parents; he met Monet, Bazille and Renoir at Gleyre's studio and exhibited with the Impressionist group in 1874, 1876, 1877 and 1882. Less successful at promoting himself than his colleagues, he died, in extreme poverty, of cancer of the throat when he was just beginning to receive a measure of recognition.

It is a ticklish thing to put down on paper what a painter calls his aesthetic . . .

The aversion to indulgence in theory that Turner felt, I feel too, and I believe it is much easier to talk of masterpieces than to create them – whether with the brush or any other way . . .

As you know, the charm of a picture is many-sided. The subject, the motif, must always be set down in a simple way, easily understood and grasped by the beholder. By the elimination of superfluous detail the spectator should be led along the road that the painter indicates to him, and from the first be made to notice what the artist himself has felt.

Every picture shows a spot with which the artist himself has fallen in love. It is in this – among other things – that the unsurpassed charm of Corot and Jongkind consists.

The animation of the canvas is one of the hardest problems of painting. To give life to the work of art is certainly one of the most necessary tasks of the true artist. Everything must serve this end: form, colour, surface. The artist's impression is the life-giving factor, and only this impression can free that of the spectator.

And though the artist must remain master of his craft, the surface, at times raised to the highest pitch of liveliness, should transmit to the beholder the sensation which possessed the artist.

You see that I am in favour of a variation of surface within the same picture. This does not correspond to customary opinion, but I believe it to be correct, particularly when it is a question of rendering a light effect. Because when the sun lets certain parts of a landscape appear soft, it lifts others into sharp relief. These effects of light, which have an almost material expression in nature, must be rendered in material fashion on the canvas.

Objects must be portrayed in their particular context, and they must especially be bathed in light, as is the case in nature. The progress to be realized in the future will consist in this. The means will be the sky (the sky can never be merely a background). Not only does it give the picture depth through its successive planes (for the sky, like the ground, has its planes), but through its form, and through its relations with the whole effect or with the composition of the picture, it gives it movement . . .

I emphasize this part of a landscape because I would like to make you understand the importance I attach to it.

An indication of this: I always begin a picture with the sky . . .

The painters I like? To mention only contemporaries: Delacroix, Corot, Millet, Rousseau, Courbet, are masters. And finally, all those who loved and had a strong feeling for nature.

GUSTAVE CAILLEBOTTE

Letter to Pissarro

January 24, 1881

Gustave Caillebotte (1848–94), painter and collector. Introduced by Degas, he joined the Impressionist group in 1876 and subsequently showed in five of their exhibitions, which he also helped to organize. His bequest of 65 Impressionist paintings was left to the Luxembourg museum on the condition that it be accepted as an undivided collection. The 40 pictures which were finally accepted, over considerable opposition from the École des Beaux-Arts and artists of the official Salon, formed the nucleus of the collection at the Jeu de Paume, now at the Musée d'Orsay.

What is to become of our exhibitions? This is my well-considered opinion: we ought to continue, and continue only in an artistic direction, the sole direction – in the final sense – that is of interest to us all. I ask, therefore, that

a show should be composed of all those who have contributed real interest to the subject, that is, you, Monet, Renoir, Sisley, Mme Morisot, Mlle Cassatt, Cézanne, Guillaumin; if you wish, Gauguin, perhaps Cordey, and myself. That's all, since Degas refuses a show on such a basis. I should rather like to know wherein the public is interested in our individual disputes. It's very naïve of us to squabble over these things. Degas introduced disunity into our midst. It is unfortunate for him that he has such an unsatisfactory character. He spends his time haranguing at the Nouvelle-Athènes or in society. He would do much better to paint a little more. That he is a hundred times right in what he says, that he talks with infinite wit and good sense about painting, no one doubts (and isn't that the outstanding part of his reputation?). But it is no less true that the real arguments of a painter are his paintings and that even if he were a thousand times right in his talk, he would still be much more right on the basis of his work. Degas now cites practical necessities, which he doesn't allow Renoir and Monet. But before his financial losses was he really different from what he is today? Ask all who knew him, beginning with yourself. No, this man has gone sour. He doesn't hold the big place that he ought according to his talent and, although he will never admit it, he bears the whole world a grudge.

He claims that he wanted to have Raffaëlli and the others because Monet and Renoir had reneged and that there had to be someone. But for three years he has been after Raffaëlli to join us, long before the defection of Monet, Renoir, and even Sisley. He claims that we must stick together and be able to count on each other (for God's sake!); and whom does he bring us? Lepic, Legros, Maureau. . . . (Yet he didn't rage against the defection of Lepic and Legros, and moreover, Lepic, heaven knows, has no talent. He has forgiven him everything. No doubt, since Sisley, Monet, and Renoir have talent, he will never forgive them.) In 1878 [he brought us] Zandomeneghi, Bracquemond, Mme Bracquemond; in 1879 Raffaëlli. . . . and others. What a fighting squadron in the great cause of realism!!!!

If there is anyone in the world who has the right not to forgive Renoir, Monet, Sisley, and Cézanne, it is you, because you have experienced the same practical demands as they and you haven't weakened. But you are in truth less complicated and more just than Degas. . . . You know that there is only one reason for all this, the needs of existence. When one needs money, one tries to pull through as one can. Although Degas denies the validity of such fundamental reasons, I consider them essential. He has almost a persecution complex. Doesn't he want to convince people that Renoir has Machiavellian ideas? Really, he is not only not just, he is not even generous. As for me, I have no right to condemn anyone for these motives. The only person, I repeat, in whom I recognize that right is you. I say the only person; I do not recognize that right in Degas who has cried out against all in whom he admits talent, in all periods of his life. One could put together a volume from what he has said against Manet, Monet, you. . . .

I ask you: isn't it our duty to support each other and to forgive each other's weaknesses rather than to tear ourselves down? To cap it all, the very one who has talked so much and wanted to do so much has always been the one who has personally contributed the least. . . . All this depresses me deeply. If there had been only one subject of discussion among us, that of art, we would always have been in agreement. The person who shifted the question to another level is Degas, and we would be very stupid to suffer from his follies. He has tremendous talent, it is true. I'm the first to proclaim myself his great admirer. But let's stop there. As a human being, he has gone so far as to say to me, speaking of Renoir and Monet: "Do you invite those people to your house?" You see, though he has great talent, he doesn't have a great character.

I shall sum up: do you want an exclusively artistic exhibition? I don't know what we shall do in a year. Let us first see what we'll do in two months. If Degas wants to take part, let him, but without the crowd he drags along. The only ones of his friends who have any right are Rouart and Tillot. . . ."

The Café de la Nouvelle-Athènes in the Place Pigalle became a popular venue for discussion amongst artists and writers in the 1870s and 1880s including Manet, Degas, Renoir, Monet, Duranty and Moore.

Jean-François Raffaëlli (1850–1924), painter of anecdotal realist pictures and a friend of Degas. He was the principal stumbling-block to agreement within the Impressionist group. He dominated the 1881 and 1882 shows, making the largest single contribution to both exhibitions.
Ludovic-Napoléon Lepic (1839–99); Alphonse Legros (1837–1911); Alphonse Maureau (dates unknown).
Federico Zandomeneghi (1841–1917); Félix Bracquemond (1833–1914); Marie Bracquemond (1841–1916).

Paul Gauguin. *Nude.* 1880. 45¼ × 31½" (115 × 80 cm). Ny Carlsberg Glyptotek, Copenhagen.

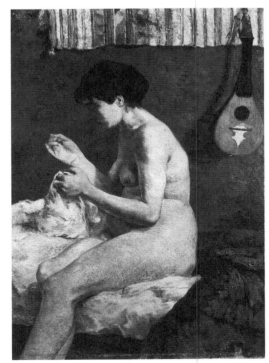

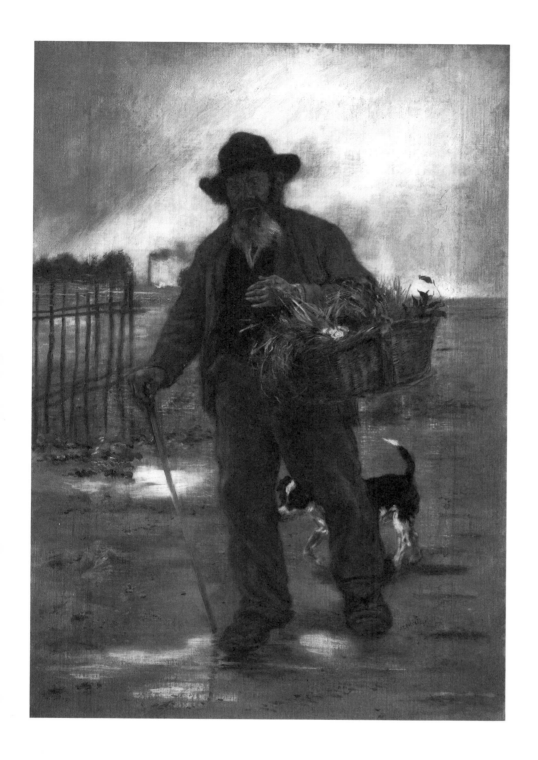

J. F. Raffaëlli. *Returning from Market.*
1880. 28¼ × 19¼″ (71.8 × 49 cm).
Courtesy Museum of Fine Arts, Boston
(Henry C. and Martha B. Angell
Collection).

CAMILLE PISSARRO

Letter to Caillebotte

January 27, 1881

My dear Caillebotte,
I must ask you to forgive me for not having been more prompt in answering
the letter you wrote me in connection with the request from Renoir and
Monet to be brought back into our exhibition, and the conditions that these
gentlemen want to stipulate. I had to take time to reflect. Without going into
all the details, and keeping rather to personal matters, I must declare myself
wholly against your idea of considering the affair purely from an artistic
point of view, which is in my view the only one actually fraught with
difficulties and bound to divide us all. It is far from certain that, using this

*In the end Caillebotte declined to exhibit in the
sixth Impressionist exhibition (2 April–1
May 1881), which was mainly organized by
Degas and dominated by himself and his
followers. With the exception of the seventh
exhibition, in which they both returned to the
fold, Renoir declined to exhibit with the
Impressionists from 1879 (the fourth group
show) onwards and Monet from 1880 (the
fifth group show). They both chose to exhibit
at the Salon.*

173

principle, you, I and even Degas would have the luck to be accepted by certain artists who, precisely because of their talent, have an individuality which they apply to all their judgements. The only practicable principle, and which is also as fair as possible, is not to abandon colleagues whom one has accepted, rightly or wrongly, and whom one cannot then throw out just like that; it is also a question of decency. You know me well enough to be convinced that I would like nothing more than to have Renoir and Monet, but what I find supremely unfair is that, having left us in the lurch and not having worried for a moment about laying us open to irremediable disaster, they should now, not having been successful at the Officiel, be eager to return to us with conditions laid down as though they were conquerors when, in all justice, people ought to suffer due punishment for faults committed. . . . I am sorry, my dear Caillebotte, despite my friendship for you and all the gratitude I owe you, I cannot accept these propositions.

As for what you tell me of Degas, you must admit that if he has sinned greatly, imposing several artists upon us who do not fulfil the conditions of the programme, he sometimes has a happy touch; remember that it was he who brought us Mlle Cassatt, Forain and *yourself*: he will be forgiven a great deal.

From your letter, I fear that we shall not manage to understand one another, but one day perhaps, seeing the quicksands of art sinking beneath your feet, you will see that I was right.

PIERRE-AUGUSTE RENOIR

Letters to his Dealer

March 1881–February 1882

ALGIERS, MARCH 1881

My dear Monsieur Durand-Ruel,
I shall now try to explain why I am sending to the Salon. There are in Paris barely fifteen collectors capable of appreciating a painter unless he has exhibited at the Salon. There are eighty thousand who will not buy even a

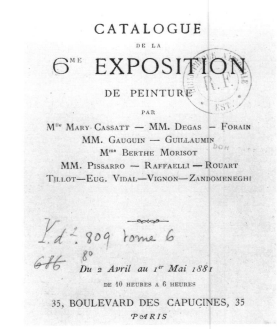

Catalogue from the Sixth Impressionist Exhibition. 1881. Bibliothèque Nationale, Paris.

Mary Cassatt (1844–1926), expatriate American painter who settled in Paris in 1874. A friend of Degas, she exhibited at his invitation in four of the Impressionist exhibitions and was instrumental in promoting Impressionism in the United States.

(*Below left*) Henri Gervex. *The Jury for Painting, Salon des Artistes Français.* 1885. 115½ × 151" (294 × 384 cm). Musée d'Orsay, Paris.

(*Below*) Pierre-Auguste Renoir. Photograph. 1880/5.

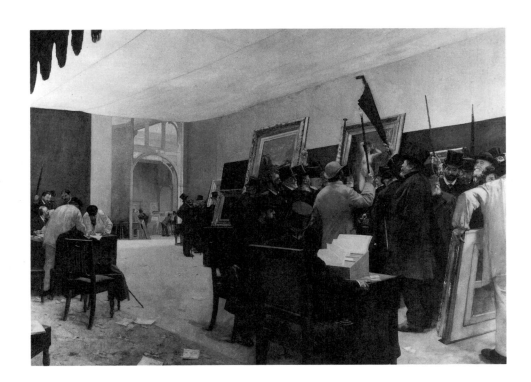

nose if a painter is not in the Salon. That is why I send two portraits each year, little though that is. Furthermore, I am not going to fall into the obsessive belief that something is bad just because of where it is. In a word, I don't want to waste my time resenting the Salon. I don't even want to seem to do so. I believe a painter should produce the best painting possible. . . . That is all. Now if people accused me of neglecting my art, or making sacrifices which go against my own ideas of an idiotic sense of ambition, then I would understand the criticism. But since this is not the case, I cannot be criticized in this way, quite the contrary. All I am concerned with at this moment, as always, is making good things. I want to make you splendid paintings which you will be able to sell for very high prices. I shall soon manage to do this, I hope. I have stayed in the sun, away from all painters, to reflect at length. I think I have reached my aim, and have found what I am looking for. I may be wrong, but it would greatly surprise me. A little more patience and soon I hope to give you the proof that one can send work to the Salon *and* do good paintings.

I therefore beg you to plead my case with my friends. The fact that I am sending work to the Salon is purely a matter of business. In any case, it's like certain medicines. If it does no good, at least it does no harm.

I think I have recovered my health. I shall be able to work solidly and make up for lost time.

Which reminds me, I wish you good health. And a lot of rich collectors. But keep them for my return. I shall be here for another month. I don't want to leave Algiers without bringing back something of this marvellous country. Fondest wishes to our friends and yourself,

<div align="right">Renoir.</div>

<div align="center">* * *</div>

My dear Monsieur Durand-Ruel,
In order to prove to you that my brother is not exhibiting for serious, genuine and artistic reasons. I am sending you the rough copy he wrote from his bed. Style apart, it expresses his thought: it is up to you to judge whether you should override it.
Kind regards,

<div align="right">Edmond Renoir.</div>

<div align="center">* * *</div>

DRAFT OF THE LETTER OF FEBRUARY 26, 1882 (ADDED BY EDMOND RENOIR)
. . . Unfortunately I have one aim in my life, which is to raise the value of my paintings. The means I employ are perhaps not very good, but it suits me. To exhibit with Pissarro, Gauguin and Guillaumin is like exhibiting with any old rabble. For two pins Pissarro would invite the Russian Lavrof (the anarchist), or some other revolutionary to join in. The public does not like anything that smacks of politics and at my age I do not want to be a revolutionary. To associate with the Israelite Pissarro is tantamount to revolution.

Furthermore, these gentlemen know that I have taken a great step forward because of the Salon. They are in a hurry to make me lose what I have gained. They will overlook nothing with that aim, only to leave me once I've fallen. I will not have it. Get rid of these people and present me with artists like Monet, Sisley, Morisot etc., and I am all yours, for that is no longer politics, it is pure art.

<div align="right">Renoir.</div>

<div align="center">* * *</div>

UNDATED (EARLY 1882)
I hope indeed that Caillebotte will exhibit, and I also hope that these gentlemen will drop this ridiculous title "*Indépendants.*" I would like you to tell these gentlemen that I am not going to give up exhibiting at the Salon. This is not for pleasure, as I told you, but so as to dispel the revolutionary taint which frightens me. . . . It is a small weakness for which I hope to be pardoned. . . . Delacroix was right to say that a painter ought to obtain all honours possible at any cost.

Paul Durand-Ruel (1831–1922), the Impressionists' first dealer, whose historic role as their defender and friend began in the early 1870s when he started buying Pissarro and Monet, and later, through their introduction, Degas, Renoir and Sisley. In spite of the difficulty he experienced for nearly two decades in marketing their work, his commitment to them remained steadfast. It was largely his support that enabled them to live, while his firm came close to bankruptcy. A breakthrough came in 1886 when the American Art Association invited him to mount an exhibition of Impressionism in New York which proved to be such a financial success (compared to Paris and London) that he opened a branch there in 1888. His sales formed the nucleus of the important American collections now in Chicago, Washington, New York and Boston museums.

DENIS ROUART

THE CORRESPONDENCE OF BERTHE MORISOT

1885

Berthe Morisot's existence was now divided between her studio, her little garden, and the Bois de Boulogne – these were the places where she worked. Referring to the dissensions among the Impressionists, which were at that time hindering the organization of an exhibition, Berthe wrote to Edma:

"I am working with some prospect of having an exhibition this year: everything I have done for a long time seems to me so horribly bad that I should like to have new, and above all better, things to show to the public. This project is very much up in the air, Degas' perversity makes it almost impossible of realization; there are clashes of vanity in this little group that make any understanding difficult. It seems to me that I am about the only one without any pettiness of character; this makes up for my inferiority as a painter."

* * *

"I am not myself these days; perhaps this is only because of the change of season, but the burden of life seems hard to bear. I had made up my mind and I had persuaded Eugène to spend a month in Venice, and these accursed quarantines make it impossible for me to carry out my plans. I know from the Italians themselves that they take advantage of this opportunity to show their dislike for everything French, and they create countless vexations for us . . . Yet I had a strong wish to go abroad and to find sun and warmth, to walk in the galleries and the palaces, and to see an art that is different. In this respect northern Italy is incredibly rich. Paris certainly has a thousand things to offer, and there is undeniably always something new to be seen; and yet, if you continually live here you reach the point of saturation."

J.-K. HUYSMANS

L'ART MODERNE

"Appendice"

1882

This year, 1882, neither M. Degas, nor Mlle Cassatt, nor MM. Raffaëlli, Forain or Zandomeneghi have exhibited. On the other hand two deserters have returned to the fold: MM. Caillebotte and Renoir: lastly, the so-called Impressionist painters, MM. Claude Monet and Sisley, are once more on view.

From the point of view of contemporary life, this exhibition is unfortunately extremely summary. No more dance halls or theatre scenes, no more intimate interiors, no more gangways and girls at the Folies-Bergère, no more social outcasts and working people; the dominant note is landscape. Truly the circle of modernism has shrunk too much and one cannot sufficiently deplore this diminution, brought about by base disputes in the collective work of a small group which had hitherto defied the vast army of officialdom.

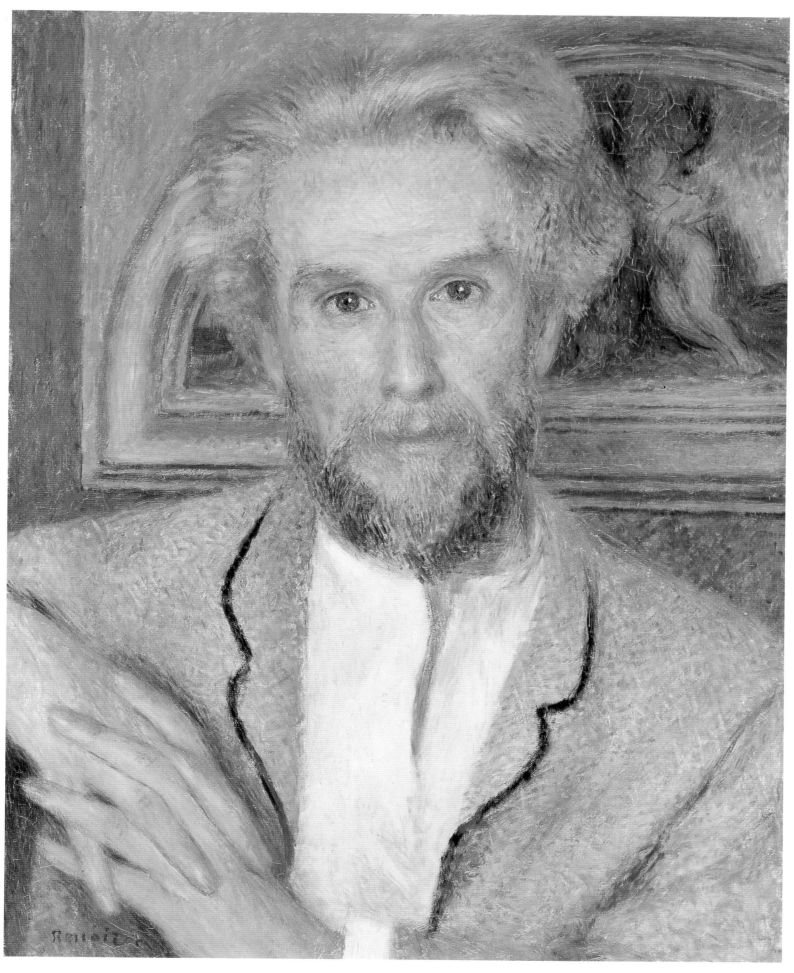

COLOURPLATE 49. Pierre-Auguste Renoir. *Portrait of Victor Chocquet*. 1875. 18⅛ × 14½″ (46 × 37 cm).
Fogg Art Museum, Cambridge, Massachusetts (Bequest of Grenville L. Winthrop).

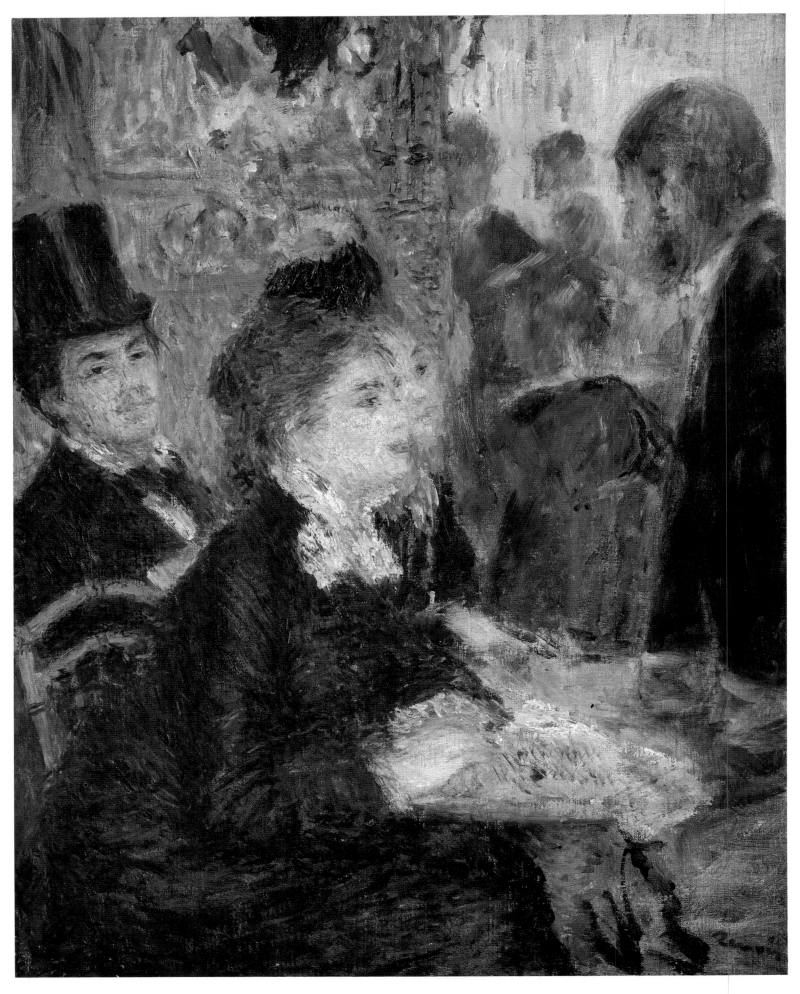

COLOURPLATE 50. Pierre-Auguste Renoir. *The Café*. 1876/7. 13¾ × 11″ (35 × 28 cm).
Kröller-Müller Museum, Otterlo.

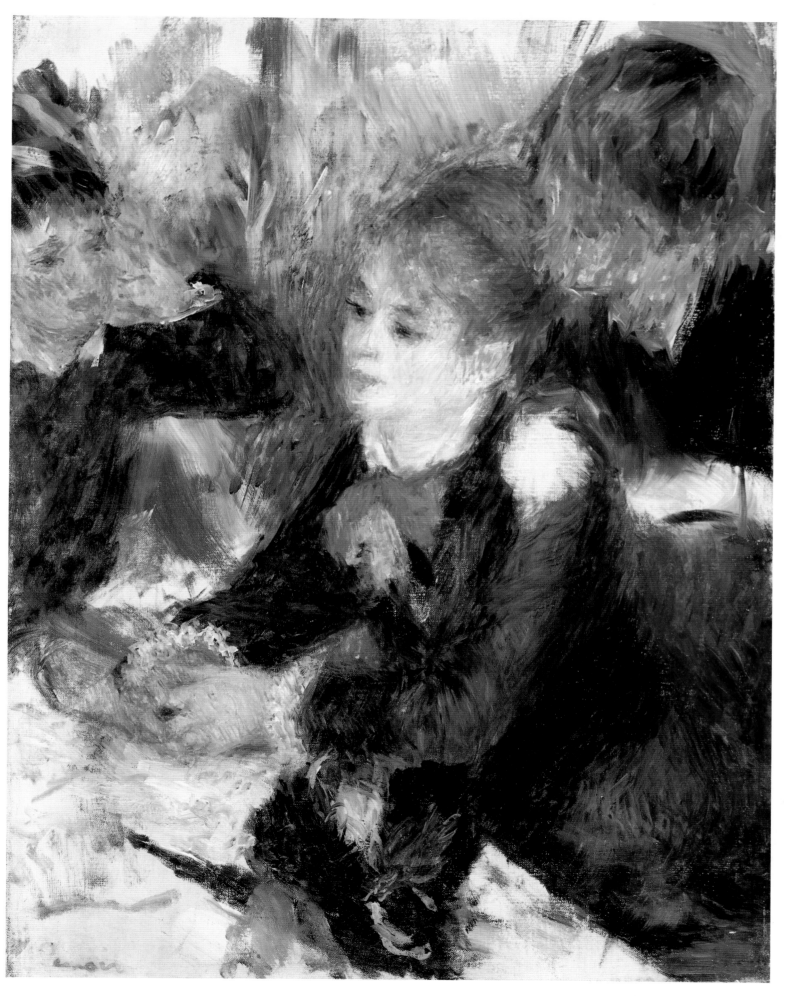

COLOURPLATE 51. Pierre-Auguste Renoir. *At the Milliner's. c.*1878. 12¾ × 9⅝″ (32.4 × 24.4 cm).
Fogg Art Museum, Cambridge, Massachusetts (Annie S. Coburn Bequest).

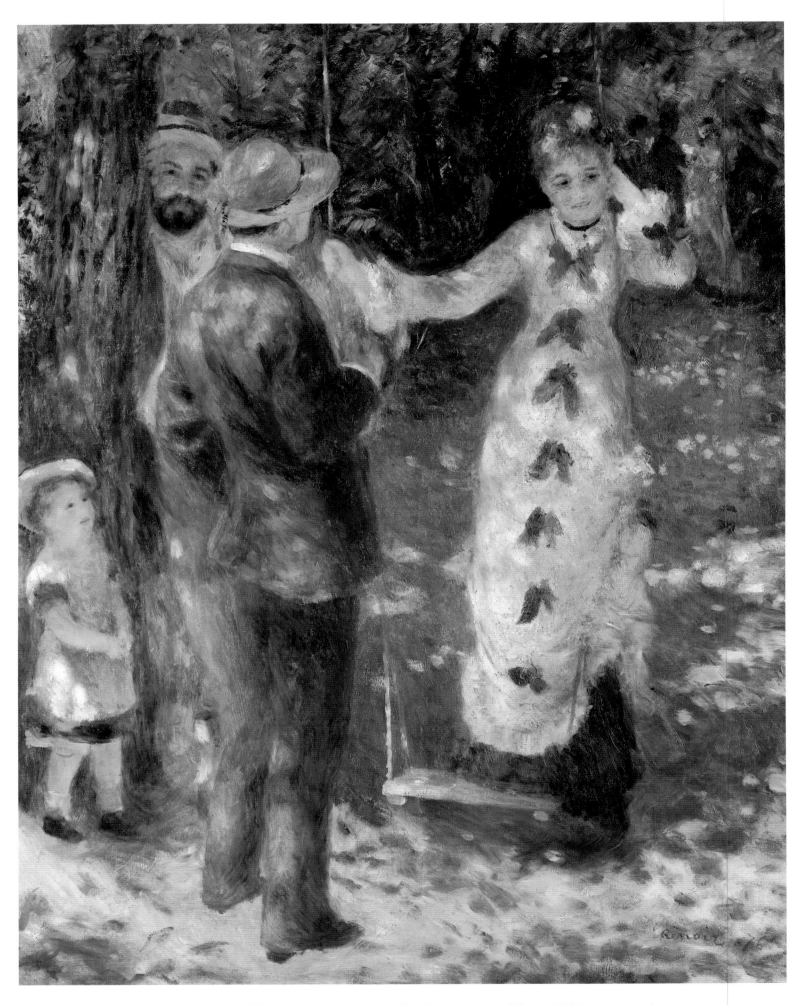

COLOURPLATE 52. Pierre-Auguste Renoir. *The Swing*. 1876. 36¼ × 28¾″ (92 × 73 cm).
Musée d'Orsay, Paris.

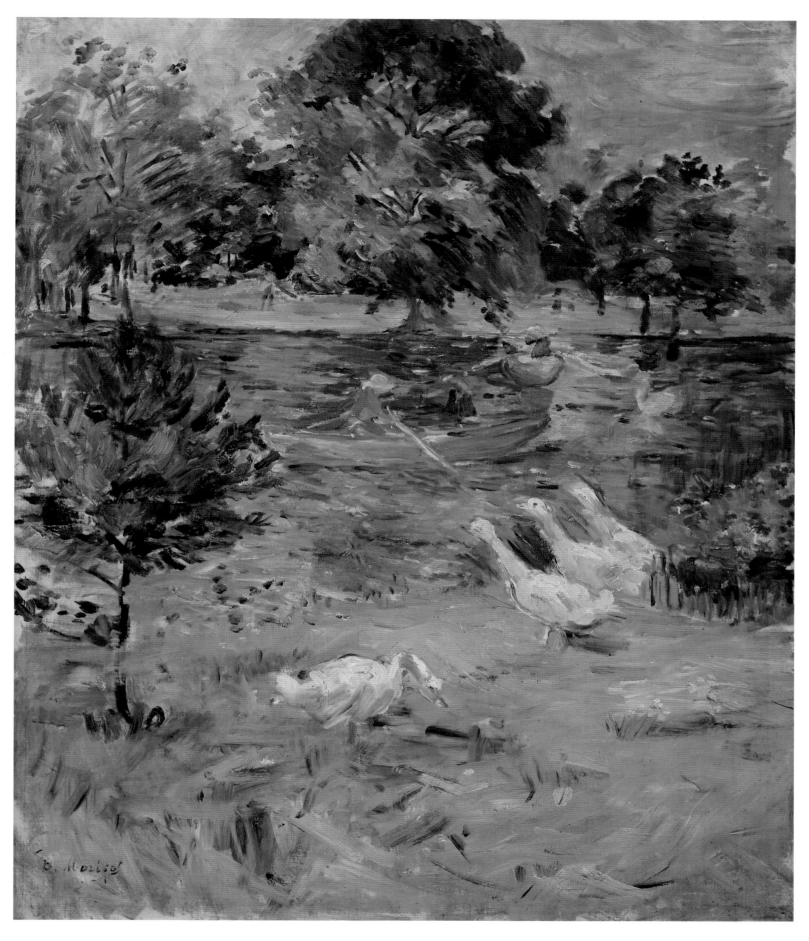

COLOURPLATE 53. Berthe Morisot. *Girl in a Boat with Geese. c.*1889. 25¾ × 21½″ (65.4 × 54.6 cm).
National Gallery of Art, Washington DC (Ailsa Mellon Bruce Collection).

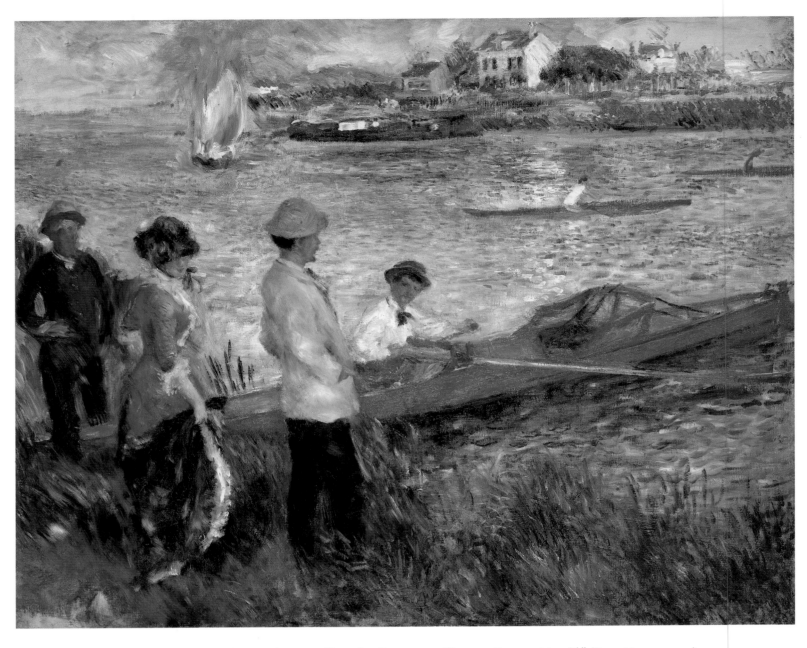

COLOURPLATE 54. Pierre-Auguste Renoir. *Oarsmen at Chatou*. 1879. 32 × 39½″ (81.3 × 100.3 cm). National Gallery of Art, Washington DC (Gift of Sam A. Lewisohn).

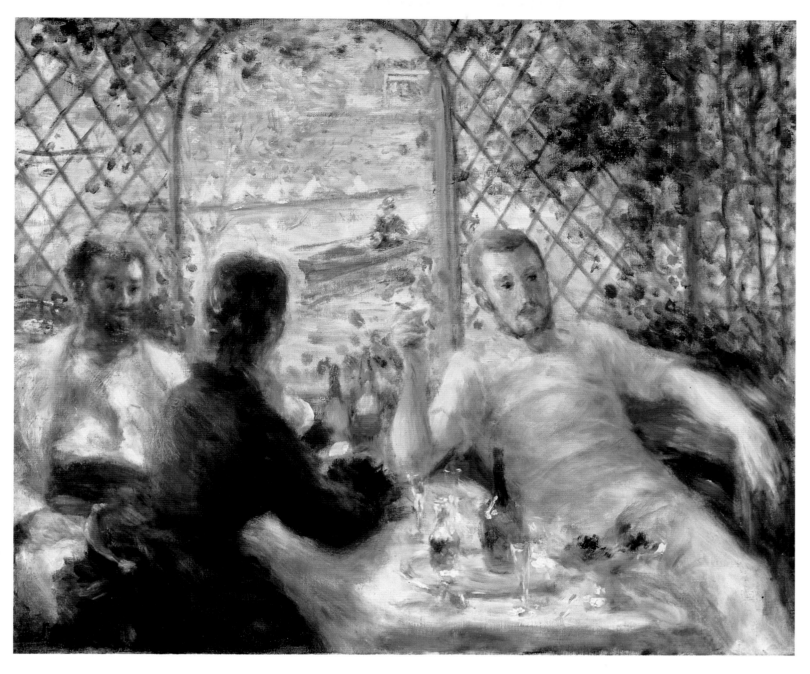

COLOURPLATE 55. Pierre-Auguste Renoir. *The Canoeists' Luncheon*. 1879–80. 21½ × 26″ (55.1 × 65.9 cm).
The Art Institute of Chicago (Potter Palmer Collection 1922.437).

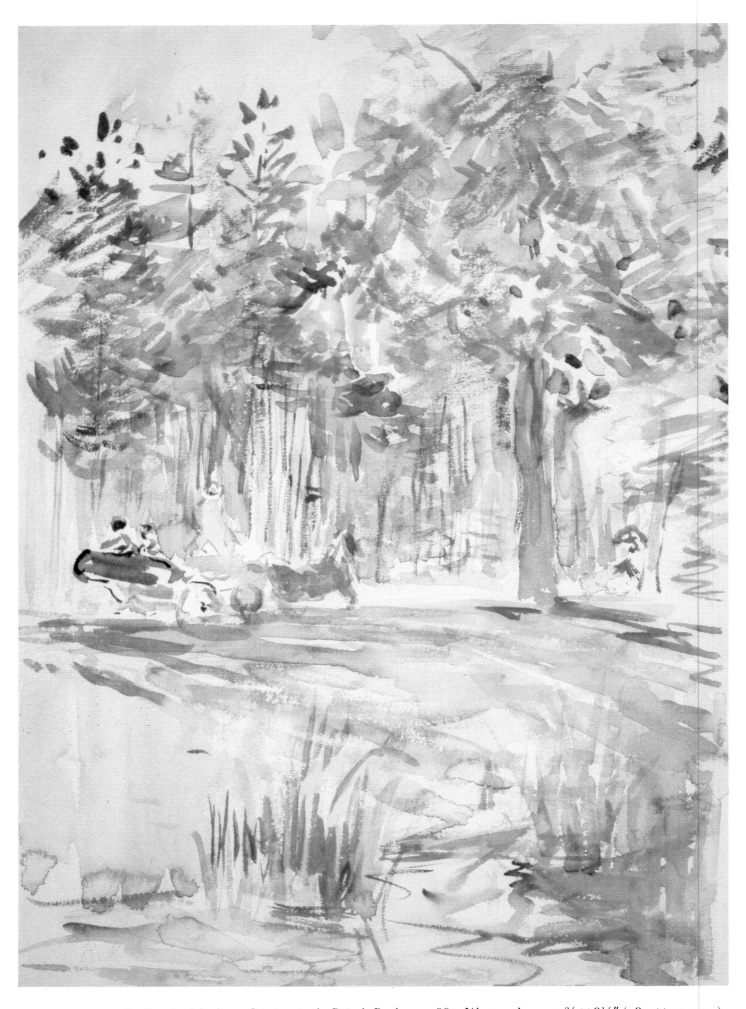

COLOURPLATE 56. Berthe Morisot. *Carriage in the Bois de Boulogne*. 1889. Watercolour, 11⅜ × 8⅛″ (28.9 × 20.7 cm).
Ashmolean Museum, Oxford.

Hang it all! You may hate one another's guts but you march in the same rank against the common enemy; you may even insult one another afterwards, if you like, away from the spectators, in the wings, but you pull together, for it is madness to dissipate your forces when you are struggling, a few of you, against a whole crowd. Furthermore, if you insisted on thus barring entry to your group with the excuse of achieving a more consistent collection of works, admitting only artists using similar means, without taking each one's temperament into account, without acknowledging that a single goal may be achieved by different means, you would inevitably end up with monotony of subject-matter and uniformity of means, in a word, with the most complete sterility.

At all events, and though deploring in particular the departure of M. Degas, who is irreplaceable, let us enter the gloomy room of the Panorama de Reichshoffen where, on this occasion, the Independents have set up their caravan.

M. CAILLEBOTTE

I have already written at length about the work of this painter, in my Salon of 1880; I said how well-grounded the attitudes of his figures were, and how accurate the milieux which contain them; the pictures he is exhibiting this year are evidence that his great qualities have remained intact; there is the same refined sense of modernism, the same tranquil virtuosity of execution, the same scrupulous study of light.

Two of his canvases are decisive: one, the *Game of Bezique*, is more life-like than those of the old Flemish painters where the players are almost always looking at us out of the corner of their eye, where they are more or less playing to the gallery, above all in the work of the worthy Teniers. Nothing like that here. Imagine that a window has been opened up in the wall of the gaming room and that opposite us, cut off by the window frame, you can see people – without being seen by them – smoking, absorbed, frowning, hands hovering above the cards, pondering the triumphant coup.

The other picture takes us into a bedroom on whose balcony a gentleman, with his back to us, contemplates the vista of an endless boulevard, the two banks of its roofs containing waves of leaves rising from the trees beneath on the pavements.

Since these two paintings are of the order I have already discussed, I shall not stress their originality, for in this appendix to my previous Salons I wish to limit myself simply to demonstrating the suppleness and variety of this painter's talent. At the Panorama he is exhibiting samples of all genres: interiors, landscapes, seascapes and still lifes.

Unlike most of his colleagues, he is never static, adopting no particular speciality, and thus avoiding a certain repetitiveness and inevitable retrenchment; his paintings of fruit on beds of white paper are extraordinary. Juice wells up under the skins of his pears whose pale gold surfaces are slashed with green and pink; a haze dulls the beads of his grapes, which become damp; there is an austere reality, an absolute fidelity of tone; this is still life freed of its tithe of banality, it is the antithesis of those hollow fruits with their impermeable outer skins swelling out against the usual backgrounds of rubber grey and soot black.

We shall find the same integrity in a pastel seascape and in a view of Villers-sur-Mer with its brilliant execution of crude patches in full sunlight, as in a Japanese image. Although literary and artistic injustice no longer has the power to move me, I am surprised, despite myself, at the persistent silence maintained by the press in connection with such a painter.

M. GAUGUIN

Not progressing, alas! Last year this artist brought us an excellent study of a nude; this year, nothing of any merit. At most, I might mention his new view of the church of Vaugirard as being stronger than the rest. As to his studio interior, the colour is dull and blotchy; his sketches of children are curious, but they are reminiscent, to the point of confusion, of the interesting sketches by Pantazzis, the Greek painter, who exhibits in Brussels circles.

The seventh Exposition des Artistes Indépendants opened in March 1882 at 251 rue Saint-Honoré and saw the return of Caillebotte, Renoir, Monet and Sisley. It was held in premises specially built for the display of a painted panorama of the battle of Reichshoffen, one of the most disastrous defeats for France of the Franco-Prussian war.

Caillebotte: Game of Bezique *(1880), Private Collection, Paris.*

Marine *(c. 1880), Private Collection, Paris;* Regatta at Villers *(1880), Private Collection, Paris.*

Gauguin: View of the Church of Vaugirard *(1881), Wildenstein 61.*

MLLE MORIZOT [*sic*]

Her usual self – hasty sketches, delicate, even charming in tone, but there is no certainty, no work that is full and complete. Still the same, insubstantial, vanilla-flavoured floating islands, painted desserts!

M. GUILLAUMIN

He is gradually unravelling the chaos in which he has long struggled. As early as 1881 solid patches, vivid impressions of sunsets were emerging from the coloured cloudbursts of his canvases; this time his *Châtillon landscapes* and his *Watering-trough on the Quai des Célestins* are almost balanced, but M. Guillaumin's eye remains singularly unsettled when he considers the human face; his former lavish rainbow colours reappear in his portraits, flashing brutally from top to bottom of his canvases.

M. RENOIR

A gallant and daring charmer. Like Whistler, the American who gave his pictures titles of this kind: *Harmony in green and gold, in amber and black, Nocturnes in silver and blue*, M. Renoir could give several of his paintings the title of harmonies, adding the names of the most radiant tints.

This artist is very productive; I remember a large canvas, from 1876, representing a mother and two daughters, a strange painting in which the colours looked as if they had been rubbed away with a wad of cloth, where the oil vaguely imitated the fainter tones of pastel. In 1877 I noted M. Renoir as doing firmer works, of a more resolute colouring and a surer sense of modernity. Undoubtedly, and despite the visitors who were sniggering idiotically before them, these canvases bespoke a precious talent; since then, M. Renoir seems to me definitively to have settled down. Despite the poverty of our chemical ingredients, he has truly succeeded in capturing those mirages of light, that gold haze which sparkles and trembles in a ray of sun and which so fascinated Turner. He is the true painter of young women, expertly rendering the surface of their skin, their velvety flesh, their lustrous eyes and elegant attire in all the gaiety of sunlight. His *Woman with a fan*, exhibited this year, delights one with the delicate sparkle of her great dark eyes; I am less fond, for instance, of his *Luncheon at Bougival*; some of his oarsmen are good, some of his oarswomen are charming, but the picture lacks a certain strength; his young girls are dainty and merry, but they do not have the smell of the Paris girl; they are spring tarts who have just recently breezed in from London.

M. PISSARRO

His *Road to Pontoise at Auvers*, his *Sunset*, his *View of Pontoise Prison*, with their great dappled skies and soaring trees so firmly rooted to the soil, are pendants to the magnificent landscapes he exhibited on the boulevard des Capucines; here we have the same personal interpretation of nature, the same clear-sighted syntax of colour. Apart from his Seine-et-Oise landscapes, M. Pissarro is exhibiting a whole series of peasant men and women, and this reveals to us a whole new side of the painter! As I believe I have already written, in his works the human figure sometimes had something of a Biblical bearing – this is no longer the case; M. Pissarro has entirely freed himself of memories of Millet; he paints his country people without false grandeur, simply, as he sees them. His delicious little girls in red stockings, his old woman in a headscarf, his shepherdesses and washerwomen, his peasant women eating or cutting grass, are real little masterpieces.

M. SISLEY

M. Sisley was one of the first, along with M. Pissarro and M. Monet of whom I shall say more anon, to turn to nature, to dare to consult her, to attempt faithfully to render the sensations he felt before her. His artist's temperament being less restive and less nervous, his eye less disordered than those of his two confrères, today M. Sisley is less individual, less

Renoir: Girl with a Fan *(c. 1881), Hermitage, Leningrad;* Luncheon of the Boating Party *(1880–1), Colourplate 75.*

The Restaurant Fournaise at Chatou. Photograph (Collection Sirot-Angel, Paris).

personal than they. He is a painter of very real worth, but here and there he still shows signs of extraneous influence. Certain reminiscences of Daubigny assail me when looking at his contribution this year and indeed his autumn leaves put me in mind of Piette. Yet his work has resolution, it has individuality; it also has a lovely melancholy smile and often even a sort of blessedness.

M. CLAUDE MONET

M. Monet is the landscapist, with MM. Pissarro and Sisley, for whom the epithet Impressionist was especially created.

For a long time M. Monet has been floundering, delivering up uncertain abbreviations, cobbling together bits of landscape, bitter salads of orange peel, green spring onions and ribbons of hairdressers' blue – the latter in simulation of the running waters of a stream. Of course, his artist's eye took things to extremes; but one should also say that he had a certain carelessness and an absence of over-obvious study. Despite the talent implied by certain sketches, I was increasingly losing interest, I confess, in this rushed and muddled painting.

Impressionism as practised by M. Monet led straight to a dead end; it was the stillborn offshoot of realism, where the real work was begun and then always abandoned midway. M. Monet has certainly made the greatest contribution to persuading the public that the word "Impressionism" referred exclusively to painting which had remained in a state of inchoate confusions, of uncertain beginnings.

Happily, this artist has undergone a sudden change; he seems to have decided to stop daubing piles of canvases at random; he seems to have gathered himself together, and he has been wise to do so, for this time he has given us some very lovely and very finished landscapes.

His ice breaking up under a red-brown sky is of an intense melancholy and his seascapes with waves breaking on the cliffs are among the truest I know. Then there are his landscapes, his views of Vétheuil, and a marvellously coloured field of poppies flaming beneath a pale sky. There is no doubt that the painter of these pictures is a great landscape painter whose eye, now that it is cured, seizes all the phenomena of light with superb accuracy. The spray of his waves, whipped up in sudden shafts of light, is wonderfully true, his streams glide by, dappled by the myriad colours of the things they mirror, in his canvases the slight cold breath of the water rises up into the foliage and slips through the tips of the grasses. M. Monet is the painter of seascapes par excellence! His painting, like that of M. Pissarro, is now in full flower. His earlier pictures, where the water looked like spun glass with streaks of vermilion and Prussian blue, are far behind; as is his bogus Japanese woman, exhibited in 1876, a fancy-dress figure surrounded by fans, and whose dress was so heavily encrusted with red that she looked like a piece of vermilion stonework.

I am delighted to be able to applaud M. Monet because it is to his efforts and those of his Impressionist colleagues in landscape painting that the redemption of painting in general is now due; luckier and more gifted than poor Chintreuil who took risks in his time and died in harness, without managing fully to give expression to those sun- and rain-filled effects which he tried so desperately to render, MM. Pissarro and Monet have at last emerged victorious from the terrible fray. One may say that the formidable problems of light, in painting, have at last been resolved in their canvases.

ébauche: *the preliminary "laying-in" of a painting intended as a finished picture.*

Monet: The Icefloes *(1880), Shelburne Museum, Shelburne, Vermont; (*Vétheuil*)* L'Île aux Fleurs *(1880), Metropolitan Museum of Art, New York.*

JULES LAFORGUE

IMPRESSIONISM: CRITICAL VIEWS

"The Eye and the Poet"

October 1883

Jules Laforgue (1860–87), Symbolist poet and critical writer. His interests were wide-ranging and brought together ideas from science, philosophy and psychology which he applied to art. His poetry had a considerable impact on the development of modernism and influenced the early T. S. Eliot.

THE ACADEMIC EYE AND THE IMPRESSIONIST EYE: POLYPHONY OF COLOUR. In a landscape flooded with light, in which beings are outlined as if in coloured grisaille, where the academic painter sees nothing but a broad expanse of whiteness, the Impressionist sees light as bathing everything not with a dead whiteness but rather with a thousand vibrant struggling colours of rich prismatic decomposition. Where the one sees only the external outline of objects, the other sees the real living lines built not in geometric forms but in a thousand irregular strokes, which, at a distance, establish life. Where one sees things placed in their regular respective planes according to a skeleton reducible to pure theoretic design, the other sees perspective established by a thousand trivial touches of tone and brush, by the varieties of atmospheric states induced by moving planes.

The Impressionist eye is, in short, the most advanced eye in human evolution, the one which until now has grasped and rendered the most complicated combinations of nuances known.

The Impressionist sees and renders nature as it is – that is, wholly in the vibration of colour. No line, light, relief, perspective or chiaroscuro, none of those childish classifications: all these are in reality converted into the vibration of colour and must be obtained on canvas solely by the vibration of colour.

The article of which this is an extract was written on the occasion of an exhibition which included Monet, Pissarro, Renoir and Degas at the Gurlitt Gallery in Berlin in October 1883. It is unclear whether the German magazine in which it was to have appeared ever came out, but it was published in Laforgue's Mélanges Posthumes *in 1902.*

In the little exhibition at the Gurlitt Gallery, the formula is visible especially in the work of Monet and Pissarro ... where everything is obtained by a thousand little dancing strokes in every direction like straws of colour – all in vital competition for the whole impression. No longer an isolated melody, the whole thing is a symphony which is living and changing like the "forest voices" of Wagner, all struggling to become the great voice of the forest – like the Unconscious, the law of the world, which is the great melodic voice resulting from the symphony of the consciousness of races and individuals. Such is the principle of the *plein-air* Impressionist school. And the eye of the master will be the one capable of distinguishing and recording the most sensitive gradations and decompositions on a simple flat canvas. This principle has been applied not systematically but with genius by certain of our poets and novelists.

This refers to Act II of Siegfried *in which the hero tries to understand the song of the birds.*

FALSE TRAINING OF THE EYES. Now everyone knows that we do not see the colours of the palette in themselves but rather according to the illusions which the paintings of the past have developed in us, and above all we see them in the light which the palette itself gives off. (Compare the intensity of Turner's most dazzling sun with the flame of the weakest candle.) What one might call an innate harmonic agreement operates automatically between the visual effect of the landscape and the paint on the palette. This is the proportional language of painting, which grows richer in proportion to the development of the painter's optical sensibility. The same goes for size and perspective. In this sense, one might even go so far as to say that the painter's palette is to real light and to the tricks of colour it plays on reflecting and refracting realities what perspective on a flat canvas is to the real planes of spatial reality. On these two things, the painter builds.

Cham. *Le Charivari*, April 22, 1877. "The Impressionist painters doubling the effect of their exhibition by executing it to Wagner's music." British Library.

MOBILITY OF LANDSCAPE AND MOBILITY OF THE PAINTER'S IMPRESSIONS. You critics who codify the beautiful and guide the development of art, I would have you look at this painter who sets down his easel before a rather

evenly lighted landscape – an afternoon scene, for example. Let us suppose that instead of painting his landscape in several sittings, he has the good sense to record its tonal values in *fifteen minutes* – that is, let us suppose that he is an Impressionist. He arrives on the scene with his own individual optic sensibility. Depending on the state of fatigue or preparation the painter has just been through, his sensibility is at the same time either bedazzled or receptive; and it is not the sensibility of a single organ, but rather the three competitive sensibilities of Young's fibrils. In the course of these fifteen minutes, the lighting of the landscape – the vibrant sky, the fields, the trees, everything within the insubstantial network of the rich atmosphere with the constantly undulating life of its invisible reflecting or refracting corpuscles – has undergone infinite changes, has, in a word, lived.

In the course of these fifteen minutes, the optical sensibility of the painter has changed time and time again, has been upset in its appreciation of the constancy and relative values of the landscape tones. Imponderable fusions of tone, opposing perceptions, imperceptible distractions, subordinations and dominations, variations in the force of reaction of the three optical fibrils one upon the other and on the external world, infinite and infinitesimal struggles.

One of a myriad examples: I see a certain shade of violet; I lower my eyes towards my palette to mix it and my eye is involuntarily drawn by the white of my shirt sleeve; my eye has changed, my violet suffers.

So, in short, even if one remains only fifteen minutes before a landscape, one's work will never be the real equivalent of the fugitive reality, but rather the record of the response of a certain unique sensibility to a moment which can never be reproduced exactly for the individual, under the excitement of a landscape at a certain moment of its luminous life which can never be duplicated.

There are roughly three states of mind in the presence of a landscape: first, the growing keenness of the optical sensibility under the excitement of this new scene; second, the peak of keenness; third, a period of gradual nervous exhaustion.

To these should be added the constantly changing atmosphere of the best galleries where the canvas will be shown, the minute daily life of the landscape tones absorbed in perpetual struggle. And, moreover, with the spectators the same variation of sensibility, and with each an infinite number of unique moments of sensibility.

Subject and object are then irretrievably in motion, inapprehensible and unapprehending. In the flashes of identity between subject and object lies the nature of genius. And any attempt to codify such flashes is but an academic pastime.

CAMILLE PISSARRO AND J.-K. HUYSMANS

Correspondence

1883

OSNY PRÈS PONTOISE, MAY 15, 1883

My dear Huysmans,
I have just reread your book with great care. My opinion remains the same as to the literary form, but what a gulf separates us as far as painting is concerned.

How is it that you say not a word about Cézanne, whom we all acknowledge as one of the most amazing and enquiring spirits of our time, and who has had a very great influence on modern art? . . .

Your articles on Monet surprised me greatly. How is it that his amazing vision, his phenomenal technique and his rare and powerful decorative

Huysmans had sent Pissarro a copy of his book L'Art Moderne *(1883), a collection of his reviews, 1879–1881.*

sense did not strike you as early as 1870? . . . but you should have another look at those paintings of his that are at Durand-Ruel's or with collectors. I saw some of them recently; I was struck with admiration before so beautiful and so sustained an oeuvre. You are making a serious mistake.

Might you permit me to say, my dear M. Huysmans, that you have allowed yourself to become embroiled in *literary* theories, which can be applicable only to the school of Gérôme . . . and a modernized version at that!

Will you forgive my frankness? If I had no feeling for your talent, I would say nothing.

Your nonetheless devoted C. Pissarro

* * *

Let's see, I find Cézanne's personality congenial, for I know through Zola of his efforts, his vexations, his defeats when he tries to create a work! Yes, he has temperament, he is an artist, but in sum, with the exception of some still lifes, the rest is, to my mind, not likely to live. It is interesting, curious, suggestive in ideas, but certainly he is an eye case, which I understand he himself realizes. . . . In my humble opinion, the Cézannes typify [the impressionists who didn't make the grade]. You know that after so many years of struggle it is no longer a question of more or less manifest or visible intentions, but of works which are real childbirth, which are not monsters, odd cases for a Dupuytren museum of painting.

J.-K. Huysmans

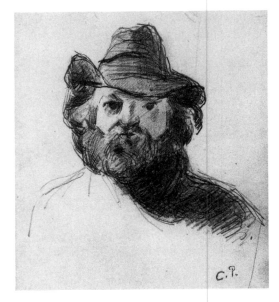

Camille Pissarro. *Portrait of Paul Cézanne.* 1874. Pencil, 7⅜ × 4⅜″ (18.6 × 10.9 cm). Musée du Louvre, Paris.

Dupuytren was the founder of a medical museum of anatomy.

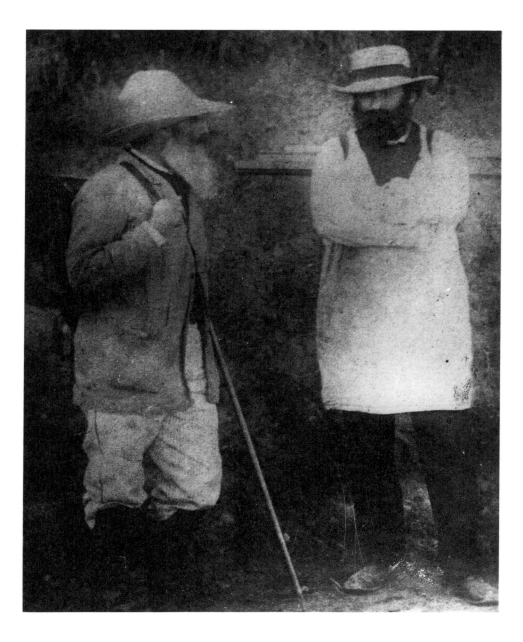

Pissarro and Cézanne. Photograph. *c.*1877.

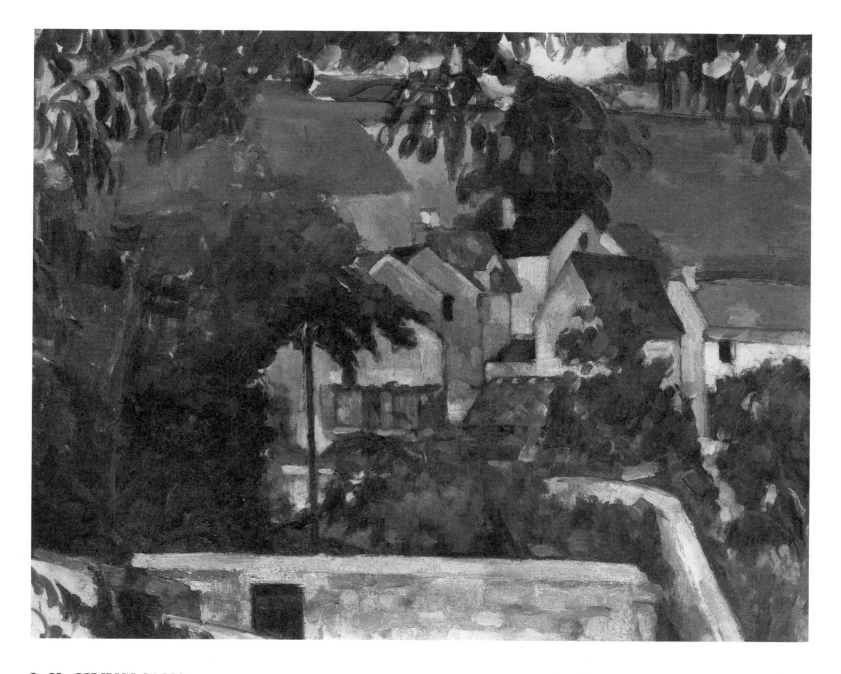

J.-K. HUYSMANS

CERTAINS

"Cézanne"

1889

In full light, in porcelain fruit dishes or on white tablecloths, rough, unpolished pears and apples are fashioned with a trowel, brushed up with the touch of a thumb. Close up, a wild rough-cast of vermilion and yellow, of green and blue; at a distance, in focus, fruit intended for the showcases of chevets, ripe and succulent fruit, the object of envy.

And truths omitted until they can be perceived, strange but real tones, patches of singular authenticity, nuances of line, subordinated to the shadows which spread around the fruit and scatter, giving a plausible and charming blue tinge which make these canvases initiatory works, whereas one is accustomed to the usual still-life paintings dashed off with a bituminous repoussoir against unintelligible backgrounds.

Then sketches of landscapes outdoors, tentative retardation of branches, attempts with their freshness spoiled by retouching, childish and barbaric sketches, in short, disarming disequilibrium; houses perched on one side, like drunkards, fruit all askew in tipsy pottery; naked women bathers, encircled by crazy, but exciting lines for the glory of one's eyes, with the fiery passion of a Delacroix, without refinement of vision and without a fine touch, whipped up by a fever of dissipated colours, hurled, in relief, against the heavy canvas which curves!

In short, a revealing colourist who contributed more than the late Manet to the Impressionist movement, an artist with diseased eyes who, in the exasperated apperception of his sight, discovered the preambles of a new art, so it seems that one sums up this too much forgotten painter, Cézanne.

He did not exhibit again after 1877, when he showed in rue le Peletier sixteen canvases, of which the perfect honesty of art served to enliven the crowd for a long time.

VINCENT VAN GOGH

Letter to his Sister Wil

June/July 1888

You ask whether I sent something to the "Arti" Exhibition – certainly not! Only, Theo sent Mr Tersteeg a consignment of pictures by impressionist painters, and among them there was one of mine. But the only result has been that neither Tersteeg nor the artists, as Theo informed me, have seen anything in them.

Hermanus Tersteeg, director of the firm of dealers Goupil and Co. at The Hague when Vincent began work there in 1869, and a friend of the family.

Well, this is extremely comprehensible, for it is invariably the same thing all over again. One has heard talk about the Impressionists, one expects a whole lot from them, and . . . when one sees them for the first time one is bitterly, bitterly disappointed, and thinks them slovenly, ugly, badly painted, badly drawn, bad in colour, everything that's miserable.

This was my own first impression too when I came to Paris, dominated as I was by the ideas of Mauve and Israëls and other clever painters. And when there is an exhibition in Paris of Impressionists only, it is my belief that a lot of visitors come back from it bitterly disappointed, and even indignant, in a state of mind comparable to the mood of the decent Dutchmen in the days of yore, who left church and a moment later heard a discourse by Domela Nieuwenhuis or one of the other socialists.

Anton Mauve (1838–88), Jozef Israëls (1824–1911): Dutch painters of the Hague School.

Domela Nieuwenhuis (1846–1919), spokesman for socialism in Holland who later became an anarchist.

And yet – you know it – within ten or fifteen years the whole edifice of the national religion collapsed, and – the socialists are still there, and will be there for a long time to come, although neither you nor I are very much addicted to either creed.

Well, Art – the officially recognized art – and its training, its management, its organization, are stagnant-minded and mouldering, like the religion we see crashing, and it will not last, though there be ever so many exhibitions, studios, schools, etc. Will last as little as the bulb trade.

But this is none of our business; we are neither the founders of something new, nor are we called on to be the preservers of something old.

But this is what remains – a painter is a person who paints, in the same way that a florist is in reality a person who loves plants and grows them himself, which is not done by the flower merchant.

And consequently, though some of those twenty painters or so who are called Impressionists have become comparatively rich men, and rather big fellows in the world, yet the majority of them are poor devils, whose homes are cafés, who lodge in cheap inns and live from hand to mouth, from day to day.

But in *a single day* those twenty whom I mentioned paint everything they lay eyes on, and better than many a big noise who has a high reputation in the art world.

I tell you this in order to make you understand what kind of tie exists between me and the French painters who are called Impressionists – that I know many of them personally, and that I like them.

And that furthermore in my own technique I have the same ideas about colour, even thought about them when I was still in Holland.

VINCENT VAN GOGH

Letter to his Brother Theo

August 1888

You are shortly to make the acquaintance of Master Patience Escalier, a sort of "man with a hoe," formerly cowherd of the Camargue, now gardener at a house in the Crau. The colouring of this peasant portrait is not so black as in the "Potato Eaters" of Nuenen, but our highly civilized Parisian *Portier* – probably so called because he chucks pictures out – will be bothered by the same old problem. You have changed since then, but you will see that *he* has not, and it really is a pity that there are not more pictures *en sabots* in Paris. I do not think that my peasant would do any harm to the de Lautrec in your possession if they were hung side by side, and I am even bold enough to hope the de Lautrec would appear even more distinguished by the mutual contrast, and that on the other hand my picture would gain by the odd juxtaposition, because that sun-steeped, sunburned quality, tanned and air-swept, would show up still more effectively beside all that face powder and elegance.

What a mistake Parisians make in not having a palate for crude things, for Monticellis, for common earthenware. But there, one must not lose heart because Utopia is not coming true. It is only that what I learned in Paris is leaving me, and I am returning to the ideas I had in the country before I knew the Impressionists. And I should not be surprised if the Impressionists soon find fault with my way of working, for it has been fertilized by Delacroix's ideas rather than by theirs. Because instead of trying to reproduce exactly what I have before my eyes, I use colour more arbitrarily, in order to express myself forcibly. Well, let that be, as far as theory goes, but I'm going to give you an example of what I mean.

I should like to paint the portrait of an artist friend, a man who dreams great dreams, who works as the nightingale sings, because it is his nature. He'll be a blond man. I want to put my appreciation, the love I have for him, into the picture. So I paint him as he is, as faithfully as I can, to begin with.

But the picture is not yet finished. To finish it I am now going to be the arbitrary colourist. I exaggerate the fairness of the hair, I even get to orange tones, chromes and pale citron-yellow.

Behind the head, instead of painting the ordinary wall of the mean room, I paint infinity, a plain background of the richest, intensest blue that I can contrive, and by this simple combination of the bright head against the rich blue background, I get a mysterious effect, like a star in the depths of an azure sky.

Again, in the portrait of the peasant I worked this way, but in this case without wishing to produce the mysterious brightness of a pale star in the infinite. Instead, I imagine the man I have to paint, terrible in the furnace of the height of harvest-time, as surrounded by the whole Midi. Hence the orange colours flashing like lightning, vivid as red-hot iron, and hence the luminous tones of old gold in the shadows.

Oh, my dear boy . . . and the nice people will only see the exaggeration as a caricature.

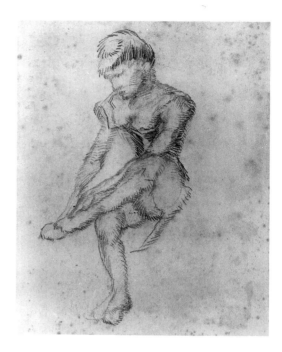

Vincent van Gogh. *Sketch of Seated Woman (Front View)*. Paris, March 1886–February 20, 1888. Pencil, 11¾ × 9″ (30 × 23 cm). Vincent van Gogh Foundation, Van Gogh Museum, Amsterdam.

Adolphe Monticelli (1824–86), Provençal painter admired by Van Gogh and Cézanne.

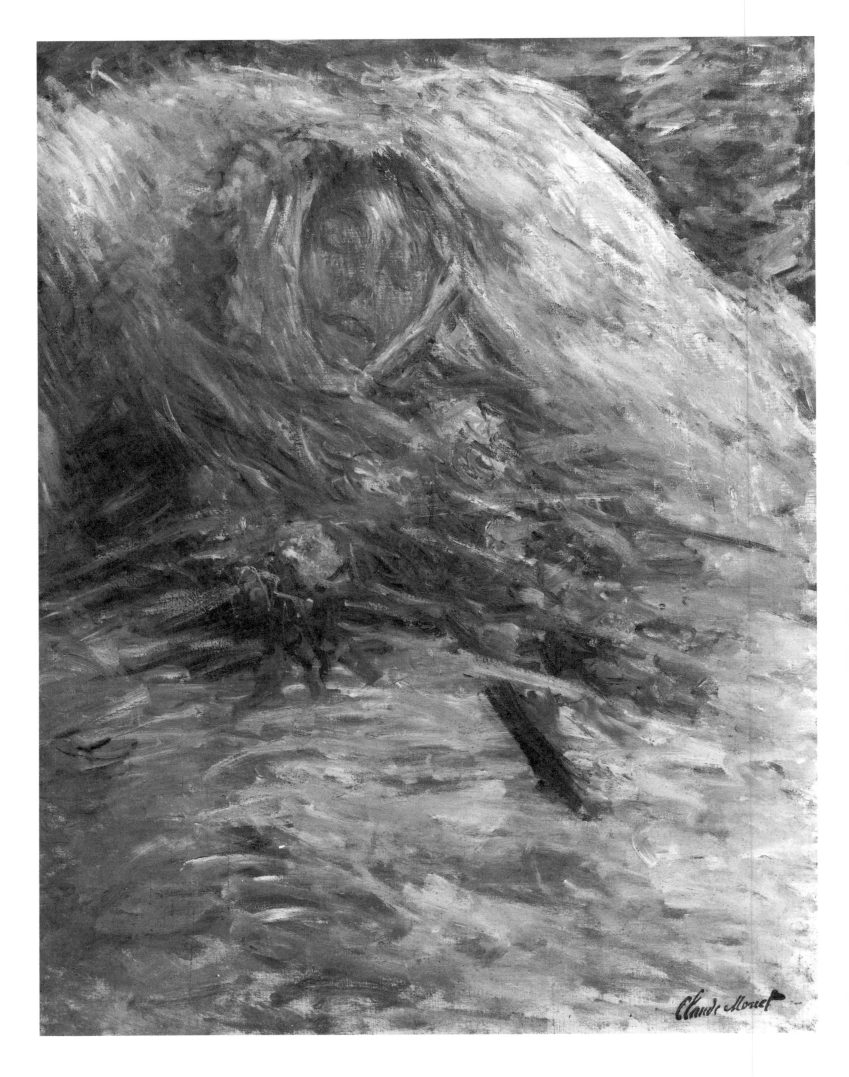

GEORGES CLEMENCEAU
CLAUDE MONET
Camille on her Deathbed
1929

One day I told Monet, "It is humiliating for me. We see things completely differently. I open my eyes and I see shapes and nuances of colour, which, until proven otherwise, I take to be the transitory aspects of things as they are. My eye stops at the reflecting surface and goes no further. It is different with you. The steel ray of your vision pierces the shell of appearances and you penetrate to their deeper substance in order to break that down into luminous media, thence to reconstruct the substance with your painter's brush. Subtly, you recreate the effect of sensations upon our retinas in very nearly all its vigour. When I look at a tree, I see only a tree, but you, you look through half-closed eyes and think, 'How many shades of how many colours are there within the nuances of light in this simple tree trunk?' Then you set about breaking down those values in order to rebuild and develop the ultimate harmony of the whole – and all for us. And you torment yourself, seeking that keen analysis that will allow you to approximate the interpretative synthesis best. And you doubt yourself, you are unwilling to understand that you are hurtling like a missile toward the infinite, and that you must be satisfied to come only close to a goal that you will never achieve completely."

"You cannot know," replied Monet, "how close you are to the truth. What you describe is the obsession, the joy, the torment of my days. To the point that one day, when I was at the deathbed of a lady who had been, and

Georges Clemenceau (1841–1929), physician, publisher, writer, politician and statesman. He was premier of France from 1906 to 1909 and from 1917 to 1920. In 1881 he founded the republican newspaper La Justice. *Although his first meeting with Monet was in the early 1860s, it was through Geffroy, who was then art critic for the paper, that in 1886 Clemenceau renewed their friendship and became a staunch critical supporter.*

(*Opposite*) Claude Monet. *Camille on her Deathbed.* 1879. 35½ × 26¾" (90 × 68 cm). Musée d'Orsay, Paris.

(*Below*) Claude Monet. *The Break-up of the Ice.* 1880. 24 × 39" (70 × 99 cm). University of Michigan Museum of Art (Russell B. Stearns and Andrée B. Stearns, Dedham, Massachusetts).

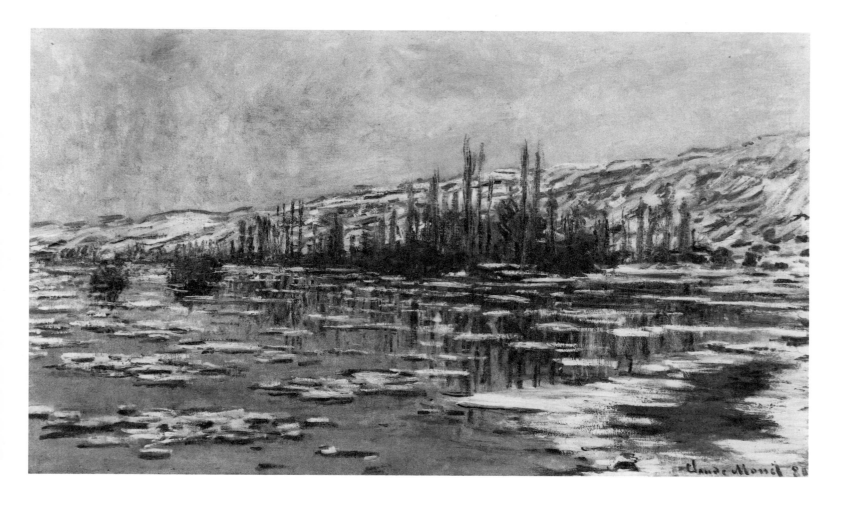

still was, very dear to me, I found myself staring at the tragic countenance, automatically trying to identify the sequence, the proportions of light and shade in the colours that death had imposed on the immobile face. Shades of blue, yellow, grey, and I don't know what. That's what I had become. It would have been perfectly natural to have wanted to portray the last sight of one who was to leave us forever. But even before the thought occurred to memorize the face that meant so much to me, my first involuntary reflex was to tremble at the shock of the colours. In spite of myself, my reflexes drew me into the unconscious operation that is but the daily order of my life. Pity me, my friend."

PIERRE-AUGUSTE RENOIR

Letter to Durand-Ruel

November 21, 1881

NAPLES

Dear Monsieur Durand-Ruel,

I have been meaning to write to you for a long time, but I wanted to send you a mass of pictures as well. But I am still bogged down in experiments – a malady. I'm not satisfied, so I clean things off, again and again. I hope the mania is coming to an end; that is why I am giving you this sign of life. I do not think I shall bring back very much from my travels. But I think I shall have made progress, which always happens after experimenting for a long time. One always comes back to one's first love, but with a note added. Anyhow, I hope you will forgive me if I don't bring you back a great deal. Besides, you'll see what I shall do for you in Paris.

I am like a child at school. The new page is always going to be neatly written, and then pouf! . . . a blot. I'm still making blots . . . and I am 40 years old. I went to look at the Raphaels in Rome. They are very fine and I ought to have seen them earlier. They are full of skill and wisdom. He didn't try to do the impossible, like me. But his work is fine. I prefer Ingres for oil paintings. But the frescoes are admirable in their simplicity and nobility.

I take it you are well, as usual, and your little family too. But I shall be seeing you soon, for Italy is very fine. But Paris . . . Ah! Paris . . .

I am beginning something. I won't tell you what, because then I should spoil it. I have my superstitions.

A thousand greetings,

Renoir

Between October 1881 and January 1882 Renoir travelled in Italy visiting Venice, Rome, Naples, Calabria, Pompeii, Sorrento, Capri and Palermo. The trip was motivated by a desire to see Raphael's works and the wall-paintings at Pompeii at first hand and to clarify a number of conceptual and technical problems he was having with Impressionism in the early 1880s.

PIERRE-AUGUSTE RENOIR

Letter to Madame Charpentier

January/February 1882

L'ESTAQUE NEAR MARSEILLES

Dear Madame,

In Naples I received a letter from Deudon, who told me that you had talked a lot about me, which gave me considerable pleasure, and that you were still thinking about the pastel of your little girl. I should have rushed straight to Paris, and I did not do so because I am learning a great deal here and the

Marguerite Charpentier (1848–1904) was the wife of Georges Charpentier (1846–1905), publisher of Flaubert, Zola, the Goncourts and the journal La Vie Moderne. *The Charpentiers held a renowned literary and political salon and were among Renoir's most important patrons. Charles Deudon (1832–1914), lawyer and a patron of Renoir.*

longer I take, the better the portrait will be. Here I can do things that are quite impossible in Paris. I have perpetual sunshine and I can rub out and begin again as much as I like. That is the only way to learn, and in Paris one is forced to be satisfied with very little. I have spent a lot of time in the museum at Naples, the paintings from Pompei are extremely interesting from all points of view, so I am staying in the sunshine – not to do portraits in full sunlight, but because I think that by sunning myself and looking a good deal, I shall have attained the grandeur and simplicity of the old painters. Although Raphael did not work out of doors, he definitely studied sunlight because his frescoes are full of it. So all this looking at the outdoors has meant that I now see only the large harmonies, without any longer concerning myself with the small details which put out the sun instead of setting it aflame.

I thus hope that when I come back to Paris I shall do something which will be the result of these general studies, and that you will benefit from them. As you may well imagine, I may be entirely mistaken in all this but I shall have done all I can to avoid that. Men are made to make mistakes. You will forgive me. A thousand friendly greetings, and a warm handshake to M. Charpentier.

<div style="text-align: right">Renoir.</div>

I hope to be back at the end of the month. At the latest. I have done several studies of Italy which I shall show to you on my return.

AMBROISE VOLLARD

RENOIR, AN INTIMATE RECORD

"Renoir's Dry Manner"

1925

This is Renoir's account as retold by Vollard of the crisis that affected his work in the mid-1880s.

RENOIR: I was going to tell you last time . . . about a sort of break that came in my work about 1883. I had wrung Impressionism dry, and I finally came to the conclusion that I knew neither how to paint nor draw. In a word, Impressionism was a blind alley, as far as I was concerned.

VOLLARD: But what about all the effects of light that you rendered so well?

R.: I finally realized that it was too complicated an affair, a kind of painting that made you constantly compromise with yourself. Out of doors there is a greater variety of light than in the studio, where, to all intents and purposes, it is constant; but, for just that reason, light plays too great a part outdoors; you have no time to work out the composition; you can't see what you are doing. I remember a white wall which reflected on my canvas one day while I was painting; I keyed down the colour to no purpose – everything I put on was too light; but when I took it back to the studio, the picture looked black.

Another time I was painting in Brittany, in a grove of chestnut-trees. It was autumn. Everything I put on the canvas, even the blacks and the blues, was magnificent. But it was the golden luminosity of the trees that was making the picture; once in the studio, with a normal light, it was a frightful mess.

If the painter works directly from Nature, he ultimately looks for nothing but momentary effects; he does not try to compose, and soon he gets monotonous. I once asked a friend, who was exhibiting a series of *Village Streets*, why they were all deserted.

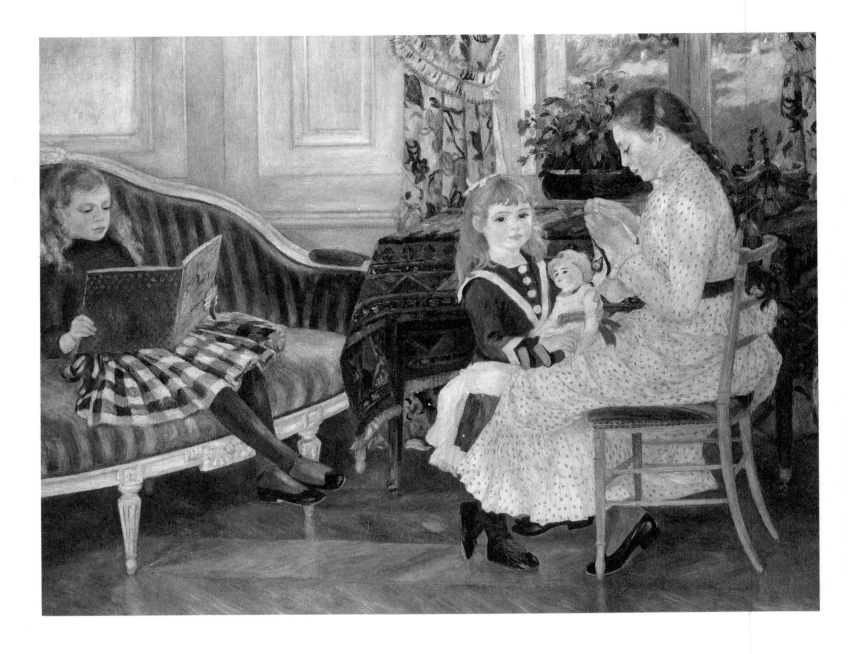

"Because," he replied, "the streets were empty while I was at work."

v.: Corot painted all his life in the open, didn't he?

r.: His studies, yes, but his compositions were done in the studio. He *corrected* Nature. Everybody used to say that he was wrong to work his sketches over indoors. I had the good fortune to meet Corot once and I told him of the difficulty I had in working out of doors. He replied: "That's because you can never be sure of what you're doing. You must always paint over again in the studio." But that did not prevent Corot from interpreting Nature with a realism that no Impressionist painter has ever been able to equal! How I have slaved to paint the colours of the stones of Chartres cathedral and the red bricks of the houses at La Rochelle as he did!

v.: Weren't the Old Masters working for these same effects of light? Duranty, I think, says that the Venetians foreshadowed them.

r.: "Foreshadowed" is good! Just look at the Titians in the Prado. You don't even have to go back as far as Titian – take Ribera, a painter who has the reputation of being the last word in black. Do you remember the rose colour of the child and the yellow of the straw in his *Infant Jesus* in the Louvre? Have you ever seen anything more luminous than that?

v.: Allow me one last question. I read somewhere that "when we study the pictures in the museums – even those which exhibit the utmost science in the disposition of the planes, the use of perspective, the forms of clouds, the

Pierre-Auguste Renoir. *Children's Afternoon at Wargemont.* 1884. 50 × 68″ (127 × 173 cm). Nationalgalerie, Staatliche Museen Preussischer Kulturbesitz, Berlin.

José de Ribera (1591–1652).

drawing of objects, the play of light, we observe one convention, or, rather, a lack of knowledge. In Ruysdael, and especially in Hobbema, the stippled, metallic foliage is the colour of ink. It is as if the sun had been blotted out.''

R.: Yes, but long before Ruysdael there were painters who filled their pictures with sunlight. Your author chooses his examples badly. In Italy, which is a warm country, Nature is more prodigal than in Holland. In the *Marriage at Cana* and the nudes of Titian, there is finer light than in any modern canvas.

V.: What about their landscapes?

R.: Look at the *Villa d'Este* of Velasquez, or the *Concert Champêtre* of Giorgione, to mention only two. Even Rembrandt – would it ever occur to you to wonder whether his pictures were painted out of doors or in the studio?

I'm sick and tired of the so-called ''discoveries'' of Impressionism. It isn't likely that the Old Masters were ignorant of them; and, if they did not use them, it was because all great artists have despised mere effects. By making Nature simpler, they made it more impressive. For instance, if the magnificence of a sunset were permanent, it would wear you out, whereas the same scene, without that special effect of light, is not at all fatiguing. With the ancient sculptors, action is reduced to a minimum. Yet you instinctively feel that their statues could move if they wanted to. When you look at Mercié's David, you almost want to help him put his sabre in its sheath!

I was looking at a nude on the easel, which had just been begun.

''From the way you talk, Monsieur Renoir, one would think that ivory black is the only colour that counts, but how do you expect me to believe that you painted flesh like that with 'mud'?''

R.: I don't mean to compare myself with Delacroix, but do you remember that phrase of his, ''Give me some mud, and I will paint you a woman's flesh''?

* * *

R.: I have told you how I discovered, about 1883, that the only thing worth while for a painter is to study the museums? I made this discovery on reading a little book that Franc-Lamy picked up along the quays; it was a treatise on painting by Cennino-Cennini, and gave some precious information on the methods of the fifteenth-century painters.

The public is always convinced you are a fool if you abandon one style to which it is accustomed and adopt another; even my best friends complained of these new leaden colours of mine ''after such pretty tones!''

I had undertaken a large picture of *Bathers* and slaved away at it for three years. (The portrait of Mademoiselle Manet with a cat in her arms is also of this period.) The best that people could find to say about it was that it was a muddle of colour!

On the other hand, I must admit that some of my paintings of this period are not very soundly painted, because, after having studied fresco, I had fancied I could eliminate the oil from the colour. The surface then became too dry, and the successive layers of paint did not adhere well. I did not know at that time the elementary truth that oil-painting must be done with oil. Of course none of those people who established the rules of the ''new'' painting ever thought of giving us this precious hint! Another reason that induced me to dry the oil out of my colour was my search for a means of preventing the paint from blackening; but I later discovered that oil is the very thing which keeps colour from becoming black; only, one must know how to handle the oil.

At this time I also did some paintings on cement, but I was never able to learn from the ancients the secret of their inimitable frescoes. I remember also certain canvases in which I had drawn all the smallest details with a pen before painting. I was trying to be so precise, on account of my distaste for Impressionism, that these pictures were extraordinarily dry.

Saloman van Ruysdael (1600–70), Meindert Hobbema (1638–1709).

Marius-Jean-Antonin Mercié (1845–1916), academic sculptor.

Cennino Cennini (c. 1370–1440), Renaissance sculptor and author of Libro dell'Arte, *an artists' handbook.*

Pierre-Auguste Renoir. *Seated Bather Wiping her Arms.* 1884–5. Pencil heightened with pen, 10¼ × 8½″ (26 × 21.5 cm). Musée du Louvre, Paris (Cabinet des Dessins).

PIERRE-AUGUSTE RENOIR

Letter to Durand-Ruel

September/October 1885

Dear Monsieur Durand-Ruel,
I think you will be pleased this time. I have gone back to the old painting, the gentle light sort and I don't intend ever to abandon it again. I want to come back only when I have a series of canvases, because, now that I'm satisfied, I make progress with each one. My work is quite different from the last landscapes and that dull portrait of your daughter. More like the woman fishing or the woman with a fan, but with a subtle difference given by a tone that I was looking for and which I've found at last. It's not so much new as a continuation of eighteenth-century painting. I don't mean the very best, of course, but I am trying to give you a rough idea of this new (and final) style of mine. (A sort of inferior Fragonard.)

I've just finished a young girl sitting on a bank which I think you'll like.

Please understand that I'm not comparing myself to an eighteenth-century master, but it's important to try and explain to you the direction I'm moving in. These painters, who didn't seem to be working from nature, knew more about it than we do.

JEAN RENOIR

RENOIR, MY FATHER

1958

More important than theories to my father was, in my opinion, his change from being a bachelor to being a married man. Always restless, unable to remain long in one place, jumping into a train with the vague notion of enjoying the misty light of Guernsey, or else immersing himself in the rose-coloured atmosphere of Algeria, he had, since leaving the rue des Gravilliers, lost the meaning of the word home. And here he was, installed in an apartment with his wife, taking meals at regular hours, his bed carefully made every day and his socks mended for him. To all these benefits another was soon to be added in the form of his first-born child. The birth of my brother Pierre was to cause a definitive revolution in Renoir's life. The theories aired at the Nouvelle-Athènes were now made to seem unimportant, by the dimples in a baby's bottom. As he eagerly sketched his son, in order to remain true to himself he concentrated on rendering the velvety flesh of the child; and through this very submission, Renoir began to rebuild his inner world.

* * *

I now come to the most important point in the meeting of these two beings: the mystery which is inexplicable to purely scientific minds, but is clear as day to those with a touch of mysticism. I mean to say that from the moment he took up a brush to paint, perhaps even earlier, perhaps even in his childhood dreams, thirty years before he ever knew her, Renoir was painting the portrait of Aline Charigot. The figure of Venus, on the vase which disappeared from my home during the Nazi occupation, is a materialization of my mother ten years before she was born. And the famous profile of Marie Antoinette, which my father painted so many times in the

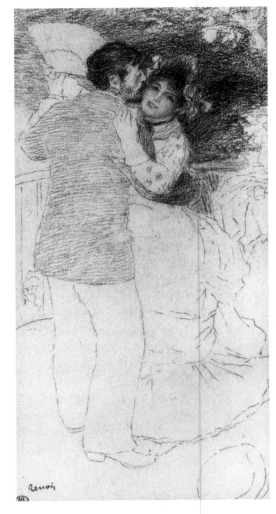

Pierre-Auguste Renoir. *Dancing Couple.* 1883. Pen and ink. 11½ × 7½" (29.2 × 19 cm). Musée du Louvre, Paris (Cabinet des Dessins).

Pierre, Renoir's first child, was born on March 21, 1885.

Aline Charigot (1859–1915) had modelled for the Luncheon of the Boating Party *(Colourplate 75) in 1880. She and Renoir married on April 14, 1890, having lived together for many years.*

workroom of the porcelain factory, had a short nose! His employer once said to him: "Watch out. The customers won't recognize their idol. You must make the nose a little longer." Naturally, Renoir did portraits of women who differed from one another physically. His interest in human beings made him strive to achieve real likenesses in his portraits. Yet whenever he painted subjects of his own choosing, he returned to the physical characteristics which were essentially those of his future wife. No one knows whether he deliberately chose such models or whether his imagination guided his hand. Oscar Wilde, whom he was to meet in later years, offered a much simpler explanation when he made the quip apropos of Turner: "Before him, there was no London fog." The theory that painters "create the world" is borne out strikingly in Renoir. For it was not only my mother who was to be born in Renoir's pictures, but we, his children also. He had done our portraits even before we came into the world, even before we were conceived, physically. He had represented us all hundreds of times; and all children, as well; all the young girls with whom he was unconsciously to people a universe which was to become his own.

That Renoir's world has come into being can no longer be doubted. I am constantly being waylaid by parents who show me their children and say: "Don't you think they are perfect little Renoirs?" And the extraordinary part is that they are! Our world which before him was filled with people with elongated pale faces has since his time seen an influx of little round, plump beings with beautiful red cheeks. And the similarity is carried further by the choice of colours for their clothing. He is responsible for that too. His contemporaries have ranted enough about "the gaudy finery with which he decked out the cooks and maids who served as his models." This criticism by a forgotten journalist was repeated to me by my father himself. Renoir let them talk. Anyone able to create a world filled with health and colour is beyond criticism. "Let the literary crowd indulge their passion for anaemia and 'whites.'" And then, to point up his remark, he added, "You'd have to pay me to sleep with the Dame aux Camélias." He would have resented anyone telling him the exact nature of the task he was so humbly to accomplish. To create even a little corner of the universe was the work of God, and not that of a capable painter who had become a good workman in painting. On the contrary, he was convinced that it was the world which was creating him; and that he was merely reproducing this life of ours, which enraptured him like a passage in a great symphony. "The cork in the flow of the stream." He only wanted to interpret faithfully the marvels he perceived so clearly for the benefit of those unable to perceive them. He would have been incensed if anyone had dared to tell him that the life which he filled his pictures with so abundantly came from within him. He would have felt just as insulted as if someone had called him an intellectual. He only wanted to be a mechanism to take in and to give out, and to that end he was careful not to squander his strength, and to keep his vision clear and his hand sure. "If it came from me alone, it would be merely the creation of my brain. And the brain, of itself, is an ugly thing. It has no value except what you put into it."

Here are some of his other reflections on the same subject:

"To express himself well, the artist should be hidden. Take the actors of ancient Greece with their masks, for example." And again: "The unknown artist of the twelfth-century Virgin in the Cluny Museum did not sign his work. Even so, I know him better than if he actually spoke to me."

One day, I was trying to pick out a Mozart sonata on the piano. Like all poor pianists, I unconsciously emphasized the "sentiment" as I played. All at once, my father interrupted me.

"Whose music is that?"

"Mozart."

"What a relief. I was afraid for a minute it was that imbecile Beethoven." And, as I expressed my surprise at his severity, he went on: "Beethoven is positively indecent, the way he tells about himself. He doesn't spare us

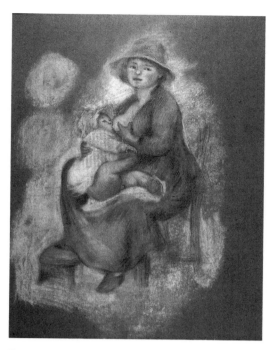

Pierre-Auguste Renoir. *Maternity (Aline and Pierre)*. 1886. Sanguine and white chalk, 36¼ × 28¾" (92 × 73 cm). Musée de Strasbourg, France.

either the pain in his heart or in his stomach. I have often wished I could say to him: 'What's it to me if you are deaf?' It's better for a musician to be deaf, anyway. It's a help, like any obstacle. Degas painted his best things when his sight was failing. Mozart had a far harder time than Beethoven, yet he was modest enough to hide his troubles. He tries to amuse me or to move me with notes which he felt are impersonal. And he is able to tell me much more about himself than Beethoven with his noisy sobbing. I want to put my arm around Mozart and try to console him. After a few minutes of his music I feel that he is my best friend, our conversation becomes intimate." Renoir was convinced that there was, happily, a constant contradiction in human affairs which would eventually restore the balance destroyed by the stupidity of the vain. "The artist who seeks to present himself entirely naked to his public ends by revealing a conventional character, which is not even himself. It is merely romanticism, with its self-confession, tears and agony, in reality the posings of a third-rate actor. But it sometimes happens that a Raphael who only wished to paint nice girls with little children – to whom he gave the title of 'Virgin' – reveals himself with the most touching intimacy."

* * *

Renoir began by putting incomprehensible little touches on the white background, without even a suggestion of form. At times the paint, diluted with linseed oil and turpentine, was so liquid that it ran down the canvas. Renoir called it "juice." Thanks to the juice, he could, with several brush-strokes, establish the general tonality he was trying for. It almost covered the whole surface of the canvas – or rather, the surface of the eventual picture, for Renoir often left part of the background blank. These "open" spots represented indispensable values to him. The background had to be clear and smooth. I often prepared my father's canvases with flake white mixed with one third linseed oil and two thirds turpentine. It was then left to dry for several days.

He would begin with little pink or blue strokes, which would then be intermingled with burnt sienna, all perfectly balanced. As a rule, Naples yellow and red madder were applied in the later stages. Ivory black came last of all. He never proceeded by direct or angular strokes. His method was round so to speak, and in curves, as if he were following the contour of a young breast. "There is no such thing as a straight line in Nature. . . ."

He succeeded in taking complete possession of his subject only after a struggle. . . . The anxious rapidity of his brush-strokes, which were urgent, precise, flashing extensions of his acute sight, made me think of the zigzag flight of a swallow catching insects. . . . The description would be incomplete if I failed to point out that Renoir in the act of painting had a wild side to him which startled me several times when I was small.

Sometimes the forms and colours were still indefinite at the end of the first session. Only on the following day was it possible to sense what would come. For the onlooker, the overwhelming impression was that the subject, defeated, was disappearing and the picture was coming out of Renoir himself. Towards the end of his life, Renoir had so perfected his method that he eliminated "little details" more quickly and got down at once to what was essential. But to the day of his death, he continued to "caress and touch the motif" the way one caresses and touches a woman so that she can express all her love. For this is what Renoir needed: that state of abandon on the part of the model, which would allow him to touch the depths of human nature, freed of all cares and prejudices of the moment. He painted bodies devoid of clothing and landscapes devoid of the picturesque. The spirit inherent in the girls and boys, the children and trees, which filled the world he created, is as purely naked as Gabrielle's nude body. And, last of all, in this nakedness Renoir disclosed his own self.

Gabrielle Renard (1879–1959), a cousin of Renoir's wife Aline; she joined Renoir's household in Paris in 1894 to look after the children and became one of Renoir's favourite models.

WALTER PACH

QUEER THING, PAINTING

"Pierre-Auguste Renoir"

1938

Walter Pach (1883–1958), American painter and writer on art. This is an excerpt from an expanded version of an article first published in Scribner's Magazine *in May 1912.*

I now give the salient features of those hours with Renoir, as I wrote them down each time at the nearest café, where I would go so as to let no new impression come into my mind and perhaps cause me to forget something. Try as I would, later on, I was never able to make an addition to the notes, which I merely joined together, as if all the talk had taken place on a single day.

"There are things about your work that we should like to know. When we find the colours in such perfect relation to one another, we wonder how you arrive at such a result. When you have laid in the first tones, do you know, for example, which others must follow? Do you know to what extent a red or a green must be introduced to secure your effect?"

"No, I don't; that is the procedure of an apothecary, not of an artist. I arrange my subject as I want it, then I go ahead and paint it, like a child. I want a red to be sonorous, to sound like a bell; if it doesn't turn out that way, I put more reds or other colours till I get it. I am no cleverer than that. I have no rules and no methods; anyone can look over my materials or watch how I paint – he will see that I have no secrets. I look at a nude; there are myriads of tiny tints. I must find the ones that will make the flesh on my canvas live and quiver.

"Nowadays they want to explain everything. But if they could explain a picture it wouldn't be art. Shall I tell you what I think are the two qualities of art? It must be indescribable and it must be inimitable. . . .

"The work of art must seize upon you, wrap you up in itself, carry you away. It is the means by which the artist conveys his passion; it is the current which he puts forth which sweeps you along in his passion. Wagner does this and so he is a great artist; another composer – one who knows all the rules – does not do this, and we are left cold and do not call him a great artist.

"Cézanne was a great artist, a great man, a great searcher. We are in a period of searchers rather than of creators. We love Cézanne for the purity of his ideal. There never once entered his mind any thought but that of producing art. He took no heed of money or of honours. With Cézanne it was always the picture ahead of him that he cared for – so much so that he thought little of what he had done already. I have some sketches of his that I found among the rocks of l'Estaque, where he worked. They are beautiful, but he was so intent on others – better ones that he meant to paint – that he forgot these, or threw them away as soon as he had finished them.

"I so much like a thing that Cézanne said once: 'It took me 40 years to find out that painting is not sculpture.' That means that at first he thought he must force his effects of modelling with black and white and load his canvases with paint, in order to equal, if he could, the effects of sculpture. Later, his study brought him to see that the work of the painter is so to use colour that, even when it is laid on very thinly, it gives the full result. See the pictures by Rubens at Munich; there is the most glorious fullness and the most beautiful colour, and the layer of paint is very thin. Here is a Velasquez" (he reached for a book of reproductions after that master, and hunted out a late portrait of the little Infanta); "it is a perfect picture. See that dress with all the heavy silver embroidery that they used in Spain at the time. If you stand away from the painting, it gives you the impression of the weight of that dress. When you come close, you find that he has used only a very little pigment – a tone, and some touches for the metal. But he knew

what the painter must do. Cézanne was a man of big qualities and big defects. Only qualities and defects make no difference. What counts is always that passion of the artist, that sweeping men with him.

"The person who goes hunting for defects is the professor."

* * *

"Have you found, M. Renoir, that your opinions of the Old Masters change much in the course of time?"

"No – only for some pictures it takes very long until one reaches the judgment one finally holds. With some pictures I do not think that I realized their true beauty till I had known them for 30 years – the Poussins, for example. The greatest works reveal a new beauty each year I come back to them. There is the *Marriage at Cana*. I admired it when I was young; one can scarce avoid doing so; one knows that it is a great thing. But it was only at a much later time that I could feel I had something of an intimate understanding of it – of the way he has controlled the architecture of that enormous picture, and the way all those brilliant, even violent colours work together without a break.

"Titian is a man who always stays great for me. His painting is a mystery. Raphael's you can understand, and you can see how he worked (that doesn't mean that you can paint Raphaels). But you can't tell how Titian worked. No one ever painted flesh as he did. And then that *Virgin with the Rabbit* seems to have light coming out from it, like a lantern. It seems to rise above painting.

"There is nothing outside of the classics. To please a student even the most princely, a musician could not add another note to the seven of the scale. He must always come back to the first one again. Well, in art it is the same thing. But one must see that the classic may appear at any period. Poussin was a classic; Père Corot was a classic. When I was a student, Corot was unknown, Delacroix and Ingres were laughed at; the men considered great were Scheffer and Delaroche. That seems strange today, but it was really so. And the thing that corrupts taste is government patronage of art. Here is a case within my immediate knowledge. A rich banker had chosen among the most illustrious painters of his time to have the portraits of his family painted. These portraits are criticized, and he replies very sagely: 'I know about finance; I don't know about painting. If those portraits are bad, it is through no fault of mine, for I looked through the catalogue of the Salon, and chose the painter with the most medals, just as I would do in buying my chocolate. If I had gone to the painter you recommended, people would say I was trying to economize.'

"The bad system begins in the schools. I was in all of them and all were bad. The professors were ignorant men; they did not teach us our trade. Even today I do not know whether my pictures will last. When I have noticed them yellowing, I have tried to find out the cause. I have changed the colours on my palette ten times and I cannot be certain yet that I have arrived at a choice that will yield a permanent result.

"Now this was not always so; it is only since the Revolution that the principles of the old masters have been swept away. Look at Nattier's pictures – how well they are preserved; then look at what follows and you will see what I mean. The Old Masters were taught each step of their trade, from the making of a brush and the grinding of a colour. They stayed with their teachers until they had learned well the ancient traditions of the craft. And the tradition has never been an obstacle to originality. Raphael was a pupil of Perugino; but that did not prevent his becoming the divine Raphael." . . .

One other little remark seemed to me to show the spirit of the man. "Sometimes I talk with the peasants down there in the South. They say their lot is an unhappy one. I ask: 'Are you sick?' 'No.' 'Then you're fortunate – you have a little money; if you've had a bad season you don't suffer from hunger; you can eat, you can sleep, you have work that takes you out into the

212

open air, into the sunlight.' What more can anyone want? They are the happiest of men, and they don't even know it. After a few more years I am going to leave my brushes and do nothing but live in the sun. That suffices."

We may be happy that he did not carry out the momentary fancy of laying down his brushes. He never tried to; indeed, the last words he spoke were about arranging some flowers to paint, as he continued to do in imagination until that last little flicker of the divine fire in him went out with the word flowers – and no more fitting one could be thought of for his dying breath. It was the divine fire that burned in him, if ever a mortal had the Promethean gift, and that is why he could speak so convincingly about the great men. If I had got no more from him than the passage above about Poussin and Corot, where he begins with such simple certainty in his statement – "There is nothing outside of the classics" – my visits would have been richly rewarded. Indeed, I know no other words of his that seem to me so important, unless it be those in a conversation with Meier-Graefe that I have quoted more than once – and I make no apology for repeating it for the reader here.

Discussing with the German critic the matter of art study and condemning the schools, as we have just heard him do – and as we heard Monet do – he sets Meier-Graefe to questioning what the alternative would be. "Nature?" He hesitates; Cézanne and Monet, among his old comrades, had always talked of studying nature. Finally he speaks out, bravely refusing the great word: "No, nature brings one to isolation. I want to stay in the ranks."

"But if it is not before nature that the young man becomes an artist, where is it?"

"Au musée, parbleu!"

Julius Meier-Graefe (1867–1935), German art historian and art critic.

GEORGES RIVIÈRE

RENOIR ET SES AMIS

Renoir on Landscapes

1921

All those lovely bouquets which Renoir amused himself by painting when he had no model, and where his extraordinary virtuosity was given free rein, were sold for the price he had paid the florist for the flowers. Often, indeed, a collector would buy a figure painting or a landscape and have a flower painting thrown in, as something insignificant and without value.

It is true that Renoir himself attached little importance to his flowers. One day he was painting some roses in a green pottery vase, and he said to me:

"Painting flowers is restful for the brain. I don't bring the same intellectual tension to bear as when I am face to face with a model. When I paint flowers, I put down colours and experiment with values boldly, without worrying about losing the picture. I wouldn't dare to do this with a figure, I'd be afraid of spoiling everything. And then the experience I've gained from these attempts I apply to my paintings. Landscape too is useful for a figure painter. In the open air, you are inspired to put tones on the canvas that you could never conceive of in the less extreme light of the studio."

"But landscape is a harsh task-master!" he added, "you spend half a day to achieve an hour's work. You finish perhaps one painting in ten, because the weather has changed. You were working on a sun effect and suddenly it rains. There were some suitable clouds in the sky and the wind drives them away; and so it goes on!"

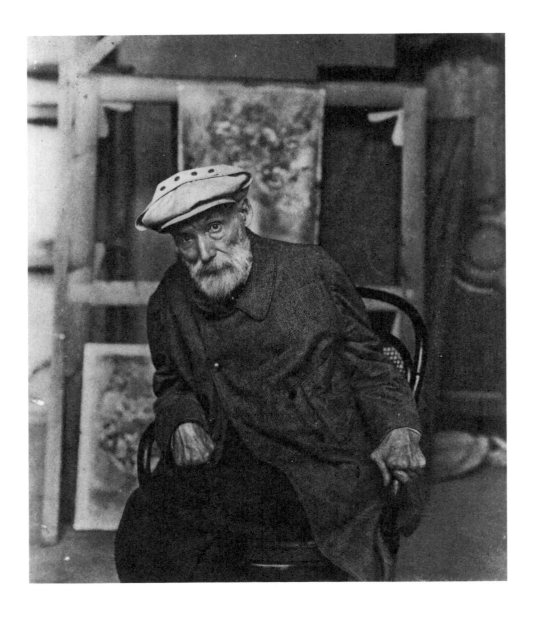

ALBERT ANDRÉ

RENOIR

Renoir in Old Age

1919

Albert André (1869–1954), painter and close friend of Renoir, of whom he wrote a biography during the last years of Renoir's life.

He wears no special painter's garb. He sits in his armchair, his spindly legs crossed; his poor feet clad in woollen slippers; his body wrapped in shawls; his pale, fine head muffled to the ears in a cap, or a white linen hat according to the season; and in his fingers the ever-present cigarette, which he constantly relights.

He welcomes friends joyfully. But if he suspects that anyone has come to see him out of curiosity, he withdraws into himself, says nothing and becomes totally disagreeable. As soon as he has rid himself of such unwelcome visitors, and is back in front of his easels, he is a man transformed. He whistles, hums the tunes which his models so often sing to him and goes into ecstasies over the beauties which only his eye can find in them.

It is only really in such moments that he may be persuaded to divulge his theory of art in all its simplicity.

This man, who has put painting above all else in his life, speaks very little of the painting he has done.

"Just look at the light on the olive trees . . . it glitters like a diamond. It's pink, it's blue. . . . And the sky coming through them. It's enough to drive you crazy. And those mountains over there which change with the clouds. . . . They're like the background in a Watteau."

"Ah! this breast! How very soft and heavy it is! That pretty fold underneath with its golden colour. . . . It's enough to bring you to your knees. If there had never been any breasts, I don't think I should ever have painted figures."

* * *

When his subject is simple, he sets to work on his canvas by drawing a few summary brush-strokes, usually in a red-brown, to give him an idea of the proportions of the component parts. "The volumes . . ." he says with a slightly sardonic air. Then straightaway using pure colours diluted with turpentine, as if he were working in watercolour, he rapidly covers the canvas and you can see something vague and iridescent appearing, colours running into each other, something that enchants you, even before a sense of the image is intelligible.

At the second session, when the turps has dried out a little, he reworks this preparation, proceeding in almost the same way, but with a mixture of oil and turps and slightly denser colour.

He lightens those areas which are to be luminous by applying pure white directly to the canvas. He reinforces the shadows and the half-tones in the same way, directly on to the canvas. There is no mixing of colours – or almost none – on his palette, which is covered only in little commas of almost pure colours. Little by little, he defines the forms, but always allowing them to merge into each other. "They must kiss . . ." he says.

A few more touches still . . . and out of the coloured mist of the first state, soft rounded forms emerge, glittering like precious stones, enveloped by transparent, golden shadows.

* * *

When starting on a complicated composition, he doesn't make what you would really call a study. Once his motif is decided on, he does some little paintings in the spirit of the subject. Sometimes it is a single figure, sometimes several. This process is a sort of practice for the definitive work.

When it is fixed in his mind, he next draws his composition in sanguine, and traces it on to his canvas.

Drawing with a hard pencil doesn't suit him, even though he has done some admirable studies in that medium. He needs something that is softer than the pencil, and more colourful, in order to realize large masses. His preference is for charcoal or for a brown-red pastel.

He can no longer change brushes while he's working. Once the brush is selected, and strapped between his paralysed fingers, it travels from the canvas to his pot of turps to be cleaned, back to the palette to be recharged, and then returns to the canvas.

When his hand becomes numb with exhaustion, someone has to retrieve the brush from his fingers, since they cannot open by themselves. He asks for a cigarette, rolls back his wheelchair, screws up an eye, gives a dissatisfied grunt or a modest expression of praise before getting back to work.

"How difficult it is in a picture to find the exact point at which to stop copying nature. The painting must not smell too strongly of the model, but at the same time, you must get the feeling of nature. A painting is not a verbatim record. For myself, I like the sort of painting which makes me want to stroll into it if it's a landscape, or if it's a female figure, to run my hand over a breast or back. Corot had some very coarse ways of describing what I mean."

J.-K. HUYSMANS

L'ART MODERNE

"L'Exposition des Indépendants en 1881"

1883

After groping around for a long while, occasionally producing a painting like last year's *Summer Landscape*, Pissarro has suddenly put his mistakes behind him and shaken off his bonds, and is exhibiting two landscapes that are the work of a great painter. The first, *Setting Sun in a Cabbage Field*, proves him to be a powerful colourist who has finally grasped and minimized the terrible dilemma of the open spaces and the great outdoors. It is the new formula, long sought after and now fully realized: the true countryside has at last emerged from that assortment of paint tubes, and the result is an abiding calm in a nature saturated with air – a serene plenitude filtering down with the sunlight, an enveloping peace emanating from this vibrant spot whose dazzling colours are muted under a vast firmament of innocent clouds.

The second, *The Cabbage Path in March*, is a hallelujah of reviving nature whose sap is bubbling, a pastoral exuberance that flings out violent colours and sounds loud fanfares of brilliant greens upheld by the blue-green tone of the cabbages, the whole shimmering in particles of sunlight and a quivering of air – hitherto unattempted in painting.

Close up *The Cabbage Path* is a patchwork quilt of curious, crude dabbings, a hodgepodge of all sorts of tones suffusing the canvas with lilac, Naples yellow, madder-red, and green; at a distance it is air in motion, the limitless sky, Nature painting, water volatilizing, sunlight diffusing, and the earth simmering and smoking.

In sum, we can now classify M. Pissarro among our most innovative and remarkable painters. If he can keep so very perceptive, quick, and discriminating an eye, we shall certainly have in him the most original landscape artist of our day.

The picture which Huysmans confusingly describes as "Setting sun in a cabbage field" is actually The Pathway at Le Chou *(1878), Musée de la Chartreuse, Douai.*

CAMILLE PISSARRO

Letters to his Son Lucien

1883

PARIS, MAY 4

My dear Lucien,
I am leaving for Pontoise this afternoon, and am bringing a maid with me. When I arrive there your mother will leave to see my show. I hope it will please her.

You will see in *L'Intransigeant* the account of the burial of our lamented Manet. Antonin Proust said some words full of emotion; the newspaper, which is biased, called his speech undistinguished, but everybody said it perfectly expressed their feelings.

Duret left today for London. He promised to look you up; he will tell you about my exhibition. It goes without saying that I received not a few compliments. The ones I value most came from Degas who said he was happy to see my work becoming more and more pure. The etcher Bracquemond, a pupil of Ingres, said – possibly he meant what he said –

Manet was buried at Passy Cemetery in Paris on May 3, 1881.
Antonin Proust (1832–1905), intimate friend of Manet, his biographer and then Minister of Fine Arts. He and Théodore Duret had been pall-bearers at Manet's funeral.

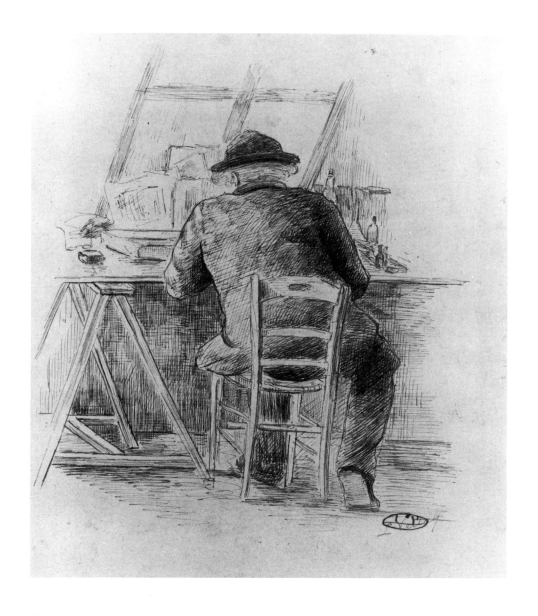

Lucien Pissarro. *Study of Camille Pissarro Etching, Seen from the Back.* c.1884. Pen and ink, 8⅝ × 7″ (22 × 17.6 cm). Ashmolean Museum, Oxford.

that my work shows increasing strength. I will calmly tread the path I have taken, and try to do my best. At bottom, I have only a vague sense of its rightness or wrongness. I am much disturbed by my unpolished and rough execution; I should like to develop a smoother technique which, while retaining the old fierceness, would be rid of those jarring notes which make it difficult to see my canvases clearly except when the light falls in front. There lies the difficulty – not to speak of drawing.

ROUEN, OCTOBER 19

Yesterday I received your letter in which you mention the various works you have begun. Let me urge you to complete whatever you begin. However I know myself the difficulty or rather the difficulties that beset one unexpectedly when working outdoors. Here the weather is always changing, it is very discouraging. I am working on nine canvases, all of which are more or less well advanced. The day after your departure I started a new painting at Le Cours-la-Reine, in the afternoon in a glow of sun [602], and another in the morning by the water below St. Paul's Church. These two canvases are fairly well advanced, but I still need one session in fine weather without too much mist to give them a little firmness. Until now I have not been able to find the effect I want, I have even been forced to change the effect a bit, which is always dangerous. I have also an effect of fog, another, same effect, from my window, the same motif in the rain [608], several sketches in oils, done on the quays near the boats [610, 611]; the next day it was impossible to go on, everything was confused, the motifs no longer existed; one has to realize them in a single session.

*The "effect" (*effet*) refers to the broad overall unity of light and atmosphere captured quickly in painting.*

Venturi & Pissarro 602: View of Rouen (Cours-la-Reine), *1883; 608:* Place de la République at Rouen, *1883; 610:* Port of Rouen *(sketch), 1883 (Collection Lucien Pissarro, London); 611:* Steamboat, Rouen, *1883.*

CAMILLE PISSARRO

Letters to Durand-Ruel

1885–86

ERAGNY [JUNE/JULY 1885]

My dear M. Durand-Ruel,

I am forced once again to torment you for money; what can I do? I promised 600 francs to keep the household going, and I've only given them 300. Might you possibly complete the sum before the end of the month? As always you would be doing me such a favour. Forgive my obsessiveness, I beg of you: believe me, I have no choice.

I have worked a lot in Gisors; unfortunately, the unsettled weather makes me ill with impatience. I have been unable to finish certain quite unusual and above all very difficult subjects as I would have liked. I am particularly upset not to have finished these studies in that my work is undergoing a process of transformation and I look forward impatiently to any results

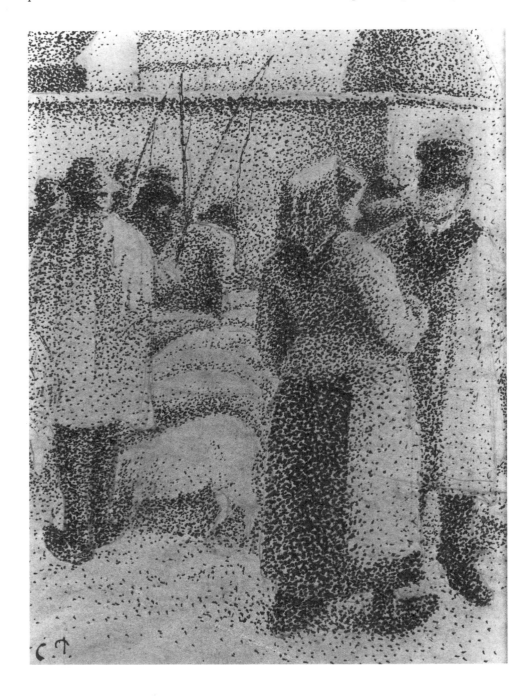

Camille Pissarro. *The Pig Market, the Fair of St Martin, Pontoise.* 1886. Pen and ink over pencil, 6⅜ × 5″ (17.5 × 12.5 cm). Musée du Louvre, Paris (Cabinet des Dessins).

whatsoever. I do however hope to make a little progress. I beg you to believe that all this causes me considerable anguish; clearly, this is a crisis!

Au revoir, my dear M. Durand-Ruel,
Your devoted

C. Pissarro.

My son tells me that you were quite pleased with Brussels. I imagine that everything you sent of mine was old stuff? I tremble at the thought!

N.B. My wife assures me that she cannot run the house with less than a thousand francs; my quandary must therefore be all too clear! . . .

ERAGNY, NOVEMBER 6, 1886

I am sending you the enclosed account of myself and my new artistic doctrines that you requested.

You may complete it by consulting the brochure of M. Félix Fénéon recently published under the title: "The Impressionists in 1886," on sale at Soiret's in Montmartre and the major bookstores.

If your son prepares a publication on this subject, I should like him to make it quite clear that M. Seurat, an artist of great worth, was the first to have the idea and to apply the scientific theory, after having studied them fully. I have only followed, as have my other colleagues, Signac and Dubois-Pillet, the example given by Seurat. I hope your son will be kind enough to do me this favour for which I will be truly grateful.

THEORY: Seek for the modern synthesis with scientifically based means which will be founded on the theory of colours discovered by M. Chevreul and in accordance with the experiments of Maxwell and the measurements of O. N. Rood.

Substitute optical mixture for the mixture of pigments. In other words: break down tones into their constituent elements because optical mixture creates much more intense light effects than the mixture of pigments.

As for execution, we regard it as inconsequential, of very little importance: art has nothing to do with it; originality consists only in the quality of drawing and the vision particular to each artist.

Here is my biography: Born at St Thomas (Danish Antilles) July 10, 1830. Came to Paris in 1841 to enter the Savary boarding school at Passy. I returned to St Thomas at the end of 1847, where I began to draw and at the same time was employed by a commercial firm. In 1852 I gave up trade and left, with Mr Fritz Melbye, a Danish painter, for Caracas (Venezuela) where I stayed until 1855; I went back into trade in St Thomas. Finally, I came back to France at the end of 1855, in time to see, for three or four days, the Universal Exposition.

Since then, I have stayed in France; as for the rest of my story as a painter, it is tied up with the Impressionist group.

FÉLIX FÉNÉON

L'EMANCIPATION SOCIALE

"Impressionism"

April 3, 1887

25 March. The streamers at the *Société des Artistes Indépendants* float red and blue along the Champs Élysées, alternatively lashed with rain and splashed with sun. The Pavillon de la ville de Paris is a riot of colour.

The exhibition opens tomorrow. Today is the dress rehearsal – the Vernissage.

This exhibition was held in the Hôtel du Grand Miroir in Brussels.

Durand-Ruel had requested "as complete a write-up as possible on yourself first and then on your beliefs, to send to New York," where he was organizing a large exhibition of Impressionist painting under the auspices of the American Art Association.
Félix Fénéon (1861–1944), art critic and writer, and one of the major spokesmen for Neo-Impressionism.
Paul Signac (1863–1935), Albert Dubois-Pillet (1845–90).

Michel-Eugène Chevreul (1786–1889), James Clark Maxwell (1831–79), Ogden N. Rood (1831–1902): scientists whose writings on colour influenced Neo-Impressionist colour theory.

Fritz Melbye (1826–96), Danish painter who "discovered" Pissarro on St Thomas in 1852 and advised him to go to Paris to study painting.

The Salon des Indépendants was instituted in 1884 to provide exhibition space as an alternative to the official Salon.

We are all familiar with the fusty vernissages of the annual Salons, with their motley trampling unculled hordes. Here, we have a public of carefully selected guests: pretty women, artists and gentlemen. Right from the threshold, which is guarded by a sort of hirsute commissionaire, we see an animated spectacle set against a background of pictures, plants and hangings: flowered dresses, menacing gestures towards the walls, bosses curtly acknowledged, groups fluidly forming and reforming. And here is the young clan of the neo-Impressionists: Georges Seurat, with the air of a sixteenth-century Huguenot, Paul Signac, brisk and voluble, Lucien Pissarro, like an untouchable from a Hindu album, Dubois-Pillet, all beard, billowing cravat and twinkling eye behind its monocle; and with them a batch of symbolist poets – shared proclivities and the harebrained attacks of a conformist press having cemented a sense of fraternity between writers and painters.

* * *

The critics have ever lectured the Impressionists.

The fellow who dispenses justice in a newspaper is inspired by two principles: first, never praise works which show signs of originality, indeed, disparage them – for the habits of the public are sacrosanct; second, lavish hyperbolic praise on all others with an eye to the eventual ownership of sketches and studies which, in hard times, might be up for grabs. Painting, in gratitude to kindly critics. They anathematize Impressionist painting in the name of the older kind. But it is well known that they know even less about the latter than the former and would be sorely tried to distinguish a Velasquez from a pair of boots.

* * *

Impressionism has initiated a new vision of Art.

For anyone who, in his mind's eye, can compare a landscape by Ruysdael or Courbet with one by Manet or Camille Pissarro, any comment upon the extent of this reform is unnecessary.

For the rest, we shall try, in mere dull words, to summarize its spirit:

1. The proscription of all historical, allegorical, mythological or overtly literary subjects;
2. As working method: execution directly from life, and not in the studio from memory, sketches or written documentation;
3. Concern for the emotional meaning of colour;
4. The attempt to emulate the brilliant light effects found in nature – the Impressionist school is a school of colourists.

This last characteristic is the most crucial: painters such as M. Degas, M. Forain and M. Raffaëlli can therefore not rightly be included under the heading of Impressionists, concerned as they are above all with movement, anecdote and character. Édouard Manet was the systematic promoter of *la peinture claire*.

At first (1859), he was under the influence of Velasquez. As early as 1863, the year of the Salon des Refusés, his true personality emerged. His palette soon brightened. Around 1870 light shone forth from his canvases in all its fullness, and from then on until his death (1883) he painted a whole series of illustrious works: *The Railroad, Argenteuil, In the Conservatory, Jeanne, Méry* . . . But Édouard Manet, intuitive in spirit and sophisticated in his art, had an uncertain, over-simplifying technique: his oeuvre lacks certainty and premeditation.

More self-aware, more analytical artists had joined him: M. Camille Pissarro, M. Cézanne, Mme Berthe Morisot, M. Claude Monet. And it was in connection with a canvas by the latter, entitled *Impression* (1874), that the word Impressionism began to be used, replacing the terms *plein-airistes*, *tachistes* etc.

* * *

la peinture claire: *painting with a new style of brightness produced by the use of predominantly pale luminous colour over a white ground.*

However, their technique had nothing precise about it: the works of these painters wore an air of improvisation; their landscapes were snatches of nature glimpsed as though through a porthole briefly opened and then reclosed: summary and approximate.

Impressionism acquired this new rigorous technique in 1885, thanks to a painter of some 25 years of age, M. Seurat.

It was not accepted either by Mme Morisot or MM. Claude Monet, Gauguin, Guillaumin etc. Of the early Impressionists, M. Camille Pissarro alone adopted it, along with MM. Paul Signac and Lucien Pissarro, Camille's son, who were then beginners, and M. Dubois-Pillet, who hitherto had been painting in pitch. This group, which constitutes the hard core of Impressionism, was joined this year by MM. Charles Angrand and Maximilien Luce.

* * *

M. Seurat's innovation has as its basis the scientific division of colour. It goes as follows: instead of mixing the colours on the palette, with the end product, when spread on the canvas, providing roughly the colour of the object to be represented, the painter will cover the canvas with separate touches corresponding, some to the local colour of that object, others to the quality of the light falling upon it, yet others to the reflections cast by neighbouring bodies, others still to the complementarities of the surrounding colours.

These touches are effected not by the thrust of the paint-brush, but by the application of a scattering of lesser spots of colour.

The following are the advantages of this manner of operating:

1. The colours are composed on the retina. We thus have an optical mixing. Now the intensity of the light of the optical mixing (mixing of colour and light) is far greater than that of the pigmentary mixing (mixing of colours and materials). This is what modern physics expresses when it tells us that all mixing of colours on the palette is a journey towards blackness.
2. This mixing on the retina imparts a luminous vibrancy which gives the picture great vitality.
3. The relief which cannot be translated precisely through the trails of paste of the traditional method, is achieved in all its infinite delicacy, since the respective proportions of the particles of colour can vary infinitely over a very small space.
4. Dexterity of the hand becomes a negligible matter, since all material difficulty of execution is removed. It will suffice that the executor should have an artist's vision, that he should be a painter, in a word, and not an illusionist.

* * *

Impressionism's high summer is over.

In days gone by, when contemplating the white frames which held the paintings of the Impressionists, the public would writhe in convulsions of unbridled joy, would suggest confining such madmen, would pity such colour-blind painters, would shout down such jokers. Today the public looks, understands dimly, and sniggers only nervously, if at all.

The flat-brimmed top hat in the portrait of Dubois-Pillet by Dubois-Pillet is a cause for bitter argument, it is true; but it is to be hoped that it will not draw blood.

CAMILLE PISSARRO

Letters to his Son Lucien

1887–88

PARIS [JANUARY 9, 1887]

My dear Lucien,
Monet has been to Durand's, he brought the paintings he did this year; he has one in bright sunlight, it is an incomprehensible fantasy; M. Caseburne himself admitted to me that it is absolutely incoherent, blobs of white mixed with Veronese greens and yellows, and the drawing is completely lost. The other canvases are more carefully done, better, but dark grey. My *Eragny* has more calm, and you can see in this painting the advantage of unmixed colours and clear and solid draughtsmanship. I assure you I would not be afraid to show my work with Monet's. Durand says that Monet pities me because of the course I have taken. So! . . . Perhaps he does, now . . . but wait. M. Robertson being insensitive to Monet's qualities, Durand asked me to explain to him, in English, the good points of Monet's work. I did my best, loyally and without hesitation, for despite his mistakes I know how gifted is this artist, but M. Robertson can't stand his work. "And who painted this horror?" It is true that he doesn't know anything, but this simple man must be offended by the disorder which results from a type of romantic fantasy which despite the talent of the artist, is not in accord with the spirit of our time. M. Robertson said several times: "I like your fans a hundred times better." "Why didn't you buy them?" I replied. You must realize that eventually we shall have all those who are not haunted by romanticism, who feel simple, naïve nature, which does not exclude character and science, like the primitives. Caseburne also pointed out: "But your *Eragny* has more air and draughtsmanship, I don't understand the boss." I say this: Monet plays his salesman's game, and it serves him; but it is not in my character to do likewise, nor is it to my interest, and it would be in contradiction above all to my conception of art. I am not a romantic! I would really have no *raison d'être*, if I did not pursue a considered technique which yet leaves me free to express myself, and does not inhibit an artist who has the gift.

ERAGNY [SEPTEMBER 20, 1887]

I have decided that it would be better to see Alexis than to write to him. I composed two or three letters, all were inadequate, and so I decided to go and see him. I was right to do so. At first I couldn't find Alexis. He was in Paris. Then I learned at *Le Cri du Peuple* that he had fought a duel with M. Bernhardt and been wounded in the right arm. – The wound is not very serious. – I presented myself to Madame Alexis who, a very subtle woman, grasped the situation thoroughly and understood my position. Alexis will be glad to give a more positive tone to his article, and is ready to serve me if need be. Then I went to the Murers; I had lunch, and then we had a talk. As if by plan, though we did not meet, Renoir and his family came by the same train to the Murers. A tremendous discussion of the dot! At one point Murer said to me: "But you know perfectly well that the dot is impossible!" Renoir added: "You have abandoned the dot, but you won't admit you were wrong!"

Nettled, I replied to Murer that he no doubt took me for a cheat, and to Renoir I said, "My dear fellow, I am not that senile. Besides, you Murer know nothing about it; and as for you Renoir, you follow your caprice, but I know where I am going!" Then there was much abuse of our young friends: Seurat discovered nothing; he takes himself for a genius, etc. You may be sure that I did not let these remarks pass unchallenged. – I had imagined that they knew something – if ever so little – of our movement, but no, they knew nothing about it.

Caseburne was Durand-Ruel's cashier.

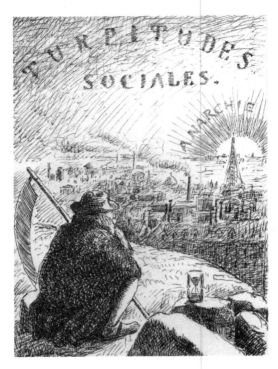

Camille Pissarro. *Social Turpitudes.* An Album of 28 Drawings. 1890. Pen and ink over pencil, 12½ × 9¾″ (31.5 × 24.5 cm). Collection Mme Catherine Skira, Geneva.

Paul Alexis (1847–1901), writer and art critic, was preparing an article for Le Cri du Peuple *on the collection of Eugène Murer (1845–1906) which contained 25 Pissarros.*

PARIS, SEPTEMBER 6, 1888

I think continually of some way of painting without the dot. I hope to achieve this but I have not been able to solve the problem of dividing the pure tone without harshness. . . . How can one combine the purity and simplicity of the dot with the fullness, suppleness, liberty, spontaneity and freshness of sensation postulated by our impressionist art? This is the question which preoccupies me, for the dot is meagre, lacking in body, diaphanous, more monotonous than simple, even in the Seurats, particularly in the Seurats. . . . I'm constantly pondering this question, I shall go to the Louvre to look at certain painters who are interesting from this point of view. Isn't it senseless that there are no Turners [here].

PARIS, OCTOBER 1, 1888

I had a long conversation with Renoir. He admitted to me that everybody, Durand and his former collectors attacked him, deploring his attempts to go beyond his romantic period. He seems to be very sensitive to what we think of his show; I told him that for us the search for unity was the end towards which every intelligent artist must bend his efforts, and that even with great faults it was more intelligent and more artistic to do this than to remain enclosed in romanticism. Well, now he doesn't get any more portraits to do.

Camille Pissarro. Photograph, in his studio at Eragny-sur-Epte. c.1890. Pissarro Museum Archive, Pontoise.

CAMILLE PISSARRO

"Advice to a Young Painter"

1896

This passage, cited in John Rewald's History of Impressionism, *is from the unpublished notes of Louis Le Bail, a young artist who sought Pissarro's advice about painting in 1896–7. It summarizes many of the procedures of the Impressionist approach to landscape.*

Look for the kind of nature that suits your temperament. The motif should be observed more for shape and colour than for drawing. There is no need to tighten the form which can be obtained without that. Precise drawing is dry and hampers the impression of the whole; it destroys all sensations. Do not define too closely the outlines of things; it is the brush-stroke of the right value and colour which should produce the drawing. In a mass, the greatest difficulty is not to give the contour in detail, but to paint what is within. Paint the essential character of things, try to convey it by any means whatsoever, without bothering about technique. When painting, make a choice of subject, see what is lying at the right and at the left, then work on everything simultaneously. Don't work bit by bit, but paint everything at once by placing tones everywhere, with brush-strokes of the right colour and value, while noticing what is alongside. Use small brush-strokes and try to put down your perceptions immediately. The eye should not be fixed on one point, but should take in everything, while observing the reflections which the colours produce on their surroundings. Work at the same time upon sky,

Camille Pissarro. *Studio Interior: Pissarro Seated at the Window with the Village beyond (Eragny).* Photograph. Pissarro Museum Archive, Pontoise.

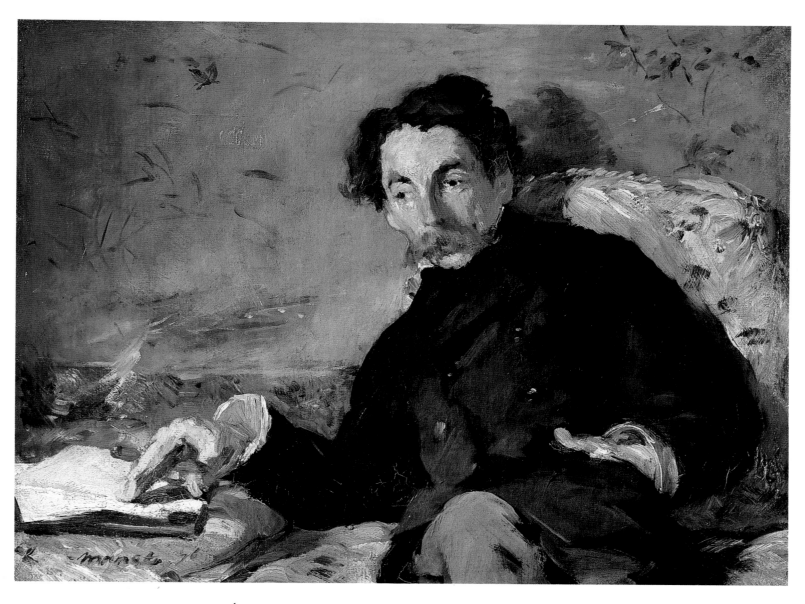

COLOURPLATE 65. Édouard Manet. *Portrait of Stéphane Mallarmé*. 1876. 10¾ × 14″ (27 × 36 cm).
Musée d'Orsay, Paris.

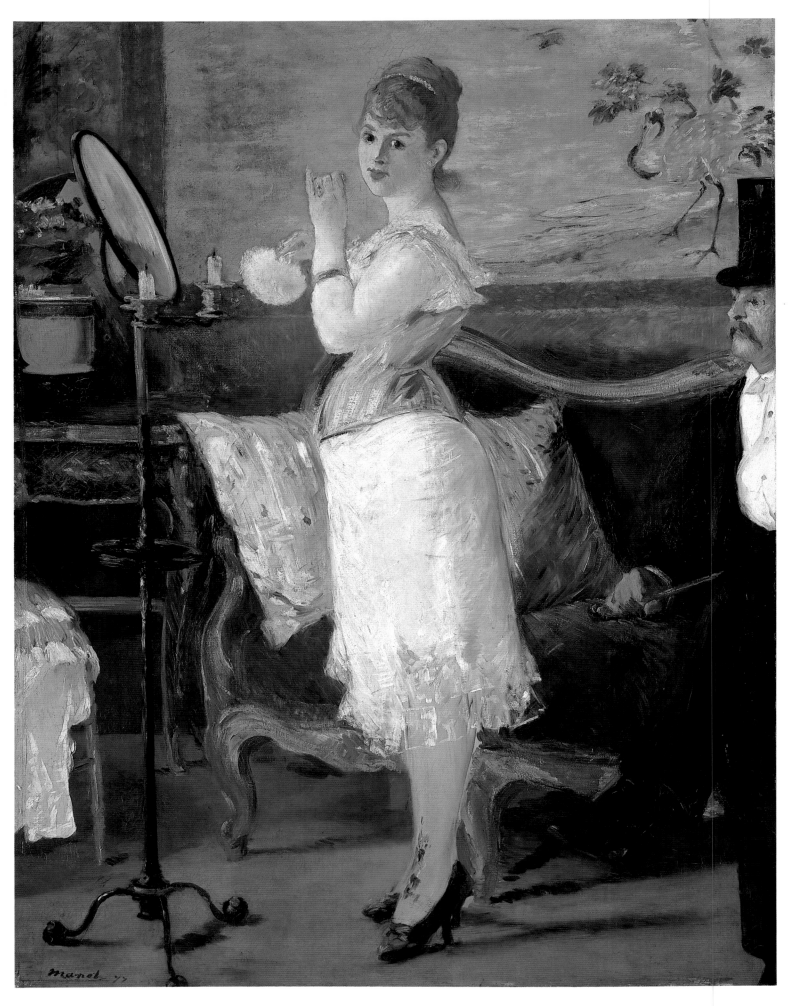

COLOURPLATE 66. Édouard Manet. *Nana*. 1877. 59 × 45¾″ (150 × 116 cm).
Kunsthalle, Hamburg.

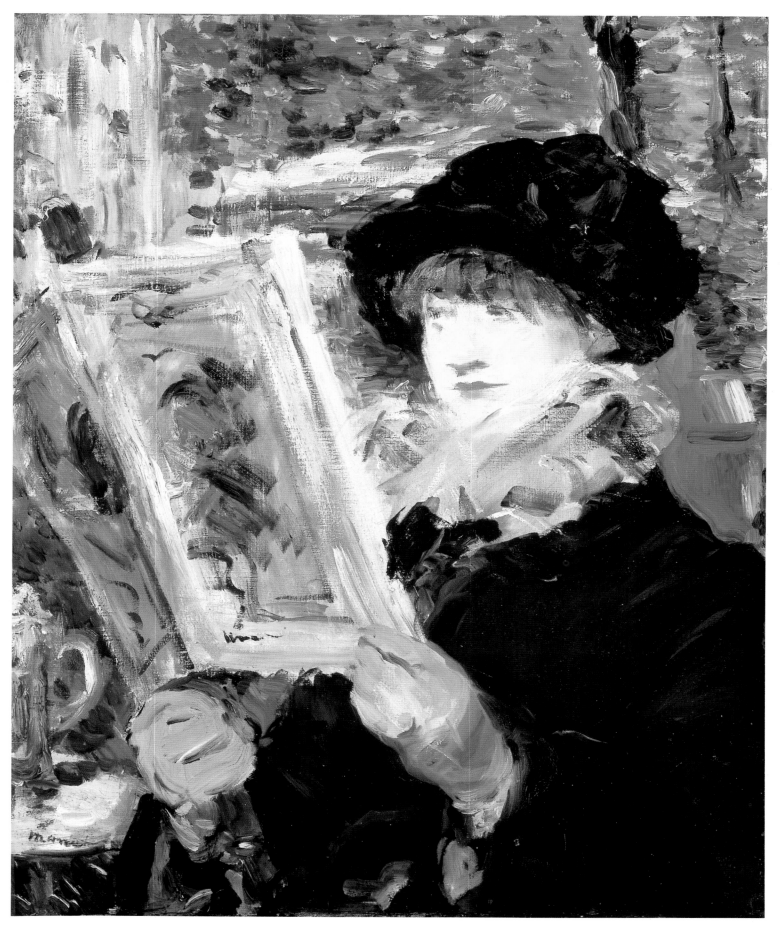

COLOURPLATE 67. Édouard Manet. *Reading "L'Illustré."* 1879. 24 × 20″ (61.2 × 50.7 cm).
The Art Institute of Chicago (Mr and Mrs Lewis Larned Coburn Memorial Collection).

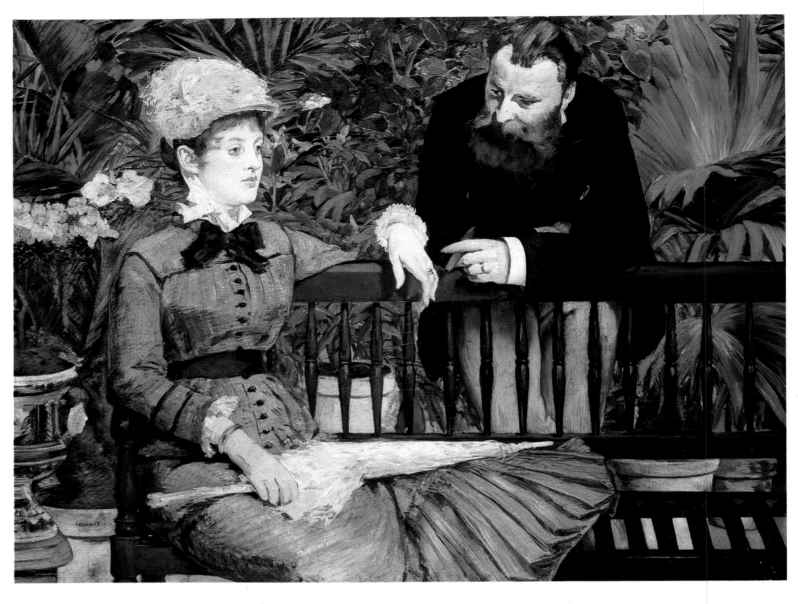

COLOURPLATE 68. Édouard Manet. *In the Conservatory*. 1879. 45¼ × 59″ (115 × 150 cm).
Staatlicher Museen Preussischer Kulturbesitz, Nationalgalerie, Berlin.

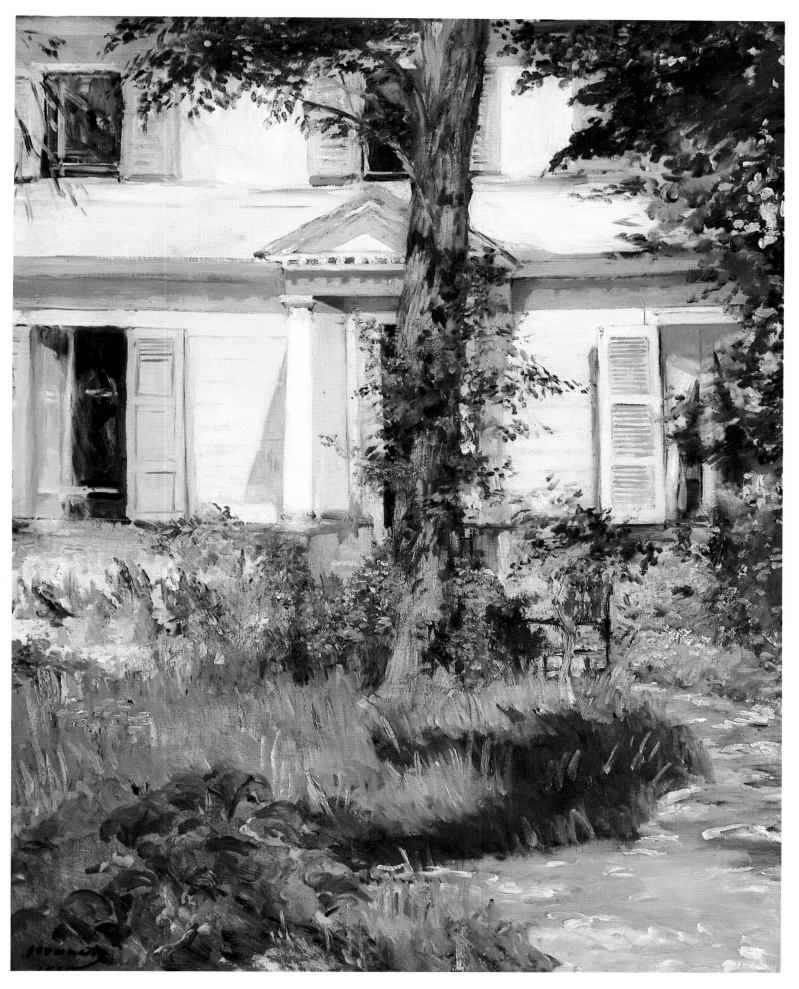

COLOURPLATE 69. Édouard Manet. *The House at Rueil*. 1882. 36¼ × 28¾″ (92 × 73 cm).
National Gallery of Victoria, Melbourne.

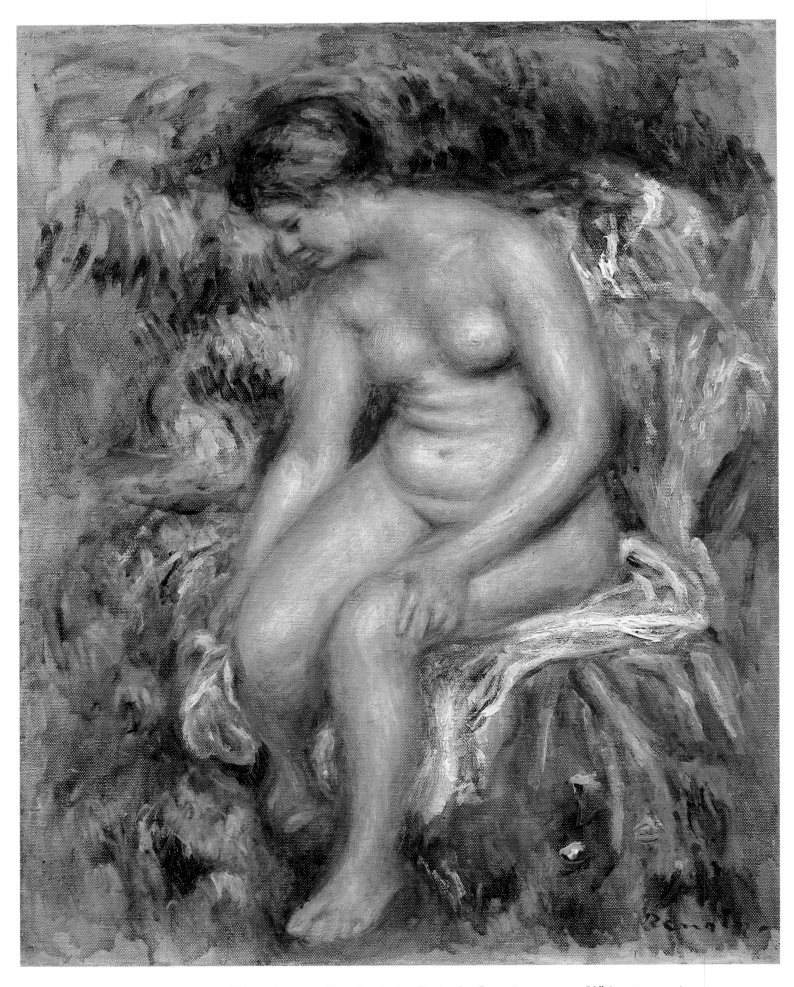

COLOURPLATE 70. Pierre-Auguste Renoir. *Bather Drying her Leg*. 1895. 20 × 15¾″ (51 × 40 cm).
Musée de l'Orangerie, Paris (Collection Jean Walter and Paul Guillaume).

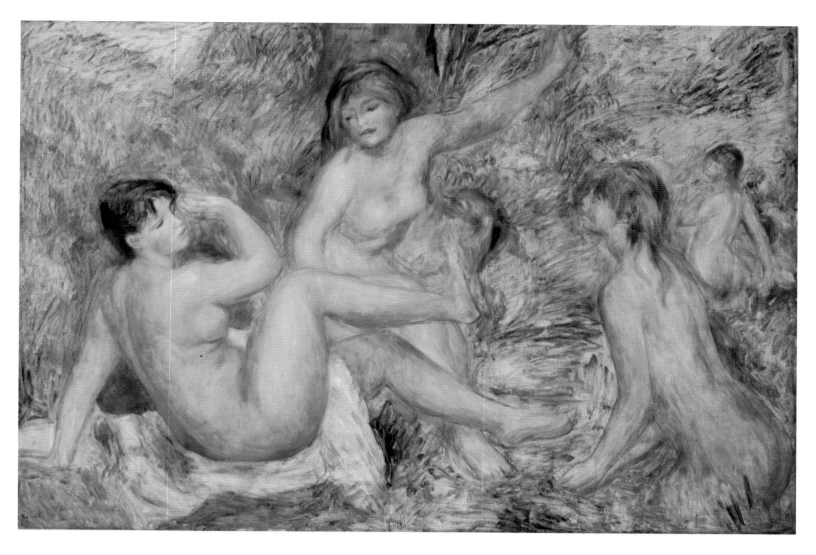

COLOURPLATE 71. Pierre-Auguste Renoir. *The Bathers* (variant). 1901–3. 45¼ × 62¼″ (115 × 158 cm). Musée Renoir, Cagnes-sur-Mer, France.

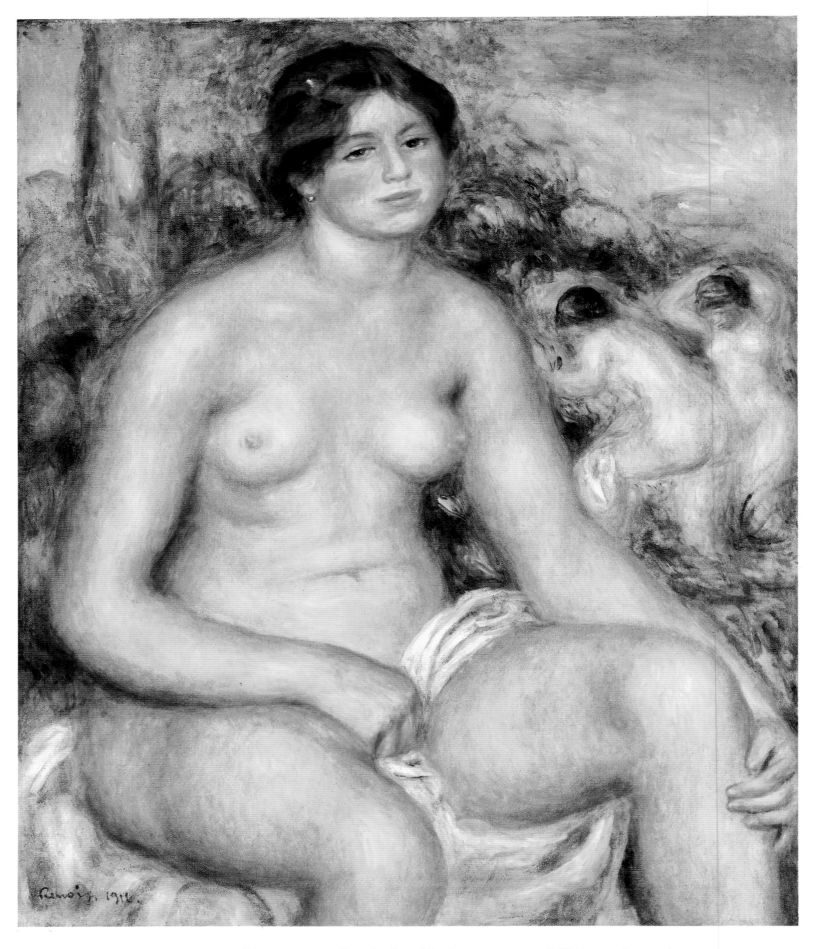

COLOURPLATE 72. Pierre-Auguste Renoir. *Seated Bather*. 1914. 32 × 26⅝″ (81.4 × 67.5 cm).
The Art Institute of Chicago (Gift of Annie Swan Coburn to Mr and Mrs Lewis Larned Coburn Memorial).

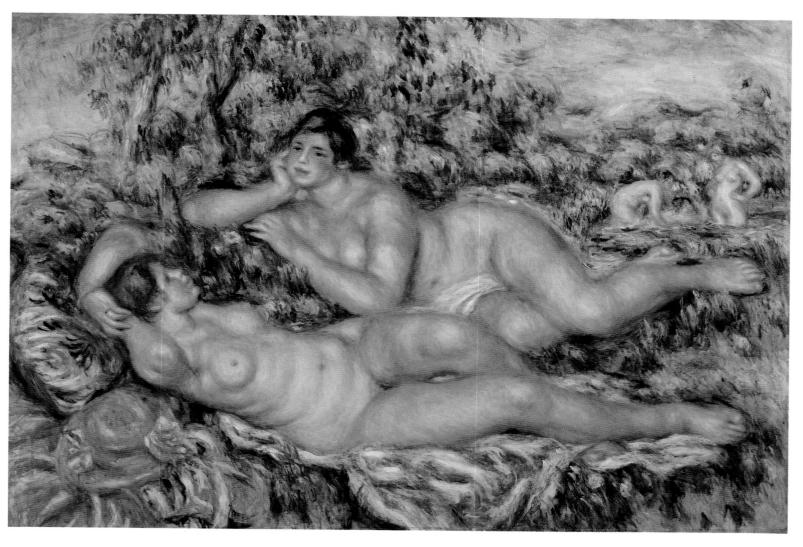

COLOURPLATE 73. Pierre-Auguste Renoir. *The Bathers (Grandes Baigneuses)*. 1918–19. 43¼ × 63″ (110 × 160 cm).
Musée d'Orsay, Paris.

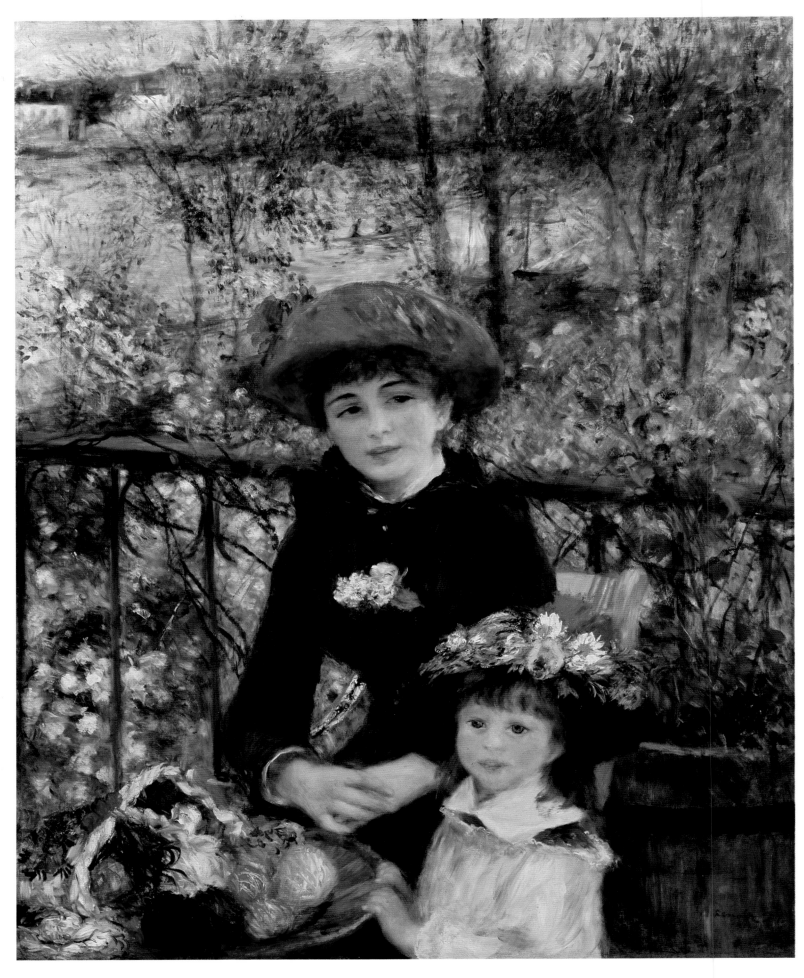

COLOURPLATE 74. Pierre-Auguste Renoir. *On the Terrace*. 1881. 39½ × 31⅞″ (100.5 × 81 cm).
The Art Institute of Chicago (Mr and Mrs Lewis Larned Coburn Memorial Collection 1933.455).

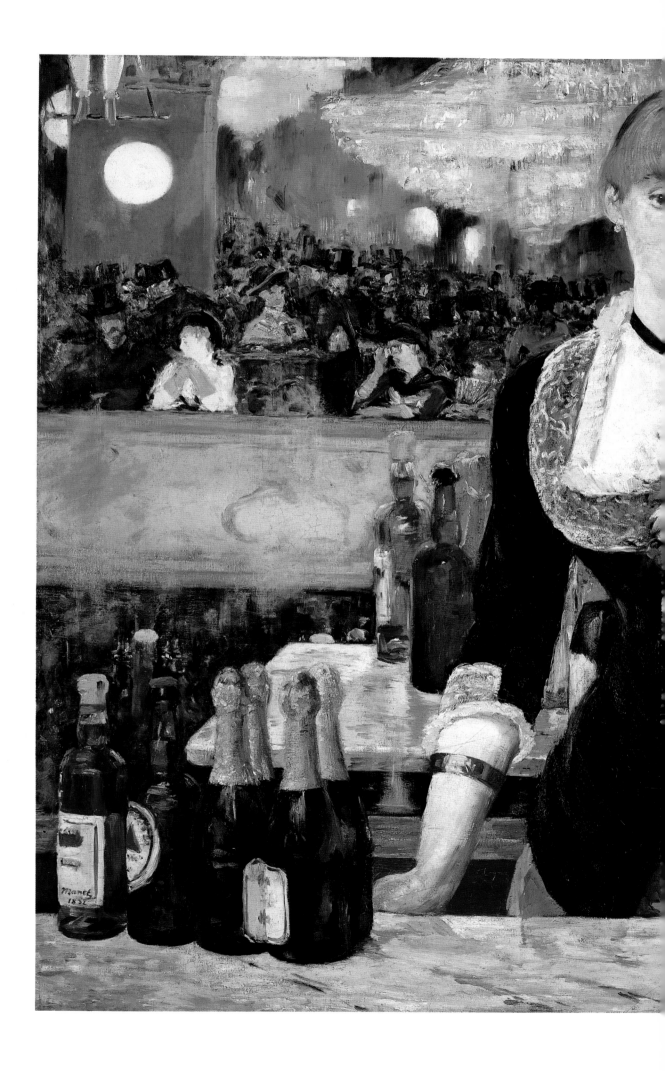

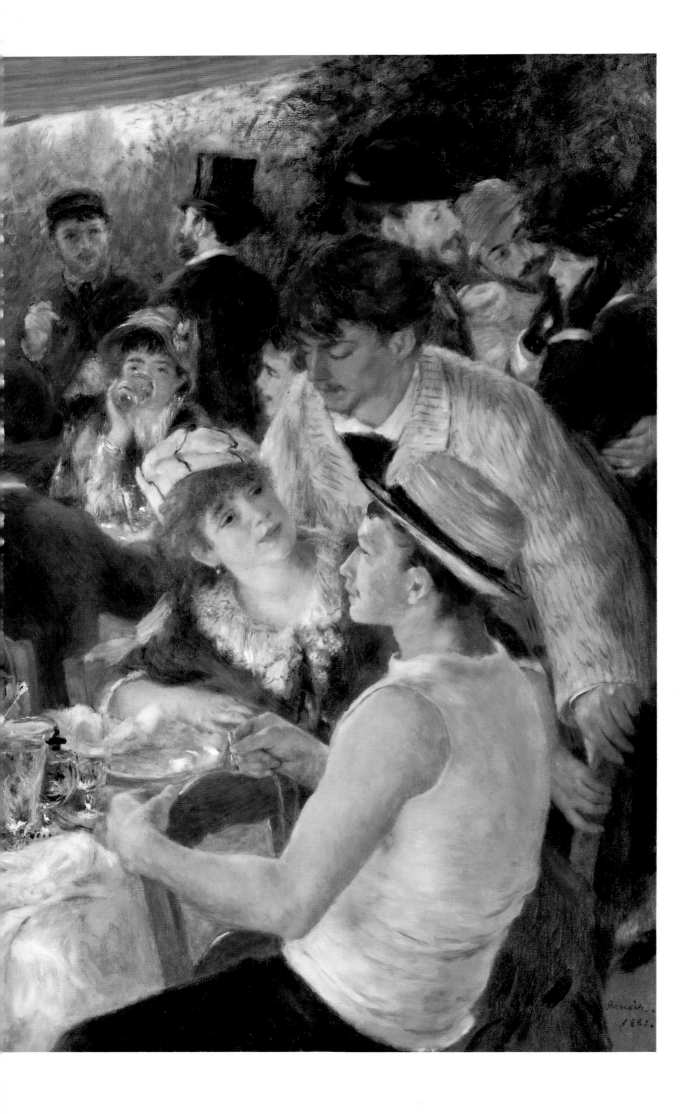

236

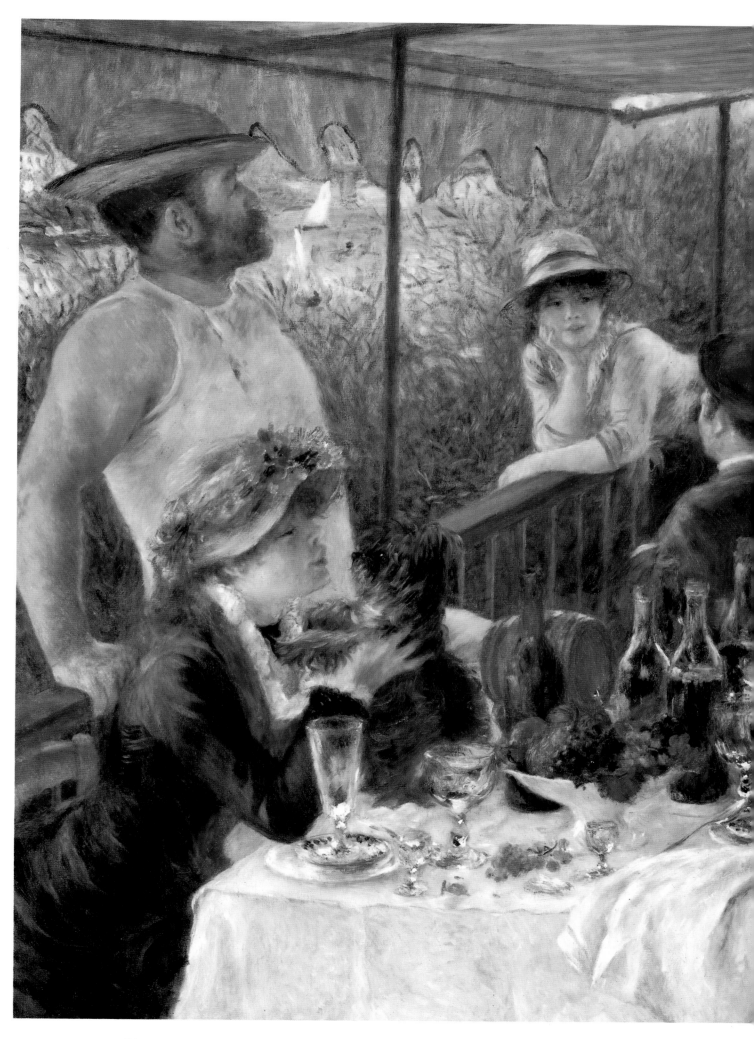

COLOURPLATE 75. Pierre-Auguste Renoir. *The Luncheon of the Boating Party*. 1881. 51 × 68″ (129.5 × 172.7 cm). Phillips Collection, Washington DC.

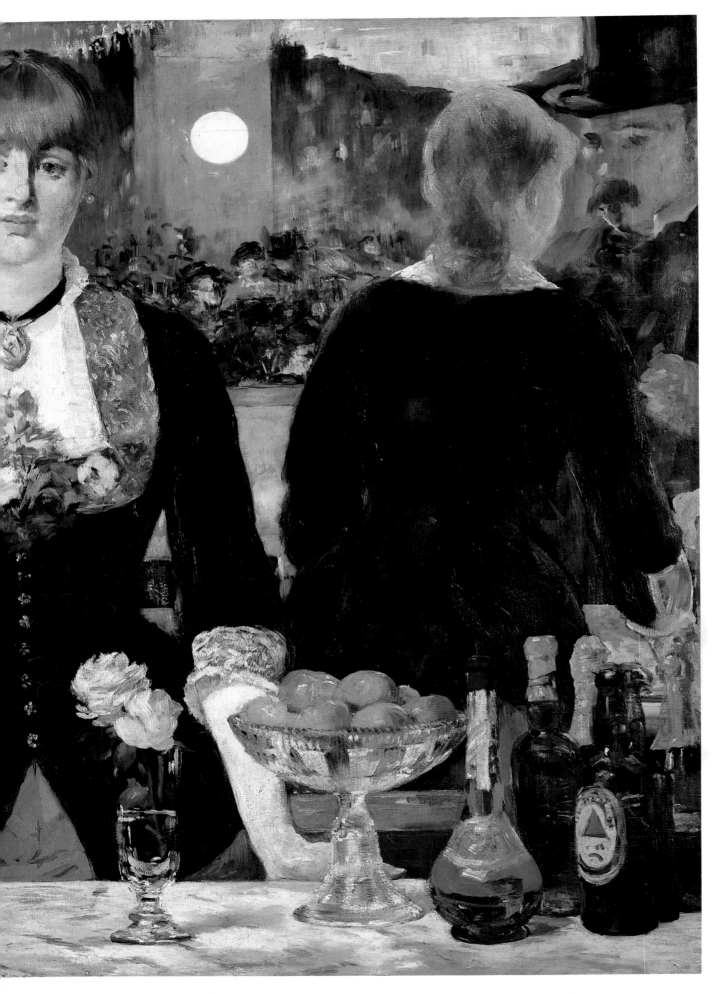

COLOURPLATE 76. Édouard Manet. *Bar at the Folies-Bergère*. 1881–2. 37¾ × 51″ (96 × 130 cm).
Courtauld Institute Galleries, London (Courtauld Collection).

water, branches, ground, keeping everything going on an equal basis and unceasingly rework until you have got it. Cover the canvas at the first go, then work at it until you can see nothing more to add. Observe the aerial perspective well, from the foreground to the horizon, the reflections of sky, of foliage. Don't be afraid of putting on colour, refine the work little by little. Don't proceed according to rules and principles, but paint what you observe and feel. Paint generously and unhesitatingly, for it is best not to lose the first impression. Don't be timid in front of nature: one must be bold, at the risk of being deceived and making mistakes. One must have only one master – nature; she is the one always to be consulted.

CAMILLE PISSARRO

Letter to Henri Van de Velde

March 27, 1896

This letter to the Belgian artist Henri Van de Velde (1863–1957) explains Pissarro's earlier rejection of Neo-Impressionism, about which he began to have doubts in 1888.

I believe that it is my duty to write you frankly and tell you how I now regard the attempt I made to be a systematic divisionist, following our friend Seurat. Having tried this theory for four years and having now abandoned it, not without painful and obstinate struggles to regain what I had lost and not to lose what I had learned, I can no longer consider myself one of the neo-impressionists who abandon movement and life for a diametrically opposed aesthetic which, perhaps, is the right thing for the man with the right temperament but is not right for me, anxious as I am to avoid all narrow, so-called scientific theories. Having found after many attempts (I speak for myself), having found that it was impossible to be true to my sensations and consequently to render life and movement, impossible to be faithful to the so random and so admirable effects of nature, impossible to give an individual character to my drawing, I had to give up. And none too soon!

CLAUDE MONET

Letter to de Bellio

June 1877

Georges de Bellio (1828–94), Romanian-born doctor and collector of Impressionist paintings. In June 1877 he purchased ten paintings from Monet and lent him 500 francs.

I am as unhappy as could be, they are going to sell up my possessions at the very moment when I was hoping to sort out my affairs. Once out on the street and stripped of everything, I can do only one thing: get a job, whatever it may be. It will be a terrible blow for me. I can't believe it, and I am making one last effort. With 500 francs, I could save the situation. I have about 25 canvases at my place and at M. S's. I will sell them to you for this price. By buying them, you will save me.

CLAUDE MONET

Letter to Théodore Duret
March 8, 1880

VÉTHEUIL

My dear Duret,

Since you are one of those who have often advised me to expose myself once more to the judgement of the official jury, I must tell you that I am indeed going to subject myself to that very test.

I am working on three large canvases, only two of which are for the Salon, as one of the three is too much a thing of my own taste for me to send it and have it rejected, so in its place I've had to do something more sensible, more bourgeois. I'm taking a considerable risk, and I'm being treated as a turncoat by the group into the bargain, but I think I've made the right decision, since I'm more or less certain to do some deals, particularly with Petit, once I have forced open the door of the Salon: I'm not doing this because I want to, and it is very unfortunate that the press and the public

Monet decided not to participate in the fifth group show in 1880, and instead submitted two paintings to the Salon. He was correct in his predictions about the judgement of the Salon jury: only the relatively conservative Seine at Lavacourt *(1880) was accepted.*

Georges Petit (1835–1900), dealer with whom, because of his academic leanings, Monet and Renoir had some misgivings about exhibiting. However, his joint Monet–Rodin exhibition in 1889 was a huge critical and financial success.

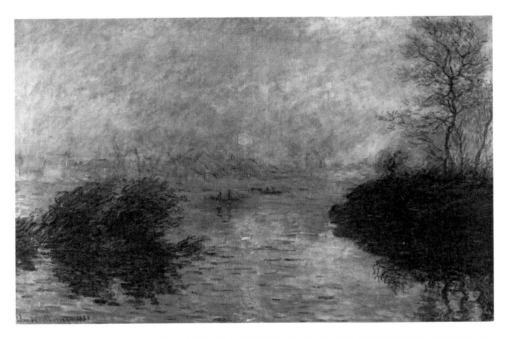

Claude Monet. *Sunset on the Seine, Winter Effect (Lavacourt).* 1880. 39⅓ × 60" (100 × 152 cm). Musée du Petit Palais, Paris (Photo Musées de la Ville de Paris).

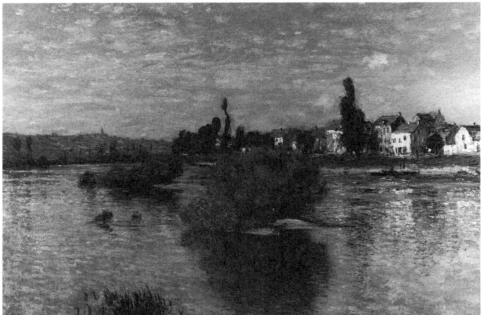

Claude Monet. *The Seine at Lavacourt.* 1880. 38¼ × 58¾" (97.1 × 149.2 cm). Dallas Museum of Fine Arts (Munger Fund).

have been so cavalier with our little exhibitions, which are highly preferable to this tawdry official affair. But since that is what must be done, I shall do it.

Having said that, can you come to my aid? A hundred francs would be a great help at this juncture because for a month now I have been working only on my Salon pictures and I cannot go and seek my fortune in Paris before March 20. I am therefore taking the liberty of asking you for this favour because I know that you will be coming soon and because I shall have something for you.

So, if you can, will you do me this great favour?

I look forward to your reply.

ÉMILE TABOUREUX

LA VIE MODERNE

"Claude Monet"

June 12, 1880

"Now then," I said without further ado, "perhaps you would be so kind as to show me to your studio?" At the sound of *that* word, sparks flew from Monet's eyes.

"My studio! But I never have *had* one, and personally I don't understand why anybody would want to shut themselves up in some room. Maybe for drawing, sure; but not for painting."

And with a gesture as expansive as the horizon, encompassing the entire Seine, now flecked with the golds of the dying sun; the hills, bathed in cool shadows; and the whole of Vétheuil itself, which seemed to be dozing in the April sunlight that sires white lilacs, pink lilacs, primaveras, and buttercups:

"That's *my* studio!"

What could I say to that?

"But surely," I said, afraid of touching on a sore point, "you must have a place to live in besides *this*?" And I pointed to the boat that had attracted my attention.

"Good Lord, yes!" he replied. "I live just over there."

It was a charming house, completely modern, where you and I, my dear editor-in-chief, could live the comfortable, middle-class life we deserve.

"And I suppose," he added in a tone that was hardly the most engaging, "I could manage to show you around – that is, if you want to."

I entered his lair without crossing myself, not wanting to make a display of my superstitions.

To tell the truth, I was expecting to find wild, savage things. Alas! I found myself in an interior furnished with only the most elementary, primitive objects: a bed, a chest of drawers, a wall cupboard, a table that was not exactly loaded down with books (I think I spotted, so help me God, a directory of addresses), and, hanging on the walls there (the totally vulgar wallpaper left me cold), were paintings by Monet!

I began by declaring to my unprepared host that I had no special or technical knowledge of painting. Perhaps that explains why we talked about it so much. And in the course of our conversation, in which I managed to introduce, with an effrontery that even as I write makes me blush, everything I knew about pictorial logomachy, I committed so many blunders that Monet, no doubt his mind resolved on the subject of my competence, proposed an outing in the boat.

I say *boat* because, in the eminently impressionistic society in which I found myself, I would never have dared to hazard the word *dinghy*, which is not "natural."

Ah, it was above all on the water that I learned how to get to know Monet!

Appearing all the while to be ecstatic over a dull little island we were skirting (you know, with willows, cane apples, and nettles where grass snakes unfailingly pullulate), I examined my painter.

Here was a big, strapping fellow, hale and hearty, with a matching trim of beard, a nose like any other nose, and eyes as limpid as spring water.

Monet is a true freshwater sailor.

He might easily have been one on saltwater too, because a large part of his childhood was spent at Le Havre. It was there that he did his first two paintings, if I'm not mistaken, which won awards at the Salon of 1865 to the most enthusiastic critical acclaim. What's more, Monet owes his first laurels to the genre of seascape – or rather, to *his* seascapes. Since then, he's simply managed to put a little less salt in his water.

What most interested me, among the hundreds of idle remarks we exchanged, was to know how Monet had become an impressionist. I risked asking him this question.

"I didn't *become* one," he answered with superb serenity. "As long as I can remember I've always been one."

"But still, didn't you belong to a school?"

"Sure. I was a student of Gleyre for three months . . . to please my family."

Well, well! There's still *some* goodness left among the impressionists.

"And then?"

"Then I met Manet, Courbet, and several others."

"Courbet's a wonderful painter, isn't he?"

"Good Lord, yes!"

"And how did you get to know Manet?"

"I never did get to know him. We met."

"But to talk about more serious matters, when you impressionists brought on that split between you and the jury who were imposed on you, did you have any particular reasons?"

"Yes, quite a few. At first the judges really did want to accept some of my canvases, some of the ones there'd been a lot of hoopla over. You want me to tell you about my 'green lady'?"

"No, no, thanks all the same. I read a few articles about it, and as soon as I saw how they were running you down, I said to myself, 'Here's a guy who must have a lot of talent'."

Monet, who is intensely modest, didn't even bother to acknowledge such base flattery with a nod. He didn't get angry either – which doesn't mean I wasn't telling the truth.

"Please go on," I asked.

"For a long time my friends and I had been systematically rejected by those very same judges. What could we do? It's not enough to paint: you have to sell them, you have to live. The dealers wouldn't have anything to do with us. And yet we *had* to exhibit. But where? Rent a space? As deep as we dug we could hardly raise enough between us to rent a box seat at the theatre in Cluny. Nadar, the magnificent Nadar, who is as good as good bread, *lent* us the space. So we, whom poor Duranty had labelled *The Batignolles School*, we made our debut in the artistic firmament as independent stars. For my own part, I was about as successful as I could have wanted, which is to say I was energetically booed by all the critics of the time. But I consoled myself on Manet's breast, who had just sent his seconds over to a journalist who had gone so far as to find one of his paintings 'admirable.'"

I interrupted: "Nowadays you seem to be keeping to yourself. I no longer see your name on the roster of 'impressionist' events."

"You're wrong. I still am and always will be an impressionist. I am the one after all who invented the word, or at least, with a picture that I exhibited, gave some reporter from *Figaro* the chance to fan that flame. He was rather successful, as you can see. I tell you, I'm an impressionist. But, except on rare occasions, I hardly see my colleagues anymore – male or female. Our little temple has become a dull schoolroom whose doors are open to any dauber."

Photograph of Monet. 1883. Collection Viollet, Paris.

CLAUDE MONET
Letters to Durand-Ruel
1882–83

[POURVILLE] SEPTEMBER 26, 1882

As I wrote to you, I'm bravely back at work. Unfortunately I can achieve nothing, I've just spent a whole week in the house stubbornly reworking a bouquet of flowers and I had to destroy it just as I did the earlier ones. During this week, the weather has been quite good and I was unable to get on with my studies of landscapes, so that I am more and more discouraged and disgusted with what I do. In a word, it's a completely wasted period for me and I must just make the best of it. I do not say that all these difficulties have not made me make certain efforts, and perhaps even progress, but at the moment it doesn't amount to anything, because I can see not one good canvas among all those I have begun. I am extremely unhappy and worried. I don't even know what I am going to do, go back to Poissy – I don't think I'd make much progress there; I'm very unsure, there are moments when I still want to stay here and rescue a few studies, but if I fail I'll be even more depressed; I may go to Rouen to my brother for a few days' rest and forget painting, if I can manage that. In any case you can always write to me at Pourville; as soon as I've decided on one thing or the other, I'll let you know.

Warmest regards from your devoted Claude Monet.

GIVERNY, JULY 22, 1883

I received your two hundred francs, for which I thank you, but I would be very grateful if, as you say you will, you could send me five hundred more for Tuesday.

This week you will probably receive a crate of paintings. The weather has been very bad for several days now and I'm taking advantage of this fact to work indoors and finish as many canvases for you as possible, but it is not as easy as you would think, since I want to give you only such works as I myself am satisfied with.

At all events, you will definitely receive a certain number because, while asking you for what I need to live on, I must also catch up and clear myself of what I owe you.

With my best wishes,

Your devoted Claude Monet.

GIVERNY, DECEMBER 1, 1883

. . . . I would like to be able to tell you that all your panels are finished, but unfortunately I can't get things to go right, though I'm really working on it. All the large ones are finished, which is the main thing. I have even done two extra ones in case one or two didn't fit in with the general arrangement; but even to produce those six panels, how many have I had to do away with? Over twenty, perhaps thirty. I'm working on the small ones at the moment and I hope that they will be easier, although those I've done need doing again. As to the other paintings, I shall soon have finished retouching them. I am eager to be through with all this, because it seems a century since I was last out working from nature in the open air. I am pleased to know that you like what I sent you, but I find it harder and harder to satisfy myself, and I even wonder if I'm going mad or whether what I'm doing is neither better nor worse than before – is it simply that nowadays I find it harder to do what I once did easily? Yet I think I'm right to be more demanding. Anyway, I'll bring you all this work next week, certainly within ten days. But don't let that stop you coming to see me if you have the time.

Your devoted Claude Monet.

PS It seems that Pissarro has been working well at Rouen.

243

CLAUDE MONET

Letters to Alice Hoschedé
February 1883

Dear Madame, ÉTRETAT, FEBRUARY 2

I am sending you herewith the hundred francs which I couldn't send you yesterday because of the lateness of the hour, I see from your letter of this morning that they will reach you just when needed. I shall arrange to send you two or three hundred for the tenth for M. Tabary.

I am so sorry to learn that you are so sad and although I understand all your worries, I would like to see you less discouraged. You simply must manage to see Hoschedé, the further things proceed the more you are in danger of letting it all get out of hand; unless you think it better to leave things to chance, because the month of April will certainly come and he may be at Vétheuil, perhaps without having come to see you, but I think somehow he must be contacted, however unwillingly, so that you can have a sensible and serious talk with him.

Don't worry about me, I never stop thinking about you, you may be sure of my love, cheer up, this absence will not be for long, I'm working as hard as I can, as I was telling you yesterday; I am very happy to be here and I hope to be able to do something good, at all events I shall bring back masses of documentation to do great things at home. Today it looks as if the weather is going to be very rough, there's a strong wind but luckily I can take shelter.

I've just had a note from my brother who is coming to spend Sunday with me and will probably ask me to stop at Rouen on the way back, but on this occasion I shan't have the time.

Till tomorrow, my dear, I'm going to post this and then settle down to try and work. Kisses to the children and the best to you, my regards to Marthe. I love you, never doubt it, and don't lose heart.

Dear Madame, ÉTRETAT, FEBRUARY 7

Alas, my lovely sun has gone, it's been raining all morning, I am wretched, because with one or two sessions I would have finished several studies and, most wretched of all, I had begun a very good one and spoilt it and I was counting on getting it back to its original state today of all days. But who knows if this fine weather will return. In a word, all that saddened me considerably, I've reviewed the work I'd done during the last few days and was most dissatisfied with it, so I've caught your black ideas, but I'll just have to keep at it and work on grey effects. As you say, I left you a fortnight ago today, I've been here working for a week, if time seems long in terms of being away from you, it seems short when I think of my work and of what I want to do, and yet if you saw what I'd managed to do during that week, you would be astonished. If it were not for the studies I began in sunny weather, I'd prefer it grey, because that would be more convenient for doing various studies as notes with a view to something really big, if indeed I have the time to do it when I get back. . . .

Dear Madame, ÉTRETAT, FEBRUARY 12

Rain again, I am destined never to finish one single thing, though it is not for lack of trying and working myself up, and yet what a lot of beautiful things there are and how clearly I see that I could do some good work: since I have been working at my window, I have done a large sketch which is very good, I think, as a sketch, but which is impossible to finish and even to exhibit. You'll see it, it is something one could make a big canvas from. This is my last week, may God grant I spend it well. I am beginning to be tired: since I've been here, I've never stopped working and also racking my brains. . . .

<div align="right">Claude Monet</div>

Alice Hoschedé's relationship with Monet is thought to have begun when her husband, Ernest Hoschedé, the owner of a chain of department stores and a patron of Monet, invited him to do some decorative panels at their house in Montgeron. After Hoschedé's sudden bankruptcy in 1877 Alice and her six children moved in with Monet's family in Vétheuil. She undertook to look after both families after Camille's death in 1879 and married Monet in 1892.

FRANÇOIS THIÉBAULT-SISSON

LE TEMPS

"About Claude Monet"

January 8, 1927

Was it the end of his stay in Argenteuil or the beginning of the time he spent in Vétheuil that served as the setting for an anecdote that demonstrates with what ardour and determination he did not allow himself to be stopped by any hardship, whether financial or technical, as he undertook the interpretation of nature? When he recounted it to me seven or eight years ago, the artist was incapable of placing it within a precise frame of time.

"It was," he told me, "around the period when I felt the need to enlarge my field of observation and refresh my vision before new sights, to detach myself momentarily from the region where I lived, and to undertake excursions for weeks at a time to Normandy, Brittany, and elsewhere. It was a period of relaxation and rejuvenation for me. I left without a preconceived itinerary, without a programme outlined in advance. I would stop wherever I found nature inviting. Inspiring motifs could be chanced upon. A sky at its most elegant or most brutal, or a rare effect of the light, determined the course of my work. It is thus that, having stopped for a day at Vernon, I discovered the curious silhouette of a church, and I undertook to paint it. It was the beginning of summer, during a period that was still a bit brisk. Fresh foggy mornings were followed by sudden bursts of sunlight, whose hot rays could only slowly dissolve the mists surrounding every crevice of the edifice and covering the golden stones with an ideally vaporous envelope. This observation was the point of departure of my *Cathedrals* series. I told myself that it would be interesting to study the same motif at different times of day and to discover the effects of the light which changed the appearance and colouration of the building, from hour to hour, in such a subtle manner. At the time, I did not follow up on the idea, but it germinated little by little in my brain. It was much later, ten or twelve years afterwards, that, having arrived in Giverny following a ten-year stay in Vétheuil and having noticed iridescent colours in the morning fog, pierced by the first luminous rays, I began my series of *Haystacks* with the same sense of observation. The series of *Cathedrals* followed after a five or six year interval. It is thus that, without seeking to do so, one discovers newness. . . . Preconceived theories are the misfortune of painting and painters. Nature is the most discerning guide, if one submits oneself completely to it, but when it disagrees with you, all is finished. One cannot fight nature."

And Monet told me how one day, finding himself in Étretat during the equinox, he had been determined to reproduce every detail of a storm. After finding out exactly how far up the waves could reach, he planted his easel on a ledge of the cliff, high enough to avoid being submerged. As a further precaution, he anchored his easel with strong ropes and attached his canvas securely to the easel. He began to paint. The sketch was already anticipating something marvellous when a deluge of water fell upon him from the sky. At the same time, the storm became doubly violent. Stronger and stronger waves rose in furious spirals, drawing imperceptibly closer to the indifferent artist. Monet was working furiously. All of a sudden, an enormous wall of water tore him from his stool. Submerged and without air, he was about to be swept out to sea when a sudden inspiration caused him to drop his palette and paint-brush and seize the rope that held his easel. This did not keep him from being tossed about like an empty barrel, and he would have dined with Pluto had chance not brought two fishermen to his rescue.

This unfortunate adventure made him lose the taste for observing the equinox storms too closely, and when he attempted to depict the capricious

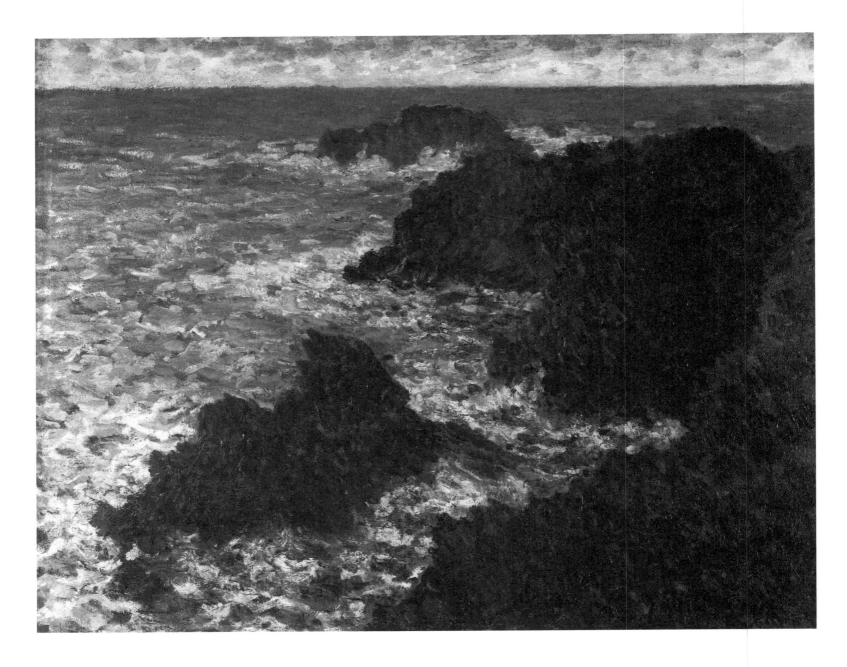

waves once again, it was during calm weather. His series of the *Rocks at Belle-Île*, where waters crash against the cliffs in some places, and slip slyly into coves to form dangerous whirlpools in others, was painted during July and August, when it was so hot that the artist worked in duck pants and a shirt at the foot of the rocks of Port-Goulphar. This place is incomparably majestic, seen as a whole, yet it is little known among tourists. I do not know if there is even a hotel there today. Then, there was only a tiny inn where customs officers came to "drain a few glasses" both in the morning and the evening and where lost hikers could find a place for the night after a comfortable and simple dinner.

Monet had settled there for the duration of his visit. One lovely evening, after an exhausting day, he climbed the short, steep path leading from the bottom of the cove to the top of the cliff and returned to the inn with his things on his back. All the tables were occupied. Glimpsing an empty place across from one of the diners, the artist sat down. The diner was as bearded as he was, with a serious, almost sullen demeanour. Monet would not have spoken if the man across from him had not broken the ice and initiated a conversation about painting. After a while, Monet introduced himself. "But I know you," replied the stranger, "I have even drawn my sword for you at the *Justice*." "Clemenceau's newspaper!" cried out the surprised painter. "Well then, you must be Gustave Geffroy." "Exactly!" And the two dinner companions cordially shook hands.

Claude Monet. *Rocks at Belle-Isle.* 1886. 25⅝ × 32¼″ (65 × 81 cm). Musée d'Orsay, Paris.

GUSTAVE GEFFROY

MONET, SA VIE, SON OEUVRE
"Pays d'Ouest"
1897

Monet's meeting at Étretat with Geffroy was the beginning of a close friendship. In 1886 at the time of their meeting Geffroy was art critic for La Justice. *He became Monet's official biographer and* Monet, sa vie, son oeuvre *was published in 1924.*

Claude Monet works before these rocky cathedrals at Port-Domois in the wind and the rain, necessarily clad like the men of the coast, covered in sweaters, boots, and wrapped in a hooded slicker. Sometimes a gust of wind will snatch his palette and brushes from his hands. His easel is lashed down with ropes and stones. No matter, the painter holds his own and proceeds to his work as into battle. Human will and courage, artistic passion and sincerity – these are the qualities that characterize that fine, rustic family of landscape artists whose works honour this century's art and constitute its claim to originality. Monet will be in the first rank of this group. Since 1865 he has been assaulted by animosities, spared no measure of carping criticism, and has had to struggle against spite and inertia. It is not difficult to predict that habits of taste and thinking will change, that it will be for Monet as it has been for so many others who have gone unappreciated and scorned. Here, in front of these masterfully, concisely designed canvases of such bold exactitude, before these luminous works, so steeped in the surrounding atmosphere and permeated by the light, where the colours disperse and mingle through the inexplicable magic of an alchemist; before these cliffs, which give the impression of the weight of the earth; before this sea, where all is continuous motion – the shape of the waves, the transparent depths, the variety of foam, the reflections of the sky – one has the feeling that something new, something great, has made its appearance in art.

But it is not possible, in this note scribbled at the end of a day, to describe in detail the coast and the sea at all times and in all weather, as they are depicted by the brush of a distinguished artist. The canvases painted at Belle-Île will be seen in Paris. Suffice it to have mentioned the deeply felt love of nature that drives Claude Monet to attempt to reproduce, on his canvases, the unchanging lines and the fugitive effects, the boundless expanses of the sea and the sky, and the velvet of a mound of clay blanketed by damp moss and withered flowers.

OCTAVE MIRBEAU

EXPOSITION CLAUDE MONET – AUGUSTE RODIN
"Claude Monet"
1889

Octave Mirbeau (1848–1917), poet, novelist and writer on the theatre and on art. His catalogue introduction to Monet's retrospective in 1889, a joint exhibition with Rodin, is an expanded version of an article that first appeared in Le Figaro *on March 10, 1889. Mirbeau's connections with the Symbolist writers Aurier, Verlaine and Mallarmé made him a significant interpreter of Monet in the late 1880s and 1890s. Monet exhibited 145 paintings in this show at the Galeries Georges Petit. Half of the paintings shown were very recent works from Belle-Île, Antibes and la Creuse.*

One day an extremely young man came to ask Claude Monet to take him on as a pupil.

"I do not teach painting," the artist answered, "I simply practise it, and I assure you that I don't have too much time even for that. As for my brushes, I wash them myself. Furthermore, since time immemorial, there always has been and always will be only one teacher – and one strangely heedless of all our artistic theories . . ." And he gestured towards the sky, its light enfolding fields and meadows, streams and hillsides.

"Go and question it, and listen to what it says. If it tells you nothing, then enter a notary's office and copy out documents. There is nothing dishonourable about that, and it is better than copying nymphs."

But the young man had already read the art critics. He went off to find M. Jules Lefebvre, who explained to him how to get a government decoration. In the meantime he has, I believe, been awarded the *prix de Rome*.

In painting, everyone is someone's master or pupil, according to whether you are old or young, or more or less an establishment figure. When you do not have genius — and the less you have — you take your revenge by professing mediocrity on others' account. You become that impudent and comical figure, an art master. To transmit the fixed laws of the *beautiful* theoretically, mechanically, from generation to generation; to teach a method for being moved, in a correct and stereotyped fashion, by a patch of nature, transformed into a topic for scholastic chatter, as one learns to measure lengths of silk or to make boots, seems, at first sight, an absurd profession. Yet none is held in greater esteem, none is better remunerated. The master stakes his pride on having the most students, the student who can most faithfully copy a master, who in his own turn copied his own master, who had already copied another. And so it goes back, from pupil to master, into the mists of time. This unbroken chain of people copying one another over time, we call tradition. It is infinitely respected. It has schools, institutes, ministries; the whole social and political organism functions around it. Governments, whatever their complexion, patronize it and see that it is officially preserved and rewarded, and that no unfortunate accident occurs to break its seamless continuity.

With M. Claude Monet, we are far from tradition. One of his most original features is that he has never been anyone's pupil. He is in the rare and happy situation of having no civil status. No Cabanel, no Bouguereau baptized him; he appears in exhibition and sales catalogues under his own name, without the accolade of any master. As a young man he entered the studio of the ageing Gleyre, it is true, but when he had thoroughly sampled its strange practices, he promptly fled, without so much as undoing his portfolio or opening his paintbox. He then had a brilliant but highly irreverent idea, an idea which undoubtedly made him the admirable painter that he is: the idea of not copying any painting from the Louvre. He merely discovered that nature proffered beings, trees, flowers, skylines, water and light, and that all this was alive, had a sovereign beauty, ceaselessly renewed, for ever young, bright, fresh and bold, and that this was worth all the dead masters sadly flaking in their peeling gold frames, under the successive layers of dust and varnish to which they are subjected. Not that he was unaffected by the joys of a Giotto, a Holbein, a Velasquez, a Delacroix, an Ingres, a Daumier, a Hokusai: no one more than he was made to feel and love them. But he rightly told himself that everyone must work for themselves, that is, express their own feelings and not repeat those of others. He started from the principle that movement is the law of the universe, that art, like literature, philosophy and science, is perpetually on the march towards new horizons and new conquerors; that yesterday's discoveries are succeeded by those of tomorrow, and that there are no set procedures and no sacred figures in which the final efforts of the human spirit are for ever fixed. M. Claude Monet admired those glories of the past, and dallied with them no longer than he remained in the studios of contemporary teachers. He looked at nature and found her bursting with love and quivering with genius; he lived in nature, dazzled by the inexhaustible magic of her changing forms, ravished by her unexpected music, and he gave his dreams free range to wander through the weightless, faery visions of light, which enfolds all living things, and brings to life all dead ones, in the charmed world of colours.

However gifted he may feel himself, however little drawn towards imitation, in his haste to produce, in his amateurish gropings, faced with the difficulties of a refractory technique, an education of the eye, which is so

William Bouguereau (1825–1905), academic painter.

painfully achieved, a young man is fatally destined, even unconsciously, to undergo the influence of his first enthusiasms. In his first canvases, so full of strivings, so *different* in intent, so full of personal qualities, where one can already sense his future mastery, one is nonetheless aware, in places, of the influence of Courbet and his dark manner, then of that of Manet and M. Camille Pissarro, that great and unappreciated talent. He became aware of this – for no one is a harsher judge of his own works than M. Claude Monet – and devoted all his energies to ridding himself of these few involuntary memories which were harming his complete development. Two important paintings date from this period of transition and desperate internal struggle: the *Luncheon on the Grass* and the *Handful of Flowers*; the first of these appeared, I believe, at the Exposition des Champs Élysées of 1864, where it was roundly insulted. These enormous canvases, with their soft, appealing, slightly sad tonalities – though in comparison with others they were like a ray of sunshine in the gloom – seemed the last word in revolutionary art. They undoubtedly marked considerable progress in *plein-air* research, which was new at the time, and their modernity alarmed the bloodless, stuffy and artistically bankrupt academies whose exponents are marking time against ochre-stained backgrounds. Nonetheless, they showed delicacy rather than strength, grace rather than real power. The shadows were soft, the light sometimes a little flat, the draughtsmanship – although quite freed from all convention – was stiff, in parts; the atmosphere was still heavy. M. Claude Monet had not attained that litheness, that elegance, that vibrant beauty of line he has since mastered, nor did he yet reveal that extraordinary acuity of vision which enables him to distinguish twenty contrasting tints within one colour, mutually affected by their orchestral position. He was not yet modelling his work with the full, luminous impasto he uses today. Soon, by means of isolating himself spiritually, concentrating upon himself and engrossing his faculties in nature alone, by forgetting theories and aesthetics and all that was not the *subject* of the present moment, his eye became alert to the swift play of reflections, the quiver of the most subtle and fleeting light; his hand became at once steady and supple, responsive to the atmospheric line, sometimes so unexpected; his palette, swept clean now and reduced to the essential colours of the rainbow, became lighter and more cheerful, rolled out the sun and moulded the sky.

It was then that he began his studies of the Seine at Argenteuil, its banks alive with sunlit greenery; his slender, graceful poplars, silvered by the breeze and making the sky tremulous with the slight movement of their leaves; his boats, with their red, blue, green and white hulls, gliding smoothly over the ruffled, reflecting water which, along with the fragmented gold of the sun, bears all the magical, flickering gaiety of the ever-changing reflections: a feast of light, a gala of limpidity, a delectation for the eye. Then we have his first seascapes: the sea of Normandy, Le Havre, Trouville, Honfleur – the sea surprised at its most mysterious, caught atmospherically at its most distant, in all its remotest solitude, cradled by the waves' eternal complaint, with its teeming boats, its sandy beaches, cliffs and rocks; the sea, to which Monet was to devote one of his grandest passions, and through which, magnificent poet that he was, he physically expressed the poignant sensation of infinity. And then his flowers, whose delicate structures, whose almost inexpressible and fragile tenderness, winged forms, brilliant, virginal colours and ethereal scents he so exquisitely captured. Then women – decked out with sovereign grace, like those of Watteau – seated or lying on lush greenswards, or stretched out beneath trees, on flowery counterpanes of gardens, which bestrew their light garments with spots of light and shade. Then, against a pink background decorated with fans, a Japanese woman whose garment is coiled at her feet in drifting folds, a miraculous landscape peopled with fairytale birds, gods and metamorphoses. Each of his canvases bespeaks not only efforts, but marks a conquest of art over nature; and if all are not of equal quality and value, many are already masterpieces. Fully master of his craft, profoundly convinced furthermore of his aim, and

Mirbeau has made a mistake with reference to Monet's Le Déjeuner sur l'Herbe, *which remained unfinished and was never exhibited.*

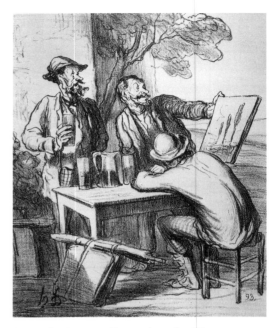

(*Above*) Honoré Daumier. *Le Charivari*, January 19, 1865. "Do you think I'll have any trouble getting a good price for this study? – No, but you'll have to find someone who's crazy about poplars." Metropolitan Museum of Art, New York (Rogers Fund, 1922).

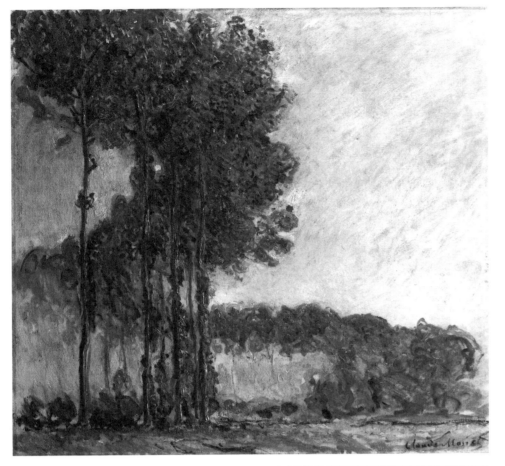

(*Above left*) Claude Monet. *Poplars*. 1891. 35½ × 36½" (90 × 93 cm). Fitzwilliam Museum, Cambridge.

(*Left*) Utagawa Hiroshige. *Numazu, Yellow Dusk*. From the series *53 Stations of the Tokaido*. Woodblock print, *ōban* size. Museum of Fine Arts, Boston (Bigelow Collection).

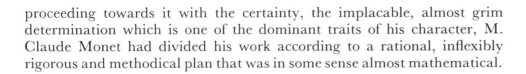

proceeding towards it with the certainty, the implacable, almost grim determination which is one of the dominant traits of his character, M. Claude Monet had divided his work according to a rational, inflexibly rigorous and methodical plan that was in some sense almost mathematical.

* * *

Most painters make do with approximate and generally dissonant representations. Their observations of the atmosphere do not go beyond the three main events of sunrise, midday and sunset; they do not take into consideration the intermediate hours with their infinite nuances, crucial though these are to painting. They do not seem aware that each hour of the day has

its special character, its different spectacles of light; just as each country has its own peculiar structure, each race its anatomical particularities, its ethnic dissimilarities of physiognomy. . . . The result is a deep lack of agreement between the various parts of a single painting, an absolute lack of unity; and, subsequently, a complete lifelessness. The art which does not concern itself with natural phenomena, even in the realms of the dream, and which closes its eyes to what science has taught us of the functioning of organisms, is not art. . . .

M. Claude Monet understands that in order to achieve a remotely exact and convinced interpretation of nature, you have to paint not only the general outlines of a landscape, its partial details, or patches of ground or greenery, but above all the time of day that you have chosen to render this landscape in one characteristic guise; you have to paint the moment. He noticed that, in a normal day, an effect lasts barely 30 minutes. Thus the problem was to record the history of these 30 minutes, that is, the degree to which they express a harmonious and consistent light and movement. This observation applies as much to figures, which are in reality merely an ensemble of light, shadow and reflection, all mobile and changing things, as it does to landscape. The motif and the moment of the motif having once been chosen, he would throw his first impressions onto the canvas. He made it a strict rule to cover the canvas within this short space of one half-hour. The admirable thing was the certainty of the draughtsmanship, the beguiling feel, the perfect precision of the character of the subject obtained in this first attempt, caught with such verve, and with which many painters would have been satisfied. But M. Claude Monet was not. Each day, at the same hour, for the same number of minutes, under the same light, and sometimes for as many as 60 sessions, he would return to his motif, trying to capture, at a single glance, the harmony of the colour and the relationships of the values dispersed throughout the subject; fixing them, as one might say, simultaneously, in their exact form, and in their fleeting design, using long, fine, firm and flexible sable brushes, which give the touch both greater solidity and greater suppleness, and greater emphasis to the modelling; juxtaposing or superimposing his virgin colours, scarcely ever mixing them, making them enter one another, so that their freshness, brightness and transparency are retained; relentlessly stopping and running to another motif if the light happened to change during this brief session. Never, even on days when work became almost an intoxication, a sweet drunkenness of the spirit which sent the hours flying by unnoticed, never did M. Claude Monet allow himself to be carried away by the temptation, strong though it might be, to persist with a canvas beyond his predetermined time. Apart from yielding marvellous artistic results, though not attained without struggle or anguish, this rare if not unique integrity of procedure allowed him to work on ten studies at the same time, almost as many as there are hours in a day. Yet this too was at the mercy of the whims of the heavens. Furthermore, he quite overlooked the processes of preparing his canvases, thinning with spirit, grinding up with copal, all the messy and pointless tricks painters saddle themselves with, the thousand little professional subterfuges with which they love to surround themselves to increase their importance in the eyes of the layman, who loves complexity. If I dwell at such length on these particularities of technique, it is to refute the ignorant criticism of those who complain that M. Claude Monet is satisfied with the approximate, whereas in fact no one, with such breadth of means, was ever so conscientious, so meticulous in his art, so faithfully representative of nature, so ardent and so patient in his pursuit of truth; as well as to refute those who accuse him of painting away madly, with a palette knife, haphazardly, impasting at random, whereas in fact each stroke, each touch of the brush is the product of considered thought, of comparison, of analysis, of a will aware of what it wants, of what it is doing and where it is going. Within a few years, thanks to this method, he succeeded in ridding himself of all but one obsession, for nature, and all but one passion, for life; at last he was able to create his own art.

And indeed life fills these canvases with renewed passion, with a breath of astonishing new art: the life of the air, of the water, of scents and lights, the elusive, invisible life of meteors, all synthesized in gestures of admirable boldness, eloquent daring, which, in reality, are simply refinements of perception denoting a superior knowledge of the great harmonies of nature. The nuptial joys of spring, the blazing daze of summer, the pangs of autumn on its bed of russet, under its draperies of gold, the splendid chill regalia of winter – life is everywhere, rekindled and triumphant. And none of this resplendence is left to chance inspiration, however felicitous, or to the whim of a brush-stroke, however brilliant. The atmosphere *really* intervenes between our eye and the appearance of the figures, seas, flowers and fields. The air bathes each object *visibly*, imbues it with mystery, envelops it in all the muted or brilliant hues it has borne hitherto. The spectacle is scientifically thought out, the harmony of the forms is in accordance with the laws of the atmosphere, with the regular and precise march of phenomena of earth and sky; everything is given movement or immobility, speech or silence, colour or lack of it, according to the time of day the painter is expressing, and according to the slow ascent or sinking of the stars, bestowers of brightness. Study any of M. Claude Monet's pictures closely, and you will see how each of the numerous details composing it are logically, symphonically connected one to the other in accordance with the direction of the light, how the least blade of grass and the shadow of the smallest branch are influenced by their horizontality or obliqueness. The exquisite, beguiling grace, the emotive strength, the evocative power, the magnificent poetry, which arouse a thrill of admiration – all are the fruit of this exactitude. Thus in these canvases, we truly breathe in the smell of the earth and the spirit of the sky . . . the sun gradually waning or rising along tree trunks, shadows lengthening or fading on greensward and water. And we have the impression – one I have often experienced before M. Claude Monet's pictures – that art is as it were eclipsing itself and that we are alone in the presence of a nature conquered and tamed by this miraculous painter. And in this nature – recreated in all its cosmic workings, its life ruled by the stars – we feel the presence of the dream, in all its joy and enchantment.

* * *

This study is necessarily brief, and it is not my purpose here to follow M. Claude Monet through his life and work. The biography of such a man, the thorough investigation of such an oeuvre, would require the space of an entire volume. My task is simply to tell of his fervent struggles, the Salon's scandalous rejection of his superb canvases, his exhibitions with the Impressionists and his exhibitions on his own, such as that organized by *La Vie moderne*, to which M. Théodore Duret, one of his oldest and staunchest defenders, devoted an excellent study. Each time we saw progress destined to remain misunderstood, ceaselessly renewed strivings which the ruck of the public, shepherded by art critics, treated as madness and mummery . . . Nor shall I say anything about his discouragement, rapidly overcome and immediately followed by frenzied work – for he was proceeding directly towards his goal, barely hampered, from time to time, by the wretchedness of an existence where he felt covert hostility at every step. What I can say, however, is that he needed a cast-iron constitution and muscles of steel to hold out, in sun, snow, wind and cold, against the trials to which he subjected himself, and a sturdy cast of character not to be dashed by all the vexations that human ignorance and baseness accumulated around him. Today, M. Claude Monet has bested hatred, he has forced insult to fall silent and respect to be paid to his name; he has what is known as *arrived*; he is what the inspectors of the Beaux-Arts would call *decoratable*. If certain mulish people, for whom art is merely the perpetual repetition of frozen forms and dead formulae, are still arguing about the *tendencies* of his talent, they no longer dare to argue about the talent itself, which has compelled recognition on its own account, through its own deep strength and magic.

Art-lovers who formerly mocked him now boast of owning his paintings; certain painters, always the first to make sport, now imitate him. And he himself, more robust and passionate than ever, richer in expertise, lives in the fullest, the most unshakeable circle of serenity that an artist could ever hope to enter.

* * *

This exhibition of 150 works from the oeuvre of M. Claude Monet is of exceptional interest, first because of the superior quality of the works themselves, secondly because we are not used to seeing them make an appearance in official exhibitions, where everything is trivialized, confused, lost sight of, where, in the crowd, one can scarcely distinguish pictures of charm, like those of J. F. Raffaëlli and M. Carrière this year. It also has in some way a biographical interest, for it embraces a period of 25 years of stubborn labour and merciless struggle: it is the summary of almost all his life as an artist. It shows him to us almost at the start, and then where he is today, taking us through the different stages which mark, not the history of his transformations, but the chronology of his progress. One thing strikes and astonishes me: and that is the absolute unity of this oeuvre, with all its diversity and abundance; it is the perfect balance of this mind, in all its passion. Since the day M. Claude Monet first took a paintbrush and sat down in front of a canvas, he knew where he wanted to go, and he went straight there, like a conqueror, without ever straying from his route, without ever falling into the rut of vague ideals, without losing himself in the byways of muddled aspirations. Gifted as he was with incomparable moral robustness and intellectual health, and further strengthened by the constant intimacy of his life in nature, he bore no trace of that contemporary sickness, so productive of lapses, so fatal to production: anxiety. Never did the corrosive aesthetic or the dispersive action of the schools eat into this spirit of bronze, adamant yet vibrant, so deliciously alive to all emotions. The subtle and complicated mechanism of his genius, admirably receptive to the most disparate sensations, a creator of the most disparate forms, is, as it were, all of a piece. From the *Woman in Green* which I regret not having seen again in this exhibition – to the dazzling figures of Giverny; from the sun-filled gaiety of Argenteuil to the tragic landscapes of the Creuse, veiled in a poignant, an almost Biblical mystery; dead vineyards under leaden skies, snow-covered haystacks lit by the faery light of dawn, virginal and radiant, lapped in transparent mist – not for a moment does he repudiate himself. His art is all joy, serenity, harmony, because it is all light, and because light illumines all things, from the flower's calyx to the chasm's rim. One may follow M. Claude Monet to Italy and to Provence, into the valley of the Vernon and along the shady banks of the Epte, over the rocks at Étretat and by the grey sea which bathes them, as over the wild cliffs of Belle-Isle and the black water lashing at their feet; one can follow him under the pines of Golfe Jouan [sic]; by the calm green seas of Antibes, into the gorges of Fresselines and across the tulip-carpeted plains of Holland – he is ever guided through these multiple aspects by a single thought: the focusing upon a stretch of ground, a bit of sea, a rock, a tree, a flower, a figure, in their own special light, in their instantaneity, that is, at the very moment when his gaze falls upon them and embraces them, harmoniously. Study these canvases chronologically, and you will see that his craft becomes progressively richer, his sensitivity unfolds, his eye discovers new fields of conquest in unknown forms and shimmerings of light; but you will never feel any hesitation, any baulking on the part of a spirit in search of itself, driven yesterday by one ideal, troubled today by another. His unswerving progress is daring, headstrong, pitiless. Yet one might almost say that he is driven by an almost unconscious force of nature, so regular and powerful is the impetus that draws him.

It has been said recently that M. Claude Monet rendered only summary aspects of nature and that "this really was not enough:" an ironic reproach

when addressed to the very man who has taken the search for expression to its furthest points, and not only in the realm of the visible, but in that of the invisible also, something no European painter had done before him; to the man who painted air and all the flow of light and the infinite reflections with which it enfolds objects and beings. If we compare a painter's colours to the sentences of a writer, and paintings to books, we may state that none ever expressed as many ideas as M. Claude Monet, or with a richer vocabulary; that, despite the straightforwardness, even occasional roughness, of his craft, no one ever analysed the character of things and the living appearance of figures more carefully, intelligently, penetratingly and closely. And the power of his art is such, its balance so admirably contrived, that all that is left of the minute analysis, of the innumerable details that make up his pictures, is a synthesis, visually astonishing and emotionally moving: a synthesis of plastic expressions and intellectual expressions, that is, the highest and most perfect form of the work of art. He is the only painter, perhaps, whose treatment of a patch of sky and a stretch of sea could ravish both eye and mind. How often, before his wild seas of Belle-Isle, his smiling seas at Bordighera, have I forgotten that they were the sum of a bit of paint on canvas! It seemed to me, so complete was the evocation, that I was lying on those strands, following the living dream, be it tender or terrible, which rises from those glassy, quaking waters, and which is lost amidst the indestructible infinite, behind the line of the horizon, merging with the sky.

No one will ever have had an existence more enviable than that of M. Claude Monet, for he has embodied art in his own flesh, and he lives only through it and for it, in a life of constant and hard work; a painful life, as for all creative people. But is pain not the reviving water in which the artist's soul is dipped and dipped again? An admirable and curious madness which is supreme wisdom since, all in all, he will have known a supreme joy such as only the elect may know. Paris, with its soul-destroying fevers, struggles and intrigues, could never suit a confirmed man of contemplation, an ardent follower of the life of things. He lives in the country in a choice landscape, in the constant company of his models: and the open air is his only studio. None is richer; and it is here, far from cliques, clamour, juries, aesthetics and vile jealousies, that he works upon the loveliest, the most substantial of the oeuvres of our time.

LILLA CABOT PERRY

THE AMERICAN MAGAZINE OF ART

"Reminiscences of Claude Monet
1889–1909"

March 1927

Lilla Cabot Perry (1848–1933), American painter. She met Monet in 1889 at Giverny.

There were two pictures on the walls of his studio which I particularly liked. They were of his step-daughter in a white dress, a green veil floating in the breeze under a sunshade, on the brow of a hill against the sky. He told me that an eminent critic called them the Ascension and the Assumption! Seeing me looking at them one day with keen admiration, he took one down off the wall and showed me a tremendous crisscross rent right through the centre of the canvas, but so skilfully mended that nothing showed on the right side. I exclaimed with horror, and asked what on earth had happened to it. With a twinkle, he told me that one afternoon he had felt thoroughly dissatisfied with his efforts and had expressed his feelings by putting his foot through the canvas. As he happened to have on *sabots*, the result was painfully evident at the time.

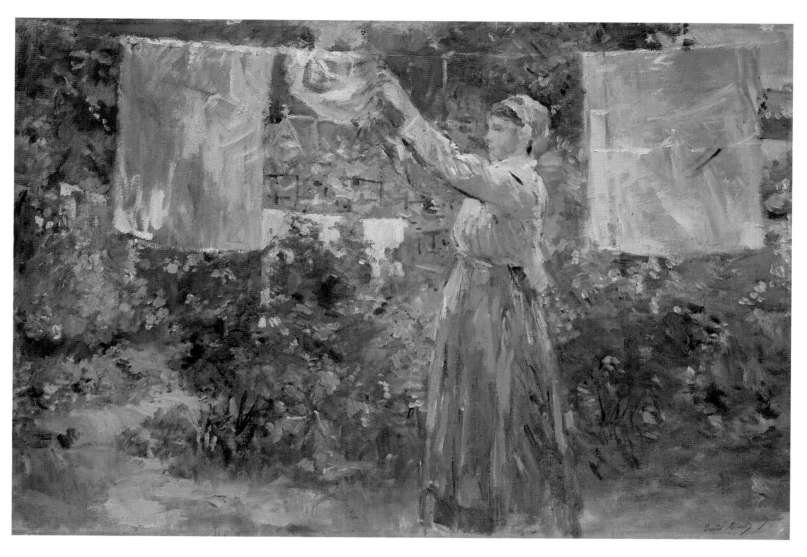

COLOURPLATE 77. Berthe Morisot. *Peasant Hanging out the Washing*. 1881. 18 × 26¼″ (46 × 67 cm).
Ny Carlsberg Glyptotek, Copenhagen.

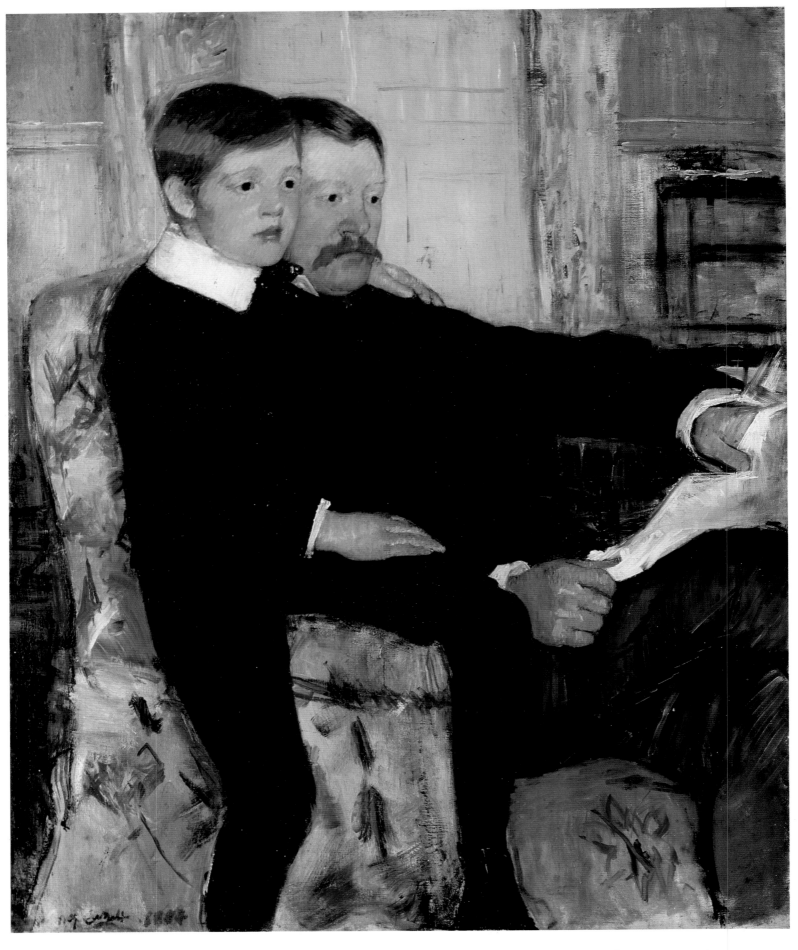

COLOURPLATE 78. Mary Cassatt. *Portrait of Alexander Cassatt and his Son.* 1884. 39 × 32″ (99 × 81.3 cm). Philadelphia Museum of Art (W. P. Wilstach Collection).

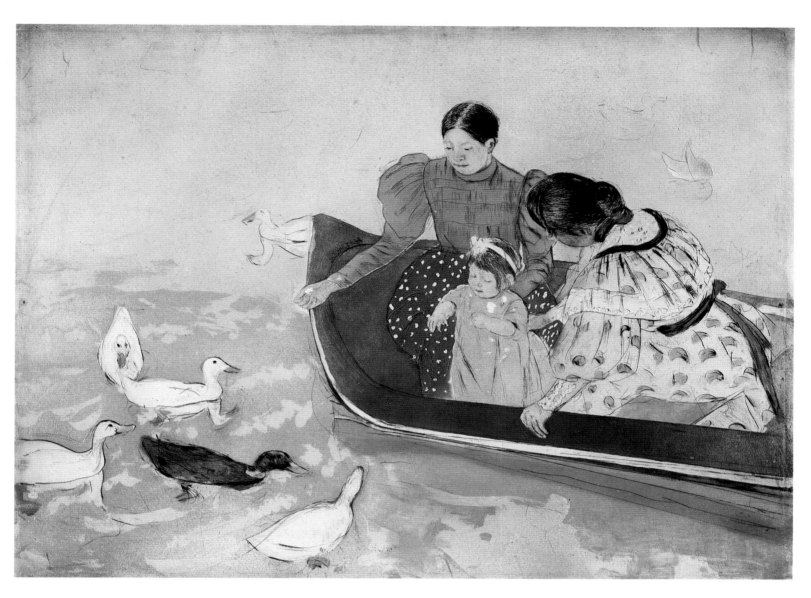

COLOURPLATE 79. Mary Cassatt. *Feeding the Ducks*. 1895. Colour etching, 11¹¹⁄₁₆ × 15¾″ (29.7 × 40 cm).
Metropolitan Museum of Art, New York (Bequest of Mrs H. O. Havemeyer, 1929;
The H. O. Havemeyer Collection).

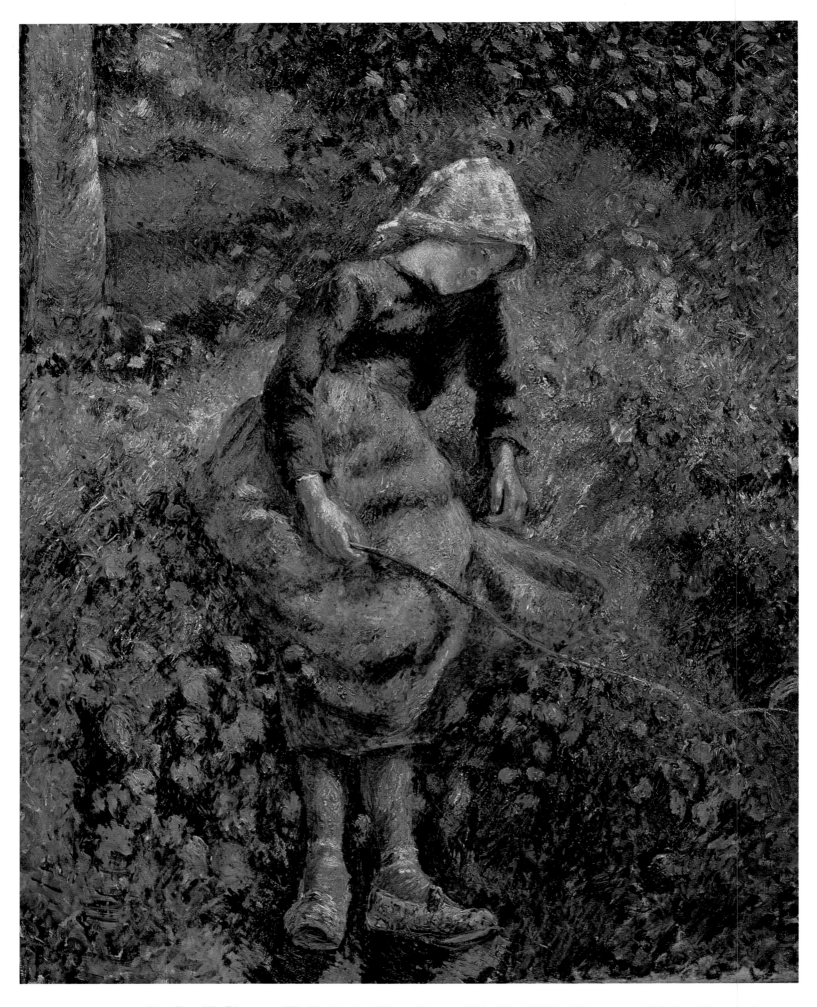

COLOURPLATE 80. Camille Pissarro. *The Shepherdess (Young Peasant Girl with a Stick)*. 1881. 32 × 25¼″ (81 × 64.7 cm).
Musée d'Orsay, Paris.

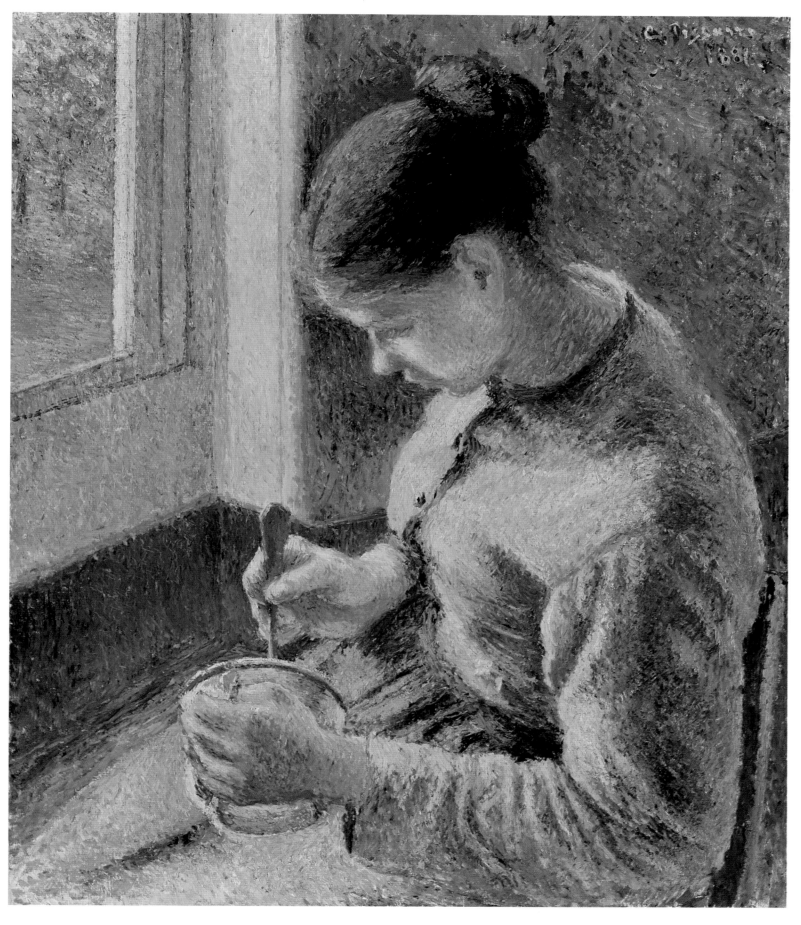

COLOURPLATE 81. Camille Pissarro. *Peasant Girl Drinking her Coffee*. 1881. 25⅛ × 21⅜″ (65.3 × 54.8 cm).
The Art Institute of Chicago (Potter Palmer Collection 1922.433).

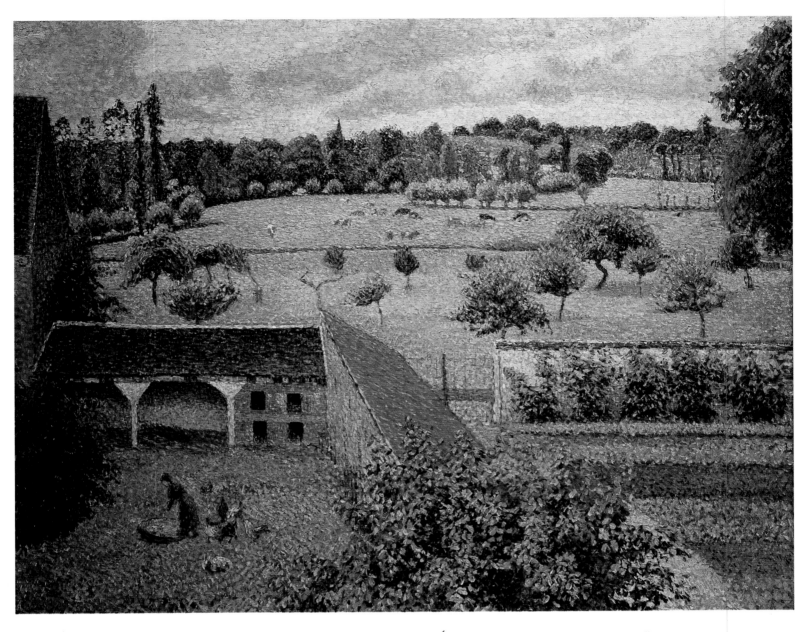

COLOURPLATE 82. Camille Pissarro. *View from my Window, Éragny-sur-Epte.* 1886–8. 25½ × 32″ (65 × 81 cm). Ashmolean Museum, Oxford.

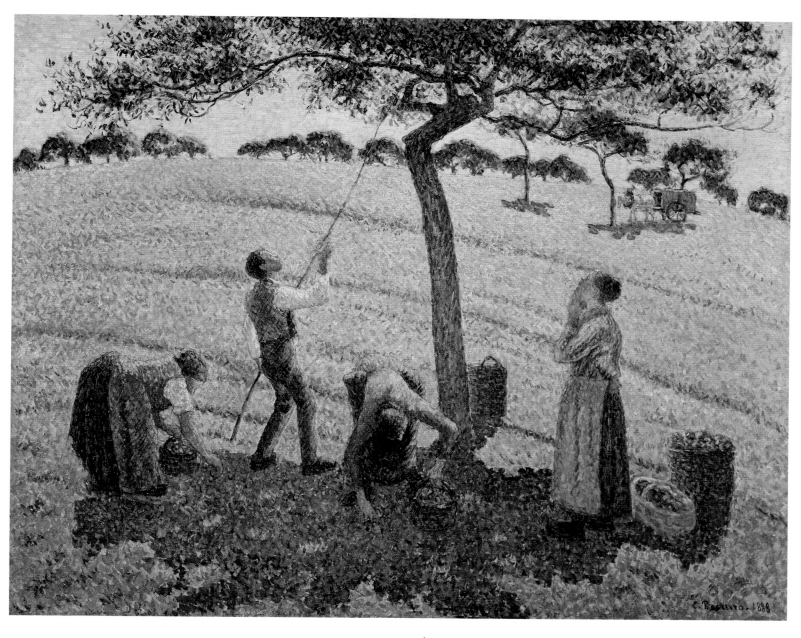

COLOURPLATE 83. Camille Pissarro. *Apple Picking at Éragny-sur-Epte*. 1888. 23 × 28½″ (60 × 73 cm).
Dallas Museum of Art, Texas (Munger Fund).

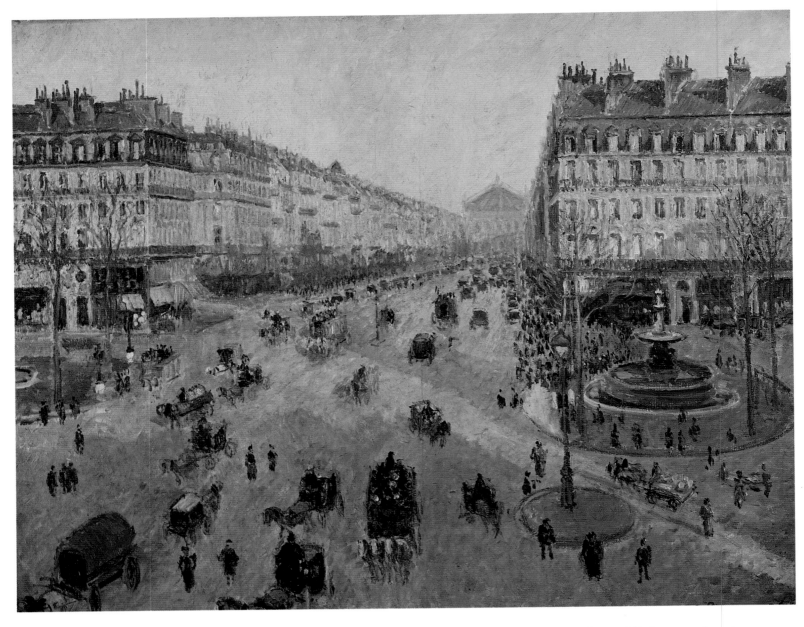

COLOURPLATE 84. Camille Pissarro. *Avenue de l'Opéra, Sun on Winter Morning.* 1898. 28¾ × 36⅛″ (73 × 91.8 cm). Musée des Beaux-Arts, Reims.

Monet was a man of his own opinions, though he always let you have yours and liked you all the better for being outspoken about them. He used to tell me that my forte was "plein air," figures out-of-doors, and once in urging me to paint more boldly he said to me: "Remember that every leaf on the tree is as important as the features of your model. I should like just for once to see you put her mouth under one eye instead of under her nose!"

"If I did that, no one would ever look at anything else in the picture!"

He laughed heartily and said:

"Vous avez peut-être raison, Madame!"

In spite of his intense nature and at times rather severe aspect, he was inexpressibly kind to many a struggling young painter. He never took any pupils, but he would have made a most inspiring master if he had been willing to teach. I remember his saying to me:

"When you go out to paint, try to forget what objects you have before you, a tree, a house, a field or whatever. Merely think here is a little square of blue, here an oblong of pink, here a streak of yellow, and paint it just as it looks to you, the exact colour and shape, until it gives your own naïve impression of the scene before you."

He said he wished he had been born blind and then had suddenly gained his sight that he could have begun to paint in this way without knowing what the objects were that he saw before him. He held that the first real look at the motif was likely to be the truest and most unprejudiced one, and said that the first painting should cover as much of the canvas as possible, no matter how roughly, so as to determine at the outset the tonality of the whole. As an illustration of this, he brought out a canvas on which he had painted only once; it was covered with strokes about an inch apart and a quarter of an inch thick, out to the very edge of the canvas. Then he took out another on which he had painted twice, the strokes were nearer together and the subject began to emerge more clearly.

Monet's philosophy of painting was to paint what you really see, not what you think you ought to see: not the object isolated as in a test tube, but the object enveloped in sunlight and atmosphere, with the blue dome of Heaven reflected in the shadows.

He said that people reproached him for not finishing his pictures more, but that he carried them as far as he could and stopped only when he found he was no longer strengthening the picture. A few years later he painted his "Island in the Seine" series. They were painted from a boat, many of them before dawn, which gave them a certain Corot-like effect, Corot having been fond of painting at that hour. As he was showing them to me, I remarked on his having carried them further than many of his pictures, whereupon he referred to this conversation and said again that he always carried them as far as he could. This was an easier subject and simpler lighting than usual, he said, therefore he had been able to carry them further. This series and the "Peupliers" series also were painted from a broad-bottomed boat fitted up with grooves to hold a number of canvases. He told me that in one of his [Poplars] the effect lasted only seven minutes, or until the sunlight left a certain leaf, when he took out the next canvas and worked on that. He always insisted on the great importance of a painter noticing when the effect changed, so as to get a true impression of a certain aspect of nature and not a composite picture, as too many paintings were, and are. He admitted that it was difficult to stop in time because one got carried away, and then added:

"J'ai cette force-là, c'est la seule force que j'ai!" And that from the greatest landscape painter in the world! I give his exact words, they show his beautiful modesty, as great as his genius.

"It is in my power to do that. It's the only power I have."

One day he referred to the many criticisms of his work, comparing it to worsted work and so forth, on account of his dragging the colour on to the canvas with the long flexible brushes he had made to order for his own use. He said he was sure some of Rembrandt's pictures had been painted even more thickly and heavily than any of his, but that time with its levelling touch had smoothed them down. In illustrating this, he took out of one of the

263

grooved boxes in which he kept his pictures a view of the Rouen Cathedral that had been kept in the box practically ever since it had been painted and put beside it one that had been hanging on the wall of his studio for some two or three years. The difference between the two was very marked, the one which had been exposed to the air and to the constant changes of temperature had so smoothed down in that short space of time that it made the other one with all its rugosities look like one of those embossed maps of Switzerland that are such a delight to children.

He said he had never really seen these Rouen Cathedral pictures until he brought them back to his studio in Giverny as he had painted them from the window of a milliner's shop opposite the cathedral. Just as he got well started on the series the milliner complained bitterly that her clients did not care to try on their hats with a man about, and that he must go elsewhere to paint, since his presence interfered with her trade. Monet was not to be daunted, he persuaded her to let him build a little enclosure shutting him off from the shop, a small cell in which he could never get more than a yard away from his canvas. I exclaimed at the difficulty of painting under such conditions, but he said that every young painter should train himself to sit near his canvas and learn how it would look at a distance, and that with time and practice this could be done. Monet had already had experience of this sort in painting on sixteen or more canvases one after the other for a few minutes at a time from his small boat on the Epte. Later on, in his water garden pictures he made good use of this same power. He had grooved boxes filled with canvases placed at various points in the garden where there was barely room for him to sit as he recorded the fleeting changes of the light on his water-lilies and arched bridges. He often said that no painter could paint more than one half hour on any outdoor effect and keep the picture true to nature, and remarked that in this respect he practised what he preached.

Once and once only I saw him paint indoors. I had come to his studio and, finding him at work, was for going away at once, but he insisted on my coming in and sitting on the studio sofa while he went on painting. He had posed his step-daughter, a beautiful young girl in her teens, in a lilac muslin dress, sitting at a small table on which she rested one of her elbows. In a vase in front of her was one life-size sunflower, and she was painted full length but not quite life size as she was a little behind the sunflower. I was struck by the fact that this indoor picture was so much lower in key, so much darker than his out-door figures or than most studio portraits and thought of this some years later when he paid the usual penalty of success by having many imitators. One day as he came back from a visit to the Champ de Mars Salon I asked him how he liked the outbreak of pallid interiors painted in melted butter and spinach tones for which he was indirectly responsible. As he sat there with his hands upon his knees I shall never forget the impetuous gesture with which he clasped his hands to his head and growled despairingly:

"Madame, des fois j'ai envie de peintre *noir!*"

My husband and I were much interested in the reminiscences of his early struggles. He told us that his people were "dans le commerce" at Havre and when, a boy in his teens, he wished to become a painter, they opposed him vigorously in the approved traditional manner. He went through some very hard times. He painted portrait heads of sea captains in one sitting for five francs a head, and also made and sold caricatures. Boudin saw one of these caricatures in a small shop, sought his acquaintance and invited him to go out painting with him. At first Monet did not appreciate this unsought privilege and went reluctantly, but after watching Boudin at work and seeing how closely his landscapes resembled nature, he was only too glad to learn all he could from the older man. There are still some early Monets extant which plainly show Boudin's influence. Even after he had painted many landscapes that were purely in his own style, the young Monet had the utmost difficulty in selling them at the modest price of fifty francs apiece.

Portrait of Suzanne Hoschedé with Sunflowers (c. *1890), W1261, Private Collection.*

"My dear woman, at times I've wanted to paint all in black!"

Faure, the singer, who was by way of being a collector, bought a landscape about this time for, I believe, the sum of one hundred francs, but brought it back a few days later and asked for his money back. He said he liked the picture himself, but his friends laughed at him so much that he could not keep it on his walls. Monet said he then and there made up his mind never to sell that picture, and he never did, though often offered large sums for it by rich Americans and others. He told me he had "la mort dans l'âme" when that picture was brought back and that he would sell the last shirt off his back before he would sell it! When we left Giverny in 1909, it was still hanging on the walls of his studio, a charming view of the Church at Vétheuil, seen across the Seine on a misty winter's day with cakes of snowy ice floating in the water. It is called *Ice floes*, and is a most exquisite and exact portrayal of nature. One can only wonder why Monsieur Faure's friends laughed at it, and laugh at them in return.

See page 195.

Monet was most appreciative of the work of his contemporaries, several of whom had been less successful than he in obtaining recognition during their lifetime. In his bedroom, a large room over the studio, he had quite a gallery of the works of such Impressionists as Renoir, Camille Pissarro, a most expressive picture of three peasant women done during his *pointilliste* period, a charming hillside with little houses on it by Cézanne, about whom Monet had many interesting things to say. There was also a delightful picture by Berthe Morisot, the one woman of his set I have heard him praise. And richly she deserved it! I met her only once, at Miss Cassatt's, she was a most beautiful white-haired old lady. She died shortly afterward and Monet and Pissarro worked like beavers hanging her posthumous exhibition at Durand-Ruel's. It was a wonderful exhibition, and I think that the picture Monet owned was bought at this show. Monet was a most devoted friend to dear old Pissarro, whom no one could help loving, and after his death he acquired another of his pictures which was kept in the studio and shown and praised to all visitors.

Monet was one of the early admirers of Japanese prints, many of which decorated his dining-room walls. The walls were painted a light yellow which showed up the prints' delicate tonality admirably and also the blue china which was the only other decoration in the room. It was a charming room with long windows opening on the garden, windows left open at mealtimes to permit countless sparrows to come in and pick up a friendly crumb. He pointed out to me one little fellow that had lost a leg and had come for three years in succession. This serious, intense man had a most beautiful tenderness and love for children, birds and flowers, and this warmth of nature showed in his wonderful, warm smile, a smile no friend of his can ever forget. His fondness for flowers amounted to a passion, and when he was not painting, much of his time was spent working in his garden. One autumn we were at Giverny I remember there was much interest in a new greenhouse. The heating must have been on a new plan, for when the plants were all in place and the heater first lit, Monet decided he must watch it throughout the night, to be sure everything went smoothly. Once his mind was made up there was little hope of moving him, so Madame Monet speedily acquiesced, and made her own plans for sharing his vigil. When the daughters heard of this there were loud outcries. What! Let their parents sit up all night with no one to look after them? Unheard of neglect! It ended by the entire family spending the night with the gloxinias. Fortunately, the heater was impeccably efficient so the adventure did not have to be repeated.

When I first knew Monet, and for some years later he used a wheelbarrow to carry about his numerous canvases. Later on he had two beautiful motor cars to take him about, but that is not the measure of his achievement, nor is it to be measured by the fact that he lived to see the French government build proper housing under his directions for his latest pictures. His real success lies in his having opened the eyes not merely of France but of the whole world to the real aspect of nature and having led them along the path of beauty and truth and light.

Paul Cézanne. *Portrait of Gustave Geffroy*.
1895. Private Collection, Paris.

CLAUDE MONET

Letters to Geffroy

1890

<div align="right">[GIVERNY] JULY 21</div>

. . . I am feeling very black, and deeply weary of painting. It is continual torture, no doubt about it! Don't expect to see anything new from me, the little I have managed to do is destroyed, scraped off, slashed. You cannot imagine how dreadful the weather has been here for the last two months. It is enough to drive you raving mad when you are trying to capture the weather, the atmosphere, the ambience.

Then there are all manner of other problems, including my wretched rheumatism. I am paying for my sessions out in the rain and snow, and what distresses me is the thought that I shall have to give up braving all weathers and working outdoors, except in good weather. How stupid life is!

Come now, that's enough complaining, come and see me as soon as you can. Warmest greetings.

... I'm grinding away, working stubbornly on a series of different effects (of haystacks), but at this time of year the sun goes down so quickly that I can't keep up with it ... I'm beginning to work so slowly that I despair, but the more I persevere, the more I see how much work it will take to succeed in expressing what I seek, namely, "instantaneity," and in particular the "envelope," the same light spreading everywhere; easy things which come in one go disgust me more than ever. I am increasingly driven by the need to express what I feel and I am determined to continue to live not too ineffectually, because it seems to me that I shall indeed make progress.

As you see, I am in good spirits. I hope you too, who are young, will have shaken off your indolence, and that you are going to produce something exciting! I would be so pleased to learn that you are coming back, and also what you are doing.

Mirbeau has become a "master gardener." He thinks of little else, apart from "Maeterlinck the Belgian," an admirable writer, apparently; I'm going to read him. Warmest greetings.

Monet shared with Mirbeau a passion for gardening and for exotic plants. Maurice Maeterlinck (1862–1949), Symbolist poet and playwright.

GUSTAVE GEFFROY

L'ART DANS LES DEUX MONDES

"Claude Monet Exhibition"

May 9, 1891

This preface, written by our associate, M. Gustave Geffroy, is taken from the catalogue of works that make up this remarkable exhibit.

The grouping together of fifteen canvases of haystacks, each representing the same subject, with a rendition of the same landscape, is an extraordinarily victorious artistic demonstration. For his part, Claude Monet has been able to substantiate the continuous appearance in new aspects, of immutable objects, the uninterrupted flood of changing and interrelated sensations, apparent in the face of a changeless spectacle. He substantiates the possibility of summing up the poetry of the universe within a circumscribed space.

For one year, the traveller has given up his travels, the hiker has forbidden hiking. He dreamed about the places he had seen and transcribed: Holland, Normandy, the south of France, Belle-Île-en-Mer, the Creuse, the villages on the Seine. He dreamed as well of places he had only visited but to which he would like to return: London, Algeria, Brittany. His fancy roamed over vast expanses and zeroed in on special areas that attracted him: Switzerland, Norway, Mont-Saint-Michel, the cathedrals of France, as lofty and beautiful as the rocks on promontories. He regretted being unable once more to capture on canvas the hurly-burly of cities, the movement of the sea, the loneliness of the sky. But he knows that an artist can spend his life in the same place without exhausting the possibilities of the constantly renewed scene around him. And right there, two steps from his tranquil house, its garden ablaze with flowers, there he stopped on the road one summer evening and looked at the field with haystacks, a humble piece of land adjoining some low cottages, surrounded by nearby hills, decked out with the unbroken procession of clouds. He stayed at the edge of this field that day and returned the next day and the day after and every day until autumn and through the whole of autumn and the beginning of winter. Had the haystacks not been removed he could have continued for an entire year recording the seasons, showing the infinite changes wrought by the weather on the eternal face of nature.

These haystacks, in that deserted field, are transitory objects on which are reflected, as on a mirror, the influences of the surroundings, atmospheric conditions, random breezes, sudden bursts of light. They are a fulcrum for light and shadow; sun and shade circle about them at a steady pace; they reflect the final warmth, the last rays; they become enveloped in mist, sprinkled with rain, frozen in snow; they are in harmony with the distance, the earth, and the sun.

They first appear during the calm of beautiful afternoons. Their edges are fringed with rosy indentations of sunlight; they look like gay little cottages set against a background of green foliage and low hills covered with rounded trees. They stand erect beneath the bright sun in a limpid atmosphere. On the same days, as evening approaches, the light on the downside of the hills has turned blue, the ground is speckled, the hay is dappled with purple, their contour is silhouetted with an incandescent line. Then there are the multicoloured, sumptuous, and melancholy festive days of autumn. When the sky is overcast, trees and houses seem remote, like phantoms. In very clear weather, blue shadows, already cool, extend along the pink earth. At the close of warm days, after a persistent sunlight that appears to depart reluctantly, leaving behind a sprinkling of golden dust on the countryside, the haystacks glow in the confusion of evening like heaps of sombre gems. Their sides split and light up, revealing garnets and sapphires, amethysts and topazes; the flames scattered in the air condense into violent fires with the gentle flames of precious stones. These red-glowing haystacks throw lengthening shadows riddled with emeralds. Later still, under an orange and red sky, darkness envelops the haystacks, which have begun to glow like hearth fires. Veils of tragedy – the red of blood, the violet of mourning – trail around them on the ground and above them in the atmosphere. Finally it is winter, with its threatening sky and the white silence of space; the snow is lit with a rosy light shot through with pure blue shadows.

With all of its faces, this same place emits expressions comparable to smiles, frowns, serious looks, mute amazement; they express force and passion, moments of intoxication. Here nature's mysterious enchantment murmurs incantations of form and colour. A refined and exalted vision takes shape; a spirit hovers amid the reflections of multiple colours, and in this matter illuminated with sparks, pointed bluish flames, scattered phosphorescent and sulphurous flashes make up the phantasmagoria of the countryside. An unquiet dream of happiness emerges in the roseate softness of day's end, rises in the coloured smoke of the atmosphere, and blends in as the sky passes over objects.

The same message conveyed by the light in the haystack landscapes is transmitted in the other canvases that Claude Monet added to this significant series exhibited here. Whether he spreads before us a meadow reddened with flowers, a field of light oats; whether he enframes a lump of earth, this massive hilltop; whether he presents these figures of airy, rhythmic girls, rising willowy in the golden sunshine and the passing clouds – he is always the incomparable painter of earth and sky, preoccupied with fleeting light conditions on the permanent background of the universe. He conveys the sensation of the ephemeral instant that comes into existence and departs and never again returns, and at the same time, he constantly evokes in each of his canvases – through the weight, the power that comes out from within the curve of the horizon, the roundness of the terrestrial globe – the course of the earth through space. He unmasks changing portraits, the faces of the landscape, the manifestations of joy and despair, of mystery and fate so that we invest everything around us with our own image. He anxiously observes the differences that occur from minute to minute, and he is the artist who sums up meteors and elements in a synthesis. He tells tales of mornings, noondays, twilights; rain, snow, cold, sunshine. He hears the voices of the evening and he makes us hear them. Pieces of the planet take shape on his canvases. He is a subtle, strong, instinctive, varied painter, and a great pantheistic poet.

GEORGES LECOMTE

LA REVUE INDÉPENDANTE

"L'Art Contemporain"

April 1892

Georges Lecomte (1867–1958), writer and friend of Pissarro and Fénéon, who shared their anarchist sympathies. He edited the Symbolist weekly La Cravache *in 1888–9. In this article Lecomte's discussion of "the decorative" reflects current thinking within the Symbolist movement about the equivalence of poetry, music and painting and about the expression of qualities of feeling and states of mind through the abstract organization of painting apart from nature.*

In our time technique is acquiring unusual importance, since a process of distribution, juxtaposing all the constituent elements of a visual impression with the aim of communion on the retina, has enabled certain painters to light up their canvases with purer, keener, clearer colours. This method makes possible a more accurate observation of the respective influence of neighbouring colours and their importance in nature, and of the action of the sun on the tonality of objects; and it has enabled artists blessed with the most sensitive vision to envelop country places and groups of houses in auras of translucent gold, softly to tint their shadows, to send the air circulating among the leaves and around people and animals, and to blur distant horizons with a subtle sunlit haze.

The division of colour in favour of lighter hues, or rather (to rise above questions of technique), this concern with luminosity, may reasonably seem characteristic of the tendencies of modern art. So we thought for a long time. But more considered examination has shaken this opinion: this concern for light seems to us not a definitive result, not a summit attained, but rather a means favourable to the realization of less debatable tendencies: by making it possible to reinstate the complex elements of the natural harmonies, it thus makes it possible better to render their decorative magnificence.

And it is this very *concern for decorative magnificence* which seems to us, all secondary considerations apart, necessarily to be the DISTINGUISHING MARK OF OUR TIME IN THE GENERAL HISTORY OF ART. Masters of all ages have probably composed their pictures in accordance with systems of lines that were interesting in themselves irrespective of any precise meaning: colours were brought together in captivating harmonies to complete the linear ornamentation. And we have no memory of a truly great work which is not simultaneously characteristic and decorative. It would thus not be in the least novel to observe this concern for ornamentation in the specific efforts of such and such a contemporary painter, since this concern is common to the great talents of all centuries. But what is peculiar to our own is the systematic and general nature of this tendency. With the decorative in view, all innovatory artists (however diverse and sometimes indecisive their means of execution may be) try to disengage the permanent characters of natural Beauty from all that is secondary and superfluous.

The unanimity of this concern also bears witness to a very elevated understanding of art, raising the contemporary schools above the discredit in which too many people unjustly hold them. It proves the abandoning of the immediate copying of nature, a greater intellectuality and a more complex plastic ideal, since a preconceived and considered system is here aiming to achieve what the masters offered, whether intentionally or unconsciously.

Furthermore, do not all great works appear clothed in special, as it were decorative beauty? The alliteration of syllables in a line of verse, the development and echoes of certain lines in a stanza which complete its thought and rhythm, the repetition of stanzas within a poem, these are the astragals and dentils which trace their arabesques over the coloured web of the words, whose graceful flow creates an overall harmony and brings together the various aspects of the basic idea. Poems in prose, if their writing is artistic, may also be mentioned here by virtue of the recurrence of ideas and phrases whose supple and highly decorative over-archings embroider

both thought and text. But above all, decorative arrangement is evident in music. Motifs are developed, abandoned for a moment and taken up again: they alternate, they interconnect; not only do they explicitly describe states of mind, they are also united to create an overall harmony. These successions of motifs in a symphony have a movement which ornaments the lyrical development of the theme.

Indeed, if the eye is able to isolate their momentary and insignificant details, are not all the great sights of nature stamped with the most majestic decorative beauty through both line and colour? The form of the horizon above the waves, the curve of a river, gradually rising ground and arborescent scrolls come together with the sumptuousness of the various hues making up the natural decor to create spectacles of immense ornamental seductiveness.

If all the composite aspects of nature seduce us by their harmonious combinations of forms and colours and if, furthermore, the great works of human art, however various the modes of expression (poetry, music, rhetoric) seem to us conceived in accordance with a decorative delineation, it is not surprising that the masters of painting and sculpture, of all schools and all ages, should have interpreted external realities in this way.

It would be easy to find examples in the cycles of the art of the past. But such historical research would be superfluous. Let us simply mention Delacroix, so close to us in his propensities and whose oeuvre contains the seeds of the innovations and interests of our contemporary schools; his most unanimously admired canvases are conceived, and their leitmotifs ordered, in accordance with arabesques of rare magnificence. All the secondary lines participate harmoniously in this central rhythm. Harmonies of colour, brought together in perfectly gauged values, complete the ornamentation by line. The tonality is one, but so is the line. It has a meaning and beauty of its own which moves us quite irrespective of its character and descriptive truth. In Delacroix's compositions any educated eye may easily isolate the primordial arabesque which is as it were the backbone of the work. Was it by pure instinct or intentionally, through conscious reflection, that Delacroix distributed his decor and his figures in this way, and arranged their gestures in accordance with this central theme? If ones assumes that he was guided by mere instinct, one should still recognize that this is an instinct found only in great painters, and that such an instinct is genius.

Concern for ornamentation through line is equally evident in Corot. But unlike Delacroix, who conceived each of his canvases according to one particular initial delineation, Corot does not renew the design of the original arabesque for each picture. His arabesque has two or three forms, more or less invariable, which are in the clear tradition of Claude Lorrain. Corot achieves his harmonies above all through accord in colour: two or three perfectly judged values, exquisitely juxtaposed, broadly synthetic, make the painting a delicious decoration independently of its real or ideal meaning.

Thus one should not be surprised that contemporary masters too, bred under this double influence, should aim at ornamental interpretations of aspects of nature.

The *plein-air* painters known by common accord as the "Impressionists" at first sought decorative beauty solely on the basis of colours rigorously revealed by light. And this exclusive concern appeared very rational, bearing in mind that these painters were interested above all in covering their canvases with the most radiant colours and with rendering the splendour of the natural scene in all its harmonic intensity. What particularly seduced them in the work of Delacroix was his knowledge of colour, the unexpectedness of certain distributions of colour to achieve a more vivid effect and more meaningful overall harmonies. In truth, their concern for decoration through colour was, at first, quite instinctive. They sought above all to render place, mood and enveloping brightness in all their truth and individuality. And it is because they were drawing nearer to authentic natural colouring that their studies acquired a decorative beauty. Only

later, when they observed the results achieved through faithfulness in the rendering of outer appearance, did they think to arrange the distribution of their colours not only with a view to the exact description of the effect, with adequate brightness, but also with a view to overall harmony.

Still they did not modify the outer aspect of things as deliberately as they do today; they did not prune away the superfluous and the momentary through a process of synthetic elimination. The natural setting was far from being the essential leitmotif, a pretext for a decorative interpretation. Quite simply, to translate the appearance of nature, they would choose one among twenty possible aspects which their painter's eye saw as both significant and harmonious. But they have not ceased working directly from nature and are still too much under her immediate influence to distort her suggestions in order to intensify the meaning and ornamental beauty of the work.

They are gradually withdrawing from reality. They continue to be scrupulously inspired by it, but they use exact data which they take from it as a starting point to build up compositions which are beautiful both for their basic character and for their decoration: they assemble lines, regulate gestures, orchestrate the lie of the land in accordance with that of the attitude of the human being who moves upon it; they compose, well away from nature. At the same time as the draughtsmanship becomes bolder, more summary and individual, the colour tends to be simplified. The sense of proportion between line and colour disappears. The painter who, along with M. Cézanne, first freed himself from too strict a communion with nature, our venerable friend M. Camille Pissarro, set gracefully outlined clouds sailing through his limpid skies, completed the curve described by the trunk of a tree by the rounded rump of an animal or the bent back of a peasant woman, linked the rise and fall of the ground to the pretty scrolls of the fronds and branches. M. Renoir, ravished by the linear beauty and relief of the human anatomy, organizes the attitudes and gestures of the body and the mobility of its physiognomy in accordance with a very ingenious decorative ensemble. Lastly, the vigorous talent of M. Claude Monet, who long restricted himself (but with what evocative power) to rendering rapid natural effects in their fleeting intensity, seems increasingly to be isolating the lasting characters of things from their complex appearances, to accentuate their decorative meaning and beauty by a more synthetic and more reflective rendering.

CLAUDE MONET

Letter to Alice Hoschedé

April 9, 1892

[ROUEN] SATURDAY 8 PM

I wish I could tell you that I am coming tomorrow, but despite my desire and indeed my need to come to Giverny, I must do all I can, given how things are, to finish my canvases. I'm being enormously lucky with the weather, but I now have such an odd way of working that I make no real progress, do what I may; all the more so since every day I discover things I hadn't seen the day before: I add some things and lose others. In a word, I'm aiming for the impossible. So I shan't come tomorrow unless I see that the weather is breaking towards evening, and even then I have to think of the morning's canvases for Monday. What complications! As you can imagine, I must really be very busy not to come. And indeed, perhaps I shall come, but it's far from certain.

CLAUDE MONET

Letters to Alice

1900–1901

My dearest, I am in a state of complete despair, and it wouldn't take much for me to drop everything on the spot and go this evening, leaving all my canvases at the paint shop until later. I don't know whether this will pass, but I'm quite on edge and deeply weary of it all. Perhaps I got out of bed the wrong side? At all events I was up at six, appalled to see the rooftops covered with snow, and I hoped that it would melt while I got dressed, but what did happen was that it became terribly foggy, so that we are in complete darkness and I had to have the lights on until half-past ten; then I thought I'd be able to work, but I've never known it so changeable, and I had to work on over fifteen canvases in turn, putting them down and then going back to them again, and it was never the thing I was looking for; then a few ill-judged brush-strokes irritated me and threw me into a rage, and I put everything into crates and now I don't even want to look out of the window, sensing that in this mood I would only make a mess of things, feeling that all my canvases are awful, as indeed they may be, even more so than I think. . . .

Photograph of Monet's studio at the time of his painting the London series. *c.*1900. Archives Durand-Ruel, Paris.

My dearest. Enforced rest for a moment and I'm making the most of it before sitting down to breakfast. The weather is very variable, but splendid. By nine o'clock I had already worked on four canvases, and although I'd got up at six, I thought I was going to have a very bad day. As always on Sundays, not a trace of fog, indeed it was appallingly clear; then the sun rose, so dazzling you couldn't look at it. The Thames was all gold. God it was beautiful, so that I set to work in a frenzy, following the sun and its reflections on the water. During that time kitchen fires were lit. Thanks to the smoke, a mist came, then clouds etc.

Half-past two. I can't tell you what a fantastic day it is. So many marvellous things, but lasting only five minutes, it's enough to drive you mad. There is definitely no country more extraordinary for a painter. . . .

Dearest, the weather is terrible here, as it was yesterday at Giverny. Torrential rain, lashing so hard against the window pane that I can hardly see anything at all. I'm taking advantage of this to write to you, happy to know that you all feel more reassured at last and hoping that you yourself will enjoy a bit of peace so that you can recover.

I'm devastated by this weather. Yesterday I was quite happy and eager and hoping to do a good day's work; the weather was superb yesterday evening but here, as I've already told you, the idea of working for two days on end is out of the question, and I will have to limit myself to making studies and rough sketches, to use in my own good time in the studio. To continue to work on a canvas is practically impossible. I transform, and often those canvases which were passable are made worse. No one will ever know the trouble it has taken me to achieve so little; and then, it must be said, working in two places is not a good idea; I sometimes break off a canvas which I could have finished in an hour, because it is time to go to the hospital. This has already happened; still, I am not disheartened. . . .

THE DUC DE TRÉVISE

LA REVUE DE L'ART ANCIEN ET MODERNE

"Pilgrimage to Giverny"

1927

The Duc de Trévise (b. 1883), collector, wrote this article after a visit to Giverny on the occasion of Monet's 80th birthday.

". . . I notice that beginning at a certain period you stopped putting figures in your landscapes; the only one I see here, standing on this hill with her white parasol, knows she's the last one; she appears to be waving good-bye to us."

"You're wrong; look, here is a portrait of the sailor in Dieppe who carried my gear. Since then, it is true, I have done only one portrait, mine, which I gave to Monsieur Clemenceau. I had done several studies of myself which I must have destroyed, except that one."

"How could you bear to give up that kind of luminous and simple composition that included people? It was so innovative."

"Well, I was driven to it for a simple reason: posing bores people."

"Master, critics in the future will put forth every possible explanation except that one; but they will be at an even greater loss to explain your famous 'series'; to make people understand that you composed entire

collections of canvases on a single motif. Philosophers will claim that it is philosophy. . . ."

"Whereas it is honesty. When I started, I was just like the others; I thought two canvases were enough – one for a 'grey' day, one for a 'sunny' day. At that time I was painting haystacks that had caught my eye; they formed a magnificent group, right near here. One day I noticed that the light had changed. I said to my daughter-in-law, 'Would you go back to the house, please, and bring me another canvas.' She brought it to me, but very soon the light had again changed. 'One more!' and, 'One more still!' And I worked on each one only until I had achieved the effect I wanted; that's all. That's not very hard to understand.

"Where it became especially difficult was on the Thames; what a succession of aspects! At the Savoy or at St Thomas's Hospital, from which I looked out, I had up to one hundred canvases under way, all on the same subject. Searching feverishly among those sketches I would choose one that was not too different from what I saw; in spite of that, I would alter it completely. When I had finished working, I would notice as I shuffled my canvases that the one I had overlooked would have suited me best, and I had it right under my hand. How stupid!"

"I beg to differ with you. You are so sensitive to the slightest change of light! Anyway, did nature really present you with an exact pictorial equivalent of a view you had already sketched? Were you really able to work five to ten times on a single canvas, painted from exactly the same vantage point?"

"Certainly – even twenty or thirty times; it was simply that some took longer than others."

PIERRE-AUGUSTE RENOIR AND CLAUDE MONET

Correspondence Concerning Renoir's Honour

August 1900

Renoir was appointed a Chevalier de la Légion d'Honneur in July 1900.

Photograph of Renoir, c. 1900.

TO CLAUDE MONET AUGUST 20

Dear Friend,

I have allowed myself to be decorated. Believe me that I'm not telling you about it in order to say that I'm right or wrong, but rather that this little ribbon should not get in the way of our long friendship. So feel free to insult me with whatever disagreeable words you choose – that's O.K. by me – but no joking about whether or not I've done something stupid. I value your friendship; for the rest, I couldn't care less.

Your friend, Renoir.

TO CLAUDE MONET AUGUST 23

Dear Friend,

I realize today, and even before, that the letter I wrote to you was silly. I felt unwell, nervous and harried. One shouldn't write at all under those conditions. I am wondering a little what it matters to you whether I'm decorated or not. You have an admirable code of conduct for yourself, whereas I can never know on one day what I shall do on the next. You ought to know me well by now, better probably than I know myself, just as I very probably know you better than you do. So please tear up that letter and don't let's talk of it again, and *vive l'amour!*

Regards to Madame Monet and all at home. *A toi*, Renoir.

GIVERNY, AUGUST 23, 1900

My dear friend,

. . . You have probably heard that Renoir is to be decorated; I am greatly saddened by this, and Renoir must know it, since the poor fellow has written to me most apologetically, and is it indeed not sad to see a man of his talent – after struggling for so long and emerging so stoutly from this struggle despite the government – accepting a decoration at the age of 60? What a poor thing man is! It would have been so nice if we had all gone unrewarded, but who knows? I may perhaps be the last to remain so, unless I become an utter dotard. But that's enough of that, you know that writing is not my strong point. I hope you and your family are well.

Kindest regards to you from your faithful Claude Monet.

CLAUDE MONET AND PAUL DURAND-RUEL

Correspondence

1905

DURAND-RUEL TO MONET PARIS, FEBRUARY 11

. . . This morning I received a letter from my son from which I feel it right to communicate to you certain passages concerning you. I quote them to you in complete confidence so that you may profit from them as you will but leaving my son and myself quite apart, to avoid recriminations. Yesterday Georges saw Rothenstein with a certain M. L. A. Harrison, a friend of Sargent's and, apparently, known to you. He was saying all manner of unpleasant things and criticized everything. Rothenstein having said that your cathedrals did not look as though they had been painted from life, but from a photograph, my son pointed out that all those canvases had been done entirely from life, and from a window overlooking the cathedral, and that all your pictures were always and entirely painted from life. Alexander [Harrison] announced firmly: "Monet paints a multitude of canvases in his studio: only recently, he asked me to send him a photograph of London and Westminster bridges so that he could finish his views of the Thames." It could be awkward if this rumour were put about in London and you would do well not to ask for photos from people like Harrison. It might be of harm to the exhibition you are planning . . .

MONET TO DURAND-RUEL GIVERNY, FEBRUARY 12

You are quite wrong to worry about what you told me, indications of nothing but bad feeling and jealousy which leave me quite cold. I know neither Mr Rothenstein nor Mr Alexander, but only Mr Harrison, whom Sargent commissioned to do a small photo of Parliament for my benefit which I was never able to use. But it is hardly of any significance, and whether my *Cathedrals* and my *London* paintings and other canvases are done from life or not is none of anyone's business and is quite unimportant. I know so many artists who paint from life and produce nothing but terrible work. That's what your son should tell these gentlemen. It's the result that counts.

Durand-Ruel's letter to Monet reports a conversation between his son Georges, also a dealer, William Rothenstein, a British artist, and Alexander Harrison, an American artist to whom Monet had been introduced by John Singer Sargent.

Rouen Cathedral.

DENIS ROUART

THE CORRESPONDENCE OF BERTHE MORISOT

1890–93

As soon as she was settled Berthe wrote to Mallarmé:

"... I have worked a great deal to prepare a room for you; nonetheless, my dear friend, you are forewarned. Wednesday I shall go to Miss Cassatt to see with her those marvellous Japanese prints at the Beaux-Arts. At five o'clock I shall be at the Gare Saint-Lazare, in the waiting room of the Mantes line. If you wish to join me there we shall travel together; you would spend Thursday with us and Friday morning you would take another express that will bring you to Paris at nine o'clock, that is to say, in time for the college, if you have classes. All this, of course, if the fresh air of the country tempts you, if the weather is good; but you would give us great pleasure. The landscape will be less pretty later on . . . No need to answer me if you come."

Mallarmé answered, nevertheless:

"Dear friend, yes; and although silence, according to your kind letter, is an affirmative answer, I feel I should write the monosyllable. And so, a little after five o'clock, Gare d'Amsterdam, near your ticket window; but – this is my only but – I must return Thursday night for I have classes Friday at dawn."

At Mézy Berthe painted a great deal. She set up a studio in the barn, in which she posed a boy from the village as St John, naked except for a sheepskin, to whom Mallarmé later alluded in a letter. She also used as a model a girl of a rather uncouth aspect, whom she had met in the village carrying a basin of milk. Berthe's first painting of her was the canvas that Claude Monet bought in 1892 at an exhibition of her works at Joyant's. Berthe planned to visit Monet with Mallarmé, whose letter referring to this project was addressed as follows:

> *Sans t'endormir dans l'herbe verte*
> *Naïf distributeur, mets-y*
> *Du tien: cours chez Mme Berthe*
> *Manet, par Meulan, à Mézy.*

[Take no nap in the fields, naïve postman. On your toes! Run to Madame Berthe Manet at Mézy, near Meulan.]

"My dear friends, here it comes, this Fourteenth of July, a bit clouded over, and I keep looking in your direction and thinking of you. As for those gentlemen, your neighbours, there was an intrigue against them at Versailles. If everything goes well I shall arrive tomorrow evening, travelling alone, alas, by the same train as last time. Are we still planning to go to see Monet on Monday? Should I write to him?"

Those "gentlemen of the neighbourhood" were pigs in a pig farm belonging to the mayor of Mézy. The Manets had applied to the authorities in an effort to get rid of them, and Mallarmé served as their intermediary.

Berthe replied:

"Thank you, dear friend, for being faithful despite the rain . . . We have not seen Monet again, nor received a letter from him; this may mean that he is expecting us without fail or that he is engrossed in work; you shall decide which it is, and do whatever you think is right; we shall follow your example . . . The naïve postman was quite dumbfounded and I quite enchanted."

Finally Monet's answer came, dated July 11. He wrote:

"We are very much at fault, but I hope this will not prevent you from carrying out your promise on July 14; or better on July 13 if it is convenient

to you. We shall be very happy to see you with your husband and your friend Mallarmé, and I hope you will raise my spirits a little, for I am in a state of complete discouragement. This fiendish painting has me on the rack, and I cannot do a thing. All I accomplish is to scrape out and ruin my canvases. I realize that having gone a long time without doing anything I should have expected this, but what I am doing is beneath anything.

"You must be cursing the weather, just as we are. What a summer! Here we are in a state of distress; my pretty models have been sick. In short, we had trouble upon trouble, which has prevented us from paying you a visit."

On Sunday, July 13 the little party left Mézy for Mantes in a carriole, and took the train to Vernon. They spent the day and dined at Giverny. Monet, to compensate Mallarmé for not having made an illustration for him, offered him a canvas. Mallarmé did not dare choose the painting he preferred, but finally took it, urged by Berthe Morisot – it was a landscape of Giverny showing the smoke of a train. Mallarmé returned radiant, his painting on his knees. "One thing that makes me happy," he said in the carriole, "is to be living in the same age as Monet."

The illustration was to have been for a collection of his prose poems which Mallarmé had hoped to bring out in 1887 and which was to have included drawings by Renoir, Degas, and Berthe Morisot as well as Monet. The collection, illustrated only by Renoir, was finally published in 1891 under the title Pages.

* * *

They stayed at Valvins from 24 August to 4 September. Mallarmé, who did not like walking, occasionally let himself be persuaded to take walks in the woods, during which he spoke to Berthe Morisot about his work, and about his project for a book that was to be "The Book," and that one could open at any page and from any side. This project was never carried out. Berthe made watercolours in the woods or from the window of the inn, from which she also painted a little study in oil of Mallarmé's boat.

Back in Paris she wrote to Mallarmé:

"1.04 is the correct time; at least I was told so at the station, and I was triumphant; but we did not leave at that time, nor even at 1.15, and the express trains passed by without stopping. After all, I think you were right, or rather that I don't understand a thing.

"It was a great disappointment to be back in Paris to which one becomes attached in the long run, by force of habit, whereas even the shortest stay in Valvins makes you hate to leave it.

Berthe Morisot. *Julie Manet with her Greyhound Laertes.* 1893. 28¾ × 31½" (73 × 80 cm). Musée Marmottan, Paris.

"Laertes was so tired last night that he crept into my suitcase and made himself a nest among the frills of your neighbour whom I admired so much. And this morning we feel so exiled not to be there with all of you that it is impossible to resist sending you a greeting and a little gossip, intended more for the ladies than for the poet."

Mallarmé wrote in reply:

"Everything has changed, even the wind, since your departure; the boat lies sleeping under the threat of rain. I am working without knowing too well on what, and am writing this on the side. Your stay here brought us a great pleasure – the feeling that I was taking walks with a dear friend in our neighbourhood; and only now do I realize how charming they were; while you were here everything seemed so natural.

"I know that you are dealing courageously with your troubles; how is Julie's finger (I am being asked about it), and when will you leave for the Limousin with your timetable? My wife has a little cough, Geneviève remembers a chatty and very special Julie in the woods; as for myself, I thought that she had a round and rosy face when she left.

"To look at the painting of the little sailboat is very satisfying.

"Thank you for your note. My best to both of you. Also to good Laertes, as Hamlet called him."

Geneviève was Mallarmé's daughter and Julie (Manet) the daughter of Berthe Morisot.

TÉODOR DE WYZEWA

PEINTRES DE JADIS ET D'AUJOURD'HUI

"Mme Berthe Morisot"

March 1891

Téodor de Wyzewa (1862–1917), a Polish-born writer on art, belonged to the Symbolist circle which included Mallarmé, Laforgue and Fénéon. He was co-founder with Édouard Dujardin of La Revue Wagnérienne *and contributed to a wide range of avant-garde periodicals.*

There is no lack of women painters in the history of art; what is lacking, rather, is women's painting, a painting expressing that particular aspect which things must offer to feminine eyes and to the feminine spirit.

Yet some women, in days gone by, tried to do just that. The pastels of Rosalba Carriera and the portraits of Mme Vigée-Lebrun – neither of which, it should be added, have any of the qualities of the superior work of art – are nonetheless redolent with a special charm, strong enough to prevent them from vanishing into the crowd of the nonentities of painting. This is because, despite everything, they translate a vision of the world which we feel to be quite distinct from our own, lighter, gentler, more elusive, such, more or less, as it must exist in the eyes of a woman.

Rosalba Carriera (1675–1757), Élisabeth-Louise Vigée-Lebrun (1755–1842).

Unfortunately, neither Rosalba Carriera nor Mme Vigée-Lebrun has been able to translate this artistic vision with any degree of art; but at least they may take credit for respecting it and not holding it unworthy of being translated. Most women painters, on the contrary, seem at present to feel only contempt for their women's vision: they do all they can to efface it and, if their works still look as if they were painted by women, one might nonetheless say that it is their husbands who have taken it upon themselves to see to their subjects. Some have even managed very successfully to assimilate our ways of seeing things; they are wondrously well possessed of all the secrets of draughtsmanship and colour; and one would be tempted to consider them as artists, were it not for the awkward impression of artifice and falsehood one always feels in the presence of their work. Something rings false, do as they may. One feels that it is not natural to them to see the world as they paint it, and that they have lent their very skilful hands to the service of the eyes of others. Is it not a similar impression to that we feel

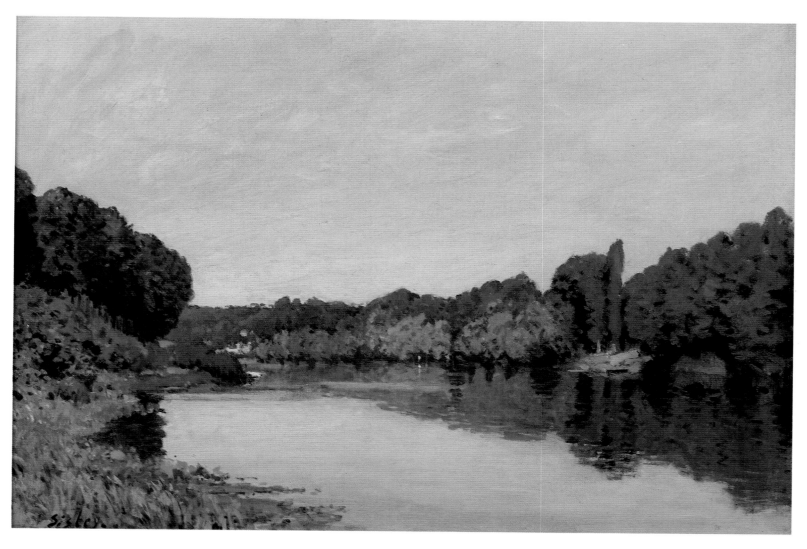

COLOURPLATE 85. Alfred Sisley. *The Seine at Bougival*. 1873. 18 × 25¾″ (46 × 65.3 cm).
Musée d'Orsay, Paris.

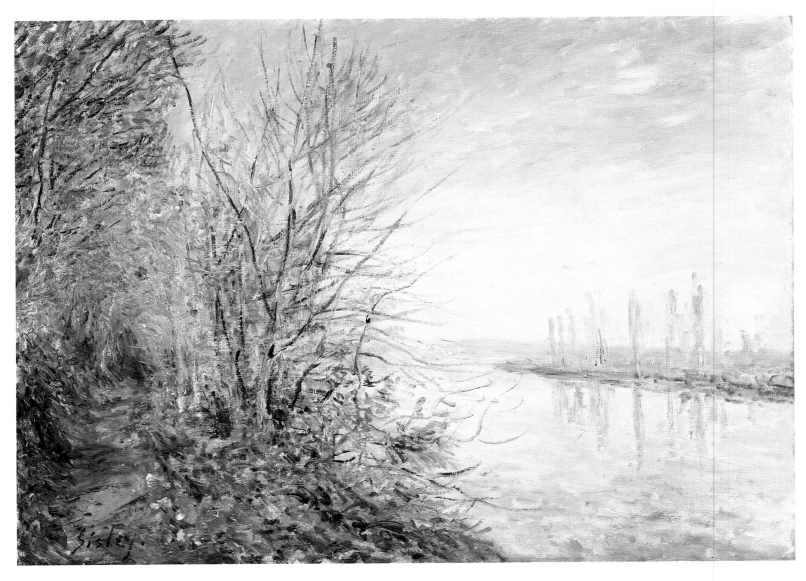

COLOURPLATE 86. Alfred Sisley. *The Chemin de By through Woods at Roches-Courtaut, St Martin's Summer*. 1880.
23½ × 32″ (60 × 81 cm).
Museum of Fine Arts, Montreal (John W. Tempest Bequest).

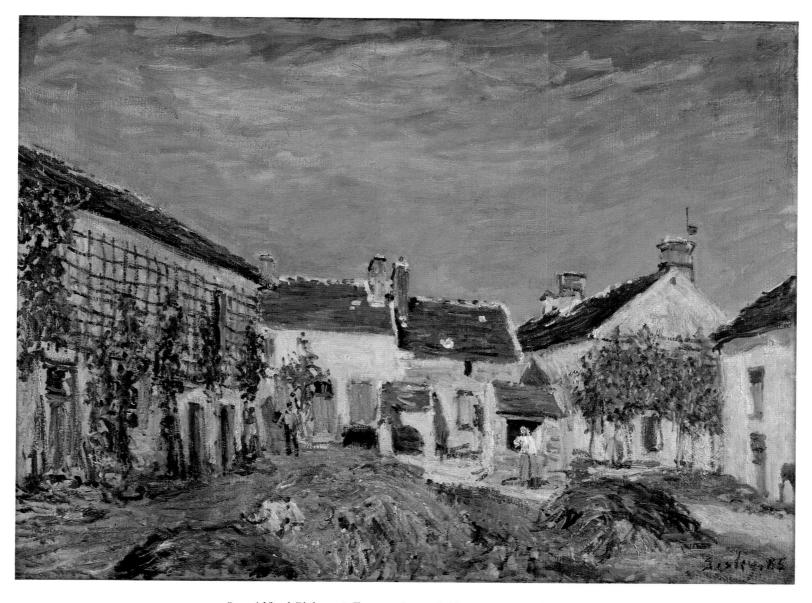

COLOURPLATE 87. Alfred Sisley. *A Farmyard near Sablons*. 1885. 21¼ × 28¾″ (54 × 73 cm). Aberdeen Art Gallery and Museum, Scotland.

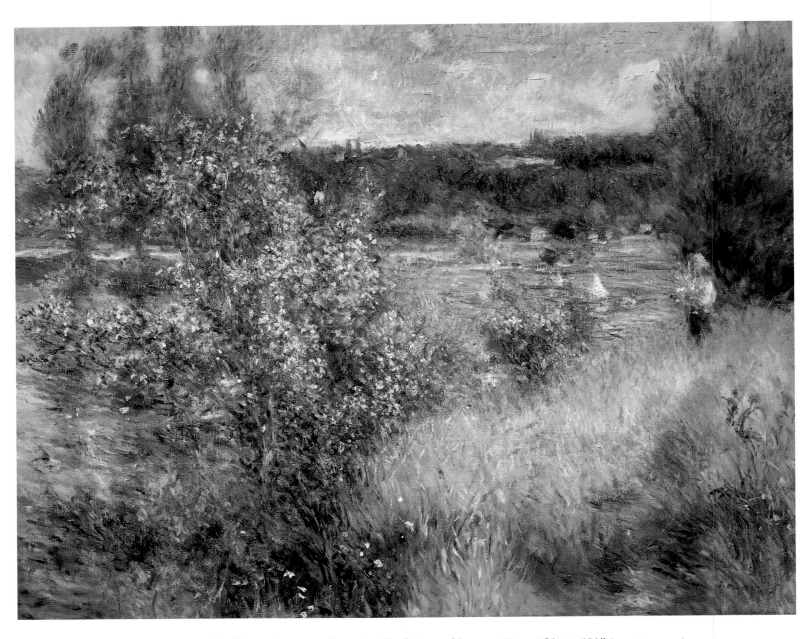

COLOURPLATE 88. Pierre-Auguste Renoir. *The Seine at Chatou*. 1881. 28⅞ × 36⅜″ (74 × 93 cm). Museum of Fine Arts, Boston (Gift of Arthur Brewster Emmons).

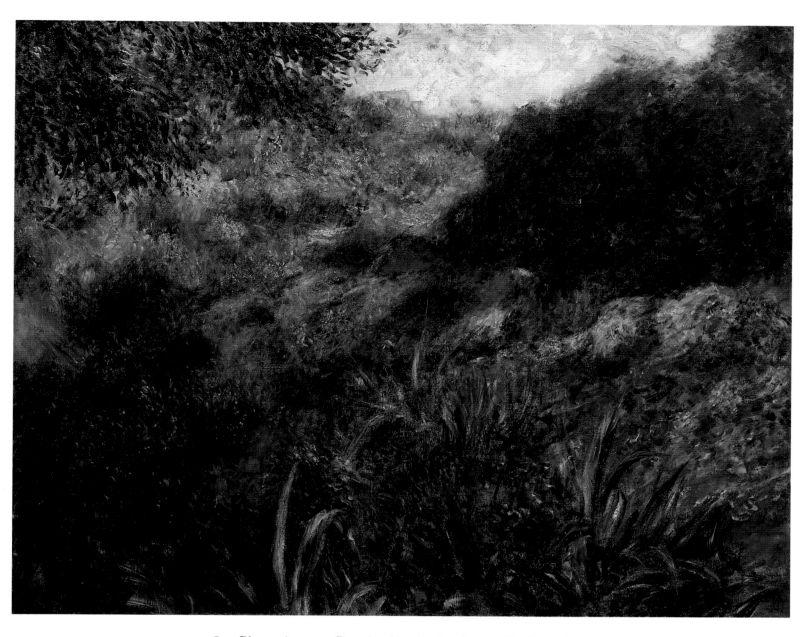

COLOURPLATE 89. Pierre-Auguste Renoir. *Algerian Landscape: The Ravin de la Femme Sauvage.*
1881. 22 × 32″ (56 × 81 cm).
Musée d'Orsay, Paris.

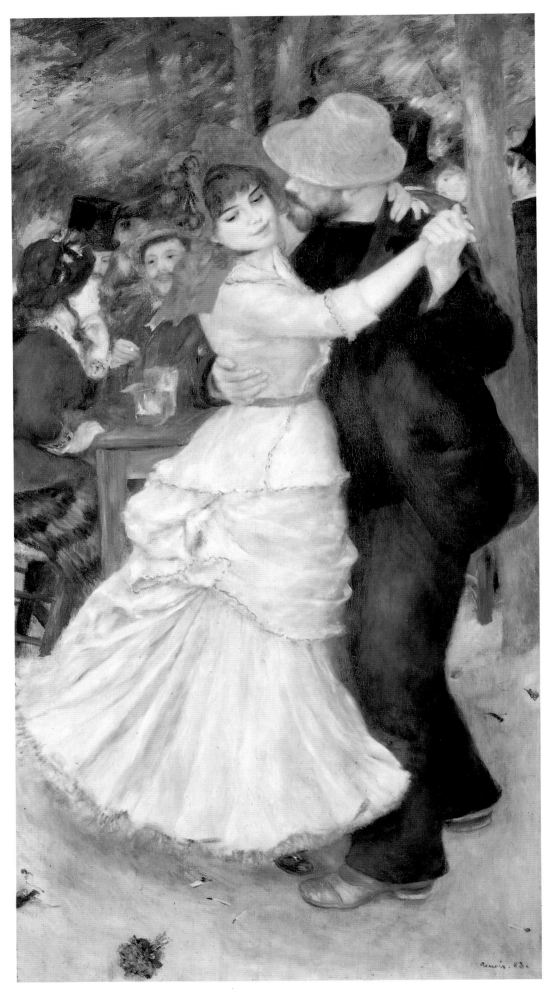

COLOURPLATE 90. Pierre-Auguste Renoir. *Dance at Bougival*. 1883. 71⅝ × 38⅝″ (181.8 × 98.1 cm).
Museum of Fine Arts, Boston (Picture Fund).

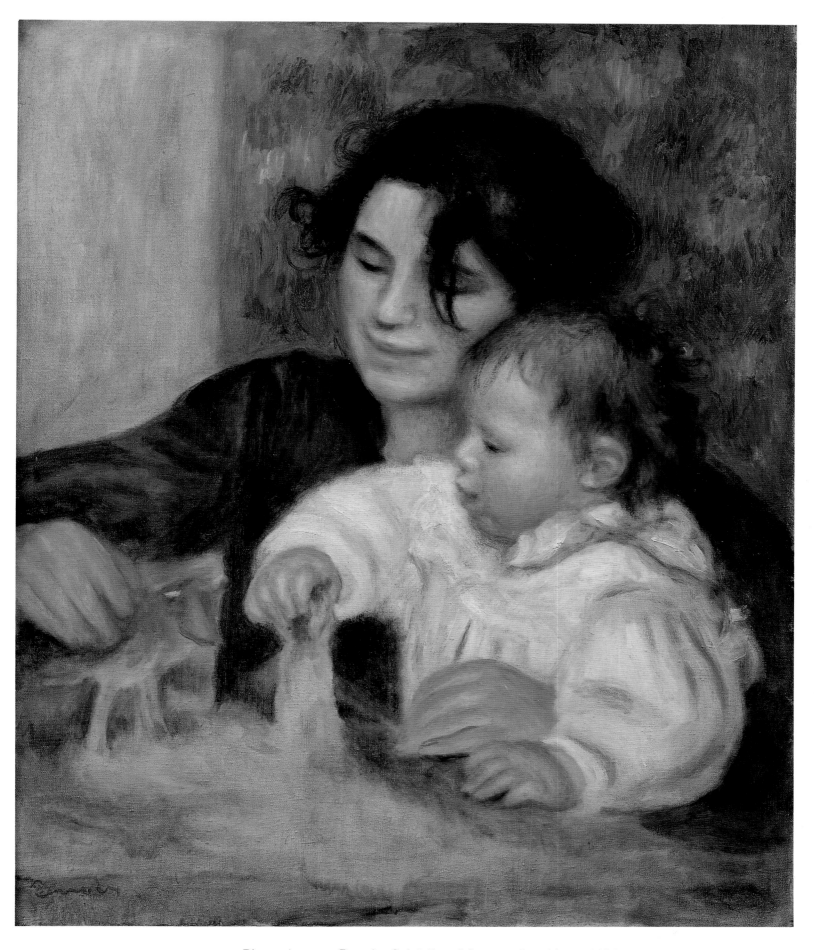

COLOURPLATE 91. Pierre-Auguste Renoir. *Gabrielle and Jean*. 1906. 25½ × 21¼" (65 × 54 cm).
Musée de l'Orangerie, Paris (Collection Jean Walter and Paul Guillaume).

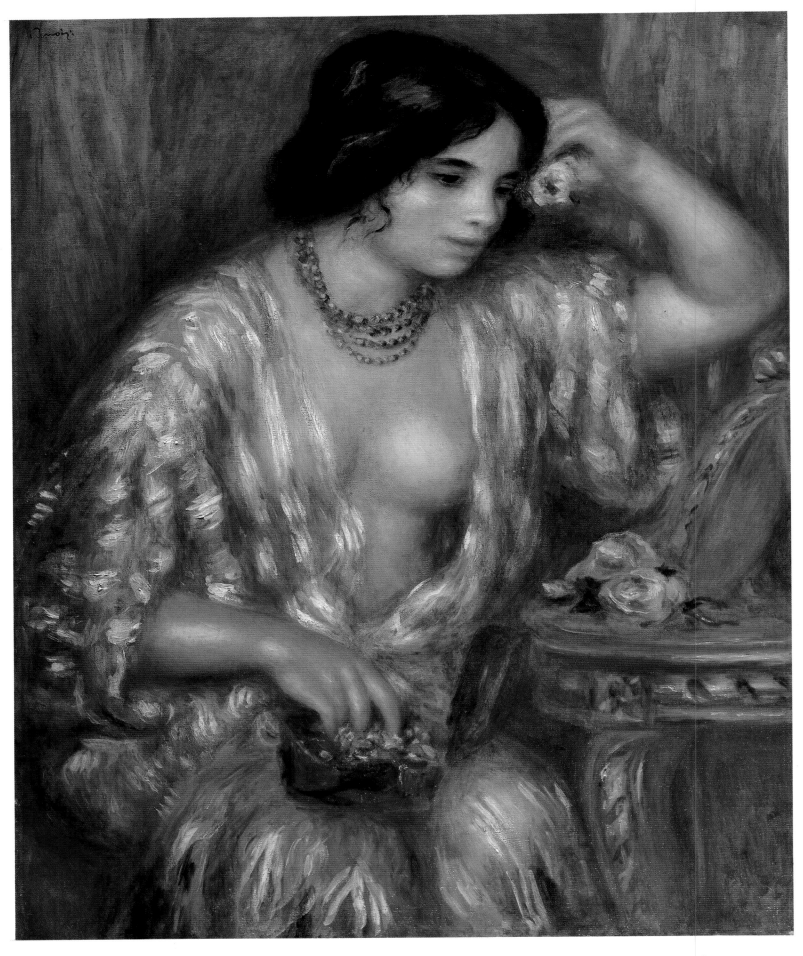

COLOURPLATE 92. Pierre-Auguste Renoir. *Gabrielle with Jewellery*. *c*.1910. 32 × 25½″ (81.3 × 64.8 cm).
Private Collection.

before those works, perfect though they be, of contemporary Japanese painters, who have felt that they should accommodate their vision to the laws of our own Western perspective, which are so new to them?

Mme Berthe Morisot's chief excellence is having agreed to look at things with her own eyes. Each of her works offers us the same indefinable charm as we are offered, with their faults, by the portraits of Rosalba Carriera and Mme Vigée-Lebrun. One discovers in them a world which is not the one we see; and, like the portraits by Rosalba and those by Mme Vigée-Lebrun, on first sight the works of Mme Berthe Morisot reveal an original and very feminine vision.

But Mme Morisot has by no means been satisfied with seeing the things she painted with a woman's eyes: she has also successfully adapted the most perfect and fitting means to render her personal vision; so that she has created a very consistent and very complete art, with all the requisite qualities thereof, and absolutely exquisite into the bargain. For the works of Mme Morisot are, in their own particular genre, perfection itself; nothing jars; everything is there that could clothe a woman's delicate sensations in the highest artistic value. Contemporary painting has one or two masters whose art is of a higher beauty, or further extends the expression of life; but, even if it is more modest, Mme Morisot's art alone realizes its ideal with a harmonious completeness.

Photograph of Morisot's studio, c.1890. Collection Sirot-Angel, Paris.

The excellence of this art comes, I think, partly from the fortunate chance which once gave Mme Morisot Édouard Manet as her teacher, and thus linked her from the start to the Impressionist movement. I even think, in truth, that the Impressionist method was especially predestined to form Mme Morisot's talent; it was, in essence, the method best fitted to bring forth at last the advent of a feminine painting.

Everything in Impressionism seemed to tend towards that end. The exclusive use of light tints accorded with the lightness, the fresh brightness and slightly facile elegance which make up the essential traits of a woman's vision. And, even more so than the technique, the principle of Impressionism itself was to help to make it a feminine mode. Woman, in fact, does not characteristically concern herself with the intimate relations between things, but perceives the universe as a graceful, shifting and infinitely shaded surface, allowing a delightful parade of transient impressions to proceed before her, as in a transformation scene. Only a woman could truly practise the Impressionist system in all its rigour; only a woman could restrict her efforts to translating her impressions, these customarily being sufficient unto themselves, and redeeming their time-honoured superficiality by an incomparable charm of softness and grace.

Moreover, of all the painters of the Impressionist school, Mme Morisot is the only one who, at the start, remained within its principles without exaggeration of any sort; she is the only one who remained faithful to them until the end. It is fascinating to compare her early paintings with those upon which her teacher Manet was working at the same time, for he was certainly the man least made for the practice of Impressionism, being the most similar of his contemporaries to the old masters, the most vigorous, the most serious-minded, the most smitten with the intimate beauty of the flesh, a beauty one must long desire before it finally agrees to reveal itself. Beneath the superficially sketchy character of Manet's paintings one may sense the dogged labour, the unceasing struggle with nature, and any number of noble artistic qualities which one would dearly like to see unhindered by the impossible desire to set down the impression at a stroke. With Mme Morisot, on the other hand, it is the impression which blossoms, in easy perfection, transformed by the surest and most delicate means; but an impression so original, so alive, so weightless, so fresh and so natural, that truly one does not dream of asking anything else from it; an impression whose charm is felt more intensely as the days go by, like those scents which, as they become absorbed, give off a stronger and more subtle smell.

After all that, I do not think (apart from this happy respect for the impression, and also all the traditions of the finest artistic dignity) that Mme Morisot learned anything at Manet's school. If she had a master, it would have been rather from among the painters of the eighteenth century, the only age from which anything of elegance and delicacy of feminine sensation entered into art. Lancret, Fragonard and Latour must always have attracted her, but above all François Boucher, of whose luminous, finely modelled flesh, velvety draughtsmanship and sense of discreet dalliance I see touches in her work.

But, in truth, Mme Morisot has had no masters other than her eyes; she was aware that she saw things in quite her own way, and it is to express just this way of seeing that she has always aimed.

For her, the world is an elegant spectacle where ugliness and bitterness have no place. A harmony of bright nuances and light, mobile forms – that is the sole object of her paintings, her pastels and her drawings. The figures look like shades, but such graceful, intimate-looking shades that no one thinks of deploring their lack of depth and life. And indeed the only life lacking to Mme Morisot's figures is material and physical life; for few figures have a more complete soul – and always such an appealing one, at once artless and subtle, smiling and melancholy, the soul of a little princess on the outskirts of Paris. Mme Morisot ranks foremost among the musicians of painting of our day: her works suggest an indefinitely varied range of feminine feelings, and no one can rival her in adapting an appropriate ensemble of lines and colours to the expression of a figure.

These precious qualities have been in evidence since her earliest works: in the first Impressionist exhibitions in which she took part, it was she who sounded the most agreeable note, already appearing a fully-fledged artist. Her companions of the time have since become more famous than she; but none of them, perhaps, has exerted a keener influence outside the group. All those painters who today fill our two Salons with *peintures claires* drew their inspiration not from Manet, nor from M. Monet, nor from M. Renoir, but from Mme Morisot. Her charm struck them as simpler, more natural, less elusive. And they have done what they could to appropriate it for themselves, without grasping that it was the subtle product of a vision of which their eyes were not capable.

Nicolas Lancret (1690–1743), Jean Honoré Fragonard (1732–1806), Georges de la Tour (1593–1652), François Boucher (1703–70).

JULES HURET

ENQUÊTE SUR L'ÉVOLUTION LITTÉRAIRE

"Symbolists and Decadents"

1891

M. STÉPHANE MALLARMÉ

One of the most widely loved *littérateurs* in the world of letters . . . Average height, pointed greying beard, long straight nose; large pointed satyr's ears, extraordinarily bright wide eyes, an expression of unusual shrewdness tempered by an air of great kindliness. He gestures perpetually as he speaks – variously, gracefully, precisely, eloquently; he lingers slightly over the ends of words, his voice softening a little; he exerts a powerful charm, and one also senses in him soaring above all a perennial pride, as of a god or visionary before whom – once one has understood this – one must immediately make an inward gesture of obeisance.

In making the distinction between the direct naming of an object and its gradual apprehension by means of nuance and suggestion, Mallarmé is indicating qualities that were seen to belong to both Symbolism in literature and Symbolism in painting. The decade of the 1890s was the period of closest association between Monet and Mallarmé. Writers within Mallarmé's circle, for example Octave Mirbeau and Georges Lecomte, described Monet's painting in terms very similar to those used by Mallarmé to refer to poetry in this interview.

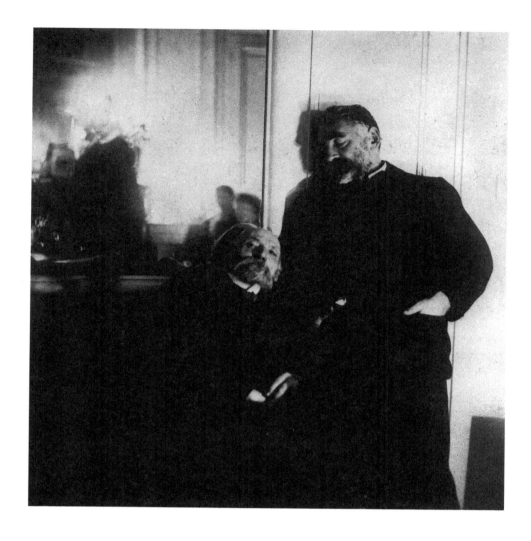

Renoir and Mallarmé. Photograph by
Degas. In the mirror, Degas and Mme
and Mlle Mallarmé in the Gobillards'
salon. *c.* 1890. 7 × 5⅛″ (17.8 × 12.9 cm).
Metropolitan Museum of Art, New York
(Gift of Mrs Henry T. Curtiss, 1965).

We are now witnessing a truly extraordinary phenomenon, he said to me,
one unique in the history of poetry: each poet is withdrawing to his own
corner, to play whatever tunes he likes on his own special flute; for the first
time ever, poets are no longer singing in unison. Hitherto, do you not think,
the poet's accompaniment was necessarily the great organs of official metre.
But now these have been overplayed, and people have become tired of them.

* * *

This new kind of verse has arisen above all because people are weary of
official verse; even its supporters share this weariness. Is it not an aberration
to open up any book of poetry whatsoever and to be sure to find uniform and
conventional rhythms throughout, just where, in fact, we are allegedly
being drawn by the essential variety of human feelings! Where is the
inspiration, where is the unexpected? and what lassitude! Official verse
should serve only in moments of spiritual crisis; today's poets quite
understand this; they have skirted around it with a very delicate feeling of
caution, or approached it with singular timidity, one might even say alarm,
and instead of making it their principle and starting-point, they have
suddenly caused it to rise up as the climax of the poem or sentence!

Furthermore, the same transformation has occurred in music: the firmly
drawn melodies of former times have been succeeded by an infinity of
broken melodies which enrich the fabric without one feeling the cadence so
strongly marked.

Is this indeed the root of the split? I asked.

Oh yes. The Parnassians, lovers of very strict verse, of verse which is
intrinsically beautiful, did not see that this new kind was just an effort that
was completing their own; an effort which at the same time had the
advantage of creating a sort of interregnum for "great" verse, which was

*The Parnassians were a group of poets,
including Théophile Gautier (1811–72),
Théodore de Banville (1823–91) and Leconte
de Lisle (1818–94), successors to the
Romantics, who appeared regularly in an
anthology of contemporary poetry published
between 1866 and 1876, Le Parnasse
Contemporain.*

exhausted and begging for mercy. Furthermore people should know that the latest arrivals are not attempting to do away with "great" verse; they aim to make the poem more airy, to create a sort of fluidity, of mobility between the endless flow of verses – something which hitherto had been somewhat lacking. In an orchestra you may suddenly hear a very lovely outburst from the brass; but you know quite well that if that were the whole piece, you would soon weary of it. The young are sparing with these high points, producing them only when they may have the greatest effect: it is thus that the Alexandrine, which no one actually invented but which sprang up spontaneously from the instrument of language, instead of remaining obsessional and fixed as at present, will be freer, more unexpected from now on; it will acquire a grandeur through association only with the solemn impulses of the soul. And in the volume of poetry of the future, the great classical verse will be punctuated by an infinitude of motifs borrowed from the individual ear.

The Alexandrine is the 12-syllable line of classical French verse.

* * *

You have talked of form, I said to M. Stéphane Mallarmé. What of content?

I think, he replied, that, as to content, the young are nearer the poetic ideal than the Parnassians, who still treat their subjects in the fashion of the old philosophers and orators, presenting objects directly. Whereas I think that poetry is purely a matter of allusion. It is contemplation of the object, the image released by the reveries it arouses; the Parnassians take hold of the thing in its entirety and proclaim it; thus they lack mystery; they deny the imagination the delicious joy of believing that it is creating. To *name* an object is to suppress three-quarters of the enjoyment of the poem, which lies in the delight of gradually guessing; to *suggest* it, that is the dream. It is the perfect use of that mystery that constitutes the symbol: to evoke an object little by little to show a state of mind or, inversely, to choose an object and abstract a state of mind from it, through a series of decipherings.

STÉPHANE MALLARMÉ
L'ART ET LA MODE
"The White Water-Lily"
August 22, 1885

Berthe Morisot drew illustrations for The White Water-Lily, *which was to have been published in the collection of Mallarmé's prose poems in 1887 (see page 277).*

For the relation of the poem to Monet and the theme of absence see Christopher Yetton: The Pool of Narcissus *(page 372).*

James Abbott McNeill Whistler. *Portrait of Mallarmé.* 1894. Lithograph, 3¾ × 2¾" (9.5 × 6.9 cm). Hunterian Art Gallery, Glasgow (Birnie Philip Bequest).

I had been rowing for a long time with a sweeping, rhythmical, drowsy stroke, my eyes within me fastened upon my utter forgetfulness of motion, while the laughter of the hour flowed round about. Immobility dozed everywhere so quietly that, when I was suddenly brushed by a dull sound which my boat half ran into, I could tell that I had stopped only by the quiet glittering of initials on the lifted oars. Then I was recalled to my place in the world of reality.

What was happening? Where was I?

To see to the bottom of my adventure I had to go back in memory to my early departure, in that flaming July, through the rapid opening and sleeping vegetation of an ever narrow and absent-minded stream, my search for water flowers, and my intention of reconnoitring an estate belonging to the friend of a friend of mine, to whom I would pay my respects as best I could. No ribbon of grass had held me near any special landscape; all were left behind, along with their reflections in the water, by the same impartial stroke of my oars; and I had just now run aground on a tuft of reeds, the mysterious end of my travels, in the middle of the river. There, the river broadens out into a watery thicket and quietly displays the elegance of a pool, rippling like the hesitation of a spring before it gushes forth.

Upon closer examination, I discovered that this tuft of green tapering off above the stream concealed the single arch of a bridge which was extended on land by a hedge on either side surrounding a series of lawns. Then it dawned on me: this was simply the estate belonging to the unknown lady to whom I had come to pay my respects.

It was an attractive place for this time of year, I thought, and I could only sympathize with anyone who had chosen a retreat so watery and impenetrable. Doubtless she had made of this crystal surface an inner mirror to protect herself from the brilliant indiscretion of the afternoons. Now, I imagined, she must be approaching it; the silvery mist chilling the willow trees has just become her limpid glance, which is familiar with every leaf.

I conjured her up in her perfection and her purity.

Bending forward with an alertness prompted by my curiosity, and immersed in the spacious silence of the worlds still uncreated by my unknown lady, I smiled at the thought of the bondage she might lead me into. This was well symbolized by the strap which fastens the rower's shoe to the bottom of the boat; for we are always at one with the instrument of our magic spells.

"Probably just somebody . . ." I was about to say. Then, suddenly, the tiniest sound made me wonder whether the dweller on this bank was hovering about me – perhaps by the river! – while I lingered there.

The walking stopped. Why?

Oh, subtle secret of feet as they come and go and lead my imagination on, and bend it to the desire of that dear shadow! She is hidden in cambric and in the lace of a skirt flowing on the ground, floating about heel and toe as if to surround her step before she takes it, as (with folds thrown back in a train) she walks forth with her cunning twin arrows.

Has she – herself the walker – a reason for standing there? And yet have I the right, on my side, to penetrate this mystery further by lifting my head above these reeds and walking from that deep imaginative drowse in which my clear vision has been veiled?

"Whatever your features may be, Madame (I whisper to myself), I sense that the instinctive, subtle charm created here by the sound of my arrival would be broken if I saw them – a charm not to be denied the explorer by the most exquisitely knotted of sashes, with its diamond buckle. An image as vague as this is self-sufficient; and it will not destroy the delight which has the stamp of generality, which permits and commands me to forget all real faces; for if I saw one (oh, don't bend yours here, don't let me see it on this ephemeral threshold where I reign supreme!), it would break the spell which is of another world."

I can introduce myself in my pirate dress and say that I happened here by chance.

Separate as we are, we are together. Now I plunge within this mingled intimacy, in this moment of waiting on the water; my reverie keeps her here in hesitation, better than visit upon visit could do. How many fruitless talks there would have to be – when I compare them to the one I have had, unheard – before we could find so intimate an understanding as we do now, while I listen along the level of the boat and the expanse of sand now silent!

The waiting moment lasts while I decide.

Oh, my dream, give counsel! What shall I do?

With a glance I shall gather up the virginal absence scattered through this solitude and steal away with it; just as, in memory of a special site, we pick one of those magical, still unopened water-lilies which suddenly spring up there and enclose, in their deep white, a nameless nothingness made of unbroken reveries, of happiness never to be – made of my breathing, now, as it stops for fear that she may show herself. Steal silently away, rowing bit by bit, so that the illusion may not be shattered by the stroke of oars, nor the plashing of the visible foam, unwinding behind me as I flee, reach the feet of any chance walker on the bank, nor bring with it the transparent resemblance of the theft I made of the flower of my mind.

Claude Monet. *The Empty Boat.* 1890. Musée Marmottan, Paris.

But if, sensing something unusual, she was induced to appear (my Meditative lady, my Haughty, my Cruel, my Gay unknown), so much the worse for that ineffable face which I shall never know! For I executed my plan according to my rules: I pushed off, turned, and then skirted a river wave; and so, like a noble swan's egg fated never to burst forth in flight, I carried off my imaginary trophy, which bursts only with that exquisite absence of self which many a lady loves to pursue in summer along the paths of her park, as she stops sometimes and lingers by a spring which must be crossed or by a lake.

LOUIS GILLET

L'ÉPILOGUE DE L'IMPRESSIONNISME

"Les 'Nymphéas' de M. Claude Monet"

August 21, 1909

Louis Gillet (1876–1943), art critic.

Clemenceau wrote to Monet shortly after the publication of this article that he considered it to be the best piece about the painter ever written.

M. Claude Monet has exhibited nothing for over six years. It was known that he was at work; indeed, even the subject of his new paintings was known. What were they going to be like, those *Water-Lilies*, those "water landscapes" over which the great artist seemed, for the first time in his life, to be hesitating? We have just seen them, during the last month, at M. Durand-Ruel's: they are the most captivating and accomplished of his masterpieces.

Monet was showing 48 paintings of water-lilies between May 6 and June 5, 1909, at Durand-Ruel's gallery.

"Now my very name is being stolen from me!" exclaimed Manet on seeing an unknown signature, not unlike his own, at the bottom of a *View of the Marne*. Since then, almost 50 years have gone by. By now we may rightly treat M. Claude Monet as a master, one of the greatest inventors ever within the formula of the landscape. He is not only the veteran of Impressionism, he is also perhaps still its most complete embodiment, the man who did the most to establish it, who best sums up its development and tendencies. Its history is known to the public only in snatches, as are almost all contemporary matters, partly because it evolved almost entirely outside official institutions. Impressionism has been judged harshly, because it is seen in isolation, with no account being taken of what surrounds it. It is seen only as disfigured by the frequently unjust anger and criticism of 30 years ago. Today, all this sound and fury has abated. With time, peace has descended upon these novelties. They have ceased to be shocking by ceasing to be new. And with his *Water-Lilies* M. Claude Monet is offering us the happiest viewpoint from which to embrace this fragment of the history of painting.

Nothing could be simpler than the aims of the Impressionists. What they wanted was the right to paint the contemporary, the right to live with their own time, in a word, the right to be "modern." This claim, it seems, should not have proved problematical. After Courbet and Millet, to go back no further, the matter was decided. The absurdity was to say that all subjects are equal, that all centuries are the same: it is all too clear that this is not the case. Life is decreasing in grandeur and nobility every day. Such progress as humanity is making is not aesthetic progress. The artist in love with pure beauty will always have a serious grievance against our forms of civilization; he will increasingly seek his diversions in the past. Does it then follow that there is nothing else for art to dream of, to attempt? If the humanist or the history painter serve the human spirit by defending its great traditions against oblivion, do they not also serve it by not overtly despising it in the present, by teaching it to see some unacknowledged charm in our very mediocrity?

* * *

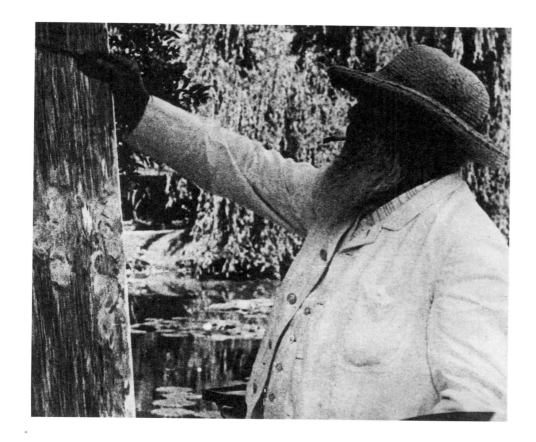

Photograph of Monet painting in his garden at Giverny. Bibliothèque Nationale, Paris.

That is what is called the "realism" of the new school. But as for all similar schools, as with Holland in former times or, if you like, with Japan, the more shabby and pedestrian the reality, the more the question of "art" became the key issue. Since things had no value in themselves, everything clearly depended upon the way they were expressed. Holland, in just such a case, saved itself through chiaroscuro. Impressionism in its turn tried light. What the minor masters of Delft or Amsterdam had committed to shadow – the careful enveloping and, as it were, the swathing and muffling of things, the smoothing of outlines, the deadening of contrasts, the stirring up of a charged atmosphere, the plunging of all forms into a sort of twilight whence they might re-emerge more distant and indecisive; this indirect, evasive, almost mysterious manner of evoking reality, of lending it, in the half-light, a fleeting appearance, of instilling into it a life familiar yet unexpected; this admixture of fiction, this supreme art of selecting without apparently altering, of calculating, of filtering, gauging the rays of light, of rarefying them, of concentrating them upon one point, so as to give the humblest thing a touch of rarity, preciousness and charm: this language of half-words, of ellipse and reticence, which so fittingly expressed intimate meanings and touching secrets – such was the formula which Impressionism was committed to replace. The circle of luminous shadow where Rembrandt, the enchanter, had confined paintings – that bewitching orb, that elusive nimbus – was now violated. French painters wanted light. They purged the palette of shadow, bitumen, sepia and bistre. They relegated the old, all-purpose black velvet mask to the pile of used accessories.

Truth to tell, in France, light had a long-standing tradition, particularly in landscape. It may be followed at the Louvre, almost without a break, from Joseph Vernet (a delightful and underrated painter) to the angelic master, Corot. . . . But there was a young man among their number – this was Monet – who combined the subtlest perceptions of the nuance with a sumptuous genius as a colourist. He was gifted with an exuberant power for action, with an expansive, joyous strength which was to prove irresistible: he had that Norman vigour typical of Poussin, Corneille or Flaubert which creates founders of schools and legislators. Thus through force of circum-

stance Monet became the centre of the group, Manet, the oldest member, and long famous, in reality simply followed. It was indeed Claude Monet who found the crucial formula of Impressionism, who made of it an instrument which he put into others' hands, but which was his alone and which always served only him.

This stroke of inspiration was the famous theory of the division of colours. The principle, which is utterly clear, is as follows: simple colour is more intense than composite colour. The consequence: since it is made up of red and blue, to obtain a purple as bright as possible, with no loss of radiance, you should not mix your components either on the palette or on the canvas: you should content yourself with putting a little pure red and a little pure blue next to one another: the result will be a feeling of purple. The mixing has occurred of itself on the retina. This is *optical mixture*.

To whom did Claude Monet owe this discovery? The idea has gained credence that he took it from Turner, during a journey to London in 1870. He might equally well have found it in any number of other painters, for this alleged secret is the bread and butter of every colourist; it is standard practice in any studio where any true painting has ever been done, from Titian to Velasquez, from Rubens to Delacroix. You will see the analysis of colour practised by masters everywhere to give a tone an unusual degree of vibrancy and brilliance. In reclaiming this principle Monet was simply taking possession of a common heritage. His real invention dates from several years later, when he saw this particular method of execution and this professional secret as the basis, both theoretical and practical, of a certain kind of art.

By reducing and decomposing both light and colour, by resolving shadow itself into coloured reflections, by looking at everything as though it were bathed and swimming in atmospheric fluid; by seeing everything as modified, altered by its surroundings; by unpicking and unravelling this envelope and applying the method of division *ad infinitum*, the artist was led to see the universe as a marvellous spectacle, an atmospheric transformation scene. Outlines fade away, contours start to ripple in haloes of pale light. Everything becomes metamorphosed into a glowing brilliance. The teasing of light, extreme incandescence, are quite as effective as traditional chiaroscuro at sending reality soaring, at dissolving it, making it vanish into a sort of vision. All that remains of the visible world is an impalpable haze, a round dance, a whirlwind of radiant atmosphere which weaves its spangled web of shifting illusion in the void. Never did a painter more resolutely deny matter. Never has the right of an imagination drunk on colour, poetry and beauty been more boldly substituted for the evidence of things and form.

Here we are poles away from the Dutch manner. But who could fail to see that the aim is the same? What has changed most is the author's state of mind, his manner of execution and of seeing. Instead of the gentle spirit who slips softly into the depths of our being, begs our acknowledgement, catches our confidence unawares, heightens everything by his exquisite sensitivity and sense of moral value, we have a more impatient and immediate kind of talent, less penetrating, more superficial, less capable of resisting the lure of the external and the magnificent echoes which the slightest jolt produces in his acoustic machine. The execution too has the same impulsiveness. Do not ask the artist either for a positive description, or definition of form and matter, or particulars, or "portrait." He will talk to you only of sensations. His whole aim is to reproduce the picture of his emotions instantaneously, to project an inner spectacle, the collection of nervous shocks which make up the visual image, as if on to a screen. The brush-stroke imitates nothing, it evokes. It is uneven, pounded, hatched, scored, hacked, slewed, sometimes thick, sometimes thin, never polished, never treated as an "end" in itself: it is the reverse side of a tapestry, whose right side gradually paints itself in the spectator's consciousness. The canvas holds only brilliant synonyms for and simulacra of reality, a picture of appearances formed, in defiance of objection, by the soul of a poet in love above all with light, and with the luminous and radiant appearance of things.

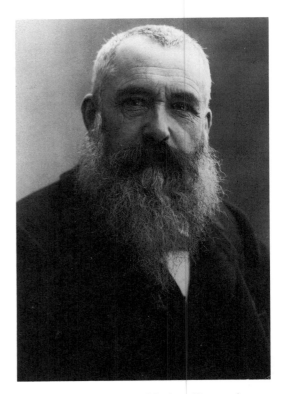

Portrait of Monet by Nadar. December 1899. Caisse Nationale des Monuments Historiques et des Sites, Paris.

And God knows, objections were not spared him! When Claude Monet was seen to be treating his first *Gares Saint-Lazare* in this spirit, the public thought he was attempting the impossible. Some groaned upon seeing a steam engine burst in upon art and regarded the monster with consternation, with the eye of a Gallo-Roman orator contemplating the Barbarians. Others conscientiously sought the engine's wheels and connecting-rods. They could make out only a cluster of incoherent blotches, a multi-coloured mud-heap from which nothing precise emerged. There was a fine uproar. If the painter had bothered, this is what he might have said: "You are asking my painting to give the information that would be given by an engineer: that is the wrong question. If you are interested in engineering, the photographer will answer your needs. The opportune arrival of his lens frees painting from a subordinate office which photography does far better. Praised be the daguerreotype, since it unburdens us of unwanted concerns; thanks to the daguerreotype, art no longer has to act as document. It is no longer expected to offer explanations and object lessons; it is relieved of its function as teacher and instructor of the masses. At last it is separated from ethics, science and literature. That being so, what does it matter what you call my subjects? What does the label I put on my pictures matter? This *Station*, which offends you because it is not in the Greek canon, is just a title, the name I give to one state of my sensibility; it is no more like the visible station than Phidias's horses are like an old cab-horse. The Japanese masters use a whole panoply of samurai, primping geishas, jagged unfurling wave-crests, birds wheeling through the sky, to create prints which look like coats-of-arms: why should I not be master of using scrolls of smoke and steam, all things that vibrate, tremble, radiate and gleam under the glass roof of a station, to create something indescribable which looks like a stained glass window?"

If the artist had spoken thus, he would have dispelled a serious misunderstanding: for it is clear that the boldness of his "subjectivism," the lushness of his vocabulary and his metaphors, the dazzling transformation he metes out to things, make this painter – realist as he may have been considered, and as he may have considered himself – in reality a *lyric artist*, indeed one of the greatest lyric artists of painting.

For fifteen years or so, the artist dispensed his magnificent reserves, his flares of poetry, at random. He cast his gaze, dazzled by sunlight and the soul's delight, over all manner of places, from the bridge at Bougival to the regattas at Chatou, from the cliffs of Calvados to the reefs of Plogoff and Lézardrieux, from the Bay of Biscay to the coast at Antibes.

The life of a landscape painter has lost much of its harshness. It is a far cry from the bourgeois outings and lengthy stays in a comfortless countryside made by the men of 1830. It is no longer the impassioned exploration of the land, the life of adventure, the pursuit of virgin sites and untouched beauty that once it was; it is no longer the heroic embracing of nature that caused Théodore Rousseau finally to lose his reason. Corot himself would go into the countryside every year. The two of them alone caused the range of the picturesque album of France to multiply a hundred-fold. Monet is unacquainted with this anguished search for the "motif." Nothing could be more banal than Étretat, Fécamp or the Côte d'Azur. He usually makes do with even tamer places: the outskirts of Paris, the Seine from Moret to Mantes are enough for him. But what he sees there he would find anywhere, since what he sees are mirages which have no existence outside himself.

This marvellous faculty of inventing, of creating new subjects, of finding artistic delight in the sparsest reality, will offer an admirable spectacle at the moment when some overall exhibition brings together the finest examples of this infinite oeuvre. And landscape passed for a lesser genre, meet for talentless copyists! The good folk of yesteryear, Van de Velde or Wynants, would be amazed at M. Claude Monet's poetic licence, at his expanse of imagination. One might even wonder, seeing his fine indifference for the

occasion or pretext for his works, whether this great landscapist truly loves nature. Does this native of Le Havre have that deep feeling for the countryside, that Virgilian touch which makes the work of Millet so delightful? Does he even have the naïve simplicity, the powerful awkward tenderness of Cézanne when contemplating his native Provence? True, it is hard to imagine Monet as a man-about-town; but is he really a country-man? He is a lover of gardens, a learned horticulturalist, an expert in rare flowers; his Japanese garden at Giverny is well-known. . . . When he began painting, M. Monet seemed to hold promise of a wide range of tastes. He painted wonderful interiors, figures and still-lifes. The *Woman in Green* was one of the chief attractions of the Salon of 1866. It might even be thought that what determined his vocation as a landscape painter was that he is most at ease with nature. This, if I dare admit it, constitutes perhaps the "limitation" of this great artist: the life of his model is insufficiently felt behind the eternal smile of his work. He lacks empathy. I would not swear that he is truly convinced that nature exists. This is the admixture of "mystery" concealed in this dazzling art. And in this context, was it not that other Norman, Flaubert, who thundered against "those brutes who believe in the reality of things?" It is enough, perhaps, for an artist to believe strongly in his art. What does it matter how M. Monet has solved the enigma of this world if his paean to it is one of the loveliest that universal nothingness has ever inspired?

It was in 1891 that M. Monet arrived at his original formula, at the truly historic date of his life: it was then that he exhibited the *Haystacks*, the first of his "series" paintings.

Three haystacks, in a field, in the centre of the painting; in the background, a vague hill in a pale mist; no accessories, no figures; not the slightest formal interest, no ghost of an anecdote; utterly insignificant as a study, utterly unremarkable as a subject. Try turning that into a dozen masterpieces! . . .

<p style="text-align:center">* * *</p>

It was as though he no longer understood things except in a cyclical form. As inner excitement engenders a succession of more or less prolonged mental reactions in the lyric poet which, together with the form of the stanza, determine the rhythm and length of the ode; or as a melody passes through a series of states before dying, and undergoes a series of modifications, obliterations, reprises, rallentandos and re-awakenings which make up the life of a specific piece from its birth to its conclusion: thus Monet arrives at the conception of what one must indeed call his "subjects." Horace said: "As painting so is poetry." "Painting is music," M. Claude Monet has him say. And indeed, as has often been observed, no colourist can be without a sense of music. A thousand affinities, delicate but sure, unite a vision of colour to a vision of sound.

"Les formes, les couleurs et les sons se répondent".

Should psychology ever choose to explore this reality and to take note of these "correspondences," Monet's "series" paintings would be a document of the first importance. No one has annexed one art to another more deliberately, nor applied the development procedures and ideas of the musician so firmly to those of the painter.

Indifference to content, whether literal or metaphorical; lack of curiosity, indeed apathy, concerning reality; a pronounced taste for colour combinations; an ability to dissociate them, in order to associate them with others, to cause them to bring forth chords and harmonies; a ceaselessly renewed enthusiasm for these kinds of emotion, an indefinite capacity to conceive them afresh, to analyse them, to multiply them by subdividing them into different images, to generate a theme and to deploy it in inexhaustible variations: one can see the stages through which, in the form of "series" paintings, and with a minimum of real landscape, M. Claude Monet felt impelled to create the most astounding sonatas of modern painting.

"Forms, colours and sounds correspond": the line is misquoted, perhaps deliberately, from Baudelaire's Correspondances: *"Fragrances, colours and sounds correspond."*

What had still to be found was the fabric, the symphonic "setting" where the motif could live and develop: this is the role Monet assigns to the atmosphere. All that is fleeting in this solar world, all that is scattered and brilliant, all that gleams, quivers, glistens, shimmers and refracts, everything which can serve as envelope or prism, or can interpose brightness between object and eye, soften a form, blur a contour, alter a local colour, resolve it into unexpected nuances, change the physiognomy and interpretation of things, make them appear young, new, strange: this world of the relative, the different, the multicoloured, is one which the master has made his own. He never wearies of following an object – any object – over the phases of a fine day, seeing it changing as the hours go by, contemplating the magic wrought by light, and the "time-coloured veil," the veil of falsehood, spreading the miracle of appearance over a form. Beneath this fabulous rayment, reality disappears. The stone of a cathedral becomes a mystery of pink or shifting blue, hoary and diaphanous, a phosphorescent dawn ghost, giving off faint flames like a block of glass emerging from a kiln; a tree becomes a mere wisp, a slight breath scarcely more corporeal than its image on the surface of the river in which it is reflected; a haystack flooded in sunshine seems to swither, clad in a shining nimbus of gold. Nature, as at midday, seems to emit a haze. All space is filled with burning sparks. Behind this cloud all forms are rarefied. The world is now all inconstancy and eeriness: questionable, uncertain, ephemeral, glittering, an empire of opal and mother-of-pearl, of glistering phantoms. Nothing could be more insubstantial, more evanescent, yet nothing could be more daring and intoxicating than this absolute nihilism taking refuge in pure art, and forging itself, in the imagination, a realm of fantasy where the casket of dreams from the Arabian Nights wafts by, faint as the sheen on a dove's neck.

And yet, so crucial as a manifesto, do the *Haystacks* and *Cathedrals* leave one convinced when taken as works of art? Very clear as a principle, are they equally clear as a result? The painting is charmless, unpolished, heavy, effortful: and this sense of struggle in a virtuoso as self-confident as M. Monet would suffice to betray the author's perplexity and the arbitrary nature of his endeavours. However desperate the effort to reduce it to an explosion of light, does some wreckage not always persist, an irreducible remnant of form? Smother this form with arpeggios and trills, steep it in the most dazzling orchestration, you will never succeed in suppressing the following ambiguity: as realities, your *Cathedrals* are of doubtful authenticity; as fantasies, they may always be belied and compromised by reality.

With the conscientiousness, the admirable tenacity which are the hallmarks of the great artist, M. Claude Monet has thus set himself to perfecting his notion, and to exhibiting it in the most favourable light. From one series to another, one sees him in pursuit of ever more disembodied effects, more nebulous, volatile and unstable by nature, better lending themselves to the whims of poetry by virtue of their uncertainty. These are the exquisite *Mornings on the Seine*, dimmed with purple mist, so liquid they might be painted muslin. Then there are his *Views of London*, the city of fog: the broad expanse of the Thames, like watered silk, the smoke from a steamer unrolling like a scarf, and a strange diffuse reddish glow, clouded like light seen through oil-paper – the sun; and, in the background, a mysterious ghost ship, the heraldic, all-blue silhouette of Westminster. The effect is very lovely.

But Monet did not rest there. And it is edifying to see this old master persisting in his search, at over 60 years of age, and still finding. He has been searching for over six years. What he was seeking so dauntlessly was right beside him. Water had long attracted him. He had long been one of its most accomplished painters. In his last series (the *Mornings* and the *Views of London*) it played an increasingly absorbing role. To paint it this time, the master did not have to leave his garden: he made it the sole subject of his *Water-Lilies*.

It is not the first time that Monet has painted this theme. We all know that pool, under its covering of floating leaves, the little green wooden bridge spanning it amidst a tangle of multifarious trees which have the bristly, rumpled look, the tousled "chinoiserie" appearance of a landscape by Boucher. Thus M. Claude Monet took pleasure in introducing us to his garden. But now such things are far from his mind. His purpose is so daring that no one previously had conceived of it; his success so complete that one forgets to be amazed by it. All of M. Monet is in this masterpiece: and he needed a whole lifetime to brood upon it.

A painting without edges, a liquid expanse, a mirror with no frame. All sense of design, positive form or horizon, disappears. Apart from the two or three groups of aquatic leaves scattered over the mirror-like surface, nothing tells us what fragment of the infinite expanse we are concerned with: there is no other landmark to determine the point of view or angle of perspective. This neutral space is given life only by reflections; and the result is a picture reversed. The trees (which are invisible) are hinted at only by their reflections. The sky – an ingenious surprise – is not overarching, but touches the lower edge of the frame, and the lightest point, usually the highest, is here at the base of the painting.

I shall pass over the unprecedented difficulty of having the top of the painting at its base, over the daunting problem raised by the intersection of three or four planes, or rather the necessity of representing them all on one unreal one; it would not be possible, in painting, to assemble more paradoxes. As a solution, it outstrips all that is most skilful in this genre. The famous stratagem by which, in a single painting, Giorgione managed to show the same figure from four sides (by a system of mirrors) is mere child's-play in comparison. Before such works, the Florentine painter who would waken his wife at night exclaiming, "Oh what a lovely thing is this perspective!" would fall to his knees. Pure abstraction in art can go no further. Here we have only the play of the imagination, the simple combination of forms for pure aesthetic pleasure. All that is most exquisite in this respect – the arabesque, the decoration of a Japanese vase, a Khorassan or Circassian carpet, all that is most conventional and most refined, all that is least fleshly and perishable, all that has most in common with music, number and geometry – none of these surpasses the beguiling idealism of the *Water-Lilies*! Here the author reaches an apogee of spiritualization. One can imagine no art more emancipated, more indeterminate, less shackled by vulgarity, meaning or humanity. One senses an enjoyment of complete freedom; and smiles, before these motifs of unbridled fantasy, at the simplicity of the naïve Arian, always convinced that man is at the centre of things. What lack of restraint, of true breeding! How much more refined are Oriental self-effacement and impersonality! Water and reflections, an exchange of imponderables by means of fluids, the interplay of air and water, seen one through the other, a tangling of slight errors, shadows playing on a mirror, what spectacle could be more worthy of the mortals that we are?

Never have philosophical doubt and fear of all affirmation (except that of art) gone beyond this point. And yet, what poetry the master has used to clothe his *Allzumenschliches*! The most tender and sumptuous dreams unfold over the watery surface: evenings of fire, twilights of purple and gold, streaming with things that glow like melting metal; Fingal's Caves, coral caverns such as Sinbad the Sailor saw, forests of madrepore like those dreamed of by Gustave Moreau as a refuge for his Galateas. Sometimes the sunset which founders on the mirroring waters has the solemnity of a fanfare fading in distant woods; sometimes we see a torn, convulsed sky, and the water is mauve and shivering with a threat of rain. The colourless element may thus be dyed a thousand shades. All this is thinly painted on the canvas, with the lightness of a watercolour, an outer limpidity which is a further example of decorum. Weary of pointless bravado, all Monet retains of the division of colour, that contentious technique, is what is needed to

Allzumenschliches: "all too human".
Nietzsche's Human All Too Human *was published in 1879 and 1880.*
Fingal: a mythical Celtic giant.
Gustave Moreau (1826–98), Symbolist painter.

make a rare note "sing" out more subtly. And once again it is a deliverance, a last bond broken with all that is systematic and academic.

But the pearls of the series are probably the *Mornings*. Here a bay of blue, a river of sapphire is created between the double crown of the inverted trees: a sort of mariner's chart of some nameless ocean, in accordance with the naïve perspective of the old portulans, a sea veined with a seaway of azure, a bluish Gulf Stream of dreams. This sea is strewn with a light squadron of lotuses, with their broad sacred flowers – the blue lotus of the Nile, the yellow lotus of the Ganges. Like those legendary islands glimpsed from afar, whose scents seemed to waft towards the navigator, each flower colours a whole picture, its subtle hue suffusing the whole spectrum. Who could resist such a call to travel, to set off on those flowery skiffs for a virginal Delos or untouched Polynesia? Painting has become pure fragrance, the merest sigh. Can one imagine any more noble and exquisite celebration than this scene without figures, this lake over which a swarm of lovely dreams might set sail and the divine ship of the *Embarkation for Cythera* might glide?

Indeed if anything, in contemporary art, is reminiscent of the poetry of the eighteenth century, with its romantic way of understanding nature, it is the art of Claude Monet. His art is so original only because it is the blossoming of a long French tradition. His descendance from it, through Corot, is seamless. Even his *japonisme* is just one more resemblance to the century of chinoiserie. Four pictures in this series of the *Water-Lilies*, round in shape, evoked these memories with the greatest clarity. I imagine for myself an intelligent art-lover, a Des Esseintes with taste. He would not have allowed this delicious quartet to be dispersed. For a hundred thousand francs he would have had a private room created, the most perfect imaginable since the time of Fragonard. And the price would not have been too high.

The hero of Huysmans's novel À Rebours.

In some years, when the artist's works are scattered through every museum in the Old and New Worlds, who will know that its most precious aspect has vanished into thin air, and that the whole striving of an artist's life has been needlessly squandered – a striving which was the most powerful effort ever made to give a decorative value to the intimate landscape, the painting of inwardness, and to bring to painting a sense of *continuity*?

People have been too quick to speak ill of "Impressionism." Had it produced only the work of Claude Monet, it would still be one of the most original movements in contemporary art. And it could be – since Cézanne is something other, since Degas's position and ideal is something apart, since Renoir is a great-grandson of Rubens – it could be that M. Monet alone constituted "Impressionism." The mistake will prove to have been to regard as a school and a method what was in fact simply the very original language of a poet of genius.

His art, so perfectly consistent, will remain as the possibly unconscious expression of an age of pure "phenomenalism." His analysis of sensations, his divisionism – which he never took as far as the pedantic methods of Seurat or M. Signac – would tally quite closely with the analysis of consciousness of the neo-critical school. It must be agreed that rarely has a philosophical doctrine found more seductive expression in the plastic arts.

The philosophy of "neo-criticism" propounded by Charles Renouvier claimed that objects could be known relative to a perceiving subject only as shifting phenomena and not in an absolute or objective form.

FRANÇOIS THIÉBAULT-SISSON

LA REVUE DE L'ART ANCIEN ET MODERNE

"Claude Monet's Water-Lilies"

June 1927

After coffee we went into the garden, and from the garden we crossed the road and the railway tracks – along which trains no longer run – and entered the realm of the *nymphéas*.

As we strolled he described how he had put the whole thing together. From a completely empty meadow devoid of trees but watered by a twisting, babbling branch of the river Epte he had created a truly fairytale-like garden, digging a large pond in the middle and planting on its banks exotic trees and weeping willows, whose branches stretched their long arms at the water's edge. Around the pond he had laid out paths arched with trellises of greenery, paths that twisted and inter-crossed to give the illusion of a vast park, and in the pond he had planted literally thousands of water-lilies, rare and choice varieties in every colour of the prism, from violet, red, and orange to pink, lilac, and mauve. And, finally, across the Epte at the point where it flows out of the pond, he had constructed a little, rustic, hump-backed bridge like the ones depicted in eighteenth-century gouaches and on *toile du Jouy*. All the money he had made since paying off his property and the costs of the repairs and new buildings he had made to improve it, once he had felt able to let himself go, had gone into this costly fantasy worthy of a wealthy *ancien régime* landowner. However, as he remarked complacently, the canvases inspired by his "last love" had more than compensated for the money he had laid out.

"Here," he told me, "you see all the motifs that I treated between 1905 and 1914, aside from my impressions of Venice. I have painted so many of these water-lilies, always shifting my vantage point, changing the motif according to the seasons of the year and then according to the different effects of light the seasons create as they change. And, of course, the effect does change, constantly, not only from one season to another, but from one minute to the next as well, for the water flowers are far from being the whole spectacle; indeed, they are only its accompaniment. The basic element of the motif is the mirror of water, whose appearance changes at every instant because of the way bits of the sky are reflected in it, giving it life and movement. The passing cloud, the fresh breeze, the threat or arrival of a rainstorm, the sudden fierce gust of wind, the fading or suddenly refulgent light – all these things, unnoticed by the untutored eye, create changes in colour and alter the surface of the water. It can be smooth, unruffled, and then, suddenly, there will be a ripple, a movement that breaks up into almost imperceptible wavelets or seems to crease the surface slowly, making it look like a wide piece of watered silk. The same for the colours, for the changes of light and shade, the reflections. To make anything at all out of all this constant change you have to have five or six canvases on which to work at the same time, and you have to move from one to the other, turning back hastily to the first as soon as the interrupted effect reappears.

"It's exceedingly hard work, and yet how seductive it is! To catch the fleeting minute, or at least its feeling, is difficult enough when the play of light and colour is concentrated on one fixed point, a cityscape, a motionless landscape. With water, however, which is such a mobile, constantly changing subject, there is a real problem, a problem that is extremely appealing, one that each passing moment makes into something new and unexpected.

Utagawa Hiroshige. *Wisteria*. From *100 Famous Scenic Locations in Edo*. Woodblock print, *ōban* size. Museum of Fine Arts, Boston (Bigelow Collection).

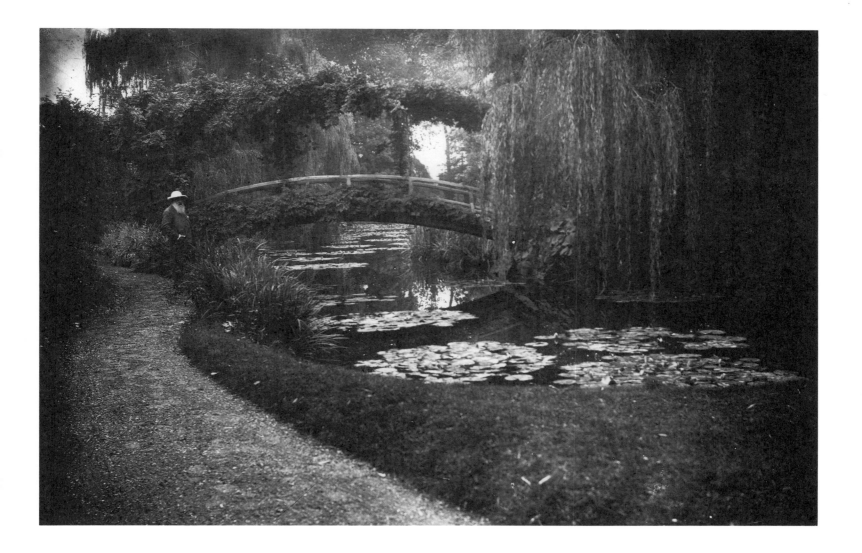

Monet by the waterlily pond with the footbridge in the background. Photograph.

"A man could devote his entire life to such work – I did, for eight or nine years, and then I suddenly stopped, filled with a kind of uncommunicable anxiety."

"Why was that?" I asked.

"The colours no longer had the same intensity for me; I was not painting the effects of light with the same precision. Reds had begun to look muddy, pinks were paler, and the intermediate or deeper tones I couldn't capture at all. Forms – those I could still see just as clearly, and I could draw them with the same precision.

"At first I wanted to keep going. Time after time here by the little bridge, just where we are now, I used to sit for hours under the baking sun, under the shelter of my parasol on my folding chair, forcing myself to go on with my interrupted task and to regain the vanished freshness of my palette! All in vain. My painting was getting more and more darkened, more and more 'old-fashioned,' and when finished with my trial, I would compare it to former works. I was overtaken with a fit of rage and slashed all my canvases with my penknife.

"Of course, I needn't tell you that in the meantime I had consulted every good ophthalmologist I could find. I was dismayed at the contradictory opinions I got. Some told me that it was old age and the resultant progressive weakening of the organs; others – and I think they were the ones who were right – gave me to understand with considerable hemming and hawing, that I was developing a cataract and that in the course of time an operation might be able to cure me. However, they were careful to tell me that the slow progress of my symptoms showed that my affliction was going to take time to develop and that it might be years before an operation would be possible. Both sides agreed on one point, however: the need for complete rest.

"I've lived through many unhappy moments in my life, but I have never lived through any as painful as the ensuing five or six months. However, a day finally came, a blessed day, when I seemed to feel that my malady was provisionally checked. I tried a series of experiments destined to give me an account of the special limits and possibilities of my vision, and with great joy I found that although I was still insensitive to the finer shades and tonalities of colours seen close up, nevertheless my eyes did not betray me when I stepped back and took in the motif in large masses – and that was the starting point for the compositions you are about to see in my studio.

"A very modest starting point, of course. I was very hesitant, and I didn't want to leave anything to chance. I began slowly to test my strength by making countless rough sketches that convinced me, first, that the study of natural light was no longer possible for me; but they also reassured me by proving to me that even if minute tonal variations and delicate transitions of colour were no longer within my power, I still saw as clearly as I ever had when dealing with vivid colours isolated within a mass of dark tones.

"How was I going to make out of that an advantage?

"Gradually I reached a decision. Ever since I had turned sixty I had always had in the back of my mind a plan to take each of the categories of motifs I had worked on over the years and to create a kind of synthesis, a kind of summing up, in one or perhaps two canvases, of all my former impressions and feelings. I had abandoned that notion, however, because it would have taken a lot of travelling and a lot of time to revisit the various sites of my life as a painter, one after the other, recapturing my past emotions. And nowadays travelling tires me. Even short two- or three-day automobile trips do me in. What would a journey of several months do to me? And besides, I wanted to stay put here, where I'm happy. I've grown used to the flowers in my garden in the spring and to the water-lilies in my pond on the Epte in the summer-time: they give flavour to my life every day. So I had abandoned the project. My cataract caused me to return to it. I had always loved the sky and the water, greenery, flowers. All these elements were to be found in abundance here on my little pond. Sometimes, in the morning or in the evening – I had given up working during the brilliantly lit hours, and in the afternoon I only come here to rest – while working on my sketches, I said to myself that a series of impressions of the ensemble, done at the times of day when my eyesight was more likely to be precise, would be of some interest. I waited until the idea took shape, until the arrangement and the composition of the motifs gradually became inscribed in my brain, and then, when the day came that I felt I had sufficient trumps in my hand to try my luck with some real hope of success, I made up my mind to act, and I acted.

"I've always been a decisive man once I've made up my mind. On the spot, I sent for the mason, an honest man with a small firm, conscientious, knowing his job. We drew up a plan, a very simple one, for an unusually large studio – 25 metres long, 15 wide. Solid walls, no opening aside from one door. Two thirds of the roof was to be glass. The workmen began digging the foundations on the first of August. Then came the general mobilization and the war. My contractor had no more workmen. The building materials could no longer be brought to the site. It took six months for my man to reach the point where he could begin construction. It wasn't finished until the spring of 1916. Then, when the work was barely com-
·pleted, I set to work. I knew what I could do and what I wanted. In two years I have completed eight of the twelve panels that I had planned to do, and the other four are now under way. In a year I'll have finished to my satisfaction, that is if my eyes don't begin acting up in the meantime."

We had arrived at the new studio. We entered, and my eyes widened in wonder. Claude Monet had enlarged his original motif with a nobility, an amplitude, and an instructive sense of decor that were totally unexpected. Utilizing a compositional process whose simplicity was one of the happiest of inspirations, he had depicted the water-lily pond from the perspective of

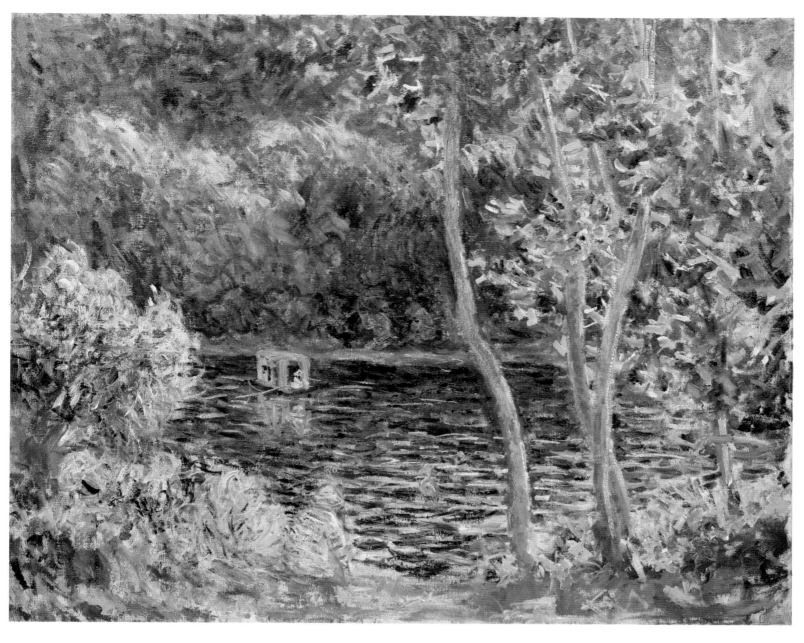

COLOURPLATE 93. Claude Monet. *The Studio-Boat*. 1876. 31½ × 39⅜″ (80 × 100 cm).
Private Collection, Paris.

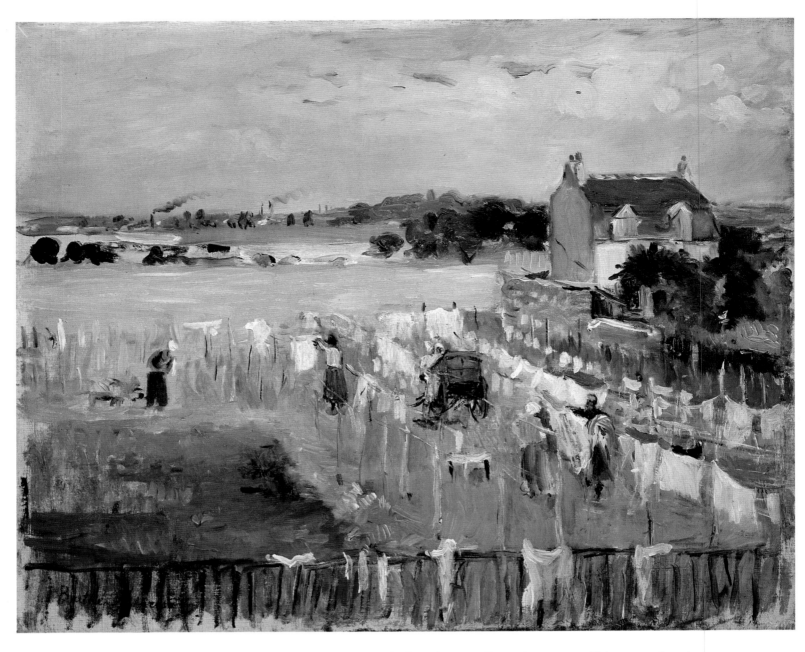

COLOURPLATE 94. Berthe Morisot. *Hanging the Laundry out to Dry.* 1875. 13 × 16″ (33 × 40.6 cm). National Gallery of Art, Washington DC (Mr and Mrs Paul Mellon Collection).

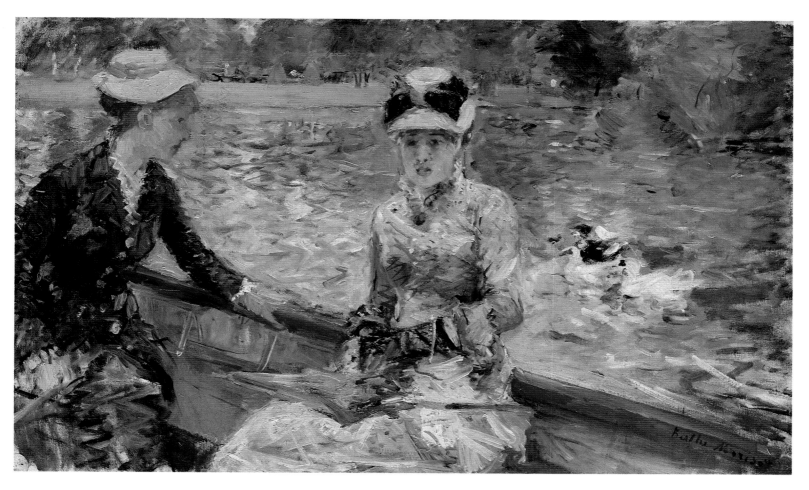

COLOURPLATE 95. Berthe Morisot. *A Summer's Day*. 1879. 18 × 29½″ (46 × 75 cm).
National Gallery, London.

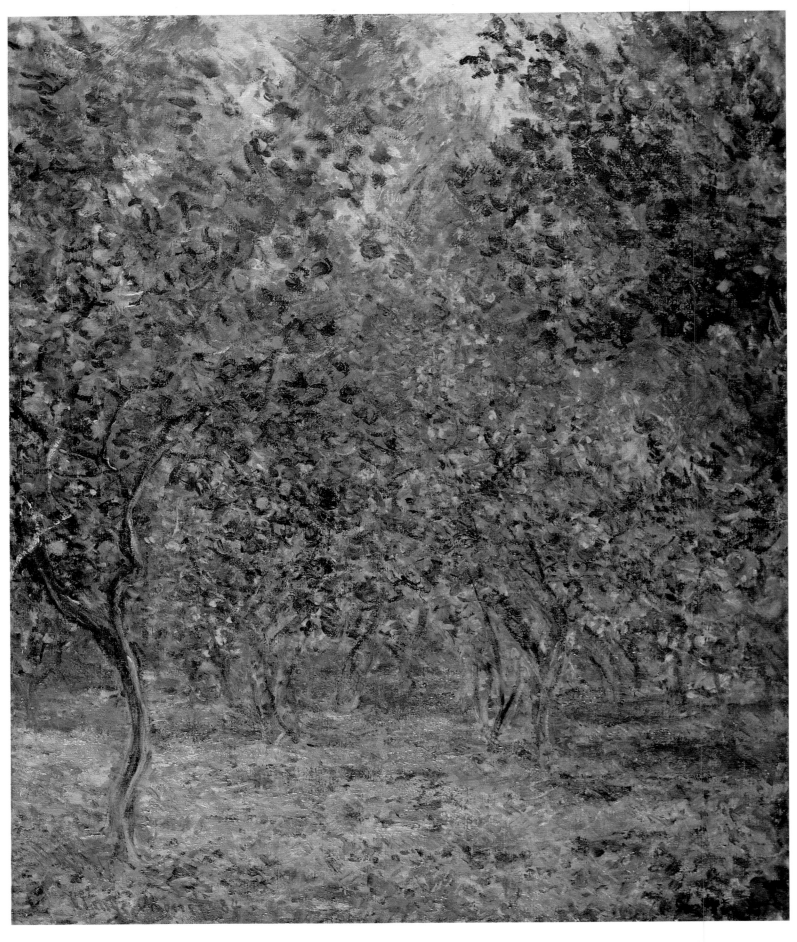

COLOURPLATE 96. Claude Monet. *Under the Lemon-Trees, Bordighera*. 1884. 28¾ × 23⅝″ (73 × 60 cm).
Ny Carlsberg Glyptotek, Copenhagen.

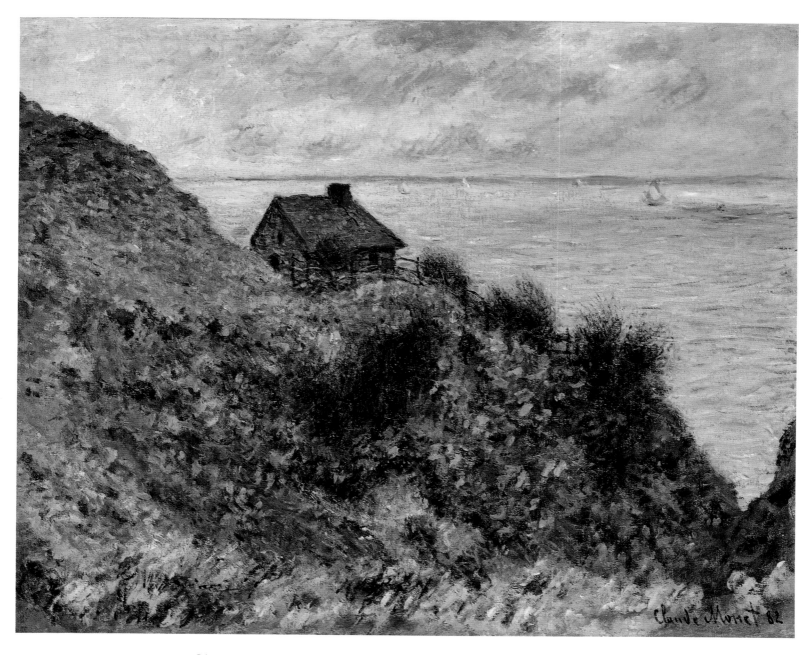

COLOURPLATE 97. Claude Monet. *The Customs Officers' Cabin at Pourville.* 1882. 31 × 38½″ (78.7 × 97.8 cm).
Private Collection.

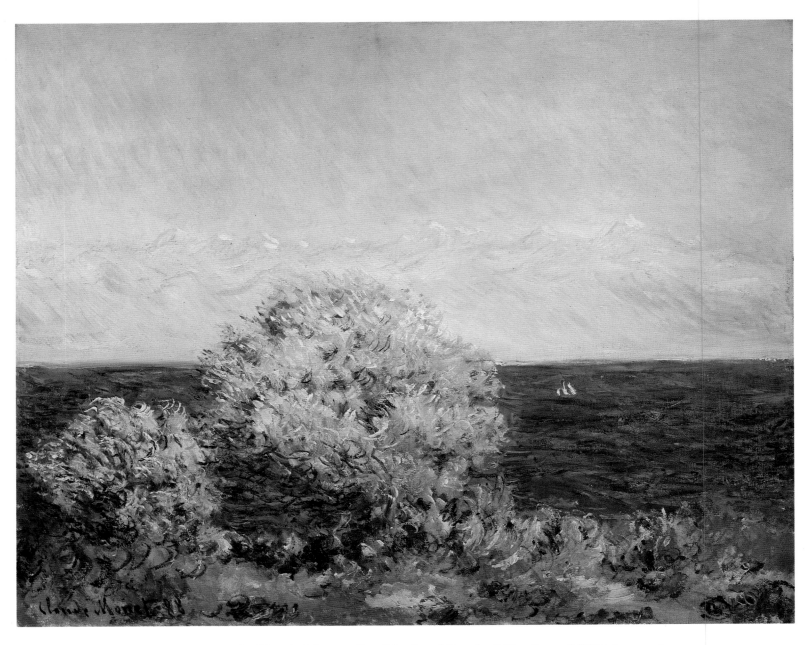

COLOURPLATE 98. Claude Monet. *Cap d'Antibes, Mistral.* 1888. 26 × 32″ (66 × 81.3 cm).
Museum of Fine Arts, Boston (Bequest of Arthur Tracy Cabot).

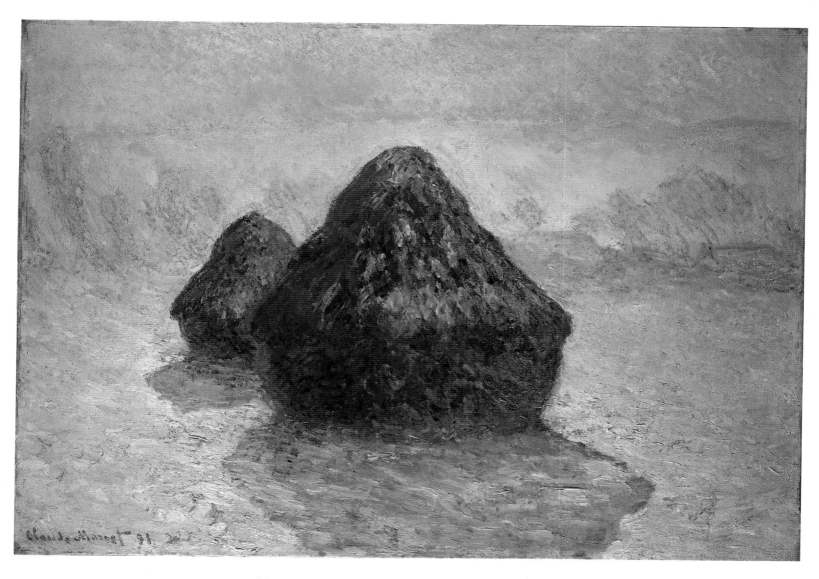

COLOURPLATE 99. Claude Monet. *Grainstacks, Snow Effect.* 1891. 25⅝ × 36¼″ (65 × 92 cm).
National Galleries of Scotland, Edinburgh.

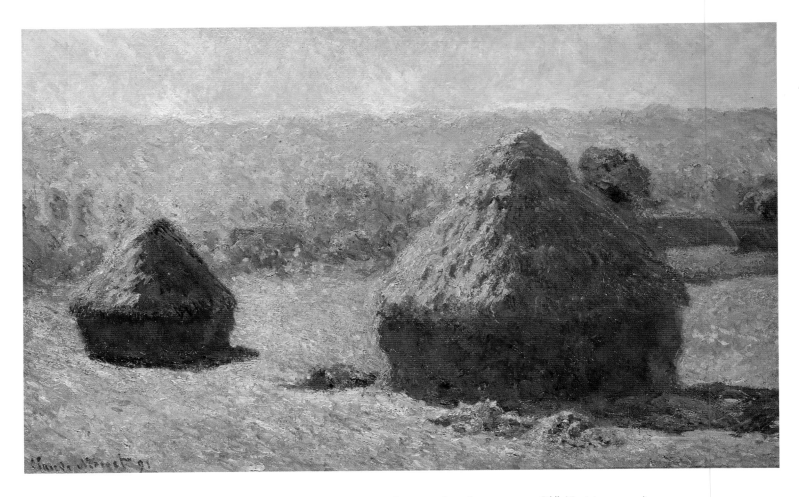

COLOURPLATE 100. Claude Monet. *Grainstacks*. 1891. 24 × 39¾″ (61 × 101 cm).
Musée d'Orsay, Paris.

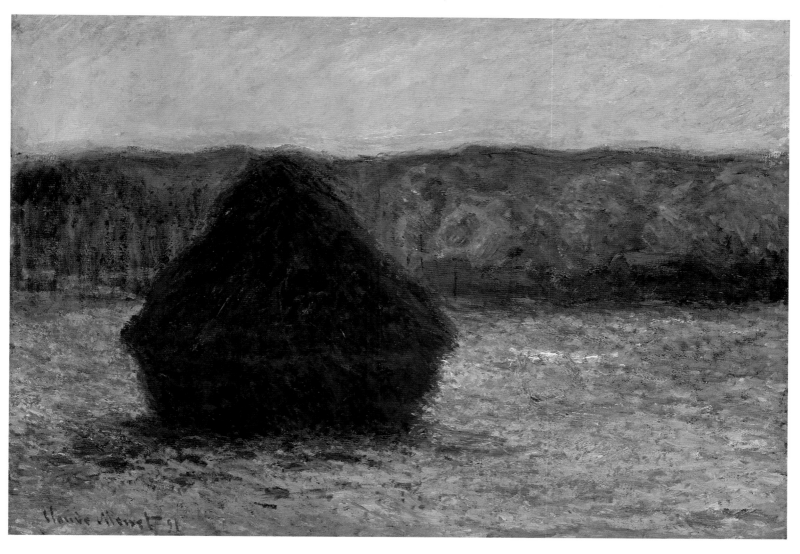

COLOURPLATE 101. Claude Monet. *Grainstacks, Sunset*. 1890–1. 25½ × 36¼″ (64.9 × 92.3 cm).
The Art Institute of Chicago (Gift of Mr and Mrs Daniel C. Searle 1983.166).

COLOURPLATE 102. Claude Monet. *Water-Lilies*. Undated. 39⅜ × 118⅛″ (100 × 300 cm).
Musée Marmottan, Paris.

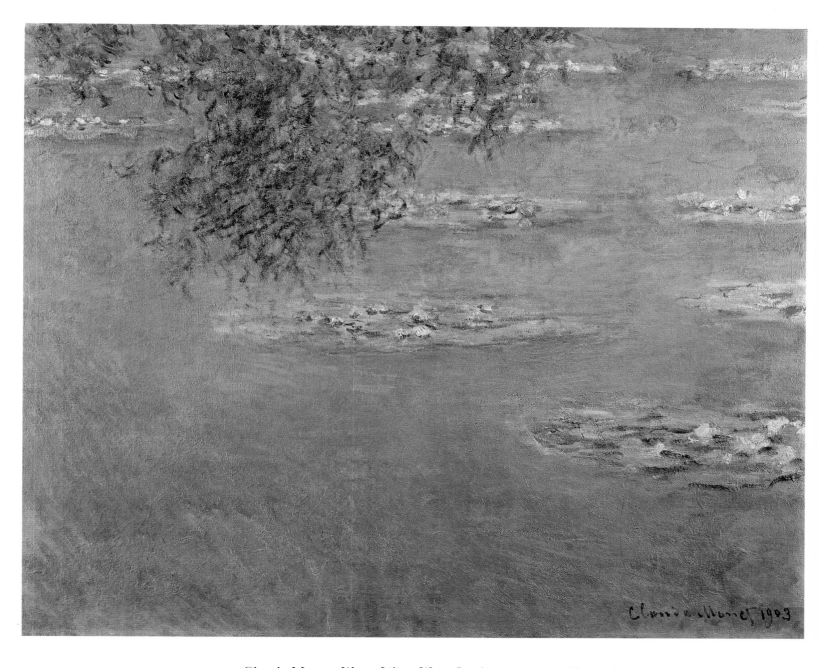

COLOURPLATE 103. Claude Monet. *Water-Lilies: Water Landscape.* 1903. 31⅞ × 39″ (81 × 99 cm).
Bridgestone Museum of Art, Ishibashi Foundation, Tokyo.

314

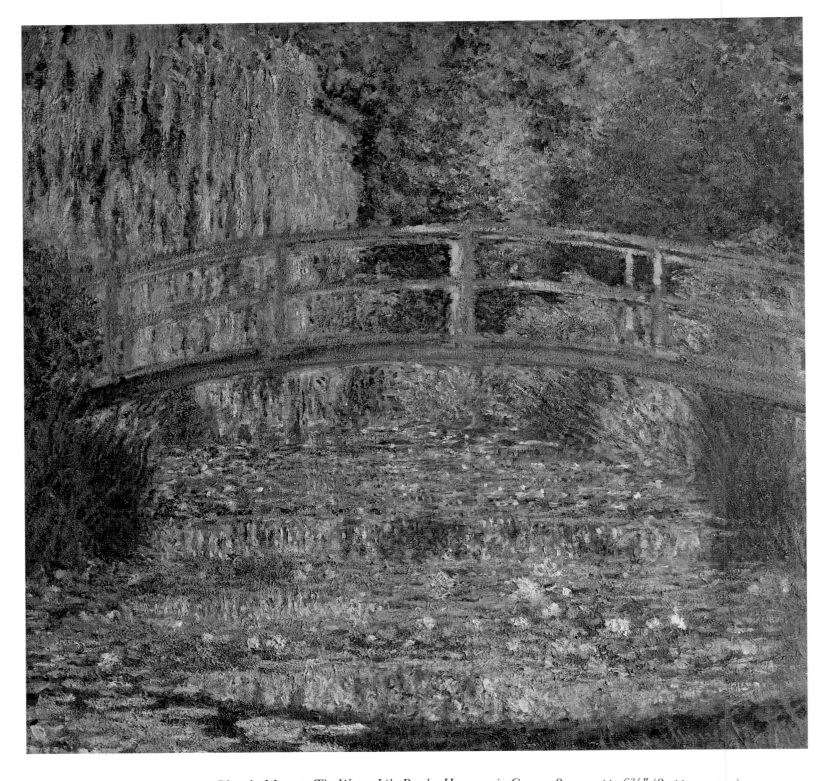

COLOURPLATE 104. Claude Monet. *The Water-Lily Pond – Harmony in Green*. 1899. 35 × 36¾″ (89 × 93.5 cm). Musée d'Orsay, Paris.

the path that encircles it, and each of the vantage points he had selected was enclosed in the framework of one of the canvases. They were all of the same height – approximately 1.80 metres. The widths varied – some were four metres, others six to eight metres. As overall settings he had taken more or less what nature offered him. In some of the paintings the view of the surface of the water was framed by the gnarled trunks of two weeping willows, and in others, where nature gave him no need to limit the boundaries of his canvas, he had eschewed all artifice and had concentrated the viewer's attention on the water itself. None of the paintings had been executed in the full light of noon. The effects were all either those of misty daybreak or mid-morning with a very soft light and no mist, or of afternoon with the setting sun, or of fading daylight, twilight, or night. This alone was enough to allow the motifs to be seen in an unimaginable variety of aspects. As for the colour effect, it was literally prodigious. On a base of either light or dark – almost black – shades of green, the artist's careful placement allowed the purples and yellows, amethysts and pinks, lilacs, violets, and mauves to play their roles to perfection. Resting on their large flat leaves, the water lilies discreetly raised their corollas surrounded by their green cupules, and the centre of the composition was almost always empty, but in a very relative sense, for it was there that the painter had deployed the play of lights and reflections on the surface of the shimmering or calm water, water wrinkled or crimpled with tiny wavelets. There, the reflection of the small cumulus clouds passing across the sky seemed to float gently, tinged with pink or fire, or one saw the trailing scarves of the mist risen in the dawn. The whole scene shimmered with the brilliance of an already fading sun whose last rays were refulgent as floods of gold in a pearl grey and turquoise sky.

And the whole thing was all of an unbelievable sumptuousness, richness, and intensity of colour and life. For a moment I thought the old man must have been teasing me when he told me of his fading eyesight. I was to find proof to the contrary, however, when I accompanied him to his everyday studio and examined twenty-five or thirty works he had cast aside, works dating back to the time when, after having experienced the onset of his infirmity, he had still attempted to go on working. Their colour notations were horribly out of tune, and although the artist was still present in the drawing, the talent for composition and the overall appeal of the work, the colourist seemed to have disappeared. It was still impossible to plumb the mystery of his wonderful achievement. "Don't bother your head about that," Monet said to me. "If I have regained my sense of colour in the large canvases I've just shown you, it is because I have adapted my working methods to my eyesight and because most of the time I have laid down the colour haphazardly, on the one hand trusting solely to the labels on my tubes of paint and, on the other, to force of habit, to the way in which I have always laid out my materials on my palette. I soon grew used to it, and I've never made a mistake. I should add that my infirmity has sometimes gone into remittance and that on more than one occasion my colour vision has come back as it was before, and I have profited from those moments to make the necessary adjustments."

Thus, it is to his nascent blindness much more than to any preconceived plan that we owe the compositions that Camille Lefèvre has set in such eminently suitable and fitting surroundings, in a framework so utterly tasteful and pure. The elliptical spaces created by the national museums' architect are not those first conceived by Monet. He had envisaged a vast rotunda in which his canvases would be set into the walls like a panorama, and it took many long discussions between himself and his "director" before he agreed to go along with the architect's ideas. He did not have the joy of seeing his work affixed to the walls before his death, and thus he was not able to see it take on its full meaning, its full suggestive power. But at least he died secure in the knowledge that, whatever its quality, his work would be displayed to the public under the most favourable conditions, and that knowledge in itself was the finest of rewards.

Camille Lefèvre (1876–1946), the architect in charge of converting the Orangerie for the installation of Monet's Water-Lilies.

317

GEORGES CLEMENCEAU

CLAUDE MONET

The Water-Lilies

1930

I have sometimes gone to sit upon the bench from which Monet saw so many things in the reflections of his water garden. My inexperienced eye had to persevere in order to follow from afar the master's brush to the extremes of his revelations. The opposite of the monkey in the fable, he profusely poured torrents of light upon the screen of his magic lantern. Almost too much, one would say, if one could complain of an excess of luminous vibrations under the transparency of the layers of milky ways which tempt us with the scintillations of the Infinite.

On its level, whatever it be, the water-lily is there only as witness of the universe amid flights of colours whose wings carry us beyond the sweep of the imagination. Also, to complete the story, here in leafy retreats is the calmed ardour of a pool of sleeping water, discovered in order to stimulate the contrast of the water garden, set afire by storms of light passing from the blinding sky to the glowing earth and from the glowing earth to the blinding sky.

For life or death in the struggle going on between sun and flower, the sensitiveness of the vegetation will be conquered by the irresistible power of the universal conflagration. Under the protection of the willows, the bouquets of water-lilies maintain for a time the brilliance of triumphant bloom. But the fine down of the clouds, pierced by all the fires of the atmosphere, envelops leaves and flowers with its reflected image to carry them off victoriously as the richest booty to the height of the burning air, while patches of dark vegetation, seen through symphonies of mauve, blue, rose-tinted mists, speak the combat of the gentle ephemeral earth and the eternal fire.

And the action over this field of battle is life itself, luminously transposed, the elemental struggle for successive instants of momentary domination. There unrolls the drama of the Water-Lilies upon the scene of the infinite world, made conscious in man whose alternations of mastery and submission are the argument of the eternal plot. In the ocean of extension and duration where all the torrents of light throw themselves into an assault upon the human retina, tempests of rainbows collide, interpenetrate, are shattered into a powder of sparks to soften themselves, to melt, to be dispersed and then rejoined, while heightening the universal tumult which excites our emotions. This indescribable hurricane in which by the painter's magic our bewildered eye receives the impact of the universe is the problem of the inexpressible world which reveals itself to our sensitivity. Those even who have not understood it are on the road to understanding it. Note will be taken of it in the course of time.

That is not all. A new spectacle is at hand. The supreme outburst of the solar triumph throws us into a ferment of ineffable sensations by means of the iridescent transparency of a mellow light wthout definite colour, in which sky and earth amid the scattered flowers and happy clouds are held in soft embrace. It is the fragile but irresistible masterpiece of the world's full ecstasy over its more intense sensations. Sublime termination of a vision of art wherein Monet, smiling, abandoned himself to the voluptuous languor of his last brush-stroke. And since we have recently learned that the cosmic waves have a voice, we can now conceive the concerts of hearing and of sight united in the chords of a universal symphony.

Let us return, however, to the paintings and see here the sombre spectacle of a bluish night where phantom-like vegetation takes the place of the triumphant blooming of the apotheosis. Finally at the exit, as a supreme

vision, the ghosts of fallen water-lilies under the flames of the setting sun, across the tangle of reeds, announce to us the provisory ending of so many cycles linked together.

Thus Monet brings us in his plenitude the novelty of a view of things which appeals to the natural evolution of our visual organism, so that we may grasp the painter's adaptation to the energy of universal sensitivities. A succession of subtle passages leads us from the direct image to the reflected and re-reflected image by diffusions of transposed light whose values entangle themselves and disentangle themselves in complete harmony. An incomparable field of luminous exchanges between sky and earth, crowned by an emotion of the world which exalts us to the height of the infinite communion of things in the supreme completion of our sensitivities.

Would that I could still hear the gently authoritative accent of that friendly voice before Nature's display in his water garden. "While you seek the world in itself philosophically," he said with his good smile, "I am simply expending my efforts upon a maximum of appearances in close correlation with unknown realities. When one is on the plane of concordant appearances one cannot be far from reality, or at least from what we can know of it. I have only looked at what the universe has shown me, to bear witness to it through my paint-brush. Is this nothing? Your error is to wish to reduce the world to your measure, whereas, by enlarging your knowledge of things, you will find your knowledge of self enlarged. Put your hand in mine and let us help one another to see things better."

EVAN CHARTERIS

LIFE OF JOHN S. SARGENT
Letters
1911/12; 1926

John Singer Sargent (1865–1925) was an expatriate American painter working in Paris and London, and a friend of Monet. In the course of writing his biography of Sargent, Evan Charteris sent Monet a copy of Sargent's letter to Frederick Jameson (whose book on modern art Sargent had recently read) for confirmation of Sargent's views of Impressionism. Monet's reply is published in the biography.

MARCH 20 [1911/12].

My dear Jameson,

I have been reading your book with great enjoyment, and feel as if my ideas and my vocabulary had gone through a very satisfactory spring cleaning and I like the opposition of your clear processes of reasoning and analysis as far as that will take one and the ultimate mystery that you lead one up to from the different directions.

There is one point only that I should quibble at and that is your use of the word *Impressionism* and *Impressionist*.

These words were coined in Paris at a particular moment when Claude Monet opened the eyes of a few people to certain phenomena of optics, and they have a very precise meaning which is not the one that you use them for, so that in the exact sense or to a Frenchman Watts' saying "All art is Impressionism" would be a misuse of words.

"Impressionism" was the name given to a certain form of observation when Monet not content with using his eyes to see what things were or what they looked like as everybody had done before him, turned his attention to noting what took place *on his own retina* (as an oculist would test his own vision). It led to his doing 50 pictures of the same object under varying degrees of light and the phenomena which he recorded would be more or less apparent when there was excess or deficiency of light and the fact that he is astigmatic accounts for his having an excellent subject for his own discoveries in this line.

A person with normal eyesight would have nothing to know in the way of "Impressionism" unless he were in a blinding light or in the dusk or dark.

If you want to know what an Impressionist tries for (by the way Degas said there is only one Impressionist "Claude Monet") go out of doors and look at a landscape with the sun in your eyes and alter the angle of your hat brim and notice the difference of colour in dark objects according to the amount of light you let into your eyes – you can vary it from the local colour of the object (if there is less light) to something entirely different which is an appearance on your own retina when there is too much light.

It takes years to be able to note this accurately enough for painting purposes and it would only seem worth while to people who would wear the same glasses as the painter and then it has the effect of for the first time coming across a picture that looks like nature and gives the sense of living – for these reasons Monet bowled me over – and he counts as having added a new perception to Artists as the man did who invented perspective.

This observation or faculty does not make a man an Artist any more than a knowledge of perspective does – it is merely a refining of one's means towards representing things and one step further away from the hieroglyph by adding to the representation of a thing the conscious Will of the Medium through which one sees it.

One of these days some genius will turn it to account and make it part of the necessary equipment of an Artist.

For the present in its exact sense "Impressionism" does not come within the scope of your considerations. Of course I agree with what you say, given the rough and tumble and un-Jamesonlike use of the word.

You can make impression stand for whatever you like but not add -sm or -ist without being challenged by the astigmatic.

<div style="text-align: right">

Yours sincerely,
John S. Sargent.

</div>

TO EVAN CHARTERIS JUNE 21, 1926

Dear Sir,

Forgive me for not having replied earlier but I am still not very well and still cannot write to you myself.

Furthermore, I can only confirm what I told you in our last interview. After having carefully reread your letter and the copy of the one from Sargent, I admit that if the translation of Sargent's letter is accurate, I cannot approve it, firstly because he makes me out to be greater than I am, then because I have always felt a horror of theories, and lastly because all I have is the merit of having painted directly from nature, while trying to pin down my impressions before the most fleeting of effects, and I am very sorry to have been the cause of the name given to a group the majority of which had nothing to do with Impressionism.

With all my regrets at not having been able to give you complete satisfaction, I remain yours sincerely

<div style="text-align: right">

Claude Monet

</div>

WASSILY KANDINSKY

REMINISCENCES

1913

I underwent two experiences which stamped my entire life and which shook me to the marrow. They were the French Impressionist exhibition in Moscow – particularly the "Haystack" by Claude Monet – and a production of Wagner in the Hof Theater: *Lohengrin*.

Previously I had only known realistic art, in fact exclusively the Russians, having often stood for long periods before the hand of Franz Liszt in the

Wassily Kandinsky's (1866–1944) theoretical writings reflect on his discoveries of the relationship between painting's formal elements and meaning. In his Reminiscences, *published in Berlin in 1913, he recalls seeing a Monet* Haystack *as his first experience of painting in an abstract sense.*

portrait by Repin, and the like. And suddenly for the first time I saw a *painting*. That it was a haystack the catalogue informed me. I could not recognize it. Ths non-recognition was painful to me. I considered that the painter had no right to paint indistinctly. I dully felt that the object of the picture was missing. And I noticed with astonishment and confusion that the picture not only draws you but impresses itself indelibly on your memory and, completely unexpectedly, floats before your eyes even to the last detail. All this was unclear to me, and I could not draw the simple conclusions of this experience. But what was entirely clear to me – was the unsuspected power of the palette, which had up to now been hidden from me, and which surpassed all my dreams. Painting acquired a fairy-tale power and splendour. And unconsciously the object was discredited as an indispensable element of a painting. All in all I had the impression, though, that a tiny bit of my fairy-tale Moscow already existed on the canvas. The "light and air" problem of the Impressionists interested me little. I always found that the clever speeches about this problem had very little to do with painting. The theory of the Neo-Impressionists later appeared to me more important, since it was ultimately concerned with the *effect of colours* and left air in peace. Nevertheless I felt at first dimly, later quite consciously, that every theory that is founded on external means represents only an individual case, alongside of which many other cases can exist with equal validity; still later I understood that the external grows from the internal or is stillborn.

Lohengrin, however, seemed to me a full realization of this Moscow. The violins, the deep bass tones, and, most especially, the wind instruments embodied for me then the whole impact of the hour of dusk. I saw all my colours in my mind's eye. Wild, almost insane lines drew themselves before me. I did not dare use the expression that Wagner had painted "my hour" musically. But it became entirely clear to me that art in general is much more powerful than I had realized and that, on the other hand, painting can develop just as much power as music possesses. And my inability to discover these powers or even to seek them made my renunciation all the bitterer.

FERNAND LÉGER

"The Origins of Painting and its Representational Value"

1913

Fernand Léger (1881–1955). Although a friend of Picasso and Braque from 1910, he remained outside their immediate circle. His interpretation of Cubism in terms of realism and the image of twentieth-century modernity was distinctive and independent. Montjoie!, in which this essay appeared, was one of the leading avant-garde periodicals of the pre-war years.

Without having the presumption to try to explain the aim and methods of an art that is already at quite an advanced stage of achievement, I shall try to answer, so far as this is possible, one of the questions most often asked by people who see modern pictures. I transcribe this question in all its simplicity: "What does that represent?" In this talk I shall concentrate on this simple question, and try, very briefly, to prove its complete inanity.

If, in the field of painting, imitation of the object had a value in itself, every picture, by anybody at all, which possessed an imitative quality would also have a value as painting; since I do not think it is necessary to labour the point and discuss such a case, I shall therefore state something which has been said already but needs saying again here: "The *realistic* value of a work is completely independent of all imitative quality."

This truth should be recognized as axiomatic in the general understanding of painting.

I am using the word "realistic" on purpose in its strictest sense, for the quality of a pictorial work is in direct proportion to its quantity of realism.

What is meant by realism in painting?

Definitions are always dangerous, for to enclose a whole concept in a few words requires a concision which over-simplifies and often obscures the issue.

I shall hazard a definition all the same. In my view, pictorial realism is the simultaneous ordering of the three great plastic qualities, line, form and colour.

No work can be truly classical – that is, last independently of the period of its creation – if one completely sacrifices one of these qualities to the detriment [sic] of the other two.

This sort of definition is inevitably rather dogmatic, I know; but I believe that it is necessary in order clearly to distinguish pictures which are classical from those which are not.

All periods have seen facile productions, whose success is as immediate as it is ephemeral, some sacrificing all depth for the sake of the charm of a coloured surface, others being content with a calligraphy and an external form which have even received a name: "Character Painting."

I repeat: all periods have had these productions, and despite all the talent they involve, such works remain no more than period pieces. They date; they may astonish, intrigue their own generation, but as they do not possess the factors needed to attain pure realism, they are bound in the end to disappear. In most of the painters who preceded the Impressionists these three indispensable factors were closely bound up with the imitation of a subject which in itself carried an absolute value. Portraits apart, all compositions – whether decorative or not – served to illustrate either religious or mythological ideas or the facts of history.

The Impressionists were the first to reject *the absolute value of the subject* and instead to consider *its relative value only*.

That is the historical link which explains modern artistic evolution as a whole. The Impressionists are the great originators of the present movement – they are its primitives, in the sense that, trying to free themselves from the imitative aspect, they considered painting in its colour only, almost entirely neglecting form and line.

Their admirable work, which issued from this conception, necessitates the comprehension of a new kind of colour. Their quest for real atmosphere is still relative to the subject: trees, houses melt together and are closely connected, enveloped in a dynamism of colour which the means at their disposal did not as yet enable them to extend *beyond* colour.

The imitation of the subject that is still a part of their work is therefore still no more than a pretext for variety – a theme and nothing more. To the Impressionists a green apple on a red carpet signifies, not the relationship between two objects, but the relationship between two tones, a green and a red.

When this truth had been formulated in living works of art, the present movement was bound to arise. I shall insist particularly on that period of French painting, for I think it is at that moment that the two great concepts of painting – *visual realism* and *realism of conception* – meet, the first completing its curve, which includes all the old painting down to the Impressionists, and the second – realism of conception – beginning with them.

Visual realism, as I have said, necessarily involves an object, a subject, and perspective devices that are now considered negative and anti-realist.

Realism of conception, neglecting all this cumbersome baggage, has been achieved in many contemporary paintings.

Among the impressionists one painter, Cézanne, fully understood what was incomplete about Impressionism. He felt the necessity of renewing *form* and *design* to match the new *colour* of the Impressionists. His life and his work were devoted to the quest for this new synthesis. . . .

The great movements in painting have one thing in common at least: they have always proceeded by revolution and reaction, not by evolution.

Manet destroyed in order to create in his own way. Let us go further back: the painters of the eighteenth century, too sensuous and too mannered, were

succeeded by David and Ingres and their followers, who adopted – and misused – contrary formulae.

This school necessitates Delacroix who, breaking violently with the preceding idea, returns to sensuousness in colour and a great dynamism in forms and drawing.

These examples are enough to show clearly that the modern concept is not a reaction against the idea of the Impressionist but is, on the contrary, a further development of their ideas and widening of their aims by the use of means which they neglected.

The "divisionism" – the fragmentation of colour – which exists, however timidly, in the work of the Impressionists, is being succeeded, not by a static contrast, but by a parallel research into the divisionism of form and of drawing.

And so the work of the Impressionists is not the end of a movement, but the beginning of another, of which the modern painters are the continuers.

The relationship between volume, line and colour will prove to have been at the root of all the production of recent years and of all the influence exercised upon artistic circles both in France and abroad.

From now on, everything can converge towards an intensity of realism obtained by purely dynamic means.

Painterly contrasts in the purest sense (the use of complementaries in colours, lines and forms) are the basic structural elements of modern pictures.

As in the history of pre-Impressionist painting, northern artists will still tend to seek their dynamic means by developing colour, while southern painters will probably give more importance to form and line.

This comprehension of the contemporary painting which has arisen in France is founded on a principle which has universal validity; the Italian futurist movement is one proof of this. Logically, as the picture itself is becoming something greater, output must be restricted.

Every dynamic tendency must necessarily move in the direction of an enlargement of formal means if it is to come to its full expression.

Many people are waiting patiently for the passing of what they call "a phase" in the history of art; they are waiting for *something else*, and they think that modern artists are going through what is perhaps a necessary stage, but will return one day to "painting for everyone."

They are making a great mistake. When an art like this is in possession of all its means, and when these allow it to realize works that are absolutely complete, it is bound to impose itself for a very long time.

We are approaching, I am convinced, a conception of art as all-embracing as those of the great periods of the past: the same tendency to large dimensions, the same collective effort. I should like to dwell on this last point; it has its importance.

Most French literary and artistic movements have manifested themselves in the same way. It is a proof of great vitality and of power to spread. Doubt can be cast on creative work that is isolated; but the vital proof of a work comes when it translates itself *collectively* into highly distinct means of personal expression.

The conception of plastic art as the expression of sentiment is certainly the one closest to the heart of the majority of the public. The old masters, besides achieving purely plastic qualities, had to satisfy this need with their paintings and to carry out a complex social task: to assist in the expressive function of architecture; and with literary values to instruct, educate and amuse the people. To this end they illustrated churches, monuments and palaces with decorative frescoes and pictures representing the great deeds of humanity. Descriptive art was a necessity of the age.

Modern painters lived like everyone else in an age which was neither more or less intellectual than those which preceded it, but only different. In order to impose a new way of seeing, to destroy all that perspective and sentiment together had helped to accumulate, it was necessary for them to have something more than their daring and their individual conception of art.

If their period had not lent itself to this – if their art had not had some affinity with their own time and if it had not been the result of evolution from the art of the past, it would not have been viable.

Present-day life, more fragmented and faster-moving than preceding periods, was bound to accept, as its means of expression, an art of dynamic "divisionism;" and the sentimental side, the expression of the subject (in the vulgar sense of the word "expression"), has reached a critical moment which we must define clearly. . . .

Without attempting to make a comparison between the present evolution, with its scientific inventions, and the revolution accomplished at the end of the Middle Ages by Gutenberg's invention in the field of human expression, I am anxious to point out that modern mechanical achievements such as colour photography, the cinematograph, the profusion of more or less popular novels and the popularization of the theatres have made completely superfluous the development of the visual, sentimental, representational and popular subject in painting.

I wonder, indeed, how all those more or less historical or dramatic pictures shown at the French Salons can hope to compete with what is shown on the screen of any cinema in the world.

Visual realism has never been achieved with such intensity in art as it now is in the cinema.

It could still, a few years ago, be maintained that moving pictures at least lacked colour; but colour photography has been invented. "Subject" pictures no longer have even this resource; their popular appeal, which was their own *raison d'être*, is no more, and the few working-class people who used to be seen in the museums, gaping in front of a cavalry charge by M. Detaille or a historical scene by M. J.-P. Laurens, are no longer to be seen; they are at the cinema.

The average bourgeois also – the man with a small business who, fifty years ago, provided a living for all the minor masters of the suburbs and the provinces – now manages very well without them.

Photography requires less sittings than portrait-painting, gives a more faithful likeness and costs less. The portrait painter is dying out, and genre and history painters will die too; not a heroic death, but simply killed by their period.

One thing will have killed another.

The means of expression having multiplied, plastic art was bound to restrict itself logically to its aim: realism of conception. This was born with Manet, developed in the work of the Impressionists and Cézanne, and is coming to its fulfilment in the work of the painters of today.

Architecture itself, stripped of all those representational ornaments, is emerging from several centuries of false traditionalism and approaching a modern and utilitarian idea of its function.

Architectural art is confining itself to its own means: relationships between lines and the achievement of balance between large masses; decorative art itself is becoming plastic and architectural.

Each art is isolating itself and limiting itself to its own field.

Specialization is a characteristic of modern life, and pictorial art, like all other manifestations of the human mind, must submit to it. The law of specialization is a logical one, for by confining each man to the pursuit of a single aim it intensifies the character of his achievements.

This results in a gain in realism in visual art. The modern conception of art is thus not a passing abstraction valid for a few initiates only; it is the total expression of a new generation whose condition it shares and whose aspirations it answers.

ALBERT GLEIZES AND JEAN METZINGER

CUBISM

1913

Albert Gleizes (1881–1953) and Jean Metzinger (1883–1956) organized the first public showing of Cubist paintings at the Salon des Indépendants in 1911. They were joint authors of Du Cubisme *which was published in 1912 to explain the history and theory of the movement.*

The word *Cubism* is only used here to spare the reader any doubts about the object of this study, and we hasten to state that the idea it implies, volume, could not by itself define a movement which aims at an integral realization of Painting.

However, we do not intend to provide definitions; we only wish to suggest that the joy of taking by surprise an art undefined within the limits of the painting, is worth the effort it demands, and to incite to this effort whoever is worthy of the task.

If we fail, what is the loss! To tell the truth, we are impelled by the pleasure man takes in speaking of the work to which he dedicates his daily life, and we firmly believe that we have said nothing that will fail to confirm real Painters in their personal dilection [*dilection*].

To evaluate the importance of Cubism, we must go back to Gustave Courbet.

This master – after David and Ingres had magnificently brought to an end a secular idealism – instead of wasting himself in servile repetitions like Delaroche and the Devérias, inaugurated a yearning for realism which is felt in all modern work. However, he remained a slave to the worst visual conventions. Unaware that in order to discover one true relationship it is necessary to sacrifice a thousand surface appearances, he accepted without the slightest intellectual control everything his retina communicated. He did not suspect that the visible world only becomes the real world by the operation of thought, and that the objects which strike us with the greatest force are not always those whose existence is richest in plastic truths.

Paul Delaroche (1797–1856) and Eugène Devéria (1808–56), history painters.

Reality is deeper than academic recipes, and more complex also. Courbet was like one who contemplates the Ocean for the first time and who, diverted by the play of the waves, does not think of the depths; we can hardly blame him, because it is to him that we owe our present joys, so subtle and so powerful.

Édouard Manet marks a higher stage. All the same, his realism is still below Ingres' idealism, and his *Olympia* is heavy next to the *Odalisque*. We love him for having transgressed the decayed rules of composition and for having diminished the value of anecdote to the extent of painting "no matter what." In that we recognize a precursor, we for whom the beauty of a work resides expressly in the work, and not in what is only its pretext. Despite many things, we call Manet a realist less because he represented everyday events than because he endowed with a radiant reality many potential qualities enclosed in the most ordinary objects.

After him there was a cleavage. The yearning for realism was split into superficial realism and profound realism. The former belongs to the Impressionists: Monet, Sisley, etc.; the latter to Cézanne.

The art of the Impressionists involves an absurdity: by diversity of colour it tries to create life, yet its drawing is feeble and worthless. A dress shimmers, marvellous; forms disappear, atrophied. Here, even more than with Courbet, the retina predominates over the brain; they were aware of this and, to justify themselves, gave credit to the incompatibility of the intellectual faculties and artistic feeling.

However, no energy can thwart the general impulse from which it stems. We will stop short of considering Impressionism a false start. Imitation is the only error possible in art; it attacks the law of time, which is Law. Merely by the freedom with which they let the technique appear, or showed the constituent elements of a hue, Monet and his disciples helped widen the

horizon. They never tried to make Painting decorative, symbolic, moral, etc. If they were not great painters, they were painters, and that is enough for us to venerate them.

People have tried to make Cézanne into a sort of genius *manqué:* they say that he knew admirable things but that he stuttered instead of singing out. The truth is that he was in bad company. Cézanne is one of the greatest of those who orient history, and it is inappropriate to compare him to Van Gogh or Gauguin. He recalls Rembrandt. Like the author of the *Pilgrims of Emmaus*, disregarding idle chatter, he plumbed reality with a stubborn eye and, if he did not himself reach those regions where profound realism merges insensibly into luminous spirituality, at least he dedicated himself to whoever really wants to attain a simple, yet prodigious method.

He teaches us how to dominate universal dynamism. He reveals to us the modifications that supposedly inanimate objects impose on one another. From him we learn that to change a body's coloration is to corrupt its structure. He prophesies that the study of primordial volumes will open up unheard-of horizons. His work, an homogeneous block, stirs under our glance; it contracts, withdraws, melts, or illuminates itself, and proves beyond all doubt that painting is not – or is no longer – the art of imitating an object by means of lines and colours, but the art of giving to our instinct a plastic consciousness.

He who understands Cézanne, is close to Cubism. From now on we are justified in saying that between this school and the previous manifestations there is only a difference of intensity, and that in order to assure ourselves of the fact we need only attentively regard the process of this realism which, departing from Courbet's superficial realism, plunges with Cézanne into profound reality, growing luminous as it forces the unknowable to retreat.

Some maintain that such a tendency distorts the traditional curve. From where do they borrow their arguments, the future or the past? The future does not belong to them as far as we know, and one must be singularly naïve to seek to measure that which exists by that which exists no longer.

Under penalty of condemning all modern art, we must regard Cubism as legitimate, for it carries art forward and consequently is today the only possible conception of pictorial art. In other words, at present, Cubism is painting itself.

CLIVE BELL

ART

"The Importance of the Impressionists"

1914

Clive Bell (1881–1964), British critic and writer on art who, with Roger Fry, introduced Impressionism and Post-Impressionism into Britain and laid the foundations of formalist art criticism.

When art is as nearly dead as it was in the middle of the nineteenth century, scientific accuracy is judged the proper end of painting. Very well, said the French Impressionists, be accurate, be scientific. At best the Academic painter sets down his concepts; but the concept is not a scientific reality; the men of science tell us that the visible reality of the Universe is vibrations of light. Let us represent things as they are – scientifically. Let us represent light. Let us paint what we see, not the intellectual superstructure that we build over our sensations. That was the theory: and if the end of art were representation it would be sound enough. But the end of art is not representation, as the great Impressionists, Renoir, Degas, Manet, knew (two of them happily know it still) the moment they left off arguing and bolted the studio door on that brilliant theorist, Claude Monet. Some of

them, to be sure, turned out polychromatic charts of desolating dullness – Monet towards the end, for instance. The Neo-Impressionists – Seurat, Signac, and Cross – have produced little else. And any Impressionist, under the influence of Monet and Watteau, was capable of making a poor, soft, formless thing. But more often the Impressionist masters, in their fantastic and quite unsuccessful pursuit of scientific truth, created works of art tolerable in design and glorious in colour. Of course this oasis in the mid-century desert delighted the odd people who cared about art; they pretended at first to be absorbed in the scientific accuracy of the thing, but before long they realized that they were deceiving themselves, and gave up the pretence. For they saw very clearly that these pictures differed most profoundly from the anecdotic triumphs of Victorian workshops, not in their respectful attention to scientific theory, but in the fact that, though they made little or no appeal to the interests of ordinary life, they provoked a far more potent and profound emotion. Scientific theories notwithstanding, the Impressionists provoked that emotion which all great art provokes – an emotion in the existence of which the bulk of Victorian artists and critics were, for obvious reasons, unable to believe. The virtue of these Impressionist pictures, whatever it might be, depended on no reference to the outside world. What could it be? "Sheer beauty," said the enchanted spectators. They were not far wrong.

That beauty is the one essential quality in a work of art is a doctrine that has been too insistently associated with the name of Whistler, who is neither its first nor its last, nor its most capable, exponent – but only of his age the most conspicuous. To read Whistler's "Ten o'Clock" will do no one any harm, or much good. It is neither very brilliant nor at all profound, but it is in the right direction. Whistler is not to be compared with the great controversialists any more than he is to be compared with the great artists. To set "The Gentle Art" beside "The Dissertation on the Letters of Phalaris," Gibbon's "Vindication," or the polemics of Voltaire, would be as unjust as to hang "Cremorne Gardens" in the Arena Chapel. Whistler was not even cock of the Late Victorian walk; both Oscar Wilde and Mr Bernard Shaw were his masters in the art of controversy. But amongst Londoners of the "eighties" he is a bright figure, as much alone almost in his knowledge of what art is, as in his power of creating it: and it is this that gives a peculiar point and poignance to all his quips and quarrels. There is dignity in his impudence. He is using his rather obvious cleverness to fight for something dearer than vanity. He is a lonely artist, standing up and hitting below the belt for art. To the critics, painters, and substantial men of his age he was hateful because he was an artist; and because he knew that their idols were humbugs he was disquieting. Not only did he have to suffer the grossness and malice of the most insensitive pack of butchers that ever scrambled into the seat of authority; he had also to know that not one of them could by any means be made to understand one word that he spoke in seriousness. Overhaul the English art criticism of that time, from the cloudy rhetoric of Ruskin to the journalese of "'Arry," and you will hardly find a sentence that gives ground for supposing that the writer has so much as guessed what art is. "As we have hinted, the series does not represent any Venice that we much care to remember; for who wants to remember the degradation of what has been noble, the foulness of what has been fair?" – "'Arry" in the "Times." No doubt it is becoming in an artist to leave all criticism unanswered; it would be foolishness in a schoolboy to resent stuff of this sort. Whistler replied; and in his replies to ignorance and insensibility, seasoned with malice, he is said to have been ill-mannered and caddish. He was; but in these respects he was by no means a match for his most reputable enemies. And ill-mannered, ill-tempered, and almost alone, he was defending art, while they were flattering all that was vilest in Victorianism.

As I have tried to show in another place, it is not very difficult to find a flaw in the theory that beauty is the essential quality in a work of art – that is, if the word "beauty" be used, as Whistler and his followers seem to have

James Abbott McNeill Whistler (1834–1903), American painter resident in London and Paris, gave his "Ten O'Clock" lecture on February 20, 1885; it was published in England and (translated by Mallarmé) in France in 1888.

Harry Quilter, the Times *art critic.*

used it, to mean insignificant beauty. It seems that the beauty about which they were talking was the beauty of a flower or a butterfly; now I have very rarely met a person delicately sensitive to art who did not agree, in the end, that a work of art moved him in a manner altogether different from, and far more profound than, that in which a flower or a butterfly moved him. Therefore, if you wish to call the essential quality in a work of art "beauty" you must be careful to distinguish between the beauty of a work of art and the beauty of a flower, or, at any rate, between the beauty that those of us who are not great artists perceive in a work of art and that which the same people perceive in a flower. Is it not simpler to use different words? In any case, the distinction is a real one: compare your delight in a flower or a gem with what you feel before a great work of art, and you will find no difficulty, I think, in differing from Whistler.

Anyone who cares more for a theory than for the truth is at liberty to say that the art of the Impressionists, with their absurd notions about scientific representation, is a lovely fungus growing very naturally on the ruins of the Christian slope. The same can hardly be said about Whistler, who was definitely in revolt against the theory of his age. For we must never forget that accurate representation of what the grocer thinks he sees was the central dogma of Victorian art. It is the general acceptance of this view – that the accurate imitation of objects is an essential quality in a work of art – and the general inability to create, or even to recognize, aesthetic qualities, that mark the nineteenth century as the end of a slope. Except stray artists and odd amateurs, and you may say that in the middle of the nineteenth century art had ceased to exist. That is the importance of the official and academic art of that age: it shows us that we have touched bottom. It has the importance of an historical document. In the eighteenth century there was still a tradition of art. Every official and academic painter, even at the end of the eighteenth century, whose name was known to the cultivated public, whose works were patronized by collectors, knew perfectly well that the end of art was not imitation, that forms must have some aesthetic significance. Their successors in the nineteenth century did not. Even the tradition was dead. That means that generally and officially art was dead. We have seen it die. The Royal Academy and the Salon have been made to serve their useful, historical purpose. We need say no more about them. Whether those definitely artistic cliques of the nineteenth century, the men who made form a means to aesthetic emotion and not a means of stating facts and conveying ideas, the Impressionists and the Aesthetes, Manet and Renoir, Whistler and Conder, &c. &c., are to be regarded as accidental flowers blossoming on a grave or as portents of a new age, will depend upon the temperament of him who regards them.

But a sketch of the Christian slope may well end with the Impressionists, for Impressionist theory is a blind alley. Its only logical development would be an art-machine – a machine for establishing values correctly, and determining what the eye sees scientifically, thereby making the production of art a mechanical certainty. Such a machine, I am told, was invented by an Englishman. Now, if the praying-machine be admittedly the last shift of senile religion, the value-finding machine may fairly be taken for the psychopomp of art. Art has passed from the primitive creation of significant form to the highly civilized statement of scientific fact. I think the machine, which is the intelligent and respectable end, should be preserved, if still it exists, at South Kensington or in the Louvre, along with the earlier monuments of the Christian slope. As for that uninteresting and disreputable end, official nineteenth-century art, it can be studied in a hundred public galleries and in annual exhibitions all over the world. It is the mouldy and therefore the obvious end. The spirit that came to birth with the triumph of art over Graeco-Roman realism dies with the ousting of art by the picture of commerce.

But if the Impressionists, with their scientific equipment, their astonishing technique, and their intellectualism, mark the end of one era, do they

not rumour the coming of another? Certainly today there is stress in the cryptic laboratory of Time. A great thing is dead; but, as that sagacious Roman noted:

> haud igitur penitus pereunt quaecumque videntur, quando alid ex alio reficit natura nec ullam rem gigni patitur nisi morte adiuta aliena.

And do not the Impressionists, with their power of creating works of art that stand on their own feet, bear in their arms a new age? For if the venial sin of Impressionism is a grotesque theory and its justification a glorious practice, its historical importance consists in its having taught people to seek the significance of art in the work itself, instead of hunting for it in the emotions and interests of the outer world.

HANS HOFMANN

EXCERPTS FROM HIS TEACHINGS

"On the Aims of Art"

1932

"Not utterly then perish all things that are seen, since nature renews one thing from out another, nor suffers anything to be begotten, unless she be requited by another's death." Lucretius, De Rerum Natura, *Book I, 262–4.*

German-born painter and teacher of painting, Hans Hofmann (1880–1966) was one of the most influential of the artists who emigrated to New York in the 1930s and 1940s. Many leading members of the post-war American avant-garde, both artists and critics, served their apprenticeship in the school of art which he founded in 1934.

ON LIGHT AND COLOUR

We recognize visual form only by means of light, and light only by means of form, and we further recognize that colour is an effect of light in relation to form and its inherent texture. In nature, light creates colour; in painting, colour creates light.

In symphonic painting, colour is the real building medium. "When colour is richest, form is fullest." This declaration of Cézanne's is a guide for painters.

Swinging and pulsating form and its counterpart, resonating space, originate in colour intervals. In a colour interval, the finest differentiations of colour function as powerful contrasts. A colour interval is comparable to the tension created by a form relation. What a tension signifies in regard to form, an interval signifies in regard to colour; it is a tension between colours that makes colour a plastic means.

A painting must have form and light unity. It must light up from the inside through the intrinsic qualities which colour relations offer. It must not be illuminated from the outside by superficial effects. When it lights up from the inside, the painted surface breathes, because the interval relations which dominate the whole cause it to oscillate and to vibrate.

A painted surface must retain the transparency of a jewel which stands as a prototype of exactly ordered form, on the one hand, and as a prototype of the highest light emanation on the other.

The Impressionists led painting back to the two-dimensional in the picture through the creation of a light unity, whereas their attempt to create atmosphere and spatial effectiveness by means of colour, resulted in the impregnation of their works with the quality of translucence which became synonymous with the transparency of the picture plane.

Light must not be conceived as illumination – it forces itself into the picture through colour development. Illumination is superficial. Light must be created. In this manner alone is the balance of light possible.

The formation of a light unity becomes identified with the two-dimensionality of the picture. Such a formation is based on comprehending light complexities. Colour unity, in the same manner, is identified with the two-dimensionality of the picture. It results from colour tensions created by colour intervals. Thus the end product of all colour intervals is two-dimensionality.

Spatial and formal unity and light and colour unity create the plastic two-dimensionality of the picture.

Since light is best expressed through differences in colour quality, colour should not be handled as a tonal gradation, to produce the effect of light.

The psychological expression of colour lies in unexpected relations and associations.

MEYER SCHAPIRO

MARXIST QUARTERLY

"The Nature of Abstract Art"

January 1937

If we consider an art that is near us in time and is still widely practised, like Impressionism, we see how empty is the explanation of the subsequent arts by reaction. From a logical viewpoint the antithesis to Impressionism depends on how Impressionism is defined. Whereas the later schools attacked the Impressionists as mere photographers of sunshine, the contemporaries of Impressionism abused it for its monstrous unreality. The Impressionists were in fact the first painters of whom it was charged that their works made as little sense right side up as upside down. The movements after Impressionism take different directions, some toward simplified natural forms, others toward their complete decomposition; both are sometimes described as historical reactions against Impressionism, one restoring the objects that Impressionism dissolved, the other restoring the independent imaginative activity that Impressionism sacrificed to the imitation of nature.

Actually, in the 1880s there were several aspects of Impressionism which could be the starting points of new tendencies and goals of reaction. For classicist painters the weakness of Impressionism lay in its unclarity, its destruction of definite linear forms; it is in this sense that Renoir turned for a time from Impressionism to Ingres. But for other artists at the same moment Impressionism was too casual and unmethodical; these, the neo-Impressionists, preserved the Impressionist colourism, carrying it even further in an unclassical sense, but also in a more constructive and calculated way. For still others, Impressionism was too photographic, too impersonal; these, the symbolists and their followers, required an emphatic sentiment and aesthetic activism in the work. There were finally artists for whom Impressionism was too unorganized, and their reaction underscored a schematic arrangement. Common to most of these movements after Impressionism was the absolutizing of the artist's state of mind or sensibility as prior to and above objects. If the Impressionists reduced things to the artist's sensations, their successors reduced them further to projections or constructions of his feelings and moods, or to "essences" grasped in a tense intuition.

The historical fact is that the reaction against Impressionism came in the 1880s before some of its most original possibilities had been realized. The painting of series of chromatic variations of a single motif (the *Haystacks*, the *Cathedral*) dates from the 1890s; and the *Water-Lilies*, with their remarkable spatial forms, related in some ways to contemporary abstract art, belong to the twentieth century. The effective reaction against Impressionism took place only at a certain moment in its history and chiefly in France, though Impressionism was fairly widespread in Europe by the end of the century. In the 1880s, when Impressionism was beginning to be accepted officially,

Meyer Schapiro (b. 1904), American art historian and art critic. He was one of the first writers on Impressionism to interpret it in terms of its social and political context.

330

there were already several groups of young artists in France to whom it was uncongenial. The history of art is not, however, a history of single wilful reactions, every new artist taking a stand opposite the last, painting brightly if the other painted dully, flattening if the other modelled, and distorting if the other was literal. The reactions were deeply motivated in the experience of the artists, in a changing world with which they had to come to terms and which shaped their practice and ideas in specific ways.

The tragic lives of Gauguin and Van Gogh, their estrangement from society, which so profoundly coloured their art, were no automatic reactions to Impressionism or the consequences of Peruvian or Northern blood. In Gauguin's circle were other artists who had abandoned a bourgeois career in their maturity or who had attempted suicide. For a young man of the middle class to wish to live by art meant a different thing in 1885 than in 1860. By 1885 only artists had freedom and integrity, but often they had nothing else. The very existence of Impressionism which transformed nature into a private, unformalized field for sensitive vision, shifting with the spectator, made painting an ideal domain of freedom; it attracted many who were tied unhappily to middle-class jobs and moral standards, now increasingly problematic and stultifying with the advance of monopoly capitalism. But Impressionism in isolating the sensibility as a more or less personal, but dispassionate and still outwardly directed, organ of fugitive distinctions in distant dissolving clouds, water and sunlight, could no longer suffice for men who had staked everything on impulse and whose resolution to become artists was a poignant and in some ways demoralizing break with good society. With an almost moral fervour they transformed Impressionism into an art of vehement expression, of emphatic, brilliant, magnified, obsessing objects, or adjusted its colouring and surface pattern to dreams of a seasonless exotic world of idyllic freedom.

Early Impressionism, too, had a moral aspect. In its unconventionalized, unregulated vision, in its discovery of a constantly changing phenomenal outdoor world of which the shapes depended on the momentary position of the casual or mobile spectator, there was an implicit criticism of symbolic social and domestic formalities, or at least a norm opposed to these. It is remarkable how many pictures we have in early Impressionism of informal and spontaneous sociability, of breakfasts, picnics, promenades, boating trips, holidays and vacation travel. These urban idylls not only present the objective forms of bourgeois recreation in the 1860s and 1870s; they also reflect in the very choice of subjects and in the new aesthetic devices the conception of art as solely a field of individual enjoyment, without reference to ideas and motives, and they presuppose the cultivation of these pleasures as the highest field of freedom for an enlightened bourgeois detached from the official beliefs of his class. In enjoying realistic pictures of his surroundings as a spectacle of traffic and changing atmospheres, the cultivated rentier was experiencing in its phenomenal aspect that mobility of the environment, the market and of industry to which he owed his income and his freedom. And in the new Impressionist techniques which broke things up into finely discriminated points of colour, as well as in the "accidental" momentary vision, he found, in a degree hitherto unknown in art, conditions of sensibility closely related to those of the urban promenader and the refined consumer of luxury goods.

As the contexts of bourgeois sociability shifted from community, family and church to commercialized or privately improvised forms – the streets, the cafés and resorts – the resulting consciousness of individual freedom involved more and more an estrangement from older ties; and those imaginative members of the middle class who accepted the norms of freedom, but lacked the economic means to attain them, were spiritually torn by a sense of helpless isolation in an anonymous indifferent mass. By 1880 the enjoying individual becomes rare in Impressionist art; only the private spectacle of nature is left. And in neo-Impressionism, which restores and even monumentalizes the figures, the social group breaks up into

isolated spectators, who do not communicate with each other, or consists of mechanically repeated dances submitted to a preordained movement with little spontaneity.

The French artists of the 1880s and 1890s who attacked Impressionism for its lack of structure often expressed demands for salvation, for order and fixed objects of belief, foreign to the Impressionists as a group. The title of Gauguin's picture – *Where do we come from? What are we? Where are we going?* – with its interrogative form, is typical of this state of mind. But since the artists did not know the underlying economic and social causes of their own disorder and moral insecurity, they could envisage new stabilizing forms only as quasi-religious beliefs or as a revival of some primitive or highly ordered traditional society with organs for a collective spiritual life. This is reflected in their taste for medieval and primitive art, their conversions to Catholicism and later to "integral nationalism." The colonies of artists formed at this period, Van Gogh's project of a communal life for artists, are examples of this groping to reconstitute the pervasive human sociability that capitalism had destroyed. Even their theories of "composition" – a traditional concept abandoned by the Impressionists – are related to their social views, for they conceive of composition as an assembly of objects bound together by a principle of order emanating, on the one hand, from the eternal nature of art, on the other, from the state of mind of the artist, but in both instances requiring a "deformation" of the objects. Some of them wanted a canvas to be like a church, to possess a hierarchy of forms, stationed objects, a prescribed harmony, preordained paths of vision, all issuing, however, from the artist's feeling. In recreating the elements of community in their art they usually selected inert objects, or active objects without meaningful interaction except as colours and lines.

ALFRED BARR

MATISSE: HIS ART AND HIS PUBLIC

"Cézanne's Three Bathers"

1951

Pissarro in the mid-'70s had confirmed Gauguin's interest in Cézanne and in 1885 had persuaded Signac to buy a Cézanne landscape. And it was Pissarro again, almost fifteen years later, who encouraged Matisse to study the master of Aix. Matisse remembers almost word for word an early and enlightening conversation with Pissarro which he dictated recently to Pierre Matisse.

PISSARRO: Cézanne is not an Impressionist because all his life he has been painting the same picture. [Matisse here explained that Pissarro was referring to the "bathers" picture which Cézanne repeated so obsessively, pursuing and developing the same qualities of composition, light, etc.] He has never painted sunlight, he always paints grey weather.
MATISSE: What is an Impressionist?
PISSARRO: An Impressionist is a painter who never paints the same picture, who always paints a new picture.
MATISSE: Who is a typical Impressionist?
PISSARRO: Sisley.

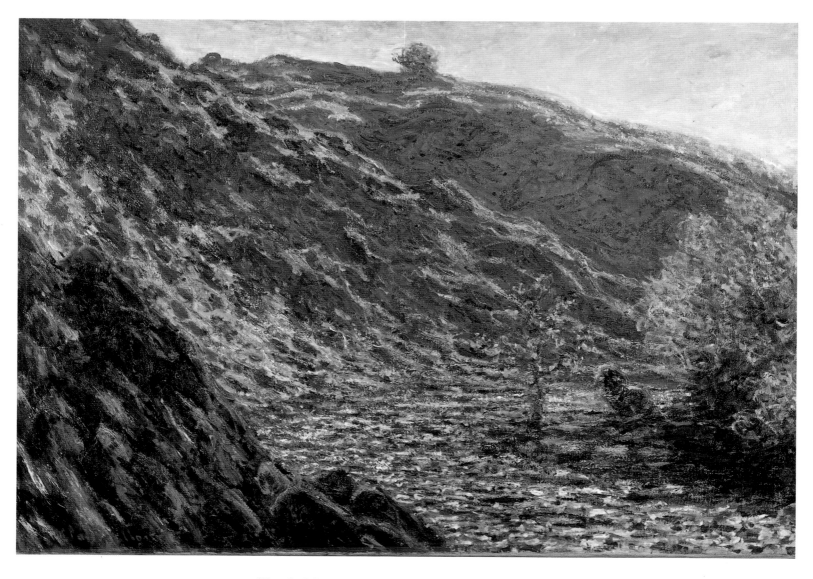

COLOURPLATE 105. Claude Monet. *Torrent, Creuse*. 1888–9. 25½ × 36½″ (64.8 × 72.7 cm).
The Art Institute of Chicago (Potter Palmer Collection).

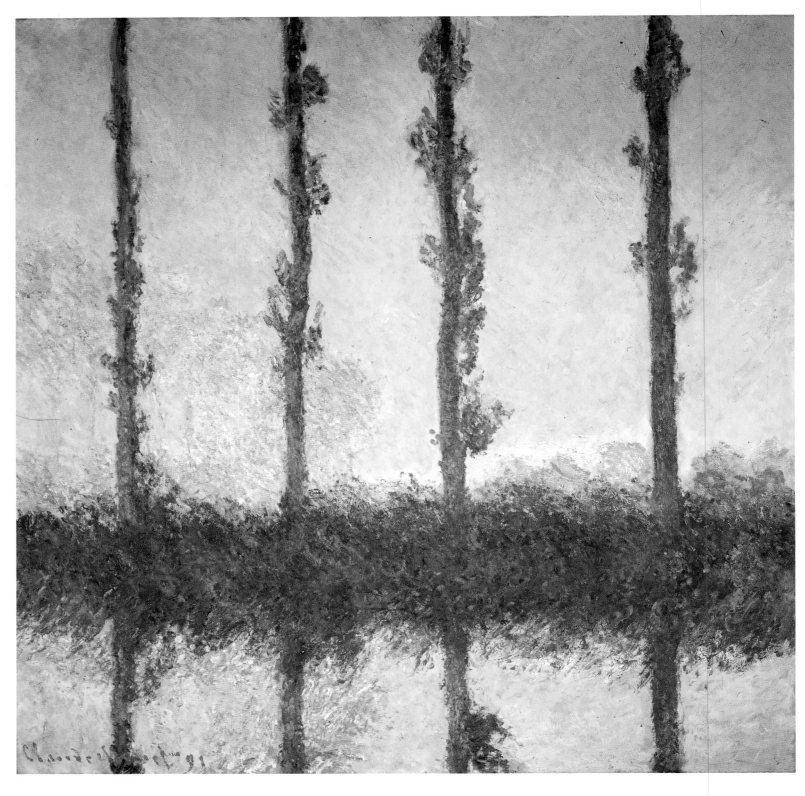

COLOURPLATE 106. Claude Monet. *Poplars*. 1891. 32¼ × 32⅛″ (81.9 × 81.6 cm).
Metropolitan Museum of Art, New York (Bequest of Mrs H. O. Havemeyer; The H. O. Havemeyer Collection).

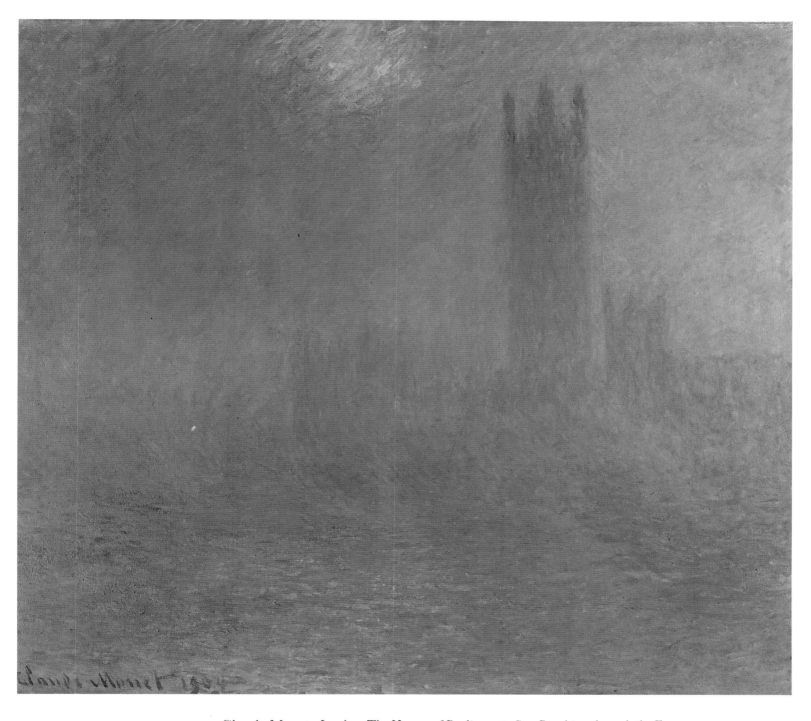

COLOURPLATE 107. Claude Monet. *London, The Houses of Parliament: Sun Breaking through the Fog.* 1904.
31⅞ × 36¼″ (81 × 92 cm).
Musée d'Orsay, Paris.

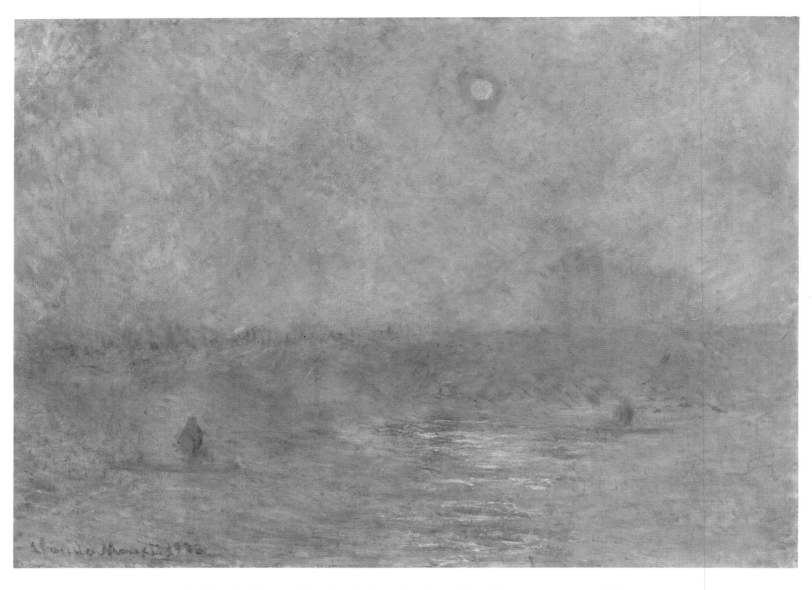

COLOURPLATE 108. Claude Monet. *Waterloo Bridge: Sun through the Mist.* 1903. 29 × 39½″ (73.7 × 100.3 cm).
National Gallery of Canada, Ottawa.

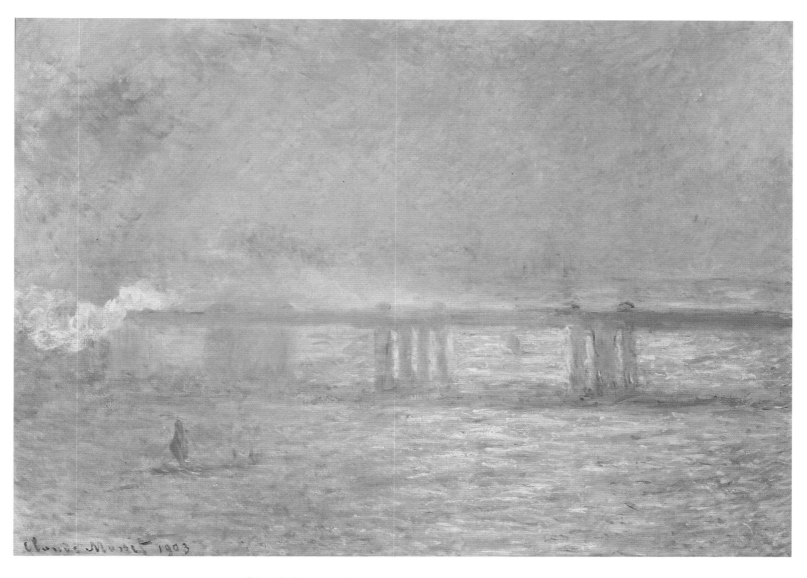

COLOURPLATE 109. Claude Monet. *Charing Cross Bridge*. 1903. 29 × 39½″ (73.7 × 100.3 cm).
Saint Louis Art Museum, Missouri (Museum Purchase).

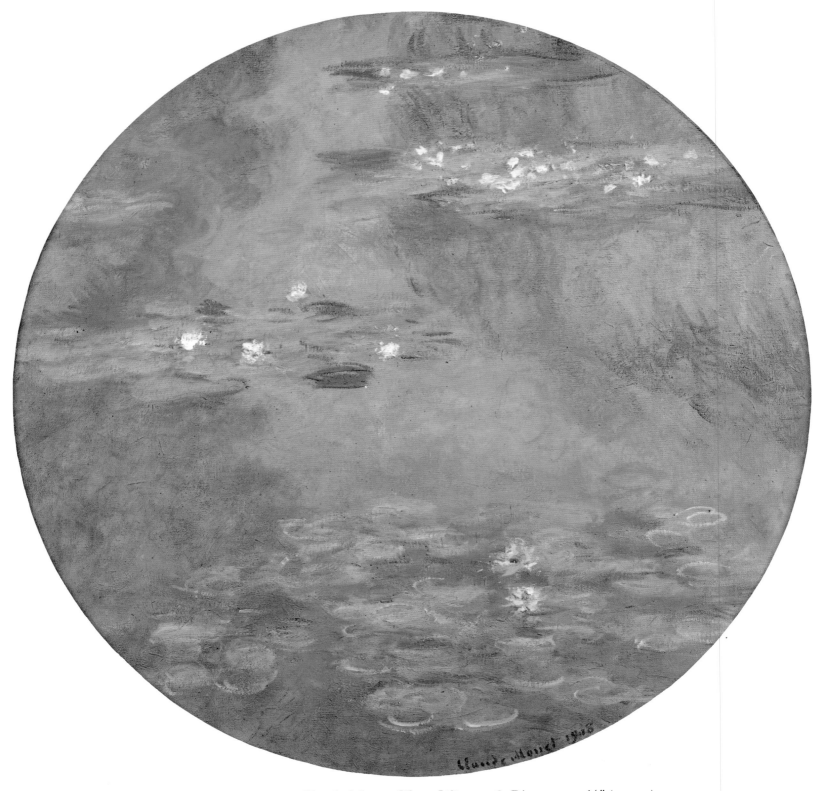

COLOURPLATE 110. Claude Monet. *Water-Lilies*. 1908. Diameter 35½″ (90 cm).
Musée Municipal Alphonse Georges Poulain, Vernon.

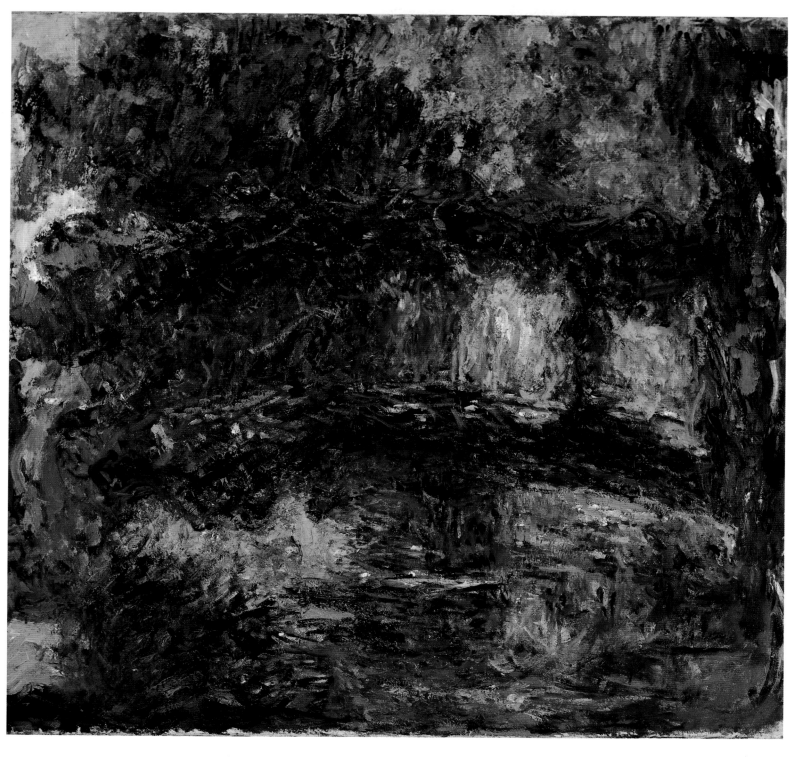

COLOURPLATE 111. Claude Monet. *The Japanese Footbridge.* 1912–15. 35 × 36¾″ (88.9 × 93.4 cm).
Museum of Fine Arts, Houston, Texas (John A. and Audrey Jones Beck Collection).

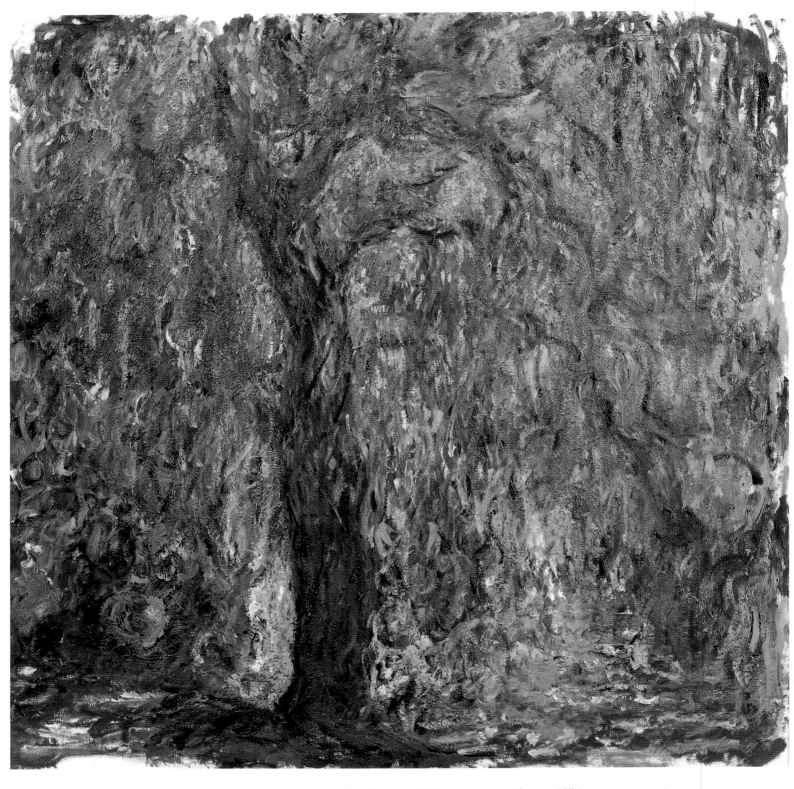

COLOURPLATE II2. Claude Monet. *The Weeping Willow.* 1919. 39⅜ × 39⅜″ (100 × 100 cm).
Musée Marmottan, Paris.

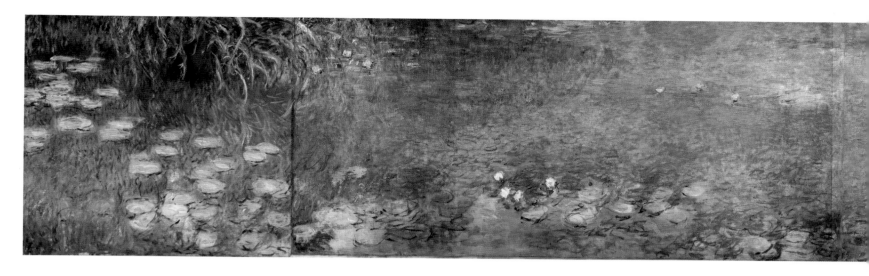

COLOURPLATE 113. Claude Monet. *Morning*. 1916–26. Four-part mural, 6′ 5½″ × 39′ 8¾″ (197 × 1211 cm). Galerie de l'Orangerie, Paris.

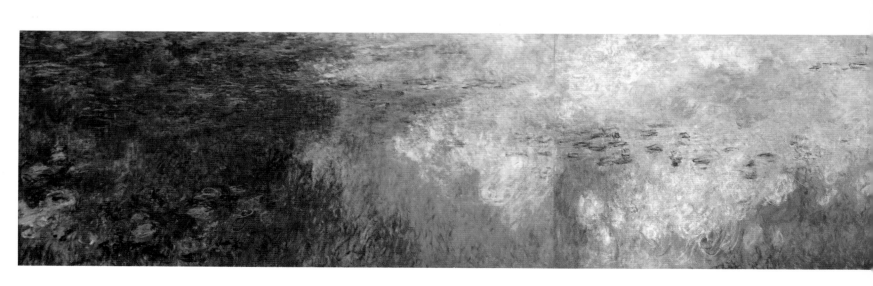

COLOURPLATE 114. Claude Monet. *The Clouds*. 1922–6. 6′ 5½″ × 41′ 9″ (197 × 1271 cm). Galerie de l'Orangerie, Paris.

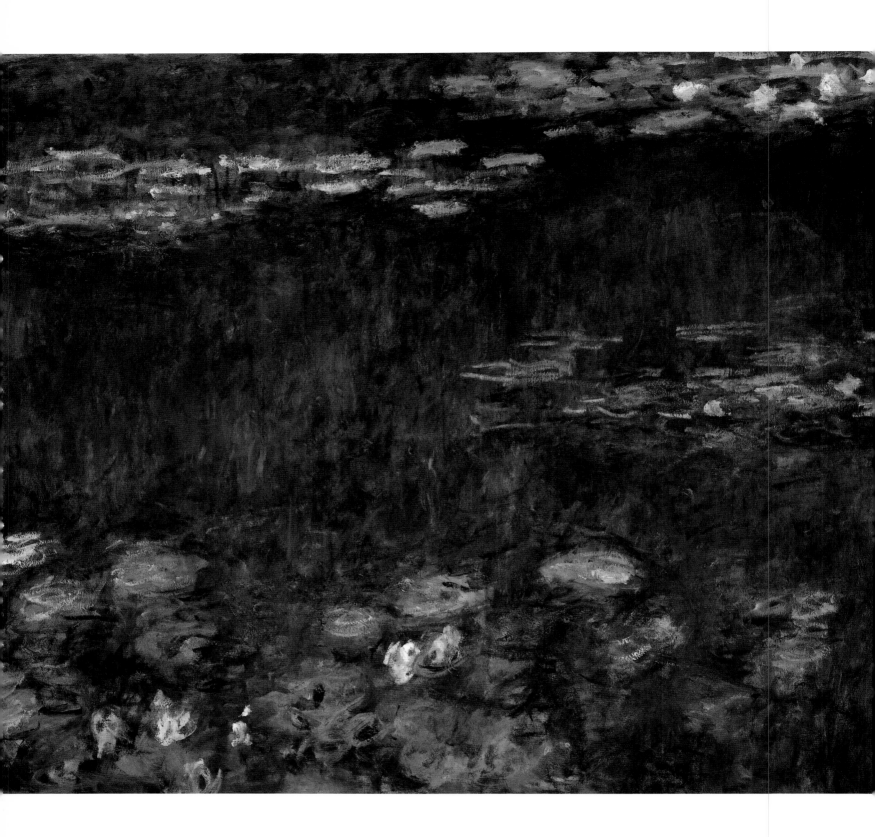

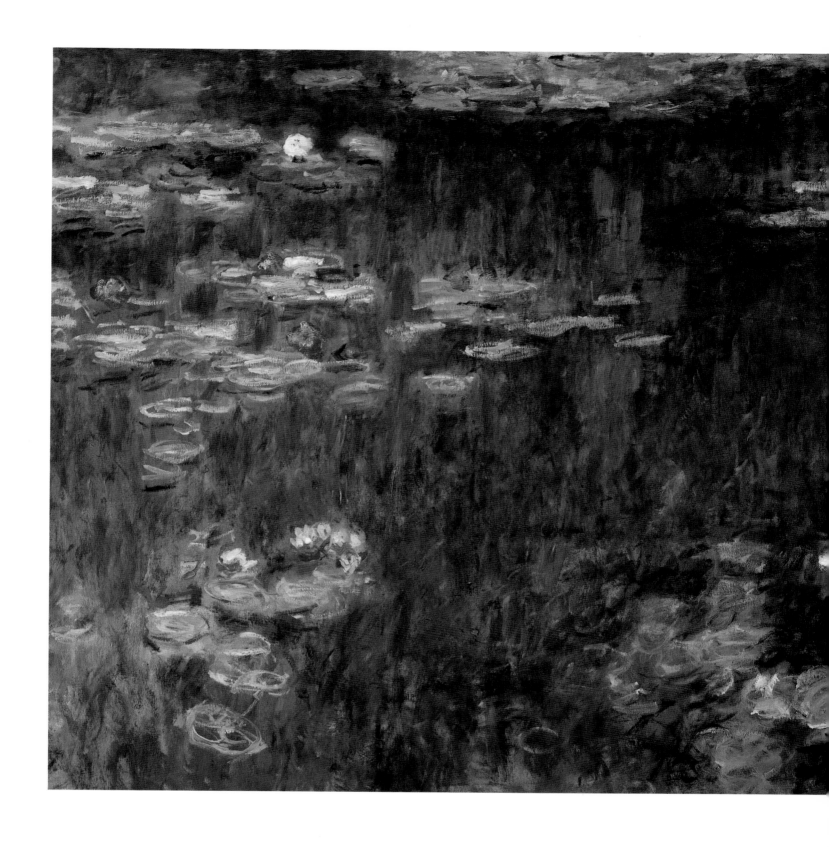

343

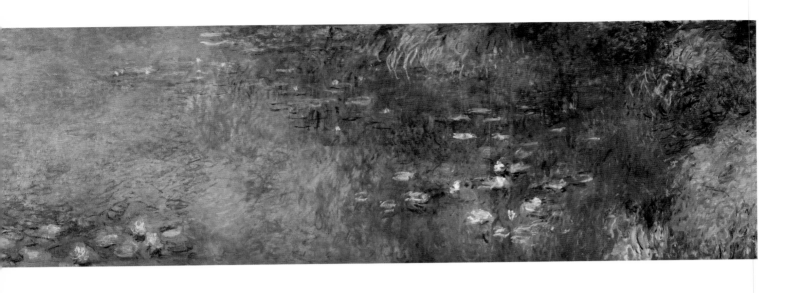

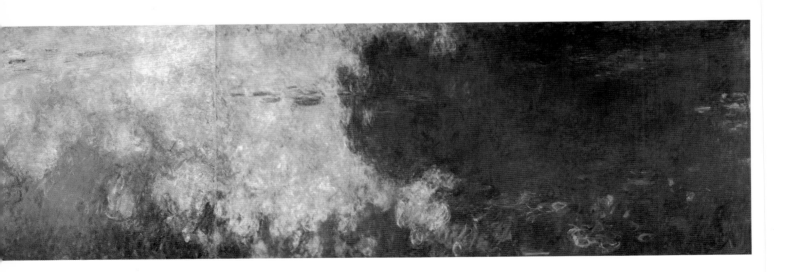

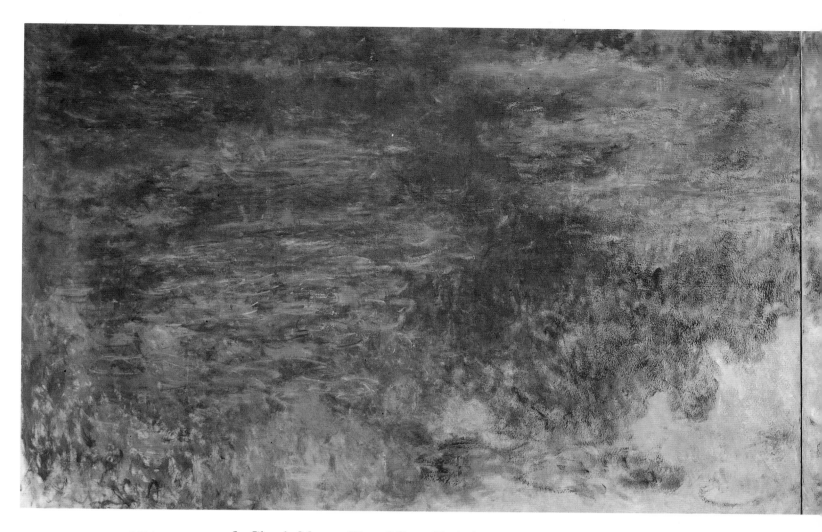

COLOURPLATE 116. Claude Monet. *Water-Lilies at Twilight*. 1916–22. 6′ 6¾″ × 19′ 8¼″ (200 × 600 cm). Kunsthaus, Zurich.

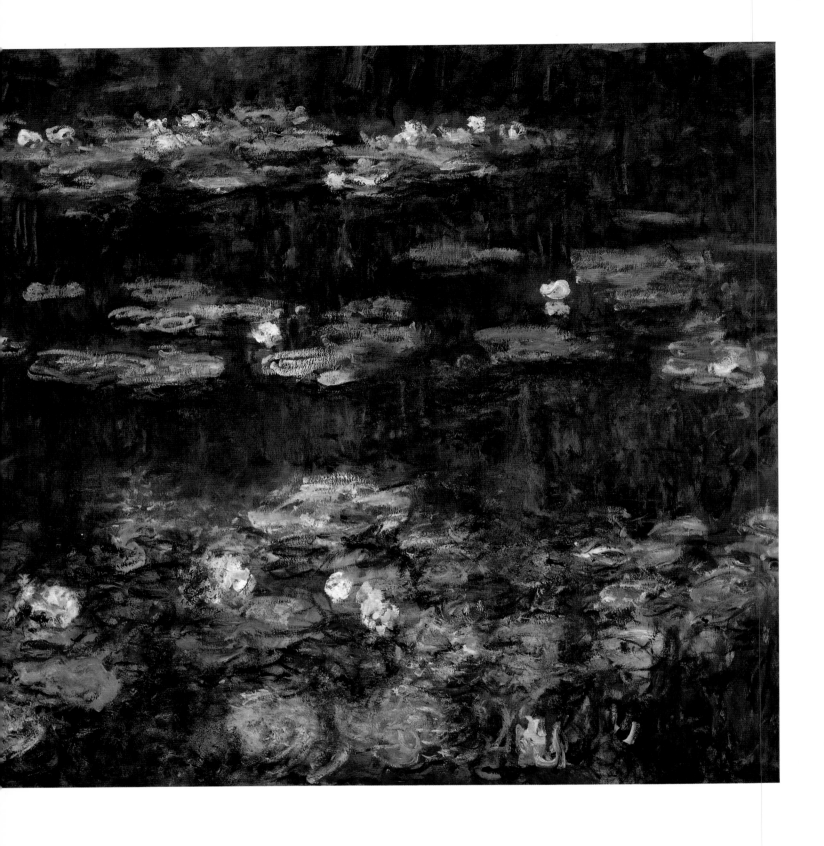

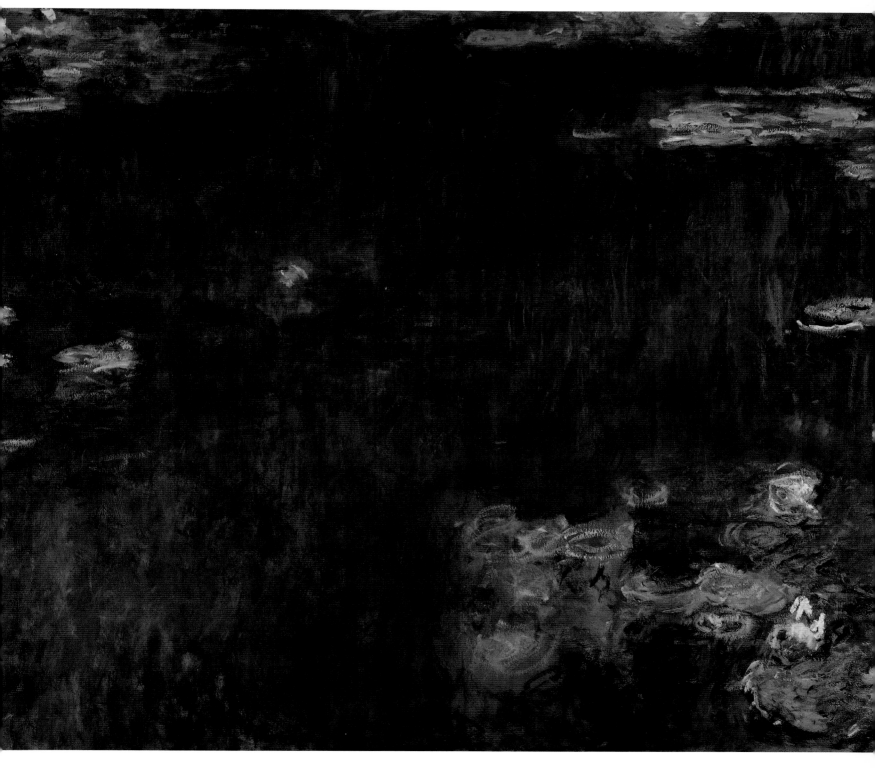

COLOURPLATE 115. Claude Monet. *Green Reflections*. 1914–18. Diptych, 6′ 5½″ × 27′ 9½″ (197 × 847 cm).
Galerie de l'Orangerie, Paris.

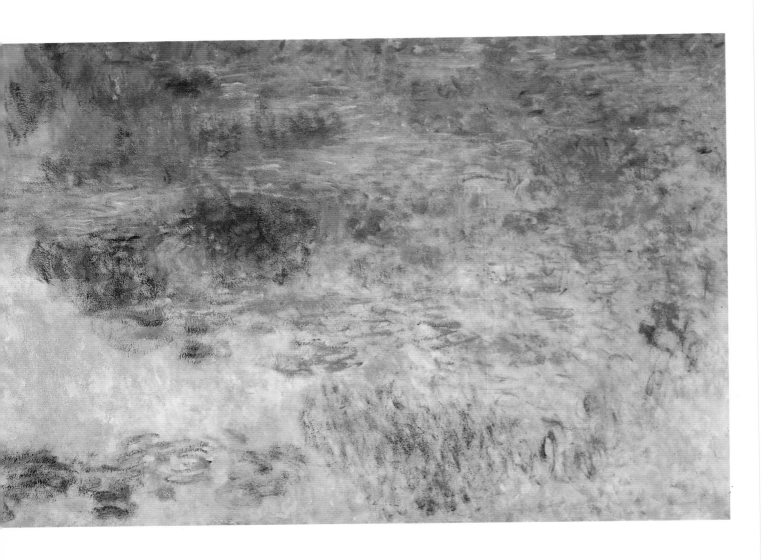

ANDRÉ MASSON

VERVE

"Monet le Fondateur"

1952

André Masson (1896–1987), an associate of André Breton and member of the Surrealist Movement from 1924.

The limpid eye, the *Raphael of the waters*, the *Master of Giverny* . . . he was venerated by his peers; then came the brutal eclipsing of the elders by swaggering youth quite naturally eager for "other things;" a wavering in taste, a loss of popularity.

His position, which was and remains of the first importance, would not in any way have been questioned if it had been admitted that it is vain, all in all, to try to remake the history of art, even if an arbitrary change in values seems necessary for the justification of contemporary adventures and exploits.

Monet's oeuvre is one of the great turning-points in painting. It created an upheaval. It meant the primacy of light (or, if one prefers, of light colour). From Bordighera he spoke of *brilliance*, of *light*, of *flame*. "Here all is iridescent, flambé." These few words suffice to authenticate him. His passion for the sun sees brightness everywhere, even in shadow, and nothing in his joyous oeuvre will be black, not even coal! His logic forbade it, as did his artistic theories; yet if his obsession with light made its mark on all his companions, they did not follow him completely on this point.

A painter of appearances (he is no theologian), he was in harmony with reality, giving a lyrical and enthusiastic account of it. He accepted the passing of time, and the ephemeral. He had a new way of seeing, of feeling, of loving nature.

Perhaps he too often allowed it to be said that he was satisfied with registering sensations of colour: "Let the eye live its own life," he said. The truth is that he knew better than anyone how to "organize his sensations," how to choose a dominant tone from amongst the inrush of infinite iridescence.

To stress the point: the enveloping atmosphere is created by the initiative of the artist. He does not abandon himself to the passivity of sight; nature offers him a profusion of relationships which he then sums up in a few main harmonies: here the imagination reclaims its rights.

There is no *a priori* form. Based on the power of light, intensification through colour has as its consequence the negation of the outlines – or limits. The finished work finds its point of balance in the fusion of its parts. The absence of formal outline will bring about prodigious invention in the realm of the brush-stroke. It is this that will give rise to the different elements making up the picture (the main one being the atmosphere). The touch has multiple accents: criss-cross, dishevelled, hesitant. Look at it from close to: what frenzy! It is sometimes positively truculent, as in the *Cathedrals*.

In Monet's first period the brush-stroke was sometimes discreet and calm, and captured the vibration of light serenely and movingly, as in a masterpiece of that time, *Saint-Germain-l'Auxerrois*. In the *Storm at Étretat*, in the museum in Lyons, and in *The Galettes* he anticipated the manner of the painter of the Sunflowers; but without the graphic stylization characteristic of the latter.

At all events, whether it was slashed or streaky, swirling or tangled, this outrageous brushwork originally prevented the scandalized public from "seeing the landscape." "Stand back," they were told. Today, this advice should be stood on its head: come close and let your eyes move over the most dazzling proof of the whirlwind set spinning by the pictorial instinct.

The "opinions" of Cézanne on art were recorded by Émile Bernard: "There are two things in the painter, the eye and the mind; each of them should aid the other. It is necessary to work at their mutual development, in the eye by looking at nature, in the mind by the logic of organized sensations which provides the means of expression."

Van Gogh was the painter of sunflowers.

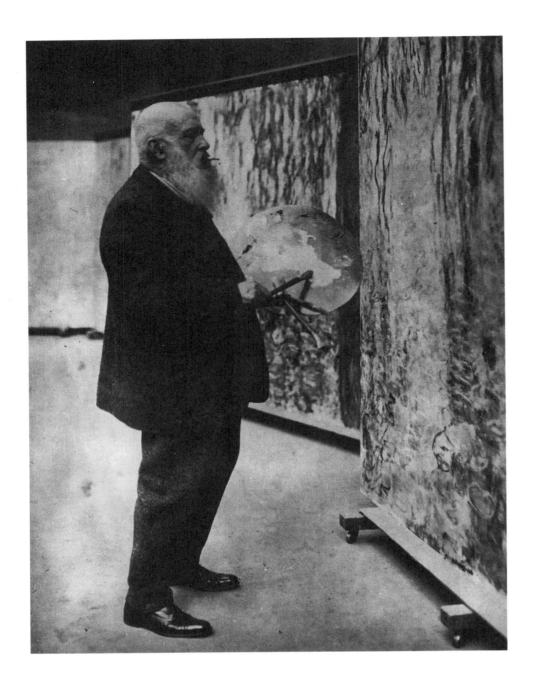

Photograph of Monet painting in the
Waterlilies studio on his 80th birthday,
1920.

Some synthetic strokes – or accents – sometimes accompany the coloured masses and "signify" them. Never will Monet be as close to the Japanese prints he set such store by as in certain paintings of Holland. This use of broad, almost flat surfaces is already in evidence in some of his very early paintings, where he was influenced by Manet's simplicity of style: in the Amsterdam canvases these are not surfaces established through "values," but already pure colour. However, his good genius saves him from using the naïve colour of the crude colour-print.

One might dream of a Claude Monet moving towards the use of the great bright, variegated expanses which were the fief of Veronese or Tiepolo. Let us dream no more, and consider his supreme work, the *Water-Lilies*. Despite their monumental size, they have nothing of the character of the great Venetian or Flemish decorations. His bent seems to me to be that of a great easel painter who decides to allow his vision a range wide enough – imposing enough – for it to embrace the whole world. (A sheet of water will suffice to be identified with the universe.) A cosmic vision, I would say, had this word not recently been debased, and put forward in connection with everyone and everything. Thus Michelangelo, creator of unique and solitary figures, awaits the day when a Vatican chapel will allow him to take wing, to show his omnipotence. That is why I take pleasure in saying

quite seriously that the Orangerie des Tuileries is the Sistine Chapel of Impressionism: a secluded place, in the heart of Paris, as it were conferring a blessed inaccessibility upon the great oeuvre it conceals: one of the high points of French genius.

Many months ago, I wrote to Georges Besson to tell him of my desire to see your young painters discovering Claude Monet. It seemed to me equally timely that he should be rediscovered by the less young.

Georges Besson, author of a monograph on Renoir.

An encouragement to start again afresh, in order to do violence to destiny and rediscover the divine experience. Divine? That is to say, human in the extreme.

A renewed contact with the unique moment (sublimation will be necessary) will rescue us from our various intellectual dead-ends, will lead us to the elaboration of a new depth by means of a rediscovered limpidity. For one cannot "begin" Impressionism all over again; but one can once more heed its most precious counsel: stay in the forefront!

GASTON BACHELARD

THE RIGHT TO DREAM

1952; 1954

Gaston Bachelard (1884–1962), French philosopher concerned with a phenomenological explanation of the relationship between the physical world and the poetic imagination.

WATER LILIES OR SURPRISES OF A SUMMER'S DAWN

Water lilies are the flowers of summer. They mark the point beyond which summer will abide by her promise. It is when the water lily flowers appear on the lake that the wise gardener takes his orange trees out of the greenhouse. And if September finds the water lily already shedding its petals, the winter will be long and hard. Only the early riser and rapid worker can gather, as Claude Monet did, a goodly store of this aquatic beauty, and tell the brief and burning story of the flowers of the river.

Picture him then, our Claude, setting out in the early morning. Does he recall, as he makes his way toward the water lily pond, that Mallarmé, the great Stéphane Mallarmé took the nymphea, the white water lily, to symbolize some Leda pursued by love? Does he recite to himself those lines in which the poet likens the lovely flower to a "noble swan's egg . . . swollen with no other force than that exquisite emptiness of self . . . ?" Caught up already in joyful anticipation of making his canvas blossom, joking with his "model" as much here in the fields as at home in the studio, he asks:

What kind of egg has the lily laid this night?

He smiles at the prospect of the surprise awaiting him. He quickens his pace. But

The white flower sits already in its egg cup.

And the whole pond smells of this fresh young flower, rejuvenated by night.

When evening comes – Monet saw this hundreds of times – the young flower disappears to spend the night beneath the water. They say it is the stem, retracting, that draws the flower down toward the dark, muddy bed. And every dawn, after the sound sleep of a summer's night, the nymphea bloom, *Mimosa pudica* of the water, is reborn with the light. And so she remains forever young, this spotless daughter of water and the sun.

This prodigal recovery of youth, this loyal obedience to the rhythm of day and night, this punctuality in announcing the very moment of sunrise – these qualities make the nymphea the floral epitome of Impressionism. The nymphea is an instant of the world. It is a morning of the eyes. It is the flower of surprise in a summer's dawn.

Doubtless there comes a day when the flower is too large, too blown, too conscious of its beauty to go into hiding when evening falls. It is as lovely as a breast. Its whiteness has taken on the faintest tinge of pink, the palest flush of temptation without which the white would be unaware of its whiteness. Did not another age name this flower the "distaff of Venus" (*clavus veneris*)? Was it not, in the life of mythology that precedes the life of all things, Heraclion the nymph who died of jealousy and her too great love of Hercules?

But Monet smiles at this flower suddenly become permanent. It is the very one that was immortalized yesterday by his brush. And so the painter can continue the story of the water's youth.

Everything in a stretch of water is new when morning comes. What vitality the chameleon-river must have to respond so immediately to the kaleidoscope of newborn light! The life of the trembling water alone renews all the flowers. The slightest movement of a quiet stream provokes an array of floral beauty.

"Moving water, flowers the water's heartbeats . . ." writes the poet. One flower more complicates the whole stream. The straighter the reed the lovelier the ripples. And a young water iris, piercing the green tangle of the water lilies, prompts the painter immediately to share with us its astonishing triumph. There it stands, every sword drawn, every leaf a finely honed blade, dangling its sulphurous tongue with stinging irony high above the water.

A philosopher musing before one of Monet's water pictures might, if he dared, develop a dialectics of the iris and the water lily, the dialectics of the straight leaf and the leaf which calmly, soberly, weightily reposes upon the surface. It is the very dialectics, surely, of the aquatic plant: the one, driven by we know not what spirit of rebellion, wishing to rise above its native element, the other remaining loyal to its element. The nymphea has learned from stagnant water its lesson of calm. Dreaming such a dialectic dream one might perhaps feel, in all its utter fragility, the sweet verticality evident in the life of stagnant waters.

The painter, however, feels all that instinctively and knows how to find in reflections a sound principle for the composition in depth of the calm universe of water.

So it is that the trees lining the bank exist in two dimensions. The shadows of their trunks enhance the depth of the pond. It is impossible to dream beside a stretch of water without formulating a dialectics of depth and reflection. It is as if the reflection is fed by some substance rising from the water's depths. The muddy bed acts like the silvering on a mirror. It joins a material darkness to all the shadows that are offered to it. The stream bed too, for the painter, holds some subtle surprises.

Sometimes a lone bubble rises from the depths, blurting out in the silence of the surface as the plant breathes, as the pond heaves a sigh. And the dreamer with the paintbrush is provoked to pity as by some cosmic tragedy. Does some deep ill lurk beneath this Eden of flowers? Are we to recall with Jules Laforgue the curse of garlanded Ophelia

And the white water lilies of the lakes where sleeps Gomorrah.

For the most cheerful, flower-strewn pool on the brightest of mornings conceals a brooding gravity.

But let us, allowing this philosophic cloud to pass, return with our painter to the dynamics of beauty.

The world asks to be seen: before ever there were eyes to see the eye of the waters, the huge eye of still waters watched the flowers bloom. And it was in this reflection – who will deny it! – that the world first became aware of its beauty. Just as, from the time when Monet first looked at a water lily, the

water lilies of the Ile-de-France have been more beautiful, more splendid. They float now upon our streams with more leaves, in greater tranquillity, sober and docile as pictures of Lotus-children. I read somewhere, I forget where, that in some Eastern gardens, to make the flowers more beautiful and make them bloom earlier and more deliberately, with unclouded confidence in their own beauty, people went to the trouble to place two lamps and a mirror lovingly before each vigorous stem that bore the promise of a young bloom. The flower could thus admire itself at night and take a ceaseless delight in its splendour.

Monet would have understood this immense charity toward the beautiful, this encouragement offered by man to all that tends toward beauty, for did he not spend his whole life enhancing the beauty of everything that fell beneath his gaze? At Giverny, when he was a rich man – so late in life! – he had a team of water gardeners to wash every stain from the broad leaves of his flowering water lilies, to generate just the right currents to stimulate their roots, to bend a little lower the weeping willow branch which, caught by the wind, ruffled the mirrored surface of the water.

In fact, in everything he did and in every endeavour of his art, Monet was a servant and guide of the forces of beauty that direct the world.

* * *

THE PAINTER SOLICITED BY THE ELEMENTS

Anterior to the work, the painter, like every creator, knows the contemplative musing, the pondering upon the nature of things. Indeed the painter experiences the revelation of the world through light too intimately not to participate with his whole being in this ceaselessly reiterated birth of a universe. There is no art more directly and palpably recreative than painting. For a great painter, meditating on the power of his art, colour is a seminal force. Knowing that colour works upon matter, that it is a veritable activity of matter, that colour lives from a constant interchange of forces between matter and light, the painter, with the fatality of primitive fancies, renews the great cosmic dreams that bind man to the elements – to fire, water, the air of the heavens, and the prodigious materiality of the substances of the earth.

Consequently colour, for the painter, possesses depth, it has a thickness, it unfolds simultaneously in a dimension of intimacy and in a dimension of exuberance. If the painter toys for a moment with flat colour or with uniform colour, it is the better to fill out a shadow, to inspire elsewhere a dream of inner depth. All the time he is working, the painter is guiding dreams that lie between matter and light, an alchemist's dreams in which he creates substances, heightens luminosities, harnesses tones that blaze too sharply, ordains contrasts in which we are constantly aware of struggles between elements. We have evidence of this in the so different dynamisms of reds and greens.

The moment we come to compare the basic themes of alchemy with the crucial intuitions of the painter we are struck by the kinship between them. A yellow painted by van Gogh is an alchemistic gold, a gold plundered from a thousand flowers and worked like some solar honey. It is never simply the gold of the wheat or the flame or the straw-bottomed chair; it is a gold individualized for all time by the endless reveries of genius. It no longer belongs to the world but is the property of a man, a man's heart, the elemental truth discovered in a lifetime of contemplation.

This kind of *generation* of new matter, rediscovering by a sort of miracle the forces of colour, takes some of the urgency out of the figurative/non-figurative debate. Things are no longer simply painted or drawn. They are born coloured, born through the very action of colour. With Van Gogh we suddenly become aware of a sort of ontology of colour. Universal fire branded a predestined man, and this fire distended the very stars in the sky. Such is the temerity of an active element, an element that stimulates matter sufficiently to turn it into a new light.

For it is always by virtue of its active character that a primordial element solicits the painter. The painter makes a crucial choice, a choice in which he engages his will, and his will does not alter its course until the work is completed. Through this choice the painter achieves the *colour he wants*, and which is so different from the accepted colour, the colour imitated. This desired colour, this fierce, aggressive colour takes its part in the struggle of the basic elements.

Let us take as an example the struggle between stone and air.

One day Claude Monet wanted the cathedral to be a truly airy thing — airy in its substance, airy to the very core of the masonry. So the cathedral took from the blue-coloured mist all the blue matter that the mist itself had taken from the sky. Monet's whole picture takes its life from this transference of blue, this alchemy of blue. This mobilization of blue has the effect of mobilizing the cathedral. Feel how the two towers are trembling with every shade of blue in the vastness of the air. See how the cathedral responds, in all its thousand nuances of blue, to every swirl of mist. It has wings, blue wings, undulating wings. Part of the periphery evaporates in gentle disobedience to the geometry of lines. An hour's impression would never have produced such a metamorphosis of grey stone into empyrean stone. The great painter has to listen dimly to the alchemistic voices of elemental transformation. Out of a still world of stone he created a drama of blue light.

Of course, if one does not participate at the deepest level of the imagination of the material elements, in the naturally excessive character of the *aerial element*, one will fail to recognize this drama of the elements, this struggle between earth and sky. One will tax the painting with being unrealistic whereas one ought, in order to have full benefit of contemplation, to go to the very core of the reality of the elements by following the painter in his primordial will, in his unquestioned confidence in a universal element.

On another occasion a different elemental dream took hold of the will to paint. Monet wanted the cathedral to become a sponge of light, absorbing in every course of masonry and every piece of ornament the ochre of the setting sun. This time the cathedral is a mellow, buff-coloured heavenly body, resembling some creature that has fallen asleep in the heat of the day. The two towers soared higher in the sky when they were infused with the aerial element. Here they are closer to the ground, more earthbound, burning only with a little blaze, like a well-tended fire in its hearth.

In this case, too, we do violence to the reserves of dream contained in the work of art if we do not supplement our contemplation of its form and colour with a meditation upon the energy of the matter which nourishes that form and gives off that colour, if we do not feel the stone being "stirred by the inner workings of heat."

The painter, then, from one canvas to the other, from the aerial canvas to the solar canvas, has effected a transmutation of matter. He has rooted colour within matter. He has found a basic material element and dug his colour into it. He urges us to a contemplation in depth by inviting us to warm to the impulse to colour that gives objects their dynamism. He has taken stone and made of it in turn mist and heat. It is quite inadequate to say that the building is "bathed" in misty twilight in the one case or in glowing twilight in the other. For a real painter, objects create their own atmosphere, all colour is an irradiation, each and every colour the unveiling of one of the secrets of matter.

If one's contemplation of a work of art is to rediscover the germs of its creation, it must open itself up to the great cosmic choices that mark the imagination of man so profoundly. Too geometric a mind, too analytical a vision, too aesthetic a judgment or one too encumbered with technical terms — any of these may prohibit participation in the cosmic forces of the elements. Such participation is a delicate affair. It is not enough simply to gaze at a stretch of water to understand water's quality of absolute motherhood, to experience water as a vital element and the original seat of all life. How many painters, lacking that special sensibility called for by the

mysteries of water, harden the liquid surface until, in Baudelaire's phrase, "the ducks swim in stone"! Participation in this gentlest and simplest of substances and that which is most subject to the other elements, requires total sincerity and long acquaintanceship. It takes a lot of dreaming to understand a stretch of still water.

And so the elements – fire, water, air and earth – which for so long served philosophers for thinking grandly of the universe, still remain principles of artistic creation. Their action upon the imagination may seem remote and it may seem metaphorical. And yet as soon as we find a work of art's proper appurtenance to an elemental cosmic force, we have the feeling of having discovered a *ground of unity* that strengthens the unity of even the best composed works. The fact is that in accepting the solicitation of the imagination of the elements, the painter receives the natural germ of an act of creation.

CLEMENT GREENBERG

ART NEWS ANNUAL

"Claude Monet: The Later Monet"

1957

Clement Greenberg (b. 1909), American writer on art and one of the most influential critics of art since the war. His advocacy of New York artists in the 1950s established the reputation of Abstract Expressionism against the dominance of the School of Paris and contributed to current definitions of Modernism.

Monet is beginning to receive his due. Recently the Museum of Modern Art and Walter Chrysler, Jr., have each bought one of the huge *Water Lilies* that were painted between 1915 and 1925, in the same series as those the French government installed in the Paris Orangerie in 1926. An avant-garde painter like André Masson and a critic like Gaston Bachelard write about him admiringly. A collector of very modern art in Pittsburgh concentrates on his later works, and the prices of these are rising again. Even more important, their influence is felt – whether directly or indirectly – in some of the most advanced painting now being done in this country.

The first impulse is to back away from a vogue – even when one's own words may have contributed to it. But the righting of a wrong is involved here, though that wrong – which was a failure in appreciation – may have been inevitable and even necessary at a certain stage in the evolution of modern painting. Fifty years ago Monet seemed to have nothing to tell ambitious young artists except how to persist in blunders of conception and taste. Even Monet's own taste had not caught up with his art. In 1912 he wrote to the elder Durand-Ruel: "And today more than ever I realize how factitious the unmerited [*sic*] success is that has been accorded me. I always hope to arrive at something better, but age and troubles have exhausted my strength. I know very well in advance that you will find my canvases perfect. I know that they will have great success when shown, but that's indifferent to me, since I know they are bad and am sure of it." Three years later he was to begin the Orangerie murals.

In middle and old age Monet turned out many bad pictures. But he also turned out more than a few very good ones. Neither the larger public, which admired him unreservedly, nor the avant-garde of that time, which wrote him off without qualification, seemed to be able to tell the difference. As we know, after 1918 enlightened public as well as critical esteem went decidedly to Cézanne, Renoir and Degas, and to Van Gogh, Gauguin and Seurat, while the "orthodox" Impressionists, Monet, Pissarro and Sisley, fell into comparative disfavour. It was then that the "amorphousness" of Impressionism became a received idea. And it was forgotten that Cézanne had belonged to, and with, Impressionism as he had belonged to nothing else.

Monet's life spanned 86 years, began in commercial Le Havre, ended in the vine-hung, pond-filled gardens of Giverny where for some 45 years he lived and worked, evolving the diffuse, almost abstract style which is having special influence on painters today. Born the same month as another epochal modernist, Rodin Monet numbered among his last friends, pall-bearers at his funeral, the painters Bonnard and Vuillard, and the states-man Clemenceau. The latter, in sensitive remembrance of the artist's lifelong love of colour, there replaced the traditional black coffin-pall with Monet's own bright-hued bedspread. The new righting of the balance seems to have begun during the last war with the growing appreciation of the works of Pissarro's last decade. Our eyes seemed to become less insensitive to a general greying tone that narrowed or attenuated contrasts of dark and light. But Pissarro still built a rather clearly articulated illusion in depth, which led critics hypnotized by Cézanne to exempt him from many of the charges they still brought against Monet and Sisley. The general pallor – or else general dusk – to which Monet became addicted in his last phase permitted only hints and notations of depth to come through, and that in what seemed to be – and very often was – an uncontrolled way. Atmosphere gave much in terms of colour, but it took away even more in those of three-dimensional form. Nothing could have meant less to the good taste of the decades dominated by Matisse and Picasso.

Sixty and seventy years ago Monet's later manner both stimulated and met – as did Bonnard's and Vuillard's early work – the new appetite for close-valued, flat effects in pictorial art. His painting was enthusiastically admired by *fin-de-siècle* aesthetes, including Proust. But in a short time its diaphanous iridescences had gone into the creation of that new, candy-box ideal of "beauty" which supplanted the chromo-lithographic one of Victorian times in popular favour. Never before or since the 1900s, appar-ently, did the precious so quickly become the banal. By 1920 popular and academic diffusion had reacted upon Monet's later art to invest it with a period flavour that made it look old-fashioned even to eyes not offended by what the avant-garde found wrong in it. Only now – when the inter-war period, with its repudiation of everything popular just before 1914, is beginning to be repudiated in its own turn – are these extrinsic associations starting to fade.

Worldly success came earlier to Monet, and in larger measure, than to any of the other master Impressionists. All of them desired it, and most of them, like Monet, needed it in order to support themselves and their families. Their attitude to the public was never intransigent. They worried about how to make an impression on the art market and were not above trying, up to a point, to satisfy the demands of prospective buyers. Cézanne, as we know, wanted all his life to make the official Salon, and few of them were ready to reject official honours. Yet the Impressionists, even after their "consecration," continued to be revolutionary artists, and their integrity established an example for all subsequent avant-gardes.

By 1880, Monet had marked himself off from his fellow Impressionists as a self-promoter, publicity-seeker and a shrewd businessman. This last he, who had been the most penurious of them all in the beginning, remained to the end; his sense of timing in raising the prices of his pictures was better than that of his dealers. This does not mean that he compromised in his work. Nor did he ever get enough satisfaction from success to feel satisfied with his art. On the contrary, after 1880, when the original momentum of Impressionism slackened even as the movement itself began to win accept-ance, he became increasingly prey to self-doubt.

The Impressionists were neither worldly nor innocent, but transcended the alternative, as men of ripened individuality usually do. It is remarkable how few airs they gave themselves, and how little they wore of the *panache* of the artist. Formed by the 1860s, which was a great school in radicalism, resoluteness and mental toughness, they retained a certain hardness of head

Monet photographed in 1920 by Henri Manuel.

356

that prevailed over personal eccentricities, even in Cézanne's and Degas' cases. Among them, Monet, Pissarro and Cézanne seem at this distance to form a group of their own – less by reason of their art or personal association than by their way of life and work. We see them – all three, stocky, bearded men – going out every day to work in the open, applying themselves to the "motif" and registering their "sensations" with fanatical patience and obsessive regularity – prolific artists in the high nineteenth-century style. Though men of fundamentally sophisticated and urban culture (Monet had the least education of the three), by middle age they were all weatherbeaten and a little countrified, without social or any other kind of graces. And yet how un-naïve they were.

The personalities of painters and sculptors seldom are as pointedly reported as those of writers. But Monet dead may be easier to approach than Monet alive. We get the impression of an individual as moody as Cézanne, if with more self-control; given to fits of discouragement and to brooding and fretting over details; absolutely unpretentious and without phrases, indeed without very many ideas, but with definite and firm inclinations. And though supposedly a programmatic painter and for a time held to be the leader of the Impressionists, he had even less than Sisley to put into words, much less theory, about his art. There was a kind of force in him that was also a kind of inertia: unable to stop when once at work, he found it equally difficult – so he himself says – to resume after having been idle for a length of time. Usually, it was the weather that interrupted him, upon which he was more dependent than a peasant. Sisley alone was a more confirmed landscapist.

Like most of the other Impressionists, Monet was not in the habit of waiting for the right mood in order to start working; he turned out painting as steadily and indefatigably as Balzac turned out prose. Nonetheless, each new day and each new picture meant renewed doubts and renewed struggle. His life's work contained, for him, little of the comforts of routine. It is significant that Monet undertook works that had the character of planned, pondered, definitive, master- or set-pieces only at the very beginning and the very end of his career; otherwise, it was dogged, day-in, day-out painting. Certainly he produced too much, and it belonged to his way of work that the bad should come out not only along with the good, but in much greater quantity. And at his worst he could look more than bad – he could look inept. Yet I feel that it was to the eventual benefit of his art that he did not settle at any point into a manner that might have guaranteed him against clumsiness. The ultimate, prophetic greatness he attained in old age required much bad painting as a propaedeutic. Monet proceeded as if he had nothing to lose, and in the end proved to be as daring and "experimental" an artist as Cézanne.

That he lacked capacity for self-criticism was to his advantage in the long run. A nice taste in an artist can alienate him from his own originality, and inhibit it. Not that Monet did not try to exercise taste in his work – or at least in finishing it. He would fuss endlessly with his pictures before letting them go, and rarely complete one to his satisfaction. Contrary to what he himself gave people to understand, he did not stop painting when the motif was no longer before him, but would spend days and weeks retouching pictures at home. The excuse he gave to Durand-Ruel at first was that he had to meet the taste of collectors for "finished" pictures, but obviously it was his own taste and his own conception of what was to be considered finished that played the largest part. One can well imagine that more paintings were spoiled than improved in the process, given the tendency of self-doubts such as those that afflicted Monet to suppress the effects of spontaneity once the stimulus of the motif was no longer there. When he stopped correcting himself obsessively and became more slapdash, "realization," it seems to me, became more frequent, and greater in scope.

If Monet was the one who drew the most radical conclusions from the premises of Impressionism, it was not with truly doctrinaire intent. Im-

pressionism was, and expressed, his personal, innermost experience, doctrine or no doctrine. The quasi-scientific aim he set himself in the 1890s – to record the effects of light on the same motif at different times of day and in different weather – may have involved a misconception of the ends of art, but it was more fundamentally part of an effort – compelled by both his own experience and his own temperament – to find a principle of consistency for pictorial art elsewhere than in the precedent of the past. Monet could not bring himself to believe in the Old Masters as Cézanne and Renoir did – or rather, he could not profit by his belief in them. In the end he found what he was looking for, which was not so much a new principle as a more comprehensive one: and it lay not in Nature, but in the essence of art itself, in its "abstractness." That he himself could not consciously recognize or accept "abstractness" – the qualities of the medium alone – as a principle of consistency makes no difference: it is there, plain to see in the paintings of his old age.

The example of Monet's art shows how untrustworthy a mistress Nature can be for the artist who would make her his only one. He first sank into prettiness when he tried to match the extravagance of Mediterranean light while keeping his colour in key according to Impressionist methods: an incandescent violet would demand an incandescent yellow; an incandescent green, an incandescent and saccharine pink; and so on. Complementaries out-bidding each other in luminosity became the ruin of many of his paintings, even where they were not handicapped to start with by the acceptance of an over-confined motif, such as a row of equidistant poplars all of the same shape and size, or one – i.e. two or three lily pads floating in a pond – that offered too little incident to design. Here a transfiguring vision was required, and Monet seemed to paint too much by method and trust himself too much to a literal honesty within his method.

But this was not always the case, and literal honesty, to his own sensations rather than to Nature, could at times save a picture for art. Monet had an adventurous spirit, rather than an active imagination, that prompted him to follow, on foot and analytically as it were, wherever his sensations led. Sometimes the literalness with which these were registered was so extreme as to become an hallucinated one, and land him not in prettiness, but on the far side of expected reality, where the visual facts turned into phantasmagoria – phantasmagoria all the more convincing and consistent as art because without a shred of fantasy. This same fidelity to his sensations permitted Monet to confirm and deepen Impressionism's most revolutionary insight, which has also been its most creative one: that values – the contrasts and gradations of dark and light – were indispensable neither to the representation of Nature nor to the integrity of pictorial art. This discovery, made in an effort to get closer to Nature, was later to be turned against her, and by Monet first of all.

After the period of his classical Impressionism, his main difficulty was in the matter of *accentuation*. His concern with unity and "harmony" and the desire to reproduce the equity with which Nature distributed her illumination would lead him to accent a picture repetitiously in terms of colour. He would be too ready to give "equivalences" of tone precedence over "dominants" – or else the last would be made altogether too dominant. The intensity of vision and its registration could become an unmodulated, monotonous one and cancel itself out, as in some of the paintings of the Rouen cathedral. At times the motif itself could decide otherwise: the sudden red of a field of poppies might explode the complementaries and equivalences into a higher, recovered, unity; but Monet seems to have become more and more afraid of such "discords."

There was good reason for his, and Pissarro's, obsession with unity. The broken, divided colour of full-blown Impressionism – which became full-blown only after 1880, in Monet's and Sisley's hands – tended to keep the equilibrium between the illusion in depth and the design on the surface precarious. Anything too definite – say, a jet of solid colour or an abrupt

contrast – would produce an imbalance that, according to the Impressionist canon, had to be resolved in terms of the general tone or "dominant" of the picture (this was analogous to traditional procedure with its insistence that every colour be modelled in dark and light), or else by being made to reflect surrounding colours. Off and on Monet painted as if the chief task were to resolve discords in general, and since these would often be excluded in advance, many of his pictures ended up as resolutions of the resolved: either in a monotonously woven tissue of paint dabs or, as later on, in an all-enveloping opalescent grey distilled from atmosphere and local colour. The solution of the difficulty lay outside the strict Impressionist canon; a definite choice had to be made: either the illusion in depth was to be strengthened at the expense of the surface design – which is the course Pissarro finally took – or vice versa.

In 1886 Pissarro observed that Monet was a "decorator without being decorative." Lionello Venturi comments that decorative painting has to stay close to the surface in order to be integrated, whereas Monet's, while in effect staying there, betrayed velleities towards a fully imagined illusion of depth in which the existence of three-dimensional objects required to be more than merely noted or indicated, as they were in his practice. In short, Monet's decorative art failed because it was unfulfilled imaginatively. This is well said, but as if it were the last word on Monet's later painting. In a number of pictures, not so infrequent as to be exceptional, and not all of which came just at the end, Monet did decisively unify and restore his art in favour of the picture surface.

As it happens, Cézanne and the Cubists made painting two-dimensional and decorative in their own way: by so enhancing and emphasizing, in their concern for three-dimensionality, the means by which it had traditionally been achieved that three-dimensionality itself was lost sight of. Having become detached from their original purpose by dint of being exaggerated, the value contrasts rose to the surface like decoration. Monet, the Impressionist, started out from the other direction, by suppressing value contrasts, or rather by narrowing their gamut, and likewise ended up on the surface: only where he arrived at a shadow of the traditional picture, the Cubists arrived at a skeleton.

Neither of these ways to what ultimately became abstract art is inherently superior to the other as far as quality is concerned. If architectonic structure is an essential ingredient of great painting, then the murals in the Orangerie must possess it. What the avant-garde originally missed in the later Monet was traditional, dark-and-light, "dramatic" structure, but there is nothing in experience that says that chromatic, "symphonic" structure (if I can call it that) cannot supply its place. Sixty years of Van Gogh, Gauguin, Seurat, Cézanne, Fauvism and Cubism have had to pass to enable us to realize this. And a second revolution has had to take place in modern art in order to bring to fruition, in both taste and practice, the first seed planted, the most radical of all.

Venturi, writing in 1939, called Monet the "victim and gravedigger of Impressionism." At that time Monet still seemed to have nothing to say to the avant-garde. But today those huge close-ups which are the last *Water Lilies* say – to and with the radical Abstract Expressionists – that a lot of physical space is needed to develop adequately a strong pictorial idea that does not involve an illusion of deep space. The broad, daubed scribble in which the *Water Lilies* are executed says that the surface of a painting must breathe, but that its breath is to be made of the texture and body of canvas and paint, not of disembodied colour; that pigment is to be solicited from the surface, not just applied to it. Above all, the *Water Lilies* tell us once again that all canons of excellence are provisional.

It used to be maintained that Monet had outlived himself, that by the time he died in 1926 he was an anachronism. But right now any one of the *Water Lilies* seems to belong more to our time, and its future, than do

Cézanne's own attempts at summing-up statements in his large *Bathers*. Thus the twenty-five years' difference in dates of execution proves not to be meaningless – and the twenty years by which Monet outlived Cézanne turn out not to have been in vain.

Modern art, dating from Manet, is still too young to let us rest on our judgments regarding it: the rehabilitation of the later Monet has already had an unsettling effect. It may not account for, but it helps clarify an increasing dissatisfaction with Van Gogh, as it helps justify impatience with an uncritical adoration of Cézanne. Van Gogh is a great artist, but Monet's example serves better even than Cézanne's to remind us that he may not have been a *master*. He lacked not only solidity and breadth of craft; he also lacked a settled largeness of view. In Monet, on the other hand, we enjoy a world of art, not just a vision, and that world has the variety and space, and even some of the ease, a world should have.

KENNETH CLARK

LANDSCAPE INTO ART

"The Natural Vision"

1949

Sir Kenneth Clark (1903–83) (Lord Clark of Saltwood), British art historian, Director of the National Gallery, London, 1934–45 and a collector of contemporary British art.

In the pictures of Argenteuil by Monet and Renoir, done between 1871 and 1874, the painting of sensation yielded its most perfect fruits. They show an unquestioning joy in the visible world, and an unquestioning belief that the new technique alone can convey it. This balance between subject, vision and technique was so complete that it not only captivated sympathetic spirits like Sisley and Pissarro, but imposed itself on painters to whom it was quite alien. Manet, for example, whose own range of responsiveness to tone and colour was similar to that of Goya – or even darker – was bewitched into trying his hand at an Argenteuil picture. Even Gauguin and Van Gogh, who were to destroy impressionism, painted some of their most beautiful pictures in this style.

There are few things more refreshing in art than the sense of delight in a newly acquired mastery. The excitement with which the impressionists conquered the representation of light by the rainbow palette, is like the excitement with which the Florentines of the fifteenth century conquered the representation of movement by the flowing plastic line. But art which depends too much on the joy of discovery inevitably declines when mastery is assured. In the lifetime – in the work – of Filippino Lippi the Quattrocento style degenerated into mannerism. By the middle of the 1880s the great impressionist moment had passed. At first Renoir and Monet tried to keep up their excitement by choosing more and more brilliant subjects. Renoir painted gardens which gave him the added problem of bright local colours, and Monet painted coast scenes which have the most intense light that can be put on canvas. Later he moved to the French Riviera, and there, in the garish sunshine of that hitherto unpaintable region, not only forms but tones are dissolved in incandescence. It was the crisis of sensational painting and each member of the group responded in a different manner. Renoir, with his fundamentally classical outlook, was inspired by the antique painting at Naples and Raphael's frescoes in the Vatican to recapture the firm outline; and thenceforward gave up naturalistic landscape painting entirely. Pissarro, who had always taken more interest than the others in the architectural composition of his pictures, joined in the return to order. . . Sisley, who had always been the least intellectual and

self-critical of the group, went on painting in the same way with declining confidence. His last pictures are a warning that simple perception of nature is not enough.

It was Monet, the real inventor of impressionism, who alone had the courage to push its doctrines through to their conclusion. Not content with the sparkle of his Riviera scenes he undertook to prove that the object painted was of no importance, the sensation of light was the only true subject. He said to an American pupil that "he wished he had been born blind and then had suddenly gained his sight so that he would have begun to paint without knowing what the objects were that he saw before him." It is the most extreme, and most absurd, statement of the sensational aesthetic. Actually Monet's technique made him particularly dependent on the nature of his subjects; and they were limited. Only sun on water and sun on snow could give full play to the prismatic vision and the sparkling touch. In such pictures Monet has remained without an equal. But in order to prove his point he chose for the subjects of his experiments, Cathedrals and Haystacks. No doubt he did so intentionally in order to show that the most articulate works of man, and the most formless, were pictorially of equal importance to the painter of light. But the choice, especially that of cathedrals, was disastrous, because grey Gothic façades do not sparkle. In an attempt to make them vehicles of light Monet painted them now pink, now mauve, now orange; and it is evident that even he, with his marvellous capacity for seeing the complementary colours of a shadow, did not really believe that cathedrals looked like melting ice-creams. In these muffled, obstinate pictures impressionism has departed altogether from the natural vision from which it sprang, and has become as much an abstraction as Gilpin's picturesque. The arbitrary colour of the cathedrals is much less beautiful than the truly perceived colour of the Argenteuil pictures; and the dialectical basis on which they are painted has prevented Monet from abandoning himself, like Turner, to poetic fantasies or musical harmonies of colour like the *Interior at Petworth*. If decadence in all the arts manifests itself by the means becoming the end, then the last works of Monet may be cited as text-book examples.

Impressionism is a short and limited episode in the history of art, and has long ago ceased to bear any relation to the creative spirit of the time. We may therefore survey, with some detachment, the gains and losses of the movement.

There was the gain of the light key. Ever since Leonardo attempted scientifically to achieve relief by dark shadows, pictures have tended to be dark spots on the wall. Those who have visited the Naples Gallery will remember with what relief, after wading through three centuries and about thirty rooms of black pictures, one comes on the rooms of antique painting, still fresh and gay in tone. They are only journeyman's work, far poorer in execution than the great canvases of Ribera and Stanzione, but they are a delight to the eye. The impressionists recaptured this tone. We are grateful that the pictures on our walls (and that, of course, is where pictures should be, not on the walls of galleries) are not only a pleasure to look into but also a pleasure to look at. This rise in tone was connected with the final liberation of colour. To read what was said of colour by Ingres, Gleyre, Gérôme and the other great teachers of the nineteenth century, one would suppose that it was some particularly dangerous and disreputable form of vice. This was a rearguard action of idealist philosophy which had maintained that form was a function of the intellect, colour of the senses. The belief was philosophically unsound, and had proved a real obstacle to free and sincere expression for centuries. Its removal gained a new liberty for the human spirit.

Then impressionism gave us something which has always been one of the great attainments of art: it enlarged our range of vision. We owe much of our pleasure in looking at the world to the great artists who have looked at it before us. In the eighteenth century, gentlemen carried a device called a Claude glass in order that they might see the landscape with the golden tone

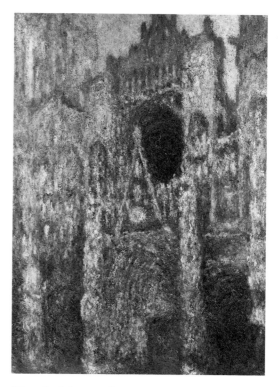

Claude Monet. *Rouen Cathedral in Full Sunlight.* 1894. 41¾ × 29″ (106.3 × 73.7 cm). Sterling and Francine Clark Art Institute, Williamstown, Massachusetts.

William Gilpin (1724–1804), whose On Picturesque Beauty *was published in 1792.*

361

of a Claude – or rather of the varnish on a Claude. The impressionists did the exact reverse. They taught us to see the colour in shadows. Every day we pause with joy before some effect of light which we should otherwise have passed without notice. Impressionism achieved something more than a technical advance. It expressed a real and valuable ethical position. As the Count of Nieuwerkerke correctly observed, it was the painting of democrats. Impressionism is the perfect expression of democratic humanism, of the good life which was, till recently, thought to be within the reach of all. It is a belief of which Bonnard's pictures and René Clair's early films were perhaps the last exponents. What pleasures could be simpler or more eternal than those portrayed in Renoir's *Luncheon of the Boating Party*; what images of an earthly paradise more persuasive than the white sails in Monet's estuaries, or the roses in Renoir's garden? These pictures prove that what matters in art is an all-pervading belief and not the circumstances of the individual artist. The men who painted them were miserably poor, and their letters show us that they often did not know where to turn for the next meal. Yet their painting is full of a complete confidence in nature and in human nature. Everything they see exists for their delight, even floods and fog.

COLOURPLATE 75

Looking back over sixty years, it may seem that this confidence in the physical world was a fundamental weakness. Art is concerned with our whole being – our knowledge, our memories, our associations. To confine painting to purely visual sensations is to touch only the surface of our spirits. Perhaps, in the end, the idealist doctrine is right, we are more impressed by concepts than by sensations, as any child's drawing will show. The supreme creation of art is the compelling image. An image is a "thing," and impressionism aimed at abolishing things. And in painting, the simplest and most enduring images are things with lines round them; and impressionism abolished line.

This is only a way of saying in pictorial terms that impressionism did not address itself to the imagination. We cannot call it the art of materialism, for that word carried too gross an implication; but we cannot (as many critics have done) call it pagan, for paganism involves the idea of remote country superstition, spring festivals and Dionysiac rites. Paganism has precisely that element of magic which impressionism excludes. That is the price we must pay for the happiness of here and now, on which it is founded.

ROSALIND E. KRAUSS

THE BURLINGTON MAGAZINE

"Manet's Nymph Surprised"

November 1967

Rosalind Krauss (b. 1940), American art critic and art historian.

Although the specific source of Manet's nymph is Rubens, she is placed within a recognizable modern landscape which plays an important role in Manet's development of the theme. One is tempted to see that as a forecast of what will occur in the *Déjeuner sur l'herbe*. There also the main figures, drawn from a relatively obscure graphic model, projected themselves to the public from within a more famous frame of reference: Giorgione's *Fête Champêtre*. Manet's broader prototype for a Susannah within a landscape should be seen finally as Rembrandt's painting in The Hague.

Manet's characteristic procedure of deliberate subversion of a known image begins here in the treatment of the figure: her flat, unmodelled body undermines illusionistic conviction and emphasizes the artificial nature of

the work of art. Further, Manet's nude seems to sit in front of a studio backdrop that is discontinuous from her; while in the Rembrandt *Susannah*, a natural landscape provides the figure with a deep setting – one which is continuous with her both spatially and emotionally: even the spotlighting of the background buildings seems to express the tremulous feelings of the startled girl. While Rembrandt's brush yields a lush sensuousness by differentiating the textures of cloth, skin, jewels and leaves, Manet's bestows only the sensuousness of paint. There is no textural variation in the Manet, but rather a gorgeous surface, everywhere celebrating the heavy luxury of the actual paint medium. Isolated as she is from her surroundings, Manet's nude is seen as a contour pattern. One is primarily conscious of her as a painted figure.

But to stop at the awareness of Manet's willed recognition of the picture as a two-dimensional object, covered with abstractly rendered shapes, is not sufficient, for this omits the difference in actual content between both Rembrandt's and Rubens's *Susannahs* and Manet's *Nymph*. In the Rubens prototype, one elder stands beside the young woman; in the Rembrandt the two old men are on the right in the shadow of a clump of trees, spying on Susannah. Her horror as she starts up and covers her body, her shocked eyes as she looks out beyond the viewer of the picture rather than at him, elicits a sympathetic response. One recognizes the mood of the painting, no matter how disturbing that mood might be; and just as the figures are all continuous with their setting *within* the picture, the emotional world of the Susannah is continuous with that of the viewer. Neither the Rembrandt nor the Rubens in any way resists the observer's sympathetic entry. In each the forms are clearly understood as a vehicle for the meaning.

In the Manet, however, the voyeurist elders have been eliminated. A nude woman stares insolently outward. The viewer realizes that *he* is in fact the "elder"; *he* is the one who disrupts the private universe of the painting. At the very moment when the viewer understands the picture's connexion to the Susannah story, he is blocked from the comfortable relationship to its subject that, given the conventions of Western art, he had come to regard as natural. Manet no longer invites sympathetic involvement in the emotional world of the picture; he creates a scene which makes one realize one's own disjunction from the work of art, as looking begins to fuse with violation.

This disruption of the spectator's traditional relationship to the subject does not suspend contact with the painting; rather it inverts it. The brazen gaze of the nude, and the compromise it involves for the viewer, engages him in the work of art in a new way. Indeed, his complicity is expressly used to *complete* the painting, as the insolent stare of the nude forces into the viewer's consciousness the meaning implicit in his delectation of her. This connexion is present in the formal machinery of the work for the conventional pictorial transitions which create the normally dependable distance between the viewer and the thing seen are eliminated in the *Nymph Surprised*, thereby establishing the immediacy – indeed, the privacy – of this new relationship. Manet stakes a correct reading of the painting on the abruptness, the effrontery of his presentation. It is precisely within the intense realism of the psychological connexion between nude and viewer that Manet locates the basis for what modern critics have called his abstraction. But in misunderstanding its origin they have contracted its range to a rigid formalism. For awareness of the painting's actual flatness – its formal balance of shapes, the relationships between dark and light patterns – is achieved by the content of the work as it pries the viewer loose from the deadening conventionalism of his expectations and awakens in him a new self-consciousness before the painting. The subject of the *Nymph Surprised* is voyeurism; the subject of the new consciousness – the object focused on in the experience with the *Nymph Surprised* – is the viewer's own act of looking, what it means to look at, to read, to perceive, a work of art.

The *Nymph Surprised* is not merely a formalist exercise; it is a painting which transforms the conventions which invest forms with meaning. Thus

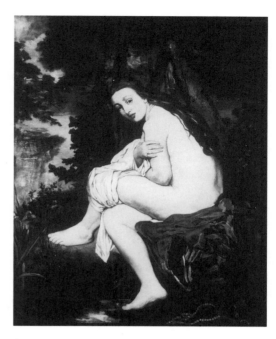

Édouard Manet. *The Nymph Surprised*. 1859–61. 57½ × 45″ (146 × 114 cm). Museo Nacional de Bellas Artes, Buenos Aires.

paradoxically, it is Manet's content which secures the painting's identity as a two-dimensional surface, which recreates it as flat. In order to accomplish his challenge to the established relationship between the spectator and the work of art, Manet exploits the conventional expectations of the viewer who approaches the painting to read off meaning from its representational forms. By suddenly forcing him to feel his response to the picture as problematic – indeed as perverse – Manet makes him aware of the painting as a discrete entity, as a collection of formal notations which subvert his efforts to read them, even while they promote responses, emotional in kind, which are related to allusive objects.

MICHEL BUTOR

ART NEWS ANNUAL

"Monet, or the World Turned Upside-Down"

1968

Michel Butor (b. 1926), French poet and novelist and an exponent, with Alain Robbe-Grillet, of the Nouveau Roman.

THE TRANSIENT

Fidelity to nature is the crux of the Impressionist strategy against the Salon or the Academy, yet one should observe the paradox introduced into it by Claude Monet. When Courbet or the young Manet says that he paints objects or people *as they are*, he implies that this may be verified; for these painters, the model must have a certain stability, must stay put, so that their representation may be compared to it, point by point. It must, therefore, be a tranquil landscape, a still-life, a ceremony, a moment of leisure. The fact of painting outdoors or with broad strokes changes nothing in these fundamental truths: indeed, one may verify the exactness of nuance as, in the Renaissance, that of detail. But Monet, with his insistence on the transient, destroyed the old fidelity. The traditional verification became impossible, denied not only to the spectator but to the painter himself. The colours he put on his canvas no longer corresponded to those he saw. The delineation of reflected light had obviously changed.

Nor should one say of him "What an eye!," as Cézanne did, but "What a memory!" He portrayed the transient so truly that we are forced to conclude that he painted in the absence of his subject. The composition is as complete as in the Franche-Comté landscapes that Courbet reconstituted in his studio. But in Courbet, as later in Cézanne, such reconstitution is based on something permanent, at the viewer's disposition, whereas in Monet it is based on something which, by definition, has disappeared forever. Our only means of verification is the encounter in nature, during a walk, of an *effect* of the same kind, having the same kind of difference from habitual vision. The instantaneity of Monet, far from being passive, requires an unusual power of generalization, of abstraction. Corot's and Courbet's *realist* landscapes said: here is nature, not as painters ordinarily represent it, but as you see it yourselves. Monet declares: here is nature, not as you or I habitually see it, but as you are able to see it, not in this or that particular effect, but in others like it. The vision I propose to you is superior; my painting will change your reality.

It was therefore necessary for him to discover unstable objects, subjects that contain a dynamism which can intervene in the viewer's vision.

Compare his landscapes with those of Sisley. Sisley adopted everything in the art of the young Monet that may be taken as a continuation of the art of Corot, but Monet's instability remains foreign to him. In Sisley all is calm.

In the dark apartments of Paris or London, he opens windows giving onto a countryside or a peaceful suburb, airy, luminous, where time slows down. One feels that nothing has moved from the time he set up his easel to the time he finished the painting. In *The Flood at Port-Marly*, he spreads before our eyes the surface of a perfectly calm stretch of water reflecting light, making colours fresher; the reflections are there only to let us know that it is water; they have no interest in themselves. In Monet, on the contrary, the reflection as it was, now forever gone, is often the heart of the composition.

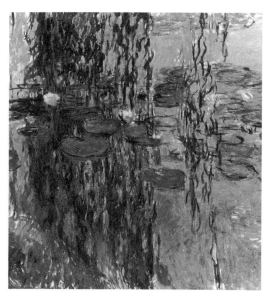

Claude Monet. *Water-lilies.* n.d. 78¾ × 70¾″ (200 × 180 cm). Musée Marmottan.

* * *

REGATTAS AT ARGENTEUIL

If we isolate the lower righthand quarter of the *Regattas*, 1872, and reverse it, we have a painting of remarkable colour intensity, violently drawn, a Fauve work. All the elements composing it, which might otherwise be slightly obscure, are explained by the upper half, which says: this is a boat, this is a house, etc. The reflections incite an analysis of what is enumerated above.

It is as if Monet were saying to us: you do not know how to see this red and this green, so beautiful in their pure state, but look: they are in this house.

It is impossible to interpret the reflected part as the simple notation of what lay before the painter's eyes. How can one suppose that Monet would have chosen any one of the millions of images that a camera might have registered? He constructed an image, animated by a certain rhythm, which we may imagine as conforming to that of the liquid surface (yet there is nothing to confirm even this), based on real objects.

The semantic relation of above and below obviously works in both directions: a) the upper names the lower: this aggregate of blotches which means nothing to you is a tree, a house, a boat; b) the lower reveals the upper: this boat, this house which seem dull to you contain secret congruences of colour, elementary images, expressive possibilities.

The upper part corresponds to what one recognizes, the reality one is used to; the lower, which leads us toward these houses and boats, corresponds to the painter's act. The water becomes a metaphor for painting. The very broad strokes with which these reflections are indicated are vigorous assertions of material and means. The liquid surface provides us with an instance in nature of the painter's activity.

ANTON EHRENZWEIG

THE HIDDEN ORDER OF ART
"The Fragmentation of 'Modern Art'"

1968

Anton Ehrenzweig (1908–66), Viennese-born art educationalist and theorist who settled in Britain in 1938. His writing was influenced by psychoanalysis and, in its turn, made an important contribution to psychoanalytic thinking about art.

The first impact of Cubism attacked conscious sensibilities and the gestalt principle ruling them. We have to give in to this attack in order to enjoy the pictures and become aware of the new highly mobile space that Cubism created. The weaving in and out of the picture plane was perhaps the first manifestation of a new abstract pictorial space which later became fully revealed in the painting of Jackson Pollock and his associates. Our attempt at focusing must give way to the vacant all-embracing stare which I have described as the conscious signal of unconscious scanning. This kind of low-level scrutiny can overcome the superficial impression of chaos and disruption and appreciate the stringent formal discipline underneath. This hidden order redeems the near-schizoid character of the excessive fragmentation found in so much modern art.

One could trace the true beginning of disruption in modern art back to French Impressionism. Classicistic painting had stressed the coherence of line and surface and had blossomed in the linear harmonies of Ingres. The Impressionists blew all coherence of line and surface to bits and stressed the significance of the single brush stroke. They freely indulged in the fragmentation of the picture plane by scattering these isolated brush strokes across the canvas. We are no longer quite so aware of the severity of the attack on conscious sensibilities which the Impressionists mounted. We may only guess its vehemence from the reaction of the academicians and their circle. After a decade or so the attack became muted, partly due to the good services of the critics who supported the new movement. They found they could gather up the scattered brush strokes into stable patterns by stepping back from the canvas and allowing the brush marks to congeal once again into solid surfaces and outlines. The art critics proclaimed that the Impressionists, far from scattering the coherence of the picture plane, had in fact constructed a new kind of atmospheric space that was in no way less precise or stable than the space constructed according to the rules of Renaissance perspective. Many post-Impressionist painters succumbed to deliberate space construction and so brought to an end the spontaneous treatment of a freely oscillating picture plane. Only the ageing Monet broke through the barrier. In his late *Lily Pond* paintings he resurrected the old vibrant pictorial space. Once again loose clusters of brush strokes were allowed to oscillate freely throughout the picture plane. No wonder that Monet was later acclaimed as a precursor of modern sensibilities.

We have seen how Picasso's Cubism, by using near-geometric elements instead of painterly brush work, re-mounted the attack on our conscious sensibilities. Cubism in turn degenerated into an academic exercise in space construction. During the nineteen-twenties and thirties academic teaching everywhere put to the test Cézanne's remark that we can see nature in (cubistic) elements of spheres, cylinders etc. Even today virtue is attributed to a kind of life-drawing which automatically converts the organic forms of the body into rigid cylinders, cubes and the like, a particularly boring exercise in constructing a geometric space lacking all the former fragmentation and eye-wandering effects. Almost all painters of the inter-war period went through some phase of Cubist space construction. This decadence explains the profound experience of exhilaration when Jackson Pollock once again blew up the solidified academic Cubism and spun his gossamer curtains of space. They kept swaying in and out as once again the eye was sent wandering in search of stable focusing points. The reaction of the secondary process against this most violent of all attacks was equally swift and ruthless. Within a few years the dazzling effect wore off. The mobile space curtains duly fused into a solid thick texture that afforded a most undisturbing background for the display of elegant domestic furniture.

The dazzling effects of optical painting organized the attack on the gestalt principle in quite explicit, almost scientific terms. Its dazzle defeats focusing on any single element altogether even for the shortest time. One art critic suggested that a painting by Bridget Riley, now in the Tate Gallery, could only be tolerated in a domestic setting by hiding it behind curtains. I very much doubt this. The secondary process will undoubtedly succeed in overcoming even this latest attack on conscious gestalt perception and convert these pictures into comfortable decorative pieces. Once the secondary process has done its work, we will understand contemporary reports on their uncomfortable dazzling quality as little as we now understand Kandinsky having been so dazzled by Monet's *Haystacks* that he was unable to pick out the haystacks from the welter of the brush work. Will there be yet another wave of attacks against our surface sensibilities? I very much doubt it. Modern art is dying.

THOMAS CROW

MODERNISM AND MODERNITY

"Modernism and Mass Culture"

1983

Thomas Crow (b. 1948), American art historian.

Establishing itself where Courbet and Manet had led, 'classic' Impressionism, the sensually flooded depictions of weekend leisure produced by Monet, Renoir, and Sisley in the 1870s [portrays life as] being lived entirely within the confines of real-estate development and entrepreneurial capitalism; these are images of provided pleasures. But they are images which, by the very exclusivity of their concentration on ease and uncoerced activity, alter the balance between the regulated and unregulated compartments of experience. They take leisure out of its place; instead of appearing as a controlled, compensatory feature of the modern social mechanism, securely framed by other institutions, it stands out in unrelieved difference from the unfreedom which surrounds it.

It is in this sense that Schapiro can plausibly speak of Impressionism's "implicit criticism of symbolic and domestic formalities, or at least a norm opposed to these." But what Schapiro does not address is how this criticism was specifically articulated as criticism: a difference is not an opposition unless it is consistently read as such. This brings us necessarily back to the question of modernism in its conventional aesthetic sense of autonomous, self-critical form – back to Greenberg, we might say. The "focal concern" of the avant-garde subculture is, obviously, painting conceived in the most ambitious terms available. It was in its particular opposition to the settled discourse of high art that the central avant-garde group style, i.e. modernism, gained its cogency and its point. They were able to take their nearly total identification with the uses of leisure and make that move count in another arena, a major one where official beliefs in cultural stability were particularly vulnerable. The *grands boulevards* and Argenteuil may have provided the solution, but the problem had been established elsewhere: in the evacuation of artistic tradition by academic eclecticism, pastiche, the manipulative reaching for canned effects, all the played-out manoeuvres of Salon kitsch. Almost every conventional order, technique and motif which had made painting possible in the past, had, by this point, been fatally appropriated and compromised by academicism. And this presented immediate practical difficulties for the simple making of pictures: how do you compose, that is, construct a pictorial order with evident coherence and closure, without resorting to any prefabricated solutions? The unavailability of those solutions inevitably placed the greatest emphasis – and burden – on those elements of picture-making which seemed unmediated and irreducible: the single vivid gesture of the hand by which a single visual sensation is registered. As tonal relationships belonged to the rhetoric of the schools – rote procedures of drawing, modelling, and chiaroscuro – these gestural notations would ideally be of pure, saturated colour.

The daunting formal problematic which resulted was this: how to build from the independent gesture or touch some stable, over-arching structure which fulfils two essential requirements: 1) it must be constructed only from an accumulation of single touches and cannot appear to subordinate immediate sensation to another system of cognition; 2) it must at the same time effectively close off the internal system of the picture and invest each touch with consistent descriptive sense in relation to every other touch. Without the latter, painting would remain literally pre-artistic, an arbitrary slice out of an undifferentiated field of minute, equivalent, and competing stimuli. Impressionism, quite obviously, found ways around this impasse,

Meyer Schapiro had written in The Nature of Abstract Art, *1937: "Early Impressionism, too, had a moral aspect. In its unconventionalized, unregulated vision, in its discovery of a constantly changing phenomenal outdoor world of which the shapes depended on the momentary position of the casual or mobile spectator, there was an implicit criticism of symbolic social and domestic formalities, or at least a norm opposed to these."*

367

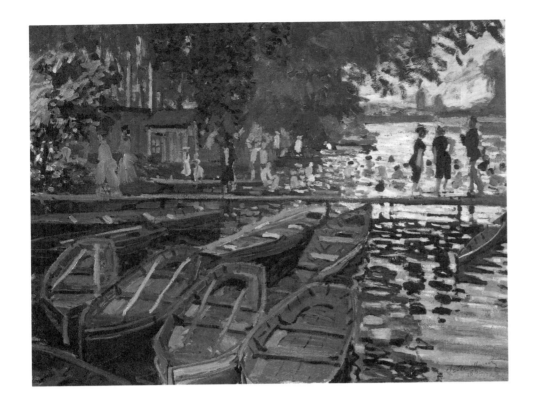

Claude Monet. *La Grenouillère.* 1869.
National Gallery, London.

discovered a number of improvised, ingenious devices for making its coloured touches gell into readability and closure: disguised compositional grids, sophisticated play within the picture between kinds of notation and levels of descriptive specificity, selecting motifs in which the solidity of larger forms is inherently obscured, and finally, building the picture surface into a tangibly constructed wall or woven mesh of pigment. The persuasiveness of these solutions, however, depended to a great degree on the built-in orders of the places they painted. The aquatic resort or dazzling shopping street offered "reality" as a collection of uncomposed and disconnected surface sensations. The disjunction of sensation from judgement was not the invention of artists, but had been contrived by the emerging leisure industry to appear the more natural and liberated moment of individual life. The structural demarcation of leisure within the capitalist economy provided the invisible frame which made that distracted experience cohere as the image of pleasure.

The most provocative and distinctive pictorial qualities of early modernism were not only justified by formal homologies with its subject matter as an already created image, they also served to defend that image by preserving it from inappropriate kinds of attention. So that the promises of leisure would not be tested against too much contrary visual evidence – not only dissonant features of the landscape like the famous factories of Argenteuil, but also the actual varieties of individual pleasure and unpleasure in evidence – the painters consistently fix on optical phenomena which are virtually unrepresentable: rushing shoppers glimpsed from above and far away, the disorienting confusion of the crowded *café-concert*, smoke and steam in the mottled light of the glass-roofed railway shed, wind in foliage, flickering shadows, and above all, reflections in moving water. These phenomena have become, largely thanks to Impressionism, conventional signs of the spaces of leisure and tourism, of their promised vividness and perpetual surprise, but as optical "facts" they are so changeable or indistinct that one cannot really hold them in mind and preserve them as a mental picture; therefore one cannot securely test the painter's version against remembered visual experience. The inevitably approximate and unverifiable registration of these visual ephemera in painting makes larger areas of the canvas less descriptive than celebratory of gesture, colour, and shape – pictorial incidents attended to for their own sake.

LAWRENCE GOWING

"Renoir's Sentiment and Sense"

1985

Sir Lawrence Gowing (1918–91), British painter and art historian.

Renoir's art cannot claim that base in sensation and logic which, as Cézanne remarked with reason, makes an artist impregnable. Renoir's vision and imagining were at the service rather of sensuality and impulse. They are thus vulnerable to criticism. Renoir makes his own kind of sense, but the meanings communicated by sensuousness and sensuality in themselves are no longer as acceptable as they were in Renoir's time.

Yet the recent neglect of Renoir overlooks qualities that we can hardly spare from the repertory that painting affords us. We can recognize their rarity yet still hardly describe what they consist of. Is there another respected modern painter whose work is so full of charming people and attractive sentiment? And all in the best possible taste. Yet what lingers is not cloying sweetness but a freshness that is not entirely explicable. It is like a scent or the bloom on a grape. The self-management was impeccably natural and effortless, as if Renoir relied on what was innate. His son compared it to the sense of direction in a migrating bird. The assumptions that he took for granted are no longer unquestioned.

Renoir possessed, it seems from the beginning, an awareness that the other future Impressionists had no idea of. He had a sense of the image trade and retained that sense through the period in which painting and drawing were changing utterly, changing in the skills they could command, the formulations they supplied and the clientele they served, the period in which artists transformed the craft and lost the trade.

* * *

Renoir had an instinct for naturalness, he never had to turn his back on anything in his boyhood make-up, as Monet and Cézanne both did. Their juvenile selves, the café cartoonist in Monet and in Cézanne the frustrated adolescent in a stew about sex and violence, were left behind or sublimated out of recognition. On the whole they were not missed. But Renoir maintained his foothold in the image trades all his life. He preserved the skills. The technique *au premier coup* with which the apprentice learned to brush Rococo-style decorations on porcelain and glazed linen blinds married fluency with conventional figuration in functional dabs not far, as Sickert pointed out, from the ideal economy of the new painting. Renoir was proud of the craft, and his facility was appreciated; his employers treated him like a member of the family.

Opinion now might not accept that one talent is any more natural than another. The meaning of the word itself has been in doubt; it was not understood that when Constable determined that there was room for "a natural painture", he meant simply a way of painting that would be nature-like, resembling. But some temperaments take to painting more wholeheartedly than others; there is no doubt that Rubens was one of them, and some of his naturalness was communicated by the fluent linear skills of eighteenth-century *rubénisme*. No one had that quality of temperament in anything like the perfection of Rubens and Watteau except Renoir. The *rubéniste* tradition expired, and a chasm has opened between us and Renoir; the historicism in his facility separates us. The appearance of relaxed normality in Renoir's art is itself deceptive. That natural confidence is in fact one of the rarest qualities in the whole history of painting. In the fullest degree it was shared only by Rubens himself.

* * *

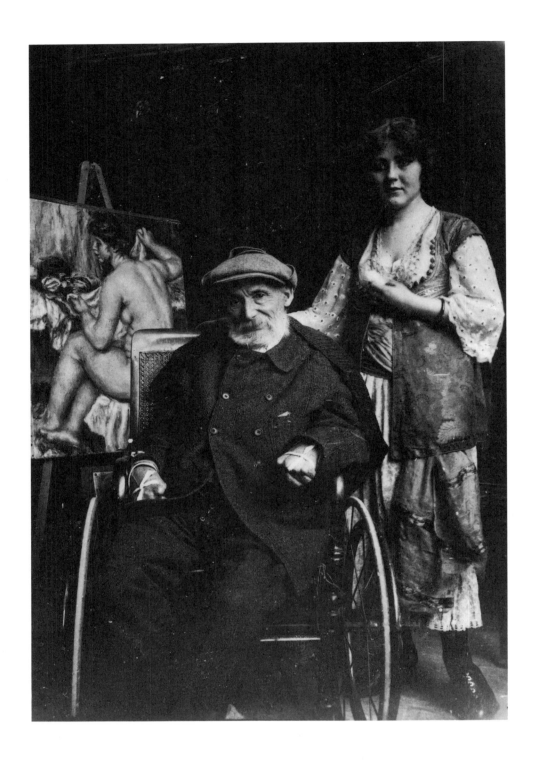

Renoir, photographed in a wheelchair with Dédée (Andrée Henschling, Jean's wife). 1915. (Archives Durand-Ruel, Paris).

Late in his life Renoir told Vollard that the first picture that caught his fancy had been Boucher's *Diana bathing*. Some of his remarks were made almost at random, but we need not doubt the truth of this one. The spirit and the bathing subject reappeared in his work at intervals through his life. As an apprentice Renoir went to the museum instead of lunch, and his clear-sightedness there was remarkable. Rather few young painters manage to ask themselves how the idea and momentum of painting reached them. They assume that these things are common property. The eighteenth century through which Renoir made his way to his tradition was not merely the style dictated by the porcelain factory. It was how he recognized himself, and it entirely suited the debonair, rather casual sensitivity which mixed with sensuality in the early portraits. Renoir never tried to deepen the gravity or darken the pleasure that was natural to him. He later complained that good humour is never taken seriously; that was surely its advantage to him.

* * *

None of his friends experiments so widely and inconsistently. None would have cared to embark on so many different styles, or to imitate them so closely. None was inspired by such unblushing hedonism. What gave Renoir's point of departure a commanding advantage was without doubt his capacity and determination from the first to please himself. It might not commend itself to the high-minded. Indeed, as we can read, it still does not. But his motivation certainly offered a compelling and, despite its traditionalism (or because of it), original blend of painterly and sexual greed. . . .

The idea of painting as a quite physical indulgence dictated the philosophy and the coherent strategy of life that were entirely his own. It was itself a kind of originality, and it was entirely conscious; questioned about it Renoir would answer with an unaffected and unforced coarseness. He was neither modest nor boastful about the phallic role in which he imagined his brush. An artist's brush had hardly ever been so completely an organ of physical pleasure and so little of anything else as it was in Renoir's hand. Its sensate tip, an inseparable part of him, seemed positively to please itself. In the forms it caressed it awakened the life of feeling and it led them not to climactic fulfilment but to prolonged and undemanding play without any particular reserve or restraint – or commitment. If the brush defines and records, it is for pleasure, and the shapes it makes, quivering in their pearly veil, discover satisfaction and completeness. One feels the surface of his paint itself as living skin: Renoir's aesthetic was wholly physical and sensuous, and it was unclouded. In essence his art had no other matter; human identity and character were seen entirely in terms of it. His ethos was ideal for an art that must express physical things in physical terms, and there was no great part in it for theory or thought or reflection, nor perhaps at root even for generosity, open-hearted though he was. His love distributed its favours at random, decorating the visible scene with its capricious indifference. The fruits of his sentiment are abundant – in every sense voluminous: few, I think, look at them unmoved.

* * *

Such explicitly illustrative pictures, especially of subjects so plainly pleasurable and enjoyed, have not attracted advanced support in the hundred years since they were painted. Serious critics do not take them seriously, unless to question their social enlightenment. These interactions of real people fulfilling natural drives with well-adjusted enjoyment remain the popular masterpieces of modern art (as it used to be called), and the fact that they are not fraught or tragic, without the slightest social unrest in view, or even much sign of the spatial and communal disjunction which some persist in seeking, is far from removing their interests.

If we look at Renoir as an illustrator of human interaction he has satisfying surprises to offer even in these best known pictures. In picture after picture, for example, a woman (Ellen Andrée in *Luncheon of the boating party*, Suzanne Valadon in *Dance at Bougival*) lets the concentrated admiration of a bearded young man, who is oblivious of anyone else or of us, rest steadily upon her; the intentness is almost palpable. She receives it; it bathes her; she luxuriates in it, smiles a little to herself. Presently an inward look and something in her bearing admit complicity. The two are at one; their state is blessed. Eventually in *Dance in the country* she laughs with open, irrepressible delight as the dance whirls her away towards the consummation of the theme that began fifteen years before with Alfred Sisley's courtly attention to his fiancée in Renoir's most substantial early picture.

COLOURPLATE 75
COLOURPLATE 90

These passages steadily embody a relationship. They are images of what is mutual, tender and ardent, which returned to the stillness of painting the satisfaction that the painter had gaily plundered and would again. They show the painting of love and the love of painting to be intimately linked and treasured resources and lastingly add them to the richness of art. We find ourselves treating this, which we had taken for makeshift picture making, as great painting and notice that in this special dimension, which is Renoir's own and no one else's, there is no contradiction.

CHRISTOPHER YETTON

ROYAL ACADEMY MAGAZINE

"The Pool of Narcissus"

1990

Christopher Yetton (b. 1940), British art critic and art historian.

In a development that was both at the root of, and emblematic of, the difference between nineteenth- and twentieth-century art, Monet seems to change from an optimistic improviser to an anguished composer. By the 1890s he has gone from being a painter of an uncomplicated world to an explorer of the complex mystery that by the end of his life he felt was ultimately unknowable. Aware of the metaphors of his poet friends, Monet wanted to pursue similar feelings from his perceptions of the world, rejecting any overt symbolism. By pursuing his experience of nature he ceases to be a direct painter of what he sees and becomes the creator of highly complex multi-layered compositions.

The basis of his early method he inherited from the academic teachers of the early part of the nineteenth century. Quick, spontaneous oil sketches capturing the overall light, known as the *effet* or *impression* of the scene, were part of the art student's syllabus. Called *pochades* or *études* their main aim was unity but they were also thought to have a freshness deriving from the naivety of the artist and to be expressive of his personality, originality and feelings. Their artlessness was highly valued in private but they were rarely exhibited. Monet learnt about this from his first teacher, Boudin, whose dictum that everything done on the spot was superior to anything done in the studio became Monet's own in spirit.

But by 1890 the realization that "more than ever" he was dissatisfied "with the easy things that come in a single stroke" indicates that a profound shift in thought and practice had taken place. The paintings of the 1890s – especially the series – embody the results of a search for a method of working which had the fugitive, open, fresh, expressive qualities of the *pochade* but which would also serve as a method which could be used in a work over a period of days, months or even years – in fact, any period of time until he was satisfied with the result as a finished picture or "tableau." The question of finish gave him so much heartache that although the 1890s works were acclaimed by his contemporaries, Monet himself became melancholic and despairing about painting – as though the more powerful, impressive and full of knowledge his work became the more impotent he felt. It is just this combination of a seemingly free, intuitive and endlessly pursuable technique, with a profound inner sense of melancholic impotence that makes Monet, every bit as much as Cézanne, the prototype of the twentieth-century artist.

Before 1880 Monet had painted a vision of an ideal normality. After 1880 he became more restless, travelling all over France in search of what to paint, seeking out more and more desolate places and worse and worse weather. When he paints the tender Antibes paintings with their atmosphere of blue rose and gold he intends them to contrast with the savagery of the Belle Isle paintings which he sees as more in tune with his own character – brutal and solitary. This all culminates in the "awesome wildness" of La Creuse, the first paintings in the exhibition. Monet appears, in fact, to be double natured, on the one hand a Don Quixote innocently setting out to restore the golden age to the world, on the other, an Ahab driven by a terrible curse, across a pathless ocean, to meet the Unnameable.

The exhibition is Monet in the Nineties: The Series Paintings *at the Royal Academy, London, September 7–December 9, 1990.*

At this moment, 1890, he returns home to Giverny, setting out only to paint motifs "two or three steps from here." The real journeys, physical hardships and struggles with extremes of weather are all turned inward to

become the endless internal voyage of the series that was "continual torture . . . enough to drive one raving mad." His method, which had been changing and developing over many years had, by the 1890s, been completely transformed. A great deal of the colour one sees in the series paintings is thin surface colour put on over an extraordinary texture. It looks as if a great deal of the texture is paint of a light colour and often white. This texture is applied in all kinds of ways to create a very varied surface. Also a very complex procedure is used to get a great variety of colour into the different levels of texture in these paintings. It is clear that at the different stages of a painting – which may often have taken a year, sometimes much longer, to complete – Monet could not have been reacting to the light/ ambience in a direct *pochade* way. Only when the painting was complete was the *effet* achieved. So that although his 1890s goals of "instantaneity," "ambience" and "the same light spreading everywhere" sound like more sophisticated descriptions of a *pochade*'s *effet*, the method of achieving them was totally opposite in its nature.

This new method involves him in a much deeper and more complex consideration of the abstract and expressive modes of pictorial unity. But although the whole process was only completed by its final touches this does not imply that it was totally planned out. Monet was always determined that the thought-out composing side to it should not overwhelm the intuitive risk-taking one. He saw a constant danger that his paintings could become "overworked." This mixture of intuition, risk-taking and the courting of seeming chaos, leading to a unity expressive of a mysterious spiritual meaning (all of which was given wide publicity in the 1890s by his writer friends) together with a fear of overworking, was a powerful legacy to the twentieth century. In general though, twentieth-century artists, with one or two exceptions such as Matisse, did not associate these aspects of painting with the perceptual experience of the world which was all-important to Monet and his friends.

Kandinsky's famous delayed recognition of one of Monet's *Haystacks*, recorded in his *Reminiscences*, made him aware of its revelatory spiritual power coming, he thought, from colour and an unexpected, almost chaotic, wildness rather than the perception of nature. He paired this with his hearing of Wagner's *Lohengrin* as the twin experiences that shaped his life, and said that both realized something of his own vision of Moscow – which he described in both visual and musical terms. This musical pairing makes it possible that Kandinsky still had Monet's painting somewhere in the back of his mind when in the conclusion of *Concerning the Spiritual in Art* he calls for a new "Symphonic Composition." He proposed that such a composition should be "subjected to a principal form" that derived its "inner resonance" by being, as the *Haystack* had been for him, "hard to detect." He also listed three different sources of inspiration for it (surely deriving from his view of Monet): a direct impression of nature; a spontaneous and unconscious improvisation, and a slowly worked expression of inner feeling.

See page 320.

It was recognized by Monet's writer friends that in his late work symbolism and direct perceptual experience of the world meet. In the London series a number of his friend Mallarmé's images come together. The sensation of a largely unseen deep space recalls the "vast gulf carried in the mass of fog" in the poem *Toast Funèbre*. The poem continues: "'Memories of horizons, O you, what is the earth?'/howls this dream, and like a voice whose clarity fades/space takes for a toy the cry 'I do not know'." Another close symbolist friend, Octave Mirbeau, saw the London pictures in similar terms "of nightmare, of the dream, of mystery . . . of chaos . . . of the invisible." The series is full of images of a spiritual experience of nothingness and of impotence that are quintessentially twentieth-century concerns. Monet's Thames bridges that do not reach the banks and go from nowhere to nowhere, "between three districts whence the smoke arose/ . . . in the waning dusk," could surely be the modern desert strand where the

new Dante, the protagonist of "Little Gidding," meets his Virgil, who will "fade on the blowing of the horn."

The early *Water Lily* paintings are of a shady, secluded Narcissus pool. Such a pool as where Mallarmé's skiff in his prose poem *The White Water Lily* came to rest, where the "lustral" unseen feminine presence quietly bound him – an enthralled prisoner. "The virgin absence sprinkled in this solitude" evoked both by the reflecting water (her mirror) and the water lilies is, in Monet's pictures as in the poem, an unseen goddess of place. Those water lilies which "enclosing with their hollow whiteness a nothing" are "swollen with nothing except the exquisite emptiness of self."

See page 290.

The *Mornings on the Seine* series announce the theme of the later *Water Lilies* – the essence of whose motif Monet saw as "the mirror of water, whose appearance alters at every moment". What the mirror reflects, which causes it to alter at every moment is, of course, the sky. But why should the sky, that earliest and most famous of *plein-air* motifs, now only be seen by Monet indirectly, by reflection, as if the pool were Perseus's shield? In the twentieth-century tradition of absence and nothingness as the fundamental spiritual experience, Heidegger identified the image of the sky as the image of the absence of God – what Mallarmé had symbolized with the pool and the water lily. Monet is famous for being an uncomplicated, unspiritual atheist but Kierkegaard believed that the modern spiritual experience was most truly faced by unbelievers. In the later *Water Lilies*, Narcissus's pool seems to expand to an oceanic vastness, the unseen divinity of place metamorphosing into something wilder and grander, and in the very late *Japanese Bridges* Ahab's tumultuous terrors reappear.

To the extent that late Monet is concerned with the experience of spiritual absence and emptiness, he can be linked with the early twentieth-century masters of that theme – to Mondrian, Malevich and so on – and his use of the series as a form of endlessness may connect with their practice that painting as an activity by its nature happened in series.

Kandinsky's ideas had a very wide currency in the early part of the twentieth century and in particular they influenced Hans Hofmann, the prime mover of so much post-war art. Clement Greenberg, picking up on Gaston Bachelard's and André Masson's enthusiasm for late Monet (Masson in the early 1950s calling the *Orangerie* "the Sistine Chapel of Impressionism"), used Kandinsky's term "symphonic" to describe the structure he saw both in the late Monets and in the new Abstract Expressionism. Greenberg emphasized that the chromatic revolution of the nineteenth century – optical colour, the replacing of tonal contrasts by colour contrasts that had been the basis of so many of the major twentieth-century movements – had its real basis in Monet. He re-emphasized, no doubt prompted by Hofmann, the qualities Kandinsky had seen – wildness, looseness, the floating combination of surface and depth, unexpected unity and the power of colour. Both Greenberg and the Abstract Expressionists selected those qualities and utterly ignored what Clemenceau reported Monet telling him, that it was only by concentrating on "a maximum of appearances" that the closely correlated "unknown realities" could appear. But although the Abstract Expressionists clearly had very different aims to Monet, and were very selective in which late paintings to admire, the inspiration and confirmation they received from his late work is undeniable. Greenberg said in 1957 that the late *Water Lilies*, ignored by the avant-garde until the 1950s, "tell us once again that all canons of excellence are provisional." Since then his own canons of excellence that he tried so hard to establish – or more particularly the theory of them – has proved volatile to say the least. However, Greenberg is worth reading with interest instead of outrage, noting his sensitive appreciation rather than his polemic and accepting his proposal of Monet as "a modern master . . . (the creator of) . . . a world of variety and space."

See pages 329, 355, 351, 349.

INDEX

(n following page number indicates notes in margin; page numbers in italics indicate illustrations)